# Photography

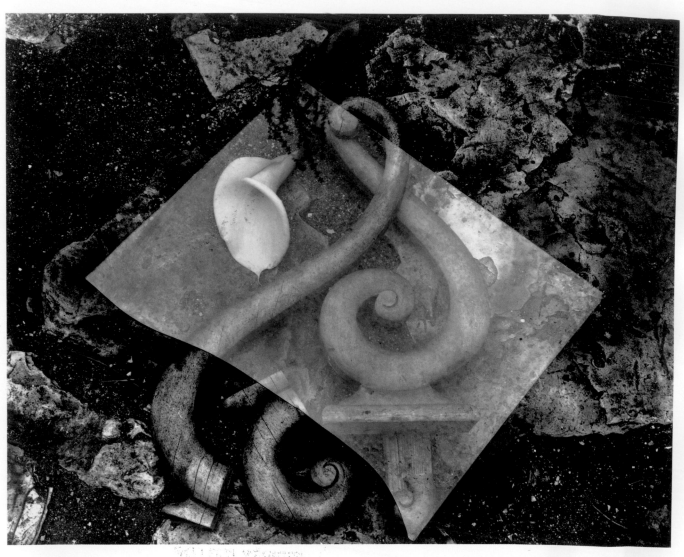

Edward Weston, *Lily and Rubbish*, 1939.

**Chapters 1, 4, 9, 10, 12, 17**

**Chapters 1, 2, 7, 8, 12, 15**

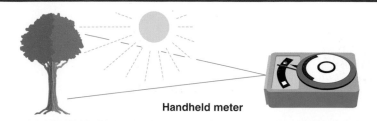

Handheld meter

**Chapters 1, 3, 7, 14, 15**

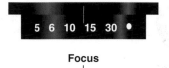

5  6  10  15  30  ●

Focus

**Chapters 1, 3, 4, 7, 8, 11, 14, 15**

**Chapters 1, 2, 3, 4, 5, 7, 8, 10, 11, 12, 13, 14, 15**

 Negative     or      Positive     or

Digital File

**Chapters 5, 7, 11, 12, 13, 14**

      or

**Chapters 6, 7, 11, 12, 13, 14, 16**

# PHOTOGRAPHY

SECOND EDITION

## BRUCE WARREN

**DELMAR**

**THOMSON LEARNING**

Australia Canada Mexico Singapore Spain United Kingdom United States

**DELMAR**
™
**THOMSON LEARNING**

Photography 2E
Bruce Warren

**Business Unit Director:**
Alar Elken

**Executive Editor:**
Sandy Clark

**Acquisitions Editor:**
James Gish

**Development Editor:**
Jeanne Mesick

**Editorial Assistant:**
Jaimie Wetzel

**Executive Marketing Manager:**
Maura Theriault

**Marketing Coordinator:**
Karen Smith

**Executive Production Manager:**
Mary Ellen Black

**Production Manager:**
Larry Main

**Art/Design Coordinator:**
Rachel Baker

**Cover Image:**
Bruce Warren

**Composition:**
Carlisle Communications

Library of Congress Cataloging-in-Publication Data
Warren, Bruce.
   Photography / Bruce Warren.--2nd ed.
     p.   cm.
   Includes bibliographical references and
     index.
   ISBN 0-7668-1777-6
   1. Photography. I. Title.
TR 146. W27 2002
771-dc21                          00-065869

## NOTICE TO THE READER

# Contents

# CONTENTS

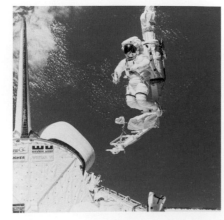

© NASA

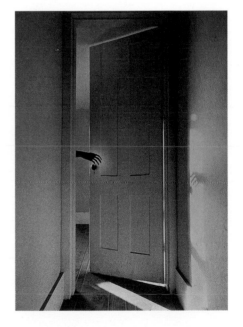

© Ralph Gibson

© Bognovitz

# CONTENTS

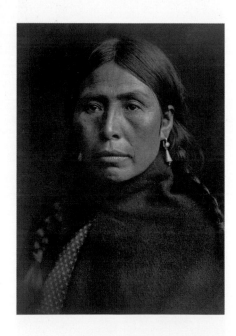

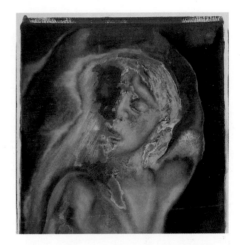

© John Reuter

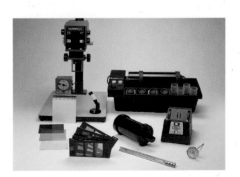

# CONTENTS

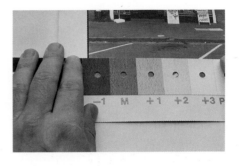

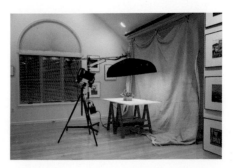

# CONTENTS

CONTENTS

# Preface

## Introduction

*Photography* is an introductory photography book that covers basic and intermediate materials, techniques, and concepts. Designed to serve as a textbook for one- and two-semester photography courses, it can also be used by the individual reader, making it an appropriate reference for all photographers. The text's hands-on approach emphasizes the experience of making photographs as a tool for learning. The balanced treatment of the varied fields of photography deepens the reader's understanding of photography as hobby, art, and profession. Black and white and color techniques are thoroughly covered in the text. New in the second edition are a chapter on digital photography and updated illustrations and technical information. There is also now a Web site associated with the book.

Over one thousand illustrations reinforce points made in the text and serve as inspiration. Exemplary photographs by well-known photographers, both contemporary and historical, demonstration photographs showing step-by-step procedures, and a wealth of drawings, charts, graphs, and tables help the reader to understand both the technical and aesthetic aspects of photography.

*Check out the Web site at http://www.delmar.com/photography/warren.*

## Coverage

The reader who is new to photography should begin making photographs immediately. Producing photographic images builds enthusiasm and provides examples of levels of technical control, aesthetics, and use of light.

- **Chapter 1: Getting Started.** Chapter 1 provides just enough technical and aesthetic information to allow the reader to operate a camera and a light meter.
- **Chapters 2–6: Mastering Skills.** Because mastery of the technical aspects of photography is necessary for success in all aspects of the art, the early chapters introduce readers to the tools and techniques of photography.
- **Chapter 7: Troubleshooting.** Chapter 7 is dedicated entirely to solving technical problems; clearly organized and illustrated troubleshooting charts help readers solve common problems and demonstrate methods of testing equipment.
- **Chapter 8: Working with Light.** Chapter 8 discusses the interaction of light and subject and introduces basic lighting techniques.
- **Chapter 9: Seeing Better Photographs.** The aesthetic aspects of photography are touched on throughout the early chapters, culminating in a detailed treatment of design and aesthetics in chapter 9.
- **Chapter 10: History of Photography.** With the technical and aesthetic information provided in the first chapters, the reader can more fully appreciate the history of photography, presented in chapter 10.
- **Chapters 11–17: Advanced Topics.** The second section of the book expands on ideas and techniques covered in the earlier chapters and addresses more advanced techniques and issues. Chapter 11 explains special effects that can be produced in the camera or in the darkroom. Basic information regarding color photography is integrated into the early chapters. Chapter 12 treats

color materials, techniques, and design in detail. Chapter 13 provides an introduction to digital photography. Chapter 14 gives an approach to previsualization and tone control, with exercises designed to establish personal standards of exposure, development, and printing. Chapter 15 provides advanced lighting techniques and shows their application by following step by step the use of light by working photographers on actual shoots. Chapter 16 discusses the presentation and display of photographs, and chapter 17 outlines how to get started in the field of photography, including the types of jobs available, markets for photographs, and marketing strategies.

## Using This Book

**Organization:** An important feature of *Photography* is its conception of photography as an integrated system of equipment, materials, and procedures, that leads from the original idea to the completed photograph. The book is organized according to this systematic approach, so that the reader always knows how a particular piece of information fits into the overall process.

**Overview:** An overview of the photographic process is provided inside the front cover; it can be used to find various topics within the book.

Color edge tab.

**Color Edge Tabs:** To make use of the color tabs at the right side of the diagram, flex the book with your thumb—the color tabs on the pages match the tabs at the front of the book. Chapter references are given below the tabs on the diagram.

**Glossary:** Within the chapters, the first appearance of each photographic term is in boldface type. These terms are formally defined in the glossary.

**Layered Information:** To prevent an overload of highly technical information, the material in this book is layered. Topics are introduced early in the text in simple form and are then covered in more detail in succeeding sections, chapters, or appendixes. Cross-references for most topics are included in the text or in margin notes. More technical and in-depth information has been placed in boxed sections, giving readers the opportunity to grasp the overall structure of a procedure or concept before exploring in more detail those that interest them most.

**Reading Lists:** Reading lists are included at the end of many chapters, and a complete bibliography appears at the end of the book, allowing further study of specific topics. Note that a number of the books listed are out of print or may be out of stock at their publishers. Nevertheless, they have been included since they are worthwhile and can be found in libraries or used book stores.

**Integrated Illustrations:** Photographs and illustrations (numbering over 1200) are essential components of *Photography*, and their captions are an integral part of the text.

**Notices:** Warnings and cautions, including health and environmental notices, are bulleted to reinforce their importance.

**Instructor's Manual:** An instructor's manual is available to adopters of this book. Prepared by Professor Eugene L. Edwards of Monroe Community College, it includes chapter overviews, outlines, learning objectives, recommended supplementary materials, and chapter tests.

**Web Site:** The Web site at *http://www.delmar.com/photography/warren* provides a valuable resource for students and instructors of photography. On the Web site you will find technical materials from this book for ready references when you are on the Web, handy links to valuable Web resources such as manufacturers of photographic products and photographers' Web sites, additional information about photography not to be found in this text, and galleries of photographic images for inspiration.

## Acknowledgments

A project of this complexity could not be completed without the help of many dedicated people. I would like to thank the professionals at Delmar Publishers for their work on the second edition, especially Jeanne Mesick, Developmental Editor; Rachel Baker, Art and Design Coordinator; and Larry Main, Production Manager. I would also like to thank the professionals at West Educational Publishing for their enthusiasm, patience, and hard work in making the first edition a reality, especially Clark Baxter, Acquiring Editor; Nancy Crochiere, Developmental Editor; Jeff Carpenter, Production Editor; Chris Hurney, Production Editor; and Kara ZumBahlen, Photo Researcher. A number of others also offered their time, support, and encouragement. Murray Bognovitz deserves special mention; he not only produced the commissioned photographs, but also invested endless hours of his own time in consultation and discussion and offered suggestions that made this book the best it could be. Others who contributed special effort include Joe Chiancone and Merle Tabor Stern. A large number of photographers, corporations, and individuals gave time and expertise to the creation of the illustrations. They are listed in the photo credits and the "Special Contributors" box on the next page.

The approach to teaching photography presented here owes a great deal to my experience as a faculty member in the photography program at Montgomery College. Many ideas came from countless meetings and discussions with my fellow faculty members, Tom Logan and Woods Price. The photography students who have passed through my classes also deserve thanks for their hard work and dedication, serving as inspiration and proving ground for my theories.

The present shape of this book also owes a great deal to the following reviewers, who took the time to carefully read and critique the first edition of the text.

C. Geoffrey Berken, Community College of Philadelphia

Arthur R. Bond, Calhoun State Community College

Eric Breitenbach, Daytona Beach Community College

Eugene Edwards, Monroe Community College

Dennis Grady, South Pomfret, Vermont

Gary L. Hallman, University of Minnesota

Jim Knipe, Radford University

Corinne McMullan, James Madison University

Tom Patton, University of Missouri–St. Louis

Kim D. Pickard, Northern Essex Community College

Neal Rantoul, Northeastern University

John W. Rettallack, Rochester Institute of Technology

Kevin Salemme, Merrimack College

Jon D. Spielberg, Community College of Philadelphia

Gerald A. Stratton, University of Cincinnati

Thomas Whitworth, University of New Orleans

Holly Wright, University of Virginia

Steve Zapton, James Madison University

The author and Delmar Publishers would also like to extend our heartfelt thanks to those who reviewed the text for the second edition. This reviewer panel provided invaluable comments and suggestions. Our thanks to:

Annu Palakunnathu Matthew, University of Rhode Island, Kingston, RI

Corinne Martin, James Madison University, Harrisonburg, VA

Al Wildey, University of Idaho, Moscow, Idaho

William G. Muller, Troy, NY

Harrison Branch, Oregon State University, Corvallis, OR

Richard Lane, Texas Christian University, Ft. Worth, TX

Dr. Charles Finley, Columbus State Community College, Columbus, OH

Jane Evans, Columbus State Community College, Columbus, OH

Bill Nieberding, Columbus State Community College, Columbus, OH

Norman E. Clevenger, Columbus State Community College, Columbus, OH

## Special Contributors

Several corporations and their representatives were particularly helpful in the creation of the commissioned photographs.

■ **Abbey Camera, Silver Spring, MD:** Robert C. Becker and David Brown
■ **Fuji Photo Film U.S.A., Inc.:** Harry Markel
■ **Ilford Photo Corporation:** R. Paul Woofter and Wendy Erickson
■ **Ken Hansen Photographic, New York:** Ken Hansen and Walter Lew
■ **Canon, U.S.A., Inc.:** Michael Sheras and Jim Rose

■ **Chrome, Inc., Washington, D.C.:** Theodore Adamstein
■ **Bogen Photo Corp.:** Lydia S. Thomas
■ **R & R Lighting, Silver Spring, MD:** Mary Ann Robertson
■ **Knoxville Museum of Art:** Stephen Wicks
■ **Distinctive Bookbinding, Inc., Washington, D.C. and New York**
■ **Seawood Photo, San Anselmo, CA:** Graham Law
■ **Phase One, Northport, NY:** Lisa Struckman
■ **Alfa Color, Gardena, CA:** Steve Trerotola

# PART I

# Basic Techniques

# CHAPTER 1

# Getting Started

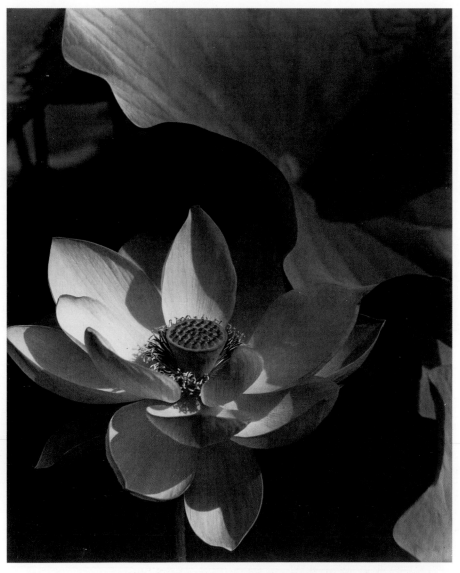

Edward Steichen, *Lotus, Mount Kisco, New York, 1915.*

Reprinted with permission of Joanna T. Steichen.

It is not difficult to take photographs. Billions of photographs are made by the public every year with successful results for their purposes. However, photography is a bit like sailing. With a little instruction it is not too hard to figure out how to get the boat to move, but it can take a lifetime to master all the intricacies. This chapter will give you just enough information to get moving. Once you have started producing photographs, you will probably want more information so that you can get even better results. Use the color edge tab guide to the photographic process on the front endsheets and the chapter references to locate more in-depth discussion of the steps covered in this chapter.

If things do not turn out as well as you expected, chapter 7 can help you with some possible cures for your problems. Mastering the technical details that make up the craft of photography is only the beginning. To make photographs that communicate your ideas or feelings, you will also have to learn the differences between human visual perception and the way photographs represent reality. The best way to do this is to start making photographs, but you will find some helpful suggestions for improving your photographic seeing in chapter 9.

## ■ Equipment and Materials

To begin making photographs you will need film, camera, and a light meter, either the one built into your camera or a separate meter.

## Film

Photographic film is a material that is sensitive to light. When a pattern of light falls on film, an image is produced. Chemical processing makes this image visible and useful for producing photographs. Any of the many types of film available, black and white or color, may be used for getting started. If you plan on processing your own film, black and white is simpler to process.

See chapter 2 for complete film information.

On the film box you will see a number labeled ISO. The higher this number is, the more sensitive the film is to light. A good starting film is one with an ISO between 100/21° and 400/27°. Several black-and-white films are available in this range:

See pages 16 and 33 for more on film sensitivity.

| ISO 100/21° | Kodak T-Max 100, Agfapan 100 Professional, Ilford Delta 100 |
| ISO 125/22° | Kodak Plus-X, Ilford FP4 |
| ISO 400/27° | Kodak Tri-X, Kodak T-Max 400, Agfapan 400 Professional, Ilford HP5, Ilford Delta 400, Ilford XP2 Super, Kodak Black and White +400 |

Ilford XP2 Super and Kodak Black and White +400 are black-and-white films designed to be processed in color print film developer (C-41).

Color films for prints in this range are offered by Kodak, Konica, Agfa, and Fuji, all available in ISO 100, 200, and 400.

For a more complete listing of films, see appendix G.

## Camera

A camera is basically a lighttight box that holds the film and has a lens that gathers light from the subject, forming an image of the subject on the film. Many different types, brands, and models of cameras are available. For the

See chapter 4 for information on camera types.

Aperture Control Ring Set at f/8.

For more on aperture see pages 30 and 81.

For more on shutters see pages 29 and 59–63.

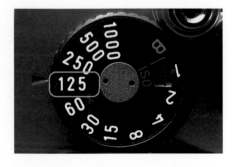

Shutter Speed Dial Set for 1/125 Second.

See pages 33–50 for complete information on light meter types and their uses.

purpose of discussing operation of the camera, we will use a basic 35mm camera, shown on page 5. This is a manual camera, meaning that you have complete control over all the settings. Other cameras may control some settings automatically.

For high-quality images the film must receive the proper amount of light, called the correct exposure. Two controls on the camera alter film exposure: the aperture and the shutter speed.

**Aperture**　The aperture is a variable-size opening in the lens, much like the iris in the eye. It is adjusted with the aperture ring. The numbers on the ring are an indication of the size of the opening and are called f-stop numbers. A standard series of f-stop numbers has been established:

$$1.4 \quad 2 \quad 2.8 \quad 4 \quad 5.6 \quad 8 \quad 11 \quad 16 \quad 22$$
More Exposure ←　　　　　→ Less Exposure

Contrary to what you might expect, larger f-stop numbers indicate smaller apertures, which admit less light. Setting the aperture at f/8 will give *less* exposure than setting it at f/4.

**Shutter Speed**　The shutter shields the film from the image formed by the lens until you are ready to take a photograph. When the shutter release (see "Locating Camera Parts," page 5) is depressed, the shutter opens for the amount of time indicated on the shutter speed control dial, which is marked with a set of standard shutter speeds in seconds:

$$1 \quad 1/2 \quad 1/4 \quad 1/8 \quad 1/15 \quad 1/30 \quad 1/60 \quad 1/125 \quad 1/250 \quad 1/500 \quad 1/1000$$
More Exposure (Slower Speeds) ←　　　→ Less Exposure (Faster Speeds)

On the shutter speed dial these are indicated as whole numbers, but the actual shutter speeds are fractions of a second. The longer shutter speeds give more exposure to the film: 1/30 second will give *more* exposure than 1/125 second. Some cameras may have longer or shorter shutter speeds in addition to the ones given on this scale.

## Light Meter

A reflective-type photographic light meter measures the amount of light coming from a subject and gives settings for the aperture and shutter speed to insure proper film exposure. Most small cameras made today have a light meter built into them. Separate light meters in their own housings—handheld light meters—are also available. A typical hand-held light meter is shown on page 9.

## ■ A Procedure for Taking Photographs

The following procedure explains how to make photographs with a manual camera. All cameras utilize the same controls, but the location and operation of those controls will vary, especially on cameras with automatic controls. If your camera is not like the one discussed, refer to your operator's manual to see how the controls on your camera correspond to the controls shown here.

Chapters 3 and 4 also help explain the operation of different types of light meters and cameras. If your camera can be set to completely manual operation, follow the procedures given here. Refer to the illustration below to locate controls.

## Locating Camera Parts

Vivitar V4000s 35mm Camera.

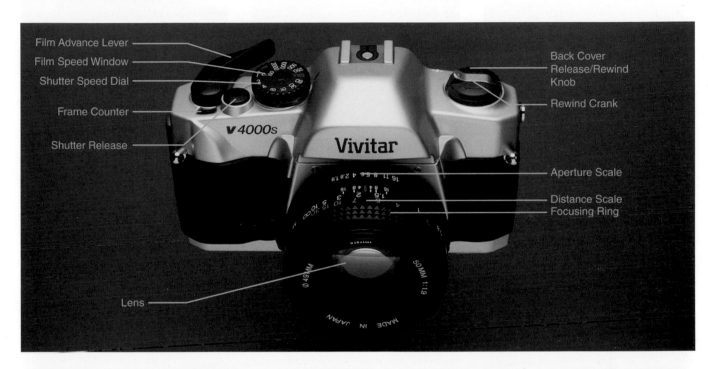

Film Advance Lever
Film Speed Window
Shutter Speed Dial
Frame Counter
Shutter Release
Back Cover Release/Rewind Knob
Rewind Crank
Aperture Scale
Distance Scale
Focusing Ring
Lens

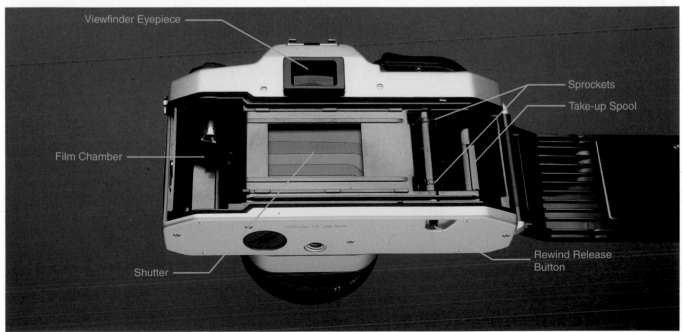

Viewfinder Eyepiece
Sprockets
Take-up Spool
Film Chamber
Rewind Release Button
Shutter

## Loading the Film into the Camera

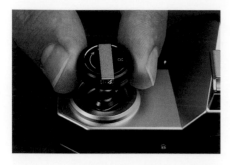

A. Pull up on the back cover release—rewind knob until the camera back pops open.

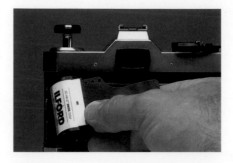

B. Leave the knob pulled up and insert the film cassette into the camera. The end with the spindle projecting should be toward the bottom of the camera. Do not expose the film cassette to direct sunlight.

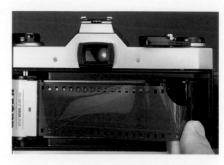

C. Push the back cover release—rewind knob all the way in, rotating it slightly if necessary. Insert the end of the narrow film leader firmly into one of the slots on the take-up spool.

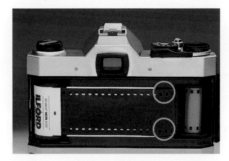

D. Operate the film-advance lever until the film is securely wrapped around the take-up spool and both edges of the film are engaged with the sprockets. If the film-advance lever will not move at any time during this procedure, press the shutter release and continue.

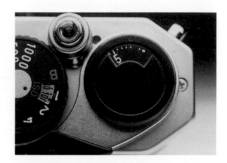

E. Close the camera back and press gently until it latches. Repeatedly press the shutter release and operate the film-advance lever until the frame counter reads 1.

## Developing Ideas for Photographs

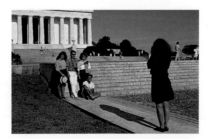

Most photographs are taken as a record of people, places, things, or events. Many other reasons for making photographs exist, and some of these are discussed in chapters 9 and 10. For now, photograph anything that interests you.

## Framing and Composing Your Photograph

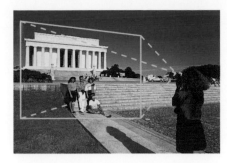

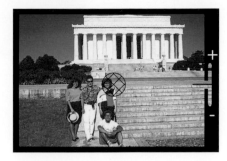

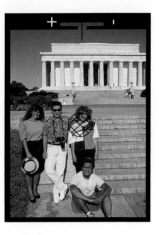

A. When you take a photograph, only part of what you see of the subject with your eyes will be included within the borders—the "frame"—of the photograph. To see what you are going to get in your photograph, look through the viewfinder of the camera.

B. If you have one central subject, move backward or forward until you have it framed as you want it. Make sure that other objects appearing in the viewfinder do not distract from the main subject. Unattractive backgrounds or strong shapes or patterns may draw attention from the subject. Move the subject to a better place if possible, or change your position for a different point of view.

C. Most cameras take a rectangular picture, so you can also turn the camera on end to get a different framing. This view shows the subject closer up with vertical framing.

## Evaluating the Light on Your Subject

Flex the book and look for red and orange edge tabs for information throughout the book on composing and lighting the subject. A complete guide to the color edge tabs can be found inside the front cover.

A. Start thinking about how the light falls on your subject, the quality of the light, the direction the light comes from, and the resulting pattern of light and shade on your subject.

B. The easiest way to control the light on your subject is to simply move the subject so that the light strikes it in a more desirable way. Other ways of controlling light are discussed in chapters 8 and 14.

# Metering and Setting Camera Controls: In-Camera Meter

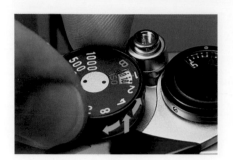

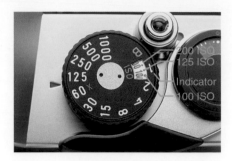

A. *Setting the ISO.* Set the number before the slash of the ISO into the film speed window labeled ISO by lifting up on the outer rim of the shutter speed ring and rotating it. On some cameras the film speed window may be labeled ASA, but the procedures are the same.

B. This dial is set for a film labeled ISO 125/22°. Note that not all numbers are marked on the scale. The two dots between the 100 ISO mark and the 200 ISO mark correspond to ISO 125 and ISO 160. (See page 33 for a list of ISO numbers.) Some cameras automatically set the ISO if DX coding is indicated in the film labeling.

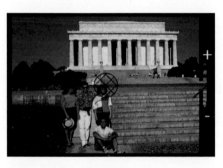

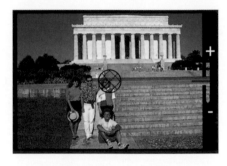

C. *Taking the Meter Reading.* Point the camera just as you will when you take the photograph. In this view through the viewfinder, the needle on the right indicates the amount of light coming from the subject, and it will rise with increasing light and fall with decreasing light. The meter needle also moves as the aperture ring and the shutter speed dial are changed.

D. *Setting the Camera Controls.* Keeping the camera pointed at the subject, change the shutter speed or the aperture settings or both until the needle is centered between the + and − signs. You will discover that several shutter speed and f-stop pairs will center the needle. All of these pairs give the same exposure to the film.

E. *Choosing Camera Settings.* The controls are now set for a shutter speed and f-stop pair of f/8 at 1/125 second. Reasons for choosing one pair over another are discussed in later chapters. For now stay with shutter speeds of 1/60 second or faster—for example, 1/125, 1/250, and so on—to reduce the possibility of image blurring due to camera movement. **NOTE:** You can set the aperture ring between f-stops to make the meter balance, but the shutter operates only at the marked speeds.

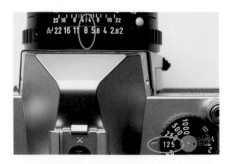

# Metering and Setting Camera Controls: Hand-Held Reflected-Light Meter

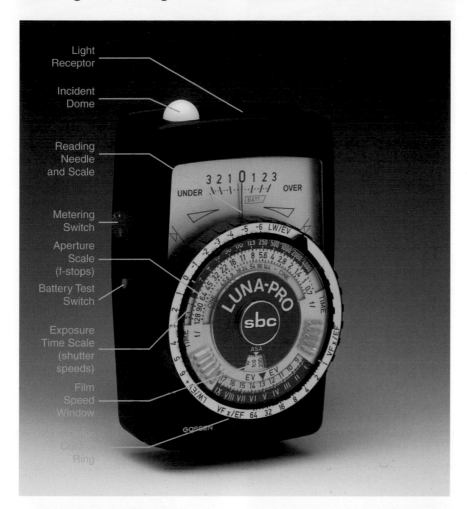

Light Receptor

Incident Dome

Reading Needle and Scale

Metering Switch

Aperture Scale (f-stops)

Battery Test Switch

Exposure Time Scale (shutter speeds)

Film Speed Window

Flex the book and look for yellow and green edge tabs for information throughout the book on measuring and controlling exposure.

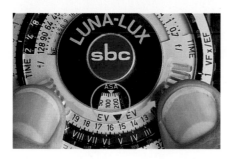

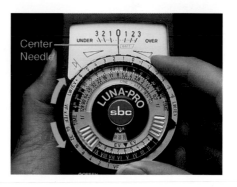

Center Needle

A. *Setting the ISO.* Set the number before the slash of the ISO into the window labeled ASA by rotating the inner dial of the meter calculator. Note that ASA has been superceded by ISO, but many meters are still marked ASA. Procedures are the same in either case. This dial is set for a film labeled ISO 125/22°. Note that not all numbers are marked on the scale. The two dots between the 100 ISO mark and the 200 ISO mark correspond to ISO 125 and ISO 160. (See page 33 for a list of ISO numbers.)

B. *Taking the Meter Reading.* Slide the white plastic incident dome to one side so that the light receptor is not covered. Holding the meter at the camera position, point the light receptor end of the meter in the same direction the camera will be pointing when the photograph is taken and push the metering switch to activate the meter. A common tendency is to tip the meter up to read the dial, in which case you are no longer metering the subject.

C. *Setting the Calculator.* The needle will move when the metering switch is pressed. While keeping the meter button depressed and the meter pointed at the subject, move the outer ring of the calculator dial as shown and you will see the needle moving with the dial. Adjust the ring until the meter needle is centered on zero. (Other types of light meters are discussed in chapter 3.)

*continued*

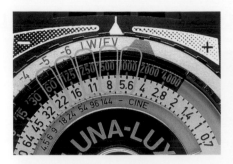

D. *Choosing Camera Settings.* Once the calculator dial has been set, you may choose any pair of shutter speed and f-stop that are matched on the calculator dial. Here f/11 is matched with 1/250 second. Set f/11 on the aperture scale of the camera and 1/250 second on the shutter speed dial. You could also set the camera for f/16 at 1/125 second or f/8 at 1/500 second or any other matching pair. The result in terms of the exposure will be the same. Choose a shutter speed of 1/60 second or faster to avoid image blur from camera movement.

E. If the shutter speeds and f-stops do not match up perfectly, choose a shutter speed and then set the aperture at the value indicated between the two f-stops. In this case, if the shutter speed is set at 1/250 second, then the f-stop should be set between f/8 and f/11. **NOTE:** You can set the aperture between f-stops, but the shutter operates only at the marked speeds.

## Focusing the Camera

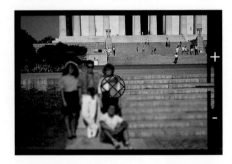

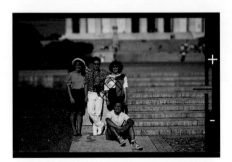

A. In the viewfinder, parts of your subject look sharp and clear, while other parts look blurred or fuzzy. This effect depends on the distance of the objects from the camera. The part of the subject that is sharp and clear is said to be in focus. Here the background is in focus and the people are not.

B. The distance at which the subject is in focus can be changed by turning the focus ring. You will be able to see the focus change if you watch through the viewfinder. Turn the focus ring until the part of the subject you think is most important looks sharp and clear in the viewfinder. Now the people are in focus and the background is not. (See chapter 4 for focusing methods on other camera types.)

C. The focus ring has a distance scale on it with a pointer, to tell you what distance will be in focus. Most cameras give this distance in both feet and meters, so be sure to read the correct scale. This camera is focused on 12 feet—a little less than 4 meters.

## Exposing the Photograph

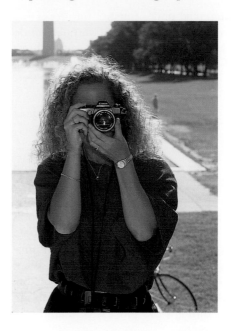

Check the focus and the framing of the subject. When you feel the moment is right, gently squeeze down on the shutter release to make the exposure on the film. To avoid blurring the image, steady the camera by holding your arms against your body and the camera against your face. After taking the photo, advance the film to the next frame with the film-advance lever.

Flex the book and look for blue edge tabs for information throughout the book on controlling the appearance of the image on your film by focus, filters, and other techniques.

## Rewinding the Film and Removing It from the Camera

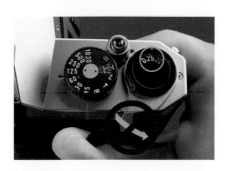

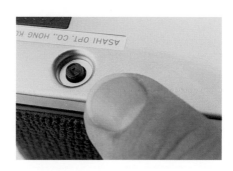

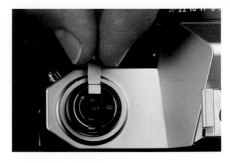

A. The number of exposures available on each roll of film is listed on its box. The film counter indicates the number of exposures you have made. After you have taken the last frame on a roll, you will be unable to advance the film. Do not force the film-advance lever.
■ **CAUTION** Do not open the back of the camera until the film has been rewound.

B. Turn the camera over and press the rewind release button on the bottom. If it does not stay in, hold it in with one finger while you perform the next steps.

C. Flip open the small crank on the back cover release–rewind knob.
■ **CAUTION** Do not pull up on the back cover release–rewind knob.
Slowly wind in the direction of the arrow until you feel the film release from the take-up spindle. If you listen carefully you can also hear the end of the film as it releases and winds into the cassette.

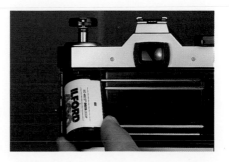

D. Pull up on the back cover release–rewind knob until the back pops open and remove the film cassette from the camera. Protect the film cassette from direct sunlight, heat, and moisture until you have it processed.

## Processing and Printing the Exposed Film

You can take your exposed film to a commercial photo finisher for processing and printing, or you can process and print the film yourself. If you plan to do your own processing and printing with black-and-white film, the procedures are given in detail in chapters 5 and 6. If you take the film to a photo finisher, it is more convenient to work with color film, since black-and-white processing and printing services are difficult to find.

## Evaluating Your First Results

If you have been careful in following directions, your first roll of film should give you good results. Look for technical quality in the prints: Are they sharp and clear? Do the tones or colors look as you expected? Now look for aesthetic qualities of each photograph: Is the subject framed in a way you like? Do extraneous distracting details appear in the print? Are the expressions of people in the photograph interesting or attractive? Do you like the way light illuminates the subject? Have you recorded an interesting moment of time? What kind of feelings or ideas do you get from the photograph? You will probably also like to find out what other people think of your images. The remaining chapters in this text will help guide you through the process of learning to make more interesting and exciting photographs.

# CHAPTER 2

# Film

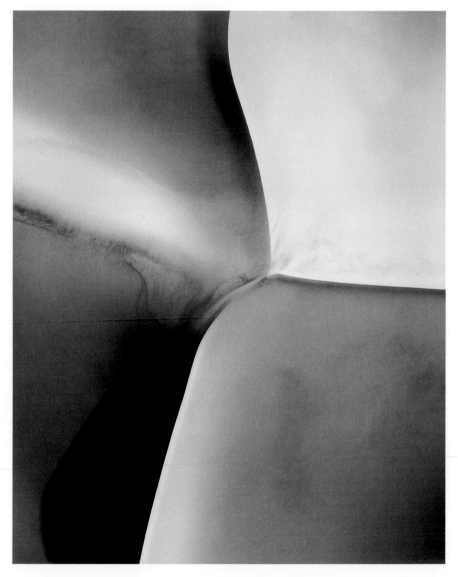

William A. Garnett, *Four-Sided Dune, Death Valley, CA, #2.*

© 1954 William A. Garnett.

## ■ Light-Sensitive Materials

It was the discovery that certain materials changed when struck by light that made photography possible. Silver salts—usually **silver halide** crystals, which are metallic silver in chemical compound with iodine, chlorine, or bromine—are the most commonly used light-sensitive (**photosensitive**) materials. When light strikes these silver salts, it reduces some of the salts to their components, giving metallic silver. Since silver in this form normally appears black, the light darkens the silver salt.

It takes a large amount of light to directly create a visible darkening of silver salts. For photographic purposes, this would mean a long exposure to the image formed by the lens on the film. Luckily, even small amounts of light create tiny specks of silver, which are not visible to the naked eye. The pattern of these invisible silver specks is called the **latent image.** The developing process causes more silver to be deposited around these latent image specks, creating a visible image composed of silver. The accumulated silver in the image is called **density.** The greater the amount of silver present in the image, the higher the density and the darker the appearance of that area of the image. The chemical development of the latent image gives usable photographic images with small amounts of exposure to light.

Since the effect of light is to turn the silver salts dark, the resultant pattern produced on the light-sensitive material is normally reversed from the tones of the subject. The result is a **negative image.** Through special development techniques—as with color slides—the silver image can be reversed again, resulting in a **positive image,** with the same tonal relationships as in the subject.

The support that carries the silver salts is called the **base** of the light-sensitive material. Two general types of base are used: photographic films use a transparent base; photographic prints use an opaque base, usually of paper.

For more information on photographic print materials, see chapter 6.

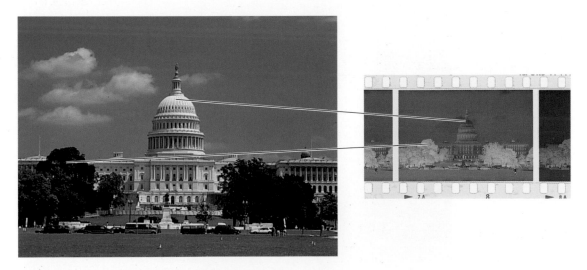

Note that the lighter parts of the subject are represented in the negative as dark tones, and the darker subject areas are represented as light tones.

## ■ Black-and-White Films

A simple photosensitive silver salt material will not show the colors of the original subject but will show only the shades of light and dark. These images are called **monochrome images,** or more commonly black-and-white images.

## Structure of Black-and-White Films

Silver salts will not adhere to a film base without a carrier, so the silver halide salts are mixed with gelatin to form an **emulsion,** which can then be coated onto the base. The gelatin also makes the silver salts more sensitive to the action of light. Certain dyes, called **sensitivity dyes,** are mixed with the emulsion to improve the film's response to some colors of light. Though only a few thousandths of an inch thick, the film contains several layers.

The manufacture of photographic film is a highly complex process. Many additional ingredients are used by manufacturers to improve the quality of the films. Mixing and coating of the emulsions are especially sensitive to contamination and environmental conditions. The emulsions are manufactured in large batches, which are generally consistent in quality, but small variations from batch to batch are unavoidable. Manufacturers identify each batch with an emulsion batch number, which is printed on each box of film. For critical work requiring strict film consistency from roll to roll, make sure all rolls are from the same emulsion batch and have been stored under the same conditions.

Emulsion Batch Number.

See pages 26–27 for information on film storage.

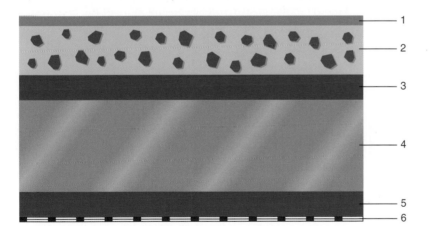

Enlarged Cross-Section of Black-and-White Film.

1. *Scratch-resistant Coating.* Helps to protect the emulsion from damage.
2. *Emulsion.* Silver halide crystals and sensitivity dyes suspended in gelatin.
3. *Adhesive.* Insures attachment of the emulsion to the base.
4. *Base.* Transparent, flexible cellulose acetate or polyester.
5. *Adhesive.* Attaches the antihalation backing.
6. *Antihalation Backing.* Contains absorbing dyes to reduce reflections from the back of the base that would create unwanted exposure on the film, called **halation.**

## Characteristics of Black-and-White Films

A number of characteristics of a film, such as sensitivity to light, grain structure, color sensitivity, contrast, exposure latitude, resolution, and acutance are determined in the manufacture of the film. Choice of film depends on how well these characteristics match the intended use of the film.

| ISO | ASA | DIN |
|------|------|------|
| 25/15° | 25 | 15° |
| 32/16° | 32 | 16° |
| 40/17° | 40 | 17° |
| 50/18° | 50 | 18° |
| 64/19° | 64 | 19° |
| 80/20° | 80 | 20° |
| 100/21° | 100 | 21° |
| 125/22° | 125 | 22° |
| 160/23° | 160 | 23° |
| 200/24° | 200 | 24° |
| 250/25° | 250 | 25° |
| 320/26° | 320 | 26° |
| 400/27° | 400 | 27° |

**Sensitivity to Light** Film sensitivity, also called film speed, indicates the amount of exposure required to produce a given amount of density in an image. More sensitive (faster) films require less exposure than less sensitive (slower) films to produce the same amount of density.

Various systems have been devised for measuring the sensitivity of film to light and assigning a number indicating the speed of the film. This film speed number is called the **exposure index.** In the United States, American Standards Association (ASA) numbers are most widely used. In Europe, Deutches Industrie Norm (DIN) numbers are used. The International Standards Organization (ISO) number combines the two systems. The number before the slash of the ISO number is the ASA. The number following the slash is the DIN. In all systems, the higher the exposure index number, the more sensitive the film to light. Films are generally categorized by speed:

| | |
|---|---|
| Slow | About ISO 50/18° or lower |
| Medium | About ISO 100/21° |
| Fast | ISO 200/24° to ISO 400/27° |
| Ultrafast | Higher than ISO 400/27° |

Full-frame Image.

**Grain Structure** The silver particles resulting from exposure and development in the film do not collect in a perfectly smooth fashion, but tend to gather in clumps. In the film this clumping is not visible to the naked eye, but when the image is magnified, as in printing, a granular texture called **grain** is seen. The size and appearance of this grain depend on a number of factors, including amount of exposure and amount and type of development, but the major influence on grain structure is the film itself. In general, faster films exhibit coarser grain. The T-grain emulsions—used in T-Max films—introduced by Kodak achieve higher sensitivity with finer grain by use of a silver halide crystal that is flatter and more tabular in structure, exposing more of the crystal surface to light.

40X Magnification of ISO 50/18° Film Image.

40X Magnification of ISO 125/22° Film Image.

40X Magnification of T-Max ISO 100/21° Film Image.

40X Magnification of ISO 400/27° Film Image.

**Color Sensitivity** Light is a form of energy, and our perception of its color depends on the particular wavelengths in the light (see the boxed section "Wavelength of Light"). The sensitivity of photosensitive materials to various colors of light may vary from the sensitivity of the human eye. Several categories of films with different color sensitivities are available:

*Panchromatic.* Panchromatic films are sensitive to all the colors visible to the human eye, but their sensitivity to individual colors varies somewhat from the

# Wavelength of Light

Light that is visible to the human eye is related to other forms of energy, including television and radio waves, radar, X rays, and gamma rays. All belong to the spectrum of electromagnetic energy. Visible light is only a tiny part of this spectrum. The energy in the electromagnetic spectrum is carried in the form of linked electric and magnetic waves. As these waves travel from a source, the energy increases to a maximum, then decreases to a minimum, and continues in this cyclical pattern. The distance the wave travels while going through one complete cycle is called the **wavelength.**

The characteristics of electromagnetic energy are determined by the wavelength. X rays have a very short wavelength—approximately 10 billionths of a centimeter—and gamma rays have even shorter wavelengths. Radio waves, on the other hand, can have wavelengths of several kilometers. The measuring unit used for the small distances in the middle of the spectrum is the nanometer, which is 1 billionth of a meter ($10^{-9}$ meter).

The visible portion of the electromagnetic spectrum is from 400 nanometers to 700 nanometers. The color we see in light is dependent on the wavelength, from violet at 400 nanometers to red at 700 nanometers. Mixtures of wavelengths are also seen as specific colors. A mixture of nearly equal amounts of all the wavelengths in the visible spectrum creates white light, which we see as colorless. When you see a rainbow or sunlight dispersed through a prism, you are seeing the component wavelengths or colors of the white light that is emitted from the sun.

The wavelengths adjacent to the visible spectrum, including infrared and ultraviolet, are important in photography even though invisible to the naked eye, since some films are sensitive to them. Most general-purpose films, both black and white and color, have some sensitivity to ultraviolet light, which is usually undesirable. Techniques for using filters to control ul-traviolet light are discussed on page 306. Special films sensitive to infrared are used for various scientific and creative purposes. ■

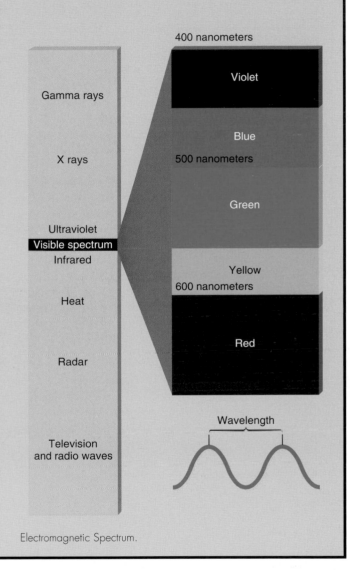

Electromagnetic Spectrum.

response of the eye. Panchromatic films are usually more sensitive to blue than to red, causing blues to reproduce somewhat lighter and reds darker in the print than expected. Panchromatic films also show some sensitivity to ultraviolet rays, which are invisible to the eye. Most general-purpose black-and-white films are panchromatic. Panchromatic films must be handled and processed in total darkness.

*Orthochromatic.* Orthochromatic films are sensitive to all colors but red, making them useful in graphic arts darkrooms where they may be used under red lights.

*Blue sensitive.* Blue-sensitive films are sensitive only to blue light and are safe to handle under yellow or amber light, making them useful in black-and-white copy work and lithographic work (the making of plates for printing).

*Infrared.* Infrared films are sensitive to infrared radiation near the visible spectrum. They are also sensitive to some visible light and must be used with special filters if only the effect of infrared is desired. Since infrared films are not sensitive to the long-wavelength infrared associated with heat, special imaging techniques must be used to record heat radiation.

Infrared films are discussed in more detail on pages 315–16.

**Contrast** The **contrast** of a film is the amount of density difference obtained for a given change in exposure on the film. Films that produce little density difference for relatively large changes of exposure are low in contrast. Since contrast may also be changed by altering the amount of development, films with inherently low contrast can produce images of normal contrast by being given more development. In general, slow-speed films have more inherent contrast than fast films and therefore usually require less development. High-contrast films are designed to produce only two tones, black and white, eliminating the intermediate tones of gray. These are used in graphic arts or for special creative effect.

For more on high-contrast images, see pages 317 and 323–25.

Print Made from Negative on Normal-Contrast Film.

© Bognovitz.

Same Subject Photographed with High-Contrast Film.

© Bognovitz.

**Exposure Latitude** **Exposure latitude** is the ability of a film to withstand overexposure or underexposure and still produce a usable image. The latitude for overexposure is usually greater than that for underexposure. In general, slow-speed films have less exposure latitude than fast films.

Note: Film resolution is not to be confused with lens resolution, which is discussed on page 67.

**Resolution** The **resolution** of a film is its ability to resolve fine detail, tested by exposing the film to a test target with closely spaced parallel lines. A high-resolution film can distinguish up to several hundred lines per millimeter, whereas a low-resolution film would distinguish fewer than fifty lines per millimeter. A film's resolution is dependent upon other factors, including the amount of exposure and development it receives.

**Acutance**   The **acutance** of a film is its ability to produce a sharp edge between two tonal areas in an image. Acutance is tested by placing a knife-edge on the film and exposing it to light. Thick, coarse-grained emulsions tend to diffuse the light around this edge, producing a less sharp image. Fine-grained films with thin emulsions will produce better acutance and thus more apparent sharpness in the final image.

**Characteristic Curve**   Imagine a test with a particular film on which successive exposures are made, starting with a very small amount of exposure, then doubling the exposure on each frame. When this film is developed, we would see a gradually increasing amount of density as the exposure increased. If we measured the density of each frame, we could make a graph of density versus exposure.

The curve shown here is typical, but a change in film, developer type, or developing techniques will change its shape. Since these curves are characteristic of particular film and developer combinations, they are called **characteristic curves.** Most manufacturers publish characteristic curves for their films. The appearance of a film's curve can give photographers information about how that film reacts to varying amounts of exposure and development.

See appendix D for more information on characteristic curves.

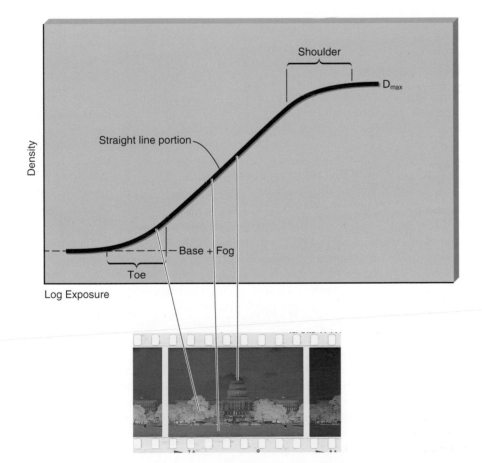

*Characteristic Curve.* This graph shows that the increase in density is not always the same for a doubling of exposure. The area labeled the **toe** on the curve shows a very small change of density with exposure. The **straight-line portion** shows a greater change of density with exposure. In the **shoulder,** the density change becomes small again, gradually leveling out.

## ■ Chromogenic Films

**Chromogenic films** are monochromatic—black-and-white—films designed to be processed with standard color print film chemistry, called C-41. Since C-41 processing is widely available at photofinishing labs, chromogenic films offer a black-and-white negative without the need to process it yourself. The most commonly available chromogenic films are Ilford XP2 Super and Kodak Black and White +400. Chromogenic negatives may be printed on black-and-white papers as described in chapter 6.

## ■ Color Films

For more detailed information on color photography, see chapter 12.

Color films are also based upon the use of silver halide emulsions, but since the silver itself does not have any color, dyes must be introduced into the film to reproduce the color we see in the subject. The following information is enough to allow you to choose and use color films.

## Positive and Negative Color Film

Two basic types of color film are available. **Color negative film,** or color film for prints, produces on the film an image that is reversed in both tone and color. When a color negative is printed directly onto color printing paper, a color positive print is obtained. **Color positive film,** or color film for slides or transparencies, produces a positive transparency suitable for projection. Using special processes, color prints can be made from transparencies, but they are more expensive than those from color negatives.

## Color Balance

The light from various light sources does not always contain the same mix of colors as the white light from the sun. Even sunlight can vary in color, depending upon the time of day or year and the weather conditions. This is not a problem for people in everyday life, because the brain has the capability to adjust for the color of the illumination so that the colors of objects look normal to our eye. Unfortunately, color films do not have this ability, so films must be manufactured for a specific color of light. This is called the **color balance** of a film.

Most color films are **daylight balance,** designed for use with daylight illumination—average direct sunlight in the middle of the day. If daylight balance film is used with illumination of a different color, that color will show in the resulting image. Light from household tungsten bulbs has a higher percentage of yellow or orange light than daylight, producing orange-tinted prints or slides with daylight films. Fluorescent lights usually have more green than daylight and will produce green prints or slides. If warned, some processing labs can correct somewhat for these problems when printing color negatives, but the color balance of slides cannot be corrected in processing.

A few films are designed for use with nondaylight sources. The most commonly available are **tungsten balance** films, designed to give correct color rendition with the tungsten light used in professional photography studios. Tungsten films will also give better results than daylight films with household tungsten lights. It is also possible to correct the color of the illuminating light with filters.

See pages 342–43 for more on color filters.

Daylight Film with Daylight Illumination.

Daylight Film with Tungsten Illumination.

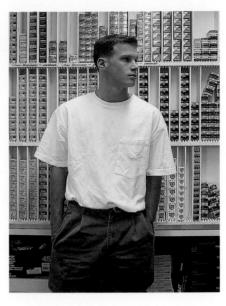

Daylight Film with Fluorescent Illumination.

## Characteristics of Color Film

**Sensitivity**   Color film sensitivity or speed is rated using ISO numbers, just as with black-and-white film.

**Grain**   As in black-and-white film, increasing speed means coarser grain. Color positive films generally have finer grain than color negative films of the same speed.

**Exposure Latitude**   Color negative films can withstand some underexposure or considerable overexposure and still produce usable images. Color positive materials have little exposure latitude—sometimes as little as one-half stop each way—and require extremely accurate exposure to achieve good results.

## ■ Instant-Print Film

Instant-print films give a finished print on the spot. Polaroid pioneered these materials, and they are now available in black and white or color and in several different formats. Some instant-prints develop right before your eyes. One type of professional black-and-white Polaroid produces both a positive print and a negative that can then be printed by standard enlarging techniques. Polachrome is an instant color slide film that can be exposed in a normal 35mm camera and then processed on the spot.

Some of the available Polaroid instant materials are listed in appendix G.

William Wegman, *Sweatered Trio*, 1990, from "Kibbles 'n Knits," 20″ × 24″ Polaroid.

© 1990 William Wegman. Courtesy of Pace/MacGill Gallery, New York.

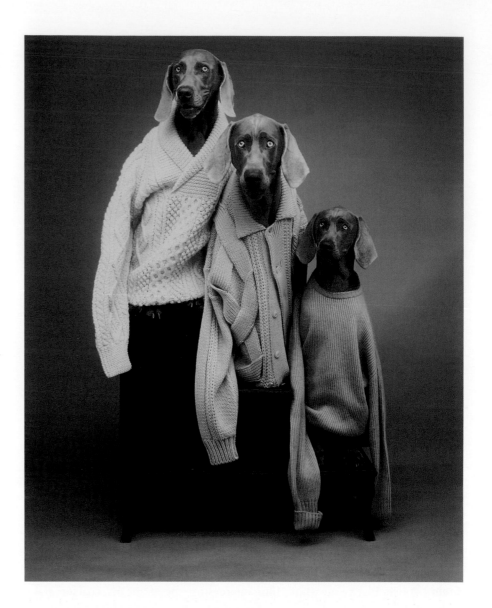

The advantages of having the results in a few seconds or minutes are obvious. Photographers use Polaroid materials to check lighting setups, which they then photograph using regular films. Polaroids are also useful as proofs to show a photographer's client how the finished photograph will look. A number of photographers are also using instant-print materials as the finished photographic product.

## ■ Film Formats and Packaging

The size of the image produced on a film, called the **format size,** varies from just a few millimeters up to 4 × 5 inches and larger. Format size is determined by the camera design. The same film size may be used by cameras of different image formats, but the size of the film obviously limits the maximum format size possible.

See pages 52–53 for detailed information on film formats.

The packaging of a film protects it from light and usually also holds the film for use in the camera. Strips of film allowing several exposures are pack-

aged in lighttight metal or plastic cartridges or cassettes or are wrapped together with opaque paper backing on spools. Manufacturers have standardized on a few combinations of film sizes and packaging, specified by a code number, name, or actual size. Some of these are shown in the illustrations on the next page.

## ■ Film Selection

A great variety of brands, types, sizes, and packaging of films is available, with new films introduced regularly. No single film will serve for all purposes, so the type of photography you do will govern your choice of film. Subtle differences in the tonal or color qualities of a film may also determine a choice for aesthetic reasons. Preliminary choices can be made on the basis of the manufacturer's description of the film's qualities or by referring to film tests periodically published in photography magazines. To decide which film is best for you, test different films yourself under the conditions you plan for use.

*See appendix G for a partial listing of the many films available.*

## Color versus Black-and-White

Black-and-white photographs are more of an abstraction of a subject than are color photographs, and some photographers feel they more readily convey drama or allow for creative interpretation of the subject. Color, on the other hand, gives more information about the subject and can carry its own aesthetic messages. A photojournalist who is photographing for black-and-white reproduction in a daily newspaper may choose a black-and-white film, whereas a photojournalist who may be published in either black and white or color may choose color film, converting the color photograph to black and white through darkroom techniques when necessary. The demand in portrait or wedding photography is predominantly for color photographs, with only a few photographers offering black-and-white prints.

## Color Negative versus Color Positive

The desired final image presentation is usually the determinant in a choice between positive or negative color. If the end result is to be a color print, either material can be used. Prints from color negatives are cheaper. Prints from slides have better sharpness, more brilliant color, more resistance to fading, and generally longer print life, though in recent tests one negative print material (Fuji Crystal Archive) showed better permanence than any other traditional print material, negative or positive. Slide films have finer grain for equivalent film speed.

A great deal of color reproduction in magazines for advertising and editorial work is done from color transparencies, so photographers doing advertising, fashion, travel, and similar work normally use color positive films. Photojournalists who work under difficult conditions may prefer color negative films for their greater exposure latitude. Wedding photographers prefer color negative films for the lower print costs and greater exposure latitude.

If the end result is to be a projected image, as in slide shows, then a color positive film should be used. Films that provide both slides and prints—actually designed for movies—are color negative films, with the slides produced from the negatives. As a result, these slides cannot match the quality of original slides from a color positive film.

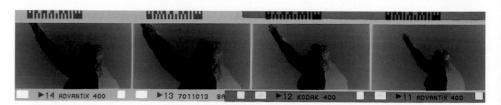

*Advanced Photo System (APS) Film.* Advanced Photo System (APS) film is packaged in a self-contained cartridge. **Cartridges** are inserted directly into the camera and require no handling of the film itself. After processing, APS films are returned to the consumer still in the self-contained cartridge, so the film is never handled directly. APS films also incorporate special features, such as a choice of formats (including panoramic) and a magnetic strip for data recording.

*135 Film.* Commonly called 35mm film, 135 film is 35mm in width with sprocket holes on both sides, packaged in cassettes for twelve, twenty-four, or thirty-six exposures. **Cassettes** require a take-up spool in the camera. The film must be rewound into the cassette after use. 35mm film is also available in long rolls—**bulk film**—which can be cut into strips and loaded into reusable cassettes. Bulk loading reduces film costs, but the extra handling required gives a higher risk of scratches or damage to the film.

*120 and 220 Films.* The 120 and 220 films are packaged as **roll film,** which is a strip of film for several exposures rolled with protective opaque paper onto a spool. Roll films are threaded onto a removable take-up spool in the camera. The exposed film is taken from the camera on the take-up spool, and the original spool then becomes the take-up spool for the next roll of film. The film—60mm in width with no sprocket holes—and spool are identical for 120 and 220, the difference being that the opaque backing continues throughout the roll for 120 but consists only of leader and trailer taped to the 220 film, allowing twice as many exposures on 220.

*4 × 5 and Larger Films.* Film sizes 4 × 5 inches and larger are commonly available only as sheet film. **Sheet film** comes as individual sheets, one for each exposure, packed in a lighttight box and must be loaded into lighttight film holders or magazines for use. Unprocessed film must be handled in total darkness.

## Film Speed

Choice of film speed depends upon the amount of light illuminating the subject, the desired camera settings (shutter speed and aperture), and the desired fineness of grain. Although faster film speeds give faster shutter speeds or smaller apertures, they also produce coarser grain. The general rule is to use the slowest possible film that will give the needed shutter speed and f-stop settings for the available illumination.

## ■ Film Care and Handling

Photographic films are relatively fragile and require care in handling and storage. The proper techniques are the same for unexposed and exposed films; however, exposed films should be processed as soon as possible for best results. If exposed films must be held for some time before processing, the tips for longer storage given below will help preserve the latent image. In general, color films are more sensitive to storage conditions than are black-and-white films.

## Film Storage

Several environmental conditions can affect film quality:

**Humidity**   Exposure to high relative humidity or liquids is damaging to film. The moisture-proof packaging should not be opened until a film is loaded into the camera. After exposure, the film should be stored in a moisture-proof container. 35mm film usually comes in a small plastic can, which can be reused for moisture protection. Zip-loc plastic bags can be used to protect films whose foil packets are destroyed by opening.

**Temperature**   Higher temperatures cause deterioration of film; lower temperatures—the lower the better—maintain the condition of film. Do not leave film or loaded cameras in automobiles, where in the summer temperatures can soar. Films can be frozen in home freezers or kept in refrigerators to extend their useful life. Films labeled Professional require refrigerated storage to maintain optimum quality.

**Warm-up Times for Refrigerated Photographic Film (in Hours)**

|  | FROM 35°F TO 70°F | FROM 0°F TO 70°F |
|---|---|---|
| One roll (35mm, 120, 220) | 1 | 1½ |
| Bulk roll (35mm, 100 ft) | 3 | 4 |
| Sheet film (10-sheet box) | 1 | 1½ |
| Sheet film (100-sheet box) | 3 | 4 |

■ **CAUTION** Refrigerators and freezers contain high humidity, so films *must* be in moisture-proof packages before they are refrigerated or frozen. Allow films to warm up to room temperature before opening to prevent condensation of moisture on them.

**Accidental Exposure to Light** Accidental exposure of unprocessed film to light causes **fogging** of a film, giving undesirable streaks and ruining images. Be careful not to disturb the lighttight packaging of the film. Although a film may be packaged for "daylight" loading, cassettes, cartridges, roll film, and sheet film holders should not be exposed to the direct rays of the sun but should be handled in subdued light. If forced to load film into a camera in direct sunlight, do so in the shadow of your body if no other shade is available.

■ **CAUTION** General-usage films removed from their lighttight containers for processing or other purposes must be handled in total darkness.

**Exposure to X rays** The use of X-ray devices at airports and other high-security locations puts film at risk. Even though security personnel may claim that the machines are safe, all photographic films are sensitive to X rays and can be fogged, especially with repeated exposure. Fast films are particularly susceptible to X-ray damage. Hand inspection is the best protection for your film. Most U.S. airports will hand inspect on request, but many areas in the world with high security risks will not. An alternative is to place your films and loaded cameras in lead-foil bags—available at camera stores—which offer some protection from X-ray exposure. Checked baggage is also often subjected to X-ray inspection.

**Age** Although proper storage extends film life, over time a film will deteriorate. Manufacturers stamp an expiration date on the film package. This is an estimated date for which the film retains optimum quality with "average" storage conditions. For normal or "amateur" films, this means storage in the original packaging at normal room temperatures. For professional films, it means refrigerated storage according to the directions. Storage of any film in a freezer at 0°F can extend the usable life well past the expiration date.

## Film Handling

Photographic films are sensitive to scratching and fingerprints. Take care that the image-bearing surfaces of a film are not touched or rubbed against abrasive surfaces. This caution applies before and after processing of the film. Film can also be scratched by dust or dirt inside the camera. Keep the camera clean as instructed in chapter 4.

See page 83 for methods of cleaning.

When advancing or rewinding film, use a slow, steady motion to prevent static electricity discharge from marking the film. Dry weather increases the possibility of static discharge.

See page 168 for an example of static discharge.

# Exposure and Meters

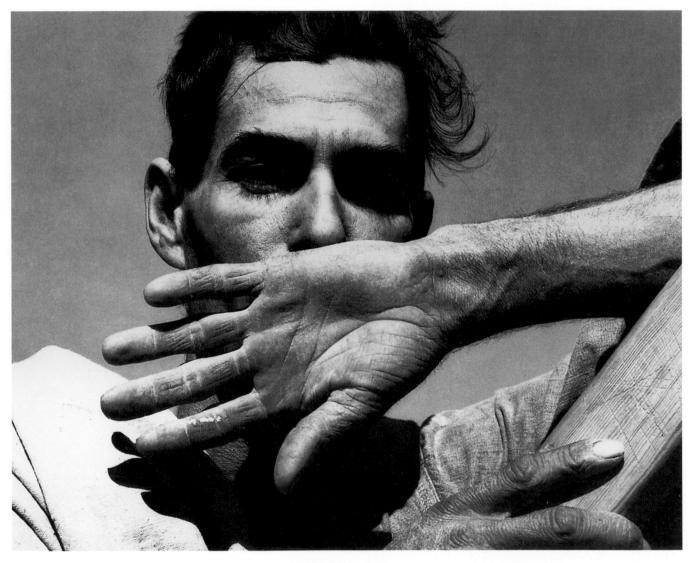

Dorothea Lange, *Migrating Cotton Picker, Eloy, Arizona, 1940.*

© The Dorothea Lange Collection, The Oakland Museum of California, The City of Oakland.
Gift of Paul S. Taylor.

A major factor in making photographic images of good technical quality is the amount of exposure to light the film receives. To achieve correct exposure, we must be able to measure and control it. The primary tool used to determine film exposure is the photographic light meter. To understand its operation, we need to clearly define film exposure and the factors that change and control it.

## ■ Film Exposure

The definition of exposure can be given as a formula:

$$\text{Film exposure} = \text{Illuminance of image on film} \times \text{Time}$$

"**Time**" is the length of time the image is allowed to fall on the film, normally equal to the time the shutter is open (the shutter speed). An exception is when the duration of the light source is shorter than the shutter speed, as with electronic flash.

"**Illuminance**" is the amount of light falling on a surface, in this case the image formed on the film from light coming from the subject. Any factors that change the amount of light coming from the subject will also change the film exposure. The amount of light reflected from the surface of the subject is called the **luminance** and is affected by two variables:

1. The **illumination,** which is the amount of light falling on the subject
2. The **reflectance,** which is the ability of the surface to reflect light

The amount of light reaching the film is also altered by passage through the lens, particularly by the size of the aperture. In addition, losses occur in the lens due to absorption and internal reflections, but with modern lenses these have been minimized and standardized to the point that they can be considered as a constant built into the system.

A simple statement summarizes this information: *Film exposure depends upon* **subject luminance** (*illumination and reflectance*) and **camera settings** (*f-stop and shutter speed*). If we wish to get correct exposure we must be able to measure or control all of these factors.

## Camera Settings and Exposure

Film exposure can easily be controlled by adjusting the shutter speed and f-stop settings on the camera.

**Shutter Speed**  Shutter speed dials are marked with standard shutter speeds in seconds:

| 1 | 1/2 | 1/4 | 1/8 | 1/15 | 1/30 | 1/60 | 1/125 | 1/250 | 1/500 | 1/1000 |
|---|-----|-----|-----|------|------|------|-------|-------|-------|--------|

More Exposure (Slower Speeds) ←      → Less Exposure (Faster Speeds)

Some cameras may have additional speeds at either end of this scale. Most cameras also have a B setting. When the shutter speed control is set on B, the shutter remains open as long as the shutter release is held down, allowing times longer than those marked on the scale.

A simple mathematical relationship exists between numbers of this scale: Each shutter speed is half the preceding one. Since film exposure depends directly on the time the shutter is open, we alter the film exposure by a factor of

NOTE: For purposes of having neat-looking numbers, some of the speeds have been rounded off—1/15 second should technically be 1/16 second and so on—but for practical purposes we can say that each shutter speed is half the one before it.

See page 74 for the origin of these f-stop numbers.

two each time we move the shutter speed dial one step: 1/125 second gives half as much film exposure as 1/60 second and 1/8 second gives twice as much film exposure as 1/15 second. The faster speeds give less film exposure, each step dividing the exposure by a factor of two. The slower speeds give more film exposure, each step multiplying the exposure by a factor of two.

**Aperture**   The aperture is a variable opening in the lens consisting of an iris-type diaphragm. The size of the aperture is controlled by a ring with **f-stop numbers,** also called f-numbers, marked on it.

A standard scale of f-stop numbers is used:

<div align="center">

1    1.4    2    2.8    4    5.6    8    11    16    22    32

More Exposure (Opening Up) ←        → Less Exposure (Closing Down)

</div>

The smaller f-stop numbers give *more* exposure because they actually represent *larger* apertures. The f-stop numbers have been chosen so that changing one step on the scale changes the film exposure by a factor of two, just as it does on the shutter speed scale: f/8 gives twice as much film exposure as f/11 and f/5.6 gives half as much film exposure as f/4. **NOTE:** Some lenses have click stops between the numbers to allow half-f-stop settings.

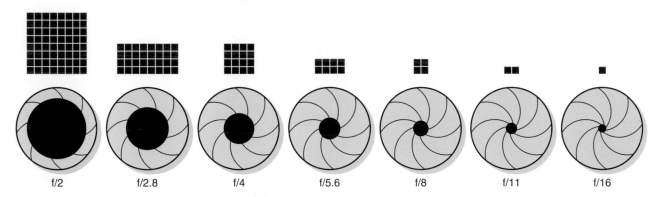

|     |     |     |     |     |     |     |
| --- | --- | --- | --- | --- | --- | --- |
| f/2 | f/2.8 | f/4 | f/5.6 | f/8 | f/11 | f/16 |

*Relative Size of the Aperture at Different f-stops.* The squares show the relative area of the aperture. Note that the area of each aperture is half the area of the preceding aperture, which explains why the amount of light passing through the aperture is reduced by half for each step on the scale.

**The Stop as a Measurement of Exposure**   When the aperture scale is moved one step, the exposure is changed by a factor of two. This is called a change of one **stop** in exposure. The terminology used by photographers is this:

<div align="center">

Doubling the exposure = **Opening up** one stop

Halving the exposure   = **Closing,** or **stopping, down** one stop

</div>

The exposure can be doubled in two ways:

**1.** Move the aperture ring to the next-larger aperture (next-smaller f-stop number)—for example, from f/8 to f/5.6.
**2.** Move the shutter speed dial to the next-slower shutter speed—for example, from 1/250 second to 1/125 second.

Likewise, the exposure can be halved by either moving to the next-smaller aperture (next-larger f-stop number) or moving to the next-faster shutter

speed. The effect on the film exposure is the same, and although technically the term *stop* applies only to the aperture, it is commonly used to describe exposure changes made with the shutter speed as well. **NOTE:** Some lenses have f-stop numbers that do not appear on the standard scale, such as f/1.2, f/1.7, f/1.8, f/3.5, and f/4.5. These f-stop numbers represent fractional stops of exposure change. Moving the aperture ring from f/2.8 to f/1.8 increases the exposure 1 1/3 stops, not one stop.

Since the change in exposure for each stop is a multiple of two, the exposure increases or decreases as a power of two:

*See appendix C for a complete list of fractional f-stop values.*

| CHANGE IN CAMERA SETTING | CHANGE IN FILM EXPOSURE |
|---|---|
| Open up one stop | $2\times$ |
| Open up two stops | $2\times2 = 4\times$ |
| Open up three stops | $2\times2\times2 = 8\times$ |
| Open up four stops | $2\times2\times2\times2 = 16\times$ |
| Close down one stop | $1/2\times$ |
| Close down two stops | $1/4\times$ |
| Close down three stops | $1/8\times$ |
| Close down four stops | $1/16\times$ |

**Shutter Speed and F-Stop Combinations**   Since both shutter speed and f-stop scales are based on factors of two, the same film exposure can be achieved with a number of different shutter speed and f-stop pairs. A camera setting of f/8 at 1/60 second produces the same exposure on the film as a camera setting of f/5.6 at 1/125 second because f/5.6 gives twice as much exposure as f/8 but 1/125 second gives half as much exposure as 1/60 second. The end result is the same. This procedure can be continued to give a set of pairs of shutter speed and f-stop settings, known as **equivalent exposure settings,** any one of which will produce the same film exposure. Achieving correct exposure on the film can be compared to filling a bucket with water, as seen below.

Normally the different shutter speed and f-stop pairs that produce equivalent film exposure also produce the same density on the film, a fact known as the **reciprocity law,** which states: *The effect of exposure on the film—that is, the*

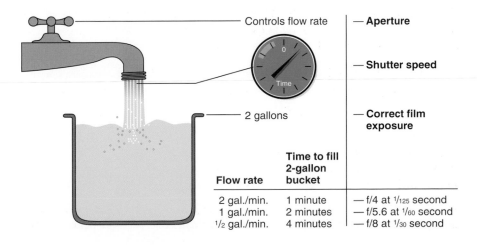

| | Flow rate | Time to fill 2-gallon bucket | |
|---|---|---|---|
| | 2 gal./min. | 1 minute | — f/4 at 1/125 second |
| | 1 gal./min. | 2 minutes | — f/5.6 at 1/60 second |
| | 1/2 gal./min. | 4 minutes | — f/8 at 1/30 second |

Controls flow rate — **Aperture**

— **Shutter speed**

2 gallons — **Correct film exposure**

The amount of water in the bucket (the amount of film exposure) can be controlled in two ways: the flow rate can be controlled with the faucet (the aperture), and the time the faucet is left on (the shutter speed) can be varied. If the bucket holds 2 gallons, we can fill it just to the top in many different ways. With a flow rate of 2 gallons per minute, it will take 1 minute to fill the bucket. At 1 gallon per minute, it will take 2 minutes to fill the bucket. You can continue halving the flow rate if you remember to double the time. All the combinations in the chart give the same result—a full bucket—just as all the equivalent exposure settings give the same amount of exposure on the film.

See pages 43–44 for reciprocity failure corrections.

*density—is the same, regardless of the rate at which the exposure is given.* In other words, the density due to a particular image illuminance and time will be the same as the density due to that image illuminance halved and that time doubled. The use of equivalent exposure settings depends upon the reciprocity law. However, the reciprocity law fails at long or very short exposure times, giving less density than expected. Reciprocity failure may be corrected by increasing the exposure time or aperture.

## Effects of Film Exposure Changes

The negatives below show effects of changing the film exposure. The overall density, or darkness, of the negative increases as the exposure increases. Negatives of low density are said to be **thin.** A more important change can be seen in the areas of the negative representing the dark tones of the subject—often called the "shadow" areas—which are the less dense, or lighter, areas in the negative. As exposure is decreased, these areas begin to lose detail, which is the visible evidence of texture or pattern.

The "best" or **optimum exposure** is the least exposure that retains detail in the areas representing the dark tones of the subject. Negatives receiving less than this optimum exposure are **underexposed** and show loss of detail in the dark subject tone areas. Prints made from underexposed negatives will also show a reduction of contrast, which is the difference between the dark and light tones of a print.

An **overexposed** negative received more than the optimum exposure and shows good detail in the dark tone areas but has unnecessarily high overall density. This produces coarser grain in the image and longer printing times when prints are made from the negatives. If the film is overexposed enough, detail will be lost in the areas representing the light tones of the subject—often called the **highlights**—and sharpness of the image will deteriorate. Loss of detail in the light subject tone areas of the negative due to overexposure is called **blocking up of highlights.**

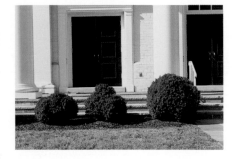

Original Subject.

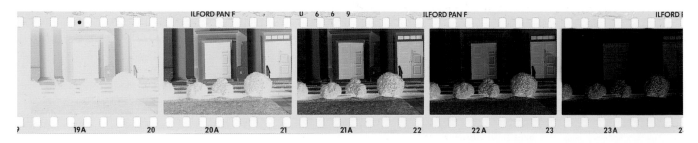

Four Stops Underexposed.   Two Stops Underexposed.   Optimum Exposure.   Two Stops Overexposed.   Four Stops Overexposed.

Underexposure:
- Low overall density of the negative (thin)
- Loss of detail in dark subject tone areas
- Reduction of contrast in negative and final print

Optimum exposure:
- Proper detail in dark subject tone areas
- Reasonable printing times
- Finer grain than with overexposed negatives

Overexposure:
- High overall density
- Coarse grain
- Long printing times
- With extreme overexposure, blocked-up highlights and reduced sharpness

## Film Sensitivity and Exposure

An ISO film speed index is derived from actual tests performed on a film by the manufacturer. The ISO number is calculated from the amount of exposure needed to produce a standard density on the film. Films with lower ISO numbers are less sensitive to light, requiring more exposure to achieve the same density. Here is a partial list of the standard scale of ISO numbers, which are a combination of the ASA and DIN numbers:

ASA **25** 32 40 **50** 64 80 **100** 125 160 **200** 250 320 **400** 500 640 **800** 1000 1250 **1600**
DIN **15** 16 17 **18** 19 20 **21** 22 23 **24** 25 26 **27** 28 29 **30** 31 32 **33**

Doubling the ASA, or adding three to the DIN, indicates that one stop less exposure is required. If ISO 100/21° film requires a camera setting of f/8 at 1/60 second for correct exposure, then an ISO 200/24° film will require one stop less exposure, or f/11 at 1/60 second, assuming the same subject and lighting. The ASA doubles every third number, each number on the scale representing a one-third stop change in the necessary exposure. An ISO 160/23° film requires one-third stop more exposure than an ISO 200/24° film.

The ISO number a manufacturer gives a film should be thought of only as a guide or starting point. Your personal equipment—camera, lens, and meter—and techniques may vary from those used in the manufacturer's film speed tests. Film speed may also vary slightly depending on the emulsion batch of the film.

Start by using the ISO provided by the manufacturer. If that does not give the desired results, the amount of exposure supplied to the film can be altered by manipulating the ISO (ASA/DIN) scale on the light meter, or on the camera if you are using a built-in meter. Setting a higher ISO into the meter will give less film exposure, as demanded by more sensitive films. Setting a lower ISO will give more film exposure.

NOTE: Some rounding of numbers is done in this scale: Two times 64 should give 128, but 125 is used, and so on.

See page 15 for a discussion of emulsion batch.

See chapter 14 for testing for your own personal film speed index.

## ■ Light Meters

To achieve correct film exposure, we must measure the amount of light coming from the subject into the camera lens. The tool used for measuring amounts of light in photography is the photographic **exposure meter,** usually called a **light meter.** Light meters may be incorporated in the camera body (**in-camera meters**) or contained in a separate housing (**hand-held meters**). Photographic light meters are also divided into two categories by the way in which they measure light: the **reflected-light meter** and the **incident-light meter.**

## In-Camera and Hand-Held Light Meters

In-camera meters have become so common that many people do not realize the meter is not an integral part of the camera. Meter and camera are two distinct pieces of equipment, even when combined in one body. The design and use of in-camera meters are governed by the same principles as those governing hand-held meters, with the major distinction being that in-camera meters can be coupled to the controls of the camera to allow direct transference of meter readings, either automatically or manually.

**Through-the-lens (TTL)** in-camera meters measure the light after it has passed through the camera lens and will sense any alterations in exposure due

See page 47 for in-camera metering methods.

to lens changes, filters, or close-up attachments, providing corrected camera settings. Some TTL meters, called **off-the-film (OTF)** meters, measure the light reflected from the film during exposure and are useful when light may change during the exposure or when the camera meter is capable of metering and controlling flash exposure.

In-camera meters without TTL metering have the light meter receptor placed on the exterior of the body. Non-TTL and hand-held meters will not adjust for lens attachments or procedures that might change the amount of light reaching the film. One exception is a non-TTL meter with the sensor located above the lens in such a way that filters placed on the lens cover the sensor as well. In that case, the effect of the filter on exposure is sensed by the meter.

## Incident- and Reflected-Light Meters

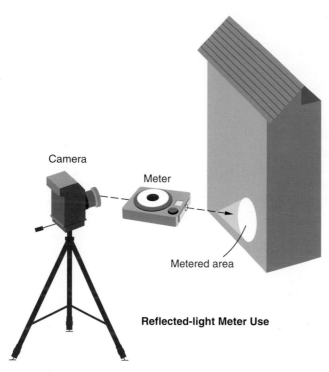

**Reflected-light Meter Use**

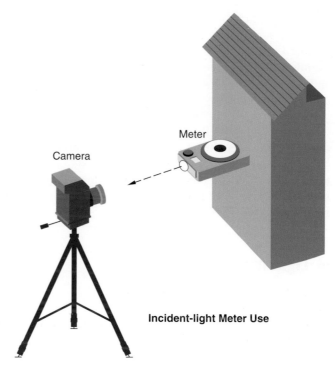

**Incident-light Meter Use**

*Reflected-Light Meter Use.* Reflected-light meters (also known as **luminance meters**) measure the amount of light emitted or reflected by the subject (the luminance). Since the light of interest to the photographer is that which enters the camera lens, these meters are normally pointed at the subject either from the position of the camera or along a line from the camera lens to the part of the subject being metered.

*Incident-Light Meter Use.* Incident-light meters (also called **illuminance meters**) are designed to measure the amount of light falling on the subject (the illuminance). For that reason they are normally placed at the position of the subject and pointed back toward the camera.

The incident-light meter gives no information on the effect of the subject on the light, which means that the photographer must be familiar with the interaction of subject and light. The major strength of the incident-light meter is its ability to measure evenness and balance of light sources, which is useful when exercising control over the lighting. Photographers working in situations where lighting is not under their control or where it is inconvenient to make meter readings at the subject most often use reflected-light meters.

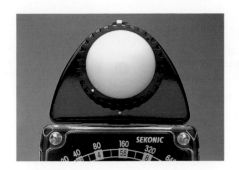

Light-receiving Dome of an Incident-Light Meter.

Segmented Receiving Element on a Reflected-Light Meter.

Light-receiving Lens on a Convertible Reflected-Light Meter (Incident Dome Slid to Side).

All in-camera meters are of the reflected-light type. Hand-held meters can be purchased in either reflected or incident types. The identifying feature of an incident-light meter is the translucent plastic dome—sometimes a disc—covering the receptor, whereas a reflected-light meter will have a lens to collect light. Many hand-held meters in use today are convertible from reflected mode to incident mode.

## Angle of View

The angle of view is a measurement of how much of a subject a meter "sees." Any light coming from the part of the subject within the angle of view is sensed by the meter and included in the meter reading. Angle of view strictly applies only to reflected-light meters, since incident-light meters are generally designed to accept light coming from anywhere in a 180°-hemisphere.

The shape of the area sensed by the meter, called the **metering pattern,** varies from meter to meter. A meter with a circular metering pattern includes any subject matter inside a conical shape extending from the meter. The angle of view for this type of meter is the angle across the cone. A meter with a rectangular metering pattern includes any subject matter within a pyramidal shape, the angle of view being measured across the diagonal of the pyramid. The metering pattern of an in-camera meter depends on sensor placement and design. (See the boxed section titled, "In-Camera Metering Patterns" on page 49.)

Convertible Meter in Incident Mode.

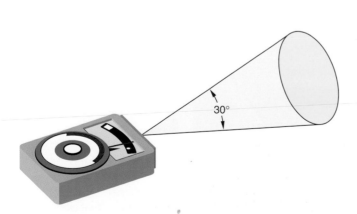

Angle of View for a Meter with a Circular Metering Pattern.

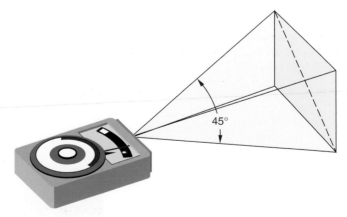

Angle of View for a Meter with a Rectangular Metering Pattern.

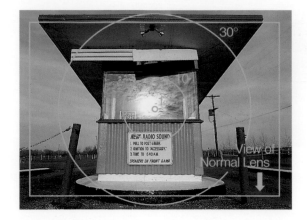

| DISTANCE FROM METER | DIAMETER OF CIRCLE SEEN BY METER | |
| --- | --- | --- |
| | 30° Meter | 1° Meter |
| 1 ft | 6.4 in. | 0.2 in. |
| 3 ft | 1.6 ft | 0.6 in. |
| 10 ft | 5.4 ft | 2.1 in. |
| 30 ft | 16 ft | 6.3 in. |

Subject Inclusion for Different Angles of View
Metered from Camera Position.

Hand-held meters are designed with various angles of view. **Averaging meters** have an angle of view of 30°–45°, covering about the same subject area as a camera equipped with a normal lens. They are called averaging meters because when used from camera position they integrate all the different luminances in a subject—due to differing subject tones or illumination—into one reading. **Restricted-angle meters** have angles of view of 5°–20°, allowing smaller areas of a subject to be read from camera position. **Spot meters** have an angle of view of only 1° or 2°, allowing very small areas of a subject to be read, and are useful for metering small subjects or if a subject cannot be approached for close-up readings.

If meter readings are to be accurate, it is important that you know what is included in a meter's angle of view. Most hand-held averaging meters do not include a viewing system, so the subject inclusion must be estimated. The chart in the illustration gives the diameter of the circle seen at different distances by a 30° meter. Hand-held meters with restricted angles of view normally have a viewing system to show subject inclusion.

## ■ Operation of Reflected-Light Meters

For more information on the use of incident meters, see chapter 15.

Since reflected-light meters are the most widely used, only their operation is discussed here.

The subject being photographed usually contains many different tones (reflectances), each providing a different luminance. The reading given by the light meter consists of an averaging of all the luminances within the metering area.

An averaging meter mixes all the tones within the metered area and produces a reading as if they were all one tone.

When a meter calculates camera settings, it must take into account the reflectance of the area metered to achieve correct film exposure. Because of the wide variety of tonal distribution in different subjects, meter manufacturers must make an assumption about the average subject reflectance. They assume that all the tones in a typical subject average out to a gray of 18 percent reflectance—an area reflecting 18 percent of the light falling on it. To the eye this looks like a tone midway between black and white, so 18 percent gray is also called **middle gray.** *Light meters will give camera settings for correct film exposure only if the average tone of the subject area metered is 18 percent gray.* Because of this design feature, it is often said, *"Light meters read everything as 18 percent gray."*

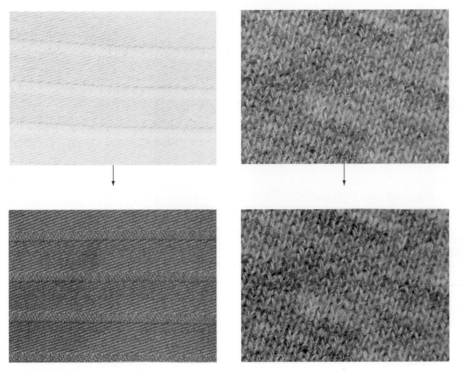

The first subject is white, the second gray, and the third black. When the meter reading from each is used for the camera settings, middle gray will be reproduced in the print.

Many subjects do not average 18 percent gray and will cause problems with metering. The illustrations show what happens when subjects of three different tones are metered. In each case they reproduce as 18 percent gray, because the light meter is designed to produce proper exposure only for an average tone of 18 percent gray. If a subject contains predominantly light tones, the meter sees it as a middle gray subject with brighter illumination and gives camera settings so that the film exposure is reduced for proper 18 percent gray reproduction. In other words, the film exposure is too low for proper reproduction of the light tones. Using the suggested camera settings for a meter reading off light tones thus produces underexposure. Conversely, metering dark tones produces overexposure.

It is up to the photographer to modify the camera settings suggested by the meter to insure the proper exposure for tones other than middle gray. Opening up from the camera settings suggested by the meter produces a tone lighter than 18 percent gray in the finished positive image, and stopping down produces a darker tone. The illustration on the next page shows the results of these exposure changes on the tones in the print.

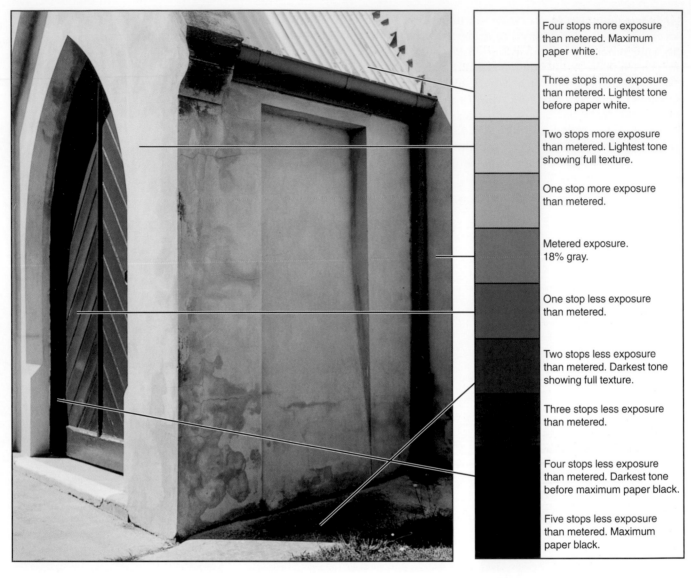

Four stops more exposure than metered. Maximum paper white.

Three stops more exposure than metered. Lightest tone before paper white.

Two stops more exposure than metered. Lightest tone showing full texture.

One stop more exposure than metered.

Metered exposure. 18% gray.

One stop less exposure than metered.

Two stops less exposure than metered. Darkest tone showing full texture.

Three stops less exposure than metered.

Four stops less exposure than metered. Darkest tone before maximum paper black.

Five stops less exposure than metered. Maximum paper black.

© Bognovitz.

The scale of grays shows the print tones resulting for opening up or closing down from the camera settings suggested by the meter. See page 409 for more complete information on what subject matter looks best at each tone.

# Metering Methods

Some standard methods of metering may make it easier to deal with the rather complex task of determining proper camera settings. Recording metering data in a permanent notebook will give you a reference for analyzing your results and increase the speed with which you learn to handle various metering situations.

**Overall Reading.** (Method used in chapter 1.) To make an overall reading, an averaging meter (30°–45° angle of view) is pointed at a subject from the position of the camera. In-camera meters with a metering pattern covering the full field of view of the lens—including center-weighted systems—give an overall reading. This is a quick and easy type of reading to make and will give good results in a high percentage of situations. Since an overall meter reading averages the luminances of the subject, the average tone must be close to middle gray to get proper exposure. Luckily, many subjects do come close to this average. If the subject has a predominance of light tones, an overall reading can be adjusted by opening up one or more stops. A predominance of dark tones will require stopping down to achieve correct exposure.

**Substitute Reading.** If a subject is difficult to meter because of its small size, inaccessibility, or unusual tonal distribution, something other than the subject can be metered in its place and camera settings can be based on that reading. A standard substitute is a card that is 18 percent gray in tone, available at photographic stores. Other substitutes might be objects that are similar to the subject but more accessible for metering. Some photographers meter their own hand for a skin tone exposure when it is inconvenient to measure the skin tone of the subject. The principal thing to remember about substitute readings is that they were not made directly from the subject and may therefore give incorrect exposure.

**Close-up Reading.** One area of the subject is chosen as important and a close-up meter reading is made of that area. The meter must be kept on a line from the camera lens to the area being metered. If the average tone in the area being metered is not close to an 18 percent reflectance, the camera settings suggested by the meter must be adjusted. Since proper exposure on the negative is determined by the amount of detail in the areas corresponding to the dark tones of the subject, a common use of this method is to meter the darkest area of the subject in which full detail and texture are desired, then stop down two stops from the camera settings suggested by the meter. Chapter 14 discusses in detail the use of this type of tone control through exposure.

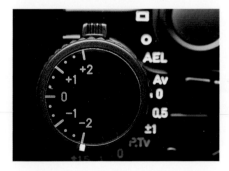

Automatic in-camera meters without exposure override can be "fooled" into giving more or less exposure by adjusting the ISO. Doubling the ASA (adding three to the DIN) will give one stop less exposure; quadrupling the ASA (adding six to the DIN) will give two stops less exposure. **IMPORTANT:** When metering a specific tone of the subject, be sure that only that tone is included in the field of view of the meter for correct results.

A. **Close-up Readings with Automatic Metering.** The automatic in-camera meter must offer automatic exposure override and a way of locking in meter readings for proper close-up readings. For a fully detailed dark tone, set the exposure override on −2 (× 1/4 on some cameras).

B. Make a close-up reading of the dark tone and lock it in, back up for proper composition, and shoot. Remember to reset the exposure override to 0 (× 1 on some cameras) when finished.

**Difficult Metering Situations**   Some frequently occurring metering situations do not respond well to a straight overall meter reading.

**A backlit subject** has the largest amount of illumination coming from behind it. In the illustration on the left, the bright background has given a falsely high overall meter reading, resulting in underexposure of the subject. To prevent this problem, do a close-up reading of the important

subject area. If it is impossible to get up close to the subject, open up one stop—or more if the background is very bright or occupies a large part of the image area—from an overall meter reading. The illustration above shows the effect of a close-up reading from the central subject.

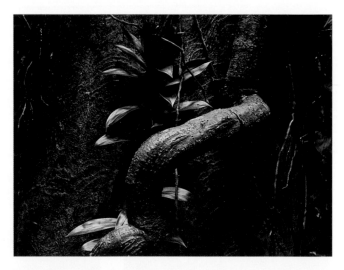

**A high key subject** has predominantly light tones. Open up one or more stops from the overall reading. A small subject against a large, light background requires the same type of correction to an overall reading, or if possible take a spot meter reading or move up and take a close-up reading of the subject.

© Bognovitz.

**A low key subject** has predominantly dark tones. Close down one or more stops from the overall reading. A small subject against a large, dark background will require the same type of correction to an overall reading, or take a close-up reading or spot meter reading of the subject.

© Bognovitz.

**Bracketing**   In difficult metering situations or when exact exposure is critical, a technique called **bracketing** can be used. To bracket, make several exposures of a subject, intentionally overexposing and underexposing from the supposed correct exposure. Bracketing is not feasible if a subject is rapidly changing but it can be used quite successfully in more controlled shooting situations. Bracketing is widely employed by professional photographers to provide insurance against exposure variations due to equipment, materials, or metering errors.

The bracketing sequence depends upon the situation. A photographer working with color transparency film, which has little exposure latitude, might bracket in half-stop increments, one or two stops each direction. For negative films, with their greater exposure latitude, one-stop or even two-stop increments might be used:

| | |
|---|---|
| f/2.8 at 1/125 sec | Two stops overexposed |
| **f/5.6 at 1/125 sec** | **Metered exposure** |
| f/11 at 1/125 sec | Two stops underexposed |

Bracketing can also be done with the shutter speed:

| | |
|---|---|
| f/5.6 at 1/30 sec | Two stops overexposed |
| **f/5.6 at 1/125 sec** | **Metered exposure** |
| f/5.6 at 1/500 sec | Two stops underexposed |

Some of today's cameras provide computer-controlled bracketing.

## Common Metering Errors

For a more detailed discussion of possible metering errors, see chapter 7, pages 158–9.

**Tilting the Meter Up.** Because of the placement of dials on the meter, care must be taken not to tip the meter up while reading. If bright sky or overhead lighting is included in the reading, underexposure will result.

**Metering Your Own Shadow.** If your shadow falls on the area being metered, falsely low readings will result in overexposure. This is most likely to occur when doing close-up meter readings or when the light is coming from behind the photographer.

## Creative Use of Exposure

The amount of exposure given to a negative affects the reproduction of tones in the final photograph. The "correct" exposure discussed so far is for a **representative photograph,** which is one that resembles the original as much as possible. For creative control, exposure changes can vary this representative appearance and thus create mood or isolate a subject.

The photograph on the right was given more exposure on the film. Note that both the graphic impact and the emotional values of the image change with exposure.

© Bognovitz.

## Determining Exposure Without a Meter

You may someday find yourself in a situation without a meter, because of battery failure or other malfunction. It is still possible to determine proper camera settings for various subjects to some degree of accuracy. Two good tools are used to do this:

*Film data sheet.* An exposure chart may be packed with the film. Following those guidelines will usually give good results. Only one camera setting—shutter speed and f-stop—is given for each case, but any equivalent exposure setting could also be used.

*f/16 rule.* In direct sunshine showing distinct shadows, using f/16 and a shutter speed of 1 divided by the ASA of the film in use will usually give good results. For example, using Plus-X film (ASA 125) in direct sunshine would give a camera setting of f/16 at 1/125 second, or any equivalent exposure setting. Tri-X (ASA 400) would give f/16 at 1/400 second; use the nearest shutter speed, f/16 at 1/500 second. Corrections to the f/16 rule can be made for cases other than direct sunshine:

| | |
|---|---|
| Direct sun on light sand or snow | Close down one stop |
| Weak, hazy sun (soft shadows) | Open up one stop |
| Cloudy bright (no shadows) | Open up two stops |
| Open shade or heavy overcast | Open up three stops |

| | |
|---|---|
| **f16 @ 1/250** Sunny beach or snow scene | **f16 @ 1/125** Clear, sunny |
| **f11 @ 1/125** Hazy sun | **f8 @ 1/125** Cloudy bright |
| | **f5.6 @ 1/125** Overcast |

Exposure Chart on Film Data Sheet.

# Exposure in Low Light

If the level of illumination on a subject is very low, it may be difficult to determine camera settings for proper film exposure. You may not be able to get a meter reading, since many meters are not very sensitive at low light levels. The reciprocity law (pages 31–32) may no longer apply. This is called **reciprocity failure** and requires exposure corrections. When working at long exposure times the camera must be stabilized to avoid image blurring.

Exposures of 1 second or longer are usually called **time exposures.** Some cameras have exposures longer than 1 second marked on the shutter speed dial. For exposures longer than those marked on your shutter speed scale, set the shutter speed at B and hold the shutter release down for the appropriate time. Some shutters have a T setting: Push the shutter release once to open the shutter, which will remain open until the shutter release is pressed a second time. To avoid movement of the camera during the exposure, mount it on a tripod and use a cable release.

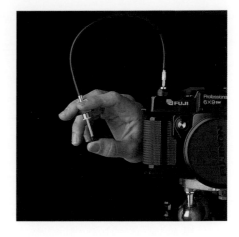

Camera on Tripod with Cable Release Attached.

**Determining Initial Camera Settings** If your meter is sensitive enough to meter the available light, use it to get a starting point for camera settings. An alternative is to use a chart or calculator for low-light exposures. Another alternative is to guess at the exposure using the table below.

## Night Exposure Chart

Choose the aperture for the ISO of your film: f/4 for ISO 25, f/5.6 for ISO 50, f/8 for ISO 100, f/11 for ISO 200, or f/16 for ISO 400. Find the indicated exposure time from the chart. If you wish to use a different f/stop, divide the time by two for every stop you open up, multiply by two for every stop down from the recommended f/stop for your ISO. NOTE: These times are not corrected for reciprocity failure. Use the graph or table on page 37 to make the necessary corrections.

| SCENE | TIME | SCENE | TIME | SCENE | TIME |
|---|---|---|---|---|---|
| Open fire as subject. | 1/30 sec | Brightly lit downtown streets. Brightly lighted sports arenas, gymnasiums, or circus performances. | 1/2 sec | Scene lit by candlelight. Floodlighted buildings. | 4 sec |
| Brightly lit ring sports events (boxing, wrestling). | 1/15 sec | | | Dimly lit interiors of public buildings. | 15 sec |
| Scene lighted by campfire. Neon signs. City skyline at twilight. Store windows. | 1/8 sec | Carnivals, fairs, amusement parks. Aerial fireworks: Exposure from fireworks depends mostly on the f-stop. Bracket with the aperture around the suggested f/stop for your ISO film at 1 second time. The shutter can be kept open for several seconds to capture multiple bursts if the sky is dark. | 1 sec | Dimly lit outdoor industrial facilities. | 15 sec |
| Brightly lit buildings interiors. Well lit stage scenes. Outside night sports (football). Bright color television pictures (use 1/8 second or longer for focal plane shutters to prevent scanlines). | 1/4 sec | | | City skyline at night. | 30 sec |
| | | | | Dimly lit city streets. Snowscape lighted by full moon. | 1 min |
| | | | | Landscape lit by full moon. | 2 min |

**Correcting for Reciprocity Failure** After determining the initial camera settings, check the charts on the next page to see if the time of the exposure requires correction for reciprocity failure. Color films will show interesting color shifts in addition to the density differences due to reciprocity failure. See the manufacturers' data for reciprocity failure corrections for color films. **IMPORTANT:** Meter calculators and exposure charts do *not* include reciprocity failure correction, so this step must be performed regardless of the source of the initial camera settings.

## Corrections for Reciprocity Failure with General-Purpose Black-and-White Films

| CALCULATED EXPOSURE TIME (SECONDS) | ADJUST APERTURE (STOPS) | OR | ADJUST EXPOSURE TIME TO (SECONDS) |
|---|---|---|---|
| BLACK-AND-WHITE FILMS | | | |
| 1 | +1 | | 2 |
| 10 | +2 | | 50 |
| 100 | +3 | | 1200 |
| T-MAX 100 | | | |
| 1 | +1/3 | | — |
| 10 | +1/2 | | 15 |
| 100 | +1 | | 200 |
| T-MAX 400 | | | |
| 1 | +1/3 | | — |
| 10 | +1/2 | | 15 |
| 100 | +1 1/2 | | 300 |

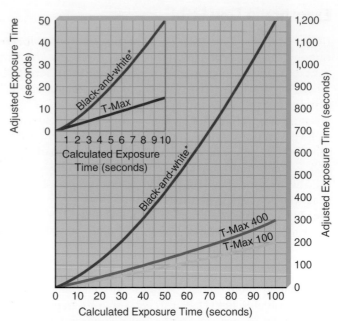

*These are average values for most general purpose black-and-white films. See the manufacturer's film data for more accurate values for each film.
Source: Reprinted courtesy of Eastman Kodak Company.

The accompanying graphs help to find values between those in the table. For situations where contrast is critical, adjustments can be made to development: for an adjusted time of 2 seconds, reduce development 10%; for 50 seconds, reduce development 20%; and for 1200 seconds, reduce development 30%. T-Max films require no adjustment of development.

**Bracketing**   Bracket sufficiently when working at long exposure times. If the first calculated exposure is 10 seconds, doing a second exposure at 11 seconds gives only a 10 percent change in exposure. Try doubling and halving the exposure several times for proper bracketing.

## Time Exposure Example

*Determine initial camera setting.*   Working in a low-light situation, a meter reading is made at f/8 at 2 seconds. (This camera setting could also have come from an exposure chart.)

*Correct for reciprocity failure.*   A 2-second exposure will require reciprocity failure correction for a standard black-and-white film. Looking at the reciprocity failure corrections graph, we see that a calculated time of 2 seconds requires an adjusted time of 6 seconds, so our adjusted camera setting is f/8 at 6 seconds.

*Bracket.*   If we wish to keep the aperture at f/8, we must bracket with the time. The following settings will give a good variation of exposure:

| | |
|---|---|
| f/8 at 1 1/2 sec | Two stops less exposure |
| f/8 at 3 sec | One stop less exposure |
| f/8 at 6 sec | Calculated exposure |
| f/8 at 12 sec | One stop more exposure |
| f/8 at 24 sec | Two stops more exposure |

If you are unsure of your initial exposure determination, the bracketing can be carried even further.

# Light Meter Design

Many different light meter designs have been developed over the years. Each design does some metering jobs better than others. Several light meter design aspects have been discussed already—in-camera versus hand-held, reflected versus incident, angle of view—but other design features affect meter operation as well.

A light meter has two major components with different functions:

*Metering mechanism.* The metering mechanism is the part of the meter that senses and measures the amount of light. It consists of a light-sensitive cell and the necessary electronic circuitry to give an indication of the amount of light striking the cell.

*Calculator.* The reading of the amount of light is transferred from the metering mechanism into the calculator, which reads out suggested camera settings, taking into account the film speed. Calculators may be mechanical—usually a device like a circular slide rule—or electronic.

Much of the variation in design of meters has to do with the type of light-sensitive elements used in the metering mechanism and the way the metering information is transferred into the calculator.

**Light-Sensitive Elements** Three major categories of light-sensitive elements are used in meter construction: selenium cells, cadmium sulfide cells, and photodiode cells.

The **selenium cell** generates electrical voltage when exposed to light. The voltage depends upon the amount of light that falls on the cell and the size of the cell and can easily be measured with a simple voltage meter.

The **cadmium sulfide (CdS) cell** varies in resistance to the flow of electrical current, depending upon the amount of light falling on it. The resistance change can be measured with a battery-driven circuit. CdS meters exhibit a memory of bright light sources, which means that after exposure to higher levels of light, falsely high readings may be obtained at lower light levels. This is a temporary effect and normally takes a few minutes or less to disappear. Users of cadmium sulfide meters should try to avoid prolonged exposure of the cell to intense sources of illumination such as the sun.

**Photodiode cells** require sensitive electronic circuits employing batteries to measure the effect of light. Photodiode meters either use silicon and are called silicon blue cell (Sbc) or silicon photodiode (SPD) meters or use gallium arsenide and are called gallium arsenide photodiode (GPD or GAP) meters. The main difference is that silicon cells are sensitive to infrared and gallium arsenide cells are not—a problem eliminated by internal filtering in the meter. A major distinguishing feature of the photodiode meters is that their response to changes in light is so fast that with the proper circuitry attached, electronic flash can be read.

Modern in-camera meters make use of either CdS or photodiode sensing cells, because of their compact size. Cameras with OTF flash-metering capability use photodiode cells.

Flash meters are discussed in chapter 15, pages 447–51.

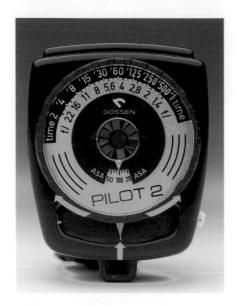

*Match-Needle Transfer.* One needle is connected to the metering mechanism and gives an indication of the amount of light. The second is connected to the outer calculator dial. Superimposing the two needles transfers the light meter reading into the calculator.

## Sensing Cell Characteristics

|  | SELENIUM | CADMIUM SULFIDE | PHOTODIODE |
|---|---|---|---|
| Advantages | Is lower in cost | Is intermediate in cost | Is compact |
|  | Uses no battery | Is compact | Is sensitive |
|  | Has no memory of bright light | Is sensitive | Responds quickly |
|  |  |  | Has no memory of bright light |
| Disadvantages |  |  |  |
|  | Is not sensitive | Uses a battery | Uses a battery |
|  | Is bulky | Has a memory of bright light | Is the highest in cost |
|  | Responds slowly | Responds slowly |  |

**Hand-Held Reading Transfer** Several systems are used to transfer the meter reading into the calculator so that camera settings can be chosen. Meter readings may be indicated by a needle, by liquid crystal display (LCD), or by a series of light-emitting diodes (LEDs).

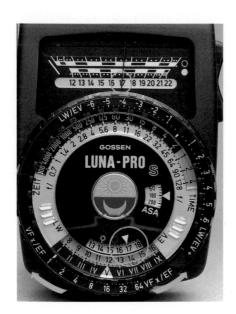

*Number Transfer.* The number indicated by the needle is a measure of the amount of light. This number is set into the meter number window on the calculator by rotating the outer calculator dial.

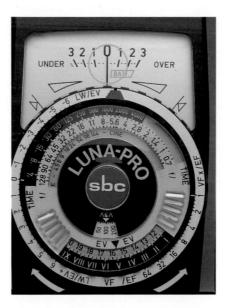

*Null System Transfer.* One needle moves with both the amount of light and the outer calculator dial. Rotate the dial until the needle is balanced in the center—the zero point—of the meter. This method is also called the centering or zero method.

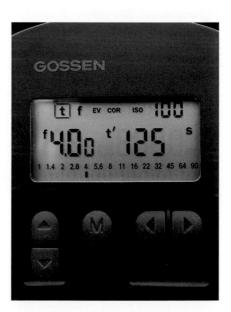

*Electronic Transfer.* The meter reading is transferred electronically into the calculator, giving a direct readout of a suggested shutter speed and f-stop pair in digital form using LCDs. Although this type of transfer requires less manipulation to get a camera setting, it only displays one shutter speed and f-stop pair at a time. If other equivalent pairs are desired, they may usually be scrolled through on the display.

**In-camera Reading Transfer**   Most in-camera meters are coupled mechanically or electronically to the shutter speed or the aperture or both, with metering information shown in the viewfinder. Transfer of the metering information to the camera controls may be done manually or automatically.

**Manual Operation**   In manual operation, the readout of the in-camera meter—usually seen in the viewfinder—is manually transferred to the camera settings by the photographer. Transfer methods are the same as with hand-held meters. The meter readout may be coupled to one or both of the camera controls, so the effect of manipulating the controls can be monitored in the viewfinder.

**Automatic Operation**   In automatic operation, the photographer sets one control manually and the meter automatically adjusts the other according to the meter reading. **Aperture priority** means that the aperture is set manually and the meter sets the shutter speed automatically. **Shutter priority** means that the shutter speed is set manually and the meter sets the aperture automatically. In **program operation,** the meter sets both the shutter speed and the aperture automatically, based on the amount of light. The photographer has no control over either camera setting. The choice of shutter speed and aperture for each light level is preselected and programmed into the meter. The programs vary from camera to camera. Some owner's manuals will give a chart outlining the shutter speed and f-stop pairs chosen for each light level.

Many of today's sophisticated cameras offer a selection of operating modes for the meter. Some cameras can be operated in manual, shutter priority automatic, aperture priority automatic, or program by a flick of a switch. Many cameras even offer more than one program mode, one favoring faster shutter speeds—often called an action program—another favoring smaller apertures.

**Readout of Camera Settings**   Hand-held meters using circular calculator dials display all the possible equivalent camera exposure settings at one glance. In-camera meters and hand-held meters with digital readout, on the other hand, provide only one equivalent exposure setting at a time. The other equivalent settings can be seen only by manipulating the controls of the camera or meter so that each is displayed in turn.

Most hand-held meters have a scale labeled EV, which stands for **exposure value.** Exposure values are often used for comparison of light meter readings. A change of one in the EV indicates a change of one stop in the meter reading. A meter reading of EV 13 is one stop higher than a reading of EV 12; twice as much light is coming from the subject. It is possible to have negative exposure values for very low light levels. **IMPORTANT:** The EV changes with the ISO, so comparison readings must be done with the meter set for the same ISO.

EVs are widely used to describe light meter sensitivity, usually at ISO 100/21°, which should be specified in the manufacturer's literature. The EV is meaningless without the ISO. EV 15 at ISO 100/21° is a typical daylight reading, giving a camera setting of f/16 at 1/125 second. An indoor exposure might yield EV 6 at ISO 100/21°, giving a camera setting of f/2 at 1/15 second. EV 0 at ISO 100/21° is a very low reading, requiring a camera setting of f/2 at 4 seconds.

*In-camera Null System Transfer.* Center the needle by manipulating the shutter speed and aperture controls.

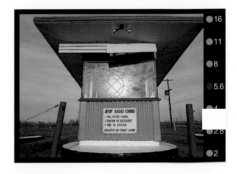

*In-camera Number Transfer.* The lit LED indicates an f-stop, which is then manually set on the aperture control ring.

## Reading Discrimination

Meter readout indicated by needle mechanisms **(analog readout)** has largely been replaced by electronic readout in numerals **(digital readout)** or a scale of flashing light-emitting diodes (LED readout). Although the new readout techniques give some convenience, they often sacrifice one strength of analog readout, the ability to estimate readings of fractional f-stops. The movement of even the cheapest needle mechanism will indicate an exposure change—a **reading discrimination**—of one-third stop or less; the reading discrimination of digital and LED readouts is limited by their design. Many LED readouts, even in the most expensive in-camera meters, will give readings only to the nearest half-stop or sometimes only to the nearest stop. Digital readouts can be designed to give readings to the nearest tenth of a stop. If you intend to do work requiring accurate meter readings—for example, color transparencies—this should be taken into account. In automatic metering mode, most cameras using LEDs control the exposure more accurately than is indicated by the readout. The problem is using these in-camera meters in manual mode, where accurate meter readings are desired.

Reading discrimination should not be confused with the accuracy of a meter. Just because a meter gives readings to a tenth of a stop does not guarantee that it is accurate to a tenth of a stop. On the other hand, a meter that reads only to the nearest half-stop can never give accuracy better than one half-stop. The accuracy of a meter can only be determined by comparing its readings to a known standard.

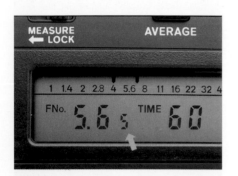

*LCD Readout.* The small number (arrow) indicates tenths of a stop.

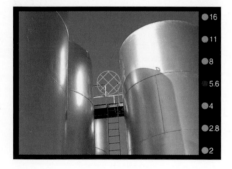

*LED Readout.* No fractional f-stop readings are possible on this scale, since only the full f-stops are indicated.

© Bruce Warren.

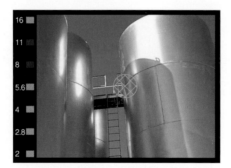

*LED Readout.* On some cameras, two LEDs light when the reading is between f-stops, giving readings to the nearest half-stop.

© Bruce Warren

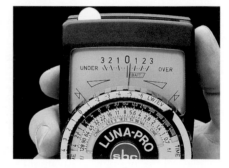

*Needle Readout.* A reading can be estimated to a fraction of a stop. Here the reading is one-third-stop higher than f/5.6 at 1/125 sec.

## Choosing a Light Meter

As with any piece of equipment, choice of type, brand, or model depends largely on the intended use. Many photographers will find no need for a meter beyond the one built into their camera. Working photographers usually have more than one meter—hand-held or in-camera—as backup or for specialized purposes.

The convenience and, with TTL types, the ability to account for exposure-modifying accessories and techniques are obvious advantages of in-camera meters. Modern cameras offer a wide selection of metering features, including various metering patterns (see the boxed section on the next page), which strongly influences the purchase of a camera.

The advantages of automatic in-camera metering are the speed and ease of operation. The disadvantage is the loss of control over the metering process. Many photographers do not feel the need for manual operation of the meter.

# In-Camera Metering Patterns

The metering pattern of non-TTL meters is usually a circle adjusted to cover the central part of the subject as seen through the viewfinder. Metering patterns of TTL meters are much more complex. The illustrations show several popular metering patterns. You should be familiar with the metering pattern of your in-camera meter so that you know what parts of the subject are influencing the meter reading. Refer to your camera's operation manual for the metering pattern, or contact the manufacturer.

The angle of view of a TTL meter depends upon the metering pattern and the lens being used on the camera. If you know the metering pattern for your TTL meter, you can see visually through the viewfinder what is being metered. Some newer TTL meters complicate this by simultaneously taking several meter readings at different points or areas in the image and then calculating a camera setting on the basis of a built-in computer program, called **matrix metering.** It is difficult to predict what results such meters will give. The choices of exposure made by the designers of the program may or may not coincide with your desires. Some cameras offer a selection of more than one metering pattern, allowing the possibility of switching from center-weighted to matrix or spot readings. ■

*Through-the-Lens Metering Patterns.*

*Center Weighted.* The entire field of view is metered, but more value is given to the center of the field.

*Matrix Metering.* Readings from each of the zones are analyzed by an in-camera computer to produce a single reading.

*Spot.* Only the area inside the small circle is metered.

All photos © Bognovitz.

However, as you progress in photography, you will find situations where manual control of metering is useful. For this reason it may be wise to choose a camera that offers both manual and automatic modes or at least exposure override of the automatic metering process. In some cameras, switching to manual mode shuts off the meter. If you wish to meter while in manual mode, this is an obvious disadvantage.

Hand-held meters offer advantages as well. They can be used independently of the camera, which is convenient if the camera is mounted on a tripod. Some models of hand-held meters offer far more sensitivity to low light levels or a wider flexibility of use through modes or accessories than do in-camera meters.

The usual first choice for a hand-held meter is a 30°–45° averaging meter. Although the ability of a spot meter to measure very small areas of a subject might seem like a powerful advantage, evaluation of spot meter readings requires considerable experience and knowledge. The choice of sensing cell, reading transfer method, and readout discrimination depends on your personal use of the meter.

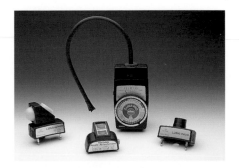

Hand-held Meter System with Accessories.

Whether you are purchasing a hand-held meter or a camera with built-in meter, the best way to determine its feel and see if its features match your needs is to go to a well-equipped camera store and experiment with as many different models as possible.

## Care and Handling of Meters

Light meters are very fragile, so the main consideration is to protect them from shock or rough handling. Allowing a hand-held meter to dangle or swing on its cord exposes it to possible damage. Meters placed in a shirt or blouse pocket may easily fall out. When placing a meter or camera on a surface, make sure it is not close to the edge. Meters should also be protected from dirt and moisture.

If treated carefully, meters do not require extensive maintenance. If your meter has a battery, change it according to the manufacturer's directions. Most batteries have a life of about a year, although some newer types will last several years. Many meters have a battery check procedure, which will indicate when the battery needs replacing. If the meter is stored for any length of time, remove the battery. If the meter quits working or you have reason to believe it is not giving proper results, test it.

See page 178 for some simple testing techniques for light meters.

# CHAPTER 4

# Camera and Lens

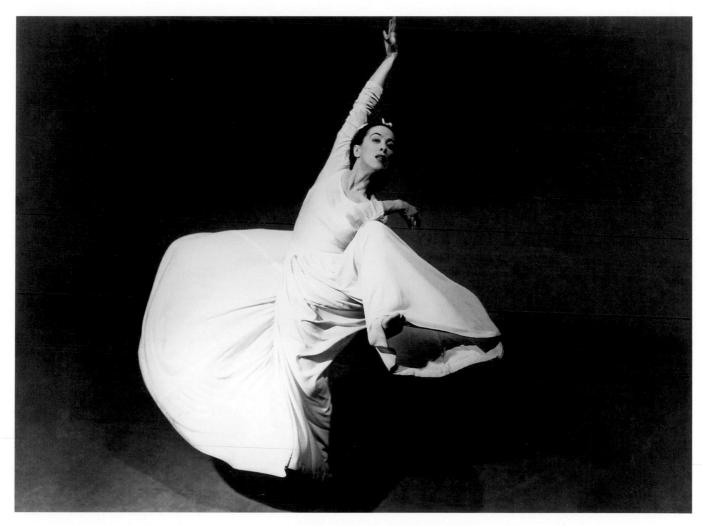

Barbara Morgan, *Martha Graham in "Letter to the World"*.
© Barbara Morgan, Willard & Barbara Morgan Archive/Time Inc. is the licensee.

Modern cameras are extremely sophisticated devices, involving computer-designed lenses, complicated electronics, and construction from high-tech materials. In spite of this complexity, all cameras are basically the same, providing a lighttight container for photosensitive materials—film—and a lens to form an image of the subject matter on the film. The other parts of the camera provide ways of controlling the exposure on the film and various devices for handling film and controlling focus of the lens. These tasks may be performed automatically by the camera or manually by manipulation of the controls. An understanding of the basic parts and operation of the camera and lens will clarify the role that the more sophisticated electronic devices play in the functioning of the camera.

## ■ The Camera

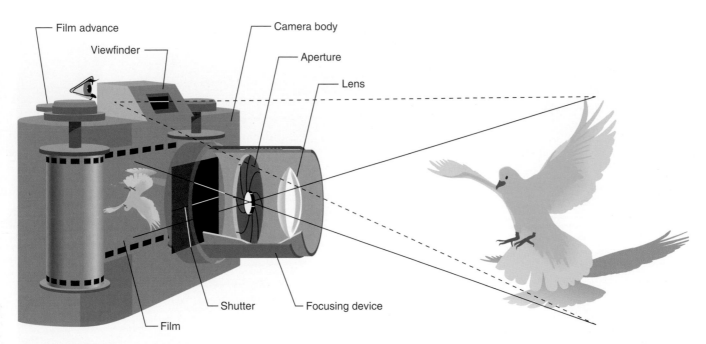

This is a simple camera, but it contains all the parts necessary for complete control in making photographs.

**Camera Body.** Lighttight enclosure protecting the film from unwanted exposure to light. Opens to allow loading of film

**Lens.** Forms an image of the subject matter on the film.

**Focusing Device.** Moves the lens in and out to select the subject distance that will be in focus.

**Viewfinder.** Shows an approximate view of the part of the subject that will appear in the image on the film and may include a method for checking the focus of the image.

**Aperture.** An opening adjusted by means of a dial, lever, or ring with marked f-stop numbers. Controls the amount of exposure on the film.

**Shutter.** Shields the film from the image until the shutter release is pressed, when it opens for a measured amount of time (the shutter speed) controlled by a knob, lever, or ring. Controls exposure on the film.

**Film Advance.** A lever or knob that moves the film forward for the next photograph.

## Format Size

Film format is also discussed on pages 22–23.

An important influence on the technical quality of a photograph is the format size—the size of the image on the film. The rendition of detail and fineness of grain generally increase with increasing format size.

    **Miniature-format cameras** are generally of the Advanced Photo System (APS) design, with a special cartridge film giving a 16 × 24mm format. Because of the small size of the negative, these cameras are generally used where extreme enlargement of the image is not necessary. Their compactness makes

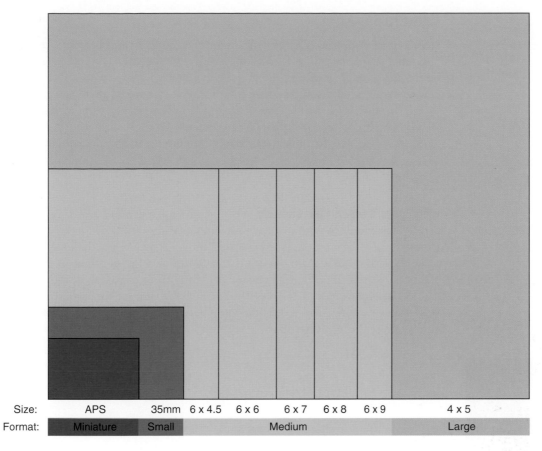

| Size: | APS | 35mm | 6 x 4.5 | 6 x 6 | 6 x 7 | 6 x 8 | 6 x 9 | 4 x 5 |
|-------|-----|------|---------|-------|-------|-------|-------|-------|
| Format: | Miniature | Small | | | Medium | | | Large |

Comparison of Various Film Format Sizes.

them popular as snapshot cameras. The Minox—famous as a "spy" camera—produces an 8 × 11mm image on specially packaged film. The Minox is a precision instrument, but because of the small image size, great care must be taken to get images of any clarity.

**Small-format cameras** normally use 135 (35mm) film and produce a 24 × 36mm image. The original Kodak Instamatic cameras and other cameras using 126 film are also small format, with a 28 × 28mm image. Small-format cameras offer compactness and ease of handling. With modern films and lenses, 35mm cameras give technical quality good enough for most photographic purposes.

**Medium-format cameras** use 120 or 220 roll film and produce several different image sizes depending on the model, including 6 × 4.5cm (usually called the 645 format), 6 × 6cm (2 1/4 × 2 1/4 inches), 6 × 7cm, 6 × 8cm, and 6 × 9cm. Medium-format cameras are useful when a larger image size and a reasonably compact camera are desired. Modern medium-format cameras are typically expensive and designed for professional use, though over the years many simple medium-format snapshot cameras have been produced.

**Large-format cameras** produce images 4 × 5 inches, 8 × 10 inches, and larger and usually use sheet film. Large-format sizes require less enlargement for viewing and produce sharper images, more detail, and finer grain. However, as the format size increases, the camera becomes larger and more difficult to handle. Film and processing costs also increase accordingly. Large-format cameras are used when the highest-clarity images are desired and the camera size and relatively slow operation are not a disadvantage.

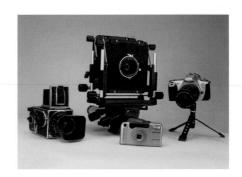

Counter-clockwise from bottom center; Miniature-Format APS Camera, Small-Format 35mm Camera, Large-Format 4 × 5-inch View Camera, Medium-Format 120 Camera.

## Camera Types

Cameras are often categorized by the method used for viewing the image. Two basic methods are used to see what subject matter will be included in the image on the film. One is looking through a **viewfinder,** which is an optical device included in the camera body separate from the lens that produces the image on the film. The other is **direct viewing** of the image formed by the camera lens. To be visible, this image must be formed on an actual surface, usually glass with a roughened surface, called **ground glass.** Several designs make use of a ground glass in the viewing system. Since the ground glass image is dim, it must be shielded from extraneous light with a housing or a dark opaque cloth while viewing.

**Viewfinder/Rangefinder Cameras**   In a viewfinder camera, viewing is done through an eyepiece with its own simple lens, having the advantages of lighter weight, quieter operation, less vibration, and a brighter view than comparable cameras with other viewing systems. Since the viewfinder is not in the same position as the camera lens, it shows a slightly different view of the subject, called **parallax error.** The rangefinder is a focusing aid included in many viewfinder cameras (see page 58). Viewfinder/rangefinder cameras are available in a variety of format sizes.

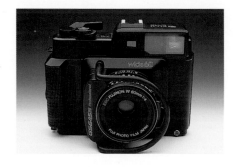

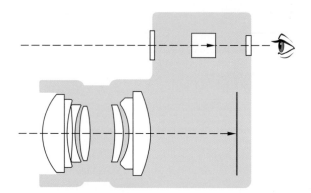

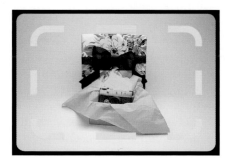

View Through Eyepiece.                    View on Film.

On this camera the viewfinder is above and to the left (when seen from behind) of the camera lens. Most viewfinders are adjusted to give the correct subject inclusion for distant subjects. For closer subjects, the different viewpoint of the viewfinder begins to be noticed, causing the top and left side of the subject seen in the viewfinder to be cut off in the film image. In some viewfinder cameras (such as the one shown) the framing lines change as the camera is focused at different distances to show correct framing. Others may have additional framing lines for close distances. Even when the subject inclusion is corrected, parallax causes an image difference due to the different point of view. In this example the viewfinder view shows slightly more separation between the red ribbon and the tissue paper in front of it and more of the toy camera than the film image.

**Single-Lens Reflex Camera**   In a **single-lens reflex (SLR) camera,** the image from the lens is deflected to a ground glass by a mirror, which swings out of the way when the shutter release is operated. The image on the ground glass is reversed right to left, since it is a mirror image. Many single-lens reflex cameras use a **pentaprism,** a specially designed prism that is located above the ground glass and shows a correctly oriented image through an eyepiece.

Single-lens reflex cameras offer the advantage of viewing the actual image that will fall on the film. Focus can be seen in the eyepiece. Interchangeable lenses are common with this type of camera, since any changes to the image can be seen directly. Disadvantages are the extra noise, weight, and bulk caused by the moving mirror and shutter types needed to provide reflex viewing and the blacking out of the viewfinder while the shutter is open. Single-lens reflex cameras are generally available in 35mm and medium-format sizes.

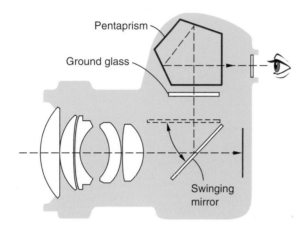
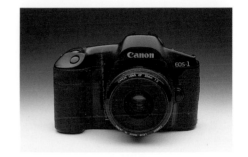

Pentaprism

Ground glass

Swinging mirror

View Through Eyepiece.

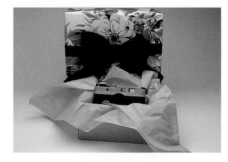
View on Film.

SLR cameras do not have parallax error. The only difference between the eyepiece view and that on the film is that the edges of the subject are cut off by most SLR viewing systems. This is known as **viewfinder cutoff** and results in slightly more of the subject appearing on the film than is seen in the viewfinder.

**Twin-Lens Reflex Camera**   In a **twin-lens reflex (TLR) camera,** two identical lenses are mounted on the camera. One forms the image on the film. The image from the other is deflected by a mirror to a ground glass for viewing and is reversed left to right.

Because of the small distance between the two lenses, twin-lens reflex cameras are subject to parallax error (page 54). They tend to be bulkier because of the separate viewing and taking lenses but are quieter and less expensive than comparable single-lens reflex cameras. Twin-lens reflex cameras are less generally available today than in past years and are usually medium format.

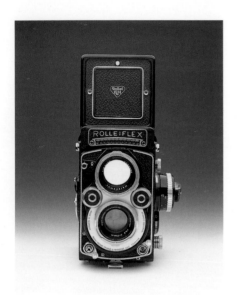

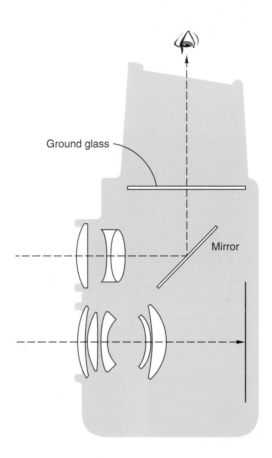

Ground glass

Mirror

TLR cameras have the viewing lens mounted directly above the taking lens. As with viewfinder cameras, the subject inclusion is correct for distant subjects. Near subjects will result in a higher view with possible cutoff of the top of the subject on the film. Notice that in these examples the viewfinder view shows more separation between the red ribbon and the tissue paper in front of it and more of the toy camera than the film image

View on Ground Glass.

Image on Film.

**View Camera**  The view camera is a direct-viewing system. The ground glass is placed in the exact position the film will occupy and then moved out of the way when the film, enclosed in a special holder, is inserted into the camera. The image seen on the ground glass of a view camera is upside-down, just as the image on the film will be.

The lens and back of a view camera can be tilted or swung to alter the focus or shape of the image, an advantage when photographing buildings or tabletop still life subjects. Since the image is viewed directly, focus can be checked by placing a magnifier on the ground glass. An opaque cloth must be draped around the ground glass for viewing the dim image. Disadvantages of the view camera are its bulk—making a tripod or other support necessary—and its relatively slow operation. View cameras are normally 4 × 5-inch format or larger and accept sheet film in holders.

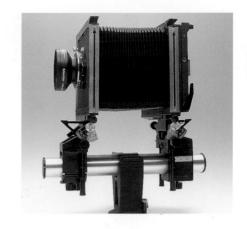

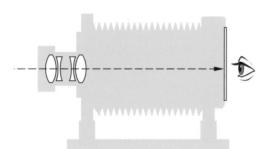
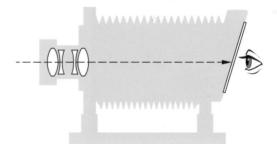

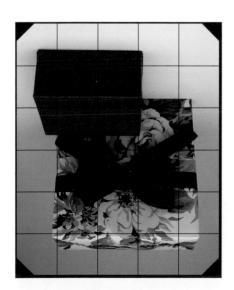

Image on Ground Glass.

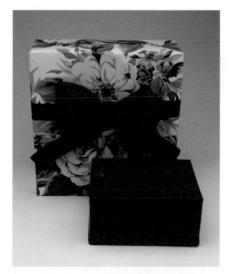

Image on Film. There is no parallax error with a view camera. The convergence of the sides of the tall box is a result of looking down on the subject from above.

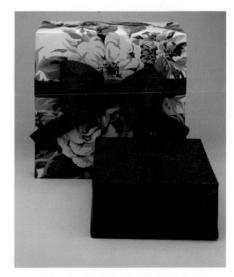

This shows the effect of tilting the back of the camera to restore the parallel appearance of the sides of the box.

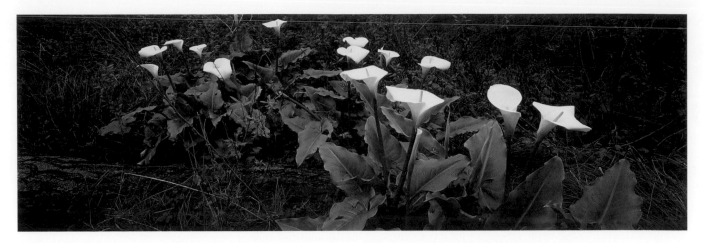

Photograph Taken with Panoramic Camera. Craig Stevens, *Calla Lilies, Pacific Grove, California,* © 1981 Craig Stevens.

*Ground-glass Focusing.* The ground-glass view on the top is out of focus. Adjust the focus control on the camera until the image is in focus as shown on the bottom.

## Specialized Cameras

Some cameras are built for specialized purposes. Underwater cameras have watertight seals for use in water without special housings. Aerial cameras produce large-format images for mapping purposes. High-speed cameras take exposures as short as a few millionths of a second for studying short-term events like explosions. Panoramic cameras record up to a 360° view of a subject, depending on the model. Instant cameras provide photographs that develop on the spot for immediate viewing.

## Focusing

In ground-glass viewing systems the focus can be seen directly on the ground glass. Viewfinder designs may include a **rangefinder,** which is an optical device for determining the distance to the subject and focusing the lens. Simpler viewfinder cameras may have fixed focus or may require a measurement or visual estimate of the distance, which is then set on a focus scale on the camera. Autofocus of the lens is offered on many point-and-shoot viewfinder cameras as well as many 35mm single-lens reflex cameras.

*Rangefinder Focusing.* The small rectangular image superimposed in the center of the viewfinder moves with the focus control on the lens. Adjust the focus control until the small image aligns with the main viewfinder image. The viewfinder view on the left shows the rangefinder out of focus; on the right it is in focus.

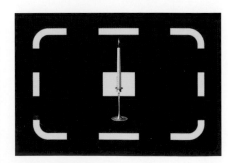

# Shutter

Two types of shutters are generally available on modern cameras: the leaf shutter and the focal plane shutter. A leaf shutter has several overlapping metal blades controlled mechanically or electrically to open for marked lengths of time, and is usually located within the body of the lens. Advantages of the leaf shutter include light weight, lack of noise, and the ability to synchronize with flash at any speed. Disadvantages include difficulty in achieving very fast shutter speeds. Also, since the shutter is in the lens, special provisions must be made for cameras with through-the-lens viewing systems or removable lenses.

Focal plane shutters are located in the camera body as close as possible to the film plane. They consist of two cloth curtains or sets of metal blades that form a slit that travels across in front of the film. The width of the slit can be reduced for faster shutter speeds. Advantages of the focal plane shutter are the ability to achieve fast shutter speeds and the convenience for through-the-lens viewing systems. Disadvantages include bulkier construction and somewhat noisier operation. Also, use with a flash is restricted to shutter speeds for which the moving slit is the full width of the image.

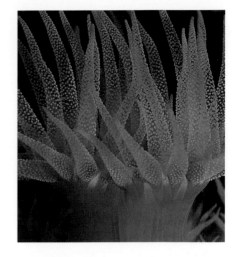

Photograph Taken with Underwater Camera. Orange tube coral, 3 × life size.

© Bruce Warren.

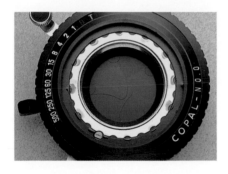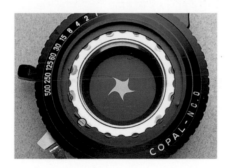

*Leaf Shutter.* Shown here closed, partially open, and fully open.

*Cloth Focal Plane Shutter.* This shutter consists of two opaque cloth curtains. The width of the slit may vary with the shutter speed, shown here closed and in midtravel for a high speed. This shutter travels horizontally.

*Metal Focal Plane Shutter.* The slit is formed by two sets of overlapping metal blades, shown here closed and in midtravel for a high speed. This shutter travels vertically.

**Effect of Motion (Subject Blur)**   If the subject or the camera moves during an exposure, the image is blurred. Since nearly everyone is familiar with this effect, a feeling of motion can be conveyed by appropriate blurring of an image. Some of the factors affecting the amount of image blur due to motion are shown in the following section.

*Image Blur.* The blur in the image on the left is due to movement of the subject during the exposure. The blur in the image on the right is due to movement of the camera during the exposure.

**Factors Affecting Motion Blur**

The blur in this image resulted from a slow shutter speed and a subject close to the camera moving relatively rapidly across the field of view of the lens. The camera was stationary and equipped with a normal focal length lens.
Shutter Speed: **1/30 sec.**
Subject Distance: **30 ft.**
Lens: **Normal.**
Subject Speed: **30 mph.**
Direction of Motion: **Across.**
Camera: **Stationary.**

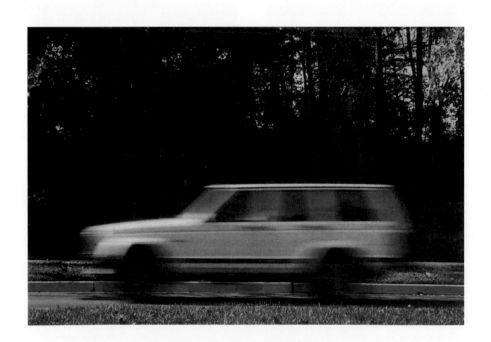

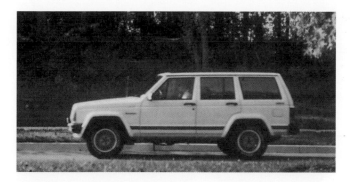

*Shutter Speed.* Faster shutter speeds produce less blur.

Shutter Speed: **1/500 sec.**       Subject Speed: 30 mph.
Subject Distance: 30 ft.           Direction of Motion: Across.
Lens: Normal                       Camera: Stationary.

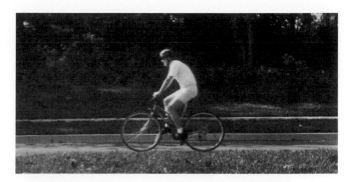

*Subject Speed.* Slower moving subjects produce less blur.

Shutter Speed: 1/30 sec.       Subject Speed: **5 mph.**
Subject Distance: 30 ft.       Direction of Motion: Across.
Lens: Normal.                  Camera. Stationary.

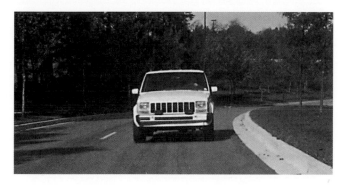

*Direction of Movement.* Subjects moving toward or away from the camera produce less blur than those moving across in front of the camera.

Shutter Speed: 1/30 sec.       Subject Speed: 30 mph.
Subject Distance: 30 ft.       Direction of Motion **Toward camera.**
Lens: Normal.                  Camera: Stationary.

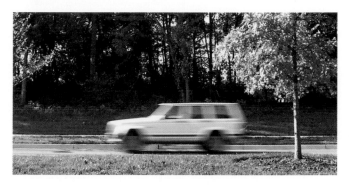

*Subject Distance.* More distant subjects produce less blur than close subjects.

Shutter Speed: 1/30 sec.       Subject Speed: 30 mph.
Subject Distance: **60 ft.**    Direction of Motion: Across.
Lens: Normal.                  Camera: Stationary.

*Lens Focal Length.* Shorter focal length (wide-angle) lenses produce less blur than longer focal length (telephoto) lenses (see pages 69–71).

Shutter Speed: 1/30 sec.       Subject Speed: 30 mph.
Subject Distance: 30 ft.       Direction of Motion: Across.
Lens: **Wide angle.**           Camera: Stationary.

*Panning.* Swinging the camera to follow the movement of the subject during the exposure produces less blur in the moving subject, but more blur in the stationary background.

Shutter Speed: 1/30 sec.       Subject Speed: 30 mph.
Subject Distance: 30 ft.       Direction of Motion: Across.
Lens: Normal                   Camera: **Moved to follow subject.**

## Portraying Motion

*Freezing Motion.* Faster shutter speeds can produce a sharp image of a moving subject so that the movement appears stopped or frozen. The shutter speed needed depends on the conditions listed in the preceding section, but most subject movement can be effectively stopped by using a shutter speed of 1/500 or 1/1000 second. If the feeling of motion is to be shown by freezing the action, the subject must be in a position it could not maintain while at rest. A moving car frozen by a fast shutter speed simply looks like a car at rest, but a jumping person frozen in midair is obviously in motion.

© Bognovitz.

*Panning.* If a slow shutter speed relative to the subject motion is used but the camera is moved to follow the motion of the subject—a technique called **panning**—the result is a reasonably sharp subject against a blurred or streaked background. Successful panning requires practice and is most easily achieved with subjects moving in a straight line across the field of view of the camera. To insure smooth panning, start following the subject before the shutter is triggered, trip the shutter at the desired point while continuing the following movement, and continue following through the motion after the shutter closes.

© Bognovitz.

*Blurring the Subject.* If the camera is held stationary and a shutter speed that is slow relative to the subject movement is used, the subject will appear blurred against a sharp background in the photograph, giving the feeling of movement. Again the shutter speed needed depends on the conditions listed in the preceding section and the amount of blur desired. Fast-moving subjects may be blurred at 1/60 second, but slower-moving subjects may require speeds of 1/8 second or slower to produce appreciable blur. If a shutter speed slower than 1/60 second is used, care must be taken to prevent camera movement (see the next section).

© Bognovitz.

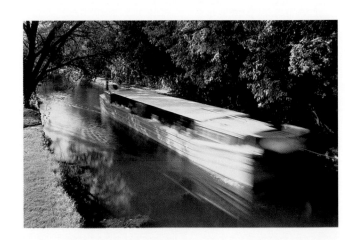

## Preventing Camera Movement

When releasing the shutter by hand, use a gentle squeezing motion of the finger rather than a jabbing or pushing movement.

Brace your arms against your body and the camera against your forehead.

Rest your arms on a nearby object.

Lean against something solid.

Set the camera on something solid. A cloth bag filled loosely with rice or lentils will stabilize the camera.

Special clamps and various other devices are also available for steadying a camera.

A monopod offers some stability.

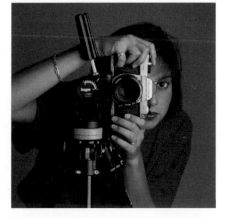

A good tripod allows adjustable support. The important characteristics are rigidity and convenience of use. Weight may be a consideration, but usually greater weight provides better stability. On better tripods the head is available separately from the legs.

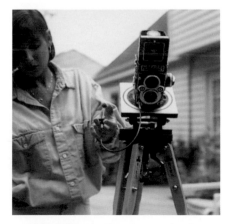

A **cable release** allows tripping the shutter without actually touching the camera, reducing the possibility of camera movement during exposure.

## ■ The Lens

## Image Formation

A lens forms an image out of the light coming from the subject. The image formation depends upon the properties of light (see the boxed section, "Behavior of Light"). Images of light can be most simply formed by a small hole in the side of a darkened enclosure, as in the pinhole camera.

*Pinhole Image.* Image formation by a pinhole depends entirely upon the straight-line travel of light, with a small disc of light in the image corresponding to each point of the subject. Since the rays of light from each point are diverging, they do not come to a focus. The image is sharper closer to the pinhole because it is less magnified. Smaller pinholes produce somewhat sharper images but give a dimmer image, requiring long exposure times. The effects of diffraction at the edges of the pinhole reduce sharpness for extremely tiny holes.

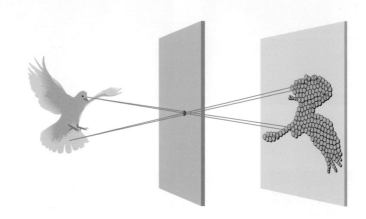

**Simple Lenses**   Glass lenses produce much brighter, sharper images than a pinhole but focus sharply on only one subject distance at a time. A lens is focused on a particular subject distance by changing the distance between lens and films. A simple lens consists of a single piece of glass, with one or both surfaces curved. Image formation depends on refraction of the rays of light striking the lens.

*Simple Lens.* The type of lens shown is a **convex lens,** as both surfaces curve out. The image formed by a simple lens is sharper than the pinhole image, but must be refocused for each subject distance.

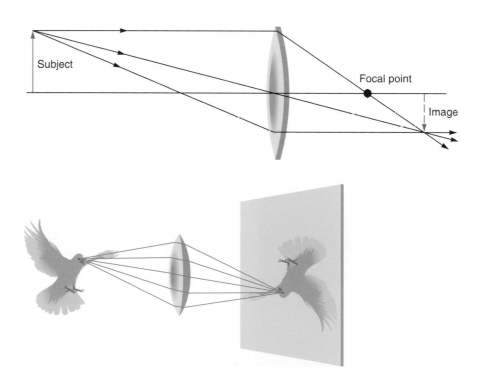

# Behavior of Light

If undisturbed, light travels in a straight line. When it encounters the surface of a material, several possible effects occur, as shown in the illustrations below. When light strikes a material, usually a combination of these effects occurs. For example, if the material is transparent some of the light may be reflected, some transmitted and in the process refracted, and some scattered or absorbed by the material, depending on its degree of transparency. ∎

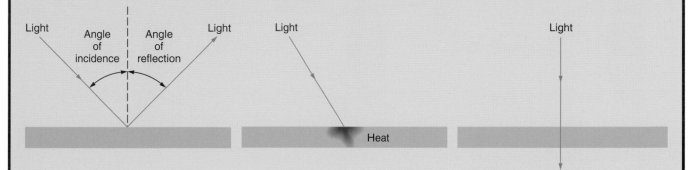

*Reflection.* Light reflected from a surface follows the law of reflection, which states that the angle of the reflection equals the angle of incidence.

*Absorption.* Some of the light may be absorbed by the material and turned into other types of energy such as heat.

*Transmission.* If the material is transparent, light actually passes through it, or is transmitted.

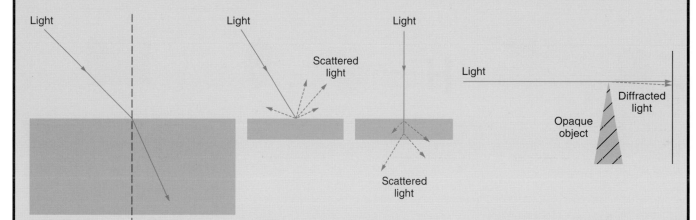

*Refraction.* When light strikes the surface of a transparent material at an angle, its path is bent as it passes into the material. The amount of bending, or refraction, depends on a property of the material called the **refractive index.** A vacuum has a refractive index of 1, air has a slightly higher refractive index, and different types of glasses have various refractive indexes higher than that of air. The direction of bending shown is for light passing from a lower to a higher refractive index.

*Scattering.* Scattering of light can happen either in reflection or in transmission. Surfaces that are not perfectly smooth or polished will cause scattering in reflection. Translucent materials cause scattering during transmission. Light scattered by reflection or transmission is said to be **diffused.**

*Diffraction.* Diffraction occurs when a beam of light passes by the edge of an opaque object. Since light travels in a straight line, the edge of the shadow cast by an opaque object should be perfectly sharp. In fact, because of the wave nature of the light, a slight bending of some of the rays of light takes place, causing the edge to show some gradation from light to dark.

**Compound Lens**   A simple convex lens with spherical surfaces does not form a perfect image, introducing image flaws known as **aberrations.** Combining two or more simple lenses—called **lens elements**—of different curvatures and indexes of refraction can reduce or eliminate most of these aberrations. A lens with more than one element is called a **compound lens.** For use, lens elements are mounted in a lens body of metal or plastic.

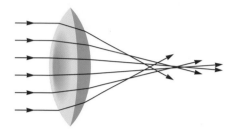

*Spherical Aberration.* Spherical aberration occurs when rays from the edge of the lens are brought to a focus at a different point than are rays from the center of the lens, because of the spherical shape of the surface. The effect is reduced by using a smaller aperture or by grinding the lens with an aspherical surface.

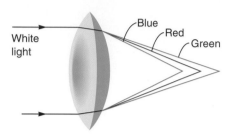

*Chromatic Aberration.* Chromatic aberration occurs when a lens brings different colors of light to different points of focus, causing a lack of sharpness in the image or in extreme cases actual color fringes. The effect can be reduced by using a smaller aperture or corrected by combining a concave, or curved-in, element and a convex element of different refractive index.

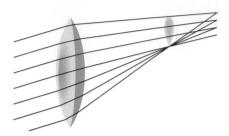

*Coma.* Coma occurs away from the center of the image when a point of light is imaged as a comet shape. The effect is reduced by using a smaller aperture or by combining several correcting elements.

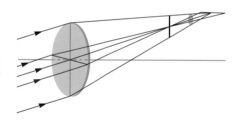

*Astigmatism.* Astigmatism occurs away from the center of the image when a point of light is imaged as short, straight lines or patches of light in different planes. The effect is reduced by using a smaller aperture or by combining several correcting elements.

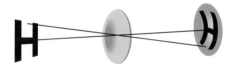

*Field Curvature.* Field curvature occurs when a flat subject is imaged sharply over a curved surface. The effect is reduced by using a smaller aperture or by combining specially ground elements.

*Curvilinear Distortion.* Curvilinear distortion occurs when straight lines in the subject are imaged as curved lines. In barrel distortion the lines curve outward from the image center, and in pincushion distortion they curve inward. This effect cannot be improved by changing the size of the aperture, but changing the position of the aperture in the lens design can reduce distortion.

Photograph Taken with Uncorrected Simple Lens.

© Bruce Warren.

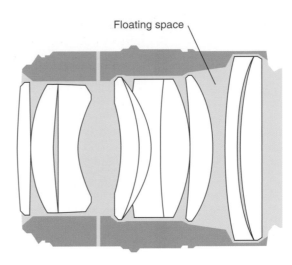

Floating space

Cross Section of a Compound Lens Mounted in a Barrel.

Canon Compact-Macro EF 50mm f/2.5 Lens, Canon USA.

**Image Quality**   The quality, or **sharpness,** of the image formed by a lens depends on the control of all the aberrations as well as the aperture used. Many other factors affect the image sharpness in the finished photograph, including camera or subject movement, accuracy of focus, film resolution, film acutance, and variables in printing such as enlarger lens quality, image movement, or print focus problems.

The perception of sharpness in an image is somewhat subjective and is difficult to test. Two objective measures of lens quality often used in lens testing are **lens resolution,** which is the ability of a lens to produce a distinct image of closely spaced lines, and **lens contrast,** which is the difference the lens can reproduce between light and dark in fine detail. Some testing methods combine these and other considerations into a subjective quality rating.

The image quality will vary with the aperture used and the distance from the center of the image and is generally improved by stopping down approximately two or three stops from the maximum aperture. Resolution is normally better at the center of the image than at the edge. Another consideration in image quality is the evenness of illuminance in the image. All lens images get dimmer as the distance from the image center increases, but this effect, called **image falloff,** can be reduced by careful lens design.

**Flare**   In passage through a lens, light may be reflected internally from the surfaces of the elements. This reflected light, known as **flare,** can spread throughout an image, reducing contrast by adding undesirable light to the dark parts of the image. In some cases flare causes unexpected images of bright light in streaks or shapes.

Flare is reduced in modern lenses by coating the surfaces with rare earth elements. It can also be reduced by making sure that no direct light from a light source outside the picture strikes the surface of the lens. A lens shade may be used for this purpose. Flare is increased by dirty or damaged lens or filter surfaces.

Patterns Due to Lens Flare.

© Bruce Warren.

The length of the lens shade must be matched to the view of the lens so that it does not show in the corners of the photograph.

**67**

## Focus

The focusing mechanism allows changing of the distance between the lens elements and the film to focus on subject matter at different distances. The closer a subject is to the lens, the longer the lens-to-film distance must be for the subject to be in focus. The lens may be on a geared track and attached to a flexible bellows as in a view camera, or the lens body may be a barrel with nesting helical threads that move the lens elements in and out as the outside sleeve of the barrel is twisted. With automatic focus lenses the movement is performed by an electric motor controlled by a distance-sensing device.

**Macro lenses** are designed for close-up work, with the ability to focus close enough for an image size equal to or half that of the original subject. The lens elements are designed for optimum image quality at these focusing distances, though a good 50mm macro lens can be used at distances to infinity and makes an excellent all-purpose normal lens.

See pages 311–14 for techniques of close-up photography.

Focal Distance for Two Different Subject Distances.

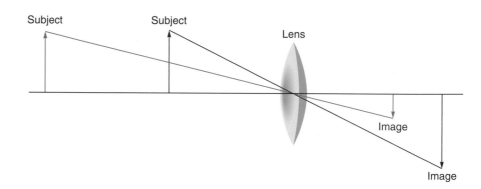

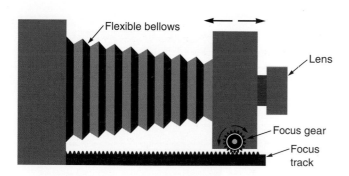

Focusing Bellows and Geared Track as Used on a View Camera.

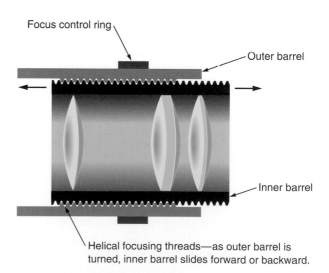

Cross Section of a Lens Barrel with Helical Focusing Threads.

**Focal Length**    As subjects become more and more distant from a lens, the lens-to-film distance for a focused image approaches a fixed minimum. For a simple lens focused on an infinitely distant subject (stars make a good substitute), the distance between the center of the lens and the film is called the **focal length** of the lens, a fixed distance determined by the curvature of the lens surfaces and the type of glass used.

Most compound lenses have a fixed focal length. **Zoom lenses** are compound lenses with internally moving elements that alter the focal length, producing a range of possible focal lengths with one lens.

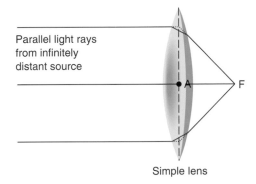

Parallel light rays from infinitely distant source

A

F

Simple lens

Parallel light rays from infinitely distant source

B

A

F

C

Light rays appear to be bent at points B and C.

A is the rear nodal point. AF is the focal length.

Compound lens

*Focal Length of Simple Lens.* Light rays from an infinitely distant subject are parallel when they enter the lens. The actual travel of two light rays is shown, with extensions to indicate the center of the lens, from which the focal length is measured.

*Focal Length of Compound Lens.* The actual travel of two light rays is shown. The extensions of the rays define the rear nodal point of the compound lens, from which the focal length is measured.

The focal length of a lens determines the size of the image—the **image magnification**—for a subject at a given distance. The longer the focal length, the more the image is magnified. A 100mm lens will produce an image of the subject that is twice as large as that produced by a 50mm lens used at the same distance from the subject. Since the size of the film remains constant, the amount of subject matter included changes with the focal length, usually indicated by the **angle of view** (see the next page).

Moderate telephotos (80mm to 100mm on a 35mm camera) are often used for head-and-shoulders portraits, as most people find the slight flattening of the features more pleasing than the forced perspective—especially the apparent enlarging of the nose—that occurs when normal or short focal length lenses are used at close distances.

Taken at 2 Feet with a 50mm Lens.

Taken at 4 Feet with a 100mm Lens.

*Lens Angle of View.* The angle of view of a lens is measured across the diagonal of the rectangle seen in the subject. The angle of view of several popular focal lengths for 35mm cameras is shown in the table.

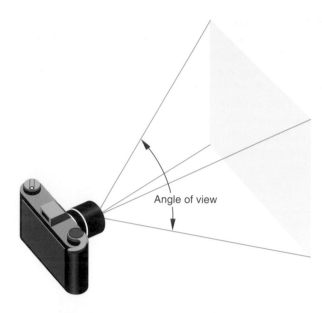

Angle of view

| LENS FOCAL LENGTH | ANGLE OF VIEW |
|---|---|
| 7.5mm | 180° |
| 14mm | 114° |
| 24mm | 84° |
| 50mm | 46° |
| 100mm | 24° |
| 200mm | 12° |
| 400mm | 6° |
| 800mm | 3° |

7.5mm

14mm

24mm

50mm Normal

100mm

200mm

400mm

800mm

*Focal Length and Subject Inclusion.* This subject was photographed from the same position with different focal length lenses as labeled.

**Normal Focal Length**    The lens that most closely approximates the view of the unaided human eye is known as a **normal focal length** lens. For the 35mm camera format, which gives a 24 × 36mm image, the normal focal length is about 50mm. As format size increases, the focal length must be increased to produce a larger image to retain the normal field of view. A 60 × 60mm image requires a normal lens of about 80mm focal length and a 4 × 5-inch format requires about a 150mm focal length. The normal focal length is approximately equal to the diagonal of the image format.

**Wide-Angle Lenses**    Lenses with focal lengths shorter than normal are called **wide-angle lenses.** On 35mm cameras, a moderate wide-angle is 35mm in focal length. A 28mm or 24mm lens will give wider coverage and a more exaggerated depth. The 16mm and shorter focal length lenses give superwide coverage and extreme depth expansion. Fish-eye lenses produce a circular image on the film and cover up to 180° of the subject.

**Long-Focus, or Telephoto, Lenses**    Lenses with longer focal length than normal are usually called **telephoto lenses,** though technically the word *telephoto* refers to a particular type of long-focus lens design, producing lenses with bodies shorter than the effective focal length. Telephoto lenses for 35mm cameras range from a moderate 70mm to 500mm (giving ten times the image magnification of the normal lens) and longer.

Compressed Spatial Feel of a 500mm Lens.

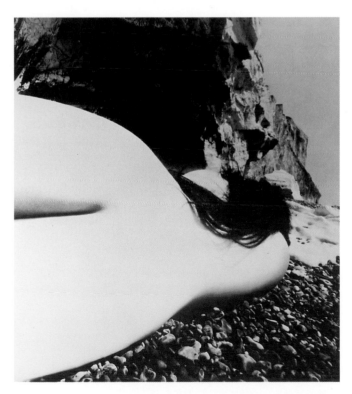

Expanded Depth Due to Wide-angle Lens. Bill Brandt, *Nude East Sussex*, 1957.

**Mirror Lenses**    Telephoto lenses with curved mirrors in place of glass lens elements are much more compact, lighter in weight, and less expensive than compound glass lenses of equivalent focal length. The image quality is usually not as good and control of exposure is complicated because a standard diaphragm aperture cannot be used with a mirror, but they offer a good alternative for many applications.

*500mm Mirror Lens and Example.* Note the doughnut shape of the out-of-focus points of light in the background of the photograph, a characteristic of mirror lenses.

**Lens Extenders**    Lens extenders—also called tele-extenders—are mounted between the lens and the camera body and contain lens elements that increase the effective focal length of a lens by two or three times. A 100mm lens combined with a 2x lens extender gives an effective focal length of 200mm. Lens extenders deteriorate image sharpness and cause a reduction of exposure on the film—two stops less for a 2x extender—limiting their use in low-light situations. Some manufacturers of quality lenses offer lens extenders carefully designed to work with specific focal lengths of their lenses. These give quality that is surprisingly high but does not approach that of an equivalent single focal length lens, and they are expensive.

**Zoom Lenses**    Some zoom lenses cover focal lengths from a moderate wide-angle to a moderate telephoto; others may offer only a range of wide-angle or telephoto focal lengths. Zoom lenses are generally larger and heavier than single focal length lenses and do not offer as large a maximum aperture, typically f/4. The image quality of zooms is generally slightly less, although the better modern zoom lenses offer results that are more than adequate for most purposes.

**Perspective**   Perspective changes with the distance from camera to subject. The apparent compression of distances with a telephoto lens is a result of the magnification of what is actually normal perspective for the distance to the subject. Wide-angle lenses have the opposite effect, apparently expanding the distances in the subject. If distance from camera to subject is changed to alter perspective, the focal length can be changed to retain the size of one object in the field of view.

24mm

50mm

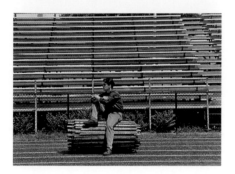

100mm

200mm

This series was photographed with lenses of different focal length, but the camera distance was changed with each to keep the central subject the same size. Note the change in the relative size of subject and background—the perspective—with distance.

   It is mistakenly thought by many that **perspective**—the relative sizes in a picture of objects at different distances from the camera—changes with the focal length of the lens. Careful inspection of the images on page 70 shows that this is not true. The relative size of objects within the photographs—all taken from the same position—is the same, more easily seen by enlarging the normal focal length image.

Left : Full Frame with 200mm Lens.
Right: Section of Frame with 50mm Lens Taken from Same Position, Magnified Four Times as Much in Printing for Same Image Size.

## Aperture

The aperture is a variable opening located near or in the lens, used for controlling the amount of light reaching the film. The numbers used to indicate the size of the aperture are called f-stop numbers or f-numbers or **relative apertures** and are defined by a formula:

$$\text{F-stop} = \frac{\text{Focal length}}{\text{Effective aperture diameter}}$$

A lens with a focal length of 100mm and an effective aperture diameter of 25mm would have a relative aperture or f-number of f/4. The f-stop number gets smaller as the aperture gets larger because the aperture diameter appears in the denominator of the definition. Two lenses of different focal lengths require different aperture sizes to achieve the same relative aperture. A 100mm lens has an aperture diameter of 25mm at f/4, but a 200mm lens would require an aperture diameter of 50mm to have the same relative aperture of f/4.

Diaphragm-Style Aperture Showing Relative Size of Aperture for f/8 and f/16.

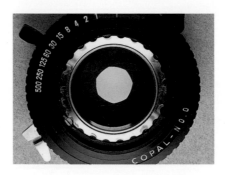

The most common type of aperture is the iris diaphragm, which is a series of metal blades overlapping to form a nearly circular opening. Some less expensive cameras use a rotating disc with different-sized openings situated just behind the lens.

Since the aperture is located in or near the lens, the brightness of an image seen in the viewfinder of a single-lens reflex camera would be affected by changing the aperture. To eliminate this inconvenience, most modern single-lens reflex cameras employ an **automatic diaphragm,** which remains fully open regardless of the f-stop setting until the picture is taken, at which time it stops down to the set aperture and reopens after the exposure.

## Depth of Field

That a lens can be focused on only one subject distance at a time would seem to present a considerable disadvantage, leaving parts of any three-dimensional subject out of focus. In fact, parts of the subject at distances other than that focused on appear acceptably in focus as well. The reason for this can best be seen by looking at image formation.

The image formed by the lens on the film can be thought of as consisting of an infinite number of points of light, which emanated originally from corresponding points of the subject. When the image is "in focus," a point on the subject images as a point on the film. When the image is "out of focus," the point is imaged as a circle of light. These circles are known as **circles of confusion.**

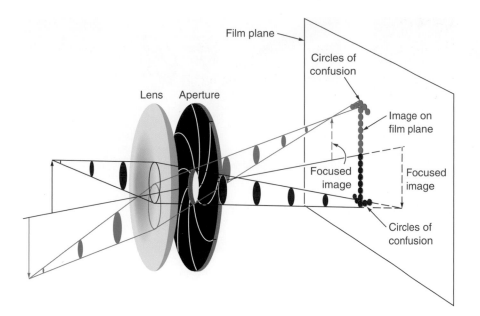

Film plane

Circles of
confusion

Lens    Aperture

Image on
film plane

Focused
image

Focused
image

Circles of
confusion

*Circles of Confusion.* Light rays come from each point on the subject, are converged by the lens, and restricted by the aperture to form a cone of light. A sharp image is formed at the tip of the cone, with each point of light in the subject represented by a point of light in the image. If the film plane is not at this point of sharp focus, each point of light images as a disc of light (the intersection of the cone with the film plane) known as a circle of confusion. The image of the subject is then composed of overlapping discs of light, causing it to look less sharp, or out of focus. The farther the film is from the point of sharp focus, the larger the circles of confusion become and the more out of focus the image appears. If the size of the aperture is reduced, the cone becomes narrower and the circles of confusion become smaller, resulting in a sharper image.

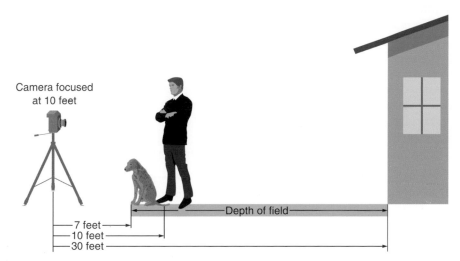

Camera focused
at 10 feet

Depth of field

7 feet
10 feet
30 feet

*Depth of Field.* If the camera was focused on the man at 10 feet, but the dog at 7 feet and the front of the house at 30 feet are acceptably sharp in the finished photograph, the depth of field is said to be from 7 feet to 30 feet.

If the circles of confusion are small enough, they are perceived as points by the eye and the image looks acceptably sharp—that is, in focus—even when it technically is not. This gives **depth of field** in the finished photograph, which means that objects some distance in front of and behind the focused distance appear acceptably sharp. Depth of field is given as the nearest and farthest distances that are acceptably sharp in a finished photograph. Several factors affect the depth of field for a given photograph, all by changing the sizes of the circles of confusion.

|  | MORE DEPTH OF FIELD | LESS DEPTH OF FIELD |
|---|---|---|
| Aperture | Smaller (e.g., f/16) | Larger (e.g., f/2.8) |
| Focused distance | Farther | Nearer |
| Lens focal length | Shorter (e.g., wide-angle) | Longer (e.g., telephoto) |
| Print size | Smaller | Larger |
| Print viewing distance | Farther | Nearer |

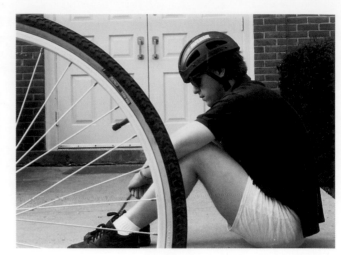

This subject has objects at three different distances: the bicycle wheel is at 3 feet, the man is at 8 feet, and the door is at 20 feet. The photograph on the left was taken with the aperture set at f/2.8 and the one on the right at f/16. The shutter speed was adjusted to keep the film exposure the same. The lens was focused on the man (8 feet) for both photographs.

**Depth-of-Field Control**   Of the factors that affect depth of field, the most easily controlled is the aperture. Changing the aperture to give more or less depth of field requires only a compensating change in the shutter speed to keep correct film exposure. The distance focused on can also be used for control. If you have a near and a far distance you wish to be in focus, the lens should be focused at an intermediate point (see the following section for depth-of-field calculations). Using lens focal length changes to control depth of field is not practical, however. Although the shorter focal length will give more depth of field, it will also include more of the subject. If you move closer to give the same subject inclusion, you lose the depth of field gained by the lens change.

**Depth-of-Field Calculator**   Lenses on many cameras provide a scale to calculate depth of field. Depth-of-field calculators are normally based on calculations of depth of field for an 8 × 10-inch print made from the full negative and viewed at about 10 inches. If you plan to make changes in these standards—for example, to produce a larger or more highly magnified print—you should make allowances for the decreasing depth of field by stopping down more than the depth-of-field calculator indicates.

Once the lens is focused, the depth of field is read by finding the distances bracketed on each side by the f-stop number set on the aperture ring. In this example, focusing the lens at 8 feet gives depth of field from 5.5 feet to 15 feet when the aperture is set to f/16.

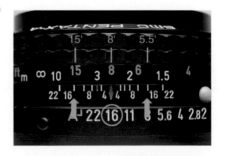

**Hyperfocal Distance** The **hyperfocal distance** is the minimum focus distance for which infinity remains within the depth of field. Focusing at the hyperfocal distance provides the greatest possible depth of field for any given aperture, from half the hyperfocal distance to infinity. The hyperfocal distance changes with the f-stop. This setting is handy for situations where you may not have time to focus, but you know subject matter will be at least half the hyperfocal distance away from the camera.

Some simple snapshot cameras cannot be focused but are prefocused on the hyperfocal distance for their single f-stop. The instructions on such **fixed focus cameras** will give a minimum distance for sharp focus, but anything from there to infinity will be acceptably sharp, usually only for snapshot-sized (about 3 1/2 × 5-inch) enlargements.

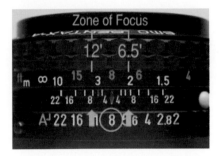

A lens with a depth-of-field scale can easily be focused at the hyperfocal distance by setting the infinity mark opposite the appropriate f-stop number on the scale. The f-stop mark on the opposite side of the scale will tell you the minimum distance that will be in focus. Here the hyperfocal distance is 15 feet for an aperture of f/16, giving depth of field from 8 feet to infinity.

## Zone Focusing

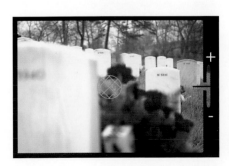

If you are going to be shooting in a situation where you know your subject distances fall between a certain minimum and maximum, you can prefocus the camera and choose the proper f-stop to cover that zone of distances using the depth-of-field scale on the lens. In this example, depth of field from 6.5 feet to 12 feet was achieved by focusing at 8 feet and setting the aperture to f/8.

**Depth-of-Field Preview** For cameras offering TTL viewing—single-lens reflex and view cameras—the change in depth of field can be seen through the eyepiece or on the ground glass as the lens is stopped down. Some single-lens reflex cameras with automatic diaphragms have a preview button for this purpose. An image viewed through a stopped-down lens may be dim and hard to distinguish and therefore may not give as accurate an assessment of depth of field as the depth-of-field calculator. In good light, however, the depth-of-field preview button can give a fairly reliable indication of the relative focus of the various subject distances.

*Depth-of-Field Preview.* The image on the left is the view through a single-lens reflex viewfinder with the automatic diaphragm wide open for viewing. The image on the right shows the effect when the preview button is pressed to stop the aperture down to the preset f-stop.

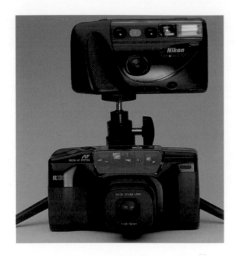

*Point-and-Shoot Cameras.* These models offer a variety of automatic features. The camera on the bottom has a variable focal length lens.

## ■ Camera Selection

First try to envision your uses for the camera. If you plan on only taking occasional photographs of friends and family to be printed as snapshots, burdening yourself with an unnecessarily bulky and complicated camera will waste your money and probably discourage you from taking as many photographs as you would with one of the many excellent point-and-shoot cameras. Most of these use 35mm or APS film, and some give such good results that they can be considered for serious uses where their limitations are outweighed by the advantages of compactness and ease of operation. The waterproof feature on a few models is useful in situations where a normal camera would be damaged by exposure to dirt or moisture.

## Camera System

If you plan to pursue photography as a serious hobby or as a profession, using your camera in a variety of situations, flexibility becomes important. You should then consider cameras with interchangeable lenses and a wide selection of accessories. Purchase of a particular camera restricts you not only to its features but also to its system of lenses and accessories. Select a system carefully so that you will not find your needs outgrowing the system in a short time. In addition to the lenses and accessories offered by the camera manufacturer, you may also be able to find "aftermarket" equipment that will work with your model of camera.

Complete System of Lenses and Accessories Produced by the Manufacturer for the Camera in the Center.

Canon EOS System.

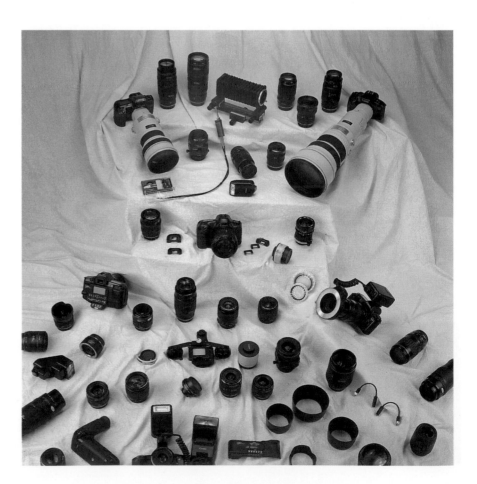

## Format Size

Larger format sizes generally give better image quality. Photographers doing advertising, landscape, architectural, or still life photography often use 4 × 5-inch or 8 × 10-inch view cameras for the excellent image quality and the focusing flexibility offered. Wedding photographers may prefer medium-format cameras because they combine reasonable portability with the quality of a larger negative, making the large prints sometimes requested by clients look their best. Photojournalists and others needing portability, flexibility, and convenience turn to 35mm cameras.

If you are just starting out in photography, a high-quality 35mm camera system will probably be the best choice. Because of the continuing improvements in films and lenses, careful use of 35mm equipment will yield excellent results for a wide variety of purposes.

## Metering System

The features of an in-camera meter may be a determinant in camera choice. Features of in-camera meters are covered in detail on pages 33–35 and 47–50.

## Camera Accessories

The accessories in a system add convenience to your picture taking or improve, enhance, or alter the quality of an image. For example, **motor drives** or **winders**—which are usually slower and lighter duty than motor drives—will automatically advance the film after each exposure. Automatic film advance is an obvious advantage when quick, repeated exposures are needed, but it can also play an important role in improving your photography in other situations as well, since it eliminates removing the camera from the eye when advancing the film, allowing a more continuous visual connection with the subject. Many of today's cameras have built-in motor drives or winders.

Other accessories, such as filters, flashes, and close-up attachments, are discussed in chapters 11 and 15.

## Electrical versus Mechanical Operation

The move toward totally electrically controlled cameras has raised an issue of reliability for some photographers. Most modern 35mm cameras incorporate electrical operation of several or all functions, many of which cannot be operated mechanically. Often the functions of the shutter and aperture are integrated into the operation of the meter. That means when your battery goes dead or a malfunction takes place in one of the components, the camera is useless.

A few cameras offer one mechanical shutter speed that will operate with a dead battery. Even fewer—for example, the Nikon FM10 and the Nikon FM2—offer the full range of shutter speeds and apertures without batteries. Carrying spare batteries is a must for electrically controlled cameras, and a spare camera body or two is an excellent idea if you want to be sure you get your photographs.

## Automatic versus Manual Functions

The trend today is to offer automation of many of the functions of the camera and lens: automatic exposure controls, automatic film winding and rewinding, automatic film speed setting, automatic focus. Each of these features adds convenience but takes away control. As you become more knowledgeable about photography, you will find yourself in situations where you can get better results by controlling the camera manually. A number of cameras allow manual override of some or all of the automatic controls. Buying a totally automatic camera will limit your flexibility sometime in the future.

Automatic focus is often useful, allowing faster work in moving situations. Autofocus systems are being improved at a rapid rate but still make undesirable focus choices in some situations, so thought should be given to choosing a camera with manual override of the autofocus feature. Try the camera you are considering to be sure that the manual focus controls provide accurate focusing and are comfortable to operate.

## ■ Lens Selection

### Lens Mounts

The mounts on lenses vary considerably from brand to brand and even from model to model within a brand. You cannot, for example, use a Nikon lens on a Canon camera or a Minolta autofocus lens on a Minolta manual focus camera. A number of independent lens companies, however, make lenses with mounts adaptable to nearly any current camera model. If you have purchased a high-quality camera, you may be better off staying with lenses built by the same company. The image quality of adaptable-mount lenses is usually not as good as that of original equipment, but such lenses may offer a good value for many purposes. Some extremely high-quality lenses on the market will adapt to most quality cameras, but they carry a correspondingly high price tag.

### Focal Length

Unless the work you are doing is very specialized, a lens of normal focal length will be useful. If you will be working in confined spaces, prefer working close to your subject matter, or like the feeling of wide-angle depth expansion, you will want to purchase a short focal length lens. Long-focus, or telephoto, lenses are useful when you wish to photograph subjects from a distance, if you want to isolate details of inaccessible subjects, or if you like the compressed spatial look of the telephoto image. If cost, weight, and size are considerations, you might investigate mirror lenses or lens extenders to achieve more extreme image magnification, keeping in mind their shortcomings (see page 72).

### Zoom versus Fixed Focal Length

Zoom lenses, with their easily adjustable focal length, offer precise and rapid framing of a subject without lens or position changes. A zoom lens covering moderate wide-angle to moderate telephoto focal lengths—about 28mm to 80mm focal lengths on a 35mm camera—might be a good general-purpose lens if you can only buy one lens to begin with.

## Minimum Focus Distance

If you plan on extreme close-up photography, then the minimum focusing distance of the lens should be examined. Macro lenses provide the closest focus without accessories but are relatively expensive and do not offer large maximum apertures, typically around f/4.

Zoom lenses that offer a "macro" feature should not be confused with true macro lenses. Although these lenses may offer a somewhat closer focusing distance than comparable lenses, they cannot focus to the closeness of a true macro, nor are they optically designed especially for close-up work.

## Image Quality

Some simple tests of the image quality of a lens are discussed on page 178, but initial judgments can be made by reading test reports in photography magazines and asking the advice of knowledgeable professionals.

## Maximum Aperture

The maximum aperture of a lens is often used as a selling point but is not always an important feature. The difference between a lens marked f/1.8 and one marked f/2 is only one-third stop. Even if a lens offers a maximum opening of f/1.4, it may not be useful to you unless you plan to do a lot of very low-light photography and do not care about the loss of depth of field when shooting at such extreme apertures. The wider apertures do give brighter viewing and somewhat easier focusing for a single-lens reflex camera, but lenses of large maximum aperture are much harder to design and build, and quality in such lenses costs more money. If faced with a choice of an f/1.4 lens and an f/2 lens from the same manufacturer, focal length and image quality being equal, buy the f/2 lens and save some money unless you have definite need for the larger opening.

## ■ Camera Equipment Purchase

## Brand Preference

Once you have decided which type of camera to buy, you have to make the next choice—what brand to buy. Some correspondence can exist between brand and quality, but too often equipment is bought on blind brand loyalty, when another brand may offer a better solution to an equipment problem. Asking photographers with extensive equipment experience is a good way to get some idea of the reliability and quality of various brands, but make any such survey as wide as possible. Any photographer who shows a fierce loyalty to one brand or implies that only one decent brand of camera is on the market is not being objective. A number of manufacturers produce quality camera equipment, and you should choose on the basis of what suits your needs and feelings.

Camera store salespeople are often knowledgeable and can give excellent advice. On the other hand, many are not well-informed or may have a hidden agenda for selling particular models—higher profit margin, excess inventory, and so on. The more people you ask for advice and the more equipment you handle and use, the more informed your choice will be. This is not a place to be lazy and take whatever is easily available or cheap. Your first camera choice can lead to purchases of lenses and accessories, and before you realize

it you have a considerable investment in equipment. Should you begin to feel limited by the system, changing brands can then become an expensive undertaking.

## Used Equipment

Some bargains are to be found in used equipment, but make sure the equipment is in excellent condition. If you are not qualified to judge the condition of the equipment, enlist the aid of a qualified service center. Never buy used equipment without thorough testing in advance. The higher price of new equipment may be justified by the warranty offered.

## Camera Dealers

Some advantage exists in buying from a local camera dealer with a reputation for backing up its merchandise, even if its prices are slightly higher. If a problem with a piece of equipment occurs immediately after purchase, local dealers will normally exchange for new equipment on the spot. Ordering from mail-order houses can prove much less expensive, but certain risks are involved. Investigate the reputation and reliability of the mail-order house. Many are reputable and have been in business for years, but others may take your money and go out of business. Long waits for equipment ordered by mail are not unusual, and if any problems with the equipment arise, solving them by mail or telephone may take considerable time, even if the company is willing to make good on the merchandise.

## Prices and Warranties

Advertised prices can sometimes be misleading. The most widely used ploy is to offer a piece of equipment at the "gray market" price. Gray market equipment is imported into the United States without the permission of the U.S. distributor. The equipment is the same, but the warranty is not. The international warranty included with gray market equipment is not accepted by U.S. factory service warranty centers, so if problems arise under warranty you must ship your equipment to Japan or another foreign country for servicing. A second misleading practice is to advertise a price that does not include a case or other item that the manufacturer normally packs with the equipment.

## ■ Camera and Lens Care and Maintenance

Cameras and lenses are delicate instruments and require care in handling for optimum performance.

■ Avoid rough handling, bumping, dropping, and banging.
■ Protect the glass lens from fingerprints and scratches. A lens cap should be used when not taking photographs. A clear glass or ultraviolet (UV) filter can help to protect the lens in potentially damaging situations. The filter should be of high quality and should be treated just like the lens. If damaged or scratched, it should be replaced.
■ Protect both the camera and the lens from moisture (especially salt water), extreme humidity (basements can be bad), heat (watch out for hot glove compartments or car trunks), dust, sand, and other grit.

■ When possible, protect the camera and the lens from the direct rays of the sun.

■ Never force any of the controls on the camera or the lens. If they are not moving when you think they should, check to make sure you are operating them correctly. A low battery can cause controls on electronic cameras to lock. If you cannot figure out the problem, seek professional help.

## Battery

A main source of problems with modern cameras and meters is improper maintenance of the battery. Check the battery on a regular basis and replace if necessary. Sometimes the problem is poor contact within the battery holder. Contacts can often be cleaned using a new pencil eraser. Take care not to touch the contact surfaces of the battery during installation. Batteries should be removed if the equipment is not used for any length of time.

## Periodic Service Center Maintenance

Cameras and lenses should be returned to a factory service center or other authorized repair service center for general maintenance on a regular basis for cleaning and checking. Equipment that receives heavy use, especially in extreme—hot, dusty, cold, damp—environments, should be serviced about once a year. Cameras receiving more moderate use and careful maintenance should be checked for meter and control accuracy periodically but would require professional cleaning less often.

## Testing Methods

You can do a few things yourself to make sure your camera and lens are in good basic operating condition. Chapter 7 covers these and more extensive testing techniques for specific problems on pages 176–80. In addition, appendix B gives information for evaluating tests of your equipment by professional camera repair centers.

## Cleaning

Wipe the camera body clean with a soft cloth. Do not use solvents or cleaners. Dust can be brushed out of crevices with a soft camel hair brush. The interior of the camera should also be cleaned periodically. Use a lens brush to carefully remove dust, but never try to clean the blades or curtain of the focal plane shutter, as they are easily damaged. Take special care to clean the pressure plate, a spring-mounted plate that is located on the camera back and holds the film flat. Remove the lens and carefully clean the mounting surfaces. Do not try to clean the mirror in a single-lens reflex camera, as it is silvered on the front surface and is extremely delicate.

Lenses should be regularly inspected for cleanliness. Clean them only when necessary, as excessive cleaning may cause damage to the delicate coatings. If dust is seen on the surface, usually a simple brushing with a lens brush and a squirt of compressed air—or a canned air substitute—is enough. If some residue remains on the lens surface after removing the dust, clean with a photographic lens cloth or lens tissue; do not use tissue or cloths designed for cleaning noncoated eyeglasses. An excellent lens-cleaning cloth can be made from cotton velvet, washed many times for softness.

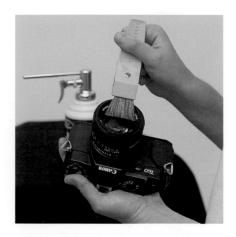

A. Use a brush and compressed air to make sure the lens surface is free of dust.

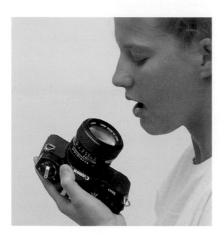

B. Breathe on the lens to mist it.

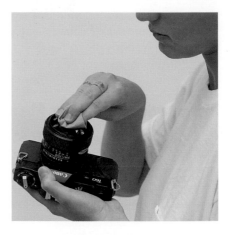

C. Use the lens-cleaning cloth to *gently* wipe the lens clean in a circular motion. Blow off any remaining lint or dust with compressed air.

D. If stubborn deposits resist this cleaning, you may use a photographic lens-cleaning solution as a last resort. Place a drop of the lens-cleaning solution on a folded lens tissue and gently wipe the lens clean. A bit of compressed air will remove any lens tissue fibers remaining on the lens after cleaning.

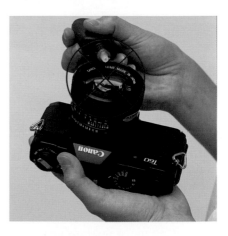

E. Never place the lens-cleaning solution directly on the surface of the lens, as it may seep into the lens mount and loosen the cement holding the elements in place.

# CHAPTER 5

# Developing Film

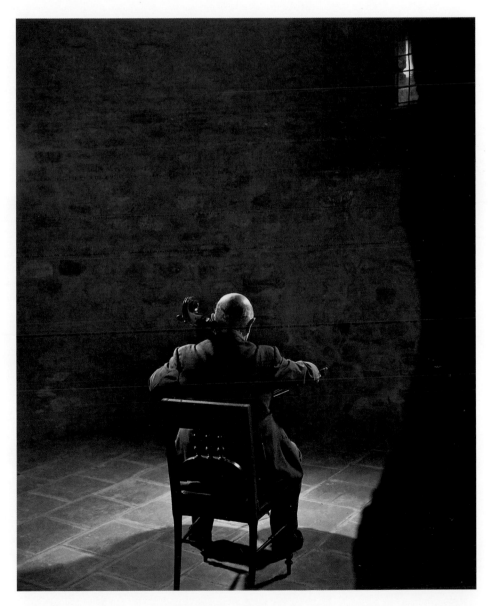

Yousuf Karsh, *Pablo Casals*.

The purpose of development is to convert the latent image formed at the time of exposure to a lasting, visible image on the film that can be viewed or printed. Developing of black-and-white film is discussed in this chapter. For more detailed information on both black-and-white and color processes, refer to chapters 11, 12, and 14. The procedures illustrated in the following sections are for 35mm film. Medium-format films are processed in much the same way, with slight differences in loading film onto reels. Sheet film requires special handling, though the processing steps are the same. Handling of these films is discussed after the processing for 35mm films.

## ■ Developing of Black-and-White Film
### Equipment, Facilities, and Materials

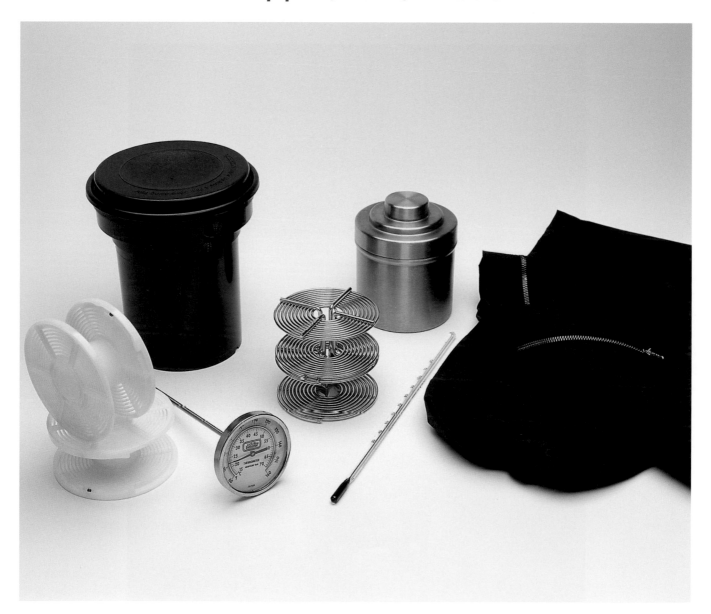

Film Developing Tanks, Changing Bags, and Thermometers.

**Developing Tank**   Panchromatic film is sensitive to all colors of light and must be handled in total darkness until most of the processing is complete. A lighttight tank to hold the film during the chemical steps will make the process more convenient. Daylight developing tanks are lighttight and have a specially designed lid that allows solutions to be poured in and out without allowing light to reach the film. Reels fit into the tank to hold the film so that the chemistry can reach all of its surfaces. Once the film is loaded into the tank, processing can be done in normal room light.

Developing tanks are available in plastic and stainless steel. High-quality stainless steel is a more durable material and is more impervious to contamination by chemicals, but it is more expensive than plastic. Most people find the stainless steel reels more difficult to load. Plastic tanks and reels can serve well with proper handling and cleaning. Choose a tank that has a lid system allowing inversion of the tank without loss of chemicals. If you intend to process both 35mm and medium-format films, purchase a tank that will hold at least two 35mm reels or one medium-format reel. Some plastic reels are adjustable, accepting several different sizes of film. Nonadjustable reels require a different reel for each size of film.

**Totally Dark Loading Space**   To load the film into the reels and place them in the developing tank, you must be in a totally dark room. Even a small closet will do, as long as it is completely lighttight. To check for light, enter the darkened room, allow your eyes 5 to 10 minutes to adjust, then move throughout the room watching for light. Peripheral vision is more sensitive to low levels of light, so watch for light leaks at the edge of your vision.

If you cannot find a dark room, lighttight changing bags may be purchased for loading film. Changing bags can be troublesome in hot or humid weather because of perspiring hands. More expensive changing bags have a frame to keep the material off your hands, or you might build your own wire frame for a cheaper bag.

**Thermometer**   Buy a thermometer that is designed for photographic use and can be read accurately to the nearest 0.5°F or 0.25°C. Stainless steel dial thermometers have quick response and are less likely to break than a glass thermometer but go out of adjustment more easily. Do not try to save a few dollars buying a cheap thermometer, since accurate control of temperature is critical, especially in the developer.

**Additional Supplies and Equipment**   The additional chemicals, containers, and tools needed are summarized in the following table. For more detailed information on the chemistry, see the in-depth section beginning on page 107.

## Film Processing Equipment and Supplies

| ITEM | FUNCTION | REMARKS |
|---|---|---|
| 1. Lighttight room or changing bag | Protect film from light while loading tank | Test room for light leaks as described on page 87. |
| 2. Daylight developing tank | Protect film from light while processing | See page 87 for desired tank design. |
| 3. Bottle opener | Open 35mm film cassettes for loading | Any standard bottle opener will work. |
| 4. Scissors | Cut film for loading | |
| 5. Thermometer | Determine temperature of processing solutions | See page 87 for thermometer types. |
| 6. Timer | Time each processing step | A watch or clock that measures in minutes and seconds will do, but a stopwatch or countdown timer will reduce the chance of errors. |
| 7. Mixing utensils | Mix chemical solutions from packaged form | You will need open containers and mixing paddles of glass, inert plastic, or stainless steel. |
| 8. Measuring utensils | Accurately measure liquids used in processing | Divisions on large containers may be too far apart to accurately measure small quantities, so use a container of a size close to the quantity being measured. |
| 9. Storage containers | Store processing solutions between uses | Storage containers should be clean and made of glass or inert plastic. Bottles previously used for other purposes may be difficult to clean well enough for photographic use. |
| 10. Water | Mix chemicals and wash film | A mixing tap for running water at controlled temperature adds convenience. You can instead use a large bucket of water at the desired temperature. |
| 11. Developer | Convert latent image into usable image | Choose a general-purpose film developer such as Kodak D-76, Sprint Standard, or another from the chart on page 92. Mix according to the directions on the package. |
| 12. Fixer (also known as "hypo") | Make image permanent and safe to expose to light | Choose a general-purpose film fixer. Follow the directions on the package for mixing and use. |
| 13. Washing aid | Shorten washing time and insure clean film | Many brands are available: Permawash, Orbit, Kodak Hypo Clearing Bath, Sprint Fixer Remover, and others. Follow directions for mixing and use. |
| 14. Wetting agent | Prevent water spots while film dries | Most popular is Kodak Photoflo, but other brands are available. Follow directions for mixing and use. |

## Suggestions for Success

The results you get when you develop film depend on the care you take with each step. To prevent errors, it helps to follow some basic procedures.

*Organization.* When you are in total darkness loading the film, it can be troublesome to discover you do not have the necessary tools to get the film into the tank. Once processing begins, you should not pause, so it is important to have everything organized in advance. Lay out all your equipment and materials before starting.

*Cleanliness.* Many problems in developing can be traced to contamination of one chemical by another. Careful washing of all processing implements—thermometer, mixing rod, and measuring, mixing, and storage containers—in warm water both before and after use will help to prevent contamination. Wash tank and reels after processing and set out to dry. Hands are a source of contamination. If they have been in contact with any of the chemicals, wash them carefully with soap and warm water and dry them on a clean towel. Careless splashing and dripping of chemicals is also a source of contamination.

*Adherence to directions.* Photography is a well-documented craft. Materials come with explicit directions. Read them completely *before* beginning work and follow them carefully.

*Consistency.* Use exactly the same procedures each time you process for consistent results. Think about what you are doing so that you can reproduce your activities precisely each time.

*Record keeping.* Recording data on the procedures and materials you use in a permanent record book can save time in the long run and accelerate the learning process.

## Loading of Film into Developing Tank

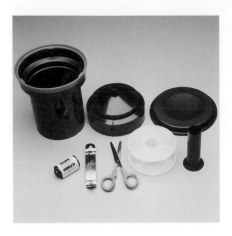

A. Lay out your equipment in the darkroom or changing bag as shown. Make sure the tank is clean and dry. Check that adjustable reels are set for the correct film size.

B. Turn off the light. Use the bottle opener to pop the cap off the flat end of the film cassette. Remove the film on its spool from the cassette by pushing on the long end of the spool.

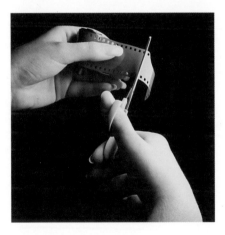

C. Trim off the narrow leader so that the end of the film is square.

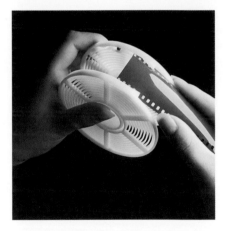

D. *Plastic Reels.* Holding the film and reel as shown, slide the end of the film into the opening of the spiral until it locks under the stainless steel balls.

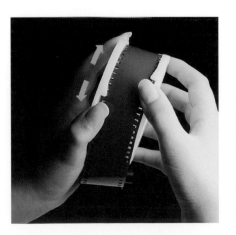

E. Move the reels back and forth to "walk" the film into the reel.

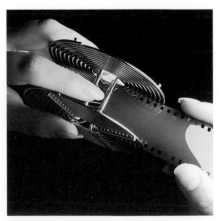

F. *Stainless Steel Reels.* Holding the film and reel as shown, insert the end of the film into the clip at the center of the reel.

G. While holding the film by the edges to produce a gentle curvature of the film, turn the reel and guide the film into the wire spiral.

H. When you reach the end of the roll, cut the film just before the tape and wind the remainder onto the reel. Note that some films do not have tape at the end of the roll, but are simply hooked to the spindle.

I. Place the reel into the tank. Some plastic reels must be put on a plastic spindle before being placed in the tank.

J. Put the double-lid system on the tank. You may now turn on the lights.

## Film Processing

Before starting, read through all the steps (pages 91–101) and make sure all your equipment and materials are set up. Also read the boxed section "Health and Environmental Concerns" on the next page.

**Timing** The developing process is continuous, with each step timed. Once you have begun, you should continue through all the steps without pause. The time it takes to pour the solution in at the beginning of a step and out at the end should be included in the time given for each step. Always try to keep pour-in and pour-out times to a minimum, but make sure the tank is thoroughly drained.

# Health and Environmental Concerns

## Health Note

Take special care to read and follow health hazard notices on each package of photographic chemical. Chemicals can be taken into the body in three ways: by breathing, by skin contact, and by mouth (ingestion).

Good ventilation in any area where chemicals are stored, handled, or used is important. Darkrooms should be equipped with exhaust fans to give a good supply of fresh air. Avoid breathing the dust from chemical powders while handling them. Many spray adhesives contain hexane, which can cause serious and irreversible nerve damage with prolonged exposure. Take special care with ventilation when using these or other aerosol sprays.

The response to contact of chemicals with the skin can be direct irritation such as burning and itching or may consist of an allergic reaction. Chemicals may also be absorbed through the skin and cause internal damage. Solvents, such as those used in some film cleaners, are often absorbed through the skin. Unnecessary contact with chemistry should be avoided as a matter of course. Protective clothing, rubber gloves, and safety goggles help to prevent skin contact. Tongs or rubber gloves for handling prints in solutions help reduce contact. Wear eye protection when mixing liquids, especially strong acids or alkalies. Photographic bleaches are usually strong and can cause burns or other dangerous reactions. When diluting a strong acid, slowly add the acid to the water. **Caution:** Never add water to acid, which may cause splattering.

A few people are particularly sensitive or allergic to some of the photographic chemistry, especially the developers. The presence of Metol—p-methylaminophenol sulfate, also known as Elon, Pictol, or Rhodol—is especially troublesome to some people. Following the preceding suggestions regarding ventilation and reducing contact should help. Sometimes a change to a developer of different makeup can reduce the reaction to the chemistry.

Ingestion of chemicals would seem to be unlikely for adults but can happen through contamination of

(continued on next page)

## Metol-Free Black-and-White Developers

| FILM DEVELOPERS | | |
| --- | --- | --- |
| Product | Manufacturer | Comments |
| FG7 | Edwal Imaging | Liquid concentrate, general purpose |
| Super 20 | Edwal Imaging | Liquid concentrate, fine grain |
| Ilfotec HC | Ilford, Inc. | Highly concentrated liquid, fine grain |
| Microphen | Ilford, Inc. | Powder, high energy, fine grain |
| Universal | Ilford, Inc. | Liquid concentrate, fine grain |
| Standard | Sprint System | Liquid concentrate, general purpose |

| PAPER DEVELOPERS | | |
| --- | --- | --- |
| Product | Manufacturer | Comments |
| "G" | Edwal Imaging | Liquid concentrate, general purpose |
| Platinum II | Edwal Imaging | Liquid concentrate, warm tone |
| LPD | Ethol Chemicals, Inc. | Liquid or powder, general purpose |
| Bromophen | Ilford, Inc. | |
| Ilfospeed | Ilford, Inc. | |
| Multigrade | Ilford, Inc. | |
| Quicksilver | Sprint Systems | Liquid concentrate, general purpose |

hands, food, or cigarettes. Use or storage of photographic chemicals in a kitchen or other food preparation area may cause accidental ingestion. All chemicals should be kept from the reach of children. Highly toxic chemicals are found in developers, toners, bleaches, and many of the solutions used in color processing.

### Environmental Concerns

Although it may be easy to pour photographic chemicals down the drain, this should not be done thoughtlessly. Even the small amounts of chemistry generated by home darkrooms are enough to produce an environmental hazard, depending on the type of sewage disposal in the area. The federal environmental protection standards mention three concerns for photographic wastes: (1) the presence of silver, (2) the presence of cyanide, and (3) the pH—a measure of acidity-alkalinity, with 7 being neutral—which should be between 6 (slightly acidic) and 9 (slightly alkaline). This means that most of the chemicals used in processing present little environmental hazard, especially if highly diluted before disposal. The dilute acids used in stop bath, the mild detergents used in wetting agents, and the chemicals in washing aids fall into this category.

Since fixer and photographic bleaches are silver solvents, they contain silver after use. Bleaches may also contain cyanide compounds. Silver is a toxic environmental pollutant and should not be disposed of in any sewer or septic system. In addition, silver is a bactericide and will impede proper operation of a septic system. Any chemistry containing silver should be collected and taken to a toxic waste or silver recovery center. Call your county or state environmental protection agency for information on disposal of toxic photographic waste. State standards are often more restrictive than the federal guidelines.

Some schools with photography programs run silver recovery programs and may be willing to accept fixer for recycling. The reclaiming system may not accept bleaches, so be sure to find out the specifications before bringing any photographic chemical waste in for treatment. Alternatively, steel wool immersed in fixer will take the silver out of solution, forming a sludge, which can then be sold for silver recovery. ∎

**Temperature Control**   Developer temperature must be determined accurately and maintained throughout the developing process. If the temperature of the room is different from that of the developer, then between agitation intervals you may want to immerse your tank in a bowl or tray of water at the exact developing temperature.

The temperature of the remaining solutions and washes is not as critical, but all should be within + or −5°F of the developer temperature to prevent **reticulation,** which is a wrinkling of the emulsion on the film caused by sudden temperature changes. For example, if your developer mixture is at 70°F, the remaining steps should fall between 65°F and 75°F. Check all solution temperatures before beginning. Warm or cool any as needed.

**Protection from Light**   When pouring chemistry into or out of the developing tank be sure to use the lid designed for that purpose to prevent exposure to light.

∎ **WARNING**   Do not remove the main tank lid until after the fixing step.

Enlarged Portion of a Print from a Reticulated Negative.

# Film Processing Steps

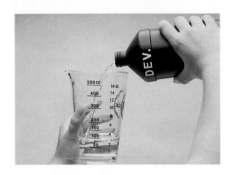

1a. *Preparation.* Mix developer to proper working dilution. For example, you may have mixed a solution of D-76 from the powder and you decide to use it at a dilution of 1:1—recommended for small-format films. If your tank requires 10 ounces of solution, you would mix 5 ounces of the D-76 solution with 5 ounces of water to make 10 ounces of D-76 1:1. For Sprint Film Developer, which is used at a dilution of 1:9, mix 1 ounce of the concentrate with 9 ounces of water for 10 ounces of working strength developer.

1b. Adjust the temperature of the water added to the developer so that the temperature of the developer mixture falls in the desired range, which should be 68°–75°F for best results with most developers. Hold the developer in its graduate for now. Using the exact temperature as measured, calculate the developing time using charts or tables supplied by the manufacturer.

2. *Prewet.* The prewet stabilizes the temperature of the tank and film and helps to keep air bubbles from sticking to the surface of the film during development. Remove the topmost lid from the tank. Fill the tank completely with water at the same temperature as your developer mixture. Replace the cap. Tap the bottom of the tank on a table or sink several times and invert repeatedly for a total time of 1 minute. Drain the water from the tank. After use, it is normal for the water and subsequent solutions to show some color from the dyes used in the film.

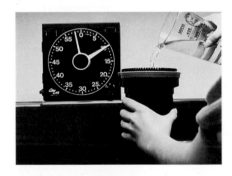

3a. *Developer.* Check the developer temperature to make sure it has not changed. Start the timer and quickly pour the developer into the tank. Some tanks must be tilted slightly for rapid pouring in of the developer.

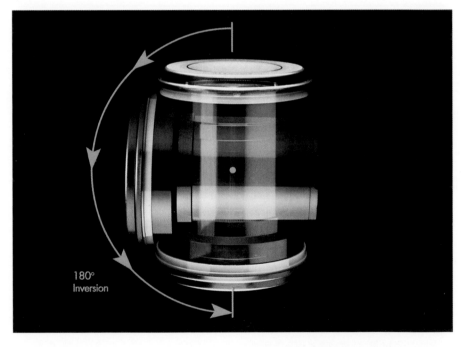

180°
Inversion

3b. The developer must be agitated during the developing process for even results. The basic agitation is to turn the tank upside down—that is, invert it—and then return it to its upright position. A complete inversion and return should take about 1 second. Inversions are done in groups of five. Before each group, rotate the tank 90° about its vertical axis. The quarter turn is followed by five inversions. Following a standard agitation pattern will help maintain consistent development:
Start timer

| | |
|---|---|
| Pour in developer | 10–15 sec |
| Tap two times on sink | 5 sec |
| Quarter turn and five inversions | 5 sec |
| Quarter turn and five inversions | 5 sec |
| Quarter turn and five inversions | 5 sec |
| Quarter turn and five inversions | 5 sec |
| Let tank rest until 1 minute has elapsed on the timer, then do: | |
| Quarter turn and five inversions | 5 sec |
| Let tank rest | 25 sec |
| Quarter turn and five inversions | 5 sec |
| Let tank rest | 25 sec |

Continue this pattern of 5 seconds of agitation out of every 30 seconds for the remainder of the developing time. Be sure to allow 15 seconds for draining the tank at the end of the developing time.

Some films and developers may require different agitation sequences, which will be specified in the manufacturer's directions. Some developers may be saved and reused with time adjustments, but if you have diluted the developer for use, dispose of it.

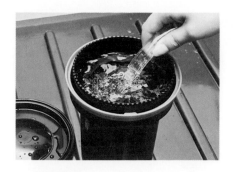

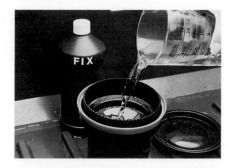

4. *Stop Bath/Rinse.* The purpose of this step is to rinse the developer from the film and stop the developing process. Concentrates for mixing an acid stop bath solution are available, but a pure water rinse can be used for small-tank developing of small- or medium-format film. Fill the tank with water at a temperature within plus or minus 5°F of the developer's, slosh it around, and drain. This is called a fill and dump. Fill and dump with water twice. Drain the tank. Total time for this step should be about 1 minute.

5a. *Fixer.* The fixer removes the undeveloped silver salts from the film, rendering it no longer sensitive to light. Pour the fixer—at a temperature within plus or minus 5°F of the developer's—into the tank, using the amount specified by the tank directions.

5b. Agitate with ten inversions initially and then for 10 seconds out of every minute for the remainder of the fixing time. The fixing time is not as critical as with developer, but stay within the time range suggested in the fixer directions. Fixer may be saved and reused. Keep track of the number of rolls of film processed, and dispose of the fixer when the manufacturer's suggested limit is reached. As an alternative to counting rolls, hypo-test solutions can be purchased for checking the condition of fixer. Used fixer contains silver, which is an environmental pollutant, so it should be recycled. Drain the tank.

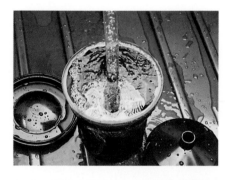

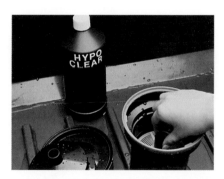

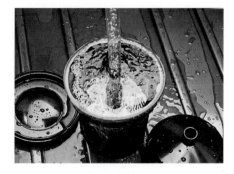

6a. *Initial Wash.* Fixer must be removed from the film to prevent staining and damage. It is safe to expose the film to light at this stage. Unless an accessory for the tank that provides forced washing is available, both parts of the double lid should be removed to allow free circulation of the wash water. With both tank lids removed set the tank under a faucet with a good flow of water adjusted to a temperature within plus or minus 5°F of the developer temperature. Direct the flow of water into the center of the film reel. Wash for 1 minute. Dumping the water out of the tank occasionally during the wash will help flush fixer out of the tank. Drain the tank.

6b. *Washing Aid.* Mix a working solution of the washing aid—at a temperature within plus or minus 5°F of the developer's—following the manufacturer's directions. Fill the tank with the solution and gently agitate by lifting and turning the film reel continually for the time specified in the directions. Drain the tank.

6c. *Final Wash.* Again set the tank with the top removed under a flow of good water. Wash for 5 minutes. Efficient film washers allowing shorter washing times are available, but when washing directly in the tank stay with a minimum final wash of 5 minutes. Drain the tank.

*continued*

# Film Processing Steps—Continued

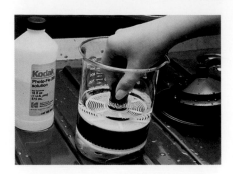

7. *Wetting Agent.* The wetting agent prevents water spots. Mix according to the manufacturer's directions at a temperature within plus or minus 5°F of the developer's. Agitate gently by lifting and turning the reel continually for the time specified in the directions—30–60 seconds for most brands. A few bubbles in the wetting agent are normal.

8. *Drying.* Carefully remove the film from the reel and hang in a dust-free place to dry. Clip a weight—such as a clothespin—to the bottom of the film to prevent curling. The film is very susceptible to damage at this stage, so keep handling to a minimum. Leave the film hanging until it is completely dry before looking at your results. Depending upon humidity conditions and temperature, this can take 2 hours or more. It is safest to leave the film overnight before handling. The film is dry when it takes a smooth curve toward the shiny side and the lower end of the roll does not feel cooler than room temperature; coolness is a sign of evaporating moisture still in the film.

9a. *Storage and Handling of Processed Film.* Transparent polyethylene storage sleeves help protect the film from damage. Using scissors, cut the dry film into lengths appropriate for the sleeves. If your working space allows, the dry film should be cut while hanging, to minimize handling and dust. Otherwise, lay the film out on a clean worktable to cut.

9b. Even after drying, film is very delicate. Never touch the image area of the film—handle only by the ends or edges. The film also scratches easily, so avoid rubbing or dragging it across other surfaces.

## Processing of Films Other than 35mm

The major difference in handling roll films is getting them onto the developing reels. Once they are in the tank, processing is the same as that outlined in the preceding section. Sheet film requires special handling and processing.

**Medium-Format Roll Films**   Be sure your film reel will accommodate the film you are using. The film width is the same on 120 and 220 films, but 220 contains twice as much film and some reels designed for 120 will not hold a full 220 roll. The only difference between loading 120 and 220 is the removal of the protective paper. The 120 is rolled inside a long strip of paper and taped at one end; the 220 has paper leader taped at each end. In most tanks, one roll of medium-format film—120 or 220—will require double the chemistry needed for one roll of 35mm film.

A. Adjust the plastic reel for 120 film by twisting one side of reel clockwise until it clicks, move sides of reel apart for proper spacing and twist counterclockwise until it clicks into place. The reel halves normally have index marks to show proper alignment for reassembly.

B. In total darkness, begin unrolling the paper backing until the film is felt. Continue to unroll, separating the film from the backing.

C. When you reach the end of the film, peel off the tape holding the film to the backing. Discard the backing and spindle. As an alternative, use scissors to cut the film just at the edge of the tape.

D. Holding reel and film as shown pull the end of the film under the stainless steel balls until it locks in place. Note: If you are using a stainless steel reel, lock the end of the film into the center of the reel and load from the center out, as was shown earlier for loading 35mm film into stainless steel reels.

E. Rotate the reel back and forth to "walk" the film into the reel. Place the reel on its spindle and assemble the tank as was described earlier. The processing steps for 120 film are the same as those described earlier for 35mm film. When looking for developing times on charts, use the roll film category. Remember to use enough chemical solution to cover the extended reel.

**Sheet Film**    Sheet film requires different handling from roll films and, in general, different processing times. Sheet film is held in special film holders when being exposed. Removal of the film from the holders is relatively easy, but handling during processing is more difficult, since the film cannot be placed in reels. Daylight developing tanks are available for 4 × 5-inch sheet film, but they typically do not give even development. It is better to process sheet film in trays—handling carefully to avoid scratches—or in sheet film hangers. Both of these methods require a totally dark room for the process through the fixer, since the film is not enclosed during processing.

A. All handling of general-purpose sheet films must be done in total darkness. To remove the sheet film from its holder, pull the dark slide (seen on the right in this illustration) halfway out. Flip open the loading gate (seen on the left of the holder). Gently grasp the film and slide it out of the holder.

B. Trays of film developer, stop bath, fixer, and washing aid should be prepared in advance with the same guidelines for temperature control as given in the 35mm film processing sequence. Slide the sheet film quickly into the developer, being careful not to scratch the film. Begin timing the development as soon as the film touches the developer.

C. Sheet film should be agitated continuously during tray processing. The agitation cycle consists of gently picking up the film by one edge, letting it drain briefly, turning it over and placing it back in the developer. Handle the film gently, both to prevent damage and to prevent overagitation of the film at the edges. Picking the film up by a different edge each time will help to produce random, even development.

D. Pick the film up by a corner 10 seconds before the end of the calculated development time and allow to drain before transferring to the stop bath. With care several sheets of film can be processed at one time, agitating by pulling the bottom sheet from the stack, turning it over and placing it on top of the stack. Count the films to keep track of which was placed in the developer first. Transferring the sheets to the stop bath in the same order they entered the developer will provide the same amount of development for each sheet. Continue through the steps of the process, using the same agitation technique you used in the development. Follow the manufacturer's time and temperature recommendations.

E. It is best to do the final wash in a washer designed for handling sheet film. Washing in an open tray is possible, but if more than one sheet is washed at a time care must be taken to avoid scratches.

F. Treat the sheet film in a solution of wetting agent prepared according to the manufacturer's directions for the time given in the instructions.

G. Hang the film in a dust-free area to dry.

H. Film hangers provide an alternative to tray processing of sheet film. After removing the film from the film holder, slide each sheet of film into a film hanger. The top of the film hanger flips open to allow the film to be inserted. Close the top to hold the film in place.

I. The processing solutions should be prepared in advance in special hard-rubber or plastic tanks designed for use with film hangers. Several film hangers can be easily handled at once. When lowering the hangers into the developer, do so slowly to prevent developing streaks. The agitation cycle is performed by slowly lifting the hangers from the tank, tipping to one side (as shown in the illustration) to allow drainage from the corner, slowly lowering the hangers back into the tank, then lifting the hangers again and tipping to the other side. Agitate in this fashion for the first 30 seconds of the development, then perform one agitation cycle every minute thereafter.

## Processing of Film in Tubes

A number of motor bases that allow agitation by rotation are available. Tanks—usually called tubes or drums when used in this way—on motor bases were originated for print processing but can be used to process both roll and sheet film. It may take some experimentation to get even development when agitating by rotation. The speed of the rotation, whether it reverses during the cycle, the amount of developer in the tube, and the design of the tube and reels will all affect the evenness of agitation. Developing times must be shortened when using motor bases, since they give considerably more agitation than the standard hand methods. With the proper drums and techniques, rotary processing can be used with all films, from disc to sheet film.

Processing Tubes, Motor Base, and Water Jacket Processor.

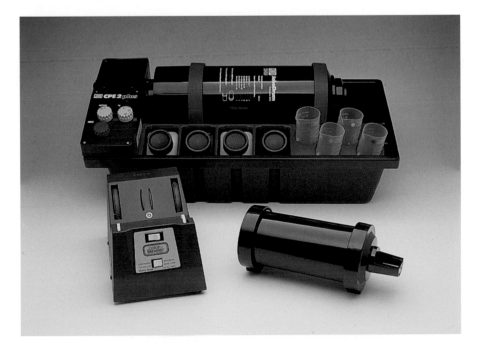

## Summary of Black-and-White Film Processing Steps

| STEP | MATERIALS | PROCEDURE | REMARKS |
|---|---|---|---|
| 1. Preparation | Film loaded in tank, developer, fixer, washing aid, wetting agent, running water source—all stabilized to proper temperature, preferably 68°–75°F unless otherwise specified in manufacturer's directions | Dilute developer to proper strength, measure temperature, and calculate proper developing time. Hold developer for step 3. | It is best to use developers at the suggested temperature, but time-temperature charts allow some flexibility. Care should be taken at temperatures much in excess of 75°F, as the film becomes soft and susceptible to damage. |
| 2. Prewet | Water at same temperature as developer | Fill tank. Tap to dislodge bubbles. Agitate by inversion and drain thoroughly. Total time is 1 min. | The prewet step can be optional, though if air bells are on the film during development, permanent spots will be left on the negatives. |
| 3. Developer | Developer mixture prepared in step 1 (recheck temperature to make sure it has not changed since mixing) | Set timer for time calculated in step 1. Start timer and pour developer into tank. Follow standard agitation cycle using inversions of the tank. Include pour-out in time. | Set the tank in a bath of water at the developing temperature during the rest periods to maintain constant temperature. |
| 4. Stop bath/rinse | Water at a temperature within 5°F of the developer's | Fill and dump tank twice. Drain thoroughly. | Commercially available acid stop baths may be used here and are recommended for sheet film or developing times less than 5 min. Follow manufacturer's directions. |
| 5. Fixer | Fixer in proper amount for tank, at a temperature within 5°F of the developer's | Start timer. Pour fixer into tank. Do 10 sec of initial agitation by inversion. Do 10 sec of agitation out of every minute thereafter. Follow manufacturer's directions for time. Drain tank. | Fixer may be reused. Pour it back in the bottle and keep track of the usage. The main tank lid may be removed after this step. |
| 6. Wash | Running water and properly diluted washing aid, both at a temperature within 5°F of the developer's | Three-step wash procedure as follows is recommended. | Dump the water completely out of the tank two or three times each minute of wash to make sure fixer is flushed from the tank. |
| a. Initial wash | Running water at a temperature within 5°F of the developer's | Place tank with main lid removed under tap with good flow of water for 1 min. | |
| b. Washing aid | Washing aid mixed according to directions at a temperature within 5°F of the developer's | Immerse film in washing aid with gentle agitation for time specified by manufacturer's directions. | |
| c. Final wash | Running water at a temperature within 5°F of the developer's | Place tank with main lid removed under tap with good flow of water for 5 min. | |

*continued on next page*

| STEP | MATERIALS | PROCEDURE | REMARKS |
|---|---|---|---|
| 7. Wetting agent | Properly diluted wetting agent such as Photoflo at a temperature within 5°F of the developer's | Immerse film in wetting agent with very gentle agitation for time suggested by manufacturer. | If in any doubt about the quality and cleanliness of the tap water, mix the wetting agent with distilled water. |
| 8. Drying | Dust-free drying area such as film-drying cabinet or shower stall, film clips or clothespins | Handling very carefully to avoid scratches and dust, hang film by one end and place a weight on the other. Let dry thoroughly before handling. | Dust settling on the film while it is wet is difficult or impossible to remove. Watch out for nearby furnace vents or fans that could throw dust on the film. Also be careful about handling wet film around sweaters or other clothing that could cause lint. |
| 9. Storage and handling | Negative sleeves, scissors | Cut negatives to proper lengths for sleeves. Carefully insert into sleeves. | Do not cut film into single frames, as these are difficult to handle. Handle film only by the edges, never touching the image area, and beware of scratching. |

## ■ Commercial Labs for Film Processing

If you do not have the facilities for processing film or do not wish to process it yourself, you may take it to a lab. The largest percentage of photography done today is in color, so finding a lab to process black-and-white film may be difficult. Costs are sometimes higher for black-and-white processing and return times longer. If you need black-and-white negatives and only color processing is available, use Ilford XP2 Super or Kodak Black and White +400, black-and-white films that can be processed in color negative (C-41) chemistry.

## ■ Effect of Development on the Negative

Since the silver image in the negative is formed during the developing step, the amount of development is critical in determining negative quality.

## Amount of Development

The amount of development is the total amount of reduction of silver salts to silver. As with any chemical reaction, a number of factors affect the amount of development:

*Time.*   The amount of development increases with time.

*Temperature.*   The amount of development increases with temperature.

*Agitation.*   The amount of development increases with increased agitation, since fresh developing agents are brought in contact with the emulsion (see the boxed section, "Agitation during Film Development" on the next page).

---

## Agitation during Film Development

If film were placed in developer and left undisturbed, uneven developing would take place. The developer near the heavily exposed areas of the film becomes exhausted in the process of reducing silver salts to silver. Bromide ions are also produced in this process, and being heavier than the developer, they drag downward across the surface of the film, inhibiting development in those areas and leaving streaks of uneven development, called **bromide drag.** Agitation during development brings fresh developer to all areas of the film and flushes away the bromide by turbulence within the developer.

For even development to take place, the agitation must provide random turbulence equally to all areas of the film. Any repeated patterns in fluid flow within the developing container may cause increased or decreased development in some areas. Since agitation is usually done by hand, it is the most common source of uneven and inconsistent development of film.

An excellent treatment of agitation techniques is an article by George Post, published in *Darkroom Photog-*

*raphy* (see the reading list at the end of this chapter). In testing several methods of agitation, Post found three methods that gave excellent results for plastic tanks. All involve vigorous inversion as the primary source of agitation. The standard agitation sequence in this chapter is one of the three. An air space above the developer seems to be an essential requirement for even agitation.

Even agitation is more difficult to achieve with stainless steel tanks and reels because of the constricted space and tightness of the reels. Post found only one technique that gave excellent results with stainless steel. A four-reel tank was used, with film loaded only in the bottom reels and the tank filled half full of developer. The large air pocket combined with the use of the vigorous inversion technique gave results comparable to those with the plastic tanks.

Consistent agitation is achieved by performing the agitation in exactly the same way each time. Time and count the inversions and follow a standard pattern for the agitation sequence. ■

---

See pages 111–12 for more on developers.

See pages 109–11 for more on contamination, aging, and reuse of developers.

*Nature of developer.* High-energy developers result in more development. Greater dilution of a developer decreases the amount of development. Contamination, aging, and reuse of a developer all decrease the amount of development.

## Negative Contrast

In general, increasing the amount of development increases the amount of silver (the density) produced in a negative. However, areas that received more exposure (light subject tones) show greater changes in density as development changes than do areas that received less exposure (dark subject tones). In other words, the density of negative areas representing subject dark tones (shadows) changes little with development, but the density of the subject light tone areas (highlights) changes a good deal. This results in a change in the *difference* between light tone and dark tone densities as the development changes. This density difference is called the **contrast** of the negative. To summarize: *The contrast of the negative increases as the amount of development increases and decreases as development decreases.*

Several other factors affect negative contrast:

Chapter 14 gives detailed information on determining subject contrast.

Chapters 8 and 15 give more information on the effect of lighting on subject contrast.

*Subject contrast.* Subject contrast is the difference between the amount of light coming from the light areas of a subject and that coming from the dark areas, and it can be measured using a reflected-light meter. The subject contrast depends on the nature of the lighting on the subject and the tones of the subject itself. Direct light, such as undiffused sunlight, usually results in higher

50% Underdeveloped.

Normally Developed.

50% Overdeveloped.

These negatives with the same exposure show the effects of 50 percent underdevelopment, normal development, and 50 percent overdevelopment. As development increases, the dark subject tone areas (the less dense areas of the negative) change very little, while the light tone areas increase in density, resulting in more contrast.

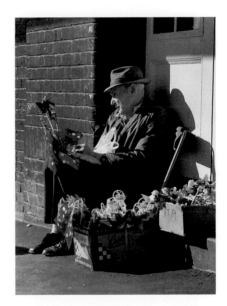

Normal Subject Contrast.

© Bognovitz.

High Subject Contrast.

© Bognovitz.

Low Subject Contrast.

© Bognovitz.

subject contrast, and diffused light, such as light on a cloudy day, normally produces lower subject contrast. Subjects with a large range of tones from very dark to very light will have higher subject contrast.

*Type of film.*   The manufacturer's suggested development times include the necessary corrections for the different types of film to produce a negative of average contrast from a subject of average contrast (see page 18).

*Exposure.*   Underexposure of a negative will reduce the negative contrast. Overexposure may slightly increase the negative contrast for small amounts of overexposure, but extreme overexposure will reduce negative contrast.

*Flare.*   When light enters a lens directly from a light source or if very bright subject areas are included in a picture, the resultant flare may reduce negative contrast.

Reduction of Contrast Due to Flare.

# Summary of Film Exposure and Development Effects

A. Two Stops **Underexposed** and 40 Percent **Underdeveloped.**

B. **Normally Exposed** and 40 Percent **Underdeveloped.**

C. Two Stops **Overexposed** and 40 Percent **Underdeveloped.**

D. Two Stops **Underexposed** and **Normally Developed.**

E. **Normally Exposed** and **Normally Developed.**

F. Two Stops **Overexposed** and **Normally Developed.**

G. Two Stops **Underexposed** and 50 Percent **Overdeveloped.**

H. **Normally Exposed** and 50 Percent **Overdeveloped.**

I. Two Stops **Overexposed** and 50 Percent **Overdeveloped.**

Effects of film exposure on the negative are discussed on page 32.

We have seen that both film exposure and film development affect the quality of a negative. A simple exercise will summarize the effects of exposure and development on film and how they relate to each other.

## Effects of Film Development Changes

■ *Contrast.*   Contrast increases in both negative and print as film development is increased.

■ *Dark tone detail.*   The negatives show little change in the thin areas—corresponding to dark subject tones—with development.

A. Two Stops **Underexposed** and 40 Percent **Underdeveloped.**

B. **Normally Exposed** and 40 Percent **Underdeveloped.**

C. Two Stops **Overexposed** and 40 Percent **Underdeveloped.**

D. Two Stops **Underexposed** and **Normally Developed.**

E. **Normally Exposed** and **Normally Developed.**

F. Two Stops **Overexposed** and **Normally Developed.**

G. Two Stops **Underexposed** and 50 Percent **Overdeveloped.**

H. **Normally Exposed** and 50 Percent **Overdeveloped.**

I. Two Stops **Overexposed** and 50 Percent **Overdeveloped.**

■ *Grain.* Careful examination of actual prints shows an increase in negative grain size with increasing film development.

## Effects of Film Exposure Changes

■ *Contrast.* Underexposed negatives show a loss of contrast. Overexposed negatives show an almost unnoticeable increase of contrast. Several stops of overexposure will result in a loss of contrast and may block up highlights.

■ *Dark tone detail.* Underexposure causes a loss of detail in dark subject tone areas.

■ *Grain.* Negative grain size increases with increasing exposure.

Normally Exposed and Normally Developed Negative (40× enlargement).

Overexposed and Normally Developed Negative (40× enlargement).

Normally Exposed and Overdeveloped Negative (40× enlargement).

Effects of Overexposure and Overdevelopment on Grain Structure.

**Effects of Combinations of Changes**   Some of the effects of incorrect exposure can be corrected by changing the development, but the end result will not be identical. In other words, *exposure and development are not interchangeable.* For example, an underexposed negative can be overdeveloped to correct for the loss of contrast due to underexposure (see print G on page 105), but the loss of dark tone detail cannot be corrected by increased development. The result will also show more grain. Photographers may intentionally underexpose and overdevelop—this is called "pushing" the film—to get faster shutter speeds under low-light conditions, but they are sacrificing shadow detail and increasing grain size (see the boxed section: "Pushing Film" on page 108). On the other hand, we can see from the prints that a negative that has been overexposed is not improved by underdeveloping. The result is simply a low-contrast dense negative (see print C on page 105). The best solution for overexposed film is to develop normally and deal with the resultant dense negatives by printing them at longer times (see print F).

## Control of Negative Quality through Exposure and Development

A "good-quality" negative transforms a range of subject tones into an acceptable range of tones in the photograph, with desired detail in dark and light tones.

**Controlling Detail**   Only correct film exposure will insure correct dark tone detail, since development has little effect on these areas. Highlight detail in the negative can be lost by gross overexposure.

**Controlling Contrast**   Photographic print materials will display only a limited range of tones, so the negative contrast must be matched to the capability of the print material. Careful film processing will prevent variations in negative contrast due to inconsistent development. Subject contrast also affects negative contrast and is not always under the photographer's control. However, the amount of film development can be changed—usually by varying the development time—to compensate for subjects that are not of average contrast. Increase the development time for low-contrast subjects and decrease it for high-contrast subjects.

Chapter 14 discusses in more detail controlling negative contrast through development.

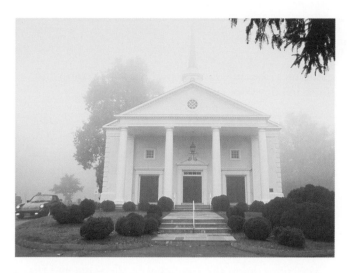

Low-Contrast Subject with Normal Development.

© Bognovitz.

Film Development Increased to Raise Contrast.

© Bognovitz.

High-Contrast Subject with Normal Development.

Film Development Decreased to Lower Contrast.

## ■ Photographic Chemicals

The availability of packaged chemicals with clear directions makes it possible to perform the steps in the photographic process without understanding what the chemicals are or how they work, but in-depth knowledge of the form and function of the constituent chemicals allows better control over the process. If problems arise, you will be better equipped to solve them.

### Forms of Photographic Chemicals

Most of the solutions used in photography are mixed from formulas that have several chemical components. Prepackaged chemicals designed to make specific solutions, such as developers or fixers, already have the proper mix of

## Pushing Film

If you wish to shoot in low-light conditions and are willing to live with some increase in grain and loss of dark tone detail, you can "push" a film, which means giving intentional underexposure and then increasing the development to bring the contrast back to printable levels. Usually the actual sensitivity of the film changes little with push processing. To underexpose the film, set the ISO scale of your meter for a higher value. Each doubling of the ISO/ASA value will underexpose your film one more stop. For example, if your film is ISO 400, setting the meter for ISO 800 will underexpose the film one stop and setting it for ISO 1600 will underexpose the film two stops.

Some film developers, such as Acufine or Diafine, may give directions for push processing. Otherwise, you must simply use trial and error to find the amount of development that will restore normal contrast. Increases in development can be achieved in three dependable ways: (1) increase the development time, (2) increase the development temperature, or (3) increase the strength of the developer. The following guidelines are for general-purpose black-and-white films and developers.

*For one-stop underexposure (double the ISO):*  Try increasing the development time by 50–60 percent. For example, if your normal development is 7 minutes at 70°F, try 11 minutes at 70°F. T-Max films require no change in development for a one-stop push.

*For two-stop underexposure (quadruple the ISO):*  Try increasing the temperature by 5°F and the time by 50–60 percent. For example, if your normal development is 7 minutes at 70°F, try 11 minutes at 75°F. For T-Max films, keep the temperature the same and try increasing the development time by 25–35 percent.

If you would like to push film but prefer working at shorter development times, try a more active developer like Kodak HC-110 dilution A. Any of the ultrahigh-speed films offer an alternative to pushing. The grain of these films will also be coarse, but you may preserve more dark tone detail on the film. ■

components and usually require only the addition of water to put them in usable form.

An alternative is to buy the component chemicals and mix them yourself according to formulas that can be found in various reference sources. The required investment in basic chemicals and weighing and measuring tools and the extra time spent in compounding formulas usually make this an impractical approach. However, some specialized solutions are not available in prepackaged form, or you may want to alter the available formulas. Mixing from basic components may then become worthwhile.

Prepackaged photographic chemicals come in either dry (powder or crystal) or liquid form. Dry chemicals must be dissolved in water to be used. Several terms are used to describe chemicals in liquid form, depending on their use:

*Working solution.*  A working solution is at the proper strength for using directly in a photographic process. Working solutions are sometimes fairly dilute forms of the chemistry and may have a short shelf life—some must be used within a few hours after mixing. A few solutions can be bought already packaged at working solution strength, but most require the addition of water to reach working strength.

*Stock solution.*  A stock solution is a liquid form of a photographic formula that has a reasonably long shelf life. Some stock solutions are already at working strength: D-76, for example, when mixed from the powder into a stock solution, can be used at that strength to process film. Other stock solutions must be diluted further to reach working strength: D-76 can also be used in a diluted form. Depending on the formula, a stock solution may be compounded by dis-

solving a packet of dry chemicals in water, mixing powders and liquids, or diluting a concentrated liquid.

*Concentrates.* Concentrates are prepackaged concentrated liquid forms of the various formulas used in photography—developers, fixers, washing aids, and so on. Some are intended to be diluted directly before use in the quantities needed at the time. Others may be a multipart formula mixed together into a stock solution.

**Dilution** When liquids must be diluted for use, the directions may give the amounts in terms of parts or a ratio. For example, if directions call for one part of a concentrate to be mixed with nine parts of water, this is the same as a dilution of 1 to 9, usually written as the ratio 1:9. In any ratio the first number refers to the chemical and the second number refers to water.

In actual usage, you must figure out how much chemical solution you need and then adjust the size of the parts accordingly. In the preceding example we have a total of ten parts: one part chemistry and nine parts water. If we needed 20 ounces of working solution of this concentrate, each of the ten parts would have to be 2 ounces, so we would mix 2 ounces of the concentrate with 18 ounces of water. A ratio of 1:1 would be achieved by mixing equal quantities of the chemistry and water.

**Water** Water is used for mixing chemical solutions and for washing films. In most areas tap water is adequate for these purposes. If your water is high in mineral content—especially iron or sulfur compounds—or has large amounts of sediment in it, it may not be suitable for mixing chemistry or possibly even for washing film. Filters can be fitted to water lines to remove sediment but not dissolved minerals. If in doubt, mix chemicals with distilled water.

## Handling and Storage of Photographic Chemicals

If properly handled, photographic chemicals are relatively safe to use. Nevertheless, the chemicals, especially in concentrated form, require a few precautions. See the boxed section, "Health and Environmental Concerns" on page 92.

**Contamination** Contamination of a solution with other chemicals can reduce its useful life, so take care that containers and other objects, including hands, that come in contact with the chemistry are clean. A thorough wash with warm soap and water and then a rinse in clean running water performed immediately after use will keep utensils and tools clean. Careless working habits in the darkroom, with splashing and dripping, are another source of contamination.

One principal mechanism of contamination is neutralization. Some photographic chemical solutions, like developers, are alkaline, or basic; others, like stop bath and fixer, are acidic. Whenever acids and bases mix, they neutralize each other. Other mechanisms of contamination can also occur, especially with color chemicals, which are complex organic compounds.

Stop baths and fixer are designed to accept a certain amount of neutralization, since their purpose is to neutralize the developer. Failure to thoroughly drain the developer before proceeding to the next step can prematurely exhaust stop or fixer. Developers are not designed to accept any

acid, so it is especially important to prevent contamination of developers with other chemistries.

A previously used container may contaminate a solution, even if thoroughly washed. Developers are especially susceptible to contamination, so it is recommended that new containers be purchased for their storage. Containers and lids should be carefully labeled and always used for the same type of chemistry.

**Utensils and Containers**   The container can affect the life of a solution in several ways. Some plastics actually let air through by osmosis. Some plastics and metals other than quality stainless steel will react with many photographic chemicals. The safest inert plastics for photographic use are polyethylene and polypropylene, but Teflon, polystyrene, and polyvinylchloride (PVC) are also good. If a plastic cannot be identified, it is best to avoid using it. Avoid metal lids. Any utensils that come in contact with the chemicals should also be of glass, inert plastic, or stainless steel.

The graduate used for mixing the working solution of a film developer should have divisions at least to the nearest ounce and should exceed the fluid capacity of your developing tank. A 1-quart container marked in ounces or a 1-liter graduate is sufficient for most small tanks. If you are using concentrates and measuring small quantities, you should have a second, smaller graduate marked in half ounces.

For mixing solutions from powders you will need large open containers. Plastic buckets or large open-mouth glass jars are inexpensive and work well. To avoid contamination, it is a good idea to have a separate mixing bucket used only for mixing developers. Use stirring rods of inert plastic, stainless steel, or glass.

**Storage Life**   Many of the chemical solutions used in photography deteriorate over time. Proper storage can help to lengthen their useful life. Developers are especially sensitive to contamination and improper storage, but other solutions can be affected as well.

Manufacturers normally supply a shelf life in the instructions for formulas that have a limited storage life. Shelf life is given for specified environmental conditions. To be sure that the shelf life is not exceeded, label the container with the date mixed. For example, the instructions for a developer may give a storage life of 6 months in a full, tightly stoppered dark brown glass bottle, stored at normal room temperature (close to 68°F). If these storage conditions are not met, the life of the developer may be shortened. If a stock solution is diluted for use, the storage life of the diluted working solution may be shortened drastically. Some working strength developers may have a life of only a few hours; other chemicals, such as stop bath, may last indefinitely in diluted form.

The major cause of developer deterioration is oxidation, which is accelerated by high temperatures or the action of light. This explains the storage conditions listed: brown bottles reduce exposure to light; storage at room temperature prevents exposure to higher temperatures (low temperatures can also damage some solutions, so they should not be chilled or refrigerated); full bottles reduce exposure to the oxygen in air. Several methods for keeping air out of the storage containers are available. Plastic bottles can be squeezed to expel the air, then capped. A chemical solution can also be divided among small containers so that a large air pocket does not occur as the solution is used.

**Working Life**   Most photographic chemical solutions may be used more than once. Since a chemical gradually deteriorates with use, its reuse is limited. This limit is called the **working life** or the capacity of the chemistry. The manufacturer should supply in the instructions the working life of a chemical. This is normally given as a number of 8 × 10-inch sheets of material that may be processed in the solution. For example, the working life of a chemistry might be given as 100 8 × 10 sheets per gallon of stock solution. If different sizes of material are used, the capacity is calculated by considering the change in area. A 4 × 5-inch sheet has one-fourth the area of an 8 × 10 sheet, so four times as many 4 × 5s can be processed in the same chemistry. A thirty-six-exposure roll of 35mm film has about the same area as an 8 × 10 sheet.

One-shot developers are designed for one-time use after dilution to working strength, with the advantage of consistently fresh developer. Other developers can be reused; however, the strength of the developer changes with use and the developing time must be increased for each use. Some developers can be replenished by the measured addition of replenisher, containing the constituents of the developer that are altered with use. Replenishment is difficult to do accurately on a small scale and is more suited to use in processing labs. Most photographers developing film in small tanks prefer the one-shot developers for their ease of use and consistency.

## ■ Film Development Process in Detail

## Developer

Since the actual image is formed during the development stage of the process, great care must be taken with this step to insure predictable results.

**Chemical Action**   The function of the developer is to produce more metallic silver around the latent image, making a visible image. The chemical process that accomplishes this is called **reduction.** The silver salts, compounded of silver and a halide—iodine, bromine, or chlorine—are reduced or broken down into silver and the halide. The silver remains in the film emulsion, showing as a black image, and the halide combines with components of the developer.

**Chemical Composition**   The main component of a developer is the reducing agent, but a number of other components are added to get a usable developer:

*Developing agents.*   A number of different reducing agents are used in developers. The most common are Metol, hydroquinone, and Phenidone. Hydroquinone produces a high-contrast image and is most commonly used in combination with either Metol or Phenidone to produce a full scale of tones in the negative.

*Accelerator.*   Most developing agents work best in an alkaline, or basic, solution, so sodium carbonate or sodium hydroxide is usually added to speed up development.

*Restrainer.*   Potassium bromide is normally added to prevent the developer from reducing the silver salts in unexposed areas of the negative.

*Preservative.*   Sodium sulfite is commonly added to reduce oxidation of the developing agents.

**Categories**    Three basic categories of film developer are available. *General-purpose developers* will give good-quality results with most films. *Fine-grain developers* will produce negatives with a somewhat finer grain structure, but often at the cost of a reduction in effective film speed. *High-energy developers* are used for films that require more development or any time a more active development is desired.

## Stop Bath/Rinse

The function of the stop bath/rinse is to stop the development. A water rinse as described earlier in the processing steps is sufficient for most films developed in a tank. If the developing times are short or it is critical that developing be stopped rapidly, an acid stop bath can be used. Stop bath is usually a highly diluted solution of acetic acid. Since the developer is alkaline, the stop bath will immediately neutralize any developer remaining on the film.

## Fixer

After the film has been developed, the unexposed and undeveloped silver halide crystals remain in the emulsion. These silver salts are still sensitive to light and must be removed from the film to prevent its turning completely black upon exposure to light. Fixer converts these unused silver salts to a soluble form, which dissolves out of the emulsion. The silver halide solvent in ordinary fixers is usually sodium thiosulfate, also known as "hypo." Ammonium thiosulfate is a faster-acting silver halide solvent used in rapid fixers. Most fixers have other components. A highly diluted acid—usually acetic acid—may be included to insure that the developer is neutralized. An agent such as potassium alum is often added, which hardens the film and makes it less susceptible to damage.

The fixing step does not require as critical control over time, temperature, and agitation as the developing step, but it is extremely important that all of the unused silver salts be removed from the film. Be sure to follow the recommendation for time, temperature, and agitation in the fixer. Fixing time is normally given as a range of times. Fix for at least the minimum, but do not exceed the maximum, as excessive fixing may bleach the image.

Fixer may be reused, within the capacity given by the manufacturer. Mark the number of rolls or sheets of film on a label on the storage bottle each time you process—or use a hypo-check solution—so that you do not exceed the capacity. Fixer also has a suggested shelf life. Date the fixer when it is mixed, and dispose of it—through recycling—after the shelf life given by the manufacturer.

Incompletely fixed negatives have a milky or cloudy appearance. If this condition is noticed immediately, the film can be saved by refixing in fresh fixer.

*Incompletely Fixed Negative.* The negative strip at the top shows the effects of insufficient fixing. Below it is the properly fixed negative.

## Washing

If the fixer is not removed from the film, it will eventually cause staining and deterioration of the image. Fixer is removed by washing the film in water. For more complete washing and better permanence with shorter wash times, a washing aid—also called hypo-clearing agent or fixer remover—should be used. A large number of these are on the market, some of which use a mixture

of ammonia and hydrogen peroxide. Follow the manufacturer's directions for use. If a washing aid is not used, a single wash of at least 30 minutes under running water must be used for film, which not only wastes resources but will not clean the film as well.

## Wetting Agent

Immersing the film in a wetting agent after washing will help to prevent water spots when the film is drying. Wetting agents are a pure and dilute detergent, which lowers the surface tension of the water, causing it to slide off the film rather than sitting in drops. Carefully follow the manufacturer's directions for use. Underdilution of the wetting agent may cause scum to form on the film. Overdilution may cause hard water marks.

If the wetting agent is working properly it is unnecessary to sponge or squeegee the water off the film before hanging it to dry. Water spotting even with the use of a wetting agent can usually be traced to one of three things: (1) improper dilution of wetting agent; (2) unusually hard or contaminated water (try mixing wetting agent with distilled water); or (3) insufficient or improper washing of the film, leaving residual fixer. Photo sponges, chamois, or squeegees can be used to remove surface water and speed drying but present a real danger of scratching the film.

## ■ READING LIST

McCann, Michael. *Health Hazards Manual for Artists*. New York: The Lyons Press, 1994.

Post, George. "Shake It Up." *Darkroom Photography* (March–April 1986).

Rempel, Siegfried, and Wolfgang Rempel. *Health Hazards for Photographers*. New York: The Lyons Press, 1993.

Shaw, Susan. *Overexposure: Health Hazards in Photography*. New York: Allworth Press, 1991.

# CHAPTER 6

# Printing Photographs

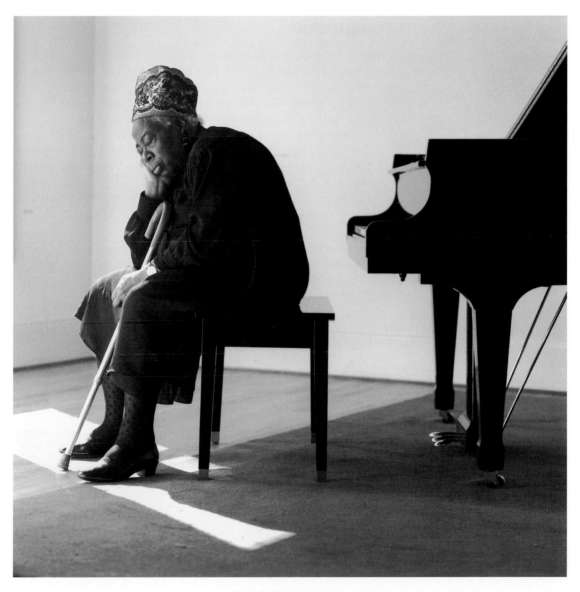

Brian Lanker, *Eva Jessye.*
© Photograph by Brian Lanker.

The desired final presentation of a photograph is most often a print. The original tones of the subject are reversed in a negative, with light subject tones showing as dark areas. Printing the image from the negative onto a photographic printing paper reverses the tones a second time, resulting in a positive image, showing the subject in its proper tonal relationships. This chapter deals with black-and-white printing techniques in detail. For information on printing color negatives and slides, refer to chapter 12.

## ■ Black-and-White Printing Papers

Black-and-white printing papers provide a positive monochrome image when exposed to the image from a negative. As with black-and-white films, the image is formed in an emulsion containing silver halides. However, the support—also called the base—is paper rather than a transparent film.

## Characteristics

**Base**   Print base materials come either as resin coated (RC) or fiber-base. Both types use paper as a base for the emulsion, but the paper in the RC print is coated on both sides with a plastic layer. Advantages of RC prints include more rapid processing and drying. Fiber-base print materials are generally higher in quality, though a few RC materials yield high-quality prints. Fiber-base prints give more flexibility in surface choice and are somewhat easier to retouch and mount for presentation than RC prints. If you are concerned about the long-term permanence of your photographic prints—on the order of many decades or even hundreds of years—fiber-base prints are generally thought to have a longer life, although more recent research seems to indicate longevity differences are not that great. A few emulsion types are available in either fiber-base or RC, but most give only one choice.

See appendix F for more information on print longevity.

The **weight** of a paper is an indication of the base thickness. Single-weight paper is the thinnest base for most print materials, although a few come in lightweight, also known as document weight. Medium weight and double weight are progressively thicker. Single-weight and double-weight papers of the same emulsion and surface type will yield identical prints. Single weight has the advantages of less bulk and lower cost. Double weight is easier to handle in processing—less likely to crease or suffer other damage—and tends to curl less after drying.

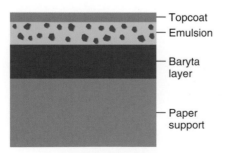

Fiber-Base Photographic Paper Structure.

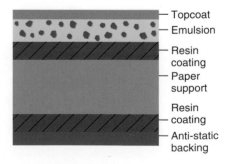

Resin-coated (RC) Photographic Paper Structure.

**Emulsion Types** A large variety of papers are offered with different emulsions. The emulsion type is usually indicated by the name of the paper. Characteristics of the paper that depend on the emulsion are image color, tonal rendition, sensitivity, and method of contrast control.

A partial selection of available printing papers is given in appendix H.

**Surface** Most photographic papers are offered with several different surface textures. Common descriptions of the surface—listed in approximately decreasing smoothness—are glossy, pearl, luster, semimatte, matte, silk, tweed, and so on. Manufacturers sometimes limit the number of surfaces available in specific emulsion types on the basis of their marketability.

**Color Sensitivity** Black-and-white printing papers are usually blue sensitive, which means limited exposure to yellow or amber light will not affect the paper. This allows working with the papers under lights of special color called **safelights.** The manufacturer will specify in the literature of a paper the type and power of the safelight that may be used. A safelight with an amber filter—Kodak's OC filter—is suitable for most general-use black-and-white papers. The red safelights used in graphic arts darkrooms are not safe for some black-and-white printing materials.

Black-and-white **panchromatic paper** is a special paper sensitive to all visible colors and is used for making black-and-white prints from color negatives. Since it is sensitive to any color of light, panchromatic paper must be handled and processed in total darkness or under an extremely dim dark green safelight. Black-and-white prints can be made on most enlarging papers from color negatives, but the rendition of tones is more representative of the subject with the use of panchromatic papers.

Color Original.

© Merle Tabor Stern.

Color Negative Printed on Blue-sensitive Paper.

© Merle Tabor Stern.

Color Negative Printed on Panchromatic Paper.

© Merle Tabor Stern.

See pages 128–32 for information on contact printing.

**Speed**    The sensitivity to light varies from paper to paper and determines the amount of exposure needed in printing. Photographic papers are much less sensitive to light than are films. The sensitivity of a paper determines its use. Less sensitive papers, called **slow papers,** are used for contact printing. More sensitive papers, called **fast papers,** are needed for enlarged images. Since the grain structure of a paper is not enlarged, it is not perceptible to the unaided eye. For that reason, increasing the paper speed has no visible effect on grain. Paper speed is not calibrated as closely as film speed, so you may find variations from box to box of the same type of paper.

**Sizes**    Photographic printing papers are available from postcard size to giant mural sizes. Common sizes are $4 \times 5$, $5 \times 7$, $8 \times 10$, $11 \times 14$, $16 \times 20$, and $20 \times 24$ inches.

**Paper Contrast**    Print contrast is the difference in tones between light and dark. **Paper contrast** is the physical response of a paper to differences in exposure and is one factor affecting the resulting print contrast. A higher-contrast paper produces greater differences in tone.

Paper contrast is given as a number, the contrast **grade,** which may range from 0 to 5. Grade 0 produces the least contrast and grade 5 the most. The normal contrast grade is 2, which means that a properly developed negative should yield a print with correct tonal rendition on a paper of contrast grade 2.

Two different products are offered for changing the paper contrast:

*Graded papers.*    The paper contrast of a graded paper is fixed. Each pack contains paper of one contrast number, which is indicated on the package as a whole number. To change the contrast, you must buy another pack of paper with a different contrast number. Some emulsions offer the complete range of contrast numbers from 0 to 5, in whole numbers only; others may offer a smaller range.

*Variable-contrast papers.*    The emulsions of variable-contrast papers change contrast with the color of light used to expose them. Yellow light produces lower contrast and magenta light produces higher contrast. By mixing the amount of yellow and magenta light through filtering on the enlarger, contrast can be varied widely using paper from the same pack.

Variable-contrast filters are available as sets and control the contrast in half-grade steps. Most variable-contrast papers can produce contrast grades from 0 to 5 in half steps. Printing without a filter approximates grade 2. Enlargers with built-in color filtering systems can be used to control the contrast of variable-contrast papers. Note that variable-contrast filters cannot be used to alter the contrast of graded papers.

The purchase of only one box of variable-contrast paper and a set of filters provides the complete range of paper contrasts in half grades. Graded paper requires a much larger inventory of packs of paper of different contrast grades and gives only whole-grade changes. On the other hand, it is easier to manufacture premium-quality graded papers, so the best-looking papers in terms of clean whites and rich blacks are graded papers. Recent advances in the technology of paper manufacturing have produced several excellent variable-contrast papers, and they are highly recommended for all but the most demanding of uses.

Grade 0.

Grade 1.

Grade 2, Normal Contrast.

Grade 3.

Grade 4.

Grade 5.

This series shows the effect of changes in paper contrast grade. The same negative was used throughout.

© Bognovitz.

**Image Color**    Although black-and-white papers are monochrome, the actual color of black varies from paper to paper and can be warm (tending toward brown), neutral, or cold (tending toward blue). The image color of a paper is determined partly by the emulsion type and sometimes by a tint added to the base material. Papers using silver chloride as the light-sensitive salt—as do some contact papers—tend to be warm in image color, and silver bromide papers are usually more neutral or cold toned. Many modern papers use both silver salts and are called chlorobromide papers. The image color of a paper can be changed after the processing by treating the print in a toning solution. Toners are available in a variety of colors.

See page 330 for more on toners.

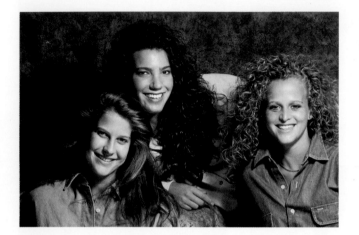

Neutral- to Cold-toned Paper.

© Bognovitz.

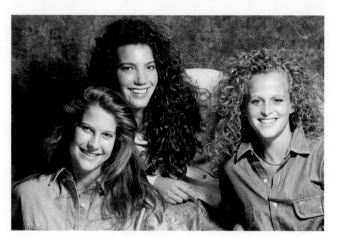

Warm-toned Paper.

© Bognovitz.

## Storage and Handling

Black-and-white papers have a fairly long shelf life if properly stored. Avoid heat, moisture, and exposure to chemical fumes. Paper can be refrigerated for longer life, but be sure to enclose it in an airtight container. When removing it from refrigeration, allow plenty of time for the paper to come to room temperature before unsealing the container.

Photographic papers must be handled carefully. The emulsion is susceptible to fingerprints and scratches, so touch only the edges. Make sure hands are clean and dry. When processing paper, handle gently to prevent creases, bends, and scratches.

**Warm-up Times for Refrigerated Photographic Papers (in Hours)**

|  | FROM 35°F TO 70°F | FROM 0°F TO 70°F |
|---|---|---|
| 25-sheet package | 2 | 3 |
| 100-sheet box | 3 | 4 |

## Printing Paper Selection

Photographic stores should have samples of prints made on the various papers. Variable-contrast papers are wonderful to learn on because of the low investment and ease of use. Although RC papers have the limitations listed earlier, their ease of handling in processing may be important, especially if you are working in a home darkroom with barely adequate washing and drying facilities. Once you have mastered the basic skills of printing, the best way to learn about photographic papers is to experiment with several different ones; then a choice can be made on the basis of the results.

See Appendix H for a selection of black-and-white printing paper.

## ■ Printing Equipment and Facilities

### Darkroom

Most rooms can be made lighttight with a little ingenuity. Rooms without windows are the easiest, but windows can be blocked with opaque materials. Doors can be made lighttight with weather stripping or flaps of black sheet vinyl—available from hardware stores—stapled to the edges.

Electrical power and running hot and cold water should be supplied to the darkroom. Power requirements are usually not very high, unless a heated print dryer is being operated. It is possible to print in a darkroom without running water, but the prints must then be taken to another room for washing.

The size of the darkroom is often determined by available space. Darkrooms have been constructed in spaces as small as a few feet square. Many home darkrooms are in converted bathrooms or closets. If large prints are to be made, more space is needed. If possible, spaces used for working with wet materials should be separated from those used for dry materials.

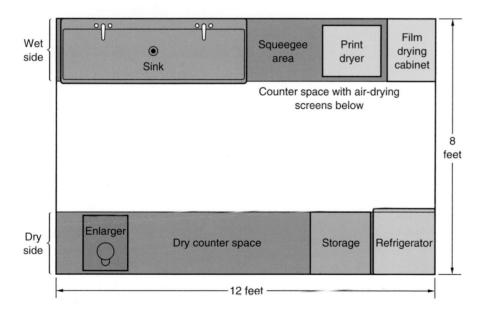

A Comfortable, Well-designed Darkroom Floor Plan, with Wet and Dry Areas Separated by Distance.

### Enlarger

The enlarger is much like a slide projector. It has a light source, a place for holding a negative, and a lens that projects the enlarged image of the negative down onto the baseboard. The head of the enlarger can be moved up and down on a column to allow for different magnifications of the image.

**Lamp Housing Designs**   Two basic lamp housing designs are made for enlargers: condenser and diffusion. Condenser enlargers generally provide more light to the negative and shorter exposures. They also produce slightly more contrast in black-and-white printing.

Diffusion enlargers supply the light to the negative in diffused, or scattered, form. They suppress the effect of dust and scratches on the negative and give a more even gradation of tonal differences, especially in the light tone areas. It

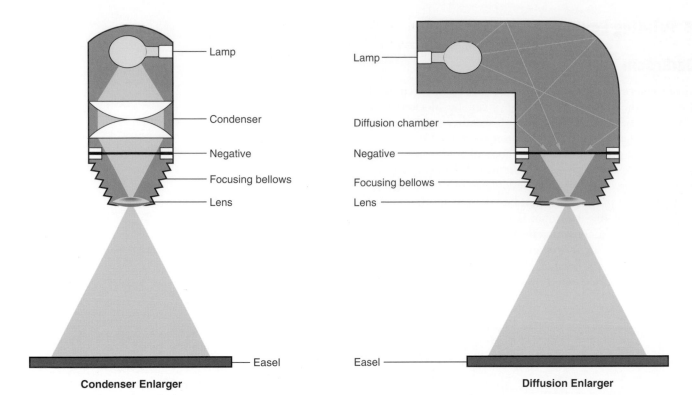

**Condenser Enlarger**

Lamp
Condenser
Negative
Focusing bellows
Lens
Easel

**Diffusion Enlarger**

Lamp
Diffusion chamber
Negative
Focusing bellows
Lens
Easel

In a condenser enlarger the light is focused by large lenses and reaches the negative traveling basically all in the same direction. In a diffusion enlarger the light is diffused by being supplied indirectly to the negative through a mixing chamber with white walls or by being passed through a diffusion material such as frosted glass or plastic.

is easier to design built-in color filtering systems for a diffusion head, so most color head enlargers are of the diffusion type.

Several types of light sources are used. Most condenser enlargers use frosted light bulbs with a tungsten filament. Some diffusion enlargers may use higher-wattage quartz-halogen tungsten bulbs, but others use "cold-light" sources such as fluorescent or mercury-vapor tubes or other discharge-type light sources. Some cold-light sources may not be suitable for color printing.

**Format Size**    Most enlarger designs will accept a range of film format sizes and are usually described by the maximum format size. A 6 × 7 enlarger will accept format sizes up to and including the medium-format 6 × 7 cm format size, and a 4 × 5 enlarger will accept formats up to 4 × 5 inches. Adjustments or changes in lens, negative carrier, and light source are usually needed to change format size.

**Enlarger Lenses**    Since the enlarger lens forms the image of the negative on the print material, the quality of the final print is heavily dependent on the quality of the enlarging lens. The lenses come in different focal lengths and coverage. Coverage indicates the maximum-size negative from which the lens will produce a good-quality, evenly illuminated image. Focal length is generally chosen according to the format size. The 50mm lenses are used for 35mm film. The 75mm to 90mm lenses are used for medium formats such as 4.5 × 6, 6 × 6, and 6 × 7 cm. The 135mm to 150mm lenses are used for 4 × 5-inch film.

The enlarger lens contains an aperture control with a range of f-stops. Lenses with a larger maximum aperture provide a brighter image when opened up for composing and focusing. Although this may offer some conve-

nience, prints are not normally made at wide-open apertures. Such lenses are more expensive, but this does not necessarily guarantee better quality at the f-stops normally used for printing. In general, however, the overall quality of a lens is in direct relationship to its price.

## Other Darkroom Equipment

**Safelight**   The instructions for a print material should specify the type and power of safelight that may be used. Many safelights have interchangeable filters, allowing their use with a variety of different materials. A safelight of the wrong color or one that is too bright may give unwanted exposure, called **fogging,** on the print. To test your safelight follow the procedures in appendix A.

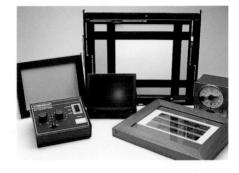

Back row: 8 × 10 inch printing easel, 11 × 14 inch adjustable printing easel, and an electric/mechanical timer. Front row: Electronic timer, safelight with OC filter, and contact printing frame.

**Timer**   Enlargers do not have built-in shutters, as a camera does. Instead the length of exposure is controlled by turning the enlarger lamp on for the needed length of time. A timer into which the enlarger is plugged will insure accurate, repeatable exposures. Timers can be electrically driven mechanical devices or may be totally electronic, with a variety of features and accessories. The electronic timers are typically more accurate, especially for short exposure times. An audible beeping signal that marks the seconds can be a great convenience when printing, since it allows counting the progress of an exposure without looking at the timer face.

**Easel**   A photographic printing easel is a frame that holds the printing material during the exposure. It is essential for accurate positioning of the image on the paper and allows the print to be exposed with clean, straight borders. Many types and sizes of easels are available, some with standard borders, others with widely adjustable borders. A special type of easel known as a contact printing frame contains a glass or plastic cover plate and is used for making contact prints.

**Focusing Magnifier**   The image of the negative must be focused on the easel for maximum sharpness. The focusing magnifier enlarges the image for more accurate focusing. Some focusing magnifiers, known as grain focusers, magnify the image enough that the actual grain structure of the film can be seen.

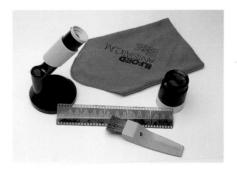

Clockwise from the bottom: Antistatic brush, enlarging focusing magnifier, antistatic cloth, magnifying loupe.

**Cleaning and Dusting Equipment**   Dust and lint on the negative will show up in the prints as white marks. Static electricity causes dust and lint to adhere to the film surface, so cleaning requires an antistatic device, available in the form of a brush, cloth, or gun. After antistatic treatment, the dust can be blown off with clean compressed air or a canned air device. Canned air is actually a gas that is liquid under compression. Some of these substances are damaging to the ozone, so shop for ones that are advertised as more environmentally safe. Fingerprints and other oily or greasy deposits may require the use of a film-cleaning fluid and cotton balls or cotton swabs. Use only film cleaner designed for still photography purposes.

**Magnifying Loupe**   A magnifying loupe is used to directly inspect your negatives for sharpness or defects. Inexpensive loupes are not very useful because of the poor quality of the optics.

## Print Processing Equipment

*Trays.* You will need a minimum of four trays designed for photographic use. Choose trays at least one size larger than the printing paper. For 8 × 10-inch prints use an 11 × 14-inch tray and so on.

*Tongs.* To avoid contact with chemicals, use print tongs for handling prints in the solutions. Tongs of stainless steel or inert plastic are less likely to cause contamination than tongs of bamboo.

*Storage containers.* Dark brown plastic or glass bottles are used for storing the stock or working solutions of the chemicals.

*Thermometer.* The thermometer described for film processing may also be used for measuring the temperature of the print processing solutions.

*Timer.* A clock or timer that is easily visible under the safelight is needed for timing the steps in processing prints.

*Washer.* A print washer is necessary for clean, long-lasting prints. Good washers are expensive. An alternative is the tray siphon shown here.

*Squeegee.* A print squeegee is used to remove excess water from prints before drying. Buy one slightly larger than your maximum print width. Squeegees are available in photographic stores. Standard, soft rubber window squeegees available in hardware stores also work well.

*Print Processing Equipment.* Front row: Print tongs, trays, squeegee. Back row: Tray siphon for print washing, vertical print washer, containers.

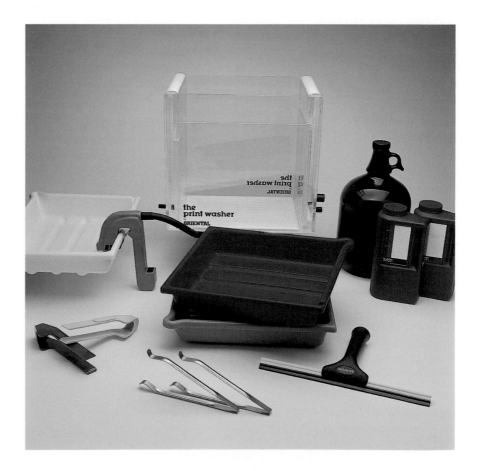

# ■ Black-and-White Print Chemistry

The steps in print processing are similar to those used for film but are fewer in number. Although some of the chemical solutions can be used for processing either films or prints, it is a good idea to mix and store separate chemistries for each process. This will help to prevent dirt or contamination in the film chemistry.

## Developers

Paper developers convert the latent image on the printing paper to a visible silver image and are generally more active than film developers. The type of developer used with a paper can affect a print's image color, contrast, and tonal rendition. When you shop for a paper developer read the manufacturer's description of its qualities. The almost unlimited combinations of paper types and developers allow a wide range of print qualities. Do not hesitate to mix brands of paper and developer.

Print developers have limited storage life and working capacity. Most have a life of less than 24 hours once they are diluted to working strength, especially when left in an open tray. Follow the manufacturer's recommended storage and usage conditions. Be sure to use clean bottles for storage.

■ **HEALTH NOTE** See page 92 for important health information regarding chemicals and a list of Metol-free developer.

## Stop Bath

The stop bath neutralizes the developer, stopping the development process and extending the life of the fixer. It can also prevent **dichroic fog,** an iridescent coating on the print resulting when developer is carried into the fixer.

Stop bath is usually a weak solution of acetic acid. An indicator stop bath contains a yellow dye that becomes bluish purple as the stop bath becomes exhausted. Under an amber safelight, the exhausted stop bath will turn dark. Mix the stop bath carefully according to the manufacturer's directions.

## Fixer

Fixer dissolves out the unused silver halides. Both standard and rapid fixers are available for use with photographic papers. Some can be used at the same strength for either film or paper, but others require different dilutions. Since the same fixers are used for either prints or films, you will find that most have hardener incorporated in them. Print toning is easier with unhardened prints. A few fixers come without hardener or can be mixed without it (e.g., Sprint Fixer). Follow the manufacturer's directions on mixing, use, and storage life.

Fixer can be reused if the working capacity or storage life is not exceeded. Hypo-check kits are available for testing the condition of fixer, but a rough test is to immerse a strip of unexposed, undeveloped film into the fixer. The film should "clear"—that is, become transparent—in less than half the suggested minimum fixing time.

Used fixer contains silver, which is a toxic pollutant. Do not pour it down the drain. Follow the disposal and recycling guidelines given in the boxed section on pages 92–93.

## Washing Aids

The same washing aids—also called hypo-clearing bath or fixer remover—used for film can be used for prints. The times may vary, depending upon the weight and type of paper. Follow the manufacturer's directions. Washing aids can be reused, but do not exceed the working capacity of the solution.

## ■ Black-and-White Negative Printing

If the preceding equipment and chemistry have been assembled, you are ready to begin printing. The following techniques are demonstrated for 35mm film but apply to other format sizes as well, with the use of equipment appropriate to the format. Two basic techniques are used for exposing the photographic paper to the image: contact printing and enlargement—also called "projection"—printing. The enlarger can be used as a light source for both methods of printing. Processing of the exposed printing paper is the same for both methods and is described in the section beginning on page 143. Remember that all handling, exposing, and processing of photographic papers must be done only under the appropriate safelight.

## Enlarger Preparation

A. *Install the Lens.* Choose the focal length of lens that is appropriate for the format size being printed (see page 122; for 35mm film use the 50mm lens). Orient the lens so that the f-stop scale and indicator are visible.

B. *Adjust the Lamp Housing for the Format Size.* On a condenser enlarger this may be done by changing the placement of the condenser lenses in the lamp housing with a control knob or by opening the housing and physically moving one of the condenser lenses from one position to another. Some enlargers may require the insertion or removal of a supplementary condenser lens. This step is extremely important to insure even lighting with condenser enlargers. Diffusion enlargers may provide even lighting over a large range of format sizes without adjustment of the lamp housing. Some diffusion enlargers designed for large formats provide an accessory diffusion chamber for use with small-format—such as 35mm—negatives, which will shorten exposure times by concentrating the light on the smaller area.

C. *Insert the Negative Carrier.* Choose the negative carrier that is appropriate for the format size being printed. The negative stage of the enlarger is between the lamp housing and the lens stage and is usually opened by use of a lever. Be sure that the negative carrier is properly centered and sitting flat in the negative stage.

D. *Turn Enlarger On.* The enlarger is now ready for use. Turn the enlarger on, and you should see a rectangle of light projected onto the baseboard.

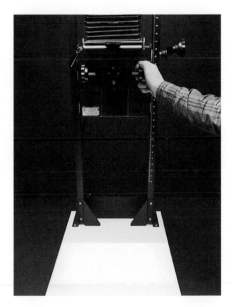

E. *Adjust Size of Image.* The size of this rectangle can be increased by moving the enlarger head up on the column. If the enlarger has a lock to hold the head in place, be sure to unlock it before moving the head.

F. *Focus.* The edge of the rectangle can be made sharp—that is, put in focus—by turning the focus control knob.

## Contact Printing

Contact printing is the oldest method of producing prints from negatives. The negative is simply laid on top of the photographic paper and covered with a sheet of glass to ensure close contact. Light is then allowed to fall on the negative, producing exposure on the paper in the pattern of the negative. The amount of exposure the paper receives depends on the brightness of the light and the time it is allowed to fall on the negative. Processing the paper will reveal a positive image the same size as the negative.

See pages 143–50 for print processing steps.

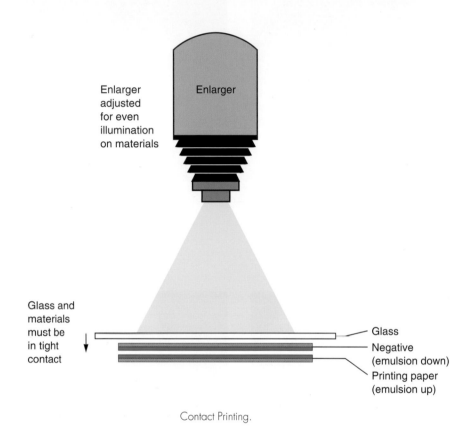

Contact Printing.

If a contact print large enough for easy viewing is desired, the negative itself must be the same size, requiring the use of large cameras. The contact print does not require the use of an enlarger, however, as any light source of the appropriate brightness and evenness can be used to expose the paper. Since no projection or enlargement of the image takes place, the resulting image is of the highest possible quality in sharpness and rendition of tone and detail.

Small- and medium-format users will find the contact print useful for editing negatives. Although the images are small they are in positive form, and a whole roll of film can be included on one sheet of paper, providing an excellent reference for choosing images. If you number your rolls of film and the corresponding contacts, you can make yourself a useful negative filing system by punching the contacts and storing them in a binder. Some polyethylene sleeves allow space at the top for writing index numbers or information, and these will print directly onto the contact sheet.

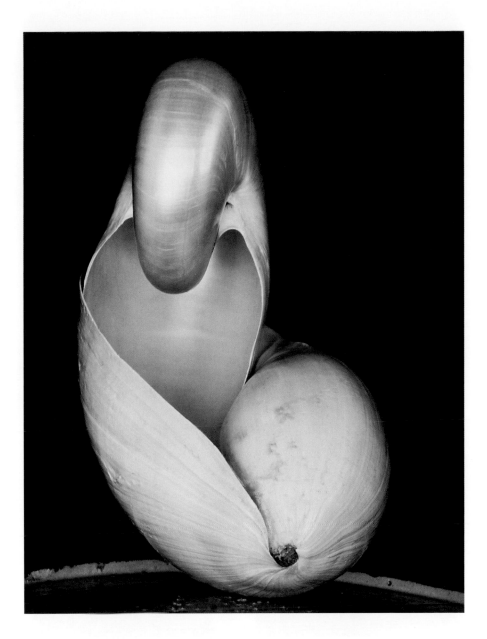

Edward Weston, *Two Shells*, 1927. This is one example of Weston's 8 × 10 view camera work, which he contact printed.

© Center for Creative Photography, Arizona Board of Regents.

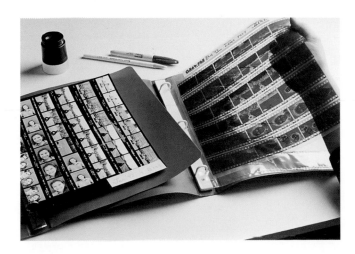

*Filing System Using Contact Proofs.* To prevent unnecessary handling of the negatives, use separate binders for the negatives and contact proofs.

**Setup** An enlarger can be used as a light source for making contact prints, providing even lighting of the negatives and easy exposure control with aperture and timer. Use photographic papers intended for enlargements when contact printing with the enlarger. Exposure times with contact papers will probably be too long to be practical.

**Exposure Determination** Exposure meters designed for use in determining print exposure do exist, but they are typically expensive and require complicated calibration for successful use. It is far easier to determine print exposure by trial and error using a **test strip.**

A test strip is a small piece cut from the printing paper that you are using for making the full-size print. It is important that the test strip be from the same pack of paper, since even the same type of paper can vary in sensitivity from package to package. Test strips should be large enough to include the important parts of the negative or negatives being printed. Two-by-five inches is a convenient minimum size. Larger strips may be cut if needed.

## Contact Printing Method

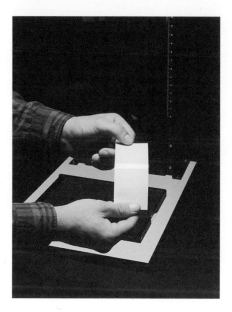

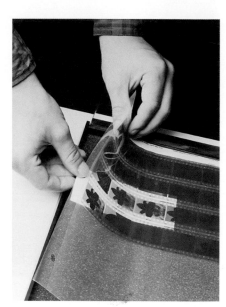

A. Set up the enlarger as described earlier. Be sure to install the negative carrier, even though you will not be placing the negatives in it for this process. Proper installation of the negative carrier and adjustment of the light housing will provide even lighting throughout the rectangle of projected light. Adjust the height of the enlarger head until the rectangle of light is somewhat larger than the size of the printing paper. All remaining steps should be performed with the darkroom illuminated only by a proper safelight.

B. Turn off the enlarger and lay a test strip from the printing paper with the emulsion side up in the area that was illuminated by the enlarger. The emulsion side of a glossy-surface paper is the shiny side. The emulsion side of matte-surface papers is more difficult to identify. Photographic papers usually curl slightly toward the emulsion side. Sometimes the brand name is printed on the back of the paper. As a last resort, a slightly moistened finger touched to a corner of the print will stick slightly on the emulsion side but not on the base. Unfortunately, this may also leave a fingerprint on the surface of the paper.

C. Place the negatives emulsion side down on top of the test strip. The emulsion side of the film is the dull side. If you are making proofs of negatives in clear polyethylene negative sleeves, the negatives may be left in the sleeves for contact printing. This will slightly deteriorate the sharpness of the contact image but is adequate for proofing. Take the negatives out of the sleeves if the sleeves are not transparent or if you desire maximum sharpness.

D. Place a sheet of plate glass over the negatives and test strip and press down if needed for good contact. Commercially available contact printing frames as shown make this procedure easier.

E. Make a series of exposure times on the strip by setting the timer for the longest time to be tried, then covering the strip progressively in sections as the time elapses. For making 8 × 10-inch contact prints on projection paper with many enlargers, try an f-stop of f/8 or f/11 and times of 5, 10, 15, and 20 seconds. Set the timer for 20 seconds. With the test strip in place, start the timer. After 5 seconds have elapsed, cover up one-fourth of the strip with an opaque card. After 5 more seconds—a total of 10 seconds—cover up one-half of the strip. After 5 more seconds—15 seconds total— cover up three-fourths of the strip. The timer will turn off the enlarger after 20 seconds.

F. Process the strip (see pages 143–50) and inspect it under white light. Choose the section that shows the best tones for the image or images. The light end of the strip received the least exposure. If the whole strip is too dark, it received too much exposure. Stop down the lens—for example, from f/11 to f/16—and make a new test strip. If the whole strip is too light, open up the lens or lengthen the time increments.

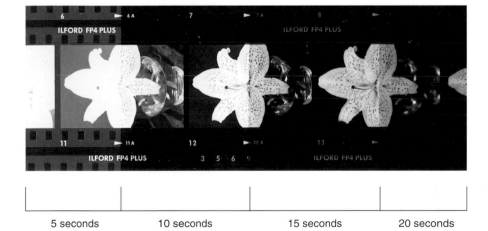

| 5 seconds | 10 seconds | 15 seconds | 20 seconds |

G. In this example, the 10 second exposure section is slightly light and the 15 second section is too dark, giving an estimated printing time of 12 seconds. If the negative exposure varies on a roll of film, it may be difficult to decide from the appearance of the images themselves which time to use. In that case, the appearance of the sprocket holes along the edges of the film can help to determine a printing time. Look for the longest time on the test strip that shows a slightly visible difference between the sprocket holes and the surrounding black and use that exposure time.

H. Once a good exposure has been found on the test strip, expose a full sheet of paper using the same techniques, exposure time, and aperture, and process.

## Projection Printing Method—Continued

D. The light projected by the enlarger is excellent for inspecting negatives, but if you are working in a group darkroom take care not to turn on the enlarger while the negative carrier stage is open, as you may fog other workers' paper. Inspect both sides. Once you are sure the negative is clean, reinstall the negative carrier in the enlarger and gently close the negative carrier stage.

E. *Composing the Image.* Place an easel for the size print you wish to make on the baseboard of the enlarger. Turn on the enlarger. You should see the image of the negative projected onto the easel. To make the image brighter and easier to see, open the enlarger lens to its maximum aperture, but stop it back down to the proper aperture before printing. Move the easel to center the image. If the image is too big or small, adjust the height of the enlarger head.

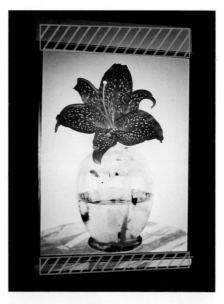

F. Focus the image until it is sharp, using the focus control. Focusing the image also changes its size, so you may have to readjust for proper image size and refocus until you get the desired size.

G. If you are projecting a 35mm negative onto an 8 × 10-inch easel, you will discover that the image is not the same proportion as the shape of the easel and that you must cut off part of the length of the image to get a full 8 inches in width. This is called a full 8 × 10 print. If you wish to see the full image of the negative, you will have an image narrower than 8 inches. This is called a **full-frame** 8 × 10 print.

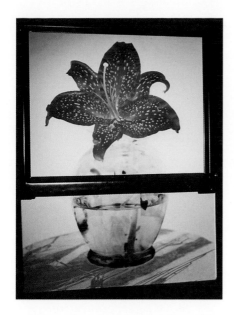

H. You can choose to include only parts of the full image by raising the enlarger head to increase the image size, then moving the easel to select the part of the image you wish to include in the print. This process is called **cropping** the image. Although this is a convenient way to change the composition of your image, greater magnification of the image produces an enlargement of the grain structure, making it more visible in the final print, and also reveals any sharpness problems the negative may have. To achieve the best-quality images, always try to compose for the desired image through the camera viewfinder when taking the photograph rather than cropping excessively in printing.

I. *Focusing.* After you have composed the image on the easel, carefully recheck the focus. This is easier to do with the lens opened to its maximum aperture. Accurate focusing is made easier by use of a focusing magnifier. First focus the image by the unaided eye, then place the focusing magnifier in an area of the image with visible detail; many focusing magnifiers will work efficiently only near the center of the image.

J. While watching the image through the focusing magnifier, gently adjust the focus back and forth until you are sure it is at the point of best sharpness. Stop the lens down to the aperture you intend to use for printing. On some lenses the focus will shift slightly as you stop down, so if your focusing magnifier provides a bright enough image, it is a good idea to recheck the focus at the printing aperture.

*continued*

## Projection Printing Method—Continued

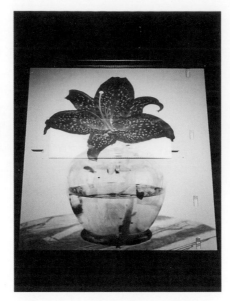

K. The heat of the bulb may cause the negative to buckle or "pop." This will cause a blurring of the image during exposure. If you are having this problem you may have to preheat the negative by leaving the enlarger on with the negative in place for about 1 minute before focusing. Before making the actual exposure you should again preheat the negative. One way to avoid a delay between preheating and printing—during which the negative might resume its original shape—is to place the printing paper in the easel, cover the lens with a black opaque card, preheat, remove the card, and immediately make the exposure.

L. *Determining the Exposure.* Exposure for the enlargement can be determined with a test strip just as described earlier for the contact print. Choose a part of the image that contains the light areas of the subject, represented by the dark parts of the negative image. Turn off the enlarger, take the test strip out of the package, and lay the test strip emulsion side up in the area you choose.

M. Expose the strip to a series of exposures just as you did with the contact print test strip. A good starting trial test strip would again be f/8 or f/11 at 5, 10, 15, and 20 seconds. Be careful not to touch the test strip with the opaque card, as doing so will move it and cause a blurring of the image.

If you are unsure of your exposure time, you can cover a larger range of exposures on a single test strip by using proportional increments of time rather than equal increments or using more increments or both. By starting with 2 seconds and doubling the time for each of six increments, you would have exposures of 2, 4, 8, 16, 32, and 64 seconds all on one strip. If you know your exposure is somewhere around 10 seconds you might do a series of exposures of 6, 8, 10,12, and 14 seconds on your test strip. Time increments that are too small make it difficult to see the dividing lines between sections.

N. For an alternative method of timing test strips, time each segment individually by setting the timer for progressively larger values, covering up all of the test strip but the segment being exposed. This yields accurate timing but is more time-consuming to perform.

Additive exposures are sometimes used to achieve the increasing increments of exposure. For example, the entire test strip is exposed for 5 seconds. One-fourth of the test strip is then covered, the timer is reset for 5 seconds, and a second exposure is made. This procedure is repeated, covering up progressively more of the strip each time. This method of exposure poses two problems. First, timer errors can add up to a sizable error after repeated exposures. Second, several repeated exposures on the paper do not produce the same amount of density as one long exposure of the same total time—a phenomenon known as the **intermittency effect.**

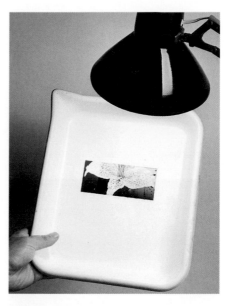

O. Process the test strip and inspect it in white light.

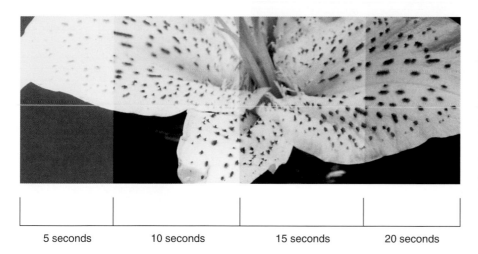

| 5 seconds | 10 seconds | 15 seconds | 20 seconds |

P. Look for the lightest section that shows all the detail in the light areas. If one time is too light and the next too dark, choose an intermediate time. Here the best time is about 10 seconds. Remember that the longer the printing time, the darker the resulting print tones.

Q. After choosing a time from your test strip, set the enlarger timer for that time, place a full sheet of paper in the easel, and turn on the timer. Process the print.

**Analysis of the First Print**   The first print of a negative is seldom a finished product and should be considered a trial or "work" print. After processing the print, inspect it under white light. Correct exposure of the print is indicated when the light areas of the subject have the correct appearance. Light areas should not be too dark but should not be so light as to lose important details in the subject or look washed out.

Some printing papers appear lighter when wet than after they dry; this phenomenon is called "drying down" to a darker tone. Only experience will tell you if your paper dries down. If so, you must compensate for this when choosing exposure times from wet prints.

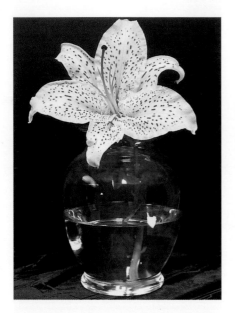

*Correctly Exposed Print.* The light tone areas are light as they should be, and show full detail.

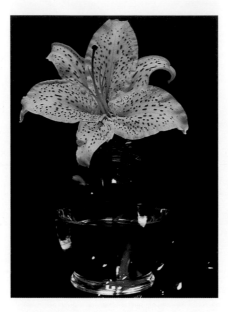

*Overexposed Print.* The light tone areas show detail, but are too dark.

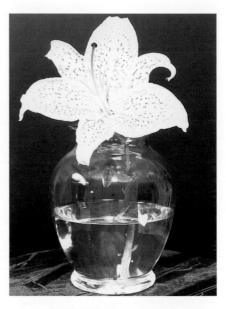

*Underexposed Print.* The light tone areas are too light, looking washed out and showing a loss of detail.

**Local Exposure Controls**   The general exposure in your print may look good, but some areas of the print may be too light or too dark. Individual parts of the print can be lightened or darkened by changing the exposure only in those local areas. **Dodging** means reducing the exposure in an area of a print by covering up that area during part of the exposure. When printing from a negative, dodging will lighten the area. **Burning** means increasing the exposure in an area of a print by covering up everything else in the print and giving additional printing time to that area. Burning will darken the area when printing from a negative.

## Burning and Dodging Techniques

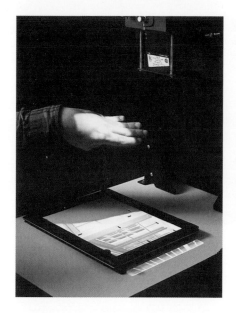

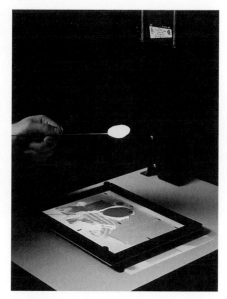

A. The tools needed for dodging or burning are opaque objects that can be used to block parts of the image during exposure. Your hands can often serve as dodging or burning tools, since they can be shaped to cover varying sizes and forms in the image.

B. For dodging small areas, shapes cut out of opaque—preferably black—cardboard work well. For areas in the middle of the image, the dodging tool can be taped to a piece of stiff wire to avoid casting an unwanted shadow from holding the tool with your hand.

C. Burning of small areas can be accomplished with appropriately shaped holes in 8 × 10-inch pieces of opaque cardboard. The hole must be smaller than the area to be burned.

D. Careful techniques must be used to blend the dodged or burned areas into the rest of the image; otherwise, it would be obvious that exposure was altered in those areas. Two methods are used to blend the areas together. Method 1 is to keep the dodging or burning tool some distance above the printing paper. The closer the tool is to the paper, the sharper and more distinct the edge of the shadow it casts will be, making it more obvious. Since the image gets smaller the closer you are to the lens, dodging and burning tools must be of smaller size than the area being dodged or burned in the print.

E. Method 2 is to keep the dodging or burning tool in motion while using it. A simple back-and-forth motion will work if you are dodging or burning a section of the print that extends from border to border, but a circular motion should be used if you are dodging or burning an area within the image. The amount of motion used depends upon the amount of blending necessary to give a smooth transition between the altered area and the rest of the print.

F. If you wish to darken an area of a print completely, without regard to its image content, a technique called **flashing** can be used. Flashing is the application of white light to an area of the print using an external light source. A pocket flashlight with the lens covered by black tape to allow only a tiny beam of light can be used for this purpose. Care must be taken not to affect other areas of the print, so some experimentation will be needed to determine the necessary brightness and length of time for the flashing.

*continued*

## Burning and Dodging Techniques—Continued

G. This print was made without burning or dodging.

© Bognovitz.

H. This is the finished print. The sketch below shows the times used for each area.

© Bognovitz.

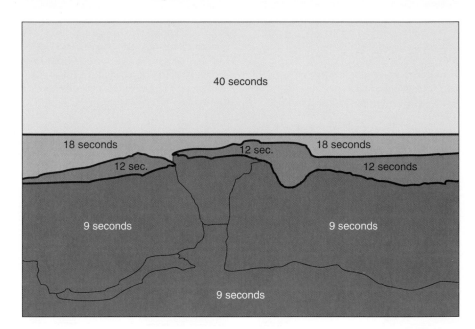

**Print Contrast Controls**   Once the desired highlight tones have been achieved by controlling the print exposure, you can inspect the full-sized print for proper contrast. Print contrast is the difference between the light tones and the dark tones. Since we have already determined correct light tones by exposure, we need only look at the dark tones to see if the contrast is correct.

Contrast is changed by altering the paper contrast. With variable-contrast paper, put a filter of a different number on the enlarger. Printing without a filter on variable-contrast paper yields approximately the same contrast as printing with a grade-2 filter. If your print was flat when printing without a filter, place a filter with a number higher than 2 on the enlarger to increase the contrast. With graded paper, you must purchase a pack of paper with a higher grade number.

Depending on the design of the enlarger and the filters, variable-contrast filters can be used either in the lamp housing—if a filter drawer is provided—

*Correct Print Contrast.* If a print shows good, deep blacks in the darkest areas without losing any important dark tone details of the subject, the contrast is correct.

*Low Print Contrast.* If the dark tones appear too light, then the print is low in contrast or "flat." This analysis technique works only if the light tones are correctly printed.

© Bognovitz.

The flat print has been corrected by using a higher contrast grade.

© Bognovitz.

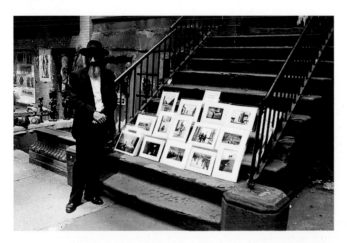

*High Print Contrast.* If the dark tones are too dark to show important details, then the contrast is too high.

© Bognovitz.

The contrasty print has been corrected by using a lower contrast grade.

© Bognovitz.

or on a mount below the lens. Some enlargers also allow the insertion of a filter between the negative and the lens. For best results, use filters in the lamp housing, since filters placed in the image path may adversely affect the quality of the image. If you must use filters in the image path, make sure they are optically flat, high-quality filters designed for such use. Filters used in the lamp housing need not be optically flat and therefore have the added bonus of being cheaper. If you are using a color head enlarger, the filter colors can be dialed into the head. The table shows some typical settings for contrast control of variable-contrast papers with a color head.

### Color-Head Enlarger Filtration for Variable-Contrast Papers

| CONTRAST GRADE | FILTRATION* |
| --- | --- |
| 0 | 80 Yellow |
| 1/2 | 55 Yellow |
| 1 | 30 Yellow |
| 1 1/2 | 15 Yellow |
| 2 | No filtration |
| 2 1/2 | 25 Magenta |
| 3 | 40 Magenta |
| 3 1/2 | 65 Magenta |
| 4 | 100 Magenta |
| 4 1/2 | 150 Magenta |
| 5 | 200 Magenta |

*Note that these filtration values should be taken only as starting guidelines. Actual filtration needed will vary depending upon the design of the enlarger and the brand and type of variable-contrast printing paper used.

**Grain Appearance in Prints**　The grainy structure you see in an enlarged print is not due to the paper but is a direct image of the grain structure of the negative itself. Choice of paper or paper contrast therefore does not affect grain size, although amount of enlargement does. However, the perception of grain in a print depends upon much more than the actual grain size. The appearance of the grain can change with the smoothness of the edges of the grain. The contrast of the image can also change the appearance of the grain. Increasing the paper contrast will make the grain more apparent, even though the grain size itself has not changed.

**Summary of Print Tone Controls**　The techniques for controlling the tonal appearance of a print can be summarized in two steps:

1. *Print exposure.* The overall exposure of a print is judged by the appearance of the light areas of the subject. Increased exposure will darken the print overall. Decreased exposure will lighten it. Individual areas can be lightened by dodging or darkened by burning.
2. *Print contrast.* Once proper light tones are achieved by exposure, contrast can be judged by the appearance of the dark areas of the subject. If the dark tones are too dark, contrast should be decreased by lowering the paper contrast grade. If the dark tones are too light, contrast can be increased by raising the paper contrast grade. Remember that contrast cannot be changed in printing by altering the exposure (varying the f-stop or time) but can only be changed by altering the paper contrast (changing the filter with variable-contrast papers or the grade with graded papers).

## ■ Black-and-White Print Processing

A typical black-and-white print processing line consists of developer, stop bath, fixer, hypo-clearing solution, and storage tray for holding prints for washing. If you have a smaller area for trays or wish to shorten the processing time for each print, you can take out the washing aid, holding the prints in the storage tray until you have enough to wash. The prints can then be processed in the washing aid as a batch before washing.

Temperature of the processing baths is not as critical for prints as it is for film, but the solutions should all be at a stable temperature near comfortable room temperature—68°–75°F for most materials. If the darkroom temperature fluctuates, you may wish to have the trays sitting in a water bath. This can be done by filling the sink up just enough to partially submerge the trays in water of the proper temperature.

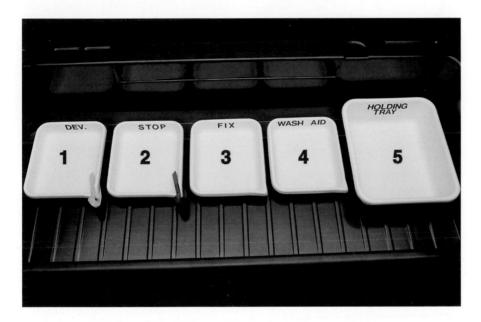

Be sure to follow the direction of processing beginning with tray 1. To prevent contamination, do not carry chemicals on hands, tongs, or prints back into previous trays.

# Print Processing Steps

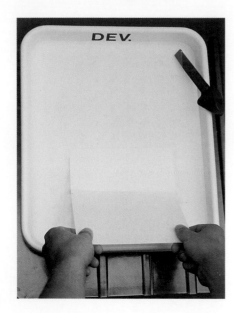

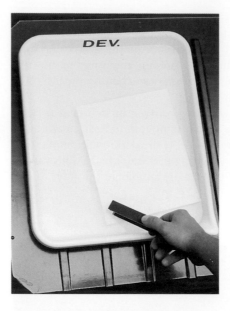

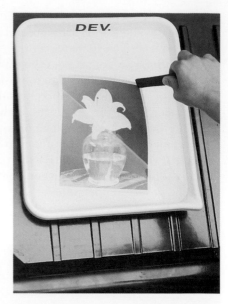

1a. *Developer.* Watching the image develop right before your eyes is an exciting part of making your own prints. Since the image is formed here, care must be taken with procedures to produce consistent prints of good quality. Slide the print quickly into the developer, one end first. The print can be placed into the developer either faceup or facedown providing it is inserted rapidly and is turned over and the agitation begun immediately. Laying the print flat on the surface of the developer and trying to push it down under the solution is not a good method for quick insertion.

1b. *Print Handling.* Tongs are preferred for handling the prints to help prevent contamination of the developer and to reduce contact with the chemicals. Two pairs are needed, one for only the developer and the other for the remainder of the solutions. The developer tongs should never be allowed to touch the other chemicals. If you must use your hands, rubber gloves are recommended to reduce chemical contact. If hands or gloves are used throughout the process, be sure to carefully wash them with soap and warm water after processing. Any traces of the other solutions on tongs, hands, or gloves will contaminate and weaken the developer. Hands should be clean and dry before returning to the enlarger or handling printing papers or negatives.

1c. *Agitation.* The print should be agitated continuously while in the developer. Agitation consists of gently lifting the print by one side and turning it over, then gently pushing it down into the developer around the edges. Do not bend or crease the print. Take care not to rub or scratch the emulsion side of the paper. The print should be turned at regular intervals—for example, once every few seconds—but it can be lifted by a different edge each time to provide even development. Prints can also be agitated by tipping the tray. Establish a careful, repetitive pattern of lifting alternate corners of the tray to achieve controllable, consistent agitation. This method is not practical in group darkrooms using large trays.

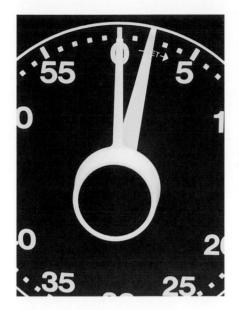

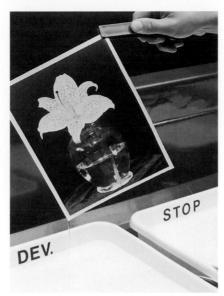

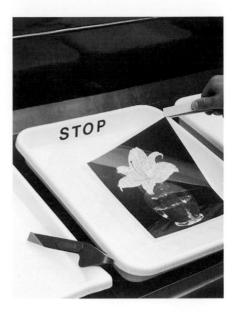

1d. *Timing.* The total amount of development time depends on the combination of printing paper and developer being used. The print developer directions should give a starting point. RC papers generally require less development than fiber-base papers. Most developer and paper combinations can be developed for 2 minutes for acceptable results, but with some papers longer development times will yield a richer maximum black in the print.

Once an acceptable developing time has been determined, it is best to stay with that exact time as a standard. Do not try to alter the development time during processing to control the appearance of the print. Print quality is difficult to judge under the safelight, so it is better to do standard processing, inspect the resulting print under white light, and correct any tonal problems in printing.

1e. Include in the development time the insertion of the print and a 10-second drain time at the end. The drain consists of holding the print up by one corner, allowing the surface liquid to drain back into the developer before proceeding to the next solution.

2. *Stop Bath.* After the print is drained, slip it into the stop bath. The developer tongs are used to transfer the print, but do not let them touch the stop bath. Pick up the second pair of tongs for handling the print during the rest of the process. Agitation in the stop bath is the same as in the developer. Follow the manufacturer's directions for time in the stop bath, which is generally less than 1 minute. Include a 10-second drain at the end of this step.

*continued*

# Print Processing Steps—Continued

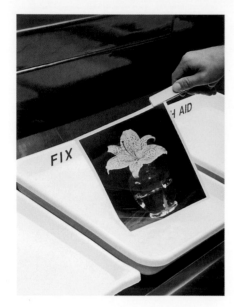

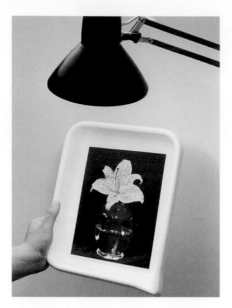

3a. *Fixer.* Transfer the print into the fixer. Agitate initially by turning the print three or four times, leaving it facedown in the fixer. Prints need not be agitated continuously in the fixer but should be turned two or more times each minute. The time in the fixer depends on the type of fixer, ranging with fiber-base papers from 2–5 minutes for rapid fixers to 5–10 minutes for standard fixers. RC printing papers require shorter fixing times, usually about half those of fiber-base papers. Follow the manufacturer's instructions. Insufficient fixing will shorten the useful life of the print and may give purplish-yellow staining. Fixing for too long can bleach the image and causes undesirable absorption of fixer, making the print more difficult to wash clean. Include a 10-second drain before proceeding to the next step.

3b. *Inspection.* If desired, the print can be inspected under white light for short periods of time after being fixed for about one-third of the minimum time. Complete the fixing time after inspection.

4a. *Washing Aid.* The permanence of prints depends on thorough washing. Fiber-base prints need special care with washing. A washing aid—hypo-clearing bath, fixer remover—should be used for shorter wash times and better print permanence. Transfer the print directly from the fixer to the washing aid. Follow the manufacturer's directions for times and agitation. A tray of water may be inserted between fixer and washing aid to provide a rinse for the print, extending the life of the washing aid.

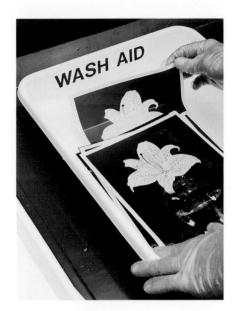

4b. As an alternative, prints may be stored in a tray of water and then treated as a batch in the washing aid. The storage tray should have a slow trickle of fresh running water or should be dumped and changed periodically. Batch processing is done by leafing through the prints bottom to top. You may wish to extend the processing time to account for the larger number of prints being handled.

5. *Storage Tray.* After the washing aid the prints may be stored in a tray of water until you are ready to wash them. Again, the storage tray should have regular changes of water. A washing aid is not necessary for RC prints. For best results with RC papers, the wet time should be kept to a minimum, so storage in holding trays should be reduced or eliminated.

6. *Washing.* Washing should remove as much of the residual fixer in the print as possible. A good wash must insure a continuous flow of fresh water across the surface of the print. Placing the prints in a tray with water running from a faucet will not provide the necessary washing action. Since fixer is heavier than water, it tends to accumulate in the bottom of the washing vessel. A good washer will flush or drain the fixer from the bottom of the washer. It will also provide for shuffling or separation of the prints to allow the wash water to flow over both surfaces of each print. Do not place unwashed prints into the washer during the washing cycle, as that will contaminate the partially washed prints. Double-weight fiber-base prints that have been treated in a washing aid and washed in an efficient washer need at least 20 minutes of final washing. Without the washing aid, prints must be washed more than an hour to approach the same standards. RC prints require less washing, and in an efficient washer 5–10 minutes is sufficient.

*continued*

# Print Processing Steps—Continued

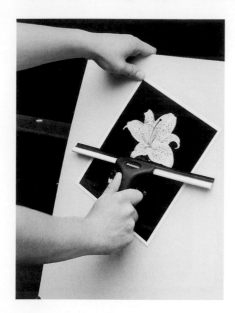

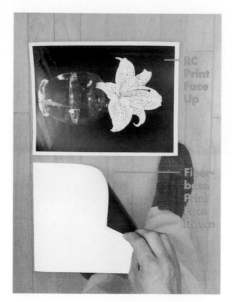

7a. *Drying.* Before drying, excess water should be squeegeed off the surfaces of the print. Place the print on a clean sheet of glass or heavy plastic. Using light pressure, squeegee the back of the print—one pass is enough—pick up the print, squeegee the glass or plastic surface, then squeegee the front of the print.

One important requirement for drying prints is cleanliness. Drying even one print that has been improperly washed will contaminate the entire drying process, with resulting damage to subsequently dried prints. Trays used for transporting washed prints, squeegees, squeegee boards, drying racks and screens, and the belts and drums of heated dryers should all be clean and free of contaminating chemicals. Drying screens, racks, belts, and implements should be thoroughly washed periodically to prevent chemical build-up.

7b. *Air Drying.* Fiber-base prints require some support, such as fiberglass window screening, during air drying to prevent excessive curling. Fiber-base prints should be squeegeed and laid facedown on the screening. Double-weight printing papers will curl less during air drying. After drying, prints can be placed under a heavy weight or in a heated mounting press for flattening.

RC printing papers do not have fiber-base paper's tendency to curl and are easy to air dry. They can be squeegeed and laid on fiberglass screening, but should be laid faceup rather than facedown. After squeegeeing, RC prints can even be hung by the corners with clothespins for drying.

7c. **Fiber-base Paper Only.** Heated print dryers for fiber-base prints usually have a cloth belt to hold the print in contact with a heated drum or platen during the drying. Some are motorized and have built-in squeegee rollers, reducing or eliminating the preliminary squeegeeing needed. Drying temperatures may exceed 200°F, so these dryers should not be used for RC papers. Glossy fiber-base print materials that are air dried or dried with the face to the belt of a heated dryer will show a smooth but not high-gloss finish. Fiber-base papers with surfaces other than glossy should be dried with their face to the belt.

**7d. Fiber-base Glossy Ferrotype Only.** The drum or platen may have a polished chrome surface for **ferrotyping** glossy fiber-base papers. To ferrotype the print, it is rolled or squeegeed into perfect contact with the chrome surface of the dryer. When dry, the print will have a shiny, high-gloss surface. Since the print actually adheres to the ferrotyping surface during drying, any dust, fingerprints, or scratches on the plate will show as imperfections in the print surface. Only glossy-surface fiber-base prints may be ferrotyped.

**7e. RC Paper Only.** RC print dryers usually blow heated air across the surface of the print. A hair dryer set at low heat can be used to speed drying of RC prints.

## Summary of Black-and-White Print Processing Steps

| STEP | MATERIALS | PROCEDURE | REMARKS |
|---|---|---|---|
| 1. Developer | Exposed print, print developer in tray at proper working dilution, tongs | Insert print rapidly one end first. Agitate continuously by turning the print over every few seconds. Time by the manufacturer's recommendations. Include a 10-sec drain at the end of the developing time. | Be careful not to contaminate the developer with traces of other processing chemicals. Use a standard developing time, making any needed changes of print tones during printing. |
| 2. Stop bath | Stop bath at proper working strength in tray | Continuously agitate by turning the print over. Follow the manufacturer's directions for time. Drain for 10 sec. | Be careful to dilute the stop bath accurately to working strength. Too strong a stop bath can pit or otherwise damage prints. |
| 3. Fixer | Print fixer at proper working strength in tray | Agitate 10–15 sec initially, then 10–15 sec each minute. Follow the manufacturer's recommended times. Drain for 10 sec. | Date the fixer and count the number of prints processed to prevent exceeding the working capacity. Do not splash or drip fixer around the darkroom. It is a strong contaminant as well as a corrosive for metal parts. |
| 4. Washing aid | Washing aid, hypo-clearing agent, or fixer remover diluted to proper working strength in tray | Transfer prints from the fixer to the washing aid. Agitate continuously for the time recommended by the manufacturer. Drain for 10 sec. (An optional water rinse may be inserted between the fixer and the washing aid.) | Double-weight prints usually require more time than single-weight prints. Follow the manufacturer's instructions for working capacity and storage. Prints may be held in a storage tray of water and treated in the washing aid as a batch. |
| 5. Storage tray | Water in tray | Store prints until enough are accumulated for a wash. | Change the water periodically in the storage tray. |
| 6. Washing | Efficient print washer | Placement of prints in the washer depends on the design of the washer. Follow the manufacturer's recommendations. Washing times depend on the efficiency of the washer, whether the print has been treated in hypo-clearing agent, and whether the print is RC, single-weight fiber-base, or double-weight fiber-base. | The thoroughness of your washing can be tested with a residual hypo-test kit, available through photographic supply stores. Prints may be held in a storage tray of water and washed as a batch. Do not add prints to the washer during the washing cycle. |
| 7. Drying | Heated dryer or drying screens, squeegee, squeegee board | Squeegee both sides of the print. (If the dryer has built-in squeegee rollers it is sufficient to squeegee only the face of the print.) Place the print in the dryer or lay it out on fiberglass screens, faceup for RC, facedown for fiber-base. | Glossy-surface fiber-base prints may be ferrotyped for highest gloss by drying in contact with a polished chrome surface. Prevent build-up of chemicals in the dryers by periodic washing of belts, drums, and screens. |

NOTE: All solutions and washes should be at room temperature, preferably 68°–75°F.

## ■ Commercial Print Processing Labs

Since most photographs taken by the public are in color, most processing labs are set up only for color film processing and printing. It is becoming increasingly difficult to find labs that can print black-and-white negatives. Custom photo labs that service professionals sometimes offer black-and-white processing and printing services.

Any lab that can process color negatives using the C-41 process can also process Ilford XP2 film, providing chromogenic black-and-white negatives. XP2 negatives can be printed on color print equipment but may show some color casts if the printer is unfamiliar with the film. Tips for finding and working with commercial processing labs are given in chapter 12, on page 361.

## ■ Print Finishing

Even with careful cleaning of your negatives before printing, you may find some white marks in a print due to dust, lint, or scratches on the negative. Print flaws can be corrected by retouching the print itself. The most basic retouching technique is **spotting,** in which dyes are applied to light spots or marks in the print with a fine brush. Although this is a relatively simple technique, it is handwork and takes practice to master.

### Spotting Equipment and Supplies

Spotone is a commercially available spotting dye for black-and-white prints and comes in several colors of black to allow matching the color of black in your print. Spotone #3 dye will provide a close match for many neutral-toned printing papers. Kits with dyes of several different blacks come with a chart giving a starting mixture for most print materials. Test the mixture and your techniques on reject prints before beginning to work on good prints.

The dyes are applied with a good-quality watercolor brush, which can be purchased in an art supply store. A brush with a fine tip, numbered 00 or 000, is usually best for spotting prints. Once you have found a good spotting brush, protect it from damage and clean and shape it carefully after each use. Do not use your spotting brush for purposes other than spotting.

## Black-and-White Print Spotting Procedures

A. Lay out the materials needed for spotting: brush, spotting dye, clean sheet of paper, print to be spotted, mixing palette, water.

B. Dip the brush in the dye and draw it over the edge of the bottle to squeeze out excess dye.

C. More of the dye can be drawn out on the typing paper.

D. Start spotting in the blackest areas of the print. The basic spotting action is a gentle dabbing with the brush.

E. For spotting lighter areas in the print, the dye in the brush must be diluted and the brush must be nearly dry. Pick up a tiny bit of water with the brush, then draw the excess moisture out on the clean paper. Repeat as necessary until the amount of dye in the brush matches the area being spotted.

F. White lines from scratches and lint are the most difficult to spot. Drawing the brush along such a line will leave dark edges. Use the same dabbing motion as before, moving along the line. Do not try to complete the spotting in one pass.

G. Go back over the line with the dabbing motion until it blends with the surrounding area. If the line goes through different tonal areas, the dye must be diluted to match each area. Here part of the line has been spotted. Several passes may be required to match the surroundings perfectly.

For more detailed information on retouching and presentation techniques, see chapter 15.

## ■ Print Presentation

If you wish to display your finished print or show it to others, you will probably want to mount it on an individual display board or incorporate it into a display book or portfolio of some kind. Proper presentation techniques can show the print to its best advantage and also protect it from the dangers of handling. Dry-mounting is an excellent method for attaching prints to display boards.

## Dry-Mounting Procedure

A. Collect the materials and tools needed for dry-mounting: dry-mounting press, clean cover sheets, tacking iron, dry-mount tissue (see table for appropriate dry-mount tissues), mat board, print trimmer, ruler, white cotton gloves.

B. Turn on dry-mount press and tacking iron. Set temperature specified in dry-mount tissue instructions. Do not exceed a temperature of 205°F for RC prints, as you may melt the plastic coating. Set tacking iron between medium and high.

C. *Predry.* Make sure the mat board and the print are clean and free of grit. Insert the mat board and the print between two clean cover sheets of plain bond paper or release sheets made for this purpose, place in the press, and close the press for 30–60 seconds depending on the thickness of your materials.

### Dry-mounting Adhesives

| PRODUCT* | COLORMOUNT | MT5 PLUS | ARCHIVALMOUNT PLUS |
|---|---|---|---|
| Recommended Temperature | 205°F 96°C | 225°F 107°C | 190°F 88°C |
| Minimum Temperature | 185°F 85°C | 185°F 85°C | 160°F 71°C |
| Bond | Permanent | Permanent | Removable |
| Use | RC, Fiber-base | Fiber-base | Fiber-base, RC |

*All products are manufactured and trademarked by Seal Products Incorporated.

D. *Tack Tissue to Print.* Place the print facedown on a clean surface. Align the dry-mount tissue with the print and use the tacking iron to tack the tissue to the print in the center only.

E. *Trim Print.* Trim the print and tissue together to remove borders or crop as desired. Use of a trimmer will insure square corners. Alternatively, a graphic arts knife and metal T square can be used.

F. *Align Print on Mat Board.* Lay the print on the mat board and move it until it is in the approximate position you desire. Measure the sides and two points on the top to make sure the print is centered and square on the board.

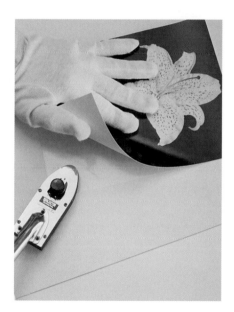

G. *Tack Print to Mat Board.* Carefully holding the print in position, pick up one corner of the print, leaving the tissue lying flat on the board, and use the tacking iron to tack the tissue to the board.

H. Tack at least one more corner of the tissue to the board. Take care not to let the tissue buckle or crease.

I. Insert the print–tissue–mat board sandwich into the dry-mount press between cover sheets with the print faceup.

*continued*

# Dry-Mounting Procedure—Continued

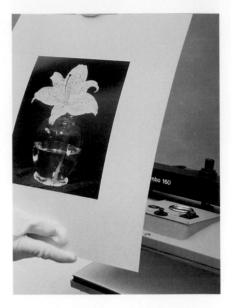

J. Close and lock the press for the time specified for the materials you are using.

K. Remove the mounted print from the press and immediately place it under weight for cooling. A weighted sheet of plate glass works well for this purpose.

L. Once the print has cooled, a very gentle flexing of the mat board will indicate if it has been properly mounted. A slight crackling sound or unadhered edges mean that the tissue was incompletely heated. In this case, the print can be placed back in the press for reheating.

## ■ READING LIST

Coote, Jack H., and Keith Watson. *Ilford Monochrome Darkroom Practice: A Manual of Black-and-White Processing and Printing.* 3d ed. Boston: Focal Press, 1996.

Curtin, Dennis, Robin Worth, Roberta Worth, and Joe DeMaio. *The Darkroom Handbook.* 2d ed. Boston: Focal Press, 1997.

# CHAPTER 7

# Troubleshooting

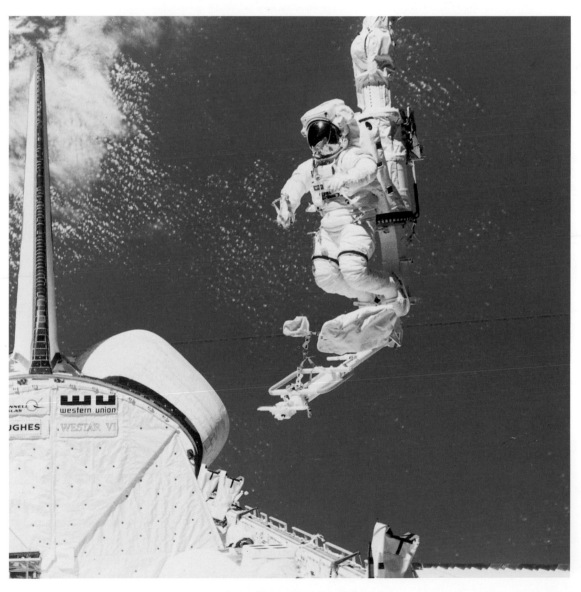

Robert Gibson, *Astronaut in EVA.*

© Courtesy of NASA.

The photographic process makes use of a system of equipment, materials, and technical procedures applied in a chain of events from the initial choice of subject to the finished photograph. The quality of the final result can be affected by changes in any step of the process.

Finding the reason for a problem is a lot like doing detective work. Possible sources of error are first narrowed down to the ones that might cause the undesired result. The one responsible can then be found by a process of elimination. This procedure is complicated by the possibility that a given problem may come from several different places in the photographic system. For example, the contrast of a print is affected by subject lighting, film exposure, film processing, printing procedures, and several other factors. It can take some time to figure out which of these may be the culprit. The following charts of photographic problems will help narrow down the possibilities. A few simple testing techniques that may help to further localize a problem follow the charts.

## ■ Troubleshooting Charts

### Film Exposure Problems

**Underexposure**

**Indication**   Low overall density of the negative and loss of shadow detail.

**Overexposure**

**Indication**   High shadow density and high overall density.

**Problem-Remedy**   If the whole roll is improperly exposed, the cause may be one of the following:

■ Wrong ISO. The wrong ISO may have been set into the meter or camera. Setting the ISO too high will cause underexposure. Setting the ISO too low will cause overexposure (see page 33).
■ Equipment malfunction, meter or camera. The meter may have been reading too high (underexposure) or too low (overexposure). The aperture or shutter on the camera may have been operating improperly. The battery may have been bad (see pages 176–78).

If individual frames are improperly exposed (exposure is inconsistent), the cause may be one of the following:

*continued*

■ Unusual subject tones. Large areas of dark tone may cause overexposure. Large areas of light tone may cause underexposure. Compensate for subject tone when shooting (see pages 36–38).

■ Background affecting meter reading. An extremely bright background may cause underexposure. A large, dark background may cause overexposure. Take a close-up meter reading of the subject if possible (see page 39).

■ Operator error. The wrong shutter speed or f-stop may have been set accidentally. The photographer may have neglected to compensate for the use of filters or reciprocity failure (see pages 307 and 43–44).

■ Equipment malfunctions. Individual shutter speeds or apertures may be inaccurate or erratic. The meter may be erratic, reading accurately at some light levels but not at others. If a written record of exposure information is kept, sometimes faulty camera settings or meter problems can be tracked down by seeing if a pattern of exposure errors for specific settings exists (see pages 176–78).

**Indication**   No image on film, but visible edge numbers and labeling.

### Blank Frames

### Problem-Remedy

■ Film did not go through camera. When loading film, make sure the film leader is securely fastened to the take-up spindle and advance the film until both edges are engaged with the sprockets before closing the back of the camera (see page 6).

■ Shutter did not open. A defective shutter may sound as if it is operating but still not be opening. The shutter tests following this chart may isolate this problem (see pages 176–78).

■ Mirror on a single-lens reflex camera failed to flip up.

■ Lens cap was left on. This would be likely only with a viewfinder-type camera, since a TTL viewing system would alert you to the problem.

If film has no image and no edge numbers, see "Other Film Developing Problems," page 166.

**Indication**   Dark streaks on negative, white streaks in print caused by unwanted exposure to light.

### Fogged Film

### Problem-Remedy

■ Loading film in bright light. Vertical streaks near the beginning of a roll are most likely caused by loading the film in bright light, which allows some light to come through the felt light trap of the film cassette. Load film into camera only in subdued light.

■ Opening back of camera before rewinding. If this is noticed immediately and the back closed, it is worth processing the film, as the inner layers of the roll may still be usable.

■ Exposing film to light leaks in camera. If the seal between the camera body and the camera back has been damaged, film may be fogged while in the camera. Fogging from camera leaks usually takes on a specific pattern on one edge or the other of the film. When tracking down camera light leaks, remember that the image is upside-down on the film, so fogging at the top of the image indicates a light leak at the bottom of the camera.

■ Exposing film to light during tank loading or processing. If film is not loaded into the developing tank in total darkness, fogging will take place. Improper assembly of the developing tank or damage to the light seals in the tank may also cause fogging.

■ Exposing film to high temperatures or overactive developer. If the film shows an even overall fogging—excessive density even in its unexposed parts—this may come from two sources. Heat damage of the film can cause general fogging. Be careful not to expose the film to high temperatures—for example, those inside of cars in the summer. Chemical fogging can also take place during the processing as a result of overactive developers.

■ Exposing entire film to strong light. If the whole roll of film, edge to edge, is completely opaque (black), a high overall exposure to light is indicated, probably at some time when the film was completely unrolled or loosely rolled so that the light could reach every part of it. If just the frames are opaque, but the edges are clear as usual, gross overexposure of each frame is indicated.

■ Exposing film to X rays. Exposure to X rays, as in airport security scanning of luggage, affects film much as does exposure to light, resulting in fogging (see page 27).

## Flare

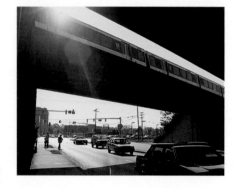

**Indication**    In the negative, dark streaks or patterns that may include the shape of the aperture or ghost images of bright objects in the photograph; in the positive image, light streaks or shapes; also general overall fogging of the frame and a resultant loss of contrast in the image.

### Problem-Remedy

■ Lens design. Flare is due to internal reflections within the lens or camera and can be reduced by careful coating of the lens with thin layers of rare earth elements. Older or cheaper lenses may exhibit more flare than quality lenses.

■ Direct light falling on lens surface. Including the sun or other light sources in the photograph may cause flare. Even light sources outside the frame can cause flare if the light is falling directly on the surface of the lens. Use a lens shade or block the light from falling on the lens (see pages 67 and 445).

■ Dirty or damaged lens. Scratches, pits, dust, fingerprints, or other dirt on the lens surface—or on any filters used on the lens—will add to flare.

## Vignetting

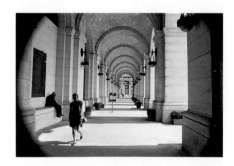

**Indication**    In the positive, darkening of the corners or edges of the image.

### Problem-Remedy

■ Improper lens shade. Using a lens shade designed for a lens with a longer focal length will cause vignetting, as the shade will extend into the field of view of the lens. Filters with thick rings or use of more than one filter may also move the lens shade out into the field of view.

■ Improper lens coverage or excessive camera movements. On a view camera or other camera allowing movements of the lens for image correction, extreme movements or use of a lens with the wrong coverage may move the film into the edge of the image, causing vignetting.

## Multiple or Overlapped Images

**Indication**   Two or more images superimposed on film.

**Double Exposure**

### Problem-Remedy

■ Camera has a defective double exposure interlock, designed to prevent releasing of the shutter until the film is advanced.
■ Operator failed to advance the film on an older camera without an interlock feature, or to change the film holder on a sheet film camera.
■ A previously exposed roll or sheet of film was loaded into the camera and exposed a second time.

## Uneven Frame Spacing

**Overlapped Images**

**Indication**   Varying width on spaces between frames or partially overlapping images on film.

### Problem-Remedy

■ Camera has a defective film-advance mechanism, requiring repair.

**Sharp Image Over
Blurred Image**

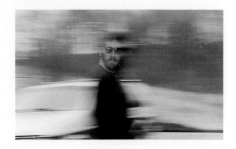

**Indication**  Sharp image superimposed on streaky, blurred image.

**Problem-Remedy**

■ This problem occurs when using flash. If the existing continuous light is bright enough to record an image on the film and the subject is moving, a sharp image from the flash is recorded as well as a blurred image from the continuous light. To prevent this problem, use a higher shutter speed (do not exceed the synchronization speed) or increase the power of the flash.

# Completely Blank or Badly Underexposed Section of Frame

**Wrong Flash Synch Speed**

**Indication**  Partial frame in shape of rectangle, either vertical or horizontal.

**Problem-Remedy**

■ Operator used a shutter speed higher than the synchronization speed recommended by the camera manufacturer when using flash. The problem occurs with focal plane shutters, some of which travel vertically, others horizontally. If the existing continuous light is bright enough, some detail may be seen in the remainder of the frame (see page 207).

**Object in Front of Lens**

**Indication**  Totally blank irregular area of film.

**Problem-Remedy**

■ A dark or unilluminated object was close to the lens, causing extreme underexposure of that area.

## Film Handling Problems

**Indication**   Torn sprocket holes on both edges of 35mm film.

**Problem-Remedy**   The film was forced to move against the sprockets in the camera when the operator performed one of two improper procedures:

■ Tried to advance the film when the end of the roll was reached.
■ Failed to push the rewind clutch release button before rewinding and then forced the film.

   If the film advance or rewind seems hard to operate, try to figure out the problem rather than forcing the controls.

**Indication**   Tear completely across a film's width, usually in jagged fashion.

**Problem-Remedy**

■ Operator forced the film after failing to push the rewind release button or at the end of the roll. Torn film can only be removed from the camera by opening the camera back in total darkness and loading the film directly into a film developing tank.

**Indication**   White or black scratches in a positive print.

**Problem-Remedy**   Two types of scratches occur:

■ White scratches are from light surface scratches on either surface of the film, most commonly on the base side. Surface scratches on the negative can sometimes be corrected in printing. Scratch treatment liquids are commercially available. These are applied directly to the negative and fill the scratch while printing. Although effective, they are messy to use. Diffusion-type enlargers will suppress the appearance of surface scratches.
■ Black scratches are from scratches on the emulsion side that are deep enough to completely remove the emulsion in that area. The only remedy for such scratches is retouching of the print by a professional retoucher.

   Scratches may come from several sources:

■ In-camera problems. Scratches caused by problems inside the camera are usually identifiable because they are perfectly straight and parallel to the edge of the film. They are caused by dust, dirt, or damage on the pressure plate, which holds the film flat in the camera. They can also be caused by dirt in the felt light trap of the film cassette. Users of bulk film may get scratches from the bulk film loader or from dirt trapped in the felt of the reusable cassettes.
■ Rough handling. Scratches due to rough handling of the film are usually random scratches. Handle film gently only by the edges. Make sure that any

**Torn Sprocket Holes**

**Torn Film**

**Scratches on Film**

surface the film is placed against—including negative sleeves—is free of grit. Dragging the negative through the negative carrier in the enlarger is a common source of scratches.

## Contrast Problems

So many parts of the photographic process have an effect on the final contrast achieved in a print that pinning down the source of incorrect contrast can become difficult:

■ Subject contrast. The range of light values displayed by the subject determines subject contrast, which can be affected by the tonal nature of the subject itself and the nature of the lighting on the subject (see pages 102–03 and 407–11).

■ Film condition. Old film or film damaged by improper storage, especially heat, may show a loss of contrast.

■ Film exposure. Underexposure of the film causes loss of contrast. Overexposure may initially cause a slight increase of contrast, but substantial overexposure will cause a loss of contrast (see pages 103–05).

■ Film development. Contrast depends directly on the amount of development the film receives, with more development producing more contrast. Among the factors that change the amount of development are development time, developer temperature, developer agitation, developer type, developer freshness, and developer dilution (see pages 101–07).

■ Printing. Contrast can be affected by the type and quality of enlarger and enlarger lens; the paper contrast, either variable contrast or graded; the condition of the printing paper; and the print developing process (see pages 140–42).

If you are having contrast problems, the possibilities can be narrowed down somewhat by a little deductive reasoning. First look at the subject to see if it may have had inordinately low or high contrast. If the subject is of reasonably normal contrast, you must decide whether the problem is due to low contrast in the negative or a problem in printing. If the highlights in the film look low in density—you should be just barely able to read well-illuminated black print on a white page through highlights of correct density—the negative is probably causing the low contrast.

If most of the negatives from a roll are printing with good contrast and only one is giving incorrect contrast, the most likely problem is exposure, since a development error would affect the whole roll. If you are getting low contrast on a whole roll, it could be from either underexposure or underdevelopment. To decide which is the problem, look at the film. If the negatives are showing loss of shadow detail, underexposure is indicated. If shadow detail is present, then the problem is most likely underdevelopment of the film.

If the negatives look reasonably close, contrast problems in printing are most easily found by changing parts of the printing system—paper, developer—one at a time. Check the enlarger as well to make sure it is properly assembled, the lens is clean, and no variable-contrast filters have been left in it. Specific reasons for incorrect contrast follow.

**Indication**  Too little difference between light and dark areas of print.

### Flat Print (Low in Contrast)

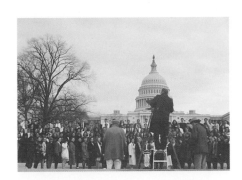

### Problem-Remedy

■ Low subject contrast. The lighting outdoors on overcast days or inside under diffused lights produces low subject contrast. A limited range of tones in the subject itself can also give low subject contrast.

■ Underexposed film. A loss of detail in the shadow area of the negative indicates underexposure of the film.

■ Extremely overexposed film. Extremely high densities in the negative—in other words, very dark negatives—indicate extreme overexposure of the film.

■ Old or damaged film. Check the expiration date on the film box. Protect film from heat and humidity.

■ Underdeveloped film. A reduction in any of the factors affecting film development will result in underdeveloped film: too low a developer temperature, too short a development time, too little developer agitation, overdiluted developer, contaminated developer, aging developer.

■ Old or damaged printing paper. Papers are not normally marked with an expiration date, so it is important to buy from stores that regularly turn over their stock of paper. Do not expose paper to extremes of heat or humidity. For long-term storage, paper can be sealed and refrigerated or frozen.

■ Underdeveloped print. Too short a print development time, overdiluted print developer, contaminated print developer, aging print developer, or cold print developer can all cause underdevelopment of a print.

■ Wrong printing contrast. A variable-contrast filter of a grade lower than 2 may have been accidentally left in the enlarger or a lower-grade pack of paper may have been used.

**Indication**  Too much difference between light and dark areas of print.

### Overly Contrasty Print

### Problem-Remedy

■ High subject contrast. Areas with very clear atmosphere and harsh sunlight or with subjects having an extreme range of subject tones produce high subject contrast.

■ Overdeveloped film. An increase in any of the factors affecting development may produce overdevelopment of a film: too high a temperature; too long a time; too much agitation; underdilution of developer; use of wrong developer, such as the stronger print developers.

■ Overdeveloped print. Too long a developing time, underdiluted print developer, or too high a developer temperature may all cause overdevelopment of a print.

■ Higher-than-normal filter or grade of paper.

# Other Film Developing Problems

**Blank Film**

**Indication**  Completely blank film with no image and no edge numbers.

**Problem-Remedy**

■ Film was not developed but was fixed. This is due to a completely depleted or neutralized developer or to placing the film in fixer by mistake before developing.

**Crescent-shaped Marks**

**Indication**  Dark, crescent-shaped marks on film that print white.

**Problem-Remedy**

■ Film was crimped while loading into the developing reel.

**Undeveloped Splotches**

**Indication**  Irregular splotches on film with no image but with undeveloped emulsion showing.

**Problem-Remedy**

■ Film was loaded on the developing reel improperly, so that adjacent loops were touching during the processing.

**Indication**   Small, blank, round spots or partially developed spots on film that print as black or dark spots.

## Problem-Remedy

■ Air bubbles formed on the film during the development process. Use a water prewet and tap the tank on a hard surface to prevent air bubbles.

**Air Bells**

**Indication**   Textured pattern on film; effect is often confused with large grain size, but closer inspection will usually reveal a specific pattern, unlike the random distribution of actual grain.

## Problem-Remedy

■ The film emulsion wrinkled because of a rapid temperature change during the processing. Temperatures after the developing bath should be within plus or minus 5°F of the developer temperature.

**Reticulation**

**Indication**   Very tiny clear spots in the emulsion that print as black spots.

## Problem-Remedy

■ Faulty emulsion manufacture.
■ Overly strong acid stop bath.
■ Dust or dirt on the film in the camera.

**Pinholes**

## Static Marks

**Indication**   Jagged lines resembling lightning or "spark" shapes, black on film, white on print.

### Problem-Remedy

■ In very dry conditions, advancing or rewinding the film at too high a speed may cause the discharge of static electricity on the film.

## Surface Marks

**Indication**   Scum or deposits on surface of film.

### Problem-Remedy

■ Hard water marks from not using wetting agent.
■ Scum or other residue from improperly mixed or dirty wetting agent or from placing a negative that still had fixer on it in wetting agent.
■ Rough handling or contact of the film with moist or dirty surfaces.

## Uneven Density

**Indication**   Uneven density from one part of negative to another; especially noticeable in subject areas with even tone, such as the sky.

**Problem-Remedy**   Film received uneven development from two possible causes:

■ Poor agitation technique. In extreme cases this can show up as streaks of excessive or low density.
■ Not enough developer in film tank to cover film.

**Indication**  Milky appearance in film.

**Milky Appearance**

**Problem-Remedy**  This appearance results from insufficient fixing from two possible causes:

- Too little time in the fixer.
- Depleted fixer.

If the film has not been exposed to too much light, this condition can be corrected by immediately refixing the film in fresh fixer and then completing the process steps which follow the fixer as usual.

## Printing Problems

**Indication**  Excessive darkness in all tonal areas of print.

**Dark Print**

### Problem-Remedy

- Excessive exposure in printing.
- Extreme overdevelopment of print.
- Accidental exposure of the paper to white light or an incorrect safelight, if the borders of the paper are dark as well.

**Indication**  Excessive lightness in all print tones.

**Light Print**

### Problem-Remedy

- Too little exposure in printing.
- Paper inserted in easel emulsion side down.
- Extreme underdevelopment of print.

## White Edges or Corners

**Indication**   Completely white edges or corners of print image.

### Problem-Remedy

■ Condenser on the enlarger was improperly set for the format size and focal length lens being used. This usually shows as white corners.
■ Obstruction—such as an improperly installed filter drawer or holder—was in the image path.
■ Defect or damage—such as improper alignment of the bulb or use of the wrong bulb or misalignment of the condenser optics—occurred in the enlarger lamp housing.

## Reversed Image

**Indication**   Print image reversed left to right, so that lettering reads as mirror image.

### Problem-Remedy

■ The negative was printed with the emulsion side up, rather than down.

## Sharp White Spots or Wiggly Lines

**Indication**   Sharp white spots or wiggly lines in print.

### Problem-Remedy

■ Dust or dirt was on the negative itself.

**Indication**   Fuzzy white spots on print.

**Fuzzy White Spots**

**Problem-Remedy**

■ Dust or dirt was on parts of the enlarger in the image path fairly close to the negative, such as on the condenser lenses or a glass negative carrier. Dust on the surfaces of the lens itself may cause some deterioration of the image but will not show up as white spots in the print.

**Indication**   Splotchy, streaky, weak blacks in print and inconsistent print darkness.

**Uneven Print Density**

**Problem-Remedy**

■ Too short a print development time.
■ Failure to agitate print during development.
■ Cold print developer—below 65°F.
■ Weak or exhausted print developer.

**Indication**   Black or white fingerprints in print, life-size or enlarged.

**Fingerprints**

**Problem-Remedy**

■ Fingerprints were left on the negative after processing. These will show in the print as enlarged and lighter than the surroundings.
■ Fingerprints were left on the printing paper from contaminated hands. These may show up as either black or white in the print but will be life-size.

**Indication**   Overall gray cast to print; borders possibly gray as well.

**Gray Cast in Print**

**Problem-Remedy**   If the borders are gray:

■ Paper was fogged by exposure to white light or a safelight of the wrong color or intensity.
■ Paper was old or damaged by heat.
■ Paper was chemically fogged by a contaminated or bad developer.

If the borders are clean white:

■ Enlarger is leaking light, which is scattered back to the paper during printing.

**Black Streaks**

**Indication**  Uneven or random black streaks in print.

**Problem-Remedy**

- Uneven exposure of the paper to white light.
- Contact of the paper with liquids or chemicals before processing.
- Rough handling of the paper, which can cause black marks or scratches.

**Dark Marks**

**Indication**  Dark marks or lines on surface of print with appearance of streaks, abrasions, or scratches.

**Problem-Remedy**

- Print developer was contaminated or paper contacted contaminating chemicals.
- Print was handled roughly in processing: for example, tongs or fingernails were dragged across surface of print. Surface scratches can also result from rough handling.

**Air Bubbles**

**Indication**  Areas of print lighter than their surroundings and in the shape of bubbles.

**Problem-Remedy**

- If the prints are laid in the developer face down and not agitated, air bubbles could be trapped below the paper, causing underdeveloped spots.

**Yellow Stains**

**Indication**  Yellow or brownish-yellow stains in print, random or overall.

**Problem-Remedy**

- Overused or contaminated print developer.
- Incomplete washing.
- Contact of print with fixer after washing, as in contaminated dryer, tray, squeegee, and so on.

**Indication**   Brownish-purple stains in print, random or overall.

**Brownish-Purple Stains**

**Problem-Remedy**

■ Inadequate print fixing.

**Indication**   Areas of print lighter than printed, especially noticeable in light tone areas.

**Bleached Image**

**Problem-Remedy**

■ Excessive print fixing.

**Indication**   Cracks in print emulsion, either local or over entire print.

**Cracks in Print Emulsion**

**Problem-Remedy**

■ The paper may have been bent too much in handling.
■ A cracked, melted appearance can be from overheating resin-coated paper in a dryer or mounting press.

**Indication**   Print emulsion peeling from paper, especially at edges of print; called frilling.

**Peeling Emulsion**

**Problem-Remedy**

■ Excessive soaking of the print in liquid.
■ Rough handling of a wet print.

**Uneven Gloss**

**Indication**   Splotchy or rough areas in glossy surface of print.

**Problem-Remedy**

■ On ferrotyped fiber-base print, this results from poor adhesion of the print to the ferrotype plate due to dirt or grease on the plate or print. Any marks or scratches on the plate will also show on the surface of the print.

■ This may also result if a print comes in contact with liquid after drying.

**Curled Print**

**Indication**   Excessive curling of print (a slight curl, usually toward the emulsion, is normal).

**Problem-Remedy**

■ Very low humidity.

■ Air drying of fiber-based prints faceup on a flat surface.

■ Too much wet time for an RC print.

■ Improper storage. Double-weight paper tends to curl less than single weight. Keep prints under some pressure in storage to prevent curling.

## Sharpness Problems

If the image in a print is not sharp, the problem could have been either in the negative itself or in the printing of the negative. Two methods may be used to discover the source of the loss of sharpness. If the grain structure is visible in the print, look closely to see if it appears sharp. If the grain structure is sharp throughout the print, any sharpness loss is in the negative itself. If the grain is too fine to be seen in the print, the negative itself must be inspected with a good-quality magnifying loupe to determine if it is sharp.

## Sharpness Loss in Negative Image

**Movement**

**Indication**   Blurring, usually streaky in appearance, of all or part of image on film.

**Problem-Remedy**

■ Movement of camera during exposure. Camera movement is indicated if the complete image is blurred.

■ Movement of subject during exposure. Only moving subjects would be blurred if the camera was stable.

**Indication** Blurring of all or part of image in negative, with a fuzzy rather than streaked appearance.

**Focus Blur**

### Problem-Remedy

■ The photographer may not have focused on the subject.
■ If part of the image is in focus but other parts are not, this could be due to insufficient depth of field.
■ If the image is not sharp even though the camera was carefully focused and the camera and subject did not move, a problem with the camera or lens may be indicated. The focusing system in the camera may be out of adjustment. The lens could be of poor quality or could be dirty or damaged.

## Sharpness Loss in Print Image

**Indication** Streaky blur in print image, even though negative is sharp.

**Movement Blur**

### Problem-Remedy

■ Enlarger or printing paper moved during the exposure.
■ Negative popped because of the heat of the enlarger bulb. Preheat the negative or use heat-absorbing glass in the enlarger.

**Indication** Blurring of entire image, with soft fuzzy look, even though negative is sharp.

**Overall Blur**

### Problem-Remedy

■ Incorrect focusing of enlarger. Use a focusing magnifier.
■ Excessive enlargement of image.
■ Poor enlarger lens quality or dirty lens or filter.

**Indication** Sharpness in part of image but blurring in remainder; so that only one area of negative can be focused on at a time.

**Partial Blur**

### Problem-Remedy

■ Enlarger is out of alignment. The negative stage, lens stage, and baseboard or easel must all be perfectly parallel.
■ Negative is not lying flat in negative carrier.

**Large Grain Size**

## Grain Structure Problems

**Indication**   Granular structure showing in print.

**Problem-Remedy**   Grain is from the negative, not the print material. Excessive grain size has several causes:

- Using high-ISO films.
- Overexposing the negative.
- Overdeveloping the negative.
- Enlarging the image too much.
- Printing with high-contrast papers or filters. This does not increase the size of the grain but may add to the apparent graininess of the image.

## ■ Testing Procedures

### Visual Shutter and Aperture Check

If your camera allows operation of the shutter with the back open—many newer models do not—you can visually check the shutter and aperture operation. These rough tests will not tell you the accuracy of the settings but will let you know if any major problems exist, such as the shutter not opening or the aperture not shutting down, and whether the settings are fairly consistent with one another.

*Visual Shutter and Aperture Check.*

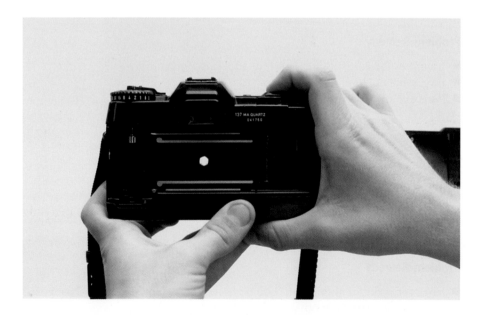

**Aperture Check**   Open the back of the camera. With the shutter speed set on B, depress and hold the shutter release while looking through the back of the camera. Rotate the aperture ring and observe the diaphragm. It should open

fully at the maximum aperture; then as you step down through all the stops, it should show a smooth reduction of the aperture with each step.

If your camera does not operate with the back open, this same check may be done by looking into the front of the lens.

**Shutter Check** Open the back of the camera and point it at a brightly lit white wall or light source. While looking through the back of the camera, operate the shutter at each speed setting checking that the shutter opens on each setting. With practice, it is possible to tell by the sound of the shutter whether it is running fairly close to its proper speed, at all but the fastest speeds.

## Shutter Speed and Aperture Test

To see if the shutter speed and f-stop pairs are giving the same amount of exposure, find or set up an evenly lit surface of uniform tone. A gray mat board works well for this purpose. Meter off the surface and then make as many exposures as possible with the different equivalent exposure settings on any black-and-white film.

For example, if the initial meter reading was f/8 at 1/60 second, shoot with as many of these cameras settings as you can with your camera: f/8 at 1/60, f/11 at 1/30, f/16 at 1/15, f/22 at 1/8, f/32 at 1/4, f/5.6 at 1/125, f/4 at 1/250, f/2.8 at 1/500, f/2 at 1/1000. For comparison, also shoot a frame that is one stop underexposed (e.g., f/8 at 1/125) and one that is one stop overexposed (e.g., f/8 at 1/30). Write down all the settings used.

When this film is developed, all of the frames with correct exposure should be the same density. If a contact print is made of this roll, printing so that the frames are a middle gray, easy comparison can be made of the various equivalent exposure settings. If any of these are lighter or darker than they should be,

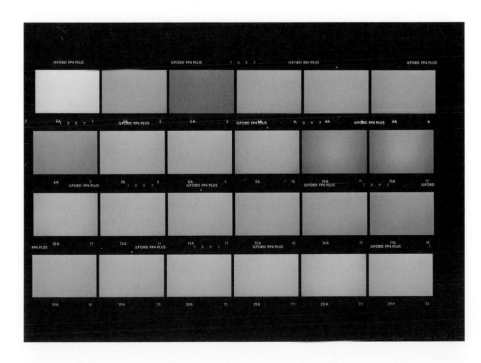

*Shutter Speed and Aperture Test.* For comparison, the first frame is one stop over and the third frame is one stop under. Most of the shutter speed-aperture combinations used in this test were consistent with each other, giving the same shade of gray. The first frame of the second strip shows some underexposure, estimated at about 1/3 to 1/2 stop when compared to the frame with one stop underexposure. The last two frames in the second strip, shot at 1/500 and 1/1000 second, show uneven exposure and about 1/3 stop underexposure. Older cameras often exhibit uneven shutter travel at higher shutter speeds.

the frames that are over- and underexposed one stop will help to show how much that setting is off.

This tests only the combination, so any errors could be due to either the shutter speed or the aperture. Repeating the test at a different illumination level on the target will give different combinations, allowing you to narrow down the cause of any errors.

## Camera Focus and Lens Sharpness Test

Pin a newspaper to a wall, making sure the newspaper is perfectly flat. Set the camera up on a tripod so that it is level with the center of the newspaper and pointed straight at it. Move the camera forward or backward until the newspaper fills the frame. Carefully focus the camera on the newspaper. Have a friend with good eyes and some photographic experience check your focus for you to verify that you are focusing correctly. Use a cable release to trip the shutter to prevent camera movement. Shoot at several different equivalent shutter speed and f-stop pairs, writing down the settings used. Be sure to include some shots with the maximum apertures on the lens: for example, f/1.4, f/2, and f/2.8.

After the film is developed, inspect the negatives for sharpness with a good-quality, high-magnification loupe. The newsprint in the image should be sharp from corner to corner. If it is not sharp anywhere in the frame and you have been careful to focus and to not let the camera move during the exposure, a problem with the focusing system or the lens itself may be indicated. Problems may be most easily seen when the large aperture openings (small f-numbers) are used. Sharpness generally improves as the lens is stopped down.

*Examination of a Camera Lens Focus and Sharpness Test.* The magnification used here is 8 times.

## Light Meter Testing

A rough test of a light meter is the f/16 rule. When pointing the meter at a subject of average tones in the middle of a sunny day, you should get a meter reading of about f/16 at a shutter speed equal to 1 divided by the ISO/ASA set into the meter. For example, if the meter is set for ISO/ASA 125, the meter reading should be about f/16 at 1/125 second.

Another testing method is comparison with another meter. Make sure both meters are measuring exactly the same area. A large, evenly lit wall is good for this purpose. If the meters disagree, further comparisons with other meters would be necessary to determine which is correct.

Alternatively, you can have the meter tested at a camera repair center.

## Professional Testing

A fully equipped camera repair center can do several tests on your equipment to see if it is operating properly: shutter speeds can be tested for accuracy and focal plane shutters for evenness of travel; the aperture can be tested for accuracy at all the f-stops; the accuracy of light meters can be tested at several different levels. The camera industry has accepted standards for exposure accuracy at various shutter speeds and apertures, and the repair center can tell you how your equipment compares with the standards. See appendix B for more complete information on professional camera testing.

## Enlarger Sharpness Test

If the negative of the newspaper from the preceding camera focus and lens sharpness test is sharp corner to corner, it may be used to test your enlarging sharpness. Correctly install the negative in the carrier, focus carefully, and make 8 × 10-inch or larger prints from it. Try prints at different apertures on the lens, from the maximum aperture up to at least the middle range of apertures. If the resulting prints do not show sharp images from corner to corner, an enlarger problem is indicated.

If the image is acceptably sharp in the center but not around the complete perimeter, a poor-quality lens is the most likely reason, especially if an improvement in edge sharpness is noticed as the lens is stopped down. Alignment of the enlarger can also cause edge sharpness problems. A small level may be laid on the negative carrier stage, lens stage, and baseboard for a rough alignment check.

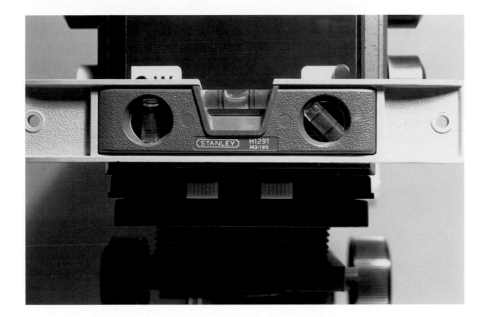

*Checking Enlarger Alignment.* Here the level is laid on the negative carrier stage. Since it is perfectly level (the bubble is centered), the lens stage and baseboard should be adjusted so that they are also perfectly level.

If misalignment is suspected, consult the instruction manual of your enlarger for alignment techniques. Some enlargers have a cast housing that does not allow alignment of the negative and lens stages, but the alignment with the baseboard can always be adjusted by inserting shims, or spacers, under the column where it is bolted to the baseboard. After the rough alignment has been checked with a level, the sharpness of the projected image from the test negative can be used to judge final alignment adjustments.

## Standard Negative

It is helpful to choose one of your negatives to serve as a standard of comparison. A good standard negative should include subject matter that you normally photograph and should print easily on normal-grade (grade 2) paper. If you make a good print of this negative, you can store the negative and print for later comparison. If problems arise with your system, the standard negative

*Print from a Standard Negative.* This image shows all the characteristics of a good standard negative. It prints well on grade 2 paper without burning or dodging. It has a large area of fully textured highlight (the white storefront at the top of the photograph), a good fully detailed dark tone area (the top of the shadowed door on the right), and a full range of tones from black to white.

© Bognovitz.

can be reprinted to see if the problems lie in your printing procedures. The standard negative can also be used to compare different printing papers and developers.

A few more tests for determining proper development times and exposure can be found in chapter 14.

# Light and Subject

Ralph Gibson, from *The Somnambulist*, 1970.

© Ralph Gibson.

The primary function of light in photography is the illumination of the subject. Many qualities of light, however, can change our perception of the subject matter. Lighting can reveal or hide the form, or three-dimensionality, and texture of the subject. Light can act as an important design element in a photograph. A subject can be isolated against its background by the presence or absence of light. Light can unify disparate visual elements and can affect the perception of space in the photograph. The quality of light can also carry psychological and emotional weight, setting a mood or feeling of time and place. Sometimes light can even become a presence in the photograph, transcending its role as illuminator or design element and serving as the subject of the photograph.

Most people in their everyday life pay little attention to light, thinking only of the practical applications: Is enough illumination here to do the job? The first step in gaining some control over the effect of light in your photographs is to develop a sensitivity to light's qualities. Study the light in everyday situations. You will find that even with a single light source such as the sun, the effects of light can be amazingly subtle and complex. The quality of the light source itself can vary in intensity, harshness, and color. The light can then be further altered by the surroundings, being diffused, reflected, blocked, and filtered by objects in the environment. The presence of additional light sources can add even more complexity.

Studying the effects of light in photographs can also be helpful. Analyze the light in published photographs you see. Try to discover the type of light source and its direction by looking at the play of light, shadows, and reflections. Notice how the light changes your perception of the subject matter. If a photograph has an identifiable mood or feeling, see if you can determine how the light helps to promote this.

Remember that the way the eye sees is somewhat different from the way the subject is reproduced by the photographic process. The eye has a much

Frederick Evans, *Kelmscott Manor: Attics 1896*. The chapter frontispiece photograph by Ralph Gibson and this photograph by Frederick Evans make effective use of light. The light has a real presence in both, and several of the functions of light can be seen: the isolation of the hand in the first photograph, the depiction of texture in this one, a feeling of three-dimensionality and a sense of space in both. Nevertheless the mood established by the light differs, being eerie and unsettling in Gibson's image and warm and inviting in this one.

Courtesy of the Library of Congress. Used with permission.

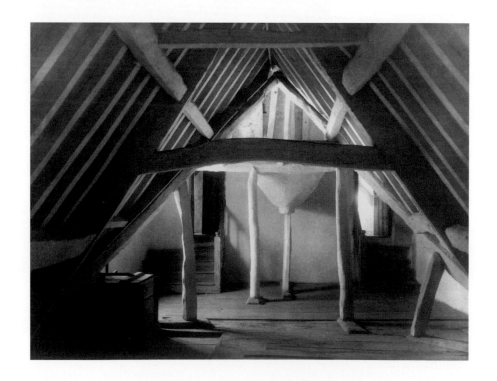

larger range of sensitivity than the film. A forest scene with brilliant beams of light coming through the trees overhead may look beautiful to the eye, with the ability to enjoy the subtle tones in the dark shadows as well as to distinguish details in the sunlit patches. If you photograph this scene you may be disappointed to see in the final result harsh splashes of white on areas of inky black shadow. The photographic response can be altered somewhat to accommodate different ranges of light, but the range of many natural scenes far exceeds the capacity of the photograph to reproduce tones.

Familiarity with the effects of light on the film will make for better lighting choices. If the preexisting lighting creates problems, it is possible to alter it or add supplemental light for the desired effect. The remainder of this chapter gives some basic techniques for analyzing and controlling the light in a photograph. For more detailed techniques, see chapter 15.

# ■ Qualities of Light

## Direction of Light

The direction of the light on a subject is altered by the relative orientation of subject and light source. The position of the camera with respect to the subject and light source can also affect the appearance of the lighting. The position of the light source is usually given with respect to that of the camera, but occasionally it is given with respect to that of the subject. The height of the light—compared with the height of the subject—also changes the appearance of the subject.

**Shadows**   The direction of the light affects the position and shape of shadows within the photograph. Lighting that produces noticeable patterns of light and shadow—called *chiaroscuro* by painters—can add a certain amount of drama to the image, as in the high 45° lighting shown on the next page. The perception of volume in the subject—its three-dimensional form—is also changed by the direction of the light.

**Reflections**   If any surfaces of the subject are reflective, reflections of the light source itself, called **specular reflections** or **specular highlights,** may be seen. Their position on the surface is affected by the relative positions of light source, subject, and camera.

Even though the examples in the following illustrations were made with artificial lighting, the same principles apply to the direction of any existing light, whether natural or artificial. In fact, studio lighting usually recalls naturally occurring situations. Sidelighting, for example, is seen naturally when a subject is illuminated from the side by window lighting or by the sun very early or late in the day. Backlighting occurs in many natural situations whenever the camera is pointed toward the light source.

The texture of a surface can be accentuated by causing the light to cross the surface at a low angle relative to the surface. This is called **cross lighting.** Remember that cross lighting is caused by the position of the light relative to the textured surface, not the position of the light relative to the camera.

# Direction of Light—Continued

Backdrop

Backdrop

Backdrop

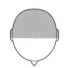

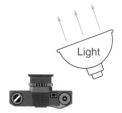

**Front Lighting**

**45° Lighting**

**Side Lighting**

Level Front Lighting

High Front Lighting

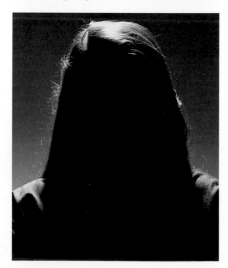

Low Front Lighting

High 45° Lighting

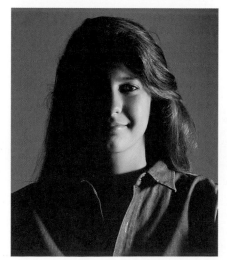

Level Side Lighting

High Back Lighting

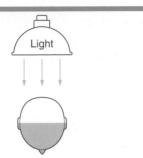

Backdrop

Light

**Back Lighting**

These overhead views show four lighting positions. The front, 45°, and side lighting positions may be used from right or left. In each position the light can be level with the subject, above the subject (high), or below the subject (low). Each lighting position alters the look of the subject. Note the lack of three-dimensionality resulting from level front lighting when compared with the results from high 45° lighting, in which the modeling provided by shadows clearly shows the form of the subject. Also note how the positions of both shadows and reflections change with the position of the light.

High Front Lighting

High 45° Lighting

Level Side Lighting

High Back Lighting

*continued*

**185**

# Direction of Light—Continued

Left: Textured Subject with Light Straight into Surface. Right: Texture Accentuated by Cross Lighting.

## Lighting Contrast

The type of lighting will affect subject contrast. Lighting contrast is the difference in the illumination supplied to the fully lit parts of a subject and the illumination supplied to the shadowed areas of the subject. The light in the shadowed areas usually comes from light reflected or scattered from the surrounding environment—known as **environmental light**—but may also come from secondary light sources.

The difference between the full effect of the light and the effect in the shadows can be measured with an incident-light meter and compared. This

Left: High Lighting Ratio—About 5:1.
Right: Low Lighting Ratio—About 2:1.

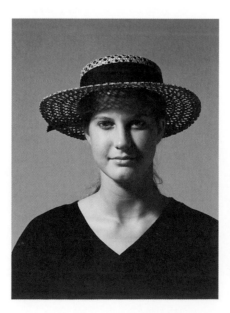 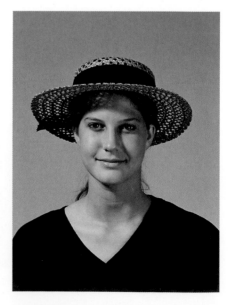

difference is the lighting contrast and is normally given as a ratio. For example, if the difference is one stop, the full effect of the lighting is twice as great as the effect in the shadows and the lighting ratio is 2:1. The higher the lighting ratio, the higher the contrast. High-contrast lighting is sometimes called "harsh" and low-contrast lighting is called "flat."

The amount of environmental light illuminating the shadows depends upon the environment surrounding the subject, called the **ambience.** High ambience means the surroundings contain highly reflective or light-colored surfaces; more reflected environmental light will reach the shadows, producing lower contrast. Low ambience means dark-colored surroundings producing less environmental light and higher contrast. A large source of environmental light is skylight, which is sunlight reflected from the sky. Light reflected from parts of the subject itself, such as light-toned clothing, can also contribute to the amount of environmental light.

Natural lighting can exist in a variety of contrasts. Direct sunlight on a clear day, especially in areas with clear atmosphere, can lead to high contrast if the ambience is low—if no light-reflecting surfaces are near the subject. On the other hand, an overcast day may lead to low contrast, since nearly all shadows are filled by scattered light from all areas of the cloudy sky. As discussed in chapters 5 and 6, the contrast due to subject lighting can be compensated for in the developing of the film or in the printing.

See pages 104–07 and 140–42.

## Specularity

The light from a heavily overcast sky differs from direct sunlight in ways other than lighting contrast. Direct sun, especially in an area with exceptionally clear atmosphere, produces distinct, sharp-edged shadows and small, harsh specular highlights. An overcast sky produces light that yields indistinct, soft-edged shadows and large, low-intensity specular highlights. These differences are due to the change in the **specularity** of the light. Direct light from the sun is an example of **specular light,** in which the rays all travel in the same general direction, as if they emanated from one point. Sources of specular light are small in size, or appear small because of their distance from the subject—as with the sun.

Light from an overcast sky is an example of **diffuse light,** which has been scattered so that it reaches the subject from many different directions. Diffusion, or scattering, of light takes place during reflection from slightly textured surfaces or transmission through translucent materials. In effect, the diffusing material becomes a new light source of larger area, providing light to the subject from more directions. The larger the area of the light source, the more diffuse—and less specular—the light.

When clouds interpose between the sun and us, sunlight is diffused by them and appears to come from the whole cloud-covered sky, providing one of the least specular sources available. Subjects receiving no direct light from the sun but only skylight are illuminated by a very diffuse source as well.

Specular sources are often called "hard" and diffuse sources "soft." This usage should not be confused with the common use of the same terms to describe high and low lighting contrast. Illumination by diffuse light sources usually produces lower subject contrast, but the loss of contrast is not due directly to the diffuse nature of the light source. Two things cause this loss of contrast. The first is that in most situations, the environment contains reflecting surfaces that will scatter light back into the shadows. This environmental light is increased by most diffuse sources, since light is scattered in so many different directions. More illumination then reaches the shadows, and

*Subject Lit by Specular Source.* The subject shown in the photograph on the left is illuminated by a specular light source. Note how sharp and well-defined the edge of each shadow is. A magnified view of the shadow edge is shown on the right.

*Subject Lit by Diffuse Source.* The photograph on the left shows the same subject illuminated by a diffuse light source. The edge of the shadow is now softer and more graduated. A magnified view of the shadow edge is shown on the right.

the contrast is reduced. The second reason for loss of contrast is that most diffuse sources are lower in intensity than comparable specular sources. Since the illumination in the shadows is affected less by this drop in intensity than that in the fully lit areas, the result is a reduction in contrast.

If care is taken to control the amount of light scattered by the environment—for example, by surrounding the subject with dark, light-absorbing surfaces—a considerable amount of subject contrast can be achieved with diffuse light sources. Conversely, the high lighting contrast often associated with specular sources can be reduced by providing more light to the shadows either by introducing light-toned reflective surfaces into the environment of the subject or by adding supplementary light to the shadows.

Our perception of the specularity of the light source in a photograph carries emotional and associative messages, as demonstrated by the examples on the next page.

Environmental light was carefully controlled to produce high contrast with a diffused light source. The shadow edge is soft.

Light was added to the shadows by use of reflectors to produce low contrast with a specular source. The shadow edge is sharp.

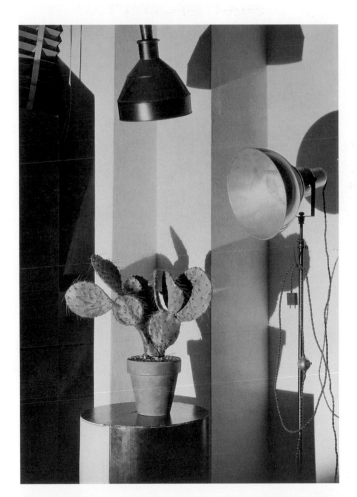

Charles Sheeler, *Cactus and Photographer's Lamp*, (1931). The use of specular light, with its well-defined shadows and harsh specular highlights, can recreate the feel of sunlight and high intensity. The angular shadows contribute to a very geometric feeling in the design of this photograph. When combined with high lighting contrast, specular light produces hard-edged, deep shadows that carry a feeling of drama or theatricality because of the similar nature of most theater lighting. Specular lighting will also produce well-defined texture, emphasizing character lines in portraits of people.

Charles Sheeler, *Cactus and Photographer's Lamp, New York*, New York. (1931) Gelatin-silver print, 9½ × 6⅝" (23.5 × 166.6 cm), The Museum of Modern Art, New York. Gift of Samuel M. Kootz. Copy Print © 2000 The Museum of Modern Art, New York.

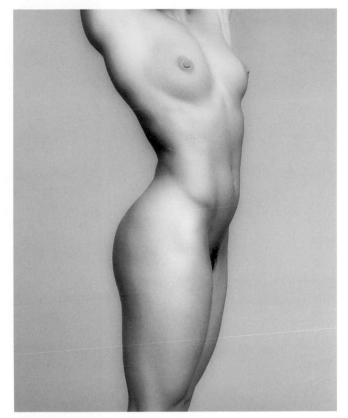

Robert Mapplethorpe, *Lydia Cheng*, 1985. Diffuse lighting conveys a sense of softness, gentleness, and sometimes romance. Here, the contours of the body are gently outlined by the diffuse light.

© 1985 The Estate of Robert Mapplethorpe.

## Color of Light

In black-and-white photography small variations in the color of the light illuminating the subject have little effect on the end result. In color photography these changes will be recorded by the film—especially color transparencies—and seen in the finished photograph. Many factors can affect the color of the light:

■ *Type of light source.* The sun produces white light and is the standard by which we judge the color of light. Light produced by light bulbs with tungsten filaments contains less blue and more yellow or orange than daylight. Fluorescent lights usually produce light with more green than daylight.

■ *Variations in sunlight.* The color of sunlight is altered by its passage through the atmosphere. Late in the day the light is more yellow than it is at midday. The season can also affect the color of the light, as can weather conditions.

Javier Vallhonrat, *Water Flowers*. Cool blues or greens often given a sense of emotional distance or reserve to a photograph.

© Javier Vallhonrat, Courtesy of the Michele Filomeno Agency, Paris.

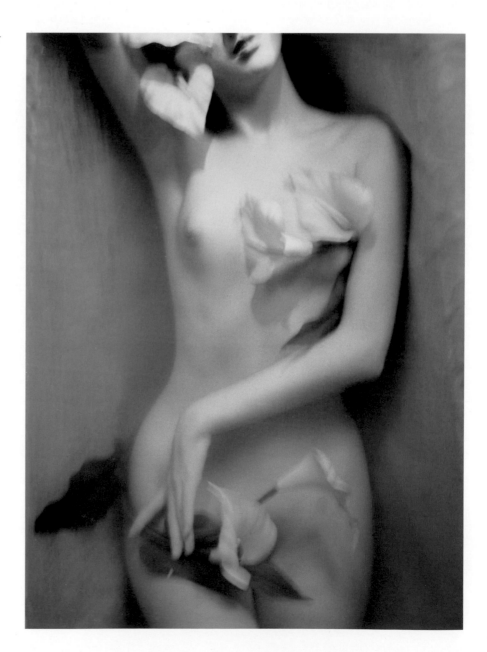

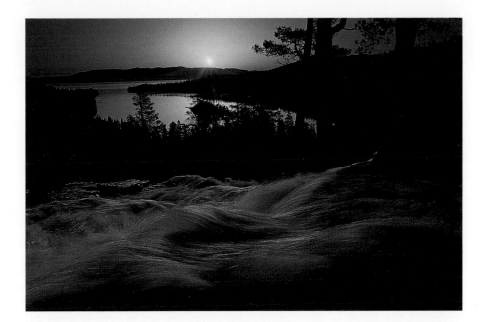

Galen Rowell, *Dawn over Eagle Falls, Lake Tahoe, California*. The warm orange or yellow light at the beginning and end of the day can produce feelings of restfulness or peace associated with those times of the day.

© Galen Rowell/Mountain Light.

The light in cloudy, rainy, or foggy conditions usually contains more blue than does direct midday sunlight. Conditions at dawn or dusk can add great amounts of reds, oranges, and yellows to the light. Haze and atmospheric effects over great distances can produce more blue in the light.

■ *Reflection.* Light reflected from a colored surface will take on the color of the surface; this is called **color contamination.** Reflected light from a green wall or green trees will cause a green cast in a color photograph. Reflected light from a clear sky—skylight—is bluish in color.

See page 340 for examples of color contamination.

We often associate emotions with the situations in which we see different colors of light. Use of similar colors of light in color photographs may recall these emotions. In black-and-white photographs the color of the light is not represented, so the other qualities of light must be relied upon to communicate such feelings and ideas.

## Intensity of a Light Source

The intensity of a light source refers to the amount of light it produces. Changing intensity results in a change in the film exposure and must be compensated for by adjusting the camera settings—the f-stop and shutter speed. The intensity of the light source illuminating the subject is not directly perceivable from a photograph, since the representation of the subject tones is controlled by exposure, development, and printing. High-intensity light is usually represented in the photograph by printing for a lighter-than-usual tone in the highlights and by the presence of extreme contrast. Intensity of the source can also have some effect on the lighting contrast and the appearance of the specular highlights (see chapter 15).

## ■ Working with Light

Two approaches can be taken to dealing with light in photography. In the first approach, the preexisting light is accepted as is with no attempt to modify or change it. Getting good results depends on discovering the chance moment when light and subject interact in a beautiful, meaningful, or exciting way. The only control available if this approach is taken is to move your subject matter within the light, change the camera position for a better view of the effect of the light, or wait for more desirable light. The second approach is to either modify the preexisting light to achieve the desired effect, add supplementary lights, or eliminate all preexisting light—as in a studio—and build the lighting you desire with artificial lights.

Even though these sound like opposite approaches, the principles involved are exactly the same. You are still searching for the play of light, shadow, and reflections that will reveal the subject as you wish to photographically portray it. Photographers working on assignment often resort to the second technique, since they may not have the leisure time to wait for or find the precise natural lighting conditions they need. In any case, even when the lights are being manipulated, the intent is often to reproduce the look and feeling of a natural lighting situation, which would necessitate an understanding of natural light before attempting to control artificial lighting.

Ansel Adams, *Mount Williamson, the Sierra Nevada, from Manzanar, California,* 1945. The low back lighting provided by the sun accentuates the texture of the boulder field.

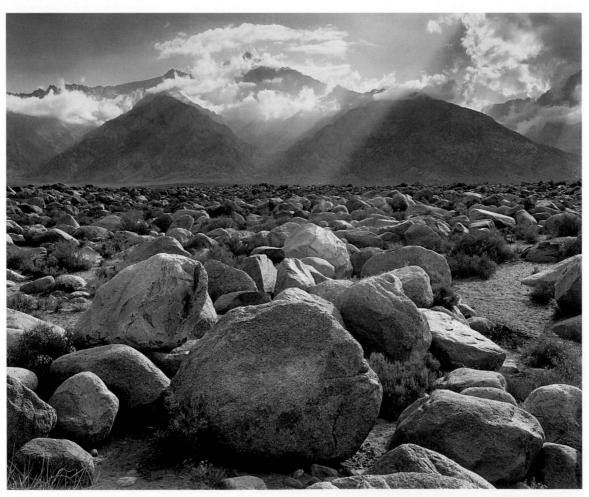

## Daylight Photography

The light from the sun can undergo many natural modifications. One joy of photography is observing and recording the infinite variations of daylight. The direction, quality, and color of the light change from hour to hour, from day to day, and from season to season. A landscape that looks perfectly ordinary in the middle of the day may be spectacularly transformed by the golden, raking light of the evening sun. Do not put your camera away on bad-weather days. The hazy, glowing light on a foggy day can add mystery or beauty to your subject. The effect of sunbeams splashing through a window or dappling a forest floor can be intensified by haze or smoke in the air. Daylight can also provide soft lighting on an overcast day or in indirect sunlight—as in open shade situations where the light is either skylight or light reflected from surrounding objects.

The very diffuse light resulting from a heavily overcast day can give the feeling of dreariness associated with bad weather, but if handled with proper exposure, development, and printing, it will give a luminous, glowing quality to highlights that the specular harshness of direct sun is unable to convey.

© Bruce Warren.

**Working with Daylight**  Several methods are available to the photographer for controlling the effect of daylight on the subject.

**Move the Subject.** The direction of the sunlight falling on the subject can be altered by orienting the subject to the sun for the desired effect. On the left, the sun is providing a high 45° lighting. By turning the model toward the sun, as seen on the right, high front lighting is achieved.

**Change the Camera Position.** The point of view of the camera can radically change the appearance of the light on the subject. The difference between having the sun behind the camera, as on the left, and then walking around so that the sun is behind the subject, as on the right, is one example of this type of control.

© Bognovitz.

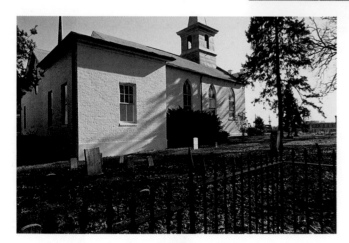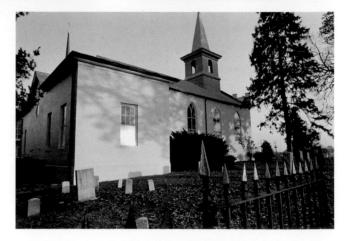

**Wait for Better Lighting.** If the quality of the daylight is not giving you what you want, wait for a different time of day or year or for different weather conditions. The overhead lighting at noon may not produce attractive portrait lighting, but waiting until later in the afternoon or shooting earlier in the morning may give a better position of the sun. This subject is seen in early afternoon on the left and at sundown on the right.

© Bognovitz.

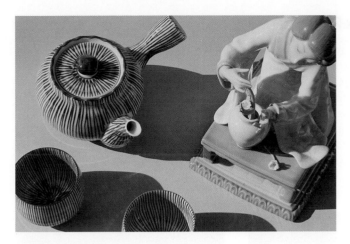

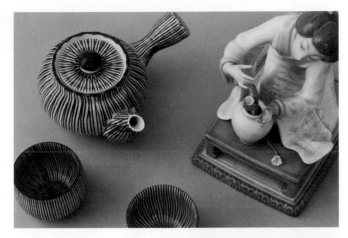

**Modify the Daylight.** A. To reduce the hardness of the direct sunlight, diffuse the light by placing a translucent material, such as thin white cloth, between the sun and the subject. This will also reduce the lighting contrast by cutting the intensity of the light illuminating the fully lit areas. On the left the still life is lit by direct sunlight. On the right a diffusion screen has been inserted as seen in the set shot.

B. To reduce the lighting contrast without affecting the hard-edged shadows produced by specular direct sunlight, more light can be added to the shadows by using a white reflecting surface, such as a large white card or other white material. The photograph on the right shows the effect on the shadows when the fill card is placed as shown in the set shot.

**195**

See pages 43–44 on photography with low illumination levels.

## Available-Light Photography

In many situations it is impossible or ill-advised to introduce supplementary light, even though the preexisting level of light may be quite low. Most photographers use the term *available light* to describe this situation. Modern high-speed films have made photography under these conditions practical but at the price of larger grain structure.

If the subject is not moving, placing the camera on a tripod will allow the use of slower films for finer grain. If the lights cannot be controlled, study the situation and then make the best of it by choice of camera or subject position.

### Indoor Available Light

The most typical indoor lighting is a series of overhead lighting fixtures, either fluorescent or tungsten. Overhead lighting is not the most attractive for some subject matter—for example, eyes may be shadowed—but it is usually not difficult to get acceptably lit photographs in an evenly illuminated room.

A room illuminated by table or floor lamps provides more interesting light but is more difficult to work with. The result is a room with pools of light and shadow. If the exposure is for the light areas the dark areas may not show detail, and vice versa. If the room also has overhead lights they may be turned on for more general illumination.

© Bognovitz.

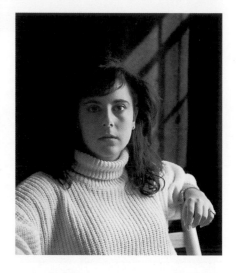

Another common indoor lighting situation is sunlight, either direct or indirect coming through windows. Try to avoid shooting directly toward windows unless you are looking for a silhouette or sufficient illumination exists from other sources to provide good exposure on the subject.

© Bognovitz.

### Modifying Indoor Available Light

Here the subject is lit from the side by a table lamp.

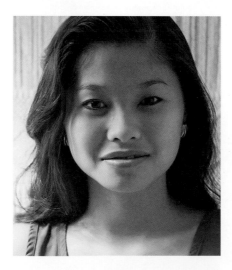

Placing a white card or other white material on the side of the subject opposite the light reduces the lighting contrast. This technique will also work with window light.

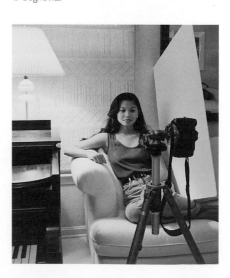

## Outdoor Available Light

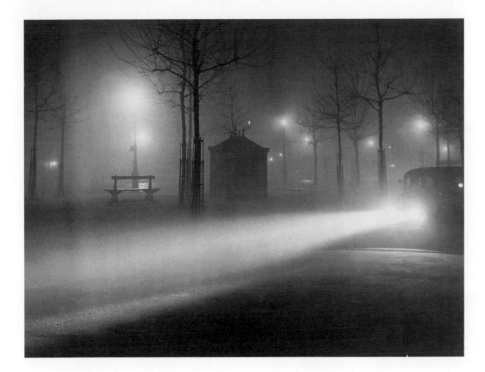

Gilberte Brassaï, *Avenue de l'Observatoire,* 1934. The only common low illumination levels with exterior sunlight happen just before dawn or after sunset or perhaps on heavily overcast or foggy days. The light comes from the sun indirectly at these times and is diffuse and low in intensity. Use a fast film if speed is important or use a tripod with slower-speed film. Outdoor artificial lights can provide good picture-taking opportunities but usually require long time exposures (see pages 43–44). Some streetlights provide enough illumination for photography with fast films.

© Gilberte Brassaï, Courtesy of Mrs. Gilberte Brassaï.

**Available Light and Color Films**   When using color film, be sure to either match the film type to the lighting or use a filter on the camera to correct the color of the light (see chapter 12). If the subject is illuminated by lights of more than one color—for example, fluorescent and tungsten—only one source may be corrected by a filter on the camera. Interesting nonstandard color rendition can be the result of photographing with mixed light sources of different color balance.

*Carlsbad Caverns, New Mexico.* The colors seen here are a result of several different types of illumination being used in the caverns, including tungsten lights, mercury vapor lights, and fluorescent lights. When viewed by the eye, these lights do not show the vivid color differences recorded by the film.

© Bruce Warren.

## ■ Controlled Artificial Lighting Techniques

Nice results in lighting can be achieved with relatively simple equipment. One or more studio lights and some reflecting and diffusing materials will get you started.

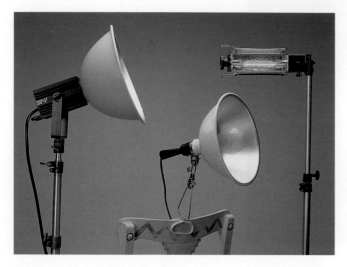

The clamp-on aluminum reflector light fixture in the center can be purchased at many department or hardware stores. Install a photoflood bulb available at photo stores. Be sure the lamp is rated for 500 watts. The light with a bowl reflector on the stand also uses photoflood bulbs. The smaller light on the right uses more expensive quartz-halogen lamps.

White foamcore board is a lightweight and durable material for reflectors. You can also use white mat boards or any other white material. White cloth or translucent plastics may be used as diffusers. Frames for supporting materials can be improvised from wire, plastic tubing, or wood.

Some safety rules should be observed with studio lights:

■ All of these lights get very hot when operating. Keep flammable materials well away from the beam of the light and remember that the lamps and housings are very hot after the lamps have been on for any period of time.
■ Electrical cords from the lights should drop straight to the floor and lie flat between the lights and the outlets with enough slack to prevent tripping. Cords stretched out above the floor in a partially lit studio are easy to run into, with the danger of pulling the lights over on someone.

## Portrait Lighting

The following illustrations show a few basic lighting positions for portraits. Each example is accompanied by a photograph of the set (a set shot) showing the relative positions of model, camera, background, and lights. The lighting diagrams on pages 184–85 will also help you in setting up the side, front, and 45° lighting. You will need a room in which any preexisting light can be eliminated and a white backdrop or blank wall to use as a background. Notice that in each case the model is seated at least 6 feet from the background. This helps to keep the model's shadow from falling on the background and allows room for lighting the background. Any light source of the types shown on page 198 may be used.

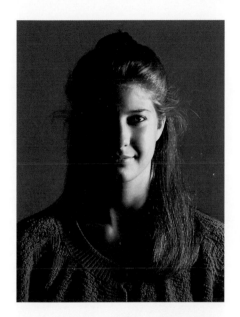

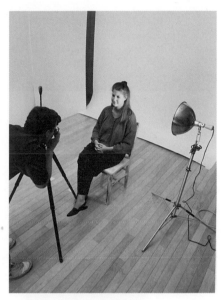

*Sidelighting.* The light is directly to the side of the subject—90° from the camera—and level with the model's head.

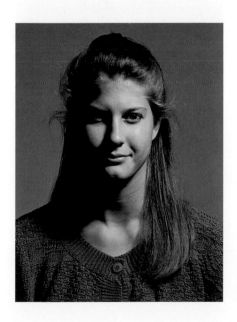

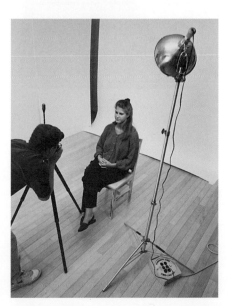

*Rembrandt Lighting.* The light is 3 or 4 feet above the model's head, pointed down, and located about 45° to the side of the camera. Adjust the position of the light until you see the triangle of light on the shadowed side of the face as shown. This position can be used from either side. The Rembrandt position is nearly equivalent to the high 45° position shown earlier, but is defined by a well-formed triangle of light under the eye.

# Portrait Lighting—Continued

*Diffused Front Lighting.* A white card is placed near the camera position, level with the model's head. The light is turned to illuminate the card, bouncing diffused light back toward the model. Be careful that no direct light strikes the camera lens. The front lighting shown earlier was a specular (direct) front light.

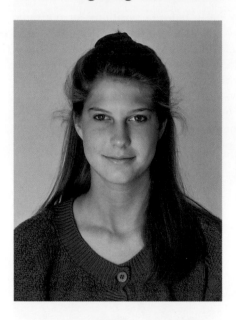 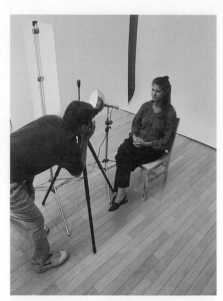

*Silhouette Lighting.* The white background directly behind the model is evenly illuminated by two lights. Do not let light fall directly on the model. The lights should be level with the model's head.

 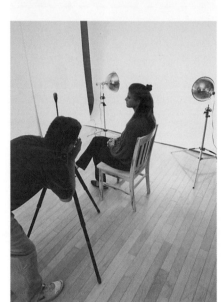

## Metering

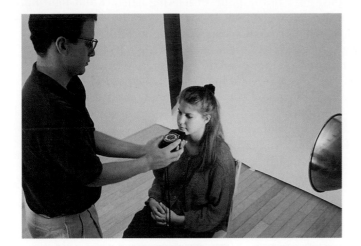

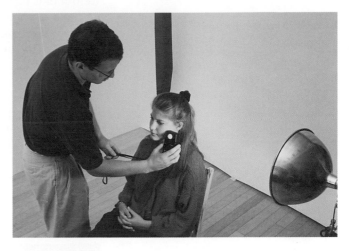

*Reflected-Light Meter.* A close-up reflected-light meter reading can be made of the lit side of the face. With a 30°–45° meter hold the meter about 6–8 inches from the face. With an in-camera meter move close enough that the lit half of the face covers the metering area in the viewfinder. Be careful not to cast a shadow when metering. For most subjects use the meter reading as is. If the model is blond and very light skinned, you may wish to open up one stop to insure correct exposure.

*Incident-Light Meter.* An alternative is to use an incident-light meter, placing it at the fully lit side of the face and pointing it back toward the camera. Use the indicated meter reading for your camera setting.

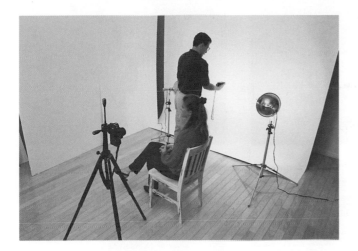

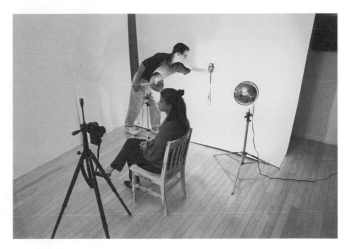

*Metering for the Silhouette.* A. Metering the silhouette lighting position requires a special technique. Since the skin tone is not illuminated, it is easier to make a reflected-light meter reading from the background. If you wish to be sure that the background will be white, open up three to four stops from the indicated camera settings. For example, if the background reads f/11 at 1/60 second, opening up three stops would produce a camera setting of f/4 at 1/60 second.

B. An incident-light meter can also be used for metering the silhouette. Place the meter at the background, pointed back toward the camera. Use the camera settings as suggested by the meter or open up one or two stops for a brighter white background.

**Combining Positions**     Notice that the contrast is high in the sidelighting and Rembrandt lighting positions, to the point of looking harsh. Front lighting, on the other hand, produces few shadows on the face, resulting in a flat, two-dimensional look. The silhouette is a special lighting position, giving only a simple outline of the subject. One of these positions may give approximately the desired effect but could be improved. For example, we may wish to reduce the contrast of the side and Rembrandt positions or add detail to the face with the silhouette. This can be done by combining more than one light or by modifying the light itself.

The mistake many people make when learning lighting is to turn on several lights and then shuffle them around trying to get some usable result. The best way to light is to start with one light and position it first, then add other lights as desired.

1a. *Position the Main Light.* The light that determines the shape and position of shadows and highlights on the subject is called the **main light** or **key light.** Turn on one light and position it for the desired shape and position of the shadows on the face. Do not worry about the contrast of the lighting at this point. Here the photographer has used Rembrandt lighting, which shows the shape of the face especially well. Sidelighting can also be used for a main light. Front lighting is used as a main light if a flattening of the features or a reduction of skin flaws and wrinkles is desired.

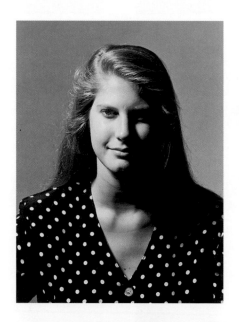

1b. Once you have the main light positioned, look at the result and decide if any modifications are necessary. If you wish to soften the shadow edges, the main light can be made larger by diffusion. This will also reduce the lighting contrast. If you wish to reduce the contrast without softening the shadow edge, proceed to the second step. Shown is diffused Rembrandt lighting, produced by turning the light away from the model and reflecting it off of a white card.

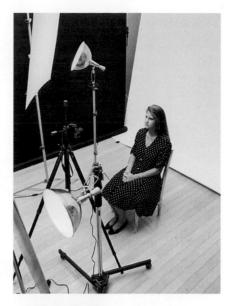

2. *Add a Fill Light.* The purpose of a fill light is to reduce contrast by adding light to the shadows created by the main light without overpowering them or creating additional shadows. The front lighting position is the best position for a fill light, since it creates the fewest shadows on the face. In addition, diffusing the fill light will soften any shadows that might be added, making them less noticeable. The intensity of the fill light should be less than that of the main light and can be adjusted by moving the light forward or back to change the lighting ratio. An alternative to adding a fill light is using a white reflecting card to reflect the main light itself back into the shadows. Shown is diffused Rembrandt lighting with a diffused front fill light.

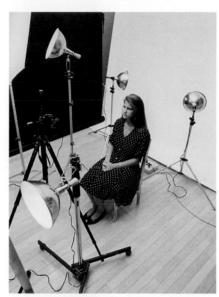

3a. *Add Effects Lights.* Once the main and fill lights have been placed, then other lights can be added for effect. So far we have let the background receive whatever illumination it can from the main and fill lights. If you want a truly white background, illuminate it as in the silhouette lighting.

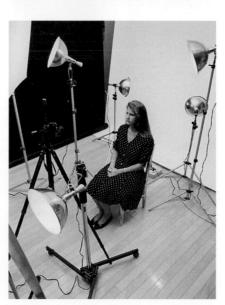

3b. Other lights can be added at this point. Here a light above and slightly behind the model has been added to illuminate the hair; this is known as a **hair light.** Metering with combination lighting should be done as described on page 201, with a close-up meter reading of the lit skin tone or an incident-light reading. Metering should be done with main, fill, and effects lights on, since the lit side of the face is illuminated by both main and fill lights and all of the lights add environmental light to the studio. When bright lights are placed behind the model, as are background lights, take care that the light from behind is not allowed to directly influence the meter reading from the skin tone or allowed to fall directly on the camera lens, which would cause flare.

## Still Life Lighting

The basic procedure for still life lighting is much the same as for portrait lighting. A main light is positioned to define the shape and position of shadows, a fill light is added to reduce the contrast if needed, and effects lights are added as desired.

A still life introduces an additional concern about proper rendering of the surfaces of the objects; the choice of lighting affects the appearance of the surfaces. In addition to the appearance of the shadows, you should also look at the position and harshness of reflections in the subject's surfaces. If the specular reflections are undesirably small and harsh, diffuse the light source by passing it through a translucent screen or reflecting it off a white card to get larger,

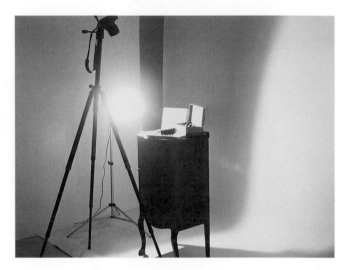

A. Specular Light Positioned Level and at the Side of the Subject.

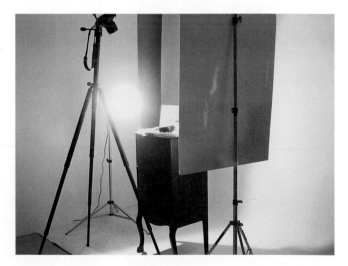

B. White Reflector Card Added at Right Side of Subject for Fill Light.

softer reflections. Repositioning the subject or the light slightly can also help to control reflections.

The goal is not to get rid of shadows and reflections. These are the indicators of the form and surface nature of the subject. A shiny surface without reflections will not look shiny. A spherical object without shadows will look flat. Your goal is to show the form and surface of the object without distracting or ugly shadows and reflections.

Good still life lighting can be achieved with either natural or artificial lighting. With natural lighting, the subject can be placed in a position receiving the desired light. The natural lighting can also be diffused or reflected to control its quality and provide fill lighting.

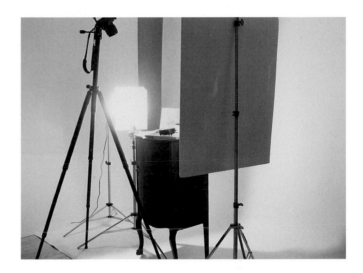

C. Diffusion Screen of Translucent Plastic Placed in Front of Main Light.

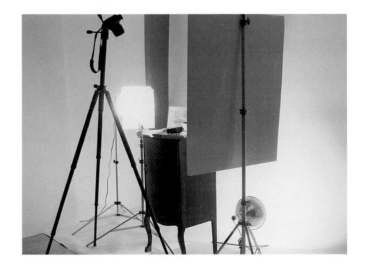

D. Light Added to Background.

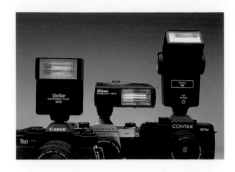

*Small On-Camera Flash Units.* The flash on the right can be tilted to direct the light toward the ceiling. Some flashes can also be pivoted to direct the light toward a wall at the side of the camera.

## ■ Lighting with Small On-Camera Electronic Flash Units

Small electronic flash units for use on cameras are widely available and provide a convenient portable supplementary light source. They have replaced the older flashbulbs, which were used in the same fashion. Electronic flash provides light only in a very short burst, sometimes as short as 1/50,000 second or less. The effect of the flash cannot be seen, so positioning a flash for the desired lighting effect can be difficult. Nevertheless, a little experimentation can provide you with the knowledge you need to make good use of your flash.

## Connecting the Flash to the Camera

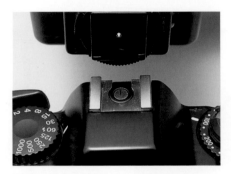

Flashes that mount directly on the camera may be set off by contacts contained in the shoe—called a **hot shoe**—in which the flash is mounted.

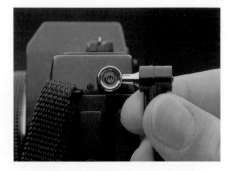

Other flashes can be set off by way of a cable connection—called a synchronization or synch cord—to the camera. Most cameras use a type of connector on the synch cord called a PC connector, shown here.

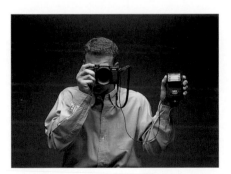

Flashes with PC connections can be operated off the camera if an extension synch cord is used. This permits more flexibility in the use of the flash.

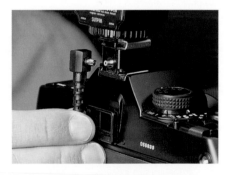

If your camera or flash offers only hot shoe connection, adapters are available for converting to PC connection, allowing use off camera.

## Synchronizing the Flash with the Shutter

The flash must be tripped so that the subject is illuminated while the shutter is open, or *synchronized* with the shutter. Synchronization is achieved by contacts on the shutter that set off the flash. Older cameras may have more than one synchronization setting, to accommodate electronic flash (**X-synchronization**) or bulbs (M or FP synchronization). Most modern cameras have only X-synchronization. Flashbulbs may be used with X-synch and slower shutter speeds—usually 1/15 or 1/30 second.

Since focal plane shutters employ a slit that travels across the film plane to achieve higher speeds, care must be taken to use the slower speeds for which the shutter opens completely when using electronic flash. The camera instructions will give the flash synchronization shutter speed, or it may be marked on the shutter speed scale with an *X*, a lightning bolt symbol, or a different color of number. For many cameras using focal-plane shutters, this speed is 1/60 second, but a number of newer cameras offer higher flash synchronization speeds. When using flash, do not set the shutter for speeds higher than the synchronization speed, or you will get only partial pictures due to the narrow shutter opening.

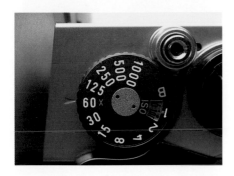

*Synchronization Shutter Speed for Electronic Flash.*

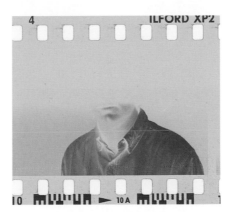

*Result of a Shutter Speed Higher than the Synchronization Speed with a Focal Plane Shutter.*

## Positioning and Modifying Flash

The principles for lighting with flash are the same as those given earlier for continuous light sources. When the light from the flash is diffused by reflection off a white surface—a wall or card—it is called **bounce flash.**

*Direct On-Camera Flash.*

*Direct Flash Moved Off the Camera.*

*Flash Bounced Off the Ceiling.*

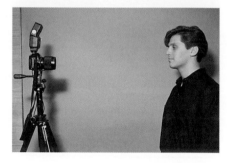

*Set Shot for Flash Bounced Off the Ceiling.*
The flash is aimed almost directly at the ceiling here because the subject is close to the camera. In general, aim the flash at a point on the ceiling midway between flash and subject.

*Flash Bounced Off a Nearby Wall.*

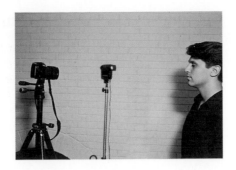

*Set Shot for Flash Bounced Off a Wall.* Again, the flash is aimed at a spot on the wall midway between flash and subject. If your flash can swivel, bounce flash from a wall can also be achieved with the flash mounted on the camera.

*Diffused Flash Used On the Camera.*

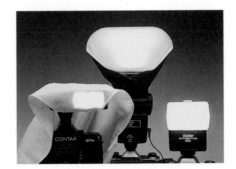

*Methods for Diffusing Flash.* On the left a handkerchief has been draped over the flash. The device in the center is a Lumiquest, which is a folding vinyl reflector attached to the flash. The flash must be capable of being tilted straight up for this device. On the right a translucent plastic dome has been clipped over the front of the flash.

*Diffused Flash Used Off the Camera.*

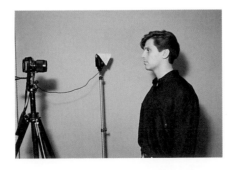

*Set Shot for Diffused Flash Used Off Camera.*

See pages 447–51 for use of flash meters.

## Determining the Flash Exposure

Flash cannot be measured with the meters designed for continuous light sources. Special meters are made for metering flash, but they are expensive. The illumination on the subject by the flash depends on the flash's power, duration, and distance from the subject. Correct exposure with electronic flash is determined in several ways, as shown in the following illustrations. Many automatic and dedicated flashes can read both the continuous light illuminating a subject and the light supplied by a flash, making it possible to use the on-camera flash as a fill light for natural lighting situations without any complicated calculations.

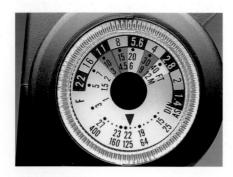

*Manual Flash Exposure Control.* Since the burst of light from small electronic flash units is much shorter than the length of time the shutter is open, the shutter speed has no effect on the flash exposure. Only the aperture can be used to control flash exposure, and the proper f-stop is determined from the distance of the flash to the subject and the ISO of the film being used by means of a chart or calculator on the flash. The flash exposure calculator shown here has been set for 100 ISO film by turning the outer dial until the black triangle points at 100 (the dot just to the right of 125) on the ASA scale. To find the correct f-stop, determine the distance from flash to subject and refer to the distance scales in feet (labeled FT) or meters (labeled M), which are the second and third scales from the top of the calculator. The required f-stop will be found on the topmost scale directly opposite the distance. In this case, if the distance from the flash to the subject is 10 feet, the camera aperture should be set at f/11.

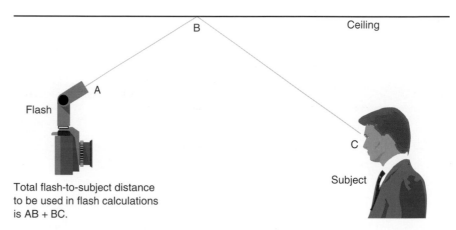

Total flash-to-subject distance to be used in flash calculations is AB + BC.

*Exposure Corrections for Diffused Flash.* If the light from the flash has been diffused by passing it through a translucent material or bouncing it off a white surface, corrections must be made to account for light losses occurring in the diffusion process. Bounce surfaces or translucent materials will cause a reduction of exposure by one stop or more. For bounce flash, use the combined distances from the flash to the bounce surface to the subject to calculate the f-stop, then open up one stop for a surface painted flat white (more for darker surfaces).

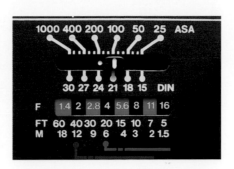

*Automatic Flash Exposure Control.* A. Most flash units on the market today offer some type of automatic flash exposure control. A sensing cell on the flash measures the amount of light coming back from the subject and automatically shuts down the flash when the proper exposure is achieved. The f-stop specified for automatic operation—some flash units offer several choices—at a given ISO must be set into the camera. If the flash is removed from the camera for lighting, the sensor on the flash will no longer be reading the light reaching the camera. Some flashes offer an extension for the sensor so that it can remain at the camera position. Otherwise, set the flash on manual for this situation. This flash has a choice of manual (M), or two automatic selections (the blue or red settings).

B. Referring to the calculator dial on the same flash, we see that when 100 ISO is set into the ASA scale, the red setting indicates that f/2 should be set on the aperture control of the lens. Just below the f-stop scale, a distance scale indicates the maximum distance for this setting, in this case 40 feet. As long as the subject is closer than 40 feet, the flash should produce correct automatic exposure. Other brands or models of automatic flashes may have a different system for determining f-stop and maximum distance.

*Dedicated Automatic Flash Exposure Control.* A more sophisticated method of automatic flash exposure control is employed by **dedicated flashes.** These work only with specific camera models and are coupled to the controls and meter in the camera through additional contacts in the hot shoe. The camera meter itself controls the flash for proper exposure, and the effect on exposure of any diffusion or bouncing of the flash will be compensated for automatically. If you wish to move a dedicated flash off the camera, a special cord containing all the contacts must be used. Most dedicated flashes automatically set the shutter speed to the proper flash synchronization speed.

# PART II

# Aesthetics and History

# CHAPTER 9

# Seeing Better Photographs

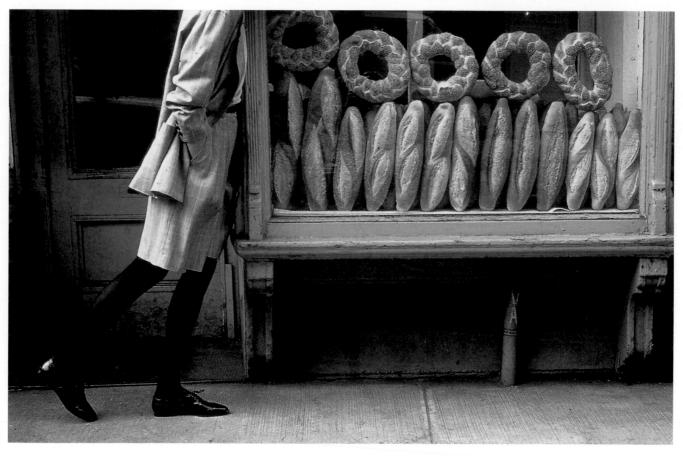

Dennis Stock, Liz Claiborne advertisement.

© Dennis Stock/Magnum Photos.

A photograph does not exactly reproduce what you see with your eyes. Many of the peculiarities of the actual image produced by the human eye are adjusted for by the mind, giving us a perception of reality that is a result of the eye and mind interaction. Photography, on the other hand, depends upon the performance of a sequence of optical and chemical processes. Although it allows limited control over the appearance of the final photograph, it is still a set of essentially mechanical processes when compared with the impressionistic workings of the eye and mind.

Some obvious differences between the photographic image and visual perception can be easily cataloged:

■ In black-and-white photography, the colors of the original subject are reduced to gray tones. Even with color film, the colors of the original are not reproduced exactly.

■ The eye has the ability to see detail in all areas of a high-contrast subject, since it can adjust to the darkest and lightest light levels. The photograph can reproduce only a limited range of these subject tones.

■ Only a small central area of the vision is sharp—that is, in focus—and only at one distance at a time. This shortcoming is compensated for by the ability of the eye to quickly focus while scanning a subject. The mind integrates little snatches of clear vision gathered by the eye, so that the entire subject appears to be sharp and in focus. The camera, on the other hand, focuses only on a plane in the subject at one distance. The additional subject matter that can be brought into acceptable sharpness with depth of field is limited.

■ The mind has the capability of "filtering out" unwanted visual information when viewing the original subject, effectively isolating important details. In a photograph such unwanted information is faithfully rendered and may be distracting. A person can comfortably view a ball game through a chain link fence, but in a photograph the fence could be a distraction to the point of obscuring the game.

■ Since photographs are two-dimensional, the ability to perceive depth due to binocular vision is lost when viewing them—except in the relatively rare three-dimensional photo processes. Depiction of depth in a photograph therefore depends upon other depth indicators such as relative size of objects, convergence of parallel lines, and atmospheric depth.

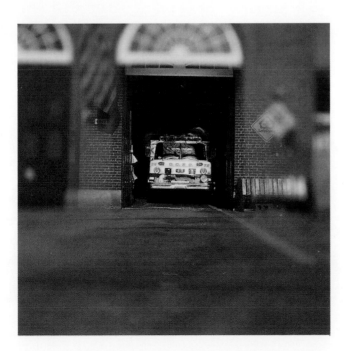

Simulation of the Actual Vision of the Human Eye.

© Bognovitz.

Many photographers like to be able to predict, or **previsualize,** what the photograph is going to look like while viewing the original subject. The more successful the previsualization, the more control the photographer can exercise over the appearance of the final photograph. Successful previsualization depends upon a thorough understanding of all the differences between human visual perception and the photographic image and careful technical control of the photographic process itself.

Previsualization is only part of the process. If true communication is to take place, the photographer must also understand the informational and psychological impact of the photographic medium on the viewer. Control over previsualization can be accomplished in a reasonably short time by anyone with an observant eye and the ability to pay careful attention to technical details. Communicating with photographs requires an understanding of both the medium and the viewer, and a lifetime can be spent on the complexities of their interaction. The material in this chapter presents some properties of the photographic medium and a few guidelines to help in the effort to communicate better with photographs.

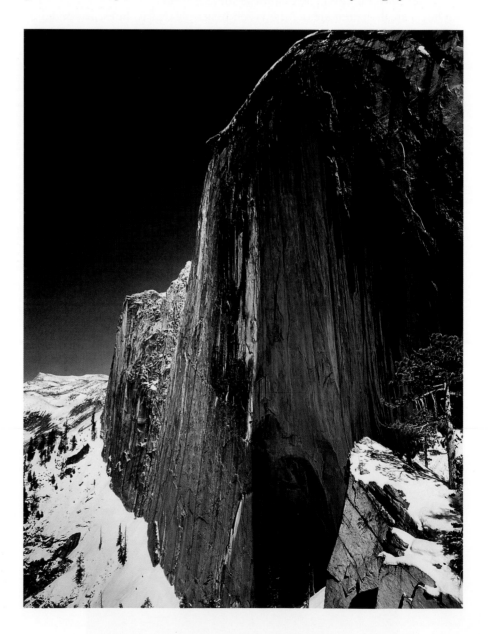

Ansel Adams, *Monolith, The Face of Half Dome, Yosemite National Park, California 1927.* Ansel Adams was interested in previsualizing the appearance of a print before making the photograph and devised a technical system of exposure and development known as the Zone System to facilitate the previsualization process.

# ■ Nature of the Photographic Medium

Photography has certain characteristics, some shared with other art media, a few unique. An understanding of the nature of the medium is important to its use in communication with the viewer.

## Feeling of Reality

Because photographs are formed from an optical image of light coming from the subject itself, they have an authenticity or feeling of reality not found in paintings or other hand-done reproductions. The old saying that photographs never lie is evidence of the general belief that photographs are a faithful reproduction of the original subject. More sophisticated viewers know that a number of techniques can be employed to give a false impression of reality through photographs—especially with the latest computer image manipulations—but photographs still carry a powerful sense of being "the real thing." This is why photography, both moving and still, has been so useful in propaganda.

Because of its relationship to reality, the first thing most people notice about a photograph is the **content,** or subject matter. Most photographs are taken with the prime intent of showing a representation of the original subject matter.

## Time

A contributor to the impact of photographs is the general knowledge that they record a specific segment of time. Freezing movement allows appreciation of a moment that would have passed unnoticed in reality. The ability to record historical or period events and subjects for inspection many years later is one of photography's most seductive charms.

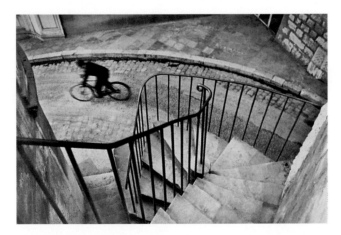

Henri Cartier-Bresson, taken in Seville, Spain. Henri Cartier-Bresson emphasized the importance of exposing at the instant that the details of the subject come together in a significant way: "If the shutter was released at the decisive moment, you have instinctively fixed a geometric pattern without which the photograph would have been both formless and lifeless."

© Henri Cartier-Bresson/Magnum Photos, Inc.

A. J. Russell, *Meeting of the Central Pacific and the Union Pacific, May 10, 1869.* This photograph of the ceremony celebrating the completion of America's first transcontinental railroad preserves the look of an era, as well as documenting an important event in America's history.

Courtesy of the Union Pacific Museum Collection.

## Two-Dimensionality

Photography is a two-dimensional art, like painting and other print media. Ways of depicting depth in a two-dimensional representation are discussed in detail later in this chapter.

## Continuous Tonality

Photographs can reproduce an almost infinite scale of tones from darkest to lightest. Other media may have a palette of only a few different tones, some as few as two.

## Reproducibility

A photographic negative can be reprinted almost indefinitely if it is protected from damage. This is one of photography's strengths in practical uses, but it has sometimes been a disadvantage in the art world where the value of a work depends partly upon its scarcity. A few photographic processes, like the original daguerreotype process and most instant-print processes, produce one-of-a-kind photographs.

## Framing

The edges of an image are called the **frame,** an important feature of two-dimensional art media. The process of selecting what is to appear in a photograph by camera position or lens choice is called *framing* the image, which produces certain visual effects. Being aware of these effects can help you to make more effective photographs.

**Cutting Forms**   Since reality is not usually neatly arranged for picture taking, the photographer must make choices about what area of the subject is going to be included in the frame. One usually inevitable result is that some shapes and forms are not shown in their entirety but are cut by the frame.

**Forced Visual Relationships**   It is difficult to ignore bothersome or extraneous visual information when it is immovably fixed in the photograph. You must learn to take note of everything appearing within the frame at the time you make a photograph, taking steps to eliminate any distracting visual information. Watch for foreground objects overlapping important subject matter, distracting objects or shapes in the background, and background objects that appear to merge with the main subject. These problems can usually be solved by either moving the camera to a different point of view or moving the subject.

**Filling the Frame**   Often photographs contain areas of background or subject matter that may not be actively distracting or ugly but add little of interest. For more dynamic images it is best to eliminate such areas. To "fill the frame" with a subject of central interest, move closer or change to a longer focal length lens. This can be carried to the point that only a small section—a **detail**—of the subject is seen. An alternative is to use the background as an environment for the subject or as a way of isolating the subject.

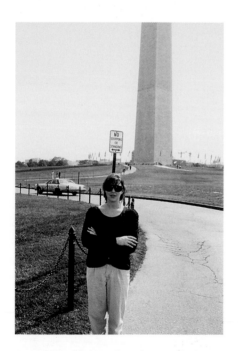

*Forced Visual Relationship.* The sign that appears to be growing out of the model's head is an example of a forced visual relationship.

**Format Shape and Framing**   All of the modern formats are rectangular in shape but may have a different ratio of width to length—known as the **aspect ratio**— ranging from the square of the 6 × 6cm format to the extremely long rectangle of the panoramic camera format. Each aspect ratio has a different visual "feel." The square is more stable and self-contained. Longer rectangles seem to more readily extend beyond themselves visually. Sometimes the subject matter itself may demand a particular aspect ratio, either for reasons of subject inclusion (as with long, narrow subjects) or because of a match between the feel of the subject and the aspect ratio (stability, verticality, etc.).

   The aspect ratio of commonly available printing papers may not match that of the negative, as with 35mm negatives and 8 × 10-inch paper. The choice to print full-frame or for a specific size paper should be considered when composing through the viewfinder. The problem of differing aspect ratios of negative and paper was discussed on page 134.

**Vertical and Horizontal Framing**   Any camera with a rectangular format other than square will give a different framing of the subject if the camera is turned so that the long dimension of the rectangle is vertical (**vertical framing**) rather than horizontal (**horizontal framing**). See page 7 for examples of vertical and horizontal framing of the same subject.

**Breaking Out of the Standard Rectangle**   Only convention and convenience limit you to the standard rectangular framing. The image can be cropped in printing to any desired ratio of sides and the printing paper trimmed accordingly. Of course you will lose part of the image seen on the negative. Many photographers have attempted to break away from the rectangular shape altogether, using circles, ovals, polygons, or irregular shapes for framing (see the next page).

**Frames within Frames**   Another way of breaking out of the feeling of the simple rectangle is to create the appearance of frames within the outer frame of the photograph (see the next page).

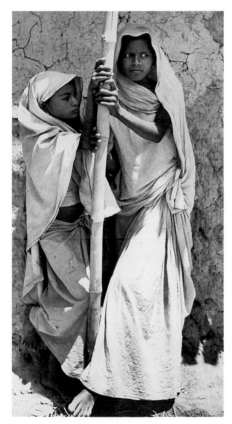

*Breaking Away from the Standard Rectangular Frame.* Emmet Gowin, *Hog Butchering, Near Danville, Virginia, 1975.* The use of a lens designed for a smaller format camera on an 8 × 10 view camera resulted in the circular image and the dark vignetting around the edges.

© Emmet Gowin, Courtesy of Pace/MacGill Gallery, New York.

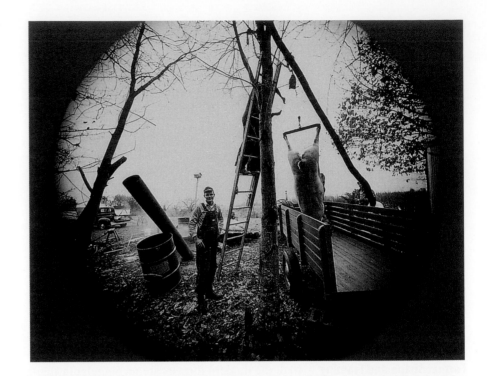

*Establishing Frames within the Frame of an Image.* Lee Friedlander, *Buffalo, New York, 1968.*

© Lee Friedlander, Courtesy Fraenkel Gallery, San Francisco.

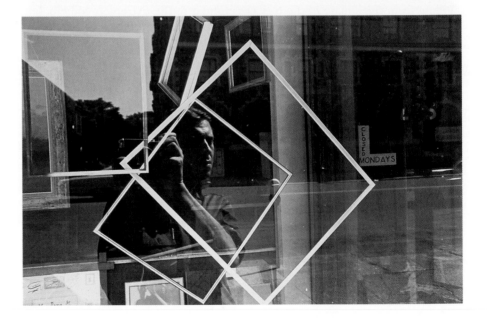

The modern 35mm camera with its eye-level viewfinder gives great convenience and ease of operation but is so much an extension of the eye that it is easy to forget the frame. The common response is to see the part of the subject that is of central importance and forget the rest. Cameras that use a directly viewed ground glass—like view cameras—often help the photographer to be more sensitive to all that is appearing in the frame, since the isolated rectangular ground glass looks much like the print. Users of eye-level viewfinders must consciously scan the entire frame to be sure that only the desired subject matter is appearing.

## ■ Composition and Visual Selection

The word **composition** is used in the arts to indicate the thoughtful arrangement of the **visual elements,** also called design elements, within a work. Artists painting or drawing can truly *compose* an image, since they have total freedom to place, arrange, and alter the appearance of the visual elements. Photographers are limited in this process by the actual physical appearance of the objects being photographed and more often depend on a process of **visual selection,** using camera position—that is, point of view—and lens focal length to alter the arrangement of visual elements within the frame. Because of these differences the word *composition* is perhaps not best suited to photography, but it is widely used.

Many authors and photographers refer to "rules" of composition, which are formulas for the arrangement of visual elements devised over the years, occasionally by artists but more often by critics and others who write about art. Slavishly following such rules may produce only safe, dull images. Great artists forge into new creative areas without regard to rules. On the other hand, some of these formulas are based on psychological and physiological principles of how people respond to visual stimuli. If you wish to communicate visually with others, some attention must be paid to these principles. A person's response to visual stimuli is partly culturally determined—what works for a person from the West may not be effective with someone from the Orient.

Following are some general design principles governing response to photographs, intended to familiarize you with some of the visual tools of the photographer and how they can be applied. It is up to the individual photographer to apply this information with some originality and sense of purpose. The important thing is not to get lost in overanalyzing an image to the point that you forget to make wonderful photographs.

These principles are closely related to those for other two-dimensional media. For a more in-depth study, consult one of the art fundamentals textbooks in the reading list at the end of this chapter.

### Visual Elements

The basic visual element in a photograph is **tonal value,** which is the amount of light an area reflects, seen as lightness or darkness. If some colors of light are selectively absorbed, an area may also show *color.* Black-and-white photographs display only one color, usually close to neutral gray in most print materials, but can display any tone from the darkest black to the lightest white the paper is capable of reproducing. In color photographs a given color can be displayed in any tone from very dark to very light.

The boundary between darker and lighter tones defines **line.** Lines may be straight or curved. If a space is enclosed by lines or defined by the outer

*Design Elements.* Tone (Value), Line Defined by Edge of Tone, Shape Defined by Closed Line, Form Defined by Shading and by Distortion of Lines on Its Surface.

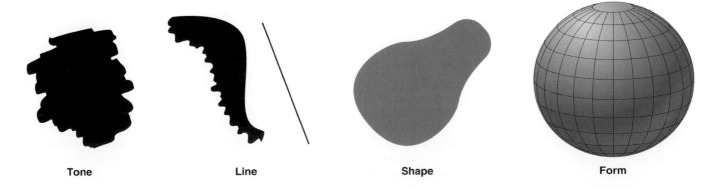

**Tone**          **Line**          **Shape**          **Form**

boundaries of a tonal value, it has **shape.** The three-dimensionality, called **form** or **volume,** of a subject must be implied, since depth cannot be directly perceived in a two-dimensional photograph. The representation of shadows on the surface of an object, also called shading or **modeling,** shows the object's form. Form can also be implied by the distortion of lines on the surface of an object.

The opening photograph for chapter 12 on page 337 shows an excellent use of image blur as a visual effect.

A visual element that is unique to photography, though it has been adopted by other media, is **image sharpness.** When the image of an object is out of focus or blurred by motion, its contribution to the design of the photograph is altered. Clear-cut lines or shapes that might have been formed by the object if it were sharp may become simply areas of tone or color.

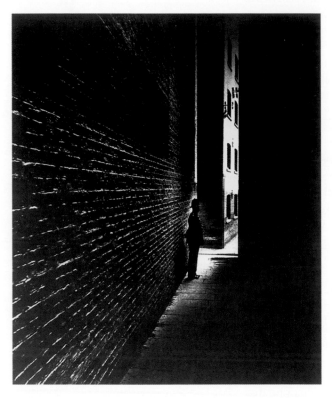

Bill Brandt, *Policeman in Bermondsey Alley, 1951.* Line plays an important role in this photograph. The converging lines of the brick wall draw the eye to the police officer. The vertical lines of the building edges accentuate his straight posture, and the horizontal lines of the paving add visual interest.

© Bill Brandt/Bill Brandt Archive Ltd.

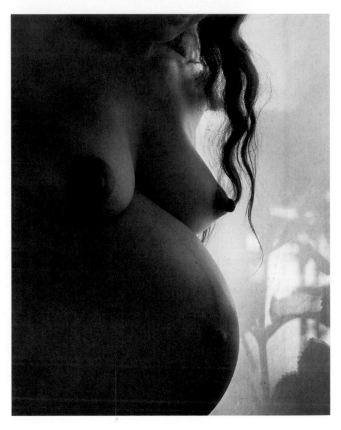

Imogen Cunningham, *Pregnant Woman, 1959.* The form of the body is defined by the shadows on its surface, produced by backlighting.

Photograph by Imogen Cunningham, © The Imogen Cunningham Trust.

Small shapes, lines, or tonal areas repeated over an area of a photograph are visually organized as **pattern.** A pattern of extremely small areas of shape, line, or tone is recognized as **texture.** In photographs pattern and texture may come from a collection of many similar objects or may be due to pattern or texture that existed on the surface of an object.

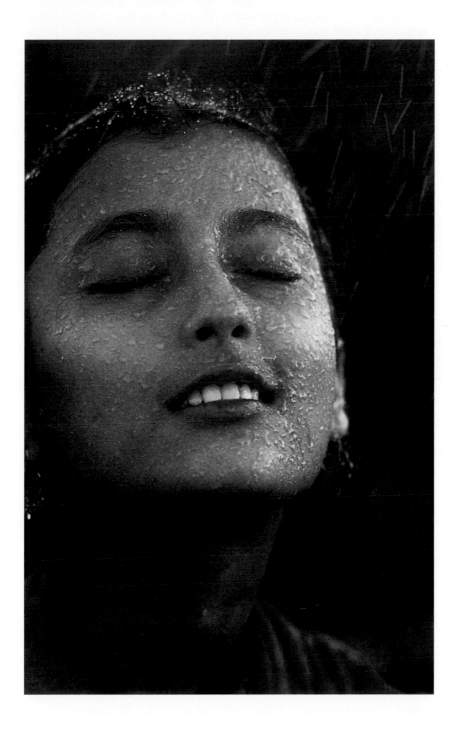

Brian Brake, Untitled. Indian woman in monsoon rain. The raindrops form a visual texture on the woman's face.

© Brian Brake/Photo Researchers.

## Associations

People associate emotions, ideas, or feelings with some types of visual elements. Dark tones imply seriousness, somberness, or drama, and light tones may provide a feeling of airiness, happiness, or warmth. Vertical lines may convey a sense of active strength, horizontal lines a feeling of stability or calm, and diagonal lines movement and instability. Curved lines may imply softness or gentleness and a sense of flow, straight lines briskness or hardness. Thin lines may have a feeling of delicacy or weakness, thick lines boldness and strength. A circle may mean completeness, a square passive stability, and a triangle active stability. Shapes can also call up associations with particular objects because of physical resemblance, as in imagined figures of animals seen in clouds.

These are only a few of the generalizations made. Making associations is a personal process, depending on one's cultural and individual background, and may be unpredictable. It can nevertheless be a useful tool for visual communication.

*Association.* The shapes and forms in this photograph call to mind objects other than those pictured.

© Bruce Warren.

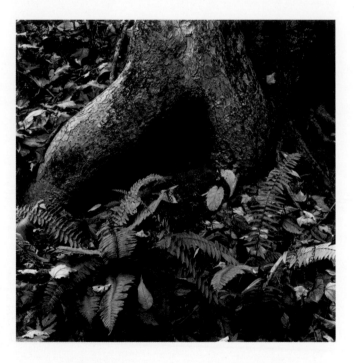

## Symbolism and Metaphor

A symbol is an object, shape, or design that represents something else, often abstract ideas or concepts. The response to symbolism depends to a great extent on the cultural training of the viewer. Some symbols in art are nearly universal, especially those that deal with general human traits. Sexual symbols—for example, phallic symbols—are widely understood, but some religious symbols, like the cross, may only call up a specific response in cultures familiar with Christianity. The swastika was an infamous symbol of World War II, but a similar design was used by Native American and Eastern cultures in an entirely different context centuries before the Nazis adopted it.

Photographs that imply ideas unrelated to the original subject matter are called **metaphors** or **equivalents.** Alfred Stieglitz's photographs of clouds, taken in the early part of the twentieth century, were intended to call up feelings associated with music or direct emotions.

*Symbolism.* W. Eugene Smith, from the *Life* essay "A Man of Mercy" (Albert Schweitzer), November 15, 1954. Several symbols reinforce the idea of a Christ-like Albert Schweitzer: the wooden cross-shaped beams seem to rest on his shoulder, the pencil looks like a nail, and the brim of the hat looks like a halo.

Estate of W. E. Smith/Black Star.

Alfred Stieglitz, *Equivalent,* 1930.

Alfred Stieglitz Collection, © 2000 Board of Trustees, National Gallery of Art, Washington, 1930, silver gelatin developed-out print.

## Visual Attraction

When a viewer looks at a photograph the eye travels over the image, seeing only a small part at a time. Some visual elements attract and guide the eye more than others. The eye tends to follow the path of a *line*. Converging lines especially seem to draw the eye to the point of convergence. The eye is drawn to areas of *tone* different from the average. In most photographs the lightest areas draw attention, but in a high key image—one with mostly light tones—a dark area may initially attract the eye. If two elements are otherwise identical the eye will generally be drawn to the one larger in *size*. All other things being equal, visual elements at the *center* of the frame are given more importance. The eye can also be drawn by certain *subject matter*, such as a human presence in a photograph, particularly the eyes of those portrayed. This is especially true when the eyes of a subject are looking directly into the camera, and therefore directly into the viewer's eyes. Any subject matter that carries a strong emotional message, such as a shocking or extremely unusual event, will also attract the eye.

*Visual Attraction of Subject Matter.* Edward Steichen, *Iwo Jima.* Although this image is fairly uniform in tone and texture, the eye is strongly drawn to the fingers of the buried soldier because of the shocking nature of the situation.

© Edward Steichen, reprinted with permission of Joanna T. Steichen.

*Visual Attraction of Line.* Robert Imhoff, Mercedes Benz. The converging lines of the wedge-shaped light area draw the eye directly to the emblem.

© Robert Imhoff.

The movement of the eye throughout a photograph generates **implied lines.** An implied line may be defined by the mental connection of two or more elements that are visually attractive, similar in shape, or in close proximity to each other. The attempt to follow the direction of a subject's gaze in a photograph to see what the subject is looking at creates an implied line. A moving object implies a line of travel.

If implied lines enclose an area they define an **implied shape.** Implied lines and shapes can carry the same associations as visible ones. For example, the arrangement of interesting objects in a photograph may form a circle, with the accompanying associations of unity and a flowing from one to the next. An arrangement implying a triangle could give a stable feel to an image.

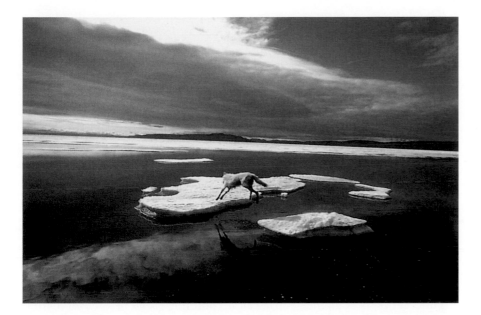

*Implied Line.* Jim Brandenburg, *Arctic Wolf (Canis lupus) Leaping onto Ice Floe,* Ellesmere. Both real and implied lines can be seen in this image. The horizon forms an actual line, but the reflection and ice floes in the foreground form an implied diagonal. The movement of the wolf also implies a line that is an arc from one floe to the next.

© Jim Brandenburg/Minden Pictures.

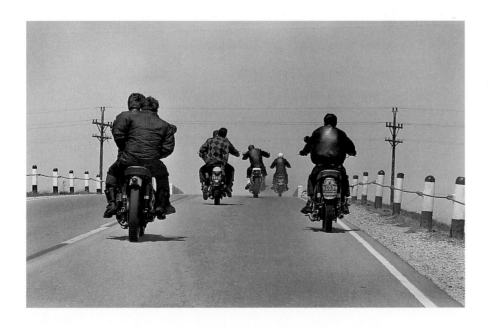

*Implied Shape.* Danny Lyon, from *Danny Lyon Photo Film,* a retrospective of his work. The motorcycles are visually connected to form an implied triangle, which gives a feeling of stability to this photograph.

© Danny Lyon/Magnum Photos, Inc.

## Visual and Psychological Contrasts

The word *contrast* simply means a difference. It has already been used in a technical sense to describe tonal differences in a subject or print or density differences in a negative. Many other types of contrast can be seen in a finished photograph.

The *tonal contrast* between adjacent areas of a print can affect the response to the image. The psychological perception of tonal differences sometimes differs from the actual physical tonal difference. A dark area looks much darker visually when it is surrounded by or adjacent to very light areas.

In color photography, **color contrast** is a difference in color. The difference may be subtle (as with slightly different related colors such as yellow in an arrangement of oranges and reds) or vibrant (as with complementary colors such as blue and yellow used together).

The *difference in sharpness* between parts of an image can draw attention to specific areas or provide a sense of movement, as discussed in the sections on depth of field and motion in chapter 4.

Visual variety can be added to a photograph by including *contrasting textures*. A smooth or glossy surface might be juxtaposed with a rough or grainy surface.

Opposite categories of *subject matter* in a photograph can draw attention to their differences or convey some kind of message to the viewer about the conflict between them. New might be juxtaposed with old, artificial with natural, rich with poor, and so on.

*Shapes* consisting of curved lines contrast with those made up of straight lines. *Forms* with irregularly curved shapes and surfaces (often called *organic forms*) contrast with forms made up of straight lines, flat surfaces, and regularly curved lines or surfaces (*geometric forms*).

A difference in *size* may be used to emphasize one subject over another. Sometimes objects of known and obvious size are included to demonstrate the actual size relationship—the **scale**—of another object in a photograph. Apparent size of objects may be altered by point of view and lens choice to create a false sense of scale.

Different parts of an image may call up differing *moods* or *emotions*. Different faces in a photograph may portray happiness and sadness, or a part of an image seen as beautiful may be contrasted with another part seen as ugly.

Lines, either implied or actual, in an image will contrast with each other if their *directions* are different. Horizontal lines contrast with both vertical and diagonal lines. Diagonal lines of one direction may contrast with diagonal lines of another.

A regularly repeated pattern in a photograph can be changed in one or more places to create a visual contrast, called **repetition with variation.**

Contrasts can serve many purposes in visual communication. Attention can be drawn to a specific subject because it contrasts with other subject matter in the same photograph. Visual interest can also result from the use of contrasts. The psychological result of contrasts can be conflict, contradiction, or tension. Any of these add psychological interest to an image and can be used for conveying a message.

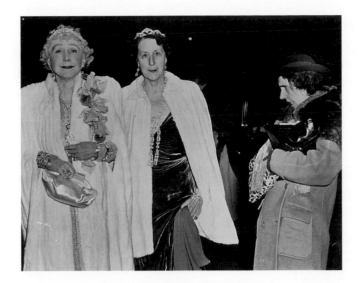

Arthur Fellig (Weegee), *The Critic*, 1943. The contrasts in clothing and attitude of the people make a pungent statement on society.

Weegee/ICP/Liaison Agency.

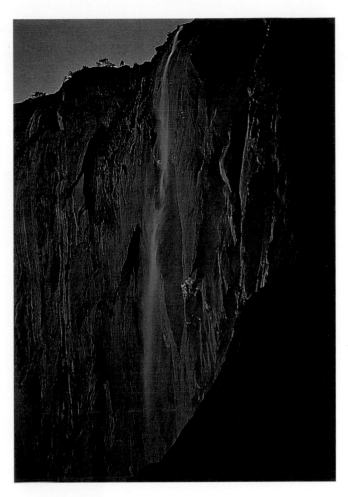

Galen Rowell, *Last Light on Horsetail Falls, Yosemite's "Natural Firefall."* The contrasts in color and tone cause the waterfall to stand out from its surroundings.

© Galen Rowell/Mountain Light.

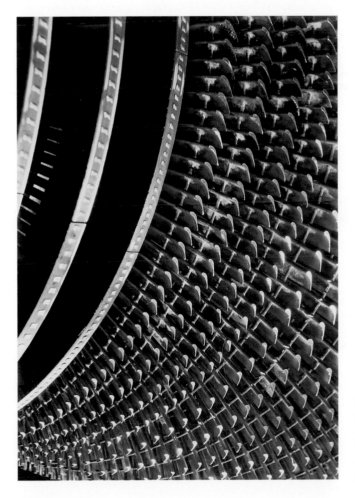

Margaret Bourke-White, *Generator Stator, AEG, 1930*. The repeated pattern in the lower right is suddenly changed in the upper left corner. This contrast in pattern is known as repetition with variation and adds visual interest to the photograph.

© Margaret Bourke-White Estate/Courtesy Life Magazine. Contributors: Jonathon B. White & Roger B. White

## Subject Emphasis

Central placement, leading lines, and filling the frame can all be used to emphasize particular objects or areas in a photograph. Any of the methods for showing contrast—difference in tone, color, sharpness, texture, subject matter, shape, size, mood, and line direction—can also be used to make one object predominate.

*Emphasizing a Subject.* W. Eugene Smith, from the essay "Nurse Midwife," *Life*, December 3, 1951. The central placement, the leading lines of the womens' arms and the wrinkles on the sheet, the implied lines of the womens' gaze, and the lighter tonal value all serve to concentrate attention on the newborn baby.

Estate of W. E. Smith/Black Star.

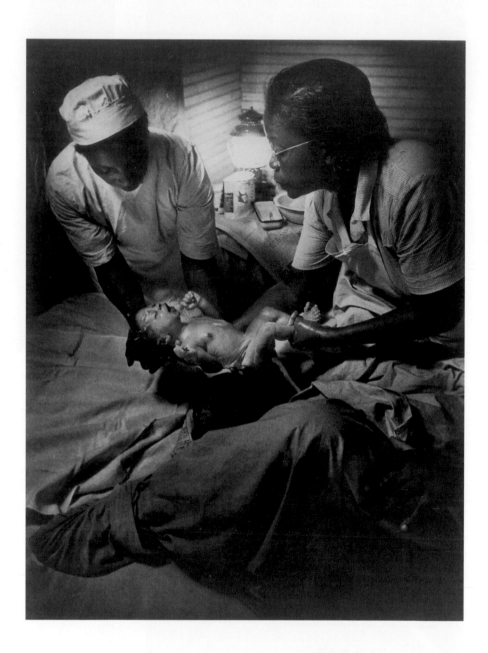

## Visual Structure

The mind is constantly trying to organize and make sense from visual information. Analysis of the spatial relationship of visual elements, recognition of identifiable shapes, and path of eye travel when viewing a photograph all lead to a sense of **visual structure.**

Knowing what attracts the eye can help in organizing the visual elements of a print to provide a rewarding visual experience. If you wish a viewer's eye to travel a comfortable path within the image—to not be led out of or to the edge of the photograph—take care not to have distracting visual elements (light tones, distinctive shapes or subjects) close to the edge of the photograph. Lines, actual or implied, leading out of the photograph can also break the viewer's interest but in some cases may provide a natural exit from the image.

An object of interest or a strong visual shape against a relatively neutral surrounding creates a simple visual structure called a **figure-ground relationship.** The object or shape is the figure and the "leftover" area of the photograph is the ground. If the ground is relatively featureless, with fairly uniform tonal values, it is often called **negative space.** The frame and the edges of the figure may cut the negative space into strong shapes as well.

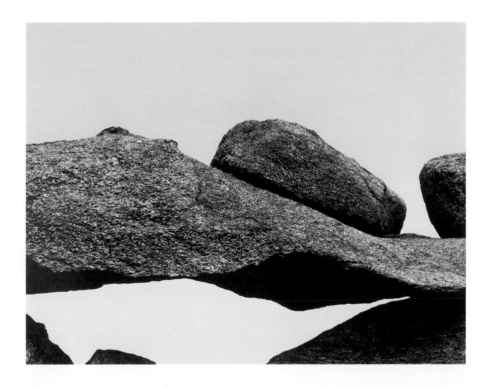

*Negative Space.* Aaron Siskind, *Martha's Vineyard 111a, 1954.* The light areas of the sky and its reflection form negative space in this photograph, which is cut into distinctive shapes by the figure of the rocks and the frame of the image.

© Aaron Siskind Foundation.

**Clarity, Simplicity, Complexity**   Careful arrangement of visual elements and the implied lines and shapes that result can produce an image that is easily "read" by the viewer. Clarity means that the viewer's eye can easily enter and travel about the image and that the message of the image is easily perceived. Sometimes clarity can be achieved by simplicity, which means that the number of visual elements is reduced to a minimum. Visual complexity is just the opposite, with a large number of visual elements competing for attention.

Complexity does not necessarily mean the loss of clarity, but greater care must be taken with visual design when an image becomes complex. A complex image that fails to organize the visual elements is often described by the viewer as "too busy," resulting in unclear visual relationships, unidentifiable shapes, or an uncomfortable path of eye travel through the image.

*Visually Simple Image.* Edward Weston, *Nude, 1927.* Although the dark outline around the body is a complex line, it has the effect of simplifying this image, which is free of visual clutter.

© Center for Creative Photography, Arizona Board of Regents.

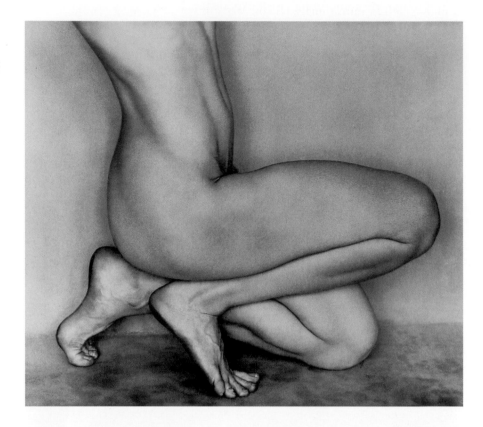

*Visually Complex Image.* Sebastiao Salgado, Gold miners in the Serra Pelada, Brazil. The figure of the man leaning on the pole in the foreground and the line of men walking down the path lend visual structure and awesome scale to this visually complex image.

© Sebastio Salgado/Contact Press Images.

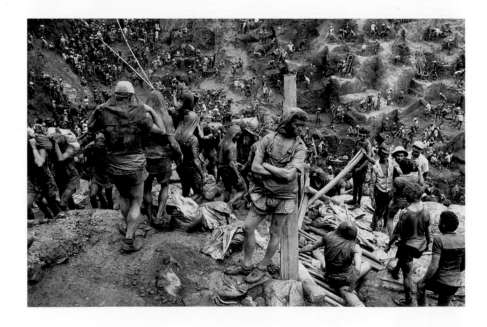

**Balance**    Balance refers to the feeling that the visual importance, or weight, of the various elements within an image is equally distributed throughout the frame. The things that give a visual element weight are its tone, shape, size, psychological importance, and placement in the frame. An image may be balanced left to right (horizontally), or top to bottom (vertically), or both.

The simplest way to achieve a visually balanced image is through **symmetry,** which means that the exact same visual elements appear in both halves of a photograph in mirror image. Symmetry can be achieved horizontally, vertically, or diagonally. Although it may sometimes give a static or lifeless feel, symmetry is a potent psychological visual symbol, as witnessed by its use in many religious symbols.

Asymmetrical balance is a little harder to achieve. It depends upon balancing the weights of the various elements, taking into account all the variables that affect their visual importance. A large shape on the right of an image may be balanced by a much smaller shape on the left if the smaller shape is very light in tone. A large rock or natural form in one area of the picture may be balanced by a tiny human figure because of the psychological importance of the person.

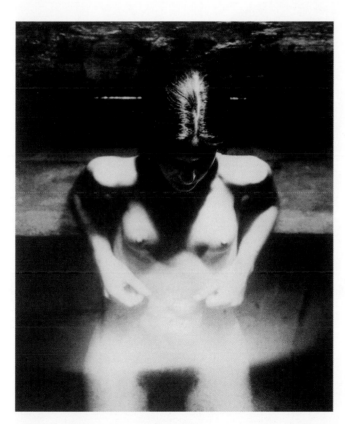

*Symmetry.* Walter Chappell, *Nancy Bathing, Wingdale, NY, 1962.* This image shows nearly perfect symmetry about a vertical axis, but the contrast between the harsh lighting and geometric forms in the top half of the image and the soft-edged shapes due to reflection and flare in the bottom half adds mystery and interest.

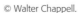

© Walter Chappell.

*Assymmetrical Balance.* André Kertész, *Chez Mondrian, 1926.* This image is far from symmetrical, yet it is carefully balanced. The interlocking rectangles of light and dark recall the paintings of Mondrian, who owned this house.

© The Estate of André Kertész.

**Unity**   Unity in a photograph means a coherence of all the visual elements, the feeling that they belong together. This is a considerably more subjective response than others discussed here, but a few simple devices can lend unity to an image. Related subject matter throughout a photograph can give unity. The intrusion of a telephone pole into a beautiful natural landscape can destroy the unity of that image for many viewers (this shattering of unity might be used as a statement of the human race's effect on the environment). Use of related colors—all blues and greens, for example—or a common tonal value throughout an image can also lend unity. Low key prints (made up predominantly of dark tones with a few light areas) and high key prints (made up predominantly of light tones with a few dark areas) create unity and emphasize certain features of the subject.

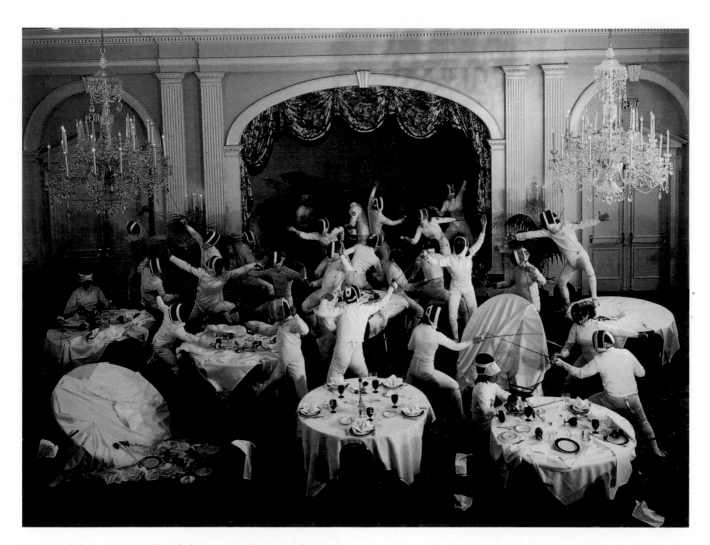

*Unity.* Neal Slavin, *Fencers.* Although this is a complex image, the repeated shapes of the tables and the similarly garbed fencers lend unity, which is reinforced by the implied oval shape they form.

© Neal Slavin/Superstock.

**Point of View**   Changing the physical point of view—determined by the position of the camera at the time of making the photograph—can vastly alter the relationship of the compositional elements in a photograph as well as add a feeling of visual freshness. The usual point of view for most people is eye level, either standing or sitting. The natural inclination for a photographer is to shoot from these same comfortable positions. To break away from this custom try getting close to the floor or choosing a high camera position.

*Effect of Changing Point of View.* The photograph on the right provides a different point of view than the eye-level view normally taken.

© Bognovitz.

*Effective Use of Point of View.* Sylvia Plachy, *Sumo Wrestlers*, New York, 1985.

© Sylvia Plachy.

**Subject Placement**   Usually a number of different objects, called subject matter, are included in a photograph. Recall that placement in the frame emphasizes and organizes the elements in a photograph. A number of conventions have developed regarding subject placement. These should be taken only as guides, not rules, but they may help in making effective photographs.

A **center of interest** is a single object or event that is of primary interest to the viewer. Occasionally a photograph has only one center of interest, but usually it has several and the strength of the photograph comes from the ways in which the photographer relates and organizes these various centers of interest.

*Rule of Thirds.* A commonly used guide for placement is the rule of thirds, which states that centers of interest should fall at points that are the intersections of lines defined by mentally subdividing an image into thirds with two vertical and two horizontal lines. Implied or actual lines in the photograph might follow any of the dividing lines. This provides a kind of geometric balance for the image, preventing elements of strong interest from falling along the edges, where they might pull the eye out of the image, or from being centered, which may sometimes look static. However, as discussed earlier, balance can be achieved in many ways besides placement, and having an object centered or near the edge of the frame may actually be a way of adding interest to the photograph.

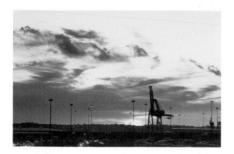

*Horizon Placement.* An extension of the rule of thirds applies to the placement of horizon lines in landscapes or implied horizon lines in interiors or table top still life photographs. Placing the horizon line at one of the two horizontal dividing lines may give more visual interest than centering it. Placement at the top divider emphasizes the land and at the bottom divider emphasizes the sky. Extreme placement turns sky or land into an accent.

© Bognovitz.

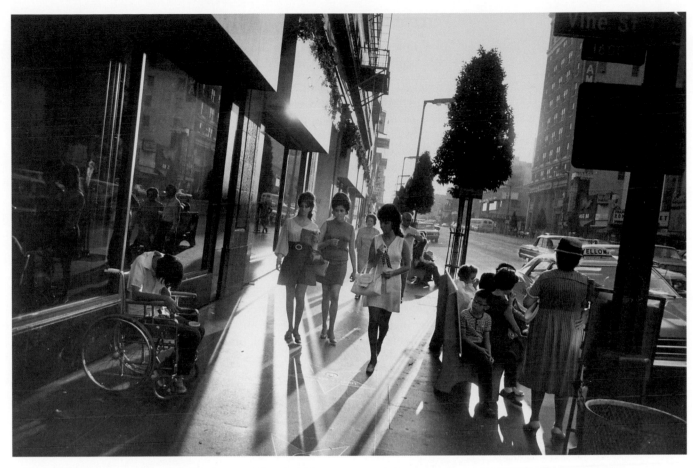

*Tilted Horizon.* Garry Winogrand, *Untitled,* (*Los Angeles, 1969*). The level of the horizon line can also affect the viewer's response. In a representative landscape most people are uncomfortable with tilted horizons, especially in scenes containing bodies of water. A landscape photographer may use a viewing screen with ruled lines or a small level on the camera to insure straight horizons. On the other hand, horizons might be radically tilted for an effect, such as to show disorientation or indicate movement.

© 1984 The Estate of Garry Winogrand/Photo Courtesy of the Center for Creative Photography. Courtesy Fraenkel Gallery, San Francisco.

*Direction of Implied Lines.* Another guideline for placement is determined by the direction of implied lines due to motion or direction of gaze of the subject. The convention is that motion should lead into rather than out of the frame. On the left, the placement of the subject close to the edge causes her gaze to lead out of the photograph. On the right, the photograph has been reframed to allow space for the subject's gaze.

## Perception of Depth

Two-dimensional photographs cannot directly show three dimensions in a subject. A number of visual clues can be used to imply depth in a photograph:

*Perspective.* One indicator of depth is the diminishing apparent size of objects that are farther from the eye, called **linear perspective.** In a photograph the relative size of an object is supplied optically, determined only by the distance from the subject matter, not by the focal length of the lens (see page 00). Parallel lines are affected by perspective. The distance between parallel lines actually remains constant, but as the lines travel away from the viewer the distance appears to become shorter, causing an apparent convergence of the lines.

*Atmospheric depth.* The presence of haze, dust particles, and pollutants in the air causes distant objects to be less distinct than near objects and can portray depth in a photograph.

*Tonal and color depth.* In general light tones tend to advance in a photograph and dark areas to recede. In color photographs some colors such as yellow or orange appear to advance and others such as blue or purple to recede.

*Vertical location.* For subject matter below eye level, objects that are placed higher in a frame usually appear to be farther away barring other depth clues. For subject matter above eye level, objects lower in the frame appear farther away, as with the ceiling of a room.

*Overlapping.* If one object overlaps another in a photograph, it must have been in front of the other and therefore closer to the camera.

*Lighting.* Depth in a subject can be shown by lighting it so that shadows indicate its form. This is especially useful if the subject is basically all of one tone or color.

If attention is not paid to the presence or absence of the proper depth clues, the viewer may gain a false impression of the actual distances within a subject. This can be disturbing if the intent is to give as true a representation of the subject as possible, but it can also be intentionally used in a photograph to alter the feeling of depth for aesthetic reasons.

*Linear Perspective.* A. Aubrey Bodine, *Parking Meters Baltimore*, ca.1960. The dwindling size of the parking meters lends depth to this photograph and is an example of linear perspective.

Courtesy Kathleen Ewing Gallery, Washington, D.C.

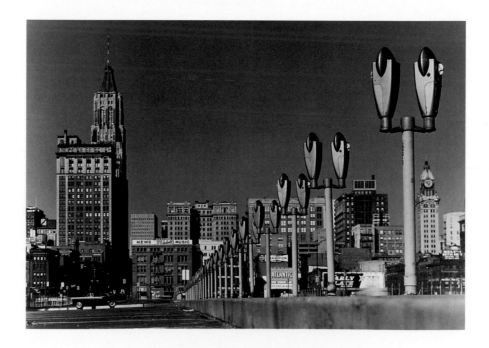

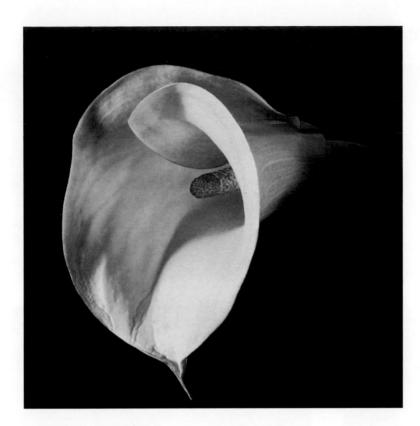

*Depth through Lighting.* Robert Mapplethorpe. *Calla Lily,* 1987. Careful lighting has given a great sense of depth and form to this flower. The light tone and bright color also make the flower come forward from the background.

© The Estate of Robert Mapplethorpe. Used with permission.

## Photographs in Groups

Photographs are often presented in groups, either as a showing in a gallery or in a book or article. The effect of each individual photograph may be altered by the context in which it is viewed. Viewers will mentally relate two or more photographs in proximity, even if no relationship was intended by the photographer or photographers.

The order in which a group of photographs appears governs some responses. Sequencing can imply a narrative, as viewers try to form some sense of continuity from one image to the next. The force of the images can be enhanced by this narrative element. Some sequences might record an event in actual chronological order. Other sequences might simply show an interesting variation or progressive change in graphic design from image to image. Still other sequences might force a relationship between seemingly unrelated subjects or image ideas.

The arrangement of a group of photographs can be thought of as a design problem. The elements of design in each print must then be compared with those of adjacent prints and the group overall. If lines extending from one photograph lead naturally into the design of the next, the viewer can progress comfortably through the sequence. Consideration of comparative design in adjacent prints can strengthen or weaken the response. A complex, subtle image may suffer next to a bold, graphic image simply because attention is drawn from it. Response to subject matter in each print can be affected by the subject matter in surrounding prints. If photographs in the group are intended as metaphor or equivalent, the effect of each individual print can be enhanced by the cumulative effect of the group.

The photographic essay, a special application of photographs in groups, presents a subject or idea more completely than would be possible with a single image. It has often been used to explore a subject for photojournalistic uses.

The next three pages show examples of photographs in groups.

# Photographs in Groups—Continued

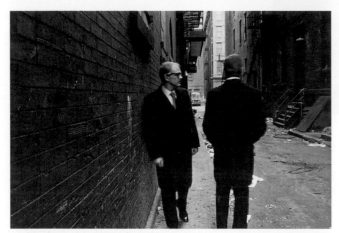

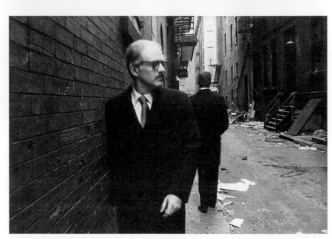

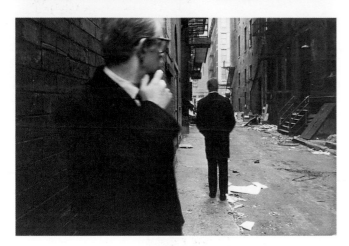

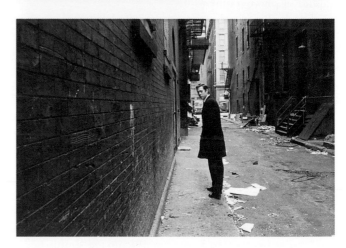

*Sequence of Photographs as Narrative.* Duane Michals, *Chance Meeting*, 1969.

© Duane Michals.

Opposite: *Photo Essay.* W. Eugene Smith, "Spanish Village," *Life*, April 9, 1951. The effectiveness of a published photo essay is influenced by its graphic layout and the use of captions. Only four pages of the ten-page essay are shown here.

Photo Essay from LIFE Magazine. W. Eugene Smith/ Life Magazine, © Time Inc.

ON THE OUTSKIRTS
At midmorning the sun beats down on clustered stone houses. In the distance is belfry of Deleitosa's church.

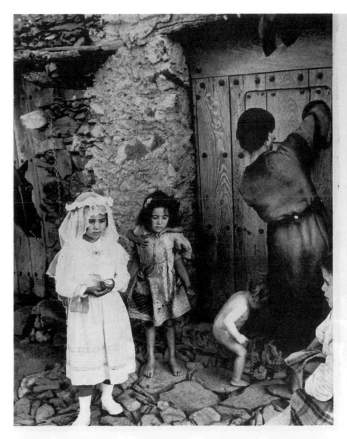

FIRST COMMUNION DRESS
Lorenza Curiel, 7, is a sight for her young neighbors as she waits for her mother to lock door, take her to church.

# Spanish Village

## IT LIVES IN ANCIENT POVERTY AND FAITH

The village of Deleitosa, a place of about 2,300 peasant people, sits on the high, dry, western Spanish tableland called Estremadura, about halfway between Madrid and the border of Portugal. Its name means "delightful," which it no longer is, and its origins are obscure, though they may go back a thousand years to Spain's Moorish period. In any event it is very old and LIFE Photographer Eugene Smith, wandering off the main road into the village, found that its ways had advanced little since medieval times.

Many Deleitosans have never seen a railroad because the nearest one is 25 miles away. The Madrid-Sevilla highway passes Deleitosa seven miles to the north, so almost the only automobiles it sees are a dilapidated sedan and an old station wagon, for hire at prices few villagers can afford. Mail comes in by burro. The nearest telephone is 12½ miles away in another town. Deleitosa's water system still consists of the sort of aqueducts and open wells from which villagers have drawn their water for centuries. Except for the local doctor's portable tin bathtub there is no trace of any modern sanitation, and the streets smell strongly of the villagers' donkeys and pigs.

There are a few signs of the encroachment of the 20th Century in Deleitosa. In the city hall, which is run by political subordinates of the provincial governor, one typewriter clatters. A handful of villagers, including the mayor, own their own small radio sets. About half of the 800 homes of the village are dimly lighted after dark by weak electric-light bulbs which dangle from ancient ceilings. And a small movie theater, which shows some American films, sits among the sprinkling of little shops near the main square. But the village scene is dominated now as always by the high, brown structure of the 16th Century church, the center of society in Catholic Deleitosa. And the lives of the villagers are dominated as always by the bare and brutal problems of subsistence. For Deleitosa, barren of history, unfavored by nature, reduced by wars, lives in poverty—a poverty shared by nearly all and relieved only by the seasonal work of the soil, and the faith that sustains most Deleitosans from the hour of First Communion (opposite page) until the simple funeral (pp. 128, 129) that marks one's end.

PHOTOGRAPHED FOR LIFE BY W. EUGENE SMITH

---

## Spanish Village CONTINUED

"EL MEDICO"
Dr. José Martín makes rounds with lantern to light patients' homes. He does minor surgery, sending serious cases to city of Cáceres, and treats much typhus.

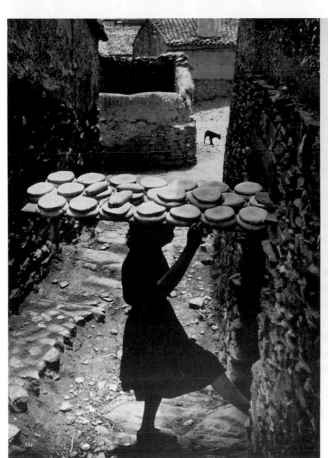

SMALL BOY'S WORK
The youngest son in the Curiel family, 5-year-old Lucero, sweeps up manure from the street outside his home. It is carefully hoarded as fertilizer, will be used on the eight small fields the family owns or rents a few miles out of town.

"SENOR CURA"
Out on a walk, the village priest, Don Manuel, 69, passes barred window and curtained door of a home. He has seldom meddled in politics—the village was bloodily split during the civil war—but sticks to ministry. Villagers like that.

◄ YOUNG WOMAN'S WORK
Lorenza Curiel's big sister Bernardina, 16, kicks open door of community oven, which the village provides for public use. At least once a week she bakes 24 loaves for the family and eight. The flour comes from family grain, ground locally.

122

Some of the materials and techniques that can be used to alter the "straight" photographic image are discussed in chapter 11.

Style is hopefully a natural outgrowth of an individual photographer's personality and vision of the world, seen through photography. Too often, in an attempt to distinguish their work from that of others, artists seek their personal style in the discovery of a new technique or "gimmick." If your ideas require special techniques or materials to support the image or aid in visual communication, then use them. If, on the other hand, these techniques are being used to "dress up" a photograph that is otherwise of little interest, it might be better to think about the substance and value of the image itself.

*Photographic Technique as an Element of Style.* Ralph Gibson, Mary Ellen Mark touching man's hand, from *The Somnambulist.* The coarse grain and high contrast couple with the imagery to give a real sense of the sleepwalker's dream.

© Ralph Gibson.

## Purpose of a Photograph

Design choices and approach grow out of the purpose of a photograph. If you take some time to think about your reasons for taking a photograph, your own choices will be more likely to support the use you intend. For a more detailed discussion of functional uses of photography, see chapter 10, beginning on page 273.

Because of their ability to show what was in front of the camera at the time, the most common purpose of photographs is informational. Photographs that are taken to give us information about the appearance of a subject or the occurrence of an event are called *documentary* or record photographs. **Snapshots** are documentary photographs of a personal and casual nature.

Some photographs present a pleasing or aesthetically interesting design or pattern in which the actual subject matter that was in front of the camera is important only in respect to its visual properties. Such photographs are often referred to as *graphic images* or *pattern pictures.*

Photographs can also be used in a symbolic way. The real objects that were being photographed may call up ideas or emotions, possibly even an idea seemingly unrelated to the original subject matter. A photograph of a mother and child is a document of particular individuals, but the intent of the photographer may be to present a more universal symbol of motherhood.

In **conceptual photography** the photograph as an art object is secondary to the idea or concept it conveys. See chapter 10, page 294, for more on conceptual photography. Sometimes photographs serve as records of conceptual art in other media.

Aaron Siskind, *Jerome, Arizona, (21), 1949.* The representation of the original subject matter is less important here than the associations and ideas that are generated by the graphic qualities of the image.

© Aaron Siskind Foundation.

Many photographs serve several purposes. A documentary photograph may provide a record of a subject but do so in a way that is pleasing or interesting from a graphic design standpoint. At the same time the photograph may be symbolic in character or may be intended as a tool to effect social change or sell a product.

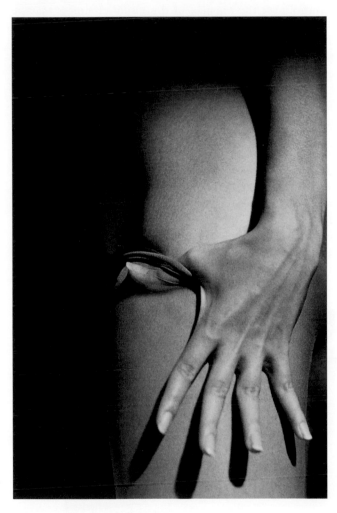

Peter Arnell (Donna Karan advertisement). In advertising photography the ultimate purpose of the photograph is to encourage someone to choose one thing over another. If the item for consideration is a product, one purpose of the advertisement may be to show the product clearly to the public. At the same time the graphic design of the photograph is used to attract attention to the product, and symbols are used to associate the product with ideas or activities that will hopefully make the viewer prefer that product over others.

Courtesy of Peter Arnell.

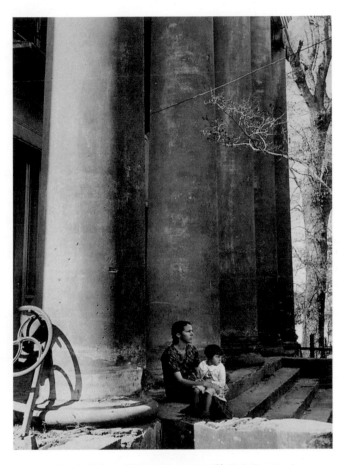

Margaret Bourke White, *Clinton, Louisiana*. Although this is a document of a time and situation, the photograph nevertheless has elegant graphic qualities. The relative scale of the people and columns and the deteriorated state of the mansion symbolize the plight of the poor in the rural South.

Margaret Bourke-White/Life Magazine, © Time, Inc.

## Craft and Idea

The craft of photography is embodied in the control of the technical steps needed to create a photograph. To successfully convey the idea behind a photograph, to fulfill its function, or to establish style, different levels of craft may be necessary.

Although a high level of craft may be seen as unnecessary for some conceptual pieces, a careful control over the nuances of the visual elements may be required for communication in other photographs. It would be difficult to convey the complexity and subtle tones of subjects, as Brett Weston has done in his exquisite prints, if little attention were paid to tonal scale, detail, fine grain, sharpness, and a generally high level of craft. On the other hand, the cumbersome equipment and painstaking techniques needed to produce such quality would not allow the freedom for the wonderfully witty photographs taken on the street by Elliot Erwitt.

In music, students are expected to master the craft of producing sound from their instrument as well as mastering the emotional and conceptual nature of the music. Too often students of photography lose that balance between concept and craft. Some concentrate almost totally on conceptual aspects and are left without the craft necessary to successfully convey ideas depending upon nuance in the photographic print. Others develop a fascination with technical aspects to the exclusion of conceptual awareness. What you should strive for is a successful wedding of craft and concept. Do not limit your ideas because you are too impatient to master the necessary craft—to practice your scales, so to speak.

Brett Weston, *Mono Lake, California, 1957.*

© The Brett Weston Archive.

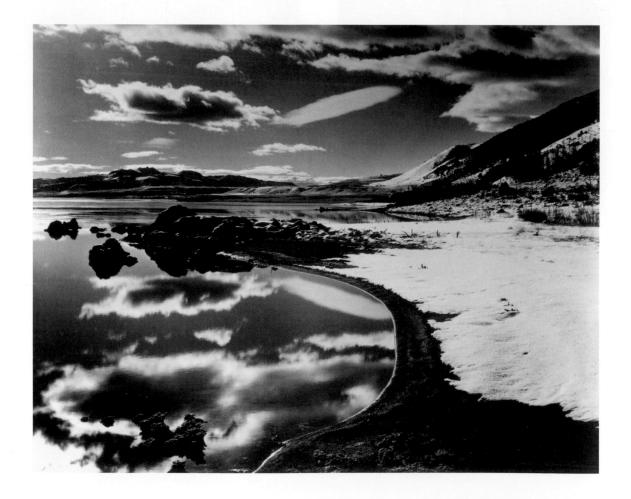

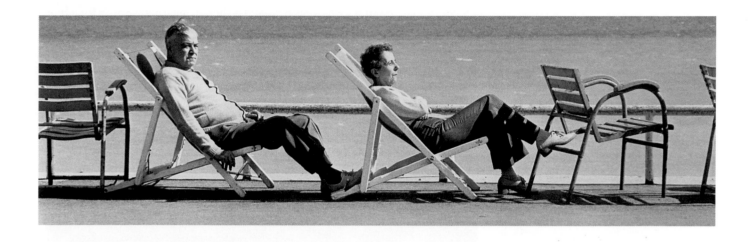

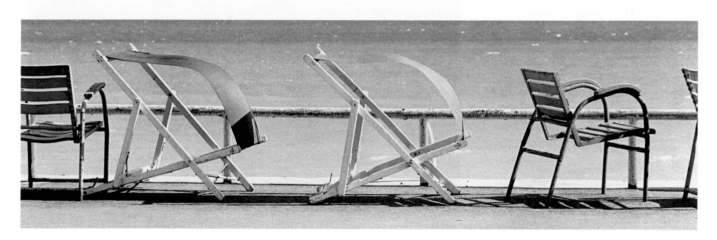

Elliot Erwitt, *Cannes*, 1975.

© Elliot Erwitt/Magnum Photos.

## Control in Photography

Any time a photograph is made, some level of control over the finished result is exercised by the photographer. Choices are made with regard to point of view, timing, materials, and equipment used. The level of control depends on the aesthetic and functional goals for the photograph. Edward Weston created a furor in some quarters when he arranged a shell in a natural setting for a more satisfying image. Many felt that the purity of the image was somehow sullied by Weston's interference with the natural arrangement.

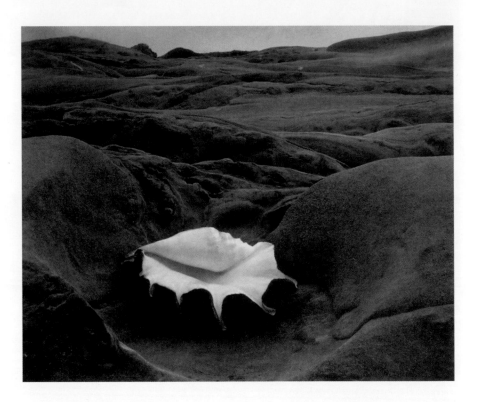

Edward Weston, *Shell and Rock Arrangement, 1931.* Weston disregarded the criticisms leveled at him for this arrangement but at the same time limited the amount of control he exercised over lighting and print manipulations in order to present what he felt was the essence of the original subject.

© Center for Creative Photography, Arizona Board of Regents.

The amount of control exercised over the photographic process helps to determine the photographic style. One extreme is the photographer who insists on photographing a subject just as it is, with no attempt to alter its appearance. Some may even limit equipment to a specific camera and lens. In the other extreme, attempts are made at every stage of the process to control the look of a photograph. Several areas offer opportunities for control:

*Subject matter.* The simple choice of a subject, even if it is photographed as found, is one level of control. Beyond that the subject can be arranged or posed. A person—or in some cases a trained animal—who responds to the direction of the photographer with regard to position and expression is called a **model.** Professional models are paid because they have certain useful physical characteristics and the ability to act and move on command. Models need not be professionals. Many snapshots are "modeled," since the poses and expressions are often assumed for some purpose. In addition the appearance of a subject can be altered by applying makeup, changing clothing, polishing, cleaning, and so on.

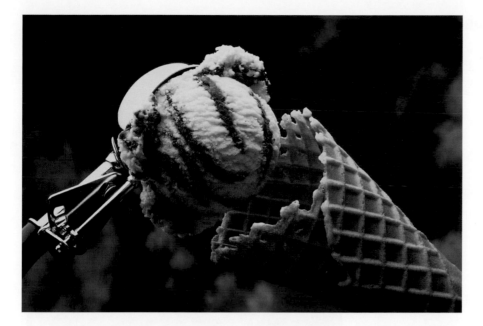

Stuart Block. Advertising photographers are in the business of creating fantasies, but they have limits of control dictated by truth in advertising. For example, artificial models of food are often used for photographs, but if the advertisement is for food, then the actual food product must be used.

© Stuart Block/Sharpshooters.

*Subject environment.*   The lowest level of control over the subject environment is to change camera position to alter the part of the environment seen in the photograph. The next level might involve simply moving the subject into a different area, as Edward Weston did with his shell. Use of props and arranged sets or backgrounds can give even more control over the environment of the subject.

*Lighting.*   Levels of lighting control vary. A photographer may accept the pre-existing lighting and try to get the best effect by choice of camera position. The next level of control is to arrange the subject for better effect from the light. Supplementary lights may also be added. The extreme is to completely eliminate any preexisting light, providing all of the lighting through controlled artificial lights. Chapter 15 discusses controlled lighting in detail.

*Technical choices.*   The choices made of camera, lens, film, developing, and printing materials and techniques are all areas of control over the appearance of the final image.

It is sometimes thought that one major difference between art and applied photography is the amount of control exercised over the process. Although photographers on assignment are often under constraints that encourage the use of controlled techniques—such as deadlines and specific functional uses for the photographs—the level of control can be and often is just as high in art photography. The goals of the photographer dictate the amount of control.

True control takes some planning in advance of the actual making of the photograph. The extent of planning in many cases is to choose some camera equipment and film and a location for photographing, then to simply go there and hope for a combination of inspiration and naturally occurring events to produce interesting photographs. In other cases photographers may want more predictable results and may plan all aspects of a photograph in advance.

For successful control it helps to follow a structured planning process such as the one outlined on pages 512–15.

*continued on next page*

# Control in Photography—Continued

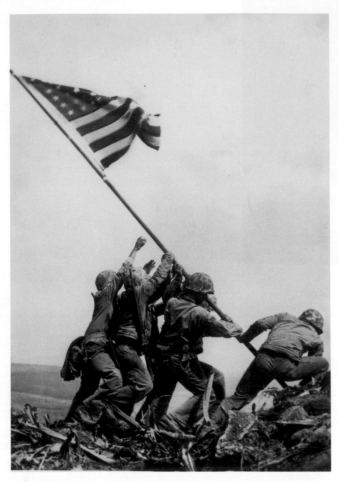

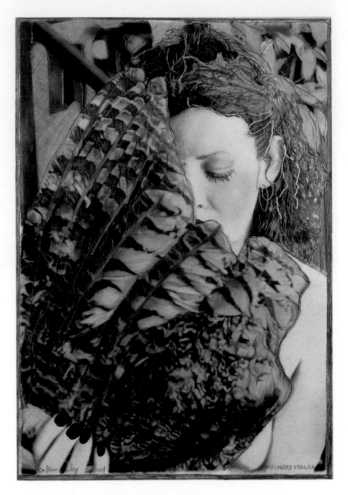

Joe Rosenthal, *Raising the Flag over Iwo Jima*. A photojournalist trying to present accurate news images is limited as to the amount of control that can be exercised before the bounds of journalistic integrity are exceeded. This photograph caused some controversy when it was found that the flag raising was not done in the heat of battle, but was a ceremonial planting of the flag after the general area had been secured. However, the photograph was not represented as anything other than what it is, and is therefore valid and truthful photojournalism.

Courtesy of the Library of Congress.

Alicia Bailey, *Imaginary Fragrance, 1984*. Art photographers choose levels of control appropriate for their statements. If a natural portrayal of subject matter is part of the aesthetic statement, the amount of control that can be exercised must be limited. Other artists are more concerned with manipulating the "real" image and may incorporate photography with other visual media in their attempts to control the look of a finished work.

© 1984 Alicia Bailey.

## ■ Better Photographic Seeing

As you can see from the preceding discussion, the task of visually communicating with photographs is complex. Gaining technical control over the medium is only the beginning. More difficult is learning to control the many visual elements of an image to communicate exactly what you want to the viewer. Three ways to learn more about this process are to practice photography, to look at other photographers' work, and to show your work to others for their response.

## Practicing Photographic Seeing

The more photographs you make, the more you will learn about how the medium works visually. When you see something you think will make a good photograph, immediately record your first impression. After you have captured this spontaneous response to the subject on film, you can then consider the subject in more detail. Try to previsualize what your first impression will look like in the finished photograph. Consider through the viewfinder the visual design of the photograph you have just made. Think about your reasons for taking the photograph in the first place, then try more photographs to see if you can better capture what you have in mind. Employ different points of view, different perspectives, different lighting, different moments in time, and so on. What you are doing as you make these photographs is visually exploring the subject.

The argument of quality versus quantity is often raised against photographers who shoot a considerable amount of film exploring a single subject. One photographer may shoot a dozen or even a hundred photographs to get the single image that says what he or she wants to say; another, who has carefully previsualized each possibility and gone through a process of mental elimination, may shoot one. What counts is the finished photograph. The value of an effective photographic image is not lessened because more than one photograph was made to come to that particular vision.

Film is relatively inexpensive, especially when compared with the time many people invest in photography, so do not be shy about using it. This is a recommendation not to mindlessly make repetitive shots of a subject but to thoughtfully investigate the subject in a variety of visual approaches. As you become more experienced, you will discover for yourself how many exposures it takes you to get a satisfying image, but in the beginning, quantity can promote learning.

Certain images have been used repeatedly in photographs, to the point that they could be called visual clichés. The nature of the photographic cliché is sometimes due to the subject matter but is more often a combination of popular subject matter and a common visual style of showing the subject. Cats, cemeteries, children, and weatherworn buildings are only a few examples of a long list of repeatedly photographed subject matter. If you begin to think that you should not photograph a particular subject just because it has been photographed before, you will make very few photographs. To keep familiar subjects from looking like clichés, approach them in a personal way that tells something new or interesting about them.

The initial attraction to a photographic subject often comes from familiarity, sometimes subconscious, with other photographs of the same thing. If you are aware of this motivation you may decide not to take a particular photograph because something similar has been done. However, too much thought about the sources of your inspiration could inhibit picture making. Recording your

*Seeing Exercise in Contact Proof Form.* A variety of images have been produced by simply changing the distance from the subject or the point of view. If you have different focal length lenses, they can also be used to produce new visual approaches to the subject.

© Merle Tabor Stern.

first impression and then exploring the subject visually with the camera will keep you making photographs and eventually allow your own personal style to surface.

Many situations do not allow a leisurely photographic investigation. Events may be occurring very rapidly and camera position may not be flexible. Photojournalists are often faced with such conditions. Speed in seeing is then crucial, and a great deal of practice under more controlled conditions will provide you with visual skills that can be employed rapidly and almost instinctively when needed.

As an exercise to encourage visual exploration, shoot a whole roll of film on a single subject. Try to make every frame a different visual approach to the subject.

## Learning by Example

Looking at the work of other photographers can help you understand the ways in which photographs communicate visually. Books, magazines, museums, and galleries publish or show photographs. Photographs for applied purposes, such as advertising and news, are widely published. A useful learning tool is an **idea book,** also called a clip file or source book, which you can assemble by clipping published images out of magazines and newspapers. Many photographers give talks during which they show and discuss their images.

To get the most out of looking at photographs, it might help to follow some guidelines. First see if you can define the *function* or use of a photograph. Is it

intended for creative expression, simply giving enjoyment, disseminating information, advertising a product, recording a newsworthy event, or some other purpose? Next try to determine what the *intention* of the photographer was in taking the photograph and the idea or concept that lies behind the image. For example, an advertising photograph may have the function of selling perfume and may do so by promoting the concept of romantic associations with the product. It helps in considering a photograph to put it in a *context* of other photographs of its type. Helpful comparisons can be made to other work by the same photographer and contemporary and historical photographs of similar function or concept.

Look also at the relationship between the image and the technique used. How do the *technical choices*—black and white or color, grain, sharpness, lighting, and so on—help to present the intention of the photographer? Look at the *graphic design* of the image. How has the photographer used the visual design elements? And last think about the *psychological impact* of the image. Does it call up in you certain emotions, moods, or ideas, and what specifically causes your reaction? Inspection of other photographers' work can help you understand the visual tools at your disposal for communicating with photography.

A useful exercise may be to try to reproduce specific photographs or emulate the style of well-known photographers in your own photographs. This forces you to look carefully at the style of the photographer being copied and helps you to acquire the technical skills necessary to produce a similar quality of work. If you decide to sell or otherwise use for profit any photographs that closely resemble or are specific copies of the work of other photographers, keep in mind the copyright laws. Numerous lawsuits have been brought and won against artists who have copied, appropriated, or adapted the work of other artists. Securing permission from the original creator of the work will avoid possible legal problems.

See pages 517–18 about copyright.

## Presenting Your Work to Others

To see how successfully you are communicating with your photographs, you must show them to other people. You are looking for a critique, which is an expression of the viewer's response to the photograph, and perhaps some suggestions for improvement. Many people are not very verbal about photographs, so you may have to encourage some responses. Do not influence viewers by explaining what you were trying to accomplish. Most people, being agreeable, will simply say what they think you want to hear or will seize on your comments just for something to say. If you have to explain the image, you are not communicating visually.

You may get some response by asking questions following the guidelines given earlier for looking at others' photographs. "What kind of feelings or emotions do you get from this photograph?" is a nonleading question, but "Don't you get a scary feeling of foreboding from this image?" will probably influence the viewer's response. If you are to learn from this kind of encounter, you must take remarks or criticisms in a positive way, rather than becoming defensive about your work.

Remember that each viewer brings a different background to a photograph. Consider a viewer's training and knowledge of photography and the other arts when evaluating her or his comments. You will quickly discover that responses are individual and subjective but that some general responses begin to emerge. It is not necessary that everyone respond in exactly the same way to each photograph. A work of art can sometimes be more effective as a direct result of its

various layers of meaning and possible interpretations. Nevertheless, if nearly everyone you show a photograph to responds with confusion about what he or she is seeing or has no response at all, you might rethink what you are doing with that particular image.

## ■ READING LIST

### Photographic Aesthetics

Barrett, Terry. *Criticizing Photographs: An Introduction to Understanding Images*, 2d ed. Mountain View, Calif.: Mayfield Publishing Company, 1996.

Bayer, Jonathan. *Reading Photographs: Understanding the Aesthetics of Photography*. New York: Photographers' Gallery, Pantheon Books, 1977.

Coleman, A. D. *Light Readings*, 2d ed. Albuequerque: University of New Mexico Press, 1998.

Hill, Paul, and Thomas Cooper. *Dialogue with Photography*. Stockport: Dewi Lewis Publishers, 1998.

Lyons, Nathan, ed. *Photographers on Photography: A Critical Anthology*. Englewood Cliffs, N.J.: Prentice-Hall, 1966.

Naef, Weston J. *The Art of Seeing: Photographs from the Alfred Stieglitz Collection*. New York: Metropolitan Museum of Art, 1978.

Newhall, Nancy, ed. *The Daybooks of Edward Weston*. (2 vols.) Millerton, N.Y.: Aperture, 1996.

Scharf, Aaron. *Art and Photography*. Baltimore: Penguin Press, 1969, rep. 1995.

Sontag, Susan. *On Photography*. New York: Anchor Press, 1990.

Szarkowski, John. *Looking at Photographs*. New York: Museum of Modern Art, 1973.

———. *The Photographer's Eye*. New York: Museum of Modern Art, 1966.

Ward, John L. *The Criticism of Photography as Art: The Photographs of Jerry Uelsmann*. Gainesville, Fla.: University of Florida Press, 1970.

Zakia, Richard D. *Perception and Photography*. New York: Light Impressions, 1979.

### Art Fundamentals

Arnheim, Rudolf. *Art and Visual Perception: A Psychology of the Creative Eye*, 2d ed. University of California Press, 1983.

Maier, Manfred. *Basic Principles of Design*. (4 vols.) New York: Van Nostrand Reinhold Co., 1978.

Ocvirk, Otto G., Robert O. Bone, Robert E. Stinson, and Philip R. Wigg. *Art Fundamentals: Theory and Practice*, 8th ed. New York: McGraw-Hill, 1997.

# CHAPTER 10

# History of Photography

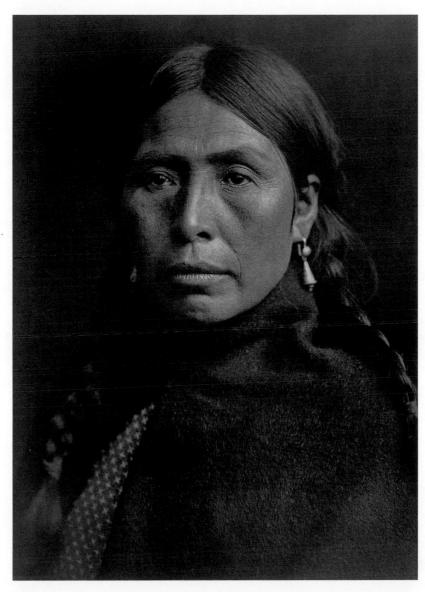

Edward Curtis, *Coastal Salish, Lummi Type.*
Courtesy of the James Jerome Hill Reference Library, Saint Paul.

Photography is so much a part of our environment that it is difficult to understand its impact on the world. Photography, including its derivatives movies and television, has had perhaps the greatest cultural effect of any technical invention. Before the invention of photography, the only visual record of distant places and events was the stylized hand rendering of artists. Suddenly photography offered a realistic representation of objects and events with an objectivity and detail never before possible. Couple this ability to record reality with the communication possibilities of an art medium, and you have a potent tool for altering cultural attitudes and views of the world.

A look at the historical development of photography helps to clarify the role it plays in our daily life and offers inspiration and a context for our own photographic endeavors. It is particularly helpful to look at the technical history of photography, photography's functional role since its invention, some aesthetic approaches in photography and important photographers, and styles and trends in applied photography.

For a more in-depth study, see one of the several excellent histories of photography listed in the reading list at the end of this chapter, especially the beautifully illustrated and comprehensive *A World History of Photography* by Naomi Rosenblum.

## ■ Technical History of Photography

The **camera obscura** (*camera* = room, *obscura* = darkened) was the first of the discoveries that made photography possible. In its earliest form a camera obscura was simply a darkened room with a small hole in one wall and a white screen on the opposite wall. An upside-down image of objects outside the room was formed on the screen by light coming through the hole. This effect was noted by Arabic scholars as early as the tenth century A.D., and some evidence indicates that Aristotle was familiar with the camera obscura as early as the fourth century B.C.

Lenses were added to the camera obscura in the middle of the sixteenth century, producing a brighter, sharper image but requiring a focusing mechanism. The camera obscura became more compact, with the image projected onto thin paper supported on glass, where it could be traced, and was widely used as a sketching aid by artists.

Many users of the camera obscura dreamed of capturing an image without laborious hand tracing, simply by the action of the light itself. The discovery by Johann Heinrich Schulze in 1725 that certain silver salts darkened when exposed to light eventually made this dream a reality. Over the next seventy-five years a number of scientists investigated the light-sensitive property of silver salts, but none of them attempted to make practical use of the discovery in producing permanent images formed by light.

Thomas Wedgwood, son of the famous potter Josiah, was the first to make such an attempt. He and his friend Sir Humphry Davy produced some temporary images on white leather treated with silver nitrate around 1800. Wedgwood's desire was to capture the camera obscura images, but he was unable to do so because of the low sensitivity of silver nitrate. He was, however, successful in producing the outlines of such things as leaves or paintings-on-glass laid on the treated white leather and exposed to the rays of the sun. Unfortunately he discovered no way of making the images permanent and they subsequently darkened when exposed to light for viewing.

George Brander, *Table Camera Obscura,* *1769.*

Courtesy of the Gernsheim Collection, Harry Ransom Humanities Research Center, The University of Texas at Austin.

## The First Photographs

The first person to permanently record the images of the camera was a Frenchman, Joseph Nicéphore Niépce. He and his brother Claude had been experimenting with various materials for capturing the effect of light, and as early as 1816 he succeeded in producing a paper negative of a camera image. Niépce even realized that by then sandwiching this negative with another piece of sensitized paper he should get a positive image, but he was unsuccessful in his attempts. He had also not discovered a method for making these images permanent.

Niépce turned to a different process, using pewter plates coated with bitumen of Judea, an asphaltic varnish that hardens with exposure to light. Initially he exposed these plates to sunlight through an oiled etching on paper, washing the plates with a solvent such as lavender oil after exposure to remove the unhardened parts of the image. The result was a positive representation of the etching on a metal plate, which he called a **heliograph,** from the Greek words for "sun writing." This plate could be etched by acid and then inked and printed.

Niépce then proceeded to place his light-sensitive plates in a camera and expose them, producing the first permanent photographs in 1826 or 1827. The exposure in the camera was about 8 hours. The direct positive camera images he produced from nature were too faint to be etched and printed, so Niépce's photographs were one-of-a-kind. The process did not use a light-sensitive silver salt and could reproduce the tones of light and dark in a subject, but not the colors. Niépce continued over the next few years in attempts to improve his process.

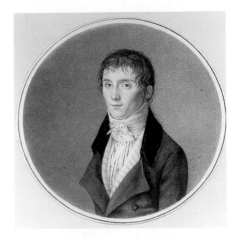

C. Lauiche, Gouache Portrait of Joseph Nicéphore Niépce.

© Gernsheim Collection. Courtesy of the Harry Ransom Humanities Research Center, The University of Texas at Austin.

Joseph Nicéphore Niépce, Photo Engraving of Cardinal d'Amboise, 1827.

Courtesy of the Gernsheim Collection, Harry Ransom Humanities Research Center, The University of Texas at Austin.

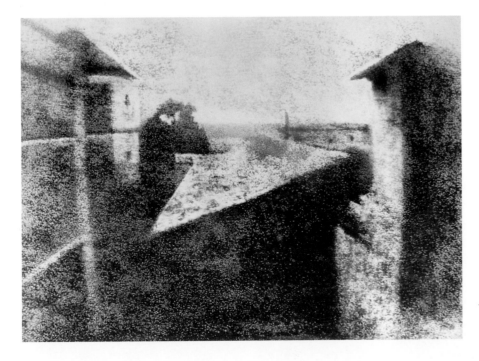

Joseph Nicéphore Niépce, The World's First Photograph, 1826. View from His Window at Gras.

Courtesy of the Gernsheim Collection, Harry Ransom Humanities Research Center, The University of Texas at Austin.

## The Daguerreotype

Meanwhile, some distance away in Paris, another Frenchman, Louis Jacques Mandé Daguerre—a painter and owner of the Diorama, a popular entertainment employing huge, semitransparent illusionistic paintings and special lighting—was using the camera obscura for a sketching aid and was also experimenting with the use of light-sensitive silver salts to capture the camera image. Through their mutual lens maker, Daguerre learned of Niépce's experiments in 1826 and contacted him with the purpose of sharing their efforts. In spite of Daguerre's reported charm Niépce was initially wary of his intent, but a partnership was eventually formed in 1829 and the two shared their research information until Niépce's death in 1833.

Daguerre did not perfect a practical photographic process until 1837, and it shared little with the heliograph technique, other than that both were done on metal plates. Daguerre's process used a copper sheet plated with silver, which was polished and fumed with iodine vapor, producing light-sensitive silver iodide on the surface of the plate. The plate was then inserted in a camera and exposed to an image. After exposure the plate was treated with the fumes from heated mercury—which produced a stronger, more visible image—and then fixed, rather ineffectively, with salt water. The resulting image was delicate, silvery, monochromatic, and one-of-a-kind. Daguerre eventually named images made by this process **daguerreotypes.**

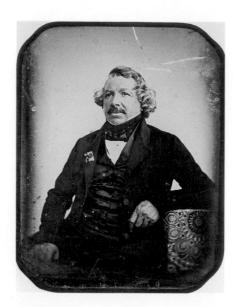

J. B. Sabatier-Blot, Daguerreotype Portrait of Louis Jacques Mandé Daguerre, 1844.

Courtesy of the International Museum of Photography at George Eastman House.

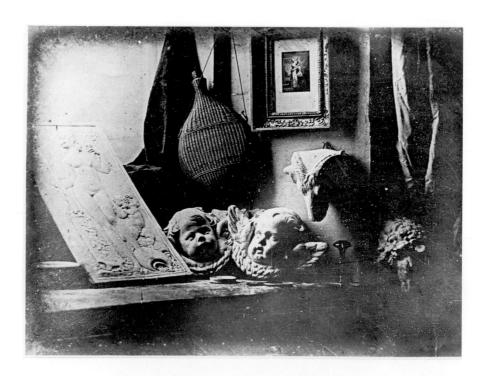

Louis Jacques Mandé Daguerre, *Still Life*, 1837. Daguerreotype.

Courtesy of the Collection de la Société Française de Photographie.

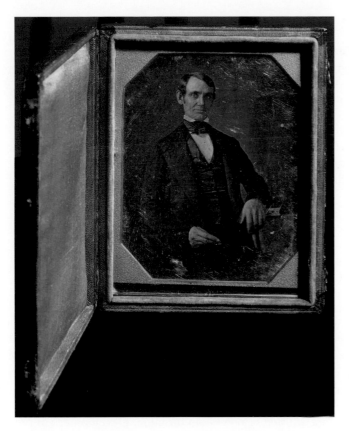

N. H. Shepherd, *Abraham Lincoln,* 1846. Daguerreotype in Case.

Courtesy of the Library of Congress.

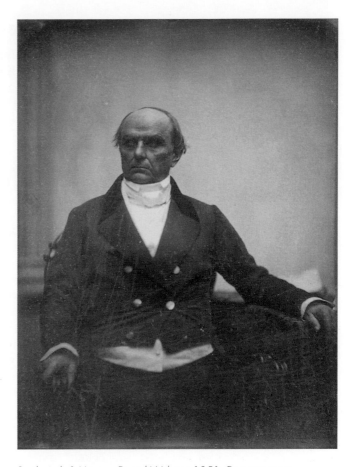

Southworth & Hawes, *Daniel Webster,* 1851. Daguerreotype.

Courtesy of the Metropolitan Museum of Art. Gift of I.N. Phelphs Stokes, Edward S. Hawes, Alice Mary Hawes, and Marion Augusta Hawes, 1937. (37.14.2)

The opportunistic and somewhat arrogant side of Daguerre's personality began to manifest itself in his relations with Niépce's son, Isidore, as he looked for ways to profit from this invention, in the process trying to accumulate to himself as much of the benefit as possible. After exploring several potential ways of exploiting the discovery, he found a champion in the distinguished scientist François Arago. Daguerre's invention was announced publicly to the Académie des Sciences on January 7, 1839, and through Arago's urging, the French government was persuaded to provide pensions to Louis Jacques Mandé Daguerre and Isidore Niépce in exchange for the rights to the invention. The details of the process were announced to the public in August of 1839, opening up its use to any interested person in France.

People were definitely interested. The response to the first photographs ranged from comments like "he was in ecstasies over the stove-pipes; he did not cease to count the tiles on the roofs and the bricks of the chimneys; he was astonished to see the cement between each brick; in a word, the poorest picture caused him unutterable joy, inasmuch as the process was then new and appeared deservedly marvelous" to the remark by French painter Paul Delaroche that "from this time on, painting is dead!"

First public announcement of the discovery of photography.

Portrait of William Henry Fox Talbot.

Courtesy of the Science Museum, London.

## The Calotype

News of Daguerre's initial announcement early in January 1839 quickly traveled across the English Channel and reached the ears of William Henry Fox Talbot in England. A cultured man knowledgeable in both literature and the sciences, Talbot had experimented with photographic processes since 1834. He quickly gathered his materials and presented his invention, which he called "photogenic drawing," to both the Royal Institution and the Royal Society at the end of January 1839.

Talbot's process made use of paper sensitized with silver chloride. Early images were made by laying objects on the sensitized paper and exposing them to light, as in what is now called a **photogram.** Later Talbot exposed the sensitized paper to an image in a camera, producing a negative image that was fixed by being bathed in salt water.

The negative image was converted to a positive image by placing it in contact with a second sheet of sensitized paper and exposing it to light in a process we now call contact printing. Talbot was thus the inventor of the negative-positive system of photography commonly used today. The great advantage of this process is its reproducibility, since nearly unlimited positives can be made from the original negative.

Talbot continued to make improvements on his process. In 1840 he introduced the **calotype**—later after further improvements called the Talbotype—which was made on paper sensitized with silver iodide. After an exposure that produced only a latent image, Talbot discovered that the negative image could be made visible by chemical development in a second bath of gallo-nitrate of silver and then fixed in a solution of potassium bromide. Development of the latent image resulted in much shorter exposure times. The negative was then contact printed on a sheet of sensitized paper to form a positive. Talbot

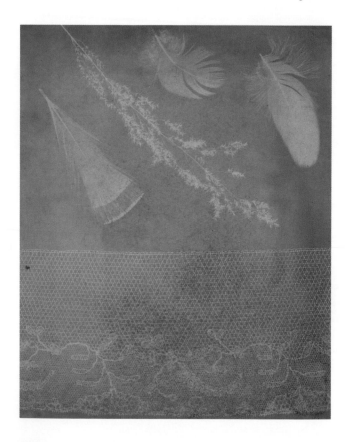

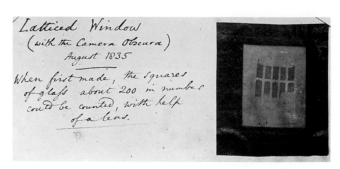

William Henry Fox Talbot, *Latticed Window in Lacock Abbey,* 1835. Earliest Known Existing Photographic Negative.

Courtesy of the Science Museum, London.

William Henry Fox Talbot, Photogenic Drawing with Feathers, Leaves and Lace (Sun Printed), 1839.

Courtesy of the Gernsheim Collection, Harry Ransom Humanities Research Center, The University of Texas at Austin.

patented the calotype and zealously prosecuted those he thought were infringing on his patents.

In spite of the improvements and the obvious advantages of a reproducible photograph on a paper base that was easily transported and incorporated into books, the calotype was never as popular as the daguerreotype. At the time the public valued the daguerreotype for its superior detail and for its preciousness. Being a unique image on a silver plate seemed to imbue it with special value. Nevertheless a number of photographers used the calotype process and produced many images of lasting value, including the first book of photographs, *The Pencil of Nature*, published by Talbot in 1844.

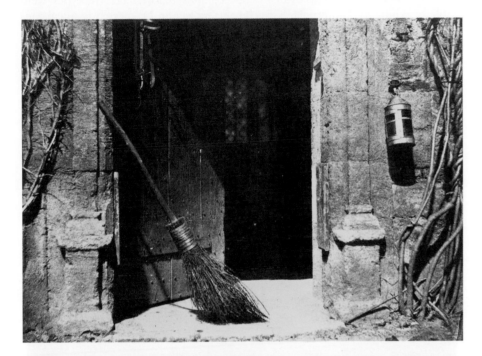

William Henry Fox Talbot, *The Open Door*, April 1844. Published in *The Pencil of Nature*, 1844. Since no method was yet available for directly reproducing photographs in ink, original photographs were glued into each copy of *The Pencil of Nature*.

Courtesy of the Science Museum, London.

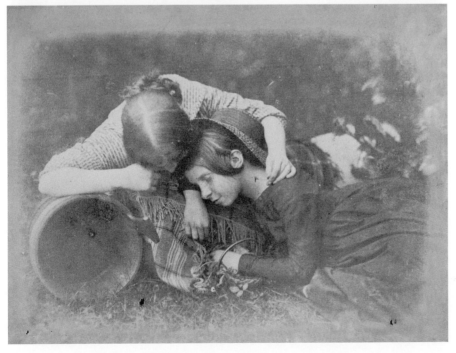

David Octavius Hill and Robert Adamson, *The McCandlish Children*, 1845. The characteristics of the calotype were well utilized by Hill, a painter, in collaboration with Adamson, a chemist. The inability of the calotype to render fine detail was seen as an advantage by Hill and Adamson, who rendered their subjects in broad masses of tone.

Collection, The Museum of Modern Art, New York.

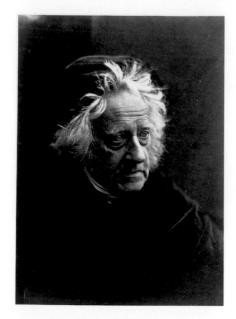

Julia Margaret Cameron, *Sir John Herschel in a Cap.*

Courtesy of the Ashmolean Museum, Oxford.

Hippolyte Bayard, *Self Portrait as a Drowned Man.*

Courtesy of the Collection de la Société Francaise de Photographie.

## Credit for the Invention of Photography

Credit for the invention of photography must be attributed to more than one individual. Niépce takes primacy as the inventor of the first working photographic process, though it was never very practical or satisfying. Talbot followed with a practical positive-negative system. But most of the glory went to Daguerre, partly because he was the first to make a public announcement of his process but mostly because of the public's preference for the daguerreotype.

Other inventors devised workable photographic processes. The Frenchman Hippolyte Bayard announced a direct positive process in 1839 and even mounted a public showing of examples of his photographs before daguerreotypes were publicly exhibited. Unfortunately for Bayard he lacked Daguerre's political connections and received little notice or reward for his independent invention.

Any discussion of the early days of photography would be incomplete without mention of the Englishman Sir John Herschel. The quality of Herschel's mind was demonstrated by his ability to reproduce Talbot's process within a few days, even though Talbot had kept the details secret. In addition Herschel discovered a true fixative for the image in sodium thiosulfate, which he had earlier discovered and incorrectly identified as sodium hyposulfite, shortened to hypo. This same fixer is used today and is still called hypo in spite of the incorrect identification.

The use of hypo was quickly adopted by both Talbot and Daguerre to replace their imperfect methods of fixing, and Talbot went so far as to include its use in his patents without credit to Herschel. Herschel was also instrumental in establishing some of the terminology we use today, including the terms *photography*, *negative*, and *positive*.

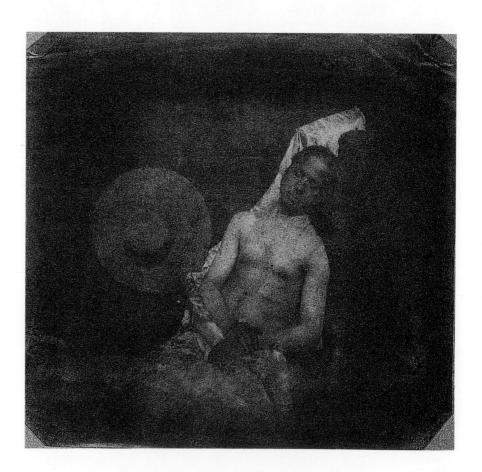

## The Collodion Wet-Plate Process

The obvious advantages of the negative-positive system encouraged the search for a process that would give the sharpness and detail of the daguerreotype combined with the reproducibility of the negative-positive system. Several methods were explored for coating the silver halide onto glass plates rather than paper.

In 1847 Niépce de Saint Victor, a cousin of Joseph Nicéphore Niépce, introduced one of the first successful glass plate processes, using albumen (egg whites) as a clear substance that would carry the silver salts and adhere to glass. Unfortunately the albumen plates were not nearly as sensitive as either the calotype or the daguerreotype, requiring very long exposures. Because of this albumen glass plates were never widely used, but it was found that the albumen and silver salt mixture could also be applied to paper, producing prints with a smooth finish capable of showing better detail than the papers treated directly with silver salts. Albumen papers were popular, and billions of eggs were used for photographic papers in the last part of the nineteenth century.

In 1851 an English sculptor, Frederick Scott Archer, discovered the use of collodion as a carrier for silver salts. Collodion is made by dissolving gun cotton (nitrocellulose) in ether and alcohol, giving a clear liquid that will adhere to glass and dries to a tough, transparent skin. For use in photography the collodion was mixed with potassium iodide and then coated on a glass plate. The plate was then sensitized by dipping it in silver nitrate, forming silver iodide. It was found that the plate had to be exposed and developed before the collodion was allowed to dry or the developing chemicals could not penetrate, so the process became known as the wet-plate process. The results were excellent. The glass negative could be printed as many times as desired, with sharpness and detail comparable to those of the daguerreotype. The wet-plate process quickly took over the industry. By the end of the 1850s only a few studios were still using the daguerreotype process.

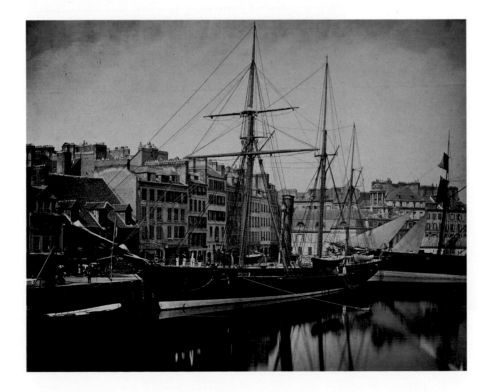

Gustave Le Gray, *The Imperial Yacht, La Reine Hortense*, 1856. Gold-Toned Albumen Print from a Wet-Plate Collodion Negative.

© The Board of Trustees of the Victoria and Albert Museum.

Still, the wet-plate process had some major disadvantages. Since the coating, exposure, and developing had to be done while the plate was damp, wet-plate photographers had to carry a complete darkroom with them wherever they went. The glass plates were heavy and fragile. At the time, printing by enlargement was not practical due to the slowness of the photographic papers, so prints were made by contact printing. Print sizes of 11 × 14 inches and larger were common, requiring glass plates of the same size. The photographers who handled these large plates and the bulky cameras that accepted them under the adverse conditions of the day have to be admired for their courage. They were photographing in wartime and in the still-wild American West, hauling the huge amounts of gear needed by mule or wagon.

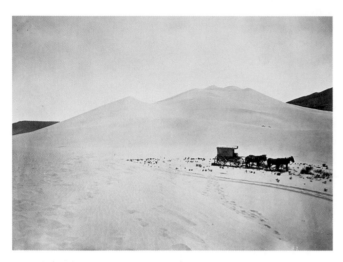

Timothy O'Sullivan, *Wagon and Mules in California Desert.* The photographer's wagon transported photographic equipment and supplies and served as a darkroom for making wet-plate collodion photographs. When routes were impassable by wagon, tents were used as darkrooms.

Courtesy of the International Museum of Photography at George Eastman House.

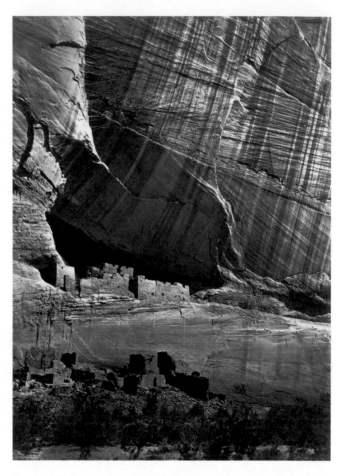

Timothy O'Sullivan, *Canyon de Chelly* (White House Ruins), Wheeler Expedition, 1873. Wet-Plate Collodion Glass Plate Negative.

Courtesy of the International Museum of Photography at George Eastman House.

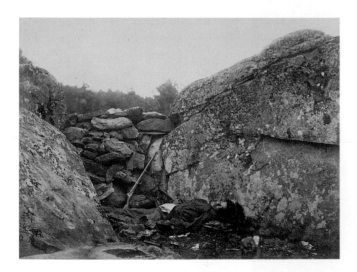

Alexander Gardner, *Home of a Rebel Sharpshooter, Gettysburg,* July 1863. Wet-Plate Collodion Process.

Collection, The Museum of Modern Art, New York.

Opposite bottom: H. C. White Co., Telegraph Hill from Knob Hill, San Francisco Disaster, 1906. The wet-plate collodion process was also used to produce stereoscopic photographs, known as **stereographs.** These were matched pairs of photographs made with cameras having two lenses, which when viewed in special viewers produced startling three-dimensional images of the subjects. Stereographs became popular in the 1850s and were commercially produced in large numbers into the twentieth century.

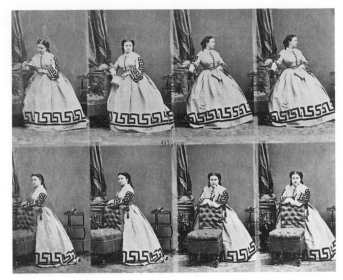

Above: B. Disderi, Carte-de-visite Portrait of Princess Gabrielle Bonaparte, ca. 1862. One popular application of collodion was the **cartes-de-visite,** which were visiting cards photographed with special cameras that could take several images on one plate. These were then printed, glued to cardboard, and cut into separate pictures to produce the proper size cards.

Courtesy of the Gernsheim Collection, Harry Ransom Humanities Research Center, The University of Texas at Austin.

Left: Matthew Brady, Portrait of Unknown Man, ca. 1860. The **ambrotype** was a slightly underexposed collodion glass plate negative displayed in a frame backed by black velvet (shown here partially displaced). When viewed at a correct angle to the light, a negative displayed in this way will appear positive. Coating the wet-plate emulsion on a black-lacquered metal sheet and exposing it directly in the camera produced a **tintype,** which was fast and inexpensive and therefore extremely popular.

Collection, The Museum of Modern Art, New York.

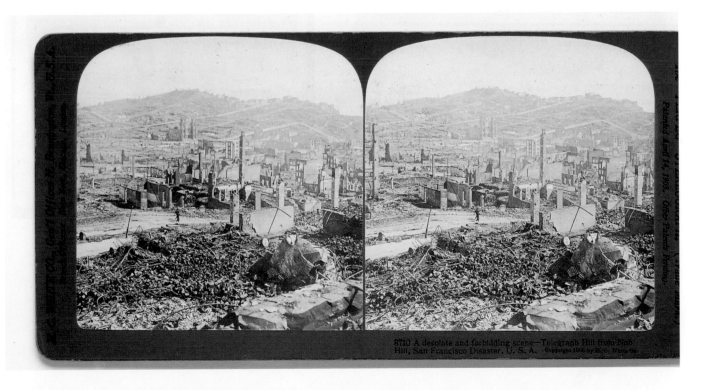

## Gelatin Emulsions

The quality and reproducibility of the wet-plate process made it useful, but investigation into eliminating some of its problems continued. The search for a dry plate with the sensitivity of the wet plate was finally ended with the discovery of gelatin as a carrier for the silver salts. Richard L. Maddox was the first to make this discovery in 1871, and Richard Kennett and Charles H. Bennett improved it into a practical process by 1879.

The gelatin dry plates were a revolution, since they allowed the manufacture of photographic plates that could be stored, carried to a site and exposed, and then developed at the photographer's leisure—in one early case 8 months after the exposures were made. No longer did a photographer have to carry a darkroom on location. Also, since the gelatin plates could be made in a factory, standardization of materials was introduced to photography.

## Flexible Film Base

The next step was to replace the heavy, fragile glass plates with a lightweight, flexible material. This idea was conceived as early as 1854, but George Eastman was the first to invent a practical way of manufacturing the flexible film base. Eastman introduced a camera, called the Kodak, using roll film on this

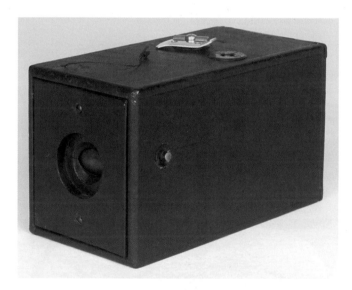

*First Kodak Camera, 1888.* The first Kodak camera was small and light, had a preset aperture and shutter speed, and did not have a viewfinder. It came loaded with a roll of film for one hundred exposures. All that was necessary was to point, using the arrow on top as a guide, shoot, and mail the camera to Eastman Company at the end of the roll, where the film was processed and the camera reloaded.

Courtesy of the International Museum of Photography at George Eastman House.

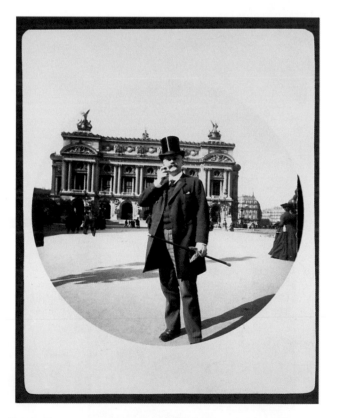

George Eastman, *Portrait of Nadar.* Taken With a No. 2 Kodak Camera. The images produced by the general public using the new Kodak cameras became known as snapshots, which indicated that they were taken quickly and easily with little thought for anything other than the subject being recorded.

Courtesy of the International Museum of Photography at George Eastman House.

base in 1888. The first flexible base was not transparent, and the emulsion had to be stripped from the backing and transferred to glass plates before developing and printing. This was a difficult procedure, so Eastman had his customers return the entire camera to him for removal, processing, and printing of the film. Eastman's motto was You Push the Button, We Do the Rest! and popular photography was born.

Hannibal Goodwin invented a usable transparent film base made of nitrocellulose, but before he was finally able to patent it in 1898 Eastman had already begun to manufacture transparent films and Kodak cameras that used them. Eastman Company was later sued and lost a patent infringement case regarding the use of these transparent films.

The introduction of transparent-based films made photography truly convenient, with the ability to take many exposures on one roll of film, change rolls at will, and even develop and print your own film with a minimum of equipment and without elaborate and difficult procedures. The public responded, and the boom in popular photography persists to this day.

## Further Improvements

The twentieth century brought mostly improvements of processes that had been devised in the nineteenth century, with a few revolutionary inventions. Films were improved by increasing speed and broadening color sensitivity. Early photographic emulsions were blue sensitive, but panchromatic emulsions were gradually developed. The flammable and unstable nitrocellulose film bases were replaced with safe, long-lived acetate. More sensitive photographic papers allowed for the use of enlargers, making possible much smaller camera formats. Lens optics were improved with the discovery of new glasses and new design and grinding techniques. Cameras became more compact and sophisticated. The Ermanox camera was introduced in 1924 with a lens boasting an f/2.0 maximum aperture, fast enough to allow available-light candid photography.

Several color processes were devised in the nineteenth century, but the first commercially available color process was the Autochrome, introduced in

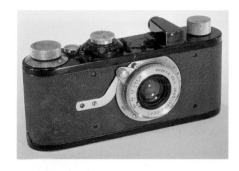

*First Leica Camera.* The first camera using 35mm film, originally a movie film, was the Leica, introduced to the public in 1925.

Courtesy of Leica Camera, Inc.

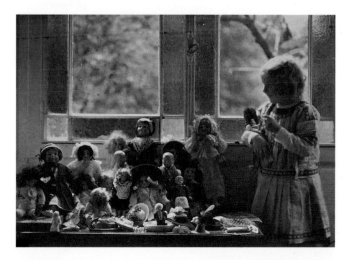

Louis Lumiere, *Yvonne Lumiere and Her Dolls,* 1913. Autochrome Color Transparency.

Photo © Dmitri Kessel.

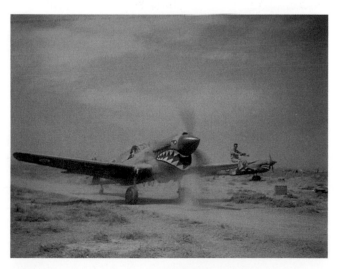

Photograph Taken with Early Kodachrome Film.

Photograph used with permission of The Trustees of the Imperial War Museum.

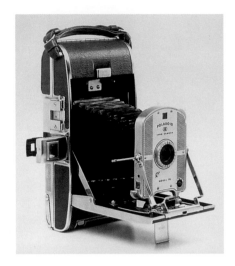

First Polaroid Land Camera.

Courtesy of the Polaroid Corporate Archives.

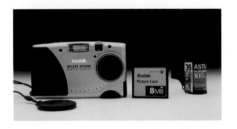

*Digital Still Camera.* The flash card storage is to the right of the camera. The 35mm film cassette was included for size comparison.

1907 and discontinued in 1932. Autochromes were positive color transparencies on glass plates and gave beautiful results. The first practical and affordable color transparency process was Kodachrome, introduced by Eastman Company in 1935.

Electrically ignited magnesium had been used for artificial illumination, but the first electric flashbulbs came on the market in 1930. The first photoelectric light meters were introduced in 1931. Before this, exposure had been determined by experience or by using crude comparison devices.

Many special techniques had been explored in the nineteenth century, including photography through microscopes and under water. The improving materials allowed even higher quality results in these endeavors. One revolutionary development was announced by Edwin Land in 1947. His Polaroid process produced a finished monochrome print only 1 minute after exposure. "Instant" photography has progressed to the point that you can now see color images develop in room light right before your eyes.

More recent advances in the technical areas of photography include extensive automation of cameras, with metering, aperture and shutter speed setting, and focusing all being performed automatically. In films, continual improvements are made, with finer grain and more sensitive emulsions being offered. Kodak's T-grain emulsions are the latest advance in the battle to reduce grain size while retaining sensitivity and are being used in several black-and-white and color films.

## Electronic Imaging

The new revolution in still photography is coming from the electronic imaging industry. Electronic digital still cameras replace the film with a screen that is a gridwork of light-sensitive cells. The response of each cell is digitized, and the information is stored in the same manner as computer data. This mass of information can be reassembled into the image and played back on a television

*Digital Still and Film Comparison.* The photograph on the left was taken with a current model point-and-shoot digital camera and printed on an inkjet printer. The photograph on the right was taken with a current model point-and-shoot camera using standard color print film. Both images are life-size sections of 4 × 6-inch prints. At larger magnifications, the film image is noticeably better, but image quality for digital cameras is rapidly improving.

screen or, with special printers, printed out as color prints. Since the image is stored as digitized electronic information, it can be easily transmitted by telephone or satellite. Digital cameras are competing successfully with film cameras in many areas of the industry.

Computers are more widely used in photography every day, both as controlling devices and for digitizing and managing visual information. Once a photograph is digitized, it can easily be modified or retouched by computer graphic techniques or even combined with any number of other photographs. The result is so high in quality that it is impossible to tell the photograph has been manipulated.

The hardware and software for high-resolution results of this kind are widely used in publishing for retouching, combining, and altering photographs. The skill with which these can be done has raised some ethical issues, especially with regards to the possibilities of photographic deception in the areas of photojournalism, propaganda, advertising, and criminal proceedings. Copyright issues have also been raised, with questions about the incorporation of parts of a photographer's image into a new image without recompense or credit.

See chapter 13 for an introduction to electronic imaging techniques.

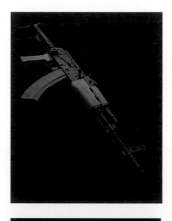

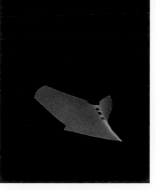
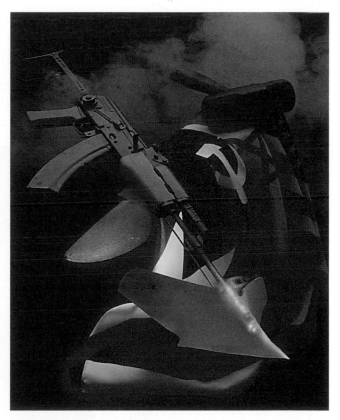

*Computer Assembled and Retouched Image.* Fil Hunter, *Swords Turning into Plowshares.* The four images shown on the left were 4 × 5-inch color transparency originals. They were combined into the larger image using computer retouching techniques and output as an 8 × 10-inch color transparency.

© Fil Hunter. Courtesy of the Dodge Color Lab. Computer retouching by the Dodge Color Lab, Washington, D.C.

## Nonsilver Processes

Although the main technical developments in photography have been in light-sensitive materials using silver salts, a number of nonsilver processes—beginning with Niépce's heliographs—have been developed over the years. Each photographic process had its own visual characteristics and aesthetic possibilities. Some processes had only a brief popularity after their introduction, but many of these have been revived and are currently used—mostly by art photographers, since the laborious handwork makes them expensive from a commercial standpoint.

Herschel experimented with the light sensitivity of iron salts, the basis of the **cyanotype** or blueprint process. Although sometimes used by photographers as a print material, the cyanotype has been most widely used for reproduction of architectural and industrial drawings.

Another process based on iron salts is the **platinotype** or platinum print. Invented by William Willis in 1873, platinum papers were commercially available from 1880 until the early part of the twentieth century. Only recently has platinum paper again become commercially available.

The **carbon process** was invented in 1856 and used paper coated with a mixture of gelatin, potassium dichromate, and carbon particles. When exposed to light the dichromate caused a hardening of the gelatin. After exposure unhardened gelatin and dichromate were washed away with hot water, leaving an image of carbon suspended in gelatin. Improvements in 1864 by Sir Joseph Wilson Swan provided for a carbon tissue that was transferred to a sheet of paper after exposure and processing. The carbon print was also an extremely permanent process. Similar tissues that were commercially available contained pigments rather than carbon in a variety of colors.

The gum process or **gum-bichromate print** was also dependent upon the hardening effect of light, in this case on gum arabic mixed with potassium dichromate. Watercolor pigments can be added to the gum-dichromate mixture, producing prints of any desired color.

Information on a few nonsilver processes is given in chapter 11.

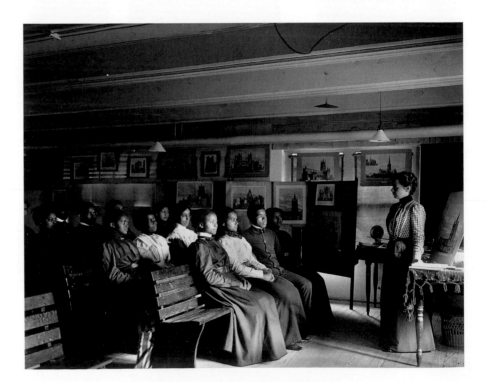

Francis Benjamin Johnston. Geography: *Studying the Cathedral Towns,* 1899–1900. Platinum Print. In the developing process, platinum salts are reduced to platinum in the presence of the exposed iron salts, producing a platinum image. Platinum is much more stable than silver, giving very permanent prints.

Collection, The Museum of Modern Art, New York. Gift of Lincoln Kirstein.

Robert Demachy, *A Study in Red*, ca. 1898.
Gum-bichromate Print.

Courtesy of the Royal Photographic Society, Bath.

## Reproduction of Photographs in Printed Media

Experiments were made from the earliest days in attempts to print photographs with mechanical techniques using ink or pigments. Niépce's original purpose in experimenting with light-sensitive materials was to transfer images to lithographic stones or plates for printing. He had some of his heliographs—those copied from etchings—etched and printed with ink but was unable to do the same with his heliographs from the camera. Some daguerreotypes were directly etched and printed using ink and were the first examples of photomechanical reproduction of photographs.

A number of other processes for printing photographs with inks were invented in the nineteenth century. The **photogravure,** the **collotype,** and the **woodburytype** were excellent reproduction processes for photographs. In fact their quality is better than that of the processes widely used today, but they are seldom employed because of their difficulty and the amount of handwork needed for success. In 1895 the photogravure process was adapted to rotary printing presses as the **rotogravure** and became the printing method of choice for high-circulation, illustrated magazines.

A major problem with all of the photomechanical printing processes mentioned so far was that they required techniques that were different from those used for type and thus could not be performed in the same press. The solution was found with the **halftone** process, in which the photographic image is

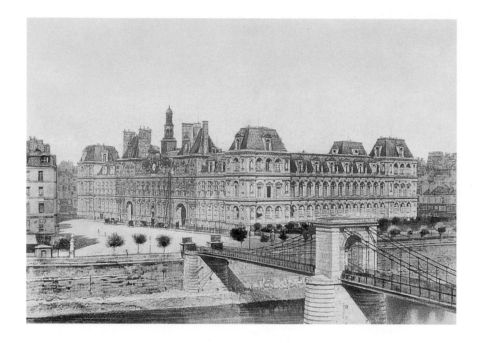

broken into dots by a finely cross-lined screen. A sensitized metal plate was exposed to a negative of the image with the dot pattern already incorporated. When the plate was etched, the dark areas of the subject were left in relief and could be inked and printed just like type. Halftones were used in newspapers as early as 1877 and were in widespread use by 1900.

The quality of the early halftones was not good, but improvements were made to the point where even color photographs could be printed in ink. The halftone process has been adapted to modern lithographic methods and is now used in nearly every area of printed reproductions of photographs. Today most printed materials, both type and illustration, are reproduced photomechanically. Desktop publishing is an exception, since the type and images are supplied to computer printers in digital form directly from a computer.

*Halftone Reproduction.* The photograph on the left has been reproduced using a halftone screen of 85 lines per inch. On the right the halftone image has been magnified four times, showing the structure of the dot pattern.

© Bognovitz.

# ■ Functional History of Photography

Of the visual media, photography is most closely related to painting, drawing, and print media such as lithographs, etchings, and engravings. Before photography was introduced, these two-dimensional media served a number of functions, the major one being representational. People, architecture, scenic views, and events, both historic and current, were all presented to the viewer in relatively realistic representations. The artist was free to alter the realism to make the subject look more attractive, dramatic, or interesting or for reasons of propaganda, but the underlying purpose was still to give the impression of a realistic rendering.

Because of the time and cost for painting, only the well-to-do could afford personal paintings, and these were often portraits. Benefactors of the church commissioned many paintings, both portraits and works of a religious nature. The invention of mechanical printing techniques for illustrations, especially the rotary press, made inexpensive images available to the public, and by the time photography came into general use a large number of illustrated weekly magazines were published. The illustrations were generally from woodblocks that were hand engraved using drawings or paintings—and sometimes photographs after 1839—as a guide. Books were also illustrated, sometimes with separately printed pictures done in color.

With the introduction of photography some people felt that the representational uses of painting, drawing, and other print media had been made obsolete and expected photography to take over these functions immediately. In fact it was a more gradual process. Once exposures were shortened enough to make portraits feasible, it became possible for nearly anyone to afford a portrait. The painters who had been doing relatively low cost miniature paintings found their business suffering, and many turned to photography. Painting still had the advantage of color and size over photographs for many years, and the rich continued to commission paintings.

The use of photography in illustrated magazines and newspapers was limited at first. The technical problems of photomechanical reproduction were partly responsible, but in addition the public still considered the woodblock engravings to be more artistic than photographs. It was not until the twentieth century that photography finally began to take over most of the functions that engraving had filled in the popular press.

The realistic nature of photography is useful in news and other reportorial areas but can be a disadvantage in illustrations for fiction, many of which are still done today by photomechanical reproductions of drawings, paintings, and other hand-done artworks. A few of the uses to which photography has been put are outlined in the following sections.

## Portraiture

Portraits of individuals and groups have been made with nearly all of the photographic processes, from the daguerreotype on. Early sitters had to endure the discomfort of holding absolutely still, clamped into neck and head braces for minutes at a time, but as exposures became shorter the experience became more pleasurable. Styles in portraiture were influenced by the formal poses and props used by painters. Formal photographic portraiture evidences some of that influence even today. These early portraits were of great importance to families, serving as remembrances of those distant or deceased.

Although many people were much taken with these representations of their loved ones or of famous personages, the subjects of the photographs themselves were not always so pleased with the results. One writer in the early days of photography put it this way: "The most terrible enemy which the daguerreotype has to combat is, without contradiction, human vanity." Techniques of posing, lighting, and retouching have been developed to answer this complaint, but today's portrait subjects are more accustomed to seeing photographs of themselves and thus find naturalistic portraits more acceptable. Photographic portraiture is still a thriving business.

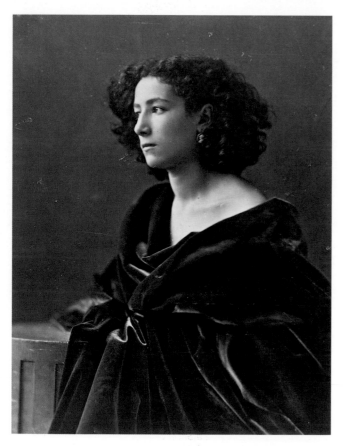

Nadar (Gaspard Félix Tournachon), *Sarah Bernhardt,* 1865.

Collection of the J. Paul Getty Museum, Malibu, California.

Right: Arnold Newman, *Piet Mondrian.*

© 1942 Arnold Newman/Liaison Agency.

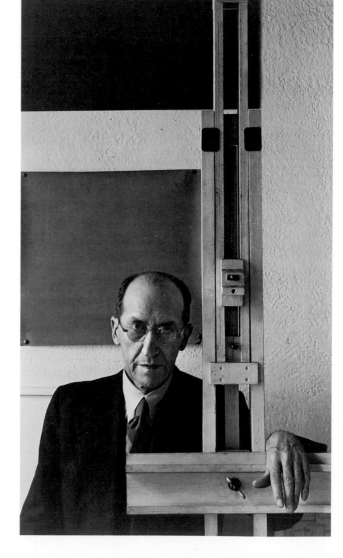

# Travel and Exploration Photography

One early use of photography was to bring back views of exotic and distant places. Initially reproduction of the images was achieved by painstaking hand engraving using the photograph as a guide. Travel and exploration continues to be a popular photographic application, as witness the long-standing success of the *National Geographic*.

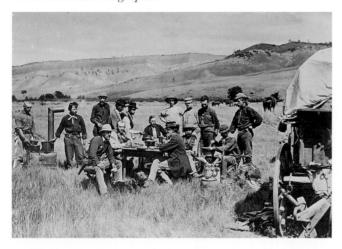

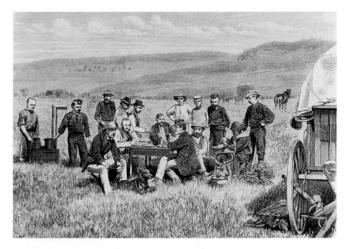

William Henry Jackson, *Hayden Survey Camp,* 1870. The camera became an important tool in the exploration of new territories. Jackson, Timothy O'Sullivan, and others took their wet-plate cameras on U.S. government expeditions into wild and uncharted terrain in the western United States and Central America. The image at left is from the original

photograph by Jackson. The image at right is from a wood engraving that appeared in *Frank Leslie's Illustrated Newspaper,* August 22, 1874, based on Jackson's photograph.

Courtesy of the Denver Public Library, Western History Collection.

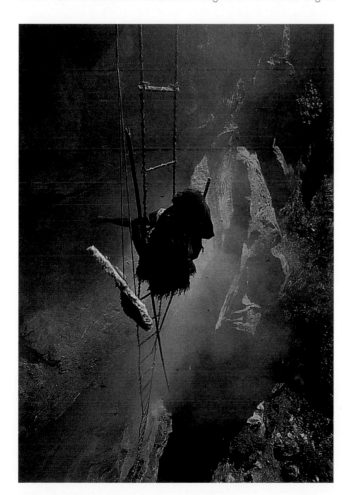

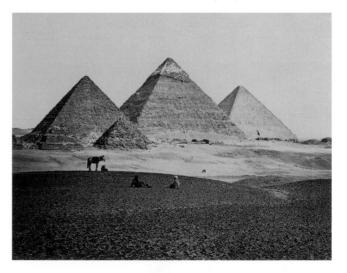

Francis Frith, *Pyramids from the Southwest, Giza,* 1858. Frith and Maxime DuCamp used the calotype process to excellent effect in Egypt.

Courtesy of the Stapleton Collection, London.

Eric Valli and Diane Summers, Honey Hunters of Nepal. Photographs from this project appeared as the cover article in the November 1988 issue of *National Geographic.*

© Valli-Summers/Minden Pictures.

## Architectural Photography

A popular early subject for photography was architecture, especially since stationary objects were so suitable for the long exposures needed. The purpose was usually to show especially famous or interesting buildings, a use that continues today. The business world also offers a market for architectural photography, since many corporations use their buildings as an expression of their success and image.

Berenice Abbott, *Pennsylvania Station Interior, New York*, 1936.

© Berenice Abbott/Commerce Graphics Ltd., Inc.

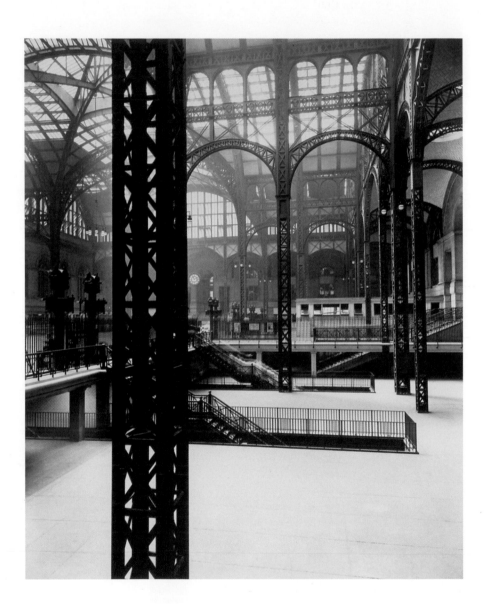

## Photojournalism

Photography's ability to record events as they happen is one of its great strengths. The earliest news photographs were taken on daguerreotypes by Hermann Biow and C. F. Stelzner of the results of a disastrous fire in Hamburg in 1842. These views never made it into the illustrated news magazines of the day, but soon other news events recorded by photographers were seen in the newspapers, first as engraved copies and later as photomechanical reproductions. Wars, disasters, affairs of state, crimes, photo interviews, and even ordinary, everyday events were all subject to the camera.

Today photojournalists cover the world, with modern communications bringing photographs of important events to the public within hours of their occurrence. Some of the best photojournalists have joined into groups such as Magnum and Black Star for marketing their images and have had great influence on the style of photojournalism.

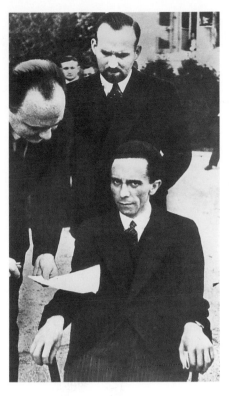

Alfred Eisenstaedt, *Joseph Goebbels*, Hitler's Propaganda Chief, 1933.

Alfred Eisenstaedt/Time Pix.

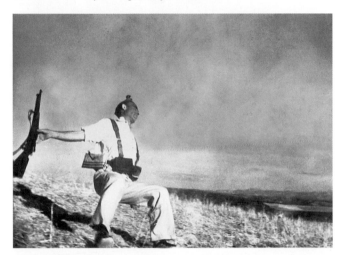

Robert Capa, *Death of a Loyalist Soldier*, 1936.

© Robert Capa/Magnum Photos, Inc.

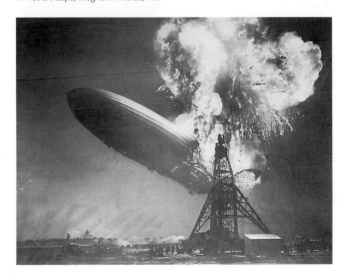

Sam Shere, *Burning of the Hindenburg*, Lakehurst, New Jersey, May 6, 1937.

© Corbis.

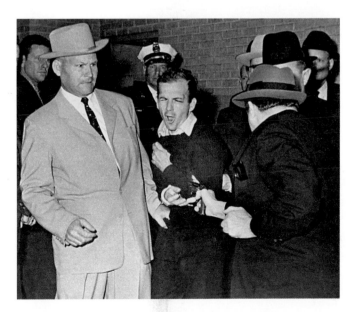

Bob Jackson, *Jack Ruby Shooting Lee Harvey Oswald*, Dallas, November 24, 1963.

© Bob Jackson.

## Documentary Photography

Any photograph that gives information about the subject photographed could be thought of as a record or document.

Documentary photography is often associated with photographers who are trying to convey a personal perspective about a subject. Jacob A. Riis, in pho-

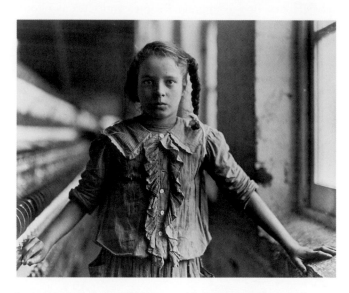

Lewis W. Hine, *Ten-Year-Old Spinner, North Carolina Cotton Mill,* 1908–09.

Courtesy of the International Museum of Photography at George Eastman House.

August Sander, *Hod Carrier.* Sander memorialized aspects of the German culture in a long and careful documentation of various social classes and types, beginning in 1910.

© Copyright 2000 Die Photoraphische Sammlung/SK Shiftung Kultur – August Sander Archive, Cologne/ARS, NY.

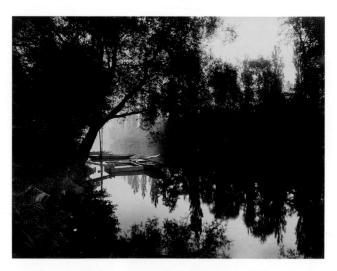

Eugène Atget, *La Marne à la Varenne* 1925–27. The photographs of Paris that Atget took over a period of many years beginning in 1898 served much the same purpose as snapshots. However, they share nothing of the casual seeing of most snapshots because of his slow, careful technique and his elegant way of looking at the city and its people.

Collection, The Museum of Modern Art, New York.

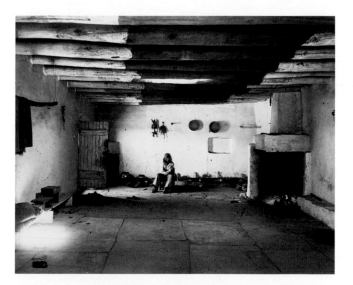

Adam Clark Vroman, *Zuñi Pueblo,* 1897. Vroman and Edward S. Curtis (see the opening photograph of this chapter) both documented Native American life and culture in the late nineteenth and early twentieth centuries. Later research has cast some doubt on the validity of Curtis's photographs as documents, since they were often staged, mixing props and clothing from various tribes.

Courtesy of the Seaver Center for Western History Research, Natural History Museum of Los Angeles County.

tographing the poor people in the slums of New York City during the 1880s, wished to show "the misery and vice that he had noticed in his ten years of experience . . . and suggest the direction in which good might be done." Two decades later Lewis Hine used his photographs to show the plight of immigrants and child laborers in an eventually successful struggle to pass laws protecting children from such exploitation.

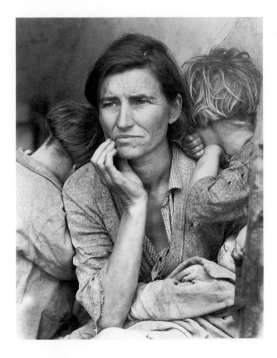

Dorothea Lange, Depression Era Mother and Children, Farm Security Administration Photograph. In a spectacularly fruitful interaction of government and art, the Farm Security Administration sent a number of photographers out across America in the 1930s to document the effect of the Depression on the American people.

Courtesy of the Collections of the Library of Congress.

## Snapshot Photography

Snapshots, the largest single use of photography since the advent of small, easily used hand-held cameras, are a kind of documentary photograph, since they are intended to serve as a personal record of a person, place, or event. Most of these are casually composed, usually with the important subjects centered in the image. Occasionally photographs taken for personal purposes have a more universal appeal, as with those of Jacques Henri Lartigue.

Jacques Henri Lartigue. Lartigue was given a hand-held camera at the turn of the century when he was only seven years old. He photographed his well-to-do French family in a fascinating variety of antics and adventures.

© Ministere De La Culture – France/AAJHL.

Kerr's Studio, Wedding Photograph of Edward and Johanna Thornblade, 1904.

Courtesy of the Thornblade family.

Edward Steichen, *Black*, 1935.

Courtesy Vogue. Copyright © 1935 (renewed 1963) by The Conde Nast Publications, Inc.

## Personal Social Photography

In spite of the ease with which snapshots can be made, people often seek a professional photographer to document the important events in their life. Many photographers make a good part of their living from photographing ceremonial rites of passage like weddings, bar mitzvahs and bas mitzvahs, and christenings. In earlier years it was even common to photograph funerals.

Lately the home video camera tends to supplant the still camera in many areas of personal photography. This trend, coupled with the overwhelming use of color materials in still photography, threatens the photographic heritage that we will leave to our descendants because of the impermanent nature of videotapes and most popular color materials.

## Advertising and Fashion Photography

With a few scattered exceptions little use was made of photographs for advertising purposes until the 1920s, when the problems of quality mass reproduction of photographs began to be solved. During the 1920s and 1930s a number of respected art photographers involved themselves in commercial applications of photography, among them Edward Steichen, Man Ray, László Moholy-Nagy, Sir Cecil Beaton, and others. The effectiveness of photography in advertising has been well proven and is today nearly omnipresent.

Fashion photography also came into its own in the 1920s with the appearance of magazines like *Vogue* dedicated to the fashion world.

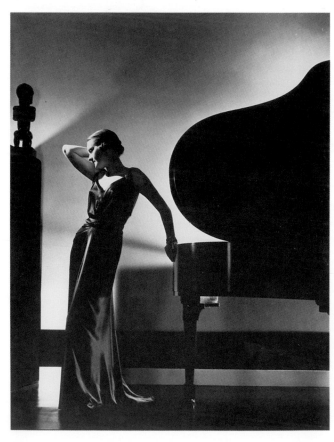

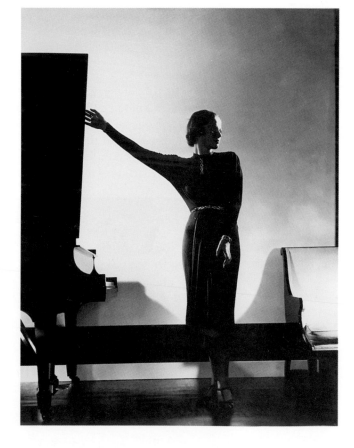

Edward Steichen, *Peeling Potatoes*, Advertisement for Jergen's Lotion, 1923.

Reprinted with permission of Joanna T. Steichen.

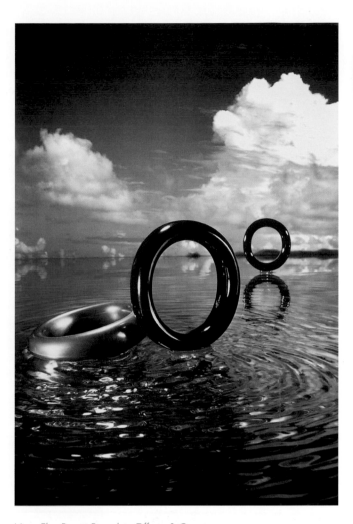

Hiro, *Elsa Peretti Bracelets*, Tiffany & Co.

© 1990 Hiro.

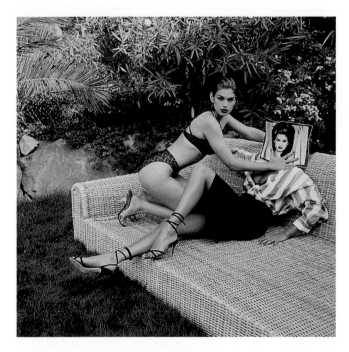

Helmut Newton, Untitled, Model Cindy Crawford.

© Helmut Newton/Maconochie Photography.

## Industrial Photography

Early photographs of the machinery and structures associated with the industrial age were made because of a fascination with these new applications of technology. Later photographers, especially in the period following World War I, found great strength and beauty in industrial subjects and portrayed them in the positive way most people then viewed industry—as a path to a better way of life. Much industrial photography was commissioned by companies for advertising or annual reports, and photographers like Margaret Bourke-White and Charles Sheeler were among those hired. Others photographed industrial subject matter for aesthetic reasons.

Paul Strand, *Oil Refinery, Tema, Ghana, 1963.*

© 1971, Aperture Foundation, Inc., Paul Strand Archive.

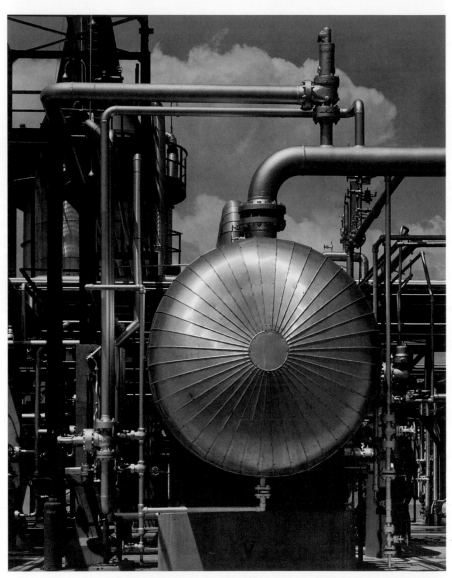

## Scientific Photography

Photography has been used from the beginning to record the results of all types of scientific work, from showing the minute appearance of natural objects through microscopes to investigating things in motion. As the necessary length of exposure shortened over the years, the motion-stopping capability of photography began to be recognized.

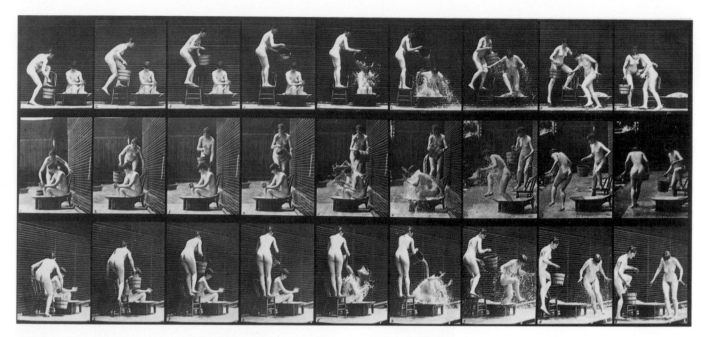

Eadweard Muybridge, Plate 408 from *Animal Locomotion*, 1887. Muybridge was a pioneer in motion studies. Commissioned by Leland Stanford, former governor of California, Muybridge set out to photograph a racehorse in action. He succeeded in 1878, proving that horses have all four feet off the ground sometime during their stride and that they never have legs extended fore and aft as mistakenly shown by generations of painters. Muybridge continued his motion studies with a wide range of subjects, including people in various forms of motion. He also extended this work to projecting the successive images rapidly, introducing the possibility of motion pictures.

Courtesy of the Miriam and Ira D. Wallach Division of Art, Prints and Photographs; The New York Public Library.

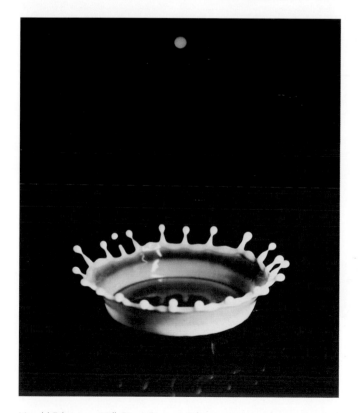

Harold Edgerton, *Milk Drop Coronet*. Edgerton was another pioneer in the study of motion. He invented the gas-filled flashtube used in electronic flashes of today.

© Harold & Esther Edgerton Foundation, 1999. Courtesy of Palm Press, Inc.

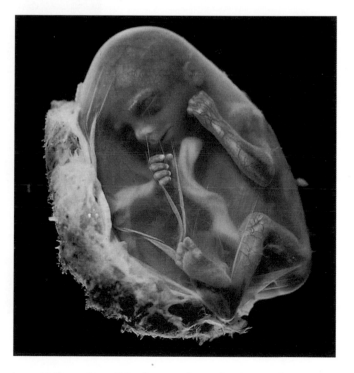

Lennart Nilsson, Fetus. Other frontiers of scientific photography are typified by Nilsson's marvelous photographs of the interior of the living human body.

© Lennart Nilsson, Courtesy of BonnierFakta, Stockholm.

## Nature Photography

Photographers have been drawn to the natural environment, photographing landscapes, wildlife, and other details of nature, for both scientific uses and aesthetic pleasure.

Eliot Porter, *Dark Canyon, Glen Canyon,* 1965.

© 1990, Amon Carter Museum, Fort Worth, Texas. Bequest of Eliot Porter.

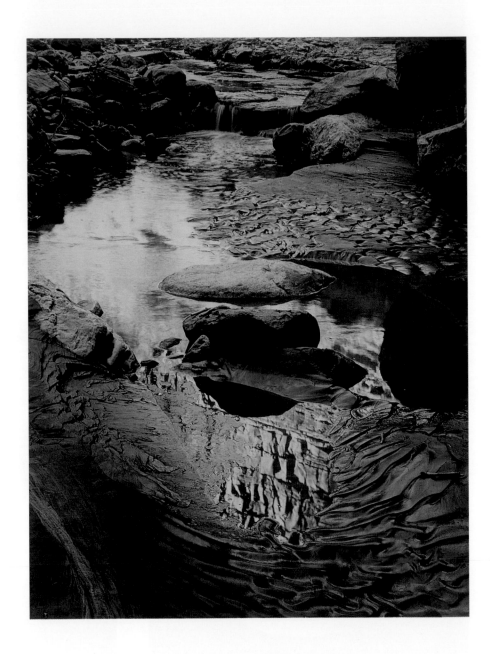

## Photography as Art

While some photographers were busy using photography for practical purposes, others were making photographs for pleasure, producing a visual object to give aesthetic enjoyment—in other words, using photography as art. Even in most photographs taken for utilitarian purposes, attention was paid to the visual design of the image. Nevertheless for many people who were accustomed to thinking of art as entailing handwork, the technical procedures involving optics, mechanics, and chemistry used to produce photographs cast doubt on photography's viability as an art form.

The discussion as to whether photography is a true art form has continued since the beginning. As more and more photographs were made, it became clear that the photographer's personal intelligence and visual style differentiated his or her images from those made by others. With the proliferation of new ways of producing visual objects based on technology, the public has become more comfortable with a definition of art having less to do with actual handwork than with the capability for a medium to display personal visual style differences and concepts. All of the media based on photography—including cinema, video, photocopying, and so on—and those based on computer generation of images seem to satisfy that criterion. Many of the shifts in stylistic direction in photography depended upon reconsideration of the definition of art and of how photography related to that definition. The following section traces the development of photography as an art form.

## ■ Aesthetic History of Photography

The initial fascination with photography was for the wonderful technical miracle it performed, but the similarities with other arts were noticed immediately and it was not long before photography was being explored as an art form. Much of Talbot's early work, including the first book of photographs, *The Pencil of Nature*, (page 261) could be classified as art photography, since his main purpose appears to have been the production of attractive visual objects.

Early photographers typically followed the visual conventions and styles then current in painting. In fact many photographers were or had been painters. The response of the art establishment to photography was generally inimical. Many painters scorned the use of photography as an expressive medium, considering it useful only as a source of studies and for scientific purposes. As interest in photography as an art increased, some theorists began to look for the unique characteristics of photography and to form philosophies for the making of photographs as art.

Two important figures in the battle to establish photography as a serious medium were Oscar G. Rejlander and Henry Peach Robinson. Both were painters-turned-photographers and felt that photographs should, to be considered a true art, be bound by the same conventions governing paintings. They used multiple printing techniques **(photomontage)** to achieve photographs that they felt satisfied these conditions.

This pictorial approach to art photography was so predominant that in the 1880s Peter Henry Emerson presented a forceful argument for photography as an art form independent from painting. In his book *Naturalistic Photography for Students of the Art* (1889), Emerson presented an aesthetic theory for photography that was based on the way the eye sees and the properties of the photographic image. He was an advocate of differential focus—meaning careful choice of focus and depth of field—in which central, important subject matter

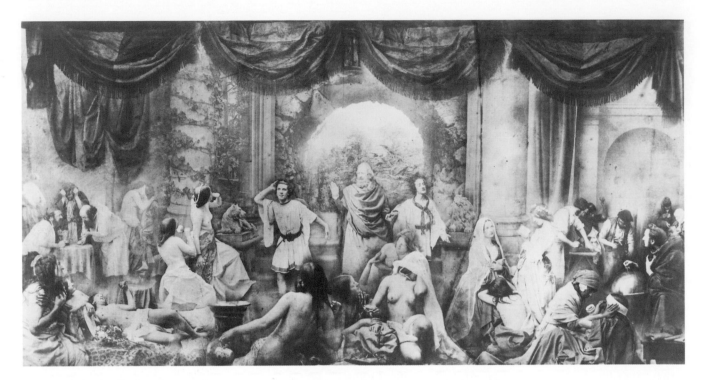

Oscar G. Rejlander, *The Two Ways of Life*, 1857. Rejlander worked in an allegorical style used by painters. Photographers—among them D. O. Hill and Robert Adamson and Julia Margaret Cameron—took up this style, producing many allegorical tableaux illustrating scenes from the Bible or from literature.

Courtesy of the International Museum of Photography at George Eastman House.

was sharp and the remainder of an image was slightly soft. Otherwise the image was to be presented straight as the camera reproduced it, with no cutting and pasting of multiple images or heavy retouching and handwork on the negative or print in an attempt to yield a more "painterly" look. Emerson's photographs lived up to his theories.

Unfortunately many photographers who considered themselves naturalists interpreted Emerson's remarks on sharpness to mean that nothing in a photograph should be sharp, and fuzzy pictures were the order of the day for many years. In 1890, partly motivated by studies by Ferdinand Hurter and Vero Driffield showing the firm scientific basis of photographic reproduction, Emerson recanted on his feeling that photography was a viable art form.

P. H. Emerson, *Gathering Water-Lilies*.

Courtesy of the International Museum of Photography at George Eastman House.

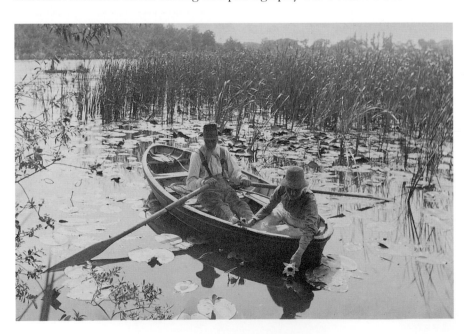

## Pictorialism

The **pictorialists** were a loosely structured group of photographers who fought the battle for photography as an art from about 1890 through the first decade or two of the twentieth century. Pictorialism covered a wide range of styles, but the main principle that gave coherence to the movement was that photography was a valid art form to be considered on an equal footing with painting, drawing, sculpture, and the other fine arts.

In England art photography had been dominated since 1853 by the Photographic Society of London, changed to the Royal Photographic Society of Great Britain in 1894. Tired of what they felt to be a lack of attention to art photography, a group of pictorialists seceded from the Photographic Society in 1892, calling themselves the Linked Ring. Members included many naturalists, followers of Emerson's theories, but Emerson himself had recanted by this time and remained a member of the Photographic Society. Members in the Linked Ring worked in a wide range of styles, from the heavily manipulated images of Henry Peach Robinson to the straight, unmanipulated, and elegant architectural images, beautifully printed on platinum paper, of Frederick H. Evans.

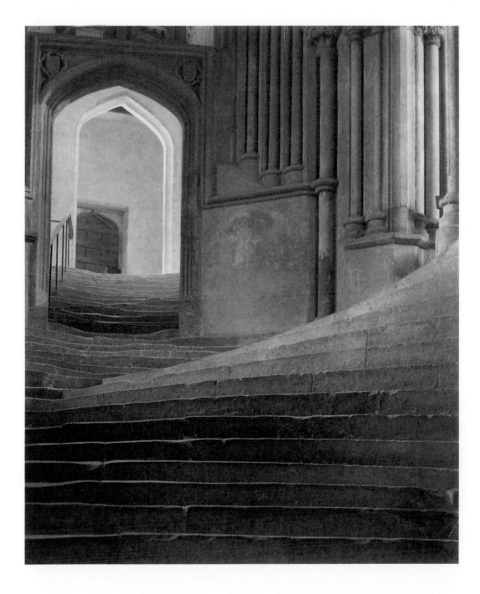

Frederick H. Evans, *Steps to Chapter House: A Sea of Steps, Wells Cathedral*, 1903. Platinum print.

© 2000, The Museum of Modern Art, New York.

During the 1880s and 1890s a young American photographer named Alfred Stieglitz had gained international acclaim in exhibits in America and Europe. After studies in Europe he returned to America and became an important force in the movement for photography as art. He was a formidable figure in the amateur camera clubs in New York and in 1902 formed a new society with the avowed intent to further the fight for the establishment of art photography. The new society was named the **Photo-Secession,** to indicate its separation from the traditional, academic approach to the arts.

The membership of the Photo-Secession, like that of the Linked Ring, covered a wide range of stylistic approaches to photography as art and included Stieglitz, Edward J. Steichen, Clarence H. White, Frank Eugene, Gertrude Käsebier, and others.

Stieglitz also published a new journal of photography, *Camera Work*. The fifty issues of *Camera Work* produced from 1903 to 1917 featured beautifully reproduced and presented photographs as well as reproductions of modern art, introducing the works of Rodin, Brancusi, Matisse, and others to the American public for the first time. Stieglitz was instrumental in many exhibits of photography and modern art through established museums and galleries and a series of private galleries that he operated, beginning with the 291 gallery.

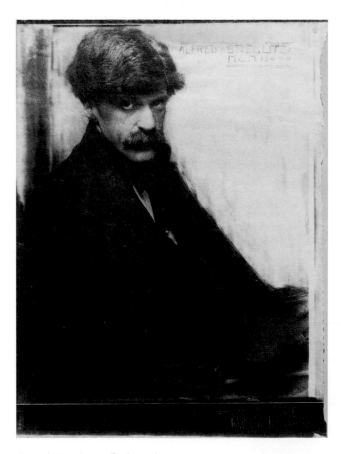

Gertrude Käsebier, *Alfred Stieglitz,* 1902.

Courtesy of the Metropolitan Museum of Art, the Alfred Stieglitz Collection.

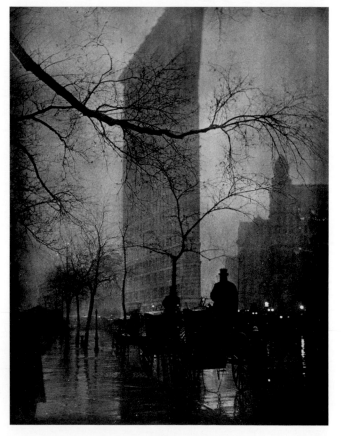

Edward Steichen, *The Flatiron Building, New York,* 1905.

Reprinted with permission of Joanna T. Steichen.

Steichen, a painter and photographer, worked with Stieglitz, contributing to the design and production of *Camera Work* and traveling in Europe to find and collect the works of the new artists that Stieglitz exhibited. Steichen also played a strong role in the Photo-Secession group as a photographer and eventually became a great influence in photography as the director of photography at the Museum of Modern Art from 1947 to 1962.

The importance of Stieglitz and his colleagues in the American establishment of modern art and photography as art should not be underestimated.

## Straight Photography

Even though Stieglitz supported the work of many photographers who practiced extreme manipulations of the photographic medium, he himself took a different approach in his work. Stieglitz believed that the photographic images should be printed without manipulation. He also championed the use of smaller hand-held cameras for the spontaneity that could be gained.

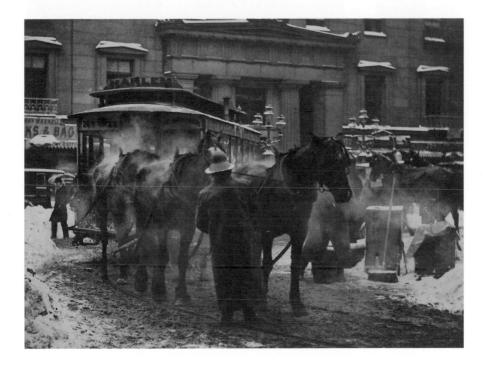

Alfred Stieglitz, *The Terminal, New York,* 1892.

© The Museum of Modern Art, New York. Gift of Georgia O'Keeffe.

In the last issues of *Camera Work* Stieglitz displayed the photographs of a young man, Paul Strand, who was working in a direct manner, employing a fully detailed, sharp image printed without manipulation.

This approach to photography culminated in a style known as **straight photography,** which was epitomized by photographers like Edward Weston, Ansel Adams, and Imogene Cunningham. Group f/64 was formed by these and other photographers in 1932 to promote an aesthetic of photography that included a clear and uncompromised purity in the approach to photographic techniques. The name of the group indicated a concern with a sharp depiction of the subject, using the great depth of field achieved with small

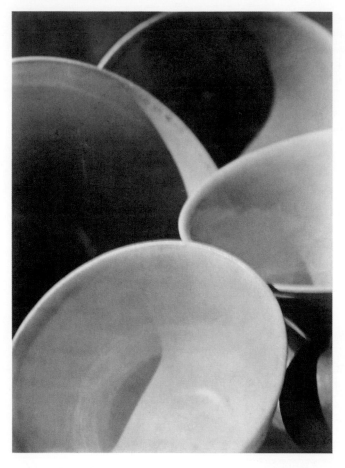

Paul Strand, *Bowls*, 1906.

Courtesy of the Metropolitan Museum of Art, The Alfred Stieglitz Collection.

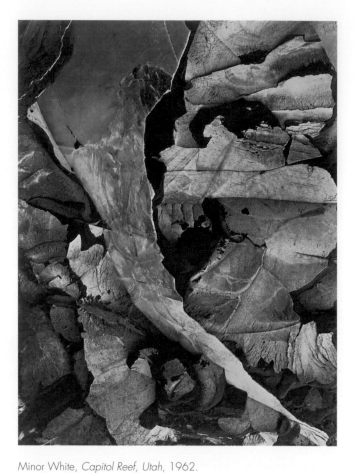

Minor White, *Capitol Reef, Utah*, 1962.

© 1982 The Trustees of Princeton University, Courtesy of the Minor White Archive.

apertures. Weston was a central figure in this school of photography, and the clarity and directness of his vision has had a major effect on art photography as practiced to this day. For a fascinating insight into the mind of a practicing artist, read Weston's *Daybooks*.

Although the straight approach to photography demands an unmanipulated use of the materials, a wide variety of visual styles can be achieved. The work of the Group f/64 members and other practitioners of the straight approach such as Brett Weston, Wynn Bullock, Paul Caponigro, Aaron Siskind, and Minor White shows distinctly personal approaches to photography as an expressive medium.

Most of the work of these photographers was done in black and white, but Edward Weston did some work in color and a number of contemporary photographers have explored similar working techniques using color.

This group of straight photographers worked almost exclusively with large-format view cameras on tripods—a working method still alive and well—but straight photography today covers a wide variety of visual approaches and equipment, including small hand-held cameras.

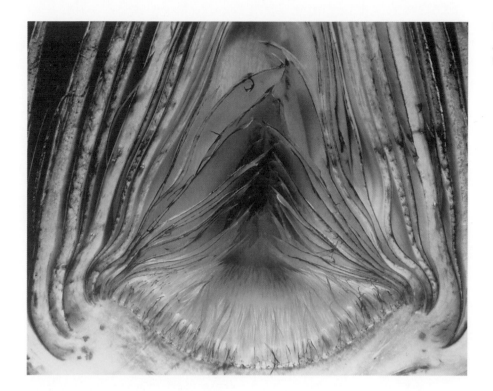

Edward Weston, *Artichoke Halved, 1930.*

© 1981 Center for Creative Photography, Arizona Board of Regents.

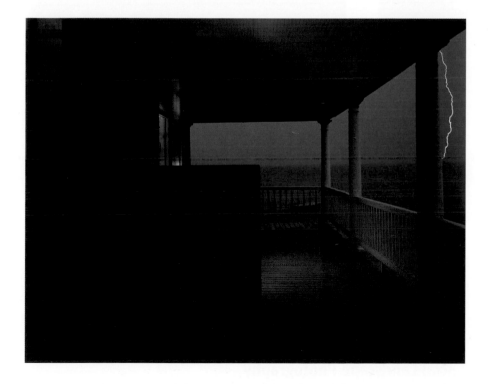

Joel Meyerowitz, *Provincetown Porch (series) #431.*

© Joel Meyerowitz. Photo courtesy of The Art Institute of Chicago.

## Bauhaus Movement

In the 1920s and 1930s the Bauhaus—a German school of architecture and design—was a center for artists influenced by a number of radical trends in art including dadaism, cubism, constructivism, and surrealism. Experimental work in photography was promoted by members of the Bauhaus like László Moholy-Nagy and independent photographers such as Man Ray, incorporating camera-less images, called photograms; extreme angles; photomontage; extreme close-ups; and a range of other techniques. Earlier experimenters with some of these techniques were Louis Ducos Du Hauron and Alvin Langdon Coburn.

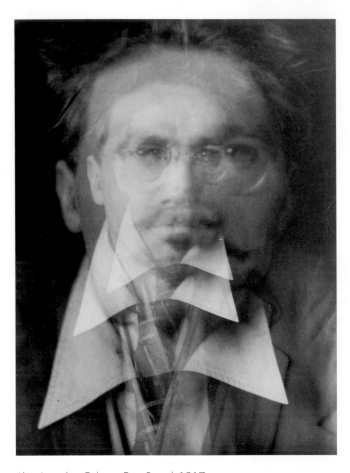

Alvin Langdon Coburn, *Ezra Pound*, 1917.

Courtesy of the International Museum of Photography at George Eastman House.

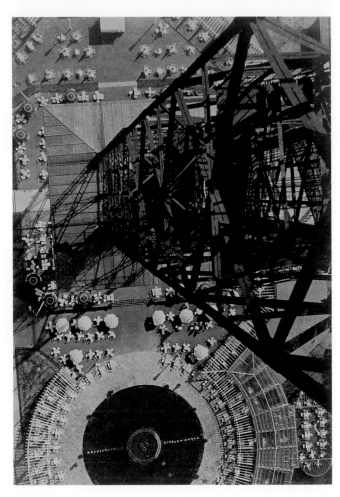

László Moholy-Nagy, Untitled, ca. 1928.

© Hattula Moholy-Nagy, Courtesy of The Art Institute of Chicago, All Rights Reserved.

## Social Landscape Photography

Since the birth of photography, photographers have been documenting the social landscape—the people, events, and artifacts that present a cultural and social picture for the times. Many of the photographs discussed previously are part of this broad category, and the work done falls under the umbrella of

straight photography. Most photographers recording the social landscape were concerned with a kind of truth that they felt the photographic process gave and for that reason did not manipulate the images in printing. War photographers, photojournalists, social documentary photographers—all contributed to this vast body of work. Although some of this work was done with a specific agenda—as were the Farm Securities Administration photographs or Hine's work—it was still performed in a way that attempted to be objective.

In the 1950s Swiss photographer Robert Frank used straight photography techniques in a new way to show the social landscape from a distinctly personal and idiosyncratic viewpoint. His photographs of America, published in the book *Les Americains* in 1958, raised considerable furor because of the uncomplimentary and, some felt, cynical view of America presented. Although Frank's technique can be classified as straight photography, his results, achieved with a hand-held 35mm camera, shared little in visual style with the photographs of Group f/64. Although somewhat formal, his images more often exhibit the loose composition and casual technical results associated with snapshots than the pristine technique and careful regard for visual structure associated with the West Coast group. Frank was a strong visual influence on a generation of photographers. (Because Mr. Frank has refused to allow publication of his photographs, no example of his work appears here.)

Other influential photographers of the social landscape in the 1960s and later include Diane Arbus, Lee Friedlander, Garry Winogrand, and Danny Lyon.

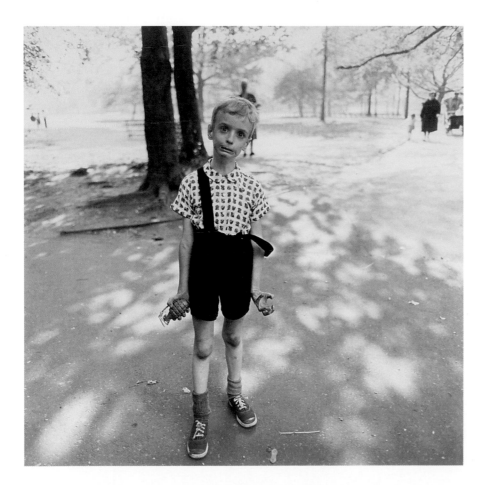

Diane Arbus, *Child with a Toy Hand Grenade in Central Park, New York City*, 1962. Arbus first started making photographs in the early 1940s, but it was not until 1955–57, while enrolled in courses taught by Lisette Model, that she began to seriously pursue the work for which she has come to be known. Often thought of as a photographer of the fringes of society—those considered to be social aberrants or freaks—Arbus also frequently photographed middle-class Americans. More than just a documentation of different stratas of society, her photographs seem to draw viewers into a powerful confrontation with their own preconceptions and prejudices.

© Estate of Diane Arbus 1972.

## Conceptual Photography

Since *concept* simply means idea, all art is essentially conceptual. The idea may be simply to present a beautiful, aesthetically pleasing object to the viewer. On other levels the beautiful object could have associative properties or content that conveys some message to the viewer. Traditionally, the production of a pleasing physical object has been the goal of an artist, even when deeper levels of idea are intended. Some artists have rebelled against this view of art. When the dadaists in the early part of the twentieth century placed mink-lined coffee cups or urinals on display in galleries and museums, the intent was not to provide a beautiful art object to the public but instead to challenge people's ideas of what art was all about. In other words, the object itself was only incidental to the concept.

Art where the object created is of secondary importance to the idea is called **conceptual art.** Sometimes the conceptual artist produces an object that is only temporary, or does not produce an object at all but simply orchestrates an event. Photography has often been used to document conceptual art. The resulting photographs are not, strictly speaking, art objects themselves but simply evidence of the concept. In photography some conceptual work has been done that plays on the characteristics of the medium.

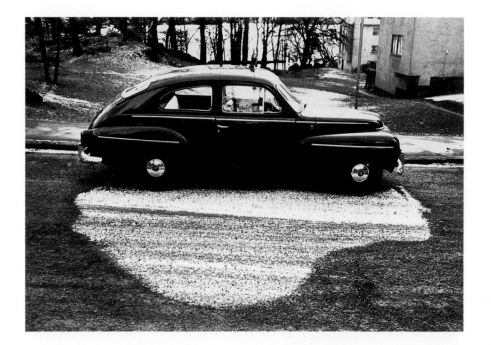

Kenneth Josephson, *Stockholm, 1967*. In his image of a car mirrored by its shadow in snow, Josephson is making a sly conceptual comment on the positive/negative nature of the photographic medium.

© Kenneth Josephson, Collection, The Museum of Modern Art, New York.

## Current Directions

Photography today offers a variety of possible stylistic directions. Many of the historic styles are still pursued by contemporary photographers. Vital work is being produced in the style of straight photography as well as the subjective realism typified by Frank's work. Old processes are being revived. Multiple printing techniques and many other special techniques are employed for breaking out of the boundaries of the straight photograph. Combinations with other media are being explored. Technology, especially computers and the digitizing of images, has opened new frontiers in the creation of images.

With photography firmly established as an art form, photographs are appearing on the walls of nearly every venerable museum and gallery. The work of contemporary photographers makes it clear that many can link choice of technique, craft, and concept into exciting new work.

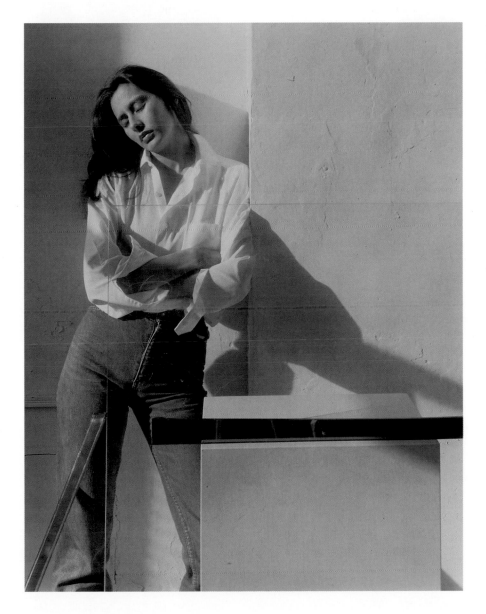

Marsha Burns, from *Postures*, 1978/33. Burns combines the luminous qualities of traditional photographic printmaking with contemporary style and attitude.

© Marsha Burns.

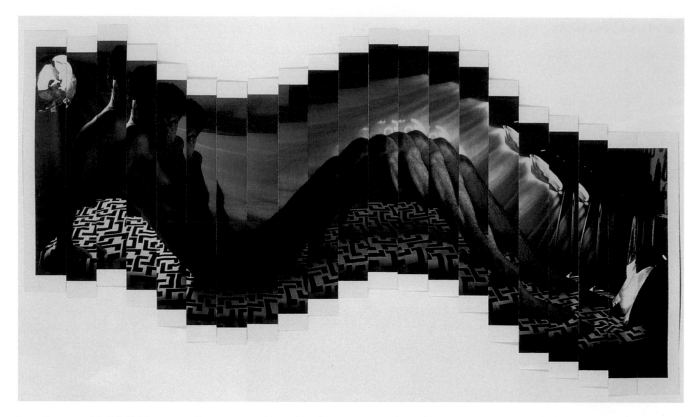

Lucas Samaras, 10/19/84 Panorama. Samaras assembles Polaroid prints into a single work.

© Lucas Samaras, Courtesy of Pace/MacGill Gallery, New York.

John Pfahl, *Blue Right Angle, Buffalo, New York, 1979,* from the series *Altered Landscapes.* Although this looks like an altered photograph, in fact the blue marks are material carefully placed on the subject, altered in size, shape, and position so that they appear to be a uniform geometric shape superimposed on the photograph.

© John Pfahl, Courtesy of the Janet Borden Gallery.

Bea Nettles, *Tomato Fantasy,* 1976. This image was done using the Kwikprint process, which gives considerable freedom in the coloration and assemblage of images.

© Bea Nettles, Courtesy of the International Museum of Photography at George Eastman House.

# ■ Styles and Trends in Applied Photography

Applied photography is the creation of photographs with a specific purpose on commission for clients and includes a number of specialties such as portrait, fashion, wedding, advertising, architecture, and scientific photography. Early applied photography usually involved the production of a simple record or document of some object. As the power of the photograph to convey ideas, moods, and feelings became more evident, commercial users began to expect more than a simple rendering of the subject matter. Concept and style became more important.

The stylistic trends in applied photography roughly parallel those in photography as art. The early portrait studios photographed in the style of the portrait painters of the day, as did the art photographers. As art photography began to explore the more photographic qualities of the medium, so did applied photography. Although much of applied photography is a committee effort, involving concepts and styles dictated by the client or the ad agency, the photographer has artistic control often enough that individual style begins to emerge.

The nineteenth century saw the development of an attitude that established a clear division between art performed for commercial purposes and "true art" created out of the soul of the artist for no monetary gain. The "best" art seemed to be associated with the idea of the starving artist laboring in a garret. Before this romantic idea of the process of art, no stigma was attached to art for commerce and nearly all art was produced on commission.

In the past—with the exception of the period of time in the 1920s and 1930s mentioned earlier—it was often difficult for an art photographer to establish a reputation if it was known that she or he also did commercial work. A good deal

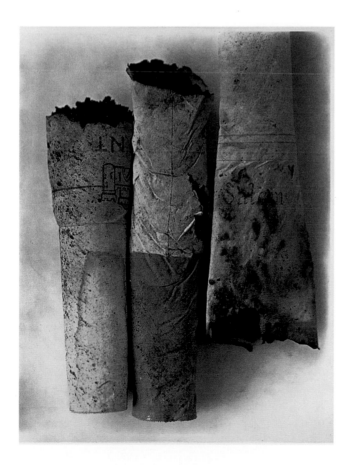

Irving Penn, *Cigarette No. 37*, 1972. Platinum Print. Penn has had a long commercial career doing fashion, still life, and portrait photography, but he has also shown his photographs in prestigious museums and galleries and his prints are sought-after collectors' items.

© 1974 Irving Penn.

Annie Leibovitz, Greg Louganis, 1984, Los Angeles, California. Leibovitz came to fame as a photographer for *The Rolling Stone,* and is noted for her portraits of famous people produced for many publications. She has also done commissioned photography for advertising, but at the same time her photographs show in museums and galleries, and sell well to collectors of art photography.

© 1991 Annie Leibovitz/Contact, from the book Photographs Annie Leibovitz, 1970–1990.

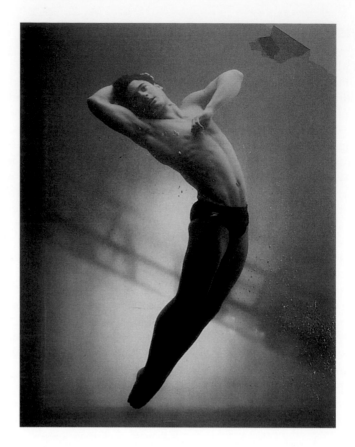

of the attitude that a piece of art is somehow lessened when it is produced for a commercial purpose still exists, but the current trend is toward acceptance of creative and interesting photography, regardless of the basis for its original conception. Photographers increasingly cross over, with those who began as artists successfully breaking into the commercial field and those who have long been commercial photographers showing and selling in art galleries and museums. Although most of the photographs shown for sale are personal work intended as art, now even photographs originally produced for commercial purposes are being shown and sold as art.

## ■ READING LIST

Frizot, Michel. *New History of Photography.* Koneman, 1999.

Gassan, Arnold. *A Chronology of Photography.* Athens, Ohio: Handbook Company, 1972.

Gernsheim, Helmut, and Alison Gernsheim. *A Concise History of Photography,* 3d ed. New York: Dover Publications, 1986.

Newhall, Beaumont. *The History of Photography from 1839 to the Present Day.* Rev. ed. New York: New York Graphic Society, 1978.

———. *The Latent Image: The Discovery of Photography.* Garden City, N.Y.: Doubleday, 1967.

Rosenblum, Naomi, *A World History of Photography,* 3d ed. New York: Abbeville Press, 1997.

# PART III

# Advanced Techniques

# CHAPTER 11

# Special Techniques

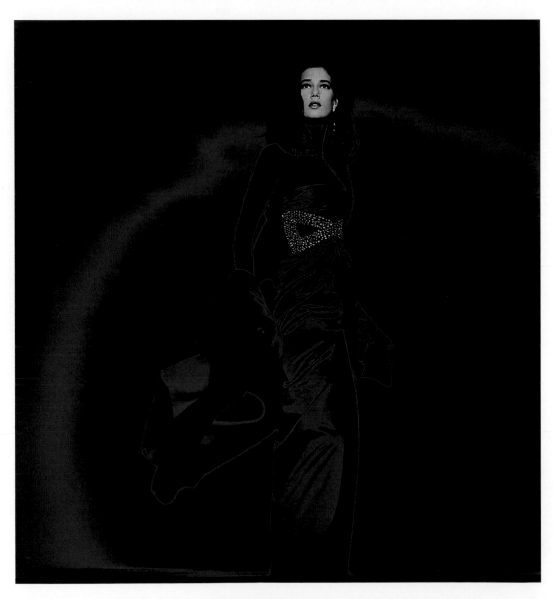

Bill Silano, "Night Lights."

© Bill Silano. Reproduced with permission from Harper's Bazaar.

In addition to the basic shooting, processing, and printing methods discussed in earlier chapters, photography offers a variety of shooting and darkroom techniques for altering or improving the final image. Some of these techniques are subtle enhancements of the quality of an image; others can so radically manipulate the appearance of a photograph that the boundaries of what is and is not photography are challenged.

This chapter introduces some of these techniques, briefly describing their technical processes. For more complete instructions and discussions, refer to the publications in the reading list at the end of the chapter.

## ■ Special Shooting Techniques

Some alterations of an image can be done in-camera, through either special equipment or special materials. Most of these techniques involve a gentle expansion of photographic vision past the normal point of view or interpretation of the subject, such as by using filters or close-up equipment. Others offer extreme modifications of the photographic rendition, as with special films and multiple exposures.

## Filters

Chapter 6 introduced filters for use with variable-contrast printing papers. Different types of filters can also be used on the camera to modify an image. A photographic filter is made of a transparent material—glass, plastic, or gelatin—with dyes incorporated so that it selectively removes specific colors or wavelengths of the light that passes through it.

Most filters require exposure corrections. See the boxed section, "Exposure Correction with Filters" on page 307.

**Filters for Black-and-White Films**   Some filters are designed primarily for black-and-white films, but others can be used with either black-and-white or color films.

Filters designed specifically for use with color films are discussed in chapter 12.

**Color Contrast Filters**   When a filter removes a specific color of light, the result is that any subject matter of that color receives less exposure on the film and reproduces darker in the print. Filters used to change the relationship of subject tones in this way are called **color contrast filters.**

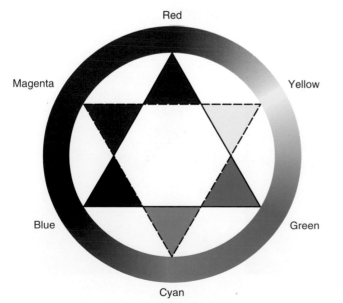

Red + Blue + Green =
White Light

Additive Primaries Are
Red, Blue, and Green

Additive Primary +
Complement =
White Light

Red + Cyan =
White Light

Blue + Yellow =
White Light

Green + Magenta =
White Light

The photographic color wheel tells how the colors of light mix and can help in predicting the effect of color contrast filters. Because of the way the human eye responds to color, white light can be thought of as a mixture of equal amounts of red, blue, and green light, called the **additive primaries.** The other colors on the wheel are mixtures of the additive primaries: red + blue = magenta; blue + green = cyan; red + green = yellow. Colors opposite on the wheel are called **complementaries.** White light results from adding any two complementaries. For example, blue + yellow = blue + (red + green) = white light.

A red filter appears red because it allows red light to pass, absorbing the other colors of light (i.e., blue and green). A pure red filter would let through only red light, but most filters allow amounts of adjacent colors to pass as well, filtering mostly the colors opposite on the color wheel, especially the complementary. A red filter therefore filters out cyan, blue, and green but usually allows some magenta and yellow to pass. In general, in the print a filter darkens most strongly its complementary color. A yellow filter darkens blue (and usually magenta and cyan), a red filter darkens cyan (as well as blue and green), and a green filter darkens magenta (as well as red and blue). The reverse works as well: a blue filter will darken yellow (as well as red and green) and so on.

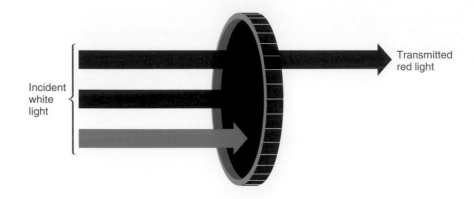

Incident white light

Transmitted red light

Filter exposure corrections as described on page 307 must be applied in each case. Color contrast filters cannot be used with color films for selective darkening of subject tones, since the film will record the actual color of the filter.

A filter cannot lighten an area. It can only darken the colors opposite it on the color wheel. The reason the red stop sign appears lighter is because of the exposure compensation given to the film.

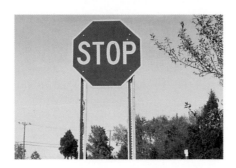

No Filter.

Red Filter.

A cyan, bluish-green, or green filter will darken the reds in a portrait, giving darker lips and a more dramatic look.

No Filter.

Blue-Green Filter.

No Filter.

A common use of color contrast filters is darkening a blue sky with a yellow, orange, or red filter. A yellow filter helps to compensate for the excessive blue sensitivity of most black-and-white films, giving a rendition closer to the way the eye sees the subject. Notice that the red filter darkens the sky more than the yellow, even though the sky is seen as blue. This is because the red dyes are more efficient and also because the sky often tends to be somewhat cyan in color.

© Bognovitz.

Yellow Filter.

Red Filter.

*No Filter.* If a color contrast filter is used to darken a specific area of the subject, don't forget that any other area containing colors near the complement of the filter will also be darkened in the print. Here the photographer wished to darken the sky.

*Red Filter.* A red filter was used to darken the sky, but the trees, shadow areas, and other areas containing blue, cyan, or green darkened as well. Landscape shadows are usually illuminated by cyan light, which is a mixture of light reflected from the sky and surrounding foliage. The red filter absorbs some of the cyan light, darkening the shadows and creating an apparent increase in contrast.

**Polarizing Filter**  Polarizing filters can be used to eliminate some reflections, reduce glare, and darken skies, but their applications are limited because of the nature of polarized light. The effect of a polarizing filter is judged by looking through it while rotating it. Good polarizing filters include a rotating mount that allows proper orientation.

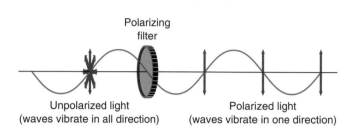

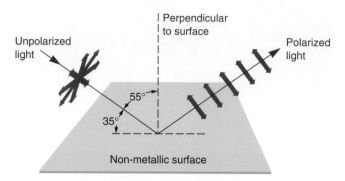

*Nature of Polarized Light.* Light is a waveform of electric and magnetic energy. In normal light the waves are vibrating in random directions. In polarized light the waves all vibrate in the same direction. The eye cannot distinguish between polarized and nonpolarized light. A polarizing filter removes all but the light vibrating in one direction, thus polarizing any random light passing through it. If a polarizing filter is rotated, the wave orientation of light allowed to pass is changed. Light that is polarized before reaching the filter can therefore be allowed to pass or be absorbed, according to the orientation of the filter.

*Polarized Light in Reflections.* Polarized light appears in nature under specific circumstances. Light reflected from nonmetallic surfaces at an angle of 35° is polarized and can be filtered out by orienting a polarizing filter against its direction. Nonmetallic surfaces common in photographs include water, glass, sand, and rock. Reflections not satisfying these strict requirements cannot be eliminated with a polarizing filter. Reflections off many nonmetallic surfaces appear as glare. If viewed at an angle of 35° glare can be eliminated or reduced with a polarizing filter.

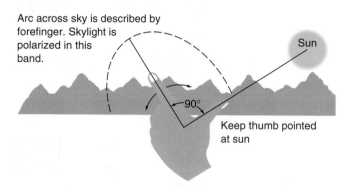

*Finding Polarized Areas of the Sky.* The light coming from the sky is reflected from the atmosphere, and as a result some of it is polarized. To find out where polarized light comes from the sky, follow the 90°-to-the-sun rule. Holding your index finger and thumb at right angles, rotate your index finger while keeping your thumb pointed at the sun. Your index finger will describe an arc in the sky where the skylight is polarized. At noon, light from the sky is polarized all around the horizon. A polarizing filter can be used to darken any area of the sky reflecting polarized light.

*Exposure Corrections.* The amount of exposure correction for a polarizing filter depends upon the amount of polarized light in the subject and the orientation of the filter, so the easiest way to get exposure corrections is to meter through the filter. Some cameras using semisilvered mirrors for metering may not give the correct exposure when metering through a standard polarizing filter with the TTL meter, requiring the use of a special polarizer called a circular polarizing filter. Refer to the factory specifications of your camera to see if it falls into this category. Since polarizing filters are neutral in color—in other words do not selectively filter out any particular color—they may be used with color film as well as black-and-white.

No Filter.

Polarizing Filter Used to Eliminate Reflections. Note that the reflection of the car is not eliminated because it is not at an angle of 35°.

Photos © Bognovitz.

No Filter.

Polarizing Filter Used to Reduce Glare.

No Filter.

Polarizing Filter Used to Darken the Sky.

Photos © Bognovitz

**UV Filter**   The UV filter removes ultraviolet (UV) radiation. Although our eye is not sensitive to UV, photographic films are, usually resulting in a somewhat hazy look in situations where a good deal of UV is present such as in mountain and ocean scenery. UV filters may be used with color as well as black-and-white films.

No Filter.

UV Filter.

**Neutral Density Filters**   Neutral density filters are neutral in color and can be used with both black-and-white and color films. They have no effect on the tonal relationship of various subject colors but simply reduce the overall exposure on the film. This is convenient if a larger aperture (for less depth of field) or slower shutter speed (for a feeling of motion) is desired but the light

Wynn Bullock. *Sea, Rocks, Time, 1966.* Neutral density filters were placed in front of the camera lens to give an exposure time of three minutes during daylight, blurring the action of the surf on the rocks. A red filter was also used to darken the sky.

© Wynn Bullock, Courtesy of the Wynn and Edna Bullock Trust.

## Exposure Corrections with Filters

Since a portion of the image light is removed by a filter, additional exposure must be given. Two basic ways of making filter exposure corrections can be used: metering through the filter and multiplying exposure by a filter factor.

### Metering through the Filter

If the filter is placed over the light meter while metering, a close approximation of the correct exposure will be found. Cameras with TTL metering will automatically take account of the loss of light due to the filter if the meter reading is taken after the filter is attached to the lens (see page 304 for special information on using TTL readings with polarizing filters). This method is less convenient for hand-held meters, since the filter would have to be removed from the camera for metering, then replaced for making the exposure. Metering through the filter will give generally acceptable results, but differences in the color sensitivity of films and meters may produce slight variations in expected exposure.

### Multiplying Exposure by a Filter Factor

The literature packed with a filter should give a **filter factor.** Multiply the exposure indicated by the meter without the filter by the filter factor to produce correct exposure with the filter. Filter factors should be applied when it is impractical to meter through the filter.

A multiplication sign following the filter factor indicates that it is a multiplication factor. For a filter factor of 2×, double the exposure time or open up one stop. If more than one filter is used, multiply the factors to find the total filter factor. The total filter factor for two filters with factors of 2× and 3× is 2 × 3 = 6 ×, about two and one-half stops more exposure. The filter summary chart on page 300 gives the conversion from filter factor to amount of exposure increase in stops. Manufacturers may give the needed exposure increase in stops rather than as a filter factor.

Some light sources have a preponderance of one or more colors. Tungsten light, for example, has more yellow and red in it than does daylight. The amount of light removed by a filter—and therefore the filter factor—varies with the color of the light. The filter factors for tungsten light and daylight are usually provided, and these are indicated in the filter summary chart when appropriate. ■

is too bright. Neutral density filters also allow the use of fast films in bright light.

The amount of exposure change for a neutral density filter is indicated by a density number. A filter marked ND 0.3 requires one stop more exposure. Densities add, so a filter marked ND 0.6 requires two stops more exposure, and so on. Stacking two or more neutral density filters will yield higher values. For example, ND 0.3 and ND 0.6 add to give ND 0.9, or three stops change in exposure. Some neutral density filters may be marked in filter factors (see the boxed section above) or stops rather than density. For example, a typical sunlight camera setting for a film of ISO 125 is f/5.6 at 1/1000 second. For shallow depth of field, an aperture setting of f/2.8 might be desired, requiring a shutter speed of 1/4000 second. If the fastest speed on the camera is 1/1000 second, neutral density filters with a total exposure correction of two stops (ND 0.6) could be added to allow shooting at f/2.8 at 1/1000 second.

**Diffusion Filters** Filters that scatter (diffuse) some of the light passing through them are called diffusion filters and are used to soften an image. The effect of a heavy diffusion filter is to scatter light areas into dark, giving a light, glowing, "romantic" look to the image. Slight diffusion can also be used to reduce the appearance of skin flaws and character lines in portraiture and fashion photography. Filters may be purchased with varying amounts of diffusion or can be improvised with window screening, nylon netting, or nylon stocking material stretched over the lens. Applying hair spray or rubbing a petroleum jelly like Vaseline on a clear glass filter will provide extreme diffusion. The amount of diffusion varies with the f-stop.

Using a diffusion filter on the enlarger while printing a negative will not yield the same effect, since the most light in the negative comes through the areas representing the dark tones of the subject. The result is a scattering of dark areas into light areas, typically producing a subdued, muddy-looking image. Most diffusion filters require little or no filter exposure correction, though any improvised diffusion filter should be metered through to find correct exposure. Diffusion filters are neutral in color and can also be used with color film.

No Filter.

Moderate-Diffusion Filter on Camera.

Heavy-Diffusion Filter on Camera.

Heavy-Diffusion Filter on Enlarger.

© Bognovitz.

**Special Effects Filters**   A number of filters are commercially available that optically alter the image to produce special effects, from multiple image prism effects to star patterns. Special effects filters can also be improvised using any transparent material that optically distorts the image. Usually exposure corrections are low for these filters but vary with the type of effect. Most can be used in either black and white or color, though some are specifically designed for color effects that cannot be reproduced in black and white.

*Special Effects Filter.* The subject before the camera was a single cup and saucer. The five images of the cup around the outside were produced by prisms in the filter.

© Bognovitz.

### Summary of On-camera Filters for Black-and-White Films

| NAME (DESIGNATION) | DESCRIPTION AND USE | FILTER FACTOR* DAYLIGHT | FILTER FACTOR* TUNGSTEN |
|---|---|---|---|
| Blue (47) | Absorbs red, yellow, and green. Used to darken red or yellow subject matter or to increase the appearance of haze. | 6× | 12× |
| Light Blue-Green (44) | Absorbs magenta, red, yellow, and ultraviolet. For portraits, darkens lips and ruddiness in cheeks. | 4× | 8× |
| Yellowish Green (11) | Absorbs blue, violet, ultraviolet, and magenta. Used to darken skies without darkening green foilage. | 4× | 3× |
| Yellow (8) | Absorbs violet, ultraviolet, and some blue. Darkens skies and other blue subject matter. Darkens haze. | 2× | 1.5× |
| Deep Yellow (15) | Absorbs blue, violet, and ultraviolet. Darkens skies and other blue subject matter with more effect than yellow (8). | 3× | 2× |
| Orange (21) | Absorbs blue, violet, and ultraviolet, and some green. Darkens sky more effectively than yellow (8) or deep yellow (15). May slightly darken greens. | 4× | 2.5× |
| Red (25) | Absorbs green, cyan, blue, and ultraviolet. Darkens sky with more effect than orange (21). Darkens foliage, haze, and shadows in landscapes. | 8× | 5× |
| Polarizing | Absorbs polarized light when properly oriented. Can reduce or eliminate reflections and glare from nonmetallic materials such as water, rocks, glass, etc. at 35°. Darkens the sky at 90° from the sun. | minimum 2.5× | |
| UV | Absorbs ultraviolet light. Has no visible color. Reduces the appearance of haze in scenes with high UV content (seascapes and mountain landscapes). Can be used as a protective cover for lens. No exposure correction needed. | 1× | 1× |
| Neutral Density (ND) | Reduces amount of exposure on film. Used to provide larger apertures or longer exposure times for creative effect. Open one stop for each increment of 0.3 neutral density. | depends on density | |

*Filter factors given here are approximations to be used only as starting points for calculating exposure corrections.
NOTE:  For a complete description of filters for both color and black-and-white films, see the Kodak publication B-3, *Kodak Filters for Scientific and Technical Uses.*

### CONVERSION FROM FILTER FACTOR TO STOPS

| Filter Factor | 1 | 1.3 | 1.6 | 2 | 2.5 | 3 | 4 | 5 | 6 | 8 | 10 | 12 | 16 | 32 |
|---|---|---|---|---|---|---|---|---|---|---|---|---|---|---|
| Open up (Stops) | 0 | ⅓ | ⅔ | 1 | 1⅓ | 1⅔ | 2 | 2⅓ | 2⅔ | 3 | 3⅓ | 3⅔ | 4 | 5 |

*On-camera Filter Types.* On the left and right are custom screw-mount glass filters. At top center are optical-grade plastic filters with holder. In the foreground center are gelatin filters with holder.

**Filter Types**   Filters for use on the camera must be optically flat to prevent deterioration and distortion of the image. The filters that satisfy this requirement are made of high-quality optical glass or of gelatin. Filters made of other materials, such as acetate, are usually not suitable for introduction into the image path and should be used only for filtering the light source. A few filters on the market are now made of optical-quality plastics, but the highest-quality filters are still produced from glass or gelatin.

**Glass Filters**   The most popular filter configuration is the custom screw-mount glass filter. The glass is mounted in a threaded ring that screws into the threads on the front of the lens. These filters must be purchased in the correct size for the front diameter of each lens. The diameter is normally given in millimeters.

This can be an expensive proposition if a set of filters must be purchased for each lens of differing front diameter. The solution is to buy a filter large enough to cover the largest lens diameter, then purchase adapter rings—often called step-up rings—to fit the filters to lenses of smaller front diameter. Series filters are designed around this idea, but step-up rings can be purchased for nearly any size of filter.

If the largest filter needed is 62mm in diameter, a 47mm–62mm step-up ring will allow fitting this filter on lenses with a 47mm-diameter screw-mount. Since the adapter rings cause the filter to extend farther out from the lens, be careful that the addition of other accessories, such as lens shades, does not cause vignetting—a blocking of the image around the edges.

Glass filters are manufactured in different ways, but usually a good indication of the quality of a filter is the price. It makes no sense to place a cheap, low-quality filter on an expensive, high-quality lens. Even the best filters cause a slight deterioration of image quality, so for maximum image quality filters should only be used when necessary.

**Gelatin Filters**   Gelatin filters consist of a dyed layer of gelatin that is carefully lacquered on each side for protection. These filters can be used in the image path and have the advantage over glass filters of being extremely thin. This is important if more than one filter is to be used on a lens at a time, as the image deterioration is related to the thickness of the filters. Gelatin filters are not mounted in a frame of any sort but most commonly come as simple 3 × 3-inch squares. A holding frame must be purchased separately for mounting them in front of the lens. Gelatin filters used to be much less expensive than quality glass filters and were therefore often purchased for infrequent use. Today the price differential is not as great, so they are used mostly in professional applications where several filters must be employed at once.

**Acetate Filters**   Acetate filters are much less expensive than other types of filters, but they should not be used in the image path, since they are not optically flat. They are convenient for filtering light sources and for use in enlarging where they are placed in the lamp housing.

**Care and Handling of Filters**   Filters to be placed in the image path should be treated with the care accorded lenses, since any defects will affect the image quality. Keep them clean and free of scratches. Glass filters can be cleaned using the same procedures outlined for cleaning lenses on page 84. Gelatin filters are easily scratched and are nearly impossible to clean without damage if

fingerprinted, so they must be handled with great care. Acetate filters are susceptible to scratching and fingerprinting and should be handled with care, although small defects are less important here, since these filters are not being placed in the image path.

**Filters as Lens Protection**   It is often recommended, especially by camera stores, that a filter be left on the lens at all times to protect the front element of the lens from damage. Since any filter causes slight image deterioration, the use of a filter for lens protection exacts a small price in image quality. When working in situations where the lens is exposed to possible damage—from blowing dirt, saltwater spray, scratching, or other rough handling—a protection filter is a good idea, since it is cheaper to replace than the lens. In other situations, where maximum image quality is desired, the filter should be removed.

The best filters to use for protection are either clear optical glass, which has little effect on the image and transmits all colors of light relatively equally, or the ultraviolet (UV) filter, which filters out ultraviolet light invisible to the eye but not to the film. Since the effect of ultraviolet light on the film is generally undesirable, the UV filter is often a best choice, and it is more generally available than clear glass.

The skylight (1A) filter is often recommended as a protection filter, but it is not a good choice if any color transparency film is to be used, since it is designed for altering the color of the light and will have a visible effect on the color of the slides.

See pages 341–43 for more information on the skylight filter and other filters for use with color films.

## Close-Up Photography

Normal lenses designed for most single-lens reflex cameras will focus reasonably close to the subject, usually about 18 inches away. At this distance the amount of subject shown covers an area approximately 6 × 9 inches with a 35mm camera. Anything closer than this requires special equipment and techniques and is generally called close-up photography.

The size of the image produced on the film can be compared with the size of the original subject, given in the form of a ratio. The size of this ratio indicates the magnification of the subject. Magnification of the subject is increased by moving the lens closer to the subject.

For example, the image dimensions of a 35mm negative are about 1 × 1.5 inches (24 × 36mm). If the subject size included is about 6 × 9 inches (144 × 216mm), the image is 1/6 the size of the original subject. The magnification is therefore 1/6 and the image ratio is 1:6.

If the image on the film is the same size as the subject, the image ratio is 1:1. If the image is larger than the subject, the magnification is greater than one. An image ratio of 2:1 means the image is twice as large as the subject— the magnification is 2×. On a 35mm negative the subject area covered at 2:1 would be 0.5 × 0.75 inch (12 × 18mm).

To focus closer with a lens, which increases the magnification, the lens must be moved farther from the film. The distance between the lens elements and the film—the **lens extension**—needed depends on the focal length of the lens, with longer focal length lenses requiring more extension for the same image magnification.

If the focus mechanism built into a lens has been extended to its maximum, other techniques must be used for increasing the lens-to-film distance. These are called **photomacrography** techniques. Photomacrography seldom

Most photographers use the term macrophotography, although photomacrography is technically more correct.

produces image magnifications exceeding 3× or 4×, although somewhat higher magnifications can be achieved with difficulty.

Even greater magnification is possible by optically coupling the camera to the lens system in a microscope, a process called **photomicrography.** The greatest magnifications are achieved by photographing the electronic image produced by electron microscopes. Photography's ability to record these unusual views of nature is one of its most fascinating and vision-expanding possibilities.

Michael Furman. Photomacrograph.

© 1989 Michael Furman Photographer, Ltd.

William Marin. Photomicrograph of ancient cast bronze, viewed with polarized illumination at 400× magnification.

© Comstock. Inc.

David Scharf. Honeybee's eye. Photographed with an electron scanning microscope.

© David Scharf, 1977.

**Photomacrography**   The tools and techniques required for photomacrography are usually within reach of the average photographer. Any of these techniques is most easily performed with single-lens reflex cameras with interchangeable lenses, though other cameras can be used with some difficulty in attaching accessories and viewing.

**Tools for Photomacrography**   Four devices are used for closer focusing: extension tubes, macro lenses, bellows attachments, and supplementary close-up lenses. The first three work by increasing the lens-to-film distance, and the last one works by optically magnifying the image.

Any of these tools used for closer focusing can be combined for even greater image magnification. For example, extension tubes or a macro lens can be used in combination with a bellows. Supplementary close-up lenses can also be combined with lens extension devices up to a point, but the image deteriorates rapidly at higher magnifications.

*Macro Lens.* A lens with extra focusing extension built into the lens body is called a macro lens. A true macro lens is also optically designed for working at very close focusing distances and will usually provide a 1:2 image ratio without additional attachments, at the same time having the capability to focus on objects at infinity. Some macro lenses feature up to a 1:1 image ratio with the built-in focusing. Many lenses offering a "macro" feature are not true macro lenses (see page 81).

*Extension Tube.* Extension tubes are metal tubes designed to fit between the lens and the camera body and are therefore custom designed to fit the lens mount of the camera. They normally come in sets of several different lengths so that a range of image magnifications can be chosen. Some extension tubes contain the necessary coupling levers for the operation of the automatic diaphragm; others may not. If automatic diaphragm operation is not supported, focusing and composing must be done by opening up the aperture, then stopping down to the desired aperture before shooting.

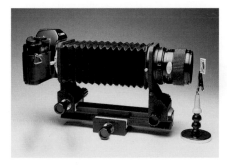

*Bellows Attachment.* The bellows attachment is designed to be mounted between the lens and the camera body and has a flexible cloth or plastic bellows that allows easy choice of lens extension. With a normal lens on a 35mm camera a bellows will usually offer image magnifications from about three-fourths life size to three times life size. Because of the minimum extension introduced by the bellows with lens and camera mounts, a lens mounted on a bellows cannot be focused on more distant subjects. Although more flexible than extension tubes, bellows attachments are typically more expensive, more delicate, and somewhat more clumsy in operation.

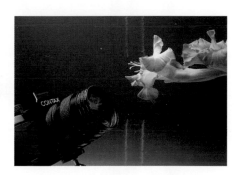

*Supplementary Close-up Lenses.* These are attached to the camera lens like filters but have curved surfaces to produce a magnification of the image. Supplementary lenses may often be the cheapest way of getting into close up photography, but the introduction of additional lens elements deteriorates the image quality, especially at the higher image magnifications in macrophotography. For better image quality, use the more expensive two-element supplementary close-up lenses available from a few manufacturers.

**Techniques for Photomacrography**   The magnification of a photographic image carries with it certain technical problems that must be solved, among them exposure changes, depth-of-field changes, and camera and subject movement.

Depth of field becomes smaller the closer a lens is focused. At the focusing distances used in photomacrography, depth of field becomes so small that it is usually necessary to work at the smallest possible apertures, such as f/16 or f/22. Even then depth of field may be only fractions of an inch.

Any extension of the lens causes a reduction in the brightness of the image on the film. In photomacrography, these changes become appreciable enough that exposure corrections must be made.

*Exposure Corrections for Photomacrography.* If you have a TTL viewing system, view a ruler marked in inches through the viewfinder and note the length of ruler visible across the long dimension of the frame. Find this length in the column for your format size in the table. Reading across the table will give you the image ratio, image magnification, and the necessary exposure correction, either in stops or as a multiple of the exposure time. The corrections are often made by altering the exposure time or, with flash, by changing its power or distance, since the aperture is usually kept small to provide depth of field. Supplementary close-up lenses do not require these exposure corrections. The reduction in image brightness caused by lens extension is sensed by through-the-lens meters, so no corrections need be applied when metering through the lens with the close-up equipment in place.

| LENGTH OF RULER SEEN IN VIEWFINDER IN INCHES (ACROSS LONG DIMENSION OF FRAME) | | | | | | EXPOSURE CORRECTIONS | |
|---|---|---|---|---|---|---|---|
| 35mm | 6 × 6 or 6 × 4.5 | 6 × 7 | 4 × 5 INCH | IMAGE RATIO | MAGNIFI-CATION | OPEN UP (STOPS) or | MULTIPLY TIME BY |
| ½ | ¾ | ⅞ | 1¹¹⁄₁₆ | 3:1 | 3× | 4 | 16.0 |
| ¾ | 1⅛ | 2⅜ | 2½ | 2:1 | 2× | 3⅓ | 9.0 |
| 1½ | 2¼ | 2¾ | 5 | 1:1* | 1× | 2 | 4.0 |
| 3 | 4½ | 5½ | 10 | 1:2 | ½× | 1⅓ | 2.25 |
| 4½ | 6¾ | 7¼ | 15 | 1:3 | ⅓× | ¾ | 1.78 |
| 6 | 9 | 11 | 20 | 1:4 | ¼× | ⅔ | 1.56 |
| 7½ | 11¼ | 13¾ | 25 | 1:5 | ⅕× | ½ | 1.44 |
| 15 | 22½ | 27½ | 50 | 1:10 | ¹⁄₁₀× | ⅓ | 1.21 |

*For 1:1 the film image is the same size as the subject (life-size).

The long exposure resulting from the small aperture and exposure correction for lens extension gives rise to two possible problems. The first is image blurring due to subject or camera motion. The second is reciprocity failure. Camera movement can be minimized by placing the camera on a solid tripod. Reciprocity failure can be compensated for using the chart in chapter 3 (pages 43–44). Both problems can be alleviated by supplying higher illumination levels on the subject. Many photographers working in photomacrography use electronic flash to provide high levels of illumination and short exposure times. However, unless your camera has the capability of coupling with the electronic flash to meter and control the flash exposure, the exposure corrections for lens extension will have to be applied manually. The flash power or the distance of the flash from the subject is then changed until the desired aperture is achieved.

# Special Films

A few photographic films are available for special uses. These were originally designed to solve specific scientific or technical needs, but the resultant image modifications can provide alternative renditions of subject matter for the creative photographer.

**Infrared Film**   Infrared films are specially designed for sensitivity to the invisible infrared wavelengths of light near the red end of the spectrum and are available in both black and white and color. These near-infrared wavelengths are not the longer wavelengths associated with heat. Special electronic techniques are needed to record the effect of heat infrared. Photography with infrared films therefore requires illumination of the subject by light containing infrared, which includes sunlight, tungsten light, and electronic flash.

Infrared film requires special handling. Since the 35mm film cassettes allow the passage of some infrared, the film must be loaded into the camera in total darkness, and the film cassette itself must never be exposed to light. Exposure of infrared film is somewhat difficult to determine, since photographic light meters do not indicate the amount of infrared light coming from a subject. Guidelines for determining exposure are supplied in the data sheet that comes with the film.

Since infrared films are also sensitive to visible wavelengths, the effect of the infrared on the film can most easily be seen if other wavelengths are filtered out by a deep red filter, such as a 25A or a 29. Filters that absorb most visible light but allow infrared to pass, such as the 87A, can also be used, but on single-lens reflex cameras such a filter would not allow composing or focusing through the lens. For flash photography the 87A filter can be placed over the flash instead. When the flash is fired, no visible light will result but enough infrared will be supplied to the subject to provide illumination for the infrared film.

© Bognovitz.

Panchromatic Film without Filter.

Infrared Film without Filter.

Infrared Film with 25A Red Filter.

Infrared Film with 87A Filter.

The lens focuses infrared rays differently than visible light, so adjustments must be made to the distances marked on the focus scale of the lens. Some lenses have a small red mark for focusing for infrared, but this is only an approximation, since the amount of focus correction depends on the focused distance and the aperture.

The qualities of infrared film are clearly shown in the illustrations and include a noticeable grain structure. This can sometimes be used to good effect, but if it is bothersome a larger-format camera should be used to produce a larger negative. Color infrared films will produce a variety of false colors depending on the filtration and are widely used in scientific photography, especially in satellite studies of vegetation.

Minor White. "Vicinity of Naples, New York," from *Sequence 10/Rural Cathedrals*, 1955. Taken on 4 × 5-inch infrared film.

© 1982 The Trustees of Princeton University, Courtesy of the Minor White Archive.

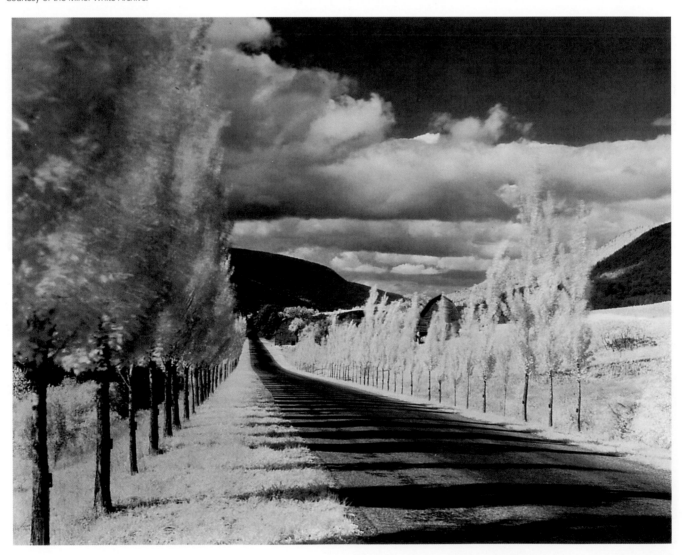

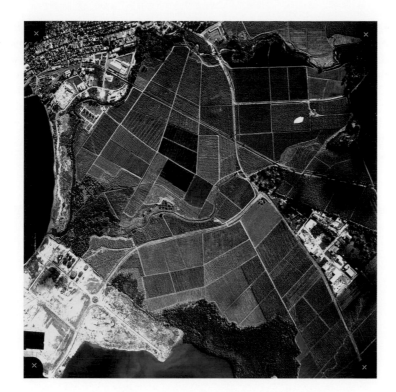

NASA. Color Infrared Aerial Photograph. Aerial infrared photographs clearly differentiate between urban and vegetated areas. Types of vegetation are easily distinguishable and even the health of vegetation can be determined. In this photograph of Jamaica, the various crops would appear as similar shades of green in a normal color photograph.

Courtesy of NASA.

**High-Contrast Film**   General-purpose films are called continuous-tone films, which means that they reproduce somewhat faithfully most of the tones in a subject. High-contrast films are designed to produce images from normal subjects that show only two tones in the print, black and white.

An example of a high-contrast film that can be used in 35mm cameras is Kodak Technical Pan. Developed in an active developer such as Kodak D-19, Technical Pan will produce a high-contrast image. Developed in Kodak Technidol developer, it gives a continuous-tone image. Images originally made on continuous-tone films can be modified by copying onto high-contrast sheet film designed for darkroom use, such as Kodalith Ortho Type 3.

See pages 323–25 for high-contrast printing techniques.

Print from Continuous-tone Film.

© Bognovitz.

Print from High-contrast Film.

© Bognovitz.

**Ultrahigh-Speed Films**   Several films with ISO numbers of 1600 or higher are available today, both in color and in black and white. High-speed films may also be push-processed for similar effect. The primary purpose is to allow low-light photography, but grain structure will also be coarse. Grain may carry emotional messages that can complement an image. Grainy black-and-white images may have a gritty feeling of reality, perhaps because of the widespread use of high-speed films in photojournalism. Grainy color images often carry a romantic feeling for many viewers, especially if image diffusion and pastel color rendition are incorporated.

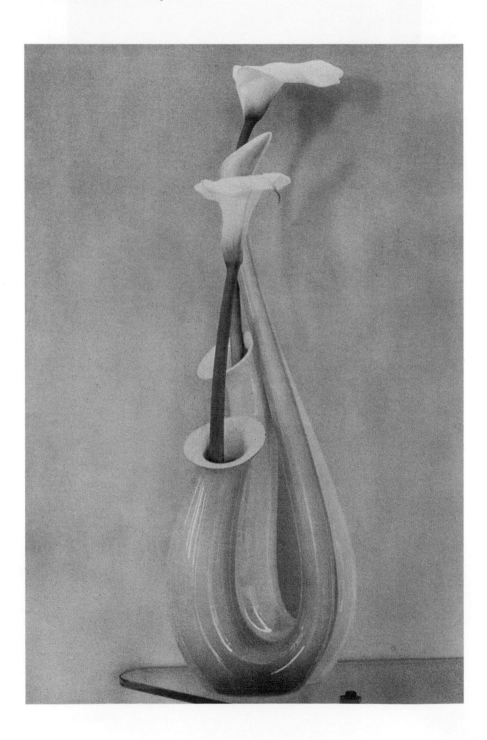

Use of Grain as an Aesthetic Element. Sheila Metzner, *Saxophone Vase 1985*.

© Sheila Metzner.

## Multiple Exposures

It is possible to make more than one exposure on the same frame of film, producing overlapping images. Multiple exposures can show the progress of an event in steps over time, or it can be used to superimpose two or more images to create unexpected relationships or new realities.

Two techniques can be used for multiple exposures. Some cameras will allow repeated exposures on the same frame by simply cocking and releasing the shutter as many times as desired. However, most modern small- and medium-format cameras include an interlock between shutter release and film advance that will allow only one exposure per frame. On manual advance cameras this interlock can sometimes be circumvented by holding the rewind clutch release button in while operating the film advance—the film being held in place with the rewind knob—but it is hard to prevent some small movement of the film during this process, making precise placement of succeeding images difficult. Multiple images can also be achieved by repeatedly flashing a subject with electronic flash while holding the shutter open on the B or T setting. This technique requires a dark working area—to prevent recording any continuous light during the long shutter opening—and a flash that can be set off manually.

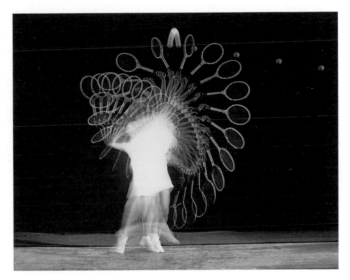

Harold Edgerton, *Gussie Moran*, (1949). This multiple exposure was achieved by keeping the shutter open and repeatedly firing an electronic flash tube at very short intervals. Electronic flash units designed to operate in this fashion are called **strobe** lights.

© Harold & Esther Edgerton Foundation, 1999, Courtesy of the Palm Press, Inc.

Jerry Lake, Untitled (palm leaves in the Philippines). This multiple exposure was achieved by opening the shutter more than once on the same sheet of film.

© 1985 Jerry Lake.

## ■ Special Darkroom Techniques

After the film is exposed, a number of manipulations are possible during the processing to create effects different from the standard rendition. Even for normally processed films an image can be modified through special printing techniques or by copying it onto special materials and then applying special processing techniques. The possibilities here are almost limitless. Refer to the many publications on special darkroom techniques—some of which are included in the reading list at the end of this chapter—for more detail on these and other manipulations. Also see chapter 13 for an introduction to special image manipulations available electronically with digital images.

■ **HEALTH NOTE** Many of these darkroom techniques involve the use of chemicals or materials that may be health hazards. Take care in handling any photographic chemical, using hand and eye protection and good ventilation. Follow directions carefully. Contamination of some materials may release poisonous gases. For more information on health hazards, see pages 92–93 and consult the reading list at the end of this chapter.

## Special Film Processing Techniques

**Reticulation**   Film reticulation is the result of extreme temperature variations during processing of the film. Although this may be an undesirable effect for normal image production, it has a wide range of creative possibilities for modifying the photographic image. For extreme reticulation effects, the film can even be frozen during processing or some of the processing solutions can be heated to high temperatures. The effects of reticulation are both permanent and unpredictable, so an element of chance is introduced into the creative process. When experimenting with the effects of reticulation, it may be more productive to make copy negatives of the originals by contact printing or enlarging onto sheet film in the darkroom and then produce the reticulation on the copy negative during processing.

*For an example of the pattern caused by reticulation, see page 93.*

**Intensification and Reduction**   Intensification and reduction are treatment techniques for previously processed negatives. Intensification is a chemical process that builds up densities in the negative, and reduction is used to reduce negative densities. These techniques can be used to correct some of the symptoms from incorrect exposure or development. An underexposed negative, for example, shows low overall density, a loss of shadow detail, and a loss of contrast. An underdeveloped negative will show good shadow detail but have low contrast. Intensifying the negative can build up the existing densities and increase the overall contrast but cannot bring back lost shadow detail. A commonly available intensifier is chromium intensifier, which involves bleaching and redeveloping the existing image. Another method of intensifying negatives is to use selenium toner—actually intended for toning prints—as outlined in an article by Ansel Adams on page 116 of the November 1980 issue of *Popular Photography*.

Reducers, such as Farmers Reducer, use chemical means to reduce the density of a negative. A negative that is excessively dense—because of overexposure or overdevelopment—can be treated to produce a less dense negative with shorter printing times. Any loss of highlight detail due to overexposure will not be recovered, and any excessive grain size due to overexposure or overdevelopment will still be evident.

Intensification and reduction should be thought of as emergency techniques. However, some argue that the selenium toning technique of intensification does not increase grain size and might be used in place of increased film development to compensate for subjects that are low in contrast.

**Sabattier Effect**   The Sabattier effect is a result of exposing the film to light partway through the developing step and then continuing the development and remaining processing steps. The outcome is a partial reversal of tones in the image. A thin line, known as the Mackie line, is also produced along boundaries between adjoining areas of dark and light subject tones. Variations of the amount of exposure during processing and the amount of development before and after processing can create a whole range of effects.

The Sabattier effect is often mistakenly called solarization, which is the result of gross overexposure of the film in the camera and produces a partial reversal of tones of similar appearance.

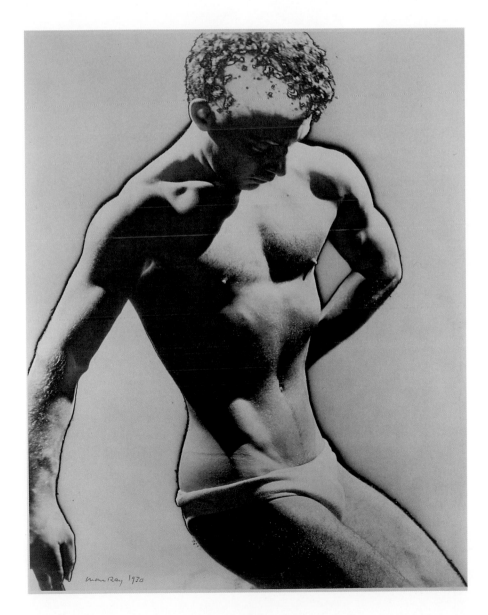

*Film Sabattier Effect.* Man Ray, Male Torso. Note the black line around the edge of the figure, an example of the Mackie line.

© 2000 Man Ray Trust/Artist Rights Society, NY/ADGP, Paris.

## Special Printing Techniques

**Photomontage**    Photomontage is the combination of parts of images from two or more negatives into one print. The simplest photomontage is the negative sandwich, in which two negatives are placed one on top of the other in the negative carrier at the same time and printed.

A more controllable method for photomontage is to print multiple images from different negatives on one sheet of printing paper.

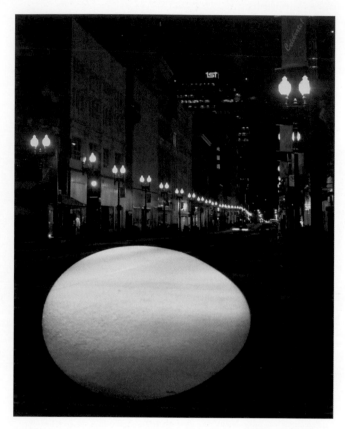

*Negative Sandwich.* The success of a negative sandwich depends on how the densities in the two negatives relate. High densities predominate, so when highlights overlap, details may be confused, but when the highlight of one negative falls in the shadow area of another, the highlight will be shown more clearly. Midtone areas will mix from both negatives to give interesting double images.

© Bognovitz.

*Texture Screen.* A special application of negative sandwiching is the use of texture screens. A texture screen is a thin negative of any even texture, which when sandwiched with another negative superimposes the texture. Various texture screens are available commercially, or you can manufacture your own by photographing textured surfaces, bracketing for underexposure to achieve the desired density in the texture screen.

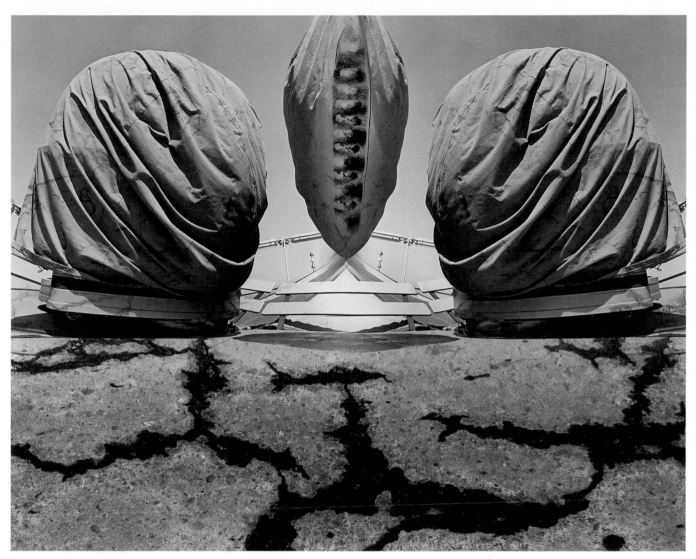

Jerry Uelsmann, Untitled, Photomontage, 1968. This photomontage was created by repeated printing of different images on the same sheet of paper. For each portion of the image taken from a different negative, the remainder of the paper must be masked or blocked from receiving light. This can involve as simple a technique as covering up the part of the print that you do not want to receive light—as in dodging and burning—or more complicated masking techniques using high-contrast sheet film materials.

© 1968 Jerry Uelsmann.

**High-Contrast Printing** If the original negative is continuous tone, a high-contrast print can be made by printing—either by contact or by enlargement—the negative onto high-contrast sheet film, such as Kodalith Orthochromatic film developed in Kodalith developer. Orthochromatic films are not sensitive to red light and can be safely used under red darkroom safelights. The amber lights used for most printing papers will fog orthochromatic film.

   **Posterization** is the reduction of a continuous-tone subject to a print containing only a few tones and can be accomplished with high-contrast materials. A simple high-contrast print is a posterization of only two tones. It is more complicated to get a posterization of four tones, since several high-contrast negatives must be produced, each with different exposure to show a different part of the tonal scale, and then each negative must be printed on the same piece of printing paper in sequence and in register.

## High-Contrast Printing—Continued

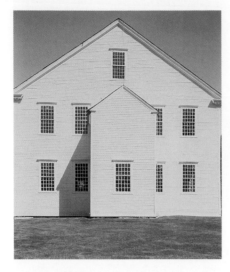

*Normal Continuous Tone Print.*

All photos © Bognovitz.

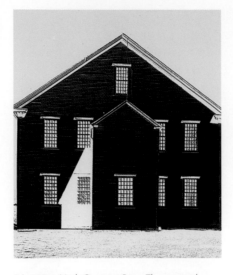

*Negative High-Contrast Print.* The original continuous-tone negative was printed onto high-contrast film. The high-contrast film positive that resulted was printed onto normal photographic paper giving this negative high-contrast print. If the original is a 35mm negative, it can be enlarged onto a larger sheet of high-contrast material to allow contact printing in subsequent steps.

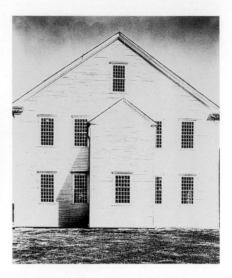

*Positive High-Contrast Print.* The high-contrast film positive from the previous step was contact printed onto a second sheet of high-contrast film to yield a high-contrast film negative. Printing this negative onto normal photographic paper gave this positive high-contrast print.

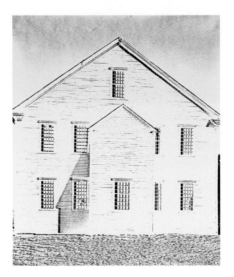

*Bas-relief.* Several different effects can be achieved by sandwiching the high-contrast film positive with the high-contrast film negative and printing them. If the negative and positive are sandwiched slightly out of register, a bas-relief print results.

*Tone-Line.* In this case, the high-contrast film positive and the high-contrast film negative were sandwiched in register back-to-back (emulsions away from each other) under glass with a piece of photographic paper on a turntable. The turntable was rotated while the sandwich was exposed with a specular light at an angle of 45° to the sandwich, allowing the light to creep between the edges of the images and producing an outline of the boundaries between light and dark.

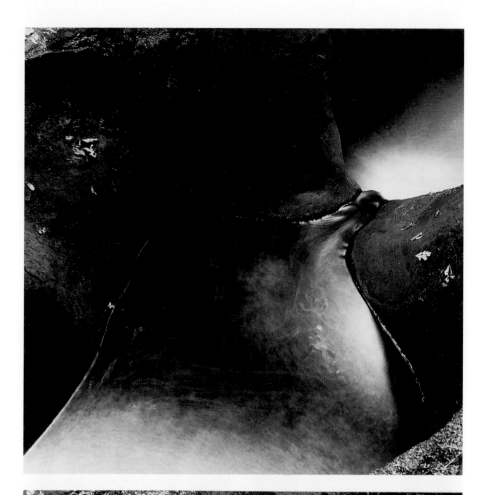

*Positive Continuous-Tone Print.*

© Bruce Warren.

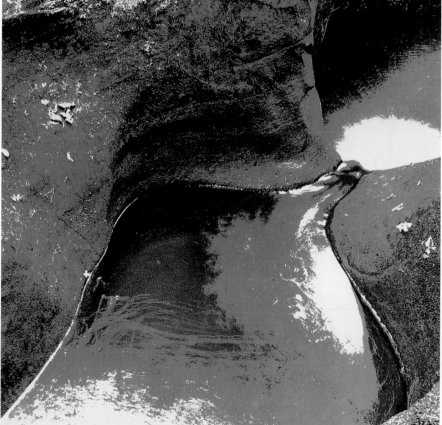

*Four-Tone Posterization.*

© Bruce Warren.

**Continuous-Tone Negative Printing**   One method for producing a continuous-tone negative print is to make a standard positive image on single-weight paper. Once this print is processed and dried, it can be placed face-to-face with a new sheet of printing paper and exposed just as you would a contact print, with the light passing through the positive print to expose the new sheet of paper. Retouching and alterations can be done on the back of the positive print with pencil or dyes before printing. This method is quick and easy but does produce a considerable increase in contrast and will show some of the texture from the exposure through paper, as well as the brand names imprinted on the back of some papers.

If a higher-quality negative print is desired, the original negative can be contact printed onto a sheet of any continuous-tone film. Panchromatic sheet film can be used but requires working in total darkness and with short exposures. An orthochromatic or blue-sensitive continuous-tone film, such as Kodak Professional B/W Duplicating Film SO-132, will allow working under safelights. Once the film positive is achieved, this can be printed directly onto printing paper to yield a negative print.

*Positive Continuous-Tone Print.*

*Continuous-Tone Negative Print from Paper Positive.* Note that the image is reversed. This can be avoided by placing the negative emulsion side up when printing the original paper positive to give a reversed positive print.

*Continuous-Tone Negative Print from Film Positive.* The original negative was contact printed onto a sheet of continuous-tone negative film. The resulting film positive was then printed to yield this continuous-tone negative print.

All photos © Bognovitz.

**Vignetting**   Vignetting is the blocking of image-forming light around the edges of a film in a specific pattern. This is done with a vignetting tool of the desired shape, which is inserted between the enlarger lens and the paper while printing. Vignetting while printing from a negative produces a white border pattern. Vignetting can also be done on the camera while making the original exposure and produces a black border shape.

**Perspective Control**   View cameras have the capability of tilting or swinging the film plane to correct the convergence of parallel lines, as is seen when looking up at a building. A limited amount of similar perspective control can be achieved when printing by tilting the easel to eliminate the convergence.

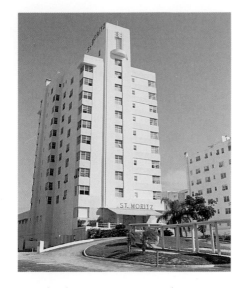

*Printed without Perspective Control.*

*Image Vignetted During Printing.*

*Image Vignetted on the Camera.* This effect was produced with a black vignetting tool. A white vignette can be produced while shooting by using a well-illuminated white vignetting tool close to the camera lens.

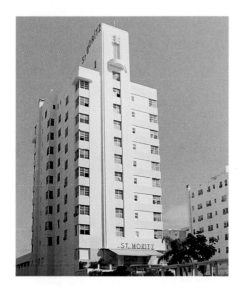

*Printed with Enlarger Perspective Control.*

Photos © Bognovitz.

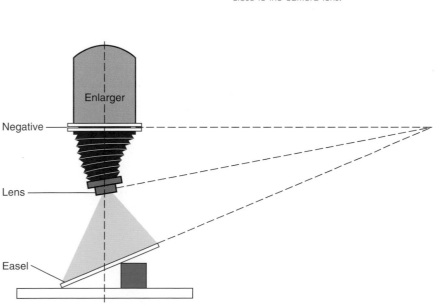

*Perspective Control on the Enlarger.* Since the paper is now at different distances from the lens, only one part of the image can be focused at a time. If the enlarger has a tilting lens stage, focus can be corrected by tilting the lens. Otherwise stop down as much as possible. Also, the required exposure is different for each part of the print. This can be corrected by using a dodging tool, sweeping it from edge to edge of the print to produce varying exposure, increasing evenly from the print edge closest to the enlarger.

**Photograms**   Photograms are made by laying objects directly onto the printing paper and exposing them to light. Experimenting with objects of various translucency, moving objects during exposure, or suspending objects above the paper during exposure can produce a full scale of print tones and interesting images.

*Photogram. Man Ray, Rayograph, 1927.*

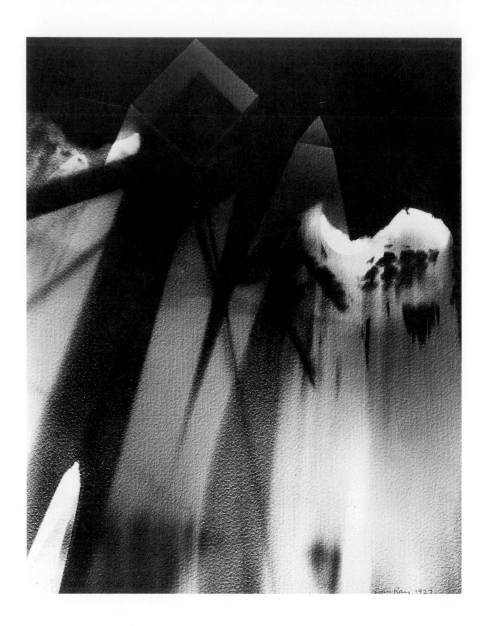

**Print Sabattier Effect**   The Sabattier technique of exposure to light during developing can also be performed on prints. This treatment may give a muddy effect unless carefully controlled, since no real highlight values are produced in the print. A mild bleach or reducer used on the print after processing will help to lighten the highlight areas.

In a variation of the print Sabattier effect, called *POP solarization*, the print is pulled from the developer; placed under the enlarger again, using a red filter over the lens to allow registering the print with the image; and reexposed to the same image a second time. This causes partial reversal in shadows and some midtones but leaves the highlights relatively clean and unaffected.

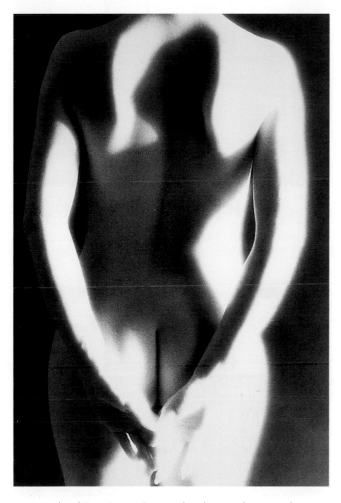

*Unmanipulated Print*. Danny Conant. This photograph was made on infrared film.

© Danny Conant Photography.

*Print Sabattier Effect*. Danny Conant.

© Danny Conant Photography.

## Postprinting Techniques

**Toning**   After processing, black-and-white prints can be treated in toners to change the color. A great deal of variation can be achieved depending on the toner dilution, toning time, and printing paper used. In addition to the color change, some toners—such as selenium toner—also increase the life of the print and are part of standard archival processing techniques.

See appendix F for more on archival methods.

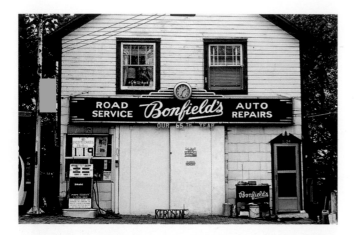

*Selenium-Toned Print.* Selenium toner can produce a range of print colors from purplish blue to reddish brown depending on toner strength and toning time.

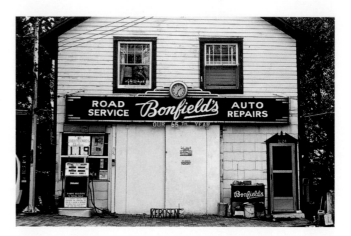

*Sepia-Toned Print.* Sepia toner produces brownish print tones.

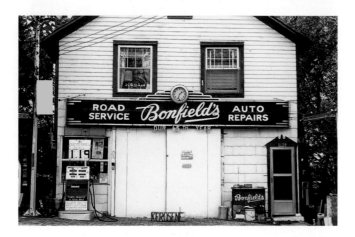

*Blue-Toned Print.* Other toners are available to produce red, green, blue, and nearly any other desired color.

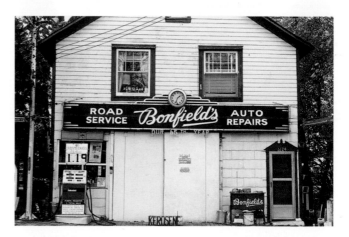

*Selectively-Toned Print.* In selective toning, only part of the image is toned at one time, the remainder of the print being painted with rubber cement or **frisket** before toning. After toning the rubber cement or frisket can be removed, with the part under it being unaffected by the toner. Multiple colors can be added by continuing this masking and toning process with other toners. In this print the door and signs were protected with Maskoid frisket and the print was toned in Kodak brown Polytoner.

All photos © Bognovitz.

**Bleaching**   Selective areas of a print may be lightened after processing by lo-
cally applying photographic bleaches with brush, cotton balls, or cotton swabs.
Spotoff is a commercially available bleach, especially useful for small areas.
Potassium ferrocyanide dissolved in water can also be used to bleach prints.
Cyanide compounds are poisonous, so handle ferrocyanide bleaches with
care. Bleaching is irreversible, and prints must be refixed and rewashed after
it is done.

■ **HEALTH NOTE**   Many toners and bleaches contain chemicals that are health
hazards. Use rubber gloves and adequate ventilation. Contamination of toners
with fixer or acids can generate poisonous gases.

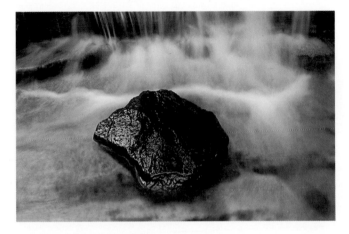

*Unbleached Print.*

© Bognovitz.

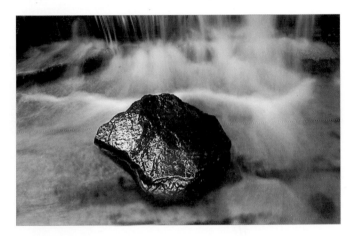

*Finished Print with Bleaching.* The areas that were bleached include the
vertical highlights in the falls, the highlights in the foam, and all of
the rock.

© Bognovitz.

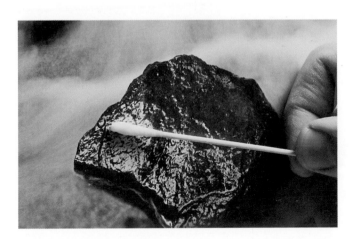

*Applying the Bleach.*

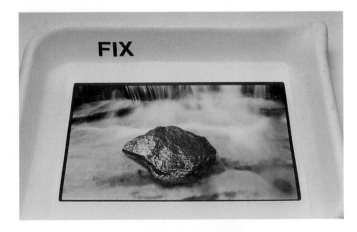

*Refixing the Print.* After bleaching, the print must be fixed, washed, and
dried as usual.

**Hand Coloring of Black-and-White Prints**   A number of water-based or oil-based paints and dyes, including food colors, Marshalls oil paints, and acrylic paints, can be applied to black-and-white prints for selective coloration. Matte-surface papers accept hand coloring more easily than glossy-surface papers. The departures from reality possible with this process allow great creative freedom and provide a crossover area between photography and the visual media of painting and drawing.

Allen Appel, *Kingbird with Flowers*. Hand-Tinted Black-and-White Photograph.

© Allen Appel, Courtesy of the Kathleen Ewing Gallery, Washington, D.C.

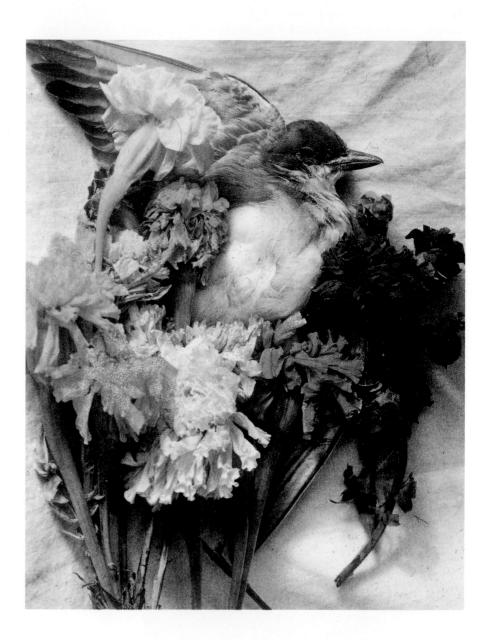

## Nonsilver Processes

Chapter 10 mentioned a number of historical photographic processes that did not make use of silver salts in the light-sensitive emulsion. Some of these early processes involved the use of chemicals that can be dangerous, so be cautious when trying to revive and use them. The supplies for a few of these nonsilver processes are becoming commercially available again, including platinum printing paper (at a premium price), kits for gum-bichromate prints, and kits for cyanotypes. In addition many of these processes can be compounded from the basic chemicals. Some sources for formulas and techniques are given in the reading list at the end of this chapter. All of these processes produce materials that are relatively insensitive to light and must be contact printed under direct sunlight or powerful artificial lights. If the original image is a small- or medium-format negative, an enlarged negative will have to be produced for the contact printing process.

A modern nonsilver process is the photosilkscreen technique, in which a light-sensitive material is adhered to a screen, exposed to an image, and then "developed" by washing in warm water, which removes the unexposed parts of the light-sensitive material. The screen can then be used to make silkscreen prints with inks.

Lilia Arbona. Photosilkscreen Print. The photographic image was first posterized, then transferred to screens for printing with different colors.

© Lilia Arbona.

## Instant-Print Manipulations

Some instant prints lend themselves to manipulation by pressure applied to the developing print, using fingernails or other hard tools. The image from other instant-print materials, such as Polaroid Type 59 or Type 669, can be transferred to paper.

John Reuter, *Spirits of Pere La Chaise*. Polaroid Transfer Print.

© John Reuter.

Michael Going. St. Maarten, 1985.
Manipulated Instant-Print Material.

## ■ READING LIST

Adams, Ansel. "Ansel's Intensifier." *Popular Photography* (November 1980). Pages 116+.

Carr, Kathleen Thormod. *Polaroid Transfers*. New York: Amphoto, 1997.

Gassan, Arnold. *Handbook for Contemporary Photography*, 4th ed. Rochester, N.Y.: Light Impressions, 1977.

McCann, Michael. *Health Hazards Manual for Artists*. New York: The Lyons Press, 1994.

"Myron: Santa Fe Transfer." *Test* (Polaroid) (Fall-Winter 1990). Article on Polaroid transfer. Page 2.

Pittaro, Ernest M., ed. *Photo Lab Index*. Dobbs Ferry, N.Y.: Morgan & Morgan, updated regularly.

Shaw, Susan. *Overexposure: Health Hazards in Photography*. New York: Allworth Press, 1996.

Stone, Jim, ed. *Darkroom Dynamics: A Guide to Creative Darkroom Techniques*. Stoneham, Mass.: Focal Press, 1985.

### Nonsilver Processes

Crawford, William. *The Keepers of Light: A History and Working Guide to Early Photographic Processes*. Dobbs Ferry, N.Y.: Morgan & Morgan, 1980.

*Photographers' Formulary Catalog*. Photographers' Formulary, P.O. Box 950, Condon, Montana 59826.

# Color Materials and Techniques

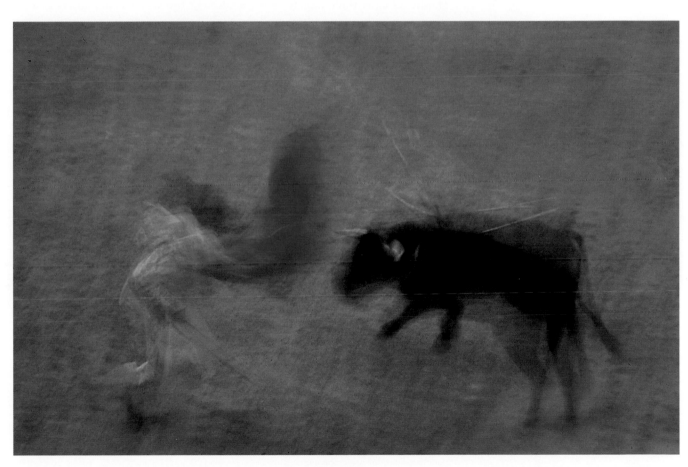

Ernst Haas.

© Ernst Haas/Tony Stone Images.

The reproduction of the colors of a subject gives another level of realism to photographs, but the perception of color is complicated and personal. Colors carry not only information about the subject but also psychological messages. Photographing in color therefore requires somewhat different ways of visual thinking than does photographing in black and white. It will help to have some theoretical background for an understanding of how color photography works, more in-depth information on color materials and processes, and familiarity with some of the variables involved in color design.

## ■ Color Theory

White light consists of a mixture of all the visible colors, or wavelengths, of light, but the human eye shows peaks of sensitivity at only three: those representing red, green, and blue. As a result we see a mixture of equal amounts of red, green, and blue light as white light. These three colors are called the additive primaries, since they combine to create white light. Other colors can be obtained by mixing various amounts of two or more of the additive primaries.

Early color processes used the additive primaries to create color photographs. Usually three negatives were taken of the same scene, one with a red filter, one with a blue filter, and one with a green filter. Film positives were made from the negatives and each positive was then illuminated by the corre-

*Additive Color.* If beams of red, green, and blue light of equal intensity are projected so that they overlap, white light is formed. The overlap of any two of the beams creates three new colors, called the subtractive primaries, since each could be thought of as the result of white light minus one of the additive primaries. Subtracting green from white light leaves red and blue, which is the same as magenta. Because magenta contains red and blue, mixing equal amounts of magenta and green light gives red, blue, and green, which is white light. Since they complement each other to form white light, green and magenta are called **complementary colors.** Similarly, blue and yellow are complements, as are red and cyan.

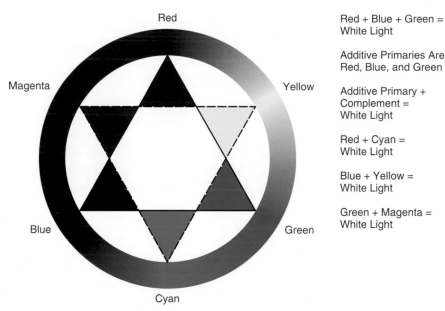

Red + Blue + Green = White Light

Additive Primaries Are Red, Blue, and Green

Additive Primary + Complement = White Light

Red + Cyan = White Light

Blue + Yellow = White Light

Green + Magenta = White Light

*Photographic Color Wheel.* The information about the relationship of colors of light and how they add is included in the photographic color wheel. Any color on the wheel can be formed by mixing equal amounts of the two colors next to it. Colors opposite each other on the wheel are complements. The color wheel for mixtures of light differs from the color wheels used by painters for mixing pigments, with different sets of primaries.

sponding color of light—red, blue, or green. The three colored images resulting were combined optically to produce a full-color photograph.

Today's photographic processes usually use a subtractive process. If filters are made in the subtractive primary colors, we find that each one controls the amount of a single additive primary. A magenta filter appears magenta to the eye because it lets red and blue light through while filtering out its complement, green. The magenta filter therefore controls the amount of green light allowed to pass. The deeper the magenta color of the filter, meaning the higher its magenta density, the less the amount of green light that is allowed to pass. Likewise a yellow filter controls the amount of blue light allowed to pass and a cyan filter controls the amount of red light. Overlapping the filters allows transmission of varying colors of light.

## Photographic Color Reproduction

Color films and papers contain three layers of emulsion with dyes corresponding to the subtractive primaries—yellow, magenta, and cyan. The yellow dye layer is sensitive to blue light, the magenta layer to green light, and the cyan layer to red light The amounts of different colors in the subject are represented by varying amounts of complementary dyes in the photograph.

*Subtractive Color.* When a magenta filter and a cyan filter overlap, the green light and the red light are filtered out, leaving blue light. Likewise, overlapping cyan and yellow filters gives green light, and overlapping yellow and magenta filters gives red light. Where all three filters overlap, the result is neutral density, since all colors are filtered equally. If the color densities of the filters are varied, intermediate colors can be created.

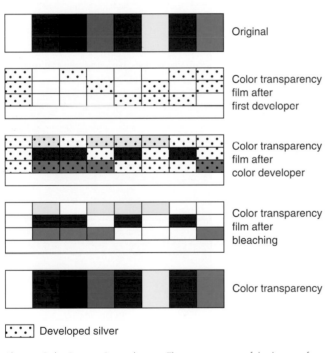

Original

Color transparency film after first developer

Color transparency film after color developer

Color transparency film after bleaching

Color transparency

<span style="white-space:nowrap">⋅⋅⋅⋅</span> Developed silver

Above: *Color Positive Reproduction.* This cross-section of the layers of a color transparency film shows how the cyan, magenta, and yellow dyes create different colors.

Right: *Color Negative Reproduction.* The color negative is a negative in the sense both that the dark parts of the negative represent the light parts of the subject and that all the colors are represented as complements. When printed on a color negative paper, tones are reversed—dark to light—and print colors are the complements of the negative colors, resulting in a positive color print.

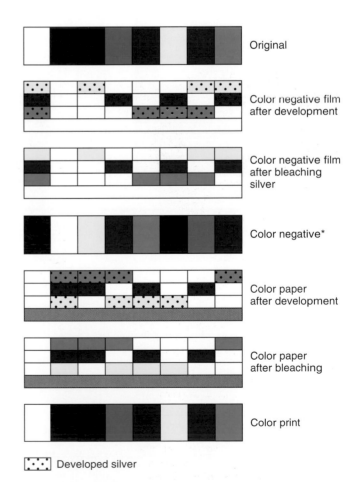

Original

Color negative film after development

Color negative film after bleaching silver

Color negative*

Color paper after development

Color paper after bleaching

Color print

<span style="white-space:nowrap">⋅⋅⋅⋅</span> Developed silver

* An actual color negative incorporates an orange dye mask for proper printing. The colors here appear as they would without the mask.

## Color Balance of Light Sources

Not all light sources produce white light. Sunlight in the middle of the day is the standard by which the color of light is judged, but daylight itself can vary depending upon the time of day, time of year, weather, and geographical location. Other light sources can vary widely in color, from the yellowish orange light of tungsten filament bulbs to the greenish light of fluorescents.

The color of light emitted by a source can be compared to that of a heated body at various temperatures. When iron is heated, a dull red glow is first seen, then as the temperature rises, the color of light emitted becomes progressively more blue. The temperature at which a given color of light is emitted—by an object that absorbs light perfectly, called a **black body**—measured in degrees Kelvin (K), is called the **color temperature.** The lower the temperature, the redder the light; the higher the temperature, the bluer the light. Average noon sunlight corresponds to about 5500°K.

The color of light can also be changed in the process of reflection from colored surfaces. These color shifts can be visible in a color photograph and are known as color contamination.

| | |
|---|---|
| 11,000°K | Skylight |
| 6,000°K | Electronic flash |
| 5,500°K  Daylight film | Daylight |
| 5,000°K | Daylight |
| 4,000°K | Flashbulb |
| 3,200°K  Tungsten film | Floodlamp |
| 2,800°K | Light Bulb |
| 1,900°K | Candlelight |

*Color Temperature of Light Sources.* Standard daylight is specified as 5500°K, but actual daylight can vary widely with location, time of day, and weather conditions. Photographic floodlamps are available in two color temperatures, 3200°K as shown in the chart, and 3400°K.

*Color Contamination by Reflection.* On the left, the shaded side of the face and the white shirt have a yellow appearance because of the light reflected from the yellow wall. On the right, the shaded side of the face and the white shirt take on a blue coloration.

| COLOR BALANCE OF FILM | COLOR TEMPERATURE OF LIGHT SOURCE |
|---|---|
| Daylight (type S) | 5500°K |
| Tungsten (type L, type B) | 3200°K |

## Color Balance of Film

The eye can quickly adjust to light sources of different color temperature, but color film cannot. Color films are made for a particular color temperature of light. Two film color balance types are currently available: daylight, and tungsten for 3200°K photofloods.

Daylight Film with Daylight Lighting.

Tungsten Film with Daylight Lighting.

Tungsten Film with Daylight Lighting and 85B Filter on Camera.

Tungsten Film with Tungsten Lighting.

Daylight Film with Tungsten Lighting.

Daylight Film with Tungsten Lighting and 80A Filter on Camera.

Daylight Film with Fluorescent Lighting

Daylight Film with Fluorescent Lighting and 40 Magenta Filter Plus 10 Red Filter on Camera.

*Matching the Color Balance of the Light Source and the Film.* It is best to use the correct color balance of film for the light source, but an alternative is to place a filter on the lens to adjust the color of the illumination to the film. Small variations in the color of light can also be corrected by the use of light balancing or color compensating filters. With color negative films some color correction can be done in the printing or by giving special instructions to the lab.

341

## Filters for Color Films

The largest category of filters for use with color films are those used for balancing the light source to the color balance of the film. Those used for large changes of balance—for example, correcting tungsten light for daylight film—are called **color conversion filters** (see the previous page). **Light balancing filters** are used for smaller differences in the color of the light source. **Color compensating (CC) filters** come in varying densities of the additive and subtractive primary colors and can be combined and used in the image path for any desired change in color balance.

A polarizing filter should be used for darkening skies with color films, since a yellow or red filter would simply turn the whole image yellow or red. A second option for darkening skies with color films is a split, or graduated, neutral density filter, half of which is clear.

A polarizing filter can often saturate the colors by eliminating surface glare. Neutral density and special effects filters can also be used with color. Color contrast filters designed for black-and-white films can be used as special effects filters for color, giving a monochromatic image the color of the filter.

Remember to apply the appropriate filter factors for correction of exposure with any filter (see page 307).

See pages 301–311 for detailed information on polarizing, neutral density, special effects, and color contrast filters.

*No Filter.*

*Polarizing Filter Used to Darken Sky.*

*Split Neutral Density Filter Used to Darken Sky.* If the border of the neutral density in the filter does not perfectly match the horizon, a lighter area can sometimes be seen.

## Summary of On-Camera Filters for Color Film

| FILTER NAME | DESCRIPTION AND USE |
| --- | --- |
| Color Compensating (CC) | Used for modifying the color balance of illumination from a light source, correcting spectral deficiencies of a light source, or adjusting illumination for a specific color emulsion. Available in a range of densities in red, blue, green, cyan, yellow, and magenta. Optically suitable for use in the image path. Usually supplied as gelatin filters so they may be stacked to produce a desired color. Filter factor varies with color and density. Color printing (CP) filters are supplied in the same range of colors and densities, but are not optically suitable for placing in the image path and are used in the lamp housing of enlargers for printing color materials. |
| Color Conversion | Designed for major changes of color balance to adjust the color of the illumination from a light source to a film of a different color balance (see page 341). |
| 85B | Amber color conversion filter that adjusts the color of daylight illumination for use with tungsten (3200°K) balance film. Exposure correction is 2/3 stop. |
| 80A | Blue color conversion filter that adjusts the color of 3200°K tungsten illumination for use with daylight balance film. Exposure correction is two stops. |
| Light Balancing | Produces smaller changes in the color of the light. The 82 series filters are bluish in color and give a cooler color rendering. The 81 series filters are yellowish in color and give a warmer color rendering. Exposure correction varies with the filter type. |
| Skylight | A pale pink filter that reduces some of the blue in subjects in open shade illuminated by light from a clear blue sky. Also absorbs ultraviolet light. Exposure correction less than 1/3 stop. |
| Polarizing | Controls reflections, reduces glare, and darkens sky under specific conditions (see pages 304–305). Exposure correction varies. |
| Neutral Density | Reduces exposure on the film when a slower shutter speed or larger aperture is desired. Exposure correction depends on density (see pages 306–307). A split neutral density filter is half clear, reducing exposure in half the image only, convenient for darkening skies without affecting the landscape. |
| Special Effects | Available in a wide variety of effects, including diffusion, multi-image prisms, star, and rainbow effects. Exposure correction varies with the type of filter. Filters designed for black-and-white films can also be used to give an overall color cast. |
| UV | Absorbs ultraviolet light, without affecting visible light. Reduces haze and bluish color cast due to ultraviolet sensitivity of film. No exposure correction. |

NOTE: For a complete description of filters for both color and black-and-white films, see the Kodak publication B-3, *Kodak Filters for Scientific and Technical Uses.*

## Color Films

## Color Positive Films

Color positive films result in a positive color original on a transparent base. These films are also known as color transparency, slide, or reversal (because the image is reversed from negative to positive during processing) films.

As with black-and-white films, sensitivity to light and grain size are related, although color positive films generally have finer grain than color negative films of the same ISO. It is important to match the color balance of a film to the light source or filter for correct balance with color positive materials, since any color differences will be seen in the transparency and there is no opportunity to correct them as with negative prints. Color positive materials are very sensitive to changes in exposure and thus have little exposure latitude.

Correct Exposure.

One-half Stop Underexposed.

One Stop Underexposed.

Exposure Latitude for Color Transparency Film.

One-half Stop Overexposed.

One Stop Overexposed

## Color Negative Films

Color negative films—also called color print films—result in a negative image reversed in both light values and colors. To make useful photographs from color negatives you must print them on color negative paper, which will reverse the light values and colors to produce a positive print.

Grain size increases with speed, although the application of T-grain technology has produced some very fine grained color negative films. Color negative film has considerable exposure latitude, giving useful results over a wide range of exposures. Most color negative films are daylight balanced, although a few tungsten-balanced films are available. For large differences between the color balance of a film and light source—as when using daylight film with tungsten illumination—use a color conversion filter. Smaller corrections can be made during printing.

Correct Exposure.

One Stop Underexposed.

Two Stops Underexposed.

Exposure Latitude for Color Negative Film. The printing times have been adjusted to give the same light-tone value in each.

One Stop Overexposed.

Two Stops Overexposed.

## Color Film Selection

Your choice of color film depends upon the intended use of the photographs. If the intention is to give slide shows, a positive slide film should be used. If the intention is to make color prints, usually a color negative film would be employed. On the other hand, prints can also be made from color positives, but at greater expense. Prints made directly from color transparencies suffer from contrast increase but offer the advantages of more saturated, brilliant colors and extended print longevity.

Photographs for reproduction in magazines and other printed works are usually photographed using color positive materials, since the quality and ease of reproduction from slides is superior to that from prints. The wide exposure latitude of color negative films might indicate their use in situations that are difficult to control, such as photojournalism and wedding photography.

For a partial listing of available color films, see appendix G.

## Exposure

The exposure techniques discussed elsewhere in this book can all be applied to determining exposure for color films. With negative films—black and white or color—the normal concern is to get proper detail in the dark tone areas, and the technique of metering the dark subject tones and stopping down (covered in chapters 3 and 14) will work.

Since transparencies are a positive image, they get lighter with increasing exposure, making the light tone areas more important in exposure determination. To insure proper light tone detail take a close-up meter reading of a light subject tone area and open up the number of stops appropriate for the tone of that area. The guidelines for proper exposure with different tones given in chapters 3 and 14 are for black-and-white negative films. You may have to experiment with your color film to find out how many stops you can open up from a meter reading of a light tone area and still hold detail in the transparency. Color positive films have much less exposure latitude than negative films, so exact exposure determination is critical. If possible it is a good idea to bracket in half-stop increments when using color transparency films.

Color films are subject to reciprocity failure, but in addition to the extra exposure needed when working at long exposures, color shifts occur because of the different response of the three emulsion layers, so some correction filtering is needed to restore realistic color. The unusual colors resulting from reciprocity failure can be used for creative purposes.

For an excellent treatment of reciprocity failure in color films, see the article "Reciprocity" by Peter Skinner and Rand Molnar in the May 1991 issue of *Photographic*, pages 50+.

## ■ Color Film Processing

Although color film processing may require a few more steps and tighter quality controls than black-and-white film processing, modern color processes are relatively simple and can be done at home with the same basic film processing equipment used for black and white. Kodak's E-6 process is used for most color transparency films. Kodak's C-41 process is used for most color negative films. Several companies market processes equivalent to E-6 or C-41. Follow the manufacturer's instructions, observing careful time and temperature control. Color chemistries are also especially sensitive to contamination.

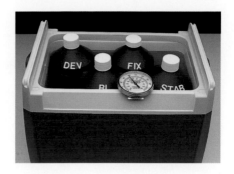

Left: *Temperature Control.* One difference between color processing and black-and-white processing is the more critical temperature control required for color, often as close as plus or minus 0.25°F (0.15°C) of the recommended processing temperature. A picnic cooler makes an excellent water jacket for keeping the chemistry at the correct temperature. Make sure the temperature is stabilized before beginning the process. For a more accurate check of the temperature, insert the thermometer into the developer bottle itself.

Right: *Temperature Control in Developing Tank.* A simple water jacket will insure that the temperature of the chemical solutions, especially the developers, does not change during the processing. Between agitation cycles place the tank in a pan filled with water at the correct processing temperature. Monitor the temperature of this bath and add warm or cold water as necessary to maintain the correct temperature.

## Lab Processing of Color Film

Color negative (C-41) processing is widely available. Labs often deliver negatives and prints in less than an hour. Color transparency (E-6) processing can be found in nearly every city around the world. Film can also be mailed or taken to large, centralized film processing labs.

Kodachrome films must be processed using the K-14 process, a difficult procedure requiring expensive equipment not suitable for self-processing. K-14 is offered by few labs other than Kodak.

## Contrast Control with Color

Because of the complex reaction of the three emulsion layers, it is difficult to control the contrast of color films by altering the development. Small changes can be achieved but not without some sacrifice of color reproduction quality. It is preferable to control the subject contrast by manipulating the lighting if possible. The various brands and types of film available exhibit different contrasts, so choice of film is one way of achieving some control over contrast. Some color printing papers also offer a limited selection of contrasts. Contrast can be reduced during printing by **masking,** in which a film mask of the image is sandwiched with the original negative or positive during printing. This is a reasonably difficult procedure to perform, but many custom labs can provide masking services.

See pages 459–467 for lighting techniques for controlling contrast.

## Push- and Pull-Processing of Color Films

Films using the E-6 process or the C-41 process can be push-processed (underexposed and overdeveloped) or pull-processed (overexposed and underdeveloped). Most custom labs offer these services for an extra charge, or if you are processing your own film you can do this yourself. Changes in color rendition, grain structure, and contrast accompany altered processing. See the next page for examples of push- and pull-processing.

Negative Film with Normal Exposure and Development.

Negative Film Underexposed Two Stops and Push-Processed Two Stops.

Negative Film Overexposed One Stop and Pull-Processed One Stop.

Grain Structure of Negative Film with Normal Exposure and Development. Enlarged 40 times.

Grain Structure of Negative Film Underexposed Two Stops and Push-Processed Two Stops. Enlarged 40 times.

Positive Film with Normal Exposure and Development.

Positive Film Underexposed One Stop and Push-Processed One Stop.

Positive Film Overexposed One Stop and Pull-Processed One Stop.

Grain Structure of Positive Film with Normal Exposure and Development. Enlarged 40 times.

Grain Structure of Positive Film Underexposed One Stop and Push-Processed One Stop. Enlarged 40 times.

# ■ Color Print Materials and Processes

Color papers are available for printing either from color negatives (negative paper) or directly from color transparencies (positive or reversal paper). The choices of base type, base weight, and surface type are usually limited. Most color papers come only in an RC medium-weight base and may offer as few as two surfaces, glossy or lustre. Depending on brand and type of color paper, only one, two, or three different contrasts may be offered.

Color print processes have been simplified to the point that they are not much more complex than black-and-white processes. Temperature requirements are sometimes higher and more carefully controlled than for black and white, but a number of processes for home application can be used at close-to-room-temperature and do not require such accurate control. Processes that can easily be used in home darkrooms are available from many manufacturers for both color negative and color positive prints.

## Color Negative Materials

Color negative print materials—often called type C, or simply C-print, materials—are the cheapest of the color print materials. The most commonly used and available color negative materials are offered by Kodak, processed using the Kodak RA-4 process. Several other companies offer RA-4 compatible color negative print processing kits, some of which are designed for use at room temperature. See the manufacturer's instructions for current techniques.

## Color Positive Materials

Prints can be made directly from color positives using any of several available materials, called reversal or direct positive color papers. Ilfochrome print materials offered by Ilford exhibit brilliant colors and are among the longest-lasting color print materials available. Several other companies offer reversal materials, known as type R print materials.

Another method for printing color positives is to make a color internegative, which involves copying the color positive onto a color negative film made especially for the purpose. Color negative prints can be made from the color internegative in the normal fashion. For the best quality, color internegatives should be made in larger formats, preferably 4 × 5 inches or larger.

## Storage and Handling

Color paper is sensitive to deterioration from improper storage. Nearly all manufacturers recommend refrigerated storage for their color papers. Be sure to seal the paper in an airtight container before refrigerating and warm the container up to room temperature before opening for use. Since color papers are sensitive to all colors of light they should be handled only in total darkness. Some papers allow the use of a safelight, but it must be so dim that it is barely worth purchasing for use.

**Warm-up Times for Refrigerated Photographic Materials (in Hours)**

|  | FROM 35° TO 70°F | FROM 0°F TO 70°F |
| --- | --- | --- |
| 10-sheet package | 1 | 1½ |
| 25-sheet package | 2 | 3 |
| 100-sheet box | 3 | 4 |
| One roll (35mm, 120, 220) | 1 | 1½ |
| Bulk roll (35mm, 100 ft.) | 3 | 4 |

## ■ Color Printing

Nearly any home darkroom can be adapted to print color with a few equipment additions. The first requirement is an enlarger with color filtration. If you already have a black-and-white enlarger a set of color printing filters may be purchased in a size appropriate for the filter drawer in the enlarger lamp housing. Enlargers with built-in color filtration are also available. These provide more convenience, since the desired filtration can simply be dialed into the enlarger controls. Some black-and-white enlargers can be converted by replacing the original lamp housing with a color head.

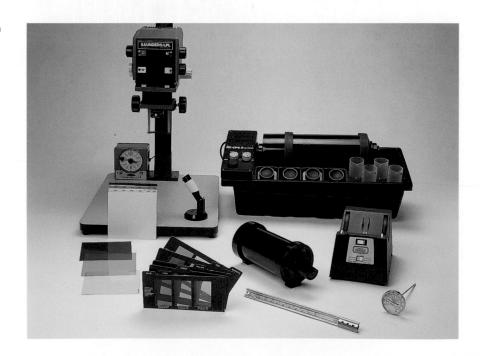

*Color Printing and Processing Equipment.* From left to right in the front: color printing filters for enlarger, color viewing filters, color thermometers. Center: processing tube for prints, which can be agitated manually or placed on the motor base seen next to it. Back: enlarger with dichroic color head, tube processor with temperature controlled water jacket.

Color prints can be processed in trays, but doing so is laborious in total darkness and increases the contact with the chemistry, which could be a health hazard. Controlling the temperature of the processing solutions is also more difficult in trays. The easiest method for home darkrooms is the use of processing tubes or drums. These are lighttight plastic tubes that can be used in normal room light once the printing paper has been exposed and placed in the tube. The chemistry is poured into and out of the tube through a lighttight top. Agitation during processing can be done manually by rolling the tube on a level surface, but a motor base will perform this task for you, leaving you free to do other things. Tube processors are available with temperature-controlled water jackets and motor-driven agitation and, on the more sophisticated models, automatic timing, filling, and dumping of chemistry.

Color viewing filters are an invaluable aid for deciding whether the color balance of your prints is correct and for suggesting filter changes to get a better print the second time.

## Printing Color Negatives

Prepare your color printing chemicals according to the directions that accompany them. Set the bottles of prepared chemicals in a water jacket—a picnic cooler will work well—to stabilize the chemicals at the recommended processing temperature. Temperature control is critical. If you do not have a temperature-controlled processor and are agitating the tube at room temperature, you should make a test run with only water to determine how much the temperature of the developer will change during the process. Pour water a few degrees warmer than the desired processing temperature (see your instructions) into the tube. Agitate it by the same method and time you will use for the developer. Measure the temperature of the water when you pour it out of the tube. Your actual developing temperature is the average of the starting and ending temperatures. If your first trial does not give you the temperature you want for processing, try again with a different starting temperature.

Murray Bognovitz. This image was photographed on color negative film.

© Murray Bognovitz.

## Exposing a Test Print

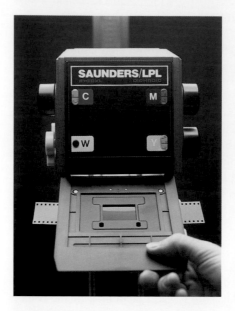

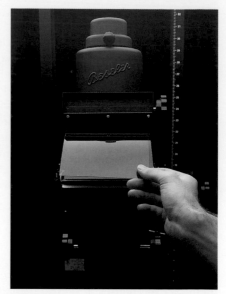

*Inserting the Negative and Setting the Filter Pack.* Insert into your enlarger a color negative that contains a fairly large area of a reasonably neutral tone—such as a gray card—for your first attempts at printing. This will give you a recognizable color to match. Clean the negative using the procedures outlined in chapter 6. The instructions with the print material you are using will give a suggested starting filter pack for making your first print. If you are using a color enlarger such as this one, simply adjust the dials on the color head until the suggested filter pack is indicated.

*Color Printing Filters.* If you are using color printing filters, select the filters that add up to the suggested pack and insert them in the filter drawer in the lamp housing. Color printing filters are marked with numbers indicating their color density. A filter marked 30 Y has a yellow density of 0.30, which means that it filters out 50% of the blue light passing through it. A density of 0.01 is often called a **point.** The color densities of the filters add. For example, if the filter pack calls for 25 yellow, this can be achieved by putting in the filters marked 05 yellow and 20 yellow.

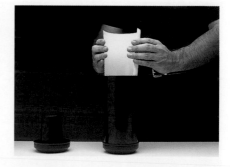

*Exposing the Test Print.* Insert a piece of 8 × 10-inch color negative paper in the easel, and make a test with four different exposures. A piece of black mat board with one corner cut out makes a convenient tool for placing four exposures on one sheet of paper. It is better to keep the time constant and vary the f-stop for the test, since changing the time can alter the color balance of the print. On this test the first quarter of the print was printed at f/5.6 for 10 seconds, the second at f/8 for 10 seconds, the third at f/11 for 10 seconds, and the fourth at f/16 for 10 seconds.

*Inserting Print in the Processing Tube.* Place the exposed print in the processing tube with the emulsion side toward the center of the tube and place the cap on the tube. You may now turn on the lights for processing.

## Processing the Color Negative Print

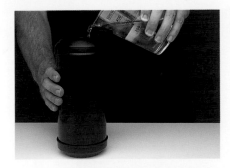

*Prewet.* Check your developer temperature, to make sure it is correct. If your process calls for a prewet step, place water at the correct processing temperature in your tube and agitate for the specified time. Pour out the prewet.

*Measuring Developer.* Measure into a graduate the amount of developer recommended for an 8 × 10 print. If the tube manufacturer and the paper manufacturer disagree on the amount of developer necessary for one 8 × 10, use the larger of the two amounts.

*Developing.* Pour the developer into the tube. Start timing as soon as the developer comes in contact with the print. With most processing tubes this does not occur until the tube is laid on its side for agitation. Agitate following the tube manufacturer's directions for the time given in the directions for the chemistry.

*Completing the Process.* Pour out the developer, and perform the remaining steps according to the manufacturer's instructions. At the end of the chemical steps, wash the print in a tray of running water for the specified time.

*Drying.* After washing, prints may be squeegeed and dried with an RC dryer, laid faceup on screens for air drying, or dried carefully with a hair dryer.

### Evaluating the Test Print

*Evaluating Exposure.* Make sure the test print is completely dry before evaluating it. Wet prints will be an opalescent bluish color. Choose the f-stop that gives the best tone and detail in the light-tone areas of the subject, remembering that more exposure creates a darker print. For example f/5.6 will produce a darker print than f/8. In this case the area that received an exposure of f/11 for 10 seconds is close to the correct time.

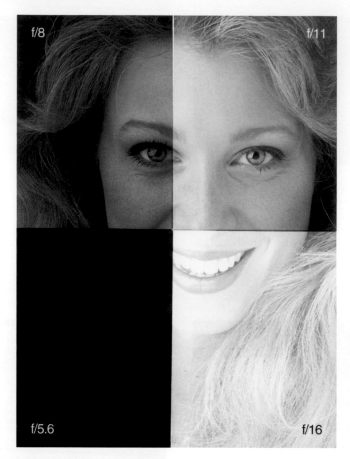

### Making a Trial Print

*Exposing the Trial Print.* Expose the first trial print at the f-stop and time chosen from the test print. Use half-stop settings or vary the time slightly if none of the sections on the test strip looked perfect.

*Processing the Trial Print.* Process the trial print in the same way as you did the test print.

**Evaluating the Color Balance and Changing the Filter Pack**   After the trial print is dry, evaluate the color. The prints in the color ring-around on the following page can be used as a guide for judging your print. Find a print that resembles yours in color. The numbers by that print tell you how much to change the filter pack in order to get a correct print on the next trial. Notice that the effect of changing filtration is the complementary of the filter. Adding yellow to the filter pack makes the print look more blue. If a print is too yellow, you must add yellow to the filter pack. The same effect is achieved either by adding a color to the filter pack or by subtracting its complementary. If a print is too blue, you must add blue to the filter pack, but since there is no blue filtration in the filter sets, you can achieve the same result by subtracting its complementary, yellow. The color wheel on page 338 will help you keep the relationship of the colors straight.

*Evaluating Color Balance with Color Viewing Filters.* Color viewing filters are also helpful in making decisions about filtration changes. Hold the viewing filter close to your eye so that the print is seen through the filter. Never view the print for more than a few seconds at a time through the viewing filters, or your eye will adjust to the color. Find the viewing filter that improves the color of the print.

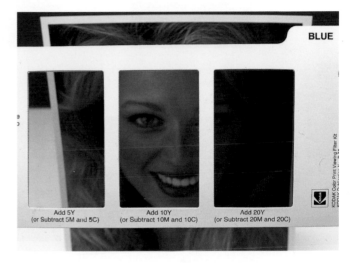

*Finding Color Corrections with Viewing Filters.* With color negative prints, if a filter of density .10 makes the print look better, only half that amount of correction—that is, 5 points—must be made to the filter pack. The color viewing filters are imprinted on both sides, giving filter pack corrections for color negatives on one side and for color positives on the other.

## Color Corrections for Negative Prints

Too Magenta:
Add 20 Magenta.

Too Red: Add 20 Magenta
and 20 Yellow.

Too Yellow: Add 20 Yellow.

Too Magenta:
Add 10 Magenta.

Too Red: Add 10 Magenta
and 10 Yellow.

Too Yellow: Add 10 Yellow.

Too Dark:
Close One Stop.

Normal.

Too Light:
Open One Stop.

Too Blue: Subtract 10
Yellow.

Too Cyan: Subtract
10 Magenta and 10 Yellow.

Too Green:
Subtract 10 Magenta.

Too Blue: Subtract 20 Yellow.

Too Cyan: Subtract 20
Magenta and 20 Yellow.

Too Green:
Subtract 20 Magenta.

**EXAMPLE**    The suggested filter pack for your paper is 40 points magenta (M) and 70 points yellow (Y): 40 M + 70 Y. Your first print looks too red. Viewing it through a 20 cyan filter improves its appearance. The filter pack correction will be half that amount—that is, 10 points. Since the print is too red you must add 10 points of red to the filter pack. The filters do not have red, but look at the color wheel to see that red (R) is the same as a combination of equal amounts of magenta and yellow:

$$10\ R = 10\ M + 10\ Y.$$

(This same correction can be read directly from the viewing filter label.) Your new trial filter pack can now be calculated:

$$\begin{array}{r} 40\ M + 70\ Y \text{ (original filter pack)} \\ + \underline{10\ M + 10\ Y} \text{ (correction)} \\ 50\ M + 80\ Y \text{ (new filter pack).} \end{array}$$

The presence of equal densities of all three filters in a pack simply adds neutral density, so you never need to have more than two colors in a pack.

**EXAMPLE**    Suppose the filter pack for your first print is 10 M + 20 Y. The print looks better when viewed through a 40 magenta viewing filter. That means the print is too green (the complement of magenta) by 20 points (one-half of the 40-point filter). If the print is too green you must add green or subtract magenta. The pack does not contain enough magenta to subtract all the magenta, so look at the color wheel to see that green (G) is a combination of equal amounts of yellow and cyan (c):

$$20\ G = 20\ C + 20\ Y.$$

Your new filter pack can be found by adding the correction:

$$\begin{array}{r} 10\ M + 20\ Y \text{ (original filter pack)} \\ + 20\ C \qquad + \underline{20\ Y} \text{ (correction)} \\ 20\ C + 10\ M + 40\ Y \text{ (corrected filter pack).} \end{array}$$

To get rid of the unwanted neutral density subtract the amount of the smallest filtration from each color. In this case 10 M is the smallest, so

$$\begin{array}{r} 20\ C + 10\ M + 40\ Y \text{ (corrected filter pack)} \\ - \underline{10\ C - 10\ M - 10\ Y} \text{ (neutral density)} \\ 10\ C + \qquad\quad 30\ Y \text{ (new filter pack).} \end{array}$$

Normal filter packs for printing color negatives contain only yellow and magenta. Only on rare occasions would cyan appear in a pack.

For small changes in filtration it will probably not be necessary to make an exposure correction, especially with color head enlargers, but large changes in filtration may require some adjustment of the print exposure. It may take some work to adjust the suggested printing filters and times to your enlarging system, but do not be discouraged by the early results, as a few prints will get you in the ballpark and you can start making acceptable color prints. Color prints may be dodged and burned just as may black-and-white materials.

## Printing Color Positives

Color positive photographs (transparencies) can be printed onto reversal color papers (Ilfochrome or type R) using the same darkroom setup as for color negatives. Stabilize the chemistry at the temperature suggested by the manufacturer of the materials. If you are processing at a temperature much above room temperature, perform the test described on page 351 to determine the average developing temperature.

If you are printing from 35mm slides you may wish to purchase a negative carrier designed to hold mounted slides. Printing procedures are similar to those for color negatives.

### Printing and Evaluating Color Positive Prints

*Exposing a Test Print.* A four-way test print can be done as described on page 352 for the color negative. Printing times are usually longer for color positive papers. This test is being done for 20 seconds at f/5.6, f/8, f/11, and f/16.

*Processing the Test Print.* Use the chemical quantities and procedures given in the instructions for the material. If the amount of chemistry required by the paper manufacturer differs from that required in the directions for the tube, use the larger of the two.

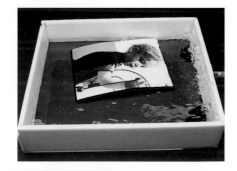

*Washing and Drying the Test Print.* Wash and dry the print just as directed for color negative prints.

## Printing and Evaluating Color Positive Prints—Continued

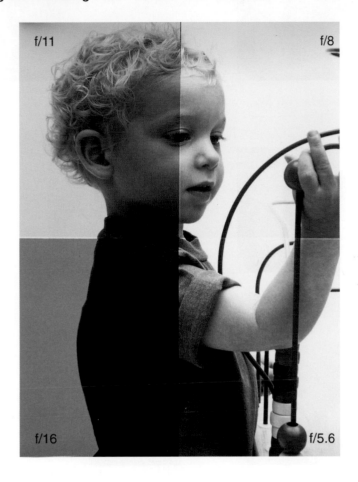

*Evaluating the Exposure.* When you evaluate the exposure on the test print, remember that in a positive process more exposure results in a *lighter* print. In this case, the area that received an exposure of f/8 for 20 seconds is close to the correct exposure.

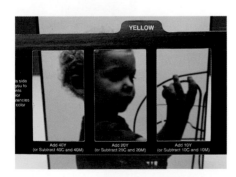

*Making a Trial Print.* After choosing the best exposure, make a full 8 × 10-inch trial print and process it.

**Evaluating Color Balance**   The color positive print can be evaluated much like the color negative print, but the amount of correction necessary is twice as much. Again, prints should be dry before evaluation. Find the print in the color ring-around on the following page that closely matches the appearance of your print. The number by that print tells you how much to change your filter pack for your second trial print. Notice that for a color positive print, reducing a filter color has the same effect in the print. If a print is too yellow, subtract yellow from the filter pack.

**Making Filter Pack Corrections**   Corrections are somewhat easier with color positive prints than with color negative prints. If viewing a print through a 10 Y filter makes the print look better, simply add 10 Y to the filter pack and the next print will be slightly more yellow. The filter pack corrections are the same amount as the color density of the viewing filter. If you end up with all three filter colors in the pack, subtract out the neutral density as described earlier.

*Evaluating Color Balance with Color Viewing Filters.* You may evaluate the color of a positive print using the color viewing filters, just as described for color negative prints, but use the side of the viewing filter labeled for positive prints. Make the changes to your filter pack indicated on the label of the filter that improves the appearance of your print.

## Color Corrections for Positive Prints

Too Magenta:
Subtract 40 Magenta.

Too Red: Subtract 40 Magenta
and 40 Yellow.

Too Yellow:
Subtract 40 Yellow.

Too Magenta:
Subtract 20 Magenta.

Too Red: Subtract 20 Magenta
and 20 Yellow.

Too Yellow:
Subtract 20 Yellow.

Too Light:
Close One Stop.

Normal.

Too Dark:
Open One Stop.

Too Blue: Add 20 Yellow.

Too Cyan: Add 20 Magenta
and 20 Yellow.

Too Green:
Add 20 Magenta.

Too Blue: Add 40 Yellow.

Too Cyan: Add 40 Magenta
and 40 Yellow.

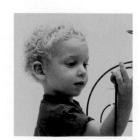

Too Green: Add 40 Magenta.

## Using Commercial Photofinishing Labs

It is easy to find a lab to make color prints from color negatives. Labs that print from color positives are not as numerous but can be found in most cities. Commercial photographic labs usually aim their services at a particular segment of the photographic market, and the services they offer depend on their intended clientele. Labs usually fall into one of three categories:

*One-hour labs.* One-hour labs are the most common and easily available. They are intended to serve the general public. Since nearly all snapshots are taken on color negative films, one-hour labs often provide only processing and printing for color negative films that are compatible with the C-41 process. Prints are available in a few standard sizes, and few or no custom services are offered. Some of these labs may offer processing of color slides using the E-6 process.

*Central processing labs.* Central processing labs are large labs that service the retail outlets that offer drop-off and pickup of prints. Most of these outlets—drugstores, grocery stores, and small photo booths—are intended to serve the general public and, like the one-hour labs, offer limited services. Some central labs also service photography stores, and these labs may offer some custom services, like cropping of the image in printing and printing in special sizes.

*Custom labs.* Custom labs are generally intended for the professional or advanced amateur photographer, and a full-service custom lab will offer a wide range of film processing and printing services. Custom services include special cropping, burning and dodging during printing, use of specialized materials and processes, masking for contrast control, making of color internegatives to allow printing color positives on color negative papers, direct printing of color positives, and sometimes custom processing and printing of black-and-white film. Prices are higher for professional custom printing.

If you plan to use a commercial lab for your processing, you should experiment with several of the labs in your area. If few labs are available to you, consider labs that do business by mail. Communication of your needs to the lab is important, especially when custom services are being used. Be sure to specify in great detail the exact requirements you have for a print. Cropping is best shown by marking the desired framing on a full-frame proof print with grease pencil. Remember that any cropping has to be consistent with the proportions of the final print size. Color balance of color prints can be corrected. Again reference to a proof print is the safest way to accomplish this.

If you leave the details of cropping, burning, dodging, and so on to the printer and are not happy with the results, you can do little about it, unless the print is obviously way off the mark. If on the other hand you clearly communicate your needs to the lab—and make sure they are written down—any failure to meet your requirements is the lab's problem and the lab will have to reprint the image to your satisfaction. Communication with the lab is somewhat more difficult when using mail-in labs.

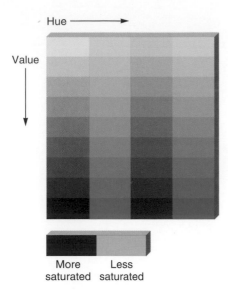

*Hue, Value, and Saturation.*

## ■ Photographic Seeing in Color

All of the suggestions for better photographic seeing and principles of design discussed in chapter 9 apply to color photographs. In addition to the visual elements listed there, you must now add the element of color. Talking about color is simplified by defining a few terms. **Hue** means the specific color or wavelength of light. **Value** is the lightness or darkness of a color—in other words, its luminance. **Saturation** refers to the brilliance or purity of a color—that is the absence of other colors in that area. The colors of the rainbow show maximum saturation.

## Perception of Color

The perception of color is much more complicated than a simple recognition of the hue, saturation, and value. The human response to color is complex and personal and depends upon the environment in which a color is seen. Colors are perceived in relationship to other colors and are difficult to judge without a standard of comparison. Once a standard—an area assumed to be white, for example—is picked, the brain adjusts so that that area *looks* white. All the other colors around that standard are also adjusted accordingly. This phenomenon explains why colors look reasonably accurate to the eye even if the color of the illuminating light changes.

The perception of the value of a color is variable as well. Subjective interpretations of value are usually labeled as "brightness." The brightness of a color depends only partly on its value or luminance. Some colors, such as yellow, appear brighter to the eye, even if they are the same luminance as adjacent colors. This effect can be accentuated if complementary colors are juxtaposed. Placing blue and yellow next to each other will make the yellow

*Color Contrast.* Roy Query, 1959 Cadillac El Dorado. The near-complementary colors—red and blue—add color contrast. The red seems brighter, even though the values in the sky and the car are similar.

© 1990 by Roy D. Query/Photography by Roy D. Query.

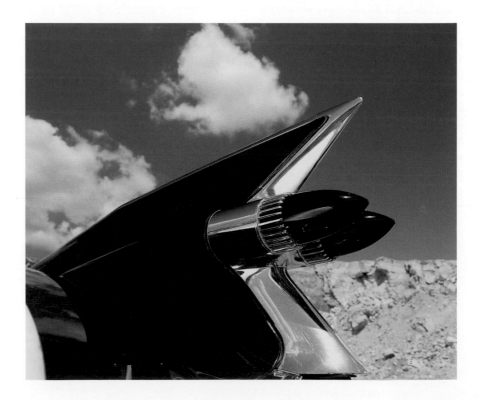

look even brighter. For this reason the feeling of contrast in color is complicated by the relationship of hues as well as the luminance or reflectance of the different areas of a subject. *Color contrast* refers to the perceived differences in brightness due to the relationship of adjacent colors rather than their value.

Colors close to each other on the color wheel are perceived as related to each other and are called **analogous colors.** Colors close to red, yellow, and orange are called **warm colors.** Those close to green and blue are called **cool colors.** Using analogous colors in a photograph lowers the color contrast.

In addition, colors carry emotional values and associations that can be used for visual communication; some are universal and some are personal or cultural responses: *red*—danger, blood, fire, anger; *yellow*—sunshine, inspiration, warmth; *green*—life, plants, growing, hope; *blue*—sky, ocean, loyalty, honesty, space; *black*—death, somberness, evil, strength, seriousness; *white*—cleanliness, purity, airiness, innocence.

## Color Design Principles

The preceding responses to color must be taken into account when you begin to compose photographs in color. The introduction of color into a photographic image creates a new level of complexity and possible confusion. A great deal of practice may be needed to learn to control the color design of your photographs. Color photographs are more realistic than black-and-white photographs for the simple reason that they give more information about the subject: the color. This can be both an advantage and a disadvantage.

The presence of realistic color may draw people to consider the subject matter that was in front of the camera rather than any other ideas or associations the photographer may be trying to convey. Some photographers turn to black-and-white materials to provide that little extra separation from reality so that the viewer responds to the underlying ideas or themes of the photograph rather than perceiving the photograph as a window through which the original subject is seen. Nevertheless careful control over color can yield photographs that are satisfying as more than simple windows on reality. Color images may be abstracted by manipulating framing, point of view, or the color materials in order to achieve some distancing of the color photograph from reality.

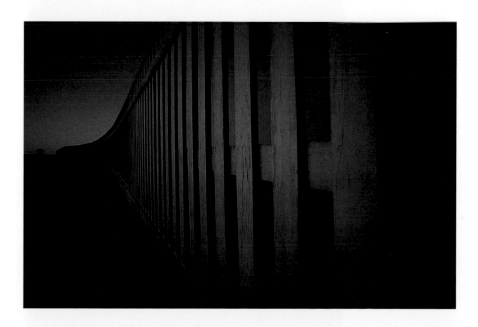

Dominant Color. Pete Turner, "Road Song" Kansas City, 1967. One way of creating unity in a color photograph is to have a single dominant color that occupies most of the visual space in the image. Counterpointing the dominant color with a small area of contrasting color can often create a great deal of tension and interest. In this image, the dominant blue color sets off the warm glow of the car lights.

© Pete Turner.

*continued*

**363**

# Color Design Principles—Continued

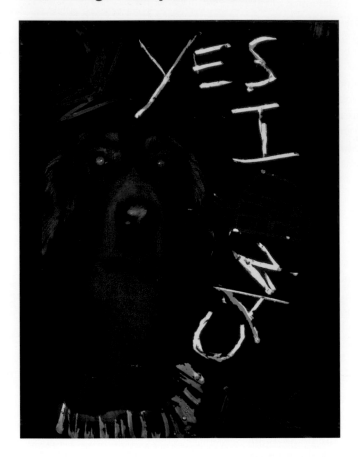

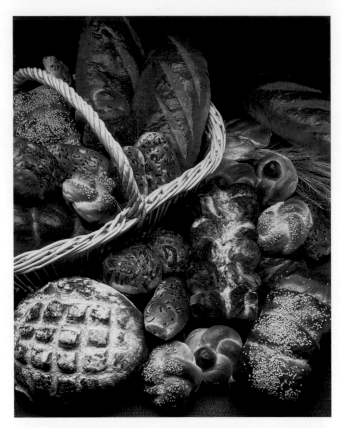

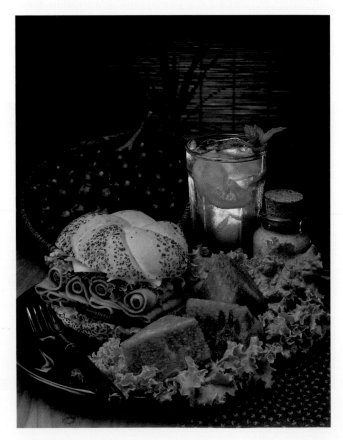

Top left: *Manipulated Color.* Fred McGann, *Yes I can and dog.* Color images can be manipulated by many of the techniques discussed in chapter 11, as well as by distorting the colors from their realistic hues by colored lighting or in printing. Here the original transparency has been altered by scratching.

© 1992 Fred McGann.

Top right: *Analagous Colors.* R. Pleasant. The tans, yellows, and browns appearing in this photograph are all closely related to the red-yellow area of the color wheel. Visual harmony can be achieved by using analogous or related colors. The warm coloration in this example also gives an inviting appearance to the photograph.

© R. Pleasant 1991/FPG International, LLC.

Bottom right: *Color Weight and Color Depth.* Paul Chauncey. Color must be considered in balancing the composition visually. Some colors have more weight (blue, violet, black) while others tend to float (yellow, orange, white). Colors also recede and advance in the visual space of the photograph in different ways. Usually warmer, lighter colors come forward while darker, cooler colors recede. Here, the warm yellows and reds of the sandwich, watermelon, and drink seem to come forward, while the cool darker colors of the grapes, background, and lettuce seem to recede.

© 1989 Paul Chauncey.

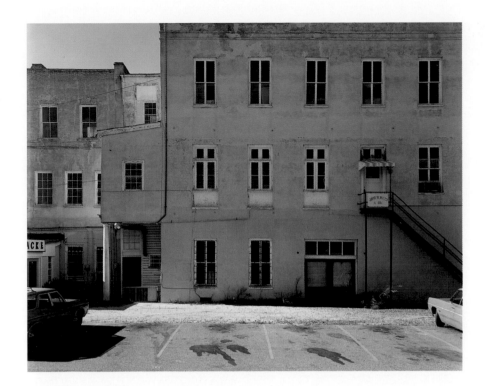

Stephen Shore, *Meeting Street, Charleston, South Carolina, August 3, 1975*. The formal design and the feeling of light in this photograph make it more than a simple window through which the place that it documents is seen.

© Stephen Shore, Courtesy of Pace/MacGill Gallery, New York.

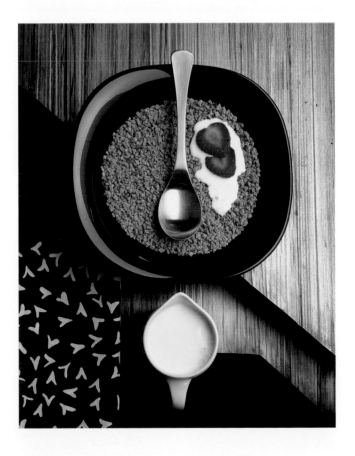

*Contrast by Differential Saturation*. Gary Perweiler. Color contrast can be used to isolate or emphasize particular elements in the composition, either through the use of complementary colors or by use of differing saturation. A brilliant saturated color will stand out against surrounding pastel colors—desaturated colors containing a considerable amount of gray—or neutral colors. Here, the saturated red of the strawberries is accentuated by the surrounding neutral and pastel colors.

© Gary Perweiler, 1987.

*Abstract Color.* Alex MacLean. *Chapel Hill, N.C.* This aerial photograph of fields is actually a realistic rendering, but the point of view and distance from which it is taken tends to abstract the image, stressing color and design rather than subject.

© 1983 Alex S. MacLean/Landslides.

## ■ READING LIST

Eastman Kodak Company. *Kodak Color Darkroom Dataguide.* Sterling Press, 1998.

Hirsch, Robert. *Exploring Color Photography*, 3d ed. New York: WCB/McGraw-Hill, 1997.

Horenstein, Henry. *Color Photography: A Working Manual.* Bulfinch Press, 1995.

Krause, Peter, and Henry Shull. *Complete Guide to Cibachrome Printing.* Tucson, Ariz.: H. P. Books, 1982.

# Digital Photography

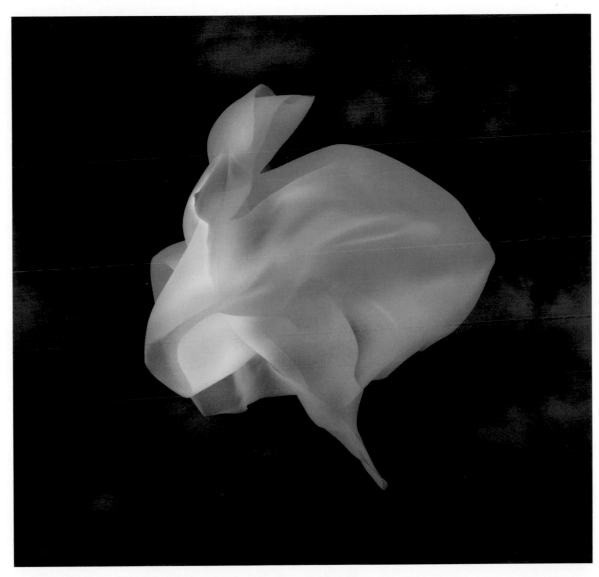

Peter Garfield, *Siren.*

© Peter Garfield

*Digital Darkroom.* This is a modern, chemical-free darkroom using digital images. When performing color correction, black-out drapes are placed over the windows to control room illumination.

Electronic photography is the production, viewing, or reproducing of photographic images by electronic means. Today it is possible to produce photographs entirely electronically, without the use of traditional silver-based photographic materials. The method used for the electronic production of higher quality images is to convert them to digital (numerical) form, so the electronic imaging process is often called **digital imaging.**

In the past few years, the use of electronic imaging in photography has become increasingly important. In the publishing industry electronic imaging has been in use for many years, and nearly all published photographs are reproduced at some stage in electronic form. As the equipment for digital imaging has improved, more photographers are using electronic cameras to produce original images without the use of traditional films. Digital original photographs are being used in catalog production, forensic photography, scientific photography, photojournalism, industrial photography, and other fields. The use of electronic cameras has also begun to make inroads into the consumer-based snapshot industry, with a number of easy-to-use digital cameras currently on the market. While today most photography is still done on traditional films with conversion to electronic form as needed, technological advances will soon make electronic photography the most common method of producing photographic images.

There are advantages and disadvantages to digital photography, when considered in the light of current technology. Digital images can retain their original quality no matter how often they are copied electronically. Traditional photographic quality deteriorates markedly with each generation of copying. Digital images also offer remarkable opportunities for manipulation of the image. Since digital images are recorded as numbers, computers can be used to alter them in ways that are difficult or impossible with traditional photographic materials. On the negative side, current digital production methods require very expensive and cumbersome equipment and materials to match the reproduction quality of even small-format, traditional photographic materials. The possibility of achieving a digital camera that approaches the convenience and quality of film-based systems improves with each technology advance, and we may soon have a reasonably compact, moderately priced digital camera that can compete with film.

Maria Eugenia Poggi. *Jijoca de Jericoa coara, Ceara, Brazil, July, 1994.* This is a digitally manipulated and produced photographic image.

© Maria Eugenia Poggi.

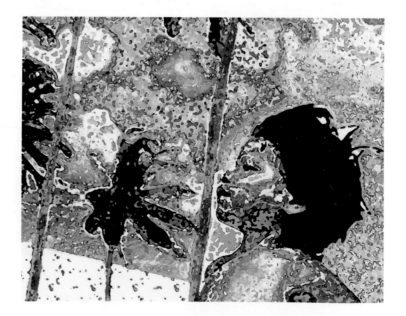

In spite of the disadvantages, digital photography already has very real applications at different stages in the production of photographs. While you may not find the cost and awkwardness of digital original equipment to your liking, you may be able to use electronic images at other stages in making photographs. Many photo labs offer quality photographic printing using digital means. Certainly, if any of your photographs are reproduced on ink-based presses, they will be converted to digital form before printing.

If you are intrigued by the possibilities of digital imaging and would like to get started, this chapter is designed to give you the information to acquire the equipment, materials, and knowledge that you will need.

## ■ Computers and Computer Terminology

The major tool used for handling digital images is the computer. A computer is a device with electronic solid-state switches that can do calculations with numbers, or anything that can be represented as numbers. Since digital images are numbers, the computer can be programmed to view, store, and manipulate the image.

To work with digital images you will need the following **hardware** (the devices used to work with the images) and **software** (the instructions the computer uses to manipulate images).

## Hardware

The following flowchart diagrams the equipment you might use to capture and process digital photographs. In general, hardware can be divided into four categories: (1) the computer; (2) input devices; (3) output devices; and (4) storage devices.

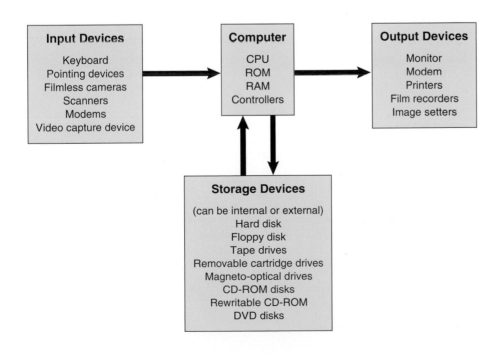

**Input Devices**

Keyboard
Pointing devices
Filmless cameras
Scanners
Modems
Video capture device

**Computer**

CPU
ROM
RAM
Controllers

**Output Devices**

Monitor
Modem
Printers
Film recorders
Image setters

**Storage Devices**

(can be internal or external)
Hard disk
Floppy disk
Tape drives
Removable cartridge drives
Magneto-optical drives
CD-ROM disks
Rewritable CD-ROM
DVD disks

*Computer.* This case contains the CPU, a hard drive, a CD-ROM drive, and other electronic control circuitry.

*Input Devices.* The keyboard and mouse provide a way of inputting information and commands to the computer.

**Computer**   The computer contains the **central processing unit (CPU)** and other electronic circuitry for performing the computations (see the boxed section "How a Computer Calculates"). The case for the computer usually also contains one or more data storage devices and allows the attachment of input and output devices, known as **peripherals.** There are several types of computers available, but the ones most widely used are the Macintosh and the IBM-PC or compatibles of these. The CPU has associated with it a **clock speed,** which partially determines the speed with which a computer does calculations. The clock speed is given in megahertz, which means million cycles (calculations) per second.

**Read-only memory (ROM)** is data permanently stored on solid-state chips in the computer, and provides the instructions the computerneeds to startself tostart itself when it is turned on.

**Random access memory (RAM)** consists of solid-state chips in the computer that the computer uses to temporarily store data while it is working. If the computer is turned off or power is interrupted, any data in RAM is lost. The amount of RAM a computer contains determines how many tasks a computer can perform at one time, and also has a major effect on the speed of operation.

**Controllers** are devices in the computer that interface with storage and other devices. The computer also contains circuitry and dedicated memory needed to run the video monitor attached to it.

**Input Devices**   Input devices feed data into the computer. Some input devices are used to directly control and input data, such as the keyboard and pointing devices (mouse, graphics pad, track-ball, joy-stick, etc.). Other input devices are specialized to provide the computer with digital files, for example digital cameras and scanners (see pages 373–74). **Modems** are input devices that allow digital data to be sent to your computer via telephone lines.

**Output Devices**   Output devices receive data from the computer and display or process it in various ways. The video monitor is an output device that allows you to view directly images generated by the computer. Also in this category are devices that print on paper or film (see pages 390–91). Modems are also an output device, allowing data to be sent from your computer to other computers via telephone lines.

**Storage Devices**   Storage devices record digital data in a form that can later be recalled by the computer (see page 377).

## Software

Software is the set of instructions (a **program**) that is used to direct and manage data computations on the computer to perform specific tasks. The software that determines the interface between the computer and the operator is called the **operating system.** The two types of computers mentioned earlier (Macintosh and IBM-PC) have their own operating systems. Programs that are designed for specific functions (like word processing, spreadsheet management, or digital image manipulation) are called **applications** and must be written to work on specific operating systems (sometimes called **platforms**). Programs are not interchangeable between platforms.

## What You Need to Get Started

To work with digital images, you will need at a minimum a reasonably fast computer with sufficient RAM and data storage to handle digital images. Dig-

## How a Computer Calculates

The heart of the computer is the central processing unit (CPU). The CPU is a solid-state "chip" that does the actual computation. Since the electronic switches in the chip can only indicate "off" or "on," each switch can represent just two digits, 0 and 1. For that reason, computers calculate numbers in binary (base 2) form. Starting from the right, in a binary number the first digit represents units, just as in base 10, allowing us to count 0 and 1. Since we are now out of numbers, the next digit to the left is used to represent 2s. The third digit from the right represents 4s (2 × 2) and so on. The chart at the right shows how the binary numbers compare to base 10 numbers. As you can see, it takes eight binary digits to count from 0 to 255.

Each binary digit is called a **bit**. Eight bits are called a **byte** and can represent up to 256 numbers (0 through 255). In digital imagery, an eight-bit binary number can represent 256 shades of gray or 256 colors. The amount of data it takes to represent an image is given in bytes or multiples of bytes. The data is stored together as a **file**. The size of the file depends on how many numbers are associated with the image. ■

| BASE 2 | | BASE 10 |
|---|---|---|
| 0 | = | 0 |
| 1 | = | 1 |
| 10 | = | 2 |
| 11 | = | 3 |
| 100 | = | 4 |
| 101 | = | 5 |
| 110 | = | 6 |
| 111 | = | 7 |
| 1000 | = | 8 |
| • | | • |
| • | | • |
| • | | • |
| 11111111 | = | 255 |
| 100000000 | = | 256 |

8 bits = 1 byte
1024 bytes = 1 kilobyte (KB)
1024 KB = 1 megabyte (MB)
1024 MB = 1 gigabyte (GB)

ital image files can vary from less than 1 megabyte to 100 or more megabytes, depending on size and quality desired. You will also need digital image processing software. There are several companies that publish digital imaging software, such as Adobe Photoshop. Photoshop is a sophisticated professional program, but there are many other smaller and less expensive programs that perform many of the image processing tasks you need.

If you don't have a digital camera or scanners, you needn't go right out and buy them, since there are service bureaus that can make digital scans for you from your existing traditional negatives, slides, or prints. One of the least expensive ways to get your photographs digitized is the Kodak Photo-CD, offered by most photofinishing labs (see page 374).

You will probably also want a computer printer, such as a high-quality inkjet printer, so you can make printed versions of your digital photos. Service bureaus can also provide print output from your digital files in a variety of materials and processes (see pages 390–91).

More detail about hardware and software can be found in the following sections.

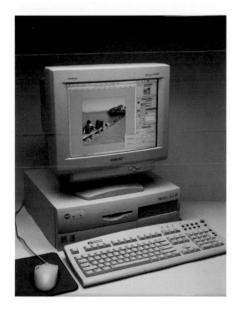

Basic Computer Workstation.

## ■ Overview of Digital Imaging

The five basic stages of image production are: (1) creating the image; (2) storing the image; (3) viewing the image; (4) editing (modifying or correcting) the image; and (5) outputting the image.

These stages apply to traditional photographic reproduction as well as electronic imaging, though the order of the steps may vary depending on the material

being used. Electronic imaging can be used at any one of these stages, with traditional means used for the remainder. For example, a photograph might be created, stored, viewed, and edited electronically, but output onto traditional materials (film or photographic paper) using digital output devices. On the other hand, the photograph can be created traditionally on film, which is then scanned to produce a digital image, and the remaining steps are performed electronically. We will deal with each of these categories in detail.

## ■ Creating Digital Images

For more on half-tone processes, see pages 271–72 and 498–502.

The methods used for creating an electronic image are a derivation from the concepts used in half-tone printing. Printing devices that use ink can technically only create two tones—ink or no ink. They are incapable of providing the continuous shades that a photograph contains. To simulate these shades of gray, the half-tone process converts the photograph to a grid-work of dots. The dots vary in size, with large dots used to represent darker tones, and smaller dots used to represent progressively lighter tones. If the spacing of the grid is fine enough, the eye blends the dots into intermediate tones. The more dots that appear per inch, the finer the quality of the image appears to the eye. Television images also make use of this concept. They are electronic images that consist of dots as well, but in this case the dots vary in brightness rather than size to simulate differing tones. Color can be reproduced in dot-based images by providing three dots that represent the amounts of the additive primary colors (red, green, and blue, indicated as RGB) or subtractive primary colors (cyan, magenta, and yellow usually used with black as well, indicated as CMYK).

Half-tone Dots.

Early electronic still photographic images were based on the same technology as television/video. The optical image fell on a grid of light-sensitive elements, which sensed the amount and color of the light at that point. This information was recorded in **analog** form, which means that the illuminance values were represented by something else, like electrical voltage or magnetic patterns on tape.

## Digital Image Structure

A similar dot technique is used for creating digital images. In a digital camera, the optical image formed by the lens falls on a solid-state electronic "chip" that contains a grid of light-sensitive elements, usually **charge-coupled devices (CCDs)**. Each element, called a picture element or **pixel** for short, can measure the illuminance ("brightness") and the percentage of the additive colors of the light falling on it. This information is recorded as numbers. Each pixel has several numbers associated with it:

Digital Image Magnified Enough to See Individual Pixels.

**1.** Its position in the grid. This requires two numbers, one each for its horizontal and vertical positions.
**2.** Three numbers that describe the amount of red, blue, and green light falling on that pixel.

All of these numbers are recorded as digital data on computer storage devices. In order to view an image stored as numbers, the data must be used to create an analog image by reassembling the grid of pixels in a visible form, such as on a computer monitor or a computer printer. Images stored in analog form (e.g., video images on tape) are susceptible to magnetic and electrical noise, and deteriorate when copied. Images stored in digital form are files of numbers, and can be copied without distortion or deterioration.

**Resolution**   The quality of a digital image depends on how many pixels it contains and the size at which it is reproduced. The combination of total number of pixels available in an image and the size at which it is output results in a specific number of pixels appearing per inch (ppi) or centimeter, known as the **resolution.** The higher the resolution of an image (i.e., the more pixels appearing per inch), the better the image can reproduce detail.

**Image Size in Pixels**   The dimensions of the image in pixels are a major consideration when choosing a method of creating digital images. As a basis of comparison, consider outputting a digital image on an offset printing press. The digital image should have a resolution about twice the half-tone line screen for optimum quality. For example, many good-quality magazines print at 150 lines per inch, so the digital image must have a resolution of 300 pixels per inch. That means an image that is $600 \times 900$ pixels would print at only $2 \times 3$ inches. In order to print at $8 \times 10$-inch size, the image must contain $2400 \times 3000$ pixels.

Other types of output devices, such as computer printers or digital enlargers, may require less than 300 pixels per inch, meaning that larger images can be output from a file of given pixel dimensions. On a device that requires only 150 pixels per inch, the $2400 \times 3000$ pixel image could print at $16 \times 20$ inch size.

There are two methods for creating digital images: (1) original digital images can be created with a **digital (filmless) camera,** and (2) photographs created using traditional materials and equipment can be converted to digital form with **scanners.**

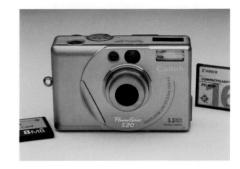

Point-and-Shoot Digital Camera. This camera uses flash card media, shown beside the camera.

## Digital Cameras

As described above, a digital camera contains a grid of tiny, light-sensitive solid-state elements that record the illuminance and color of the image at each point. The number of pixels in this grid is the major determinant of the quality of the digital image. The larger the number of pixels, the higher resolution or output sizes the camera is capable of providing. Digital cameras fall into one of three categories:

Professional 35mm-based Digital Camera.

**Low-Resolution Cameras**   These cameras produce images with relatively few pixels, generally around $640 \times 480$ pixels. They typically take the form of traditional point-and-shoot cameras, being very compact and featuring automatic focus and built-in automatic flash. Because of the small number of pixels available, images from these cameras are suitable only for small print output or for use where the images are viewed primarily on a computer monitor, as with the World Wide Web or CD-ROMs.

**35 mm-based Digital Cameras**   These are cameras designed for professional use, and provide digital images of about $1200 \times 1600$ pixels or more. They are based on traditional 35mm camera models, and have the advantage that they use the lenses developed for those models and are reasonably compact. Currently these cameras are quite expensive compared to traditional cameras, costing several thousand dollars and up.

**Digital Camera Backs**   These replace the backs on professional cameras, usually medium and large format. When used in a $4 \times 5$-inch view camera, a digital back can produce images with enough pixels to compete in quality with film in poster-size prints or larger. Digital backs are quite expensive and may be slow in operation, and may require the use of expensive, steady-state continuous lighting in the studio.

Digital Back for Use in a $4 \times 5$ View Camera. The digital back is inserted into the camera where film holders would normally be placed.

Flat-bed Scanner.

Film Scanner for 35mm Film.

Kodak Photo-CD.

# Scanners

If you don't have thousands of dollars to spend on the higher quality digital cameras, you will probably be scanning traditional photographs to create digital image files. A scanner is in some regards like a digital camera. It contains a chip with a grid of light-sensitive elements and a light source to illuminate the photograph. The light-sensitive chip is passed over the photograph to successively "scan" it and record the light values and color for each point of the image as a digital file. There are several types of scanners you may use to scan your photographs.

**Flat-Bed Scanners**   Flat-bed scanners look something like a photocopier. Most will do a good job of scanning photographic prints. Some flat-bed scanners also have the capability to scan transparent photographic materials, such as negatives or slides. The resolution of the scanner refers to the number of pixels it can create per inch of the original. When comparing scanners, only **optical resolution** should be considered. Some scanner manufacturers advertise higher resolutions that are interpolated. **Interpolation** means that new pixels are mathematically created between the "real" optical pixels that the scanner produces. Interpolated resolution does not give as good a quality image as the equivalent optical resolution.

The optical scanning resolution of the scanner and the size of the original photograph determine the number of pixels in the digital image. For example, a 4 × 5-inch photograph scanned at 300 dots per inch produces an image 1200 × 1500 pixels in size. Some models of flat-bed scanners are the least expensive scanners available, but will scan at 300 to 600 dots per inch. That means that quality output can be achieved for the same size as the original, or two to four times as large as the original depending on the image resolution demanded by the output device. If the original is quite small, the number of pixels in the resulting image is small as well. A 35mm negative (about 1 × 1-1/2 inches) scanned on a flat-bed scanner with a transparency adapter at 600 pixels per inch yields an image of only 600 × 900 pixels. This is fewer pixels than some "snapshot" digital cameras provide.

**Film Scanners**   These scanners are designed specifically for scanning negatives and transparencies directly. They may be designed for small format (35mm and APS) films only, or may take larger formats as well. Most film scanners scan at 2000 pixels per inch or higher, providing image pixel dimensions of 2000 × 3000 pixels or more and start at prices of a few hundred dollars.

**Drum Scanners**   These are capable of scanning prints or transparent materials at resolutions of 4000 or more pixels per inch. Because of their high cost and relatively difficult operation, drum scanners are generally used only by service bureaus, which can supply scans at a per-scan cost.

**Kodak Photo-CD**   An inexpensive alternative to drum scans is the Kodak Photo-CD, which provides five scans of each image on a CD-ROM disk, the largest of which is 2048 × 3072 pixels. There is also a Pro version of the Photo-CD that includes an extra scan of 4096 × 6144 pixels for larger or higher resolution output, from films up to 4 × 5 inches. The Pro Photo-CD is, however, much more expensive per scan, though still considerably cheaper than drum scans.

# ■ Storing Digital Images

Decisions about how to store (**save**) your digital images are governed by the size of the data files, the speed with which you can record and read the data, and the amount of money you wish to spend on storage media.

## Bit Depth

The bit depth for an image refers to the number of bits of data that are given for each pixel, and determines the number of shades or colors that can be represented. A single bit image has one binary digit per pixel and can only show two colors or shades per pixel (e.g., black and white). In a grayscale image using 8 bits per pixel, 256 shades of gray can be represented. A variation of 8-bit depth is **indexed color,** in which each of the 256 numbers is assigned a specific color, giving up to 256 possible predetermined colors. A 24-bit RGB image has 8 bits per color and the total combinations give 16,777,126 possible colors. Some scanners provide images with higher bit depth, but most image editing software will not handle more than 8 bits per color channel. Increasing the bit depth past 8 bits also increases file sizes and makes the images harder to manage. ■

Bit Depth of 1, Giving Two Tones or Colors.

Bit Depth of 8, Giving 256 Tones or Colors.

Bit Depth of 24, Giving 16,777,216 Tones or Colors.

## File Size

File size depends on the number of pixels in the image, the **color mode—grayscale** (monochrome), **RGB color,** or **CMYK color**—of the image, and its **bit depth** (see the boxed section on bit depth). The position of each pixel in the image grid is indicated by its position in the data file, so no numbers are required for its coordinates. For example, a file might list the data for the pixels in order from the upper left corner. The illuminance values, however, must be recorded for each pixel. If the image is grayscale (8-bit monochrome), one 8-bit number (one byte) is needed to describe the tonal value of each pixel. For example, an image that is 400 × 600 pixels contains 240,000 pixels. The data needed for a grayscale image is:

240,000 pixels × 1 byte/pixel = 240,000 bytes = 240 kilobytes.

If the image is in 24-bit RGB color, then three 8-bit binary numbers are needed for each pixel (one each for red, blue, and green) to record its tonal information. The 400 × 600 pixel images would then require:

240,000 pixels × 3 bytes/pixel = 720,000 bytes = 720 kilobytes

Larger output or higher resolution requires a greater number of pixels. An 8 × 10-inch 24 bit RGB image at a resolution of 300 pixels per inch would need 2400 × 3000 pixels, with a basic file size of 2400 × 3000 pixels × 3 bytes/pixel = 21,600,000 pixels, which is 21.6 megabytes.

Note: To be perfectly accurate you must divide by 1024 to change from bytes to kilobytes, or from kilobytes to megabytes. For simplicity, most people divide by 1000, as has been done in these calculations.

## File Formats

**TIFF:** Tagged-Image File Format. This is the most popular image file format, output by many scanners and accepted by service bureaus. TIFF format offers a lossless compression scheme known as LZW.

**Photoshop (PSD):** This is a file format designed by Adobe specifically for use in Photoshop. It supports the many features, such as layers and channels, which are available in Photoshop. It provides lossless compression. Photoshop can also save files in other formats.

**JPEG:** The Joint Photographic Experts Group (JPEG) developed this compression format to provide small files. It has different quality levels that control the amount of compression. It is a "lossy" format, but using the higher quality settings will reduce data loss somewhat.

**PICT:** Picture File Format, offering lossless compression and often used in multimedia applications. PICT can be used in combination with JPEG compression, in which case data loss is suffered.

**EPS:** The Encapsulated PostScript (EPS) file format is designed to provide page layout information to postscript type printers, and contains information for the printer.

**GIF:** Graphics Interchange Format, designed for use on the Internet. GIF provides lossless compression for images up to 8 bits (grayscale or indexed color).

**PDF:** Portable Document Files. Compressed versions of files that can be transported across the Internet and read by PDF readers such as Adobe Acrobat Reader. ■

### Comparison of File Sizes for Different File Formats*

| | | | |
|---|---|---|---|
| EPS | 3.3 MB | JPEG Maximum Quality | 637 KB |
| TIFF uncompressed | 2.3 MB | GIF (Indexed Color) | 540 KB |
| Photoshop (PSD) | 2.2 MB | JPEG Medium Quality | 168 KB |
| TIFF LZW compression | 1.6 MB | JPEG Minimum Quality | 101 KB |

*From a 24-bit RGB image 800 × 1000 pixels with no extra channels or layers.

## File Formats

There are several different file formats, and many of them have other information in them besides the image data (see the boxed section on file formats). For example, most files have a "header" that contains information about the file type, its name, creation information, color management information, and sometimes printer language information, as in the EPS file format. This additional information increases the size of the file.

Another factor in file size is whether or not the file is compressed. There are two basic types of compression, lossless and "lossy." Photoshop uses a lossless type of compression in its file formats. TIFF format also offers a lossless compression known as LZW. The JPEG file format, on the other hand, is a "lossy" compression, since it throws away data on compression, and attempts to reconstruct it on decompression. One disadvantage to any compression method is that opening and saving files takes more time.

## Storage Methods

Once you know the basic size of your files, you can then decide which of the many storage devices are most appropriate for you. A few of the currently available technologies are discussed here.

Internal Hard Disk Storage Device.

**Hard Disk**    The hard disk built into your computer would normally be a first choice, but if you are working with large or high-resolution digital images, you may fill up even a large hard disk drive quite quickly. Hard drives are also relatively expensive storage per megabyte, though they are among the fastest in terms of data retrieval. Hard disks can be internal (built-in) or external.

**Removable Media**    Removable media offer the advantage that with one drive you can get unlimited storage by simply buying more media. There are two main categories of removable storage drives, magnetic or optical. Magneto-optical drives are a combination of the two technologies.

Currently available magnetic media include floppy disks, tape cassettes, and cartridge disks. Tape drives provide the lowest cost per megabyte, but are extremely slow in retrieving data. For that reason, tape drives are mostly used for continuous data backup in business applications. Floppies, while cheap, store only 1.4 megabytes per disk, so the cost per megabyte is actually quite high. They are too small to save high-resolution images. Disk cartridges offer larger amounts of storage, from 100 megabytes up to 2 or more gigabytes. These are a good alternative for image storage. Some of them are quite rapid in data retrieval as well, comparing with slower hard drives.

External Zip Drive with Removable Media.

Optical storage offers very low costs per megabyte. The original CD-ROM recordable disks are very inexpensive and offer 650 megabytes of storage per disk, but require a special drive to record on them. Once the data is recorded, it cannot be erased or altered. Rewritable CD-ROM offers a disk that can be altered or erased, but at a much higher cost per disk. The newer DVD format offers much more storage on the same type of disk used for CD-ROM, but requires special drives. Optical drives are very slow in recording and retrieving data compared to magnetic disk drives.

**Memory Cards**    Digital cameras and some portable computers use memory chips designed to record data. These may be removable, and are often called **flash cards** or **PC** (formerly PCMCIA) **cards.** Flash cards are very compact, but are extremely expensive per megabyte, and are generally used only for transporting the image from the point of creation to your computer.

## Choosing a Storage Method

It is best to wait for major purchases of storage drives and media until you have a good idea of the type of digital imaging you are going to be doing. Once you know the approximate file size and number of your images, you can balance the cost of the drive itself, cost of removable media, speed of recording and retrieval, and convenience of the media. If you plan to use service bureaus for scanning or other services, you should inquire what removable media they support. New solutions to data storage appear regularly, so consult recent catalogs or vendors for the latest ones before you buy.

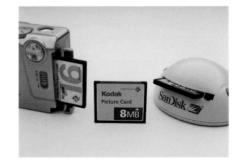

Flash Card Removable Media. On the left, a card is seen partially inserted into a digital camera. On the right is a flash card reader that can be attached to a computer for direct access to the images on the card.

Monitor for Use with Computers.

## ■ Viewing Digital Images

### Monitors

The computer monitor is the device used for viewing the digital image while you are working on it on the computer. Most current models of monitors are of the **cathode ray tube (CRT)** type, but the **liquid crystal display (LCD)** screens that have been used for several years in portable computers are now also available for desktop use.

The factors to consider when purchasing a monitor are its size and the quality of its image. Screen size is measured diagonally. Large screens are very convenient for digital imaging, since in addition to the image itself, the screen must display menus, tool boxes, and other information.

### Screen Resolution

Computer monitors produce a video image, which consists of dots of red, blue, and green light. The dots are used to represent pixels on screen. The resolution of the monitor is the number of pixels it can display horizontally and vertically. Standard resolutions are 640 × 480, 832 × 624, 1024 × 768, and 1280 × 1024 pixels. The resolution of most modern monitors is adjustable. While it may sound advantageous to run a monitor at its highest resolution, in fact, the type, menus, and information boxes displayed on the screen will appear smaller at higher resolutions. That means you can fit more on your screen, but you might be straining your eyes to see the information. A 17-inch monitor at 832 × 624 pixels gives comfortably sized type and menus. People with good close-up vision may be able to work at 1024 × 768 pixels as well.

### Video Boards

The computer monitor is run by a video controller with its own memory dedicated to displaying the image. Computers come with a built-in video control board and video memory. Unless the computer was designed for imaging work, you may find that the built-in video controller is inadequate for working on digital photographs, resulting in slow screen displays and scrolling. In that case, you can purchase an accessory video control board with additional memory to speed things up.

## ■ Editing Digital Images

Editing a digital image means correcting tonal values, color, detail, and image flaws. It can also mean manipulating the image by combining it with other images or applying special effects to radically modify the appearance of the image.

### Image-Editing Possibilities

There are many parallels between traditional and digital photography in the editing stage. Traditionally, the editing steps take place in print making and post-printing operations. For example, in the printing process the lightness and darkness and the contrast of the image can be modified by exposure and contrast control techniques. Local lightness and darkness can also be controlled by local exposure (burning and dodging). In color photography, there is little control over contrast, but the overall color balance of the image can be modified by filtration.

Traditional printing techniques are covered in chapters 5, 12, and 14.

In addition to the standard enhancement techniques, a number of traditional special techniques can be used to change the appearance of the image. Two or more images can be combined into one using multiple exposure or printing techniques. Sabbatier, posterization, or other techniques can be used.

Digital image editing can do all of the above, and more. Changing the overall lightness/darkness and contrast is easy to accomplish. Local areas can be selected for changing their lightness/darkness, and can also be individually controlled for contrast and color balance, effects that are very difficult to achieve traditionally. Special effects routines (called **filters**) in digital imaging may mimic traditional special effects (such as sabbatier effect or posterization) or may produce new effects that are impossible to achieve traditionally. Controls over image sharpness, such as simulated motion blur or focus differences, are grouped with the special effects filters. A special strength of digital imaging is its ability to seamlessly combine two or more images into one.

Once you experience the amount of control, flexibility, and visual possibilities digital image editing offers, you may find it hard to go back into a chemical darkroom. Nevertheless, currently it is difficult or impossible to achieve print output from the computer that matches the reproduction and visual qualities of some of the traditional printing materials, like high-quality black-and-white silver papers, platinum prints, and other traditional materials. Many photographers, however, are using digital imaging as an intermediate stage for producing prints on traditional materials. Most nonsilver processes, for example, require an enlarged negative for contact printing, which can be created using digital methods.

## Image-Editing Software

The software that makes it possible to perform editing operations on a digital image using the computer is called image-editing software. Adobe Photoshop is an example of professional image-editing software. There are numerous other brands on the market, but most of them closely emulate the basic operations of Photoshop, though they may not offer as many features.

Image-editing software in general is demanding of computing resources, such as hard disk space and RAM. The hardware requirements given by the software manufacturer are a minimum requirement, so if you will be working with large files you will want to increase your memory and storage space above the manufacturer's requirements. A general guideline for Photoshop is to have at least three times as much RAM as the image file size. For example, if you want to work with a 20-megabyte file, you should have at least 64 MB of RAM for Photoshop plus more memory for the operating system or other applications you may wish to run at the same time.

## Image-Editing Tutorial

The following tutorial will guide you through some of the digital editing possibilities. We will start with the tools and filters that are useful in producing straight, unmanipulated images, such as tonal and color controls, as well as basic spotting and retouching tools. The tutorial will then continue with a few of the special effects possible with digital imaging, and will also demonstrate some compositing techniques, where two or more images are combined into one. This tutorial was performed in Photoshop, but if you are using a different image editor, you will probably find identical or similar procedures. Most

See chapter 11 for information on traditional special techniques.

Howard W. Kreiner, *Busch Garden Fantasy.* This is a photograph with special effects applied using digital imaging software on a computer.

© 1999 Howard W. Kreiner.

Step 2: Open File Menu Choice.

image-editing programs have a number of alternate keyboard commands for menu items and tools. Because of the differences in programs, this tutorial uses the menus and tools rather than keyboard commands, but you will work faster if you learn the keyboard shortcuts that your program offers.

**1. Acquiring the image.** Your image can be from a digital camera or scanned from a traditional print. The image in this tutorial was originally taken as a 35mm slide, which was scanned on a 35mm film scanner.

**2. Opening the image.** Click on the File menu and select Open. Navigate through the Open File dialogue box until you find your file on disk. Click OK.

**3. Saving the file.** The file is probably an RGB file, but may be in TIFF, JPEG, or another format. Choose File/Save As . . . to open the Save File dialogue box, and save the file in the format recommended by your image-editing software, for example Photoshop's proprietary file format. If you want to retain the original scan or source file, you should save the file under a different name. As you are working on the file, you should periodically choose File/Save to save your latest changes to disk.

**4. Viewing and navigating the image.**

a. Screen magnification: Several tools are available for changing the magnification of the image on the screen and for navigating through the image if it is bigger than your monitor screen. When the image is opened, it will normally be displayed so that the entire image is visible on screen. To magnify the image, choose the Zoom tool by clicking on it, then click on the area of the image you wish to magnify. Successive clicks will continue to magnify the image. To reduce the size of the image displayed, hold down a control key (Option on Mac, Alt in Windows) and then click with the Zoom tool. Zooming does not change the file itself, but only your view of the image.

b. Moving through the image: Select the Hand tool (also known as the Pan tool) by clicking on it. You can now click and drag with the mouse button to move through the image. Another method is to use the scroll bars to navigate through the image.

The Image-editing Screen.

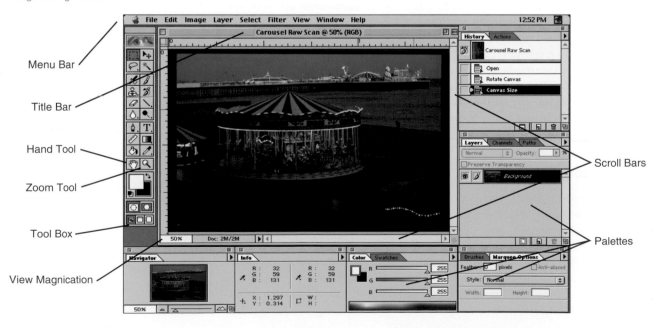

**5. Straightening and cropping the image.** This image is slightly crooked. To straighten, perform the following steps:

a. Select the entire image by choosing Select All from the Select menu on the menu bar. You will see crawling dotted lines around the image indicating that it is selected.

b. Choose Transform/Rotate from the Edit menu. Now the selection box changes to include little squares at its corners and edges. These are called **handles** and can be used to change the image inside the selection box.

c. Move the cursor just outside one of the corner handles and you will see it change to a curved double arrow. This is the rotation symbol. Some image-editing software provides horizontal and vertical guides that you can position for alignment. The blue lines in the image are guides that we have inserted to get the subject matter straight.

d. Click and drag with the mouse button depressed to rotate the image. In a few seconds the image will redraw in the new position. If it isn't exactly where you want it, move it again. Don't worry about the jaggy lines at this stage. These will clean up when you finalize the rotation. Hit return or double-click inside the selection box to finalize the rotation.

e. The image is now straight, but the borders are crooked, so we will clean these up by cropping the image around the border. Choose the Crop tool from the Tool Box. Click-drag a box approximately where you wish to crop.

f. The size and position of the crop selection box can now be changed using its handles to reposition corners or sides. You can also click-drag inside the box to move the whole box. When you have the box correctly positioned, hit Return or double-click inside the box to complete the crop.

Step 5.b: Choosing Transform/Rotate from the Menu Bar.

Step 5.c: The Rotation Symbol just Outside the Transform "Handle." The blue line is an alignment guide.

Step 5.e: Selecting the Crop Tool from the Tool Box.

Step 5.e: The Straightened Image with the Crop Selection Box Roughly Positioned.

Step 5.f: Resizing the Crop Selection Box by Click-dragging the Handles.

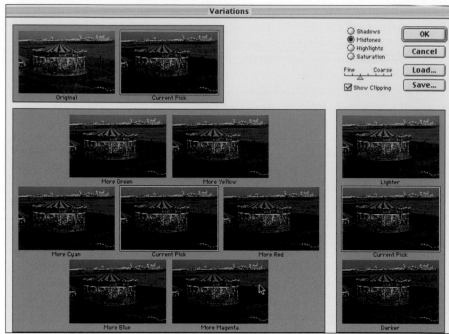

Step 6.a: The Image/Adjust Menu Selection of Tonal and Color Adjustments (above), and the Variations Dialogue Box (right).

**6. Overall color and tone correction.** In this step we are going to analyze and correct the overall lightness/darkness of the image, its overall color balance, and its overall contrast.

a. First analyze the image to see if there are noticeable image quality flaws. Look at the light values and see if they are convincingly light without losing detail. Look at the dark values and see if they are richly dark without losing detail in important areas. Look at the overall color of the image and see if it has a noticeable color cast toward any one particular color. For those of you who are first learning color correction, Photoshop offers a useful analysis tool called Variations, found under the Image/Adjust menus (see the illustration above). Variations shows you the effect of changing any one of the six additive and subtractive colors. It also shows you lighter and darker images, but does not address contrast. Variations will also perform the correction if you click on the image that you think has improved color,

Step 6.b (left): Correcting Color Casts in the Image Using Image/Adjust/Color Balance. Step 6.c (right): Changing the Brightness and Contrast of the Image using Image/Adjust/ Brightness/Contrast.

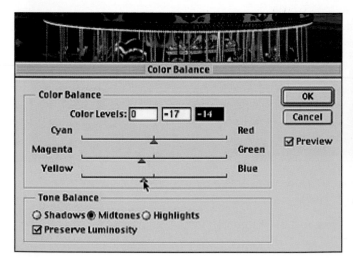

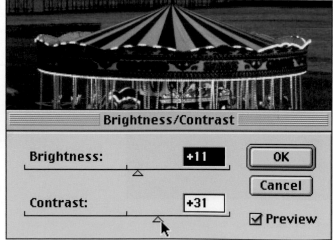

## Levels and Curves

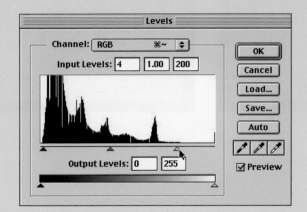

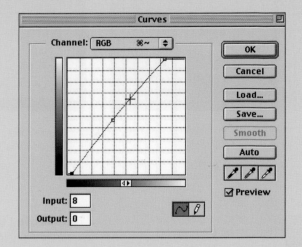

Levels and Curves are more precise methods for adjusting both the tonal values (brightness and contrast) and the color balance of an image. Both Levels and Curves have a Channel menu at the top of the dialogue box that allows you to choose RGB, Red, Green, or Blue. When working in the RGB channel, all colors are affected equally by changes. Individual colors can be changed by selecting their respective channels.

In the Levels box, changes are made by dragging the triangles under the tone graph (called a **histogram**). In this case the highlight slider has been dragged down to give brighter highlights and more contrast.

In the Curves box, changes are made by clicking and dragging on the line in the graph to change its shape. In this case, the top (highlight) end point has been dragged to the left, and the bottom (shadow) point to the right to brighten highlights, darken shadows, and increase contrast. Dragging the middle of the curve lightens or darkens midtones. Here the middle of the curve has been dragged up to lighten midtones. ■

and then click OK. However, these color and tonal changes are available as separate tools that offer far more control, so it is better to use Variations only as an analysis tool and click Cancel to exit without making the changes.

b. Once you have determined the corrections you want to make, there are several options for making corrections. These are also found in the Image/Adjust menus. Color Balance gives a lot of flexibility in changing the overall color of the image by way of sliders, boxes, and buttons that choose whether midtones, shadows, or highlights are being altered. Adjust the values until you get the best effect. With Preview on, you can see the changes as you make them.

c. To change overall brightness and contrast choose Image/Adjust/Brightness/Contrasts. . . from the menus. This is a simple dialogue box where one slider controls brightness and the other the contrast.

d. Between Color Balance and Brightness/Contrast you can probably get a pleasing overall appearance of the tones and colors in the image. For more precise control, however, advanced users prefer the use of Levels and/or Curves, found on the Image/Adjust menus. See the boxed section for a short introduction to the use of Levels and Curves.

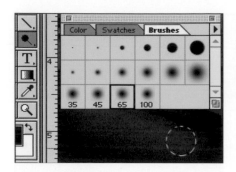

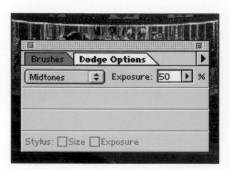

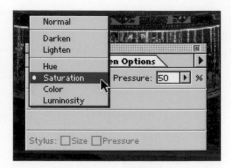

Step 7.a: Lightening an Area Using the Dodge Tool with a 65 Pixel Soft Brush.

The Dodging Tool Has Been Set at 50% Effect in the Options Palette.

Special Effects Can Be Achieved by Using the Application Mode Menu in the Options Palette

Rectangular Marquee

Oval Marquee

Lasso (freehand)

Magic Wand

Quick Mask

Step 7.b: Selection Tools Available from the Tool Box.

**7. Changing local areas.** One of the most powerful advantages of digital image editing is the ability to work on specific areas of the image. There are tools that can be used like brushes to make changes in the image. There are also selection tools, which allow you to select specific areas of the image. Only selected areas are then affected by changes.

a. Local tools: Burning, Dodging, Sharpen, Blur. These tools are applied by "brushing" them onto the image by click-dragging with the mouse. The size and hardness of the brush can be selected in the Brush palette. The options for each tool allow you to apply the tool at 100 percent effect, or reduce the percentage so less effect is achieved with each pass of the brush. With options, you can also get special effects from the tool by choosing an application mode.

b. Selection tools: There are a number of selection tools available. The Rectangular Marquee tool can be used to drag selections that are rectangular. Hold down the Shift key to make a square. The Oval Marquee cre-

Lasso Tool. Click-drag along the border of the area you wish to select. When you release the mouse button, it will complete the selection with a straight line back to your starting point.

Magic Wand Tool. Clicking once in the area we wished to select produced this result. The white specks inside the area did not get selected. Results with the Magic Wand can be adjusted by changing its tolerance setting in the Options palette.

Quick Mask Mode. Clicking on the Quick Mask icon changes any unselected area to a mask (shown here as red). The mask can be added to by painting on the image with black (which shows as red). You can subtract from the mask by painting in white. Here we are

adding to the mask (i.e., subtracting from the selection) by painting with black in the lower left corner. Once you have cleaned up and adjusted the mask, clicking on the Standard Selection icon to the left of the Quick Mask icon returns you to the crawling dashed selection line.

ates oval selections by dragging. Holding the Shift key down while dragging produces circles. The Lasso tool allows you to click-drag with the mouse to draw a selection freehand. The Magic Wand will select any contiguous areas with close to the same tonal values as the spot you click on. The Quick Mask tool allows you to add and subtract from a selection using the brush tools.

c. Feathering the selection: You can soften the edges of the selection so that changes will blend into the surrounding image by "feathering" the selection. Choose Select/Feather. . ., and the dialogue box shown in the illustration below will appear. Choosing larger feathering values in pixels will cause the selection to be blended into its surroundings over a wider area.

d. When a selection is active, any changes you make, such as painting or correcting tones or color, will only affect the selected area. This gives you control over the appearance of specific areas of the image, which would be difficult or impossible to achieve using traditional darkroom techniques.

Step 7.c: The Select/Feather . . .
Dialogue Box.

Step 7.d: Using a Selection to Change a Local Area. Here the Brightness/Contrast menu choice has been used to increase both brightness and contrast of the selected area. Color Balance, Curves, Levels, or any other control can also be used to change the selected area without affecting the remainder of the image.

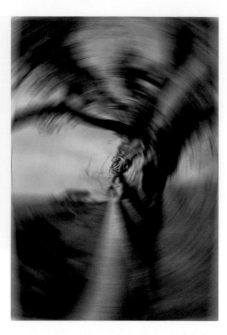

Special Effect Using Image Editing Software. This is the original unmanipulated image.

© Bruce Warren.

Here the image color and tone were radically changed by using Curves and dragging each of the channel curves into distorted shapes.

Radial Blur was chosen from the Filters menu, and set for the spin effect.

## Special Effects

Digital image-editing software contains a myriad of techniques for radically altering the straight photographic image. These range from effects that mimic traditional special effects, such as sabattier, posterization, high contrast, hand painting, blur, and others, to wild effects that are only possible using the computer. Some special effects can be achieved by manipulating the controls on the Image/Adjust menu, such as curves. Others are listed on the Filter menu, and consist of routines for altering the image by distortion, mimicking artwork, adding noise, and so on. Some of these filters come with the image editor, but there are also hundreds of special effects filters available from third-party software companies. These may operate as a **plug-in** to your image-editing software, meaning that they can be accessed from within your program.

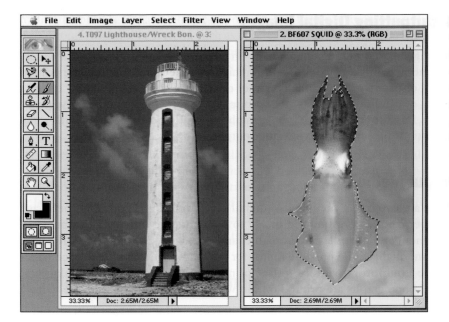

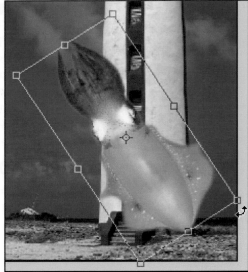

Simple Composite. On the left, we see both images open and displayed side-by-side. The squid has been selected using the Lasso and Quick Mask tools, and feathered to help it to blend with its new environment. To move it to the other image, choose Edit/Copy, then activate the lighthouse image by clicking on it and choose Edit/Paste. Some programs will allow you to simply click-drag the selection from one window to the other.

Images © Bruce Warren.

Positioning and Sizing. In Photoshop, the squid is automatically pasted in as a new layer. Choose Edit/Free Transform, and the imported object will be enclosed in a box with handles with which you can resize, stretch, move, and rotate the object until you get it where you want it. Hit Return to finalize the transform.

## Combining Images (Composites)

Another of the strengths of digital image editing on the computer is the ease with which images can be combined with each other (composited). What required laborious multiple exposure, multiple printing, collage, or montage techniques with traditional photographic materials can be accomplished easily with the selection tools and Cut and Paste commands.

## ■ Electronic Distribution of Digital Images

One great advantage to digital photographs is that they can be transported easily in electronic form. You can record images on storage media, like magnetic or optical disks, and send them to others to view on their computer. You can also send and receive digital images over phone lines or via satellite using modems. If you wish to distribute your photographs electronically, the easiest ways are to put them on magnetic or CD-ROM disks or to make them available on the World Wide Web by placing them on a Web site.

## Image Disks

CD-ROM Image Disk.

© 1997 Kieffer Nature Stock.

Placing photographs on CD-ROM or magnetic disks is becoming an increasingly cheaper method of distributing images. Many film processing companies can put your images on disk for you, and some include a software viewer on the disk, which lets people view the images as a slide show. It is also possible to put sound and video clips on the disks, but of course the price goes up as you make the disk more complicated. This is the basis of multimedia disks, which contain images, text, sound, and are usually interactive, allowing the viewer to navigate through the contents of the disk by clicking on menu choices or graphic "buttons."

An alternative is to publish your own disks. Freeware or inexpensive shareware programs (such as QuickShow) can be included on the disk for viewing ease. Check the licensing requirements of the software to be sure that it is legal for you to include it on your disks. The disks can be magnetic, but CD-ROM is a popular choice for distributing images. You can make your own CD-ROMs by purchasing a CD recorder. These are currently reasonable in price and record on very inexpensive media. The recordable CDs are not as permanent as the professionally produced CDs, however, so if you are looking for a more permanent medium, you may want to have a CD master disk pressed by a service bureau. Permanent copies can then be produced from the master in larger quantities. One nice thing about CD-ROM disks is that they can be produced with cross-platform readability, so that your images can be viewed on either IBM-PC or Macintosh computers.

The file format you use is determined by the viewing software that you place on your disk. To conserve disk space and make image viewing quicker, small file sizes are usually desirable. These can be achieved by reducing the resolution of the image to screen resolution (e.g., 72 pixels per inch), and by using compression, such as JPEG. Be sure to include your copyright on the disk and images (see the section on Copyright Law and Digital Imaging later in this chapter).

## Using the World Wide Web

The **World Wide Web** (also known as the **Internet**) has blossomed almost overnight into an amazing vehicle for communication and distribution of information, including images. To quote Deke McClelland: "The Internet may well be the most chaotic, anarchic force ever unleashed on the planet. It has no boundaries, it has no unifying purpose, it is controlled by no one, and it is owned by everyone. It's also incomprehensibly enormous, larger than any single government or business entity on the planet . . . In terms of pure size and volume, the Web makes the great thoroughfares of the Roman empire look like a paper boy's route." In other words, what a great opportunity both to see other photographers' work and to make your own available for viewing.

Web browser interface.

Image courtesy of Netscape 6.

**Access to the Internet**   To get on the Internet, you will need some equipment and services. You will need a computer with a reasonably fast modem to attach to your phone line. Get the fastest modem you can afford, since it makes Web surfing much faster and more enjoyable. You will also need an **Internet service provider.** These are springing up all over, and have many payment plans depending on the number of hours you spend on the Web. They range from international giants like America Online to local services, any of which give you complete access to the World Wide Web, but which may have varying services, features, and speed of access. You will also need an Internet browser, which is the software that allows you to navigate on the Web. The current most popular browsers are Netscape Communicator and Microsoft Explorer. Your Internet service provider usually supplies you with a browser, and you can also **download** (copy to your computer) other browsers from the Web.

The Internet is organized into **Web sites,** which individuals or corporations set up so that they can be contacted via the Web browser. Each site has an address, and you can access the site by typing in the address in your browser. The Web is a remarkable resource for researching photographic topics.

**Setting Up Your Own Web Site**   You can set up your own Web site so that others can find and look at your photographs via the Web. Some Internet service providers provide personal Web sites (sometimes called Web pages) to their customers. Your Web site consists of files that you can design to contain text, graphics, and images. You can have an opening screen (called the **home page**), which tells what your Web site is about, and on that screen you can have graphic "buttons" or highlighted text (known as **links**), which when clicked on, bring other files to the screen, or allow jumps within the same file to different sections. These links can even take the viewer to other Web sites. For example, you could have an opening screen with a "contact sheet" of your images. When the viewer clicks on any image, it could open a full-screen version of the image. Other links could provide a page with biographical detail or connect the viewer to another related Web site.

You need software such as Adobe PageMill or Microsoft Front Page to design the files for your Web site. Some word processors also include the capability of producing documents for use on the Web.

**Preparing Photographs for the Web**   It takes time to send data over the Web, so it is important that you keep your image file sizes as small as possible. In preparing image files for the Web, you are trying to achieve a balance between the size of the file (for speedier transmission) and the quality of the image that the viewer sees on his or her monitor. The following guidelines will help you to make that balance work.

*Size of the images* is determined by the pixel dimensions of the image, not its size in inches or its resolution, since that is how the receiving computer monitor displays them. An image of about 400 pixels high by 600 pixels wide will fill all or a good percentage of most monitors, so size your images in pixels, according to how much of the screen you want them to occupy. You should start with an image that is at least 400 × 600 pixels in size so that you can then resize it to the desired number of pixels using your image-editing software.

Web Page Design. This is the home page for the business Glass Garden Beads. The ovals at the bottom of the page are buttons linking with other pages in the Web site. Web page design and photograph by Chris Ward. Web site owner Cathy Collison.

© Chris Ward.

*Comparison of 24-bit Color and 8-bit Indexed Color as Seen on a Computer Monitor.* These are life-size sections of images displayed on the monitor at 100% (i.e. pixel for pixel) maginification. The millions of colors possible with 24-bit color (top) provide smoother tones, especially in the skin. Reducing the number of colors to 256 in the 8-bit indexed color image (bottom) produces coarser tonal gradations and the appearance of slightly more contrast.

© Bruce Warren.

*Color mode of the images* should be 24-bit RGB initially for the first steps of image editing, color correction, and sizing. When you adjust the color and tones in the image, keep in mind that the appearance at the viewer's end will depend on his or her monitor. If you are working on a Macintosh you will see the images brighter than someone viewing the same file on an IBM-PC. Since the highest percentage of viewers on the Web are using IBM-PC compatible computers, you may want to keep in mind that the images will be darker on their machines than on your Macintosh. Many older computers may have 8-bit monitors, rather than the 24-bit monitors most computers come with today. That means the monitor can only display 256 colors, which will reduce the reproduction quality markedly.

Once you have made the initial color and tone corrections to the file, you may want to change its color mode to indexed color to reduce the size of the file. Changing to indexed color also reduces the quality of the image. An 8-bit indexed color image has only 256 colors for display, but takes up about one-third the file size. Image-editing software will allow you to change the bit-depth of the image when you change to indexed color, so you could choose fewer colors as well. A 5-bit indexed color image shows only 32 colors.

*Choosing the file type* in which to save your images depends again on the balance between size and quality. The two image file types most widely used on the Web are JPEG and GIF. JPEG provides compression, and will work with 24-bit images to produce smaller files. Since JPEG is a "lossy" compression, the choice you make of JPEG image quality affects not only the file size but also the image quality seen after decompression. Experiment with different quality levels when saving as a JPEG to see what is acceptable to you. You will probably not want to use JPEG quality lower than medium. GIF files provide compression which is lossless, but work only with indexed color files of 8 bits or fewer.

Your choice of whether to use JPEG or GIF needs to take into account the color nature of the photograph you are sending, as well as the viewer that it is reaching. If your viewer is working with an 8-bit monitor, sending 24-bit JPEG files is wasted, since they won't see the 16 million available colors anyway. In that case the GIF file may give even higher viewing quality than the JPEG. On the other hand, if your viewers are working with 24-bit monitors and you want them to see the images at the maximum number of colors, you should send them as 24-bit RGB JPEG files and use the higher levels of JPEG quality. If you have graphics or images that contain few distinct colors and no gradations between colors, you may be better off converting them to indexed color and saving them in GIF file format. They will then display faster, and will probably appear at higher color quality level on the viewer's screen.

In any case, you should always save the original 24-bit RGB full-size color image as a master file before doing any conversions to JPEG or GIF. That way you can always return to the master file (which contains all the original data) if you change your mind about size, compression, or indexed color choices.

## ■ Ethics and the Law in Digital Imaging

Photographers and users of photography have always had a number of ethical and legal issues with which they must deal. The primary ones are the issue of copyright, which governs the ownership and usage of creative materials, and the issues of accuracy and honesty in reporting events by photographic means. The advent of digital imaging has not really changed these overriding concerns. What it has done is to make it easier to violate the legal and ethical guidelines that have been adopted over the years.

## Truth and Photography

Accurate and honest reportage with the camera has always been problematic. The adage that "a photograph never lies" has been proven false many times. Photographers and picture editors have used a myriad of techniques to mislead the viewer of a photograph. Taking a subject out of context by careful framing or cropping, for example, is a simple way of giving the wrong impression of a person or event. Choice of lighting or camera angle, or the capture of a fleeting expression, are other ways of influencing viewers' responses away from a truthful rendering of the situation. Photographers have posed their subjects to give misleading impressions. Even from the early days of photography, some enterprising propagandists have found that outright manipulation of the photographs by cutting and pasting, rephotographing, retouching, or multiple printing techniques could present a completely false view of reality. Digital image editing makes this manipulation process not only easier, but virtually undetectable in published photographs.

While people may readily accept manipulation of photographs in fine art photography or in advertising, they place the photojournalist under stricter ethical expectations. When the *National Geographic* digitally moved the pyramids of Giza so that the photograph would better fit on its vertically formatted cover, many readers were outraged by what they considered to be an untruthful rendering of the subject in a magazine long considered a bastion of honest reportage. The discussions of what are the limits of acceptable manipulation or retouching in photojournalism or documentary photography are still lively. Many feel that any manipulation at all, even the removal of distracting unrelated background from a photograph, is not allowable for truthful reportage. The important thing is to be aware of the ethical abuses possible with digital imaging, and to tread carefully in areas where the viewer is expecting an honest representation of the subject.

## Copyright Law and Digital Imaging

The fact that an image is digital in nature does not change its protection under the copyright law. The creator of the image holds the copyright unless she or he releases those rights by contract or the image was created as **work for hire.** The problem with digital imaging is the ease with which it allows images to be copied and recopied with no loss of quality. The mass distribution of images electronically has also had a misleading effect on the attitudes of some users of photographs. Some of the distributed photographs are "royalty free," which means they can be reproduced without payment to the copyright holder. Others are purchased on disks or over the Web as a group of photographs called **clip art,** which means that they can be used within the guidelines of the license without further payment. With the proliferation of this means of marketing photographs, some individuals begin to feel that anything that is on the Web or on disk is fair

Bending Reality in an Advertising Photograph. Zach Burris. In this catalog cover photograph, image-editing software was used to make summer clothing look like a frozen treat. © Lands' End. Inc.

For more on copyright law, see pages 517–18.

game for usage. That is definitely not the case, and active photographers are pursuing legal means to recover damages for improper usage of their images. A recent case involving photographers Carl and Anne Purcell, for example, involved the use of a large number of their images on the Web by America Online. The court ruled in favor of the Purcells, with an undisclosed settlement.

A few inaccurate ideas that are used as justification for "borrowing" other artists' copyrighted work are floating around. Some believe that as long as the borrowed art doesn't exceed 10 percent of the final work, that it is all right to use it without permission. Another misconception is that altering the color or distorting the image in some way releases users from the necessity of getting permissions. The fact is that any identifiable use of another's work is governed by the copyright law.

A related issue to copyright infringement is the illegal use of software. Software is copyrighted and cannot be copied or used without the express consent of the owner of the copyright. Many individuals who would not dream of shoplifting a $500 leather jacket will illegally copy a $500 computer program without a qualm.

Music is also copyrighted, so if you plan to publish multimedia disks containing music, be sure to get the necessary permissions. It is especially important for those in the creative fields who would like their own copyrights to be respected to show that same respect to other copyright holders. Users of photographs should keep copyright in mind both for ethical reasons and to protect themselves from litigation.

## ■ READING LIST

The literature for computer-related fields like digital imaging changes so rapidly, that any list may soon be out of date. Start with the suggestions below if they are still current and available, but for a more current reading list dealing with digital photography, consult your local library or search the Internet.

Adobe Creative Team. *Adobe Photoshop 5.5 Classroom in a Book*. San Jose, Calif.: Adobe Press, 1999.

Bouton, Gary David, Gary Kubicek, and Barbara Mancuso Bouton. *Inside Adobe Photoshop 5.5*. Indianapolis, Ind.: New Riders Publishing, 2000.

Dayton, Linnea, and Jack Davis. *The Photoshop 5.0/5.5 Wow! Book*. Berkeley, Calif.: Peachpit Press, 1999.

Dinucci, Darcy, Maria Giudice, and Lynne Stiles. *Elements of Web Design*. Berkeley, Calif.: Peachpit Press, 1998.

Haynes, Barry, and Wendy Crumpler. *Photoshop 5 & 5.5 Artistry*. Indianapolis, Ind.: New Riders Publishing, 2000.

McClelland, Deke, and Ted Padova. *Macworld® Photoshop® 5 Bible*. Foster City, Calif.: IDG Books Worldwide, 1998.

Pogue, David. *Macs for Dummies*, 6th ed. Foster City, Calif.: IDG Books Worldwide, 1998.

Rathbone, Andy. *Windows 98 for Dummies*. Foster City, Calif.: IDG Books Worldwide, 1998.

Stanley, Robert. *The Complete Idiot's Guide to Photoshop 5*. Que Education & Training, 1998.

Weinmann, Elaine, and Peter Lourekas. *Photoshop 5.5 for Windows and Macintosh (Visual Quickstart Guide Series)*. Berkeley, Calif.: Peachpit Press, 1999.

# Tone Control Techniques

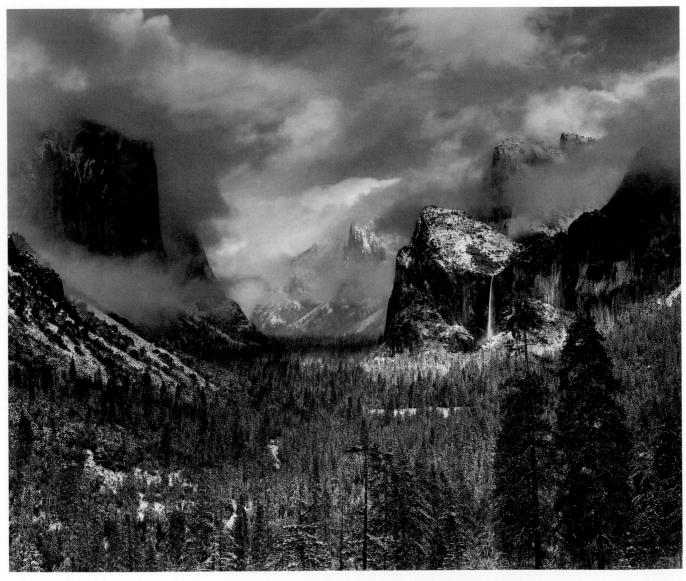

Ansel Adams, *Clearing Winter Storm, Yosemite National Park, California*, c. 1944.

When Ferdinand Hurter and Vero Driffield discovered the relationship between exposure, development, and density in the 1880s, a new world of possibilities opened for control of photographic reproduction. Many systems of exposure and development based on Hurter and Driffield's work were devised, but one of the most elegant and practical was the Zone System originated by Ansel Adams and elaborated upon by Minor White and others. The Zone System is concerned with the reproduction of specific tones of the subject as tones in the print. Reflected-light meter readings are taken from individual subject tones, providing luminance information needed to predict the print tones. Dark tone densities in the negative are then controlled by exposure and light tone densities by film development, giving limited control over the resultant print tones.

See appendix D for detailed information on characteristic curves.

Chapter 3 touched on the effect of different subject tones on reflected-light meter readings and the resulting tones in the print. A simple method was given for changing the print tone for a particular subject area: Open up from the camera settings suggested by the meter to get tones lighter than 18 percent gray, and stop down for tones darker than that.

See pages 36–38.

This chapter will expand on the theory behind this method of tone control and give some testing techniques for calibrating your equipment and materials for predictable results. The theory and methods are based on the Zone System but use a terminology for film exposure and print tones consistent with the + and − exposure controls built into many in-camera and hand-held meters. Knowing at the time of exposure exactly how your finished photograph will look opens a new world of creative possibilities.

For a comparison of the terminology used in the Zone System and the + and − system, see appendix E.

## ■ Meter Operation and Film Exposure

Throughout this chapter you will be dealing with the reproduction of individual tonal areas of a subject. Since an incident-light meter measures only the amount of light falling on the subject and tells nothing of the effect of the subject itself on the light, you must use reflected-light meters for accurate tone control. The statement *A light meter sees everything as if it were 18 percent gray* contains important information about the operation of a reflected-light meter, but it is helpful to see what this means in practical use. The first part of exercise 1 (page 420) demonstrates the real meaning behind this statement.

A reflected-light meter measures the amount of light reflected from a subject, called the luminance. Most subjects have a scale of many different luminances, and a reading of the luminance for each of these areas can be made by moving closer with the meter or by using a spot meter. Since you are interested in the light reflected toward the camera, you must still follow the rule of keeping the meter on a line from camera to subject.

See page 34.

Exercise 1 asks you to find three different tones of subject—black, gray, and white—each with basically a single luminance. If you perform the exercise correctly and your equipment is working properly, each frame on the developed film will have exactly the same density regardless of its original subject tone. When printed, each will have exactly the same shade of gray in the print.

See page 421 for results from exercise 1.

The density of all the frames is the same because the light meter provides camera settings that always produce the exact same exposure on the film, regardless of the original subject tones. This standard film exposure is the correct amount for giving a density that prints well at 18 percent gray, *providing* your equipment, developing techniques, and printing methods are standardized.

For a clearer idea of what a reflected-light meter does, you can expand the earlier statement to read, *A photographic reflected-light meter measures subject luminance and provides camera settings producing a standard film exposure that, with standardized development, will yield a negative density appropriate for printing 18 percent gray.* This "standard film exposure" is the same only so long as the ISO setting on the meter remains unchanged. If the ISO is raised, the standard film exposure produced is less, as is appropriate for more sensitive films.

## Film Exposure

One major confusion about the effect of light on film is that between camera settings and film exposure. The camera settings do not entirely specify the amount of film exposure, although many photographers say, for example, "I gave it an exposure of f/8 at 1/125 second." The phrase *f/8 at 1/125* describes not film exposure but the physical settings on the camera, two different things. Camera settings have an effect on film exposure, and this basic definition makes clear the relationship:

Film exposure = Illuminance of image on film × Time of exposure

The illuminance of the image that falls on the film does depend partly on the camera settings, since the aperture controls the amount of illuminance. But that is not all. Illuminance also depends on the original luminance of the subject, which depends on the amount of light illuminating the subject and the reflectance of the subject. Several other factors—losses of light in the lens, flare, lens extension, and so on—affect illuminance on the film, but the important ones for this discussion are subject luminance and aperture.

The time of exposure is usually the shutter speed; an exception to this would be with electronic flash where the duration of the flash is shorter than the shutter speed. You now have a new working definition of film exposure: *Film exposure depends on subject luminance and camera settings* where camera settings are the actual f-stop and shutter speed used for the exposure.

Factors Affecting Film Exposure

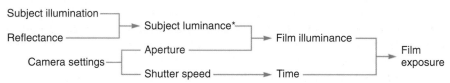

*Subject luminance may also include emitted or transmitted light.

Unlike those chosen for exercise 1, most subjects have many subject luminances, each creating its own film exposure. Instead of having a single film exposure when you make a photograph, you have as many film exposures on that frame as you had luminances in the original subject. Each film exposure represents a subject luminance, producing distinctive densities and creating a recognizable image.

If the field of view of a reflected-light meter includes more than one subject luminance, these are averaged into a single luminance by the meter according to the area of each. When a meter is manufactured, it is calibrated for subjects with an average reflectance of 18 percent, since many commonly photographed subjects come close to this average. Tone control is based on metering individual luminances of a subject rather than the average luminance, so

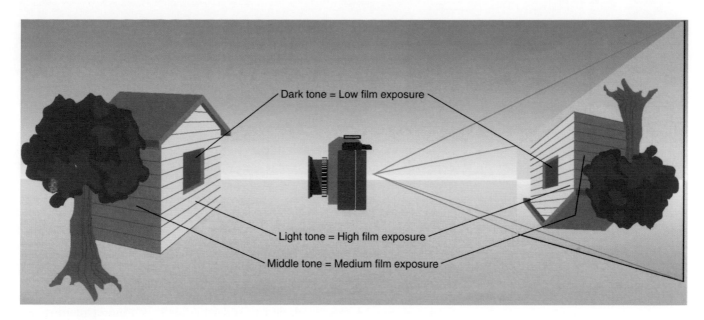

Dark tone = Low film exposure

Light tone = High film exposure

Middle tone = Medium film exposure

Relationship Between Subject Tone (Luminance) and Film Exposure.

this characteristic of the meter must be taken into account for proper exposure when the reflectance of the area being metered does not average 18 percent.

Although intended for controlling individual tones in a photograph, the principles of tone control can also be applied to overall meter readings that include several tones by mentally comparing the mix of subject tones to 18 percent gray and making appropriate adjustments.

## Placement

The second part of exercise 1 explores the possibility of controlling the tone of a subject in the print by manipulating the camera settings. As the camera settings are changed, the film exposure changes (remember that film exposure depends on subject luminance and camera settings). More exposure on the film results in a higher film density and a lighter tone in the print. Less exposure results in a darker tone.

See page 420.

If the camera settings suggested by the meter are used, the result will be the standard film exposure the meter is designed to produce. More film exposure can be produced by opening up from the suggested camera settings. Opening up one stop, or slowing the shutter speed one step, would give one stop more exposure (+1) than the standard film exposure. Closing down one stop, or speeding up the shutter speed one step, would give one stop less film exposure (−1).

In all cases the amount of film exposure is given *relative to* the standard film exposure produced by using the camera settings suggested by the meter. This provides an easy method of keeping track of how much film exposure we are getting in each area. **Relative film exposure** is defined as the amount of exposure in stops compared with the standard film exposure. **Relative exposure value** +1 (REV +1) means one stop *more* film exposure than the standard. REV −2 means two stops *less* film exposure than the standard.

It would be helpful to have a name for the standard exposure, so we are going to call it REV M. The *M* can stand for "middle," "metered," "middle

gray," or whatever you find easiest to remember, but what it means is this: If a subject luminance is metered and the suggested camera settings are used, the film exposure for the corresponding part of the image is REV M.

In the second part of exercise 1 a fixed subject luminance is used but the camera controls are manipulated to give different amounts of film exposure, from REV −5 up to REV +4. This procedure of determining film exposure by metering and then changing the camera settings is called **placement.** For example, if a subject area had a meter reading f/8 at 1/125 second, but the camera settings used were f/16 at 1/125 second—in other words, stopped down two stops—the film exposure for that area would be REV −2. You would say, "I *placed* the film exposure for that area at REV −2."

Care must be taken not to confuse meter readings and camera settings. Some meters read out in meter numbers or EVs, but most read out suggested camera settings. These are not actually camera settings but instead are indications of subject luminance, which is what a reflected-light meter is designed to read. Camera settings are the *actual* shutter speed and f-stop set on the camera when the exposure is made. To prevent this confusion between meter readings and camera settings, any shutter speed and f-stop pair should always be clearly labeled to tell whether it is a meter reading or a camera setting. Meter reading f/8 at 1/125 second will be abbreviated M.R. f/8 at 1/125 second. Camera setting f/16 at 1/125 second will be written C.S. f/16 at 1/125 second.

Remember that camera settings have several equivalent pairs that will yield the same film exposure. For that reason C.S. f/16 at 1/125 second represents all the equivalent pairs, such as C.S. f/11 at 1/250 second, C.S. f/22 at 1/60 second, and so on. All will give the same film exposure. Likewise M.R. f/8 at 1/125 second indicates the same luminance as M.R. f/5.6 at 1/250 second and so on. Using this terminology you can rewrite the preceding placement example as:

M.R. f/8 at 1/125 Second ◗ Place at REV −2 ◗ C.S. f/16 at 1/125 Second

(or any equivalent camera setting pair).

If the film is given standard processing and the negative is printed by standardized methods, the REV of each image area will determine its density in the negative and the print tone that results. The contact sheet from the second part of exercise 1 (page 421) shows the print tones for each REV, from pure black at REV −5 to about 18 percent gray for REV M to pure white for REV +4.

If your results do not look like the example it may be because your film processing or printing is not standardized. The following sections of this chapter provide methods for standardizing film processing and printing. Once you have standardized processing, placement can be used to determine the print tone of a single subject luminance. The negative REVs give tones that are progressively darker than 18 percent gray and the positive REVs give tones that are lighter. Knowing this can help you determine what to do for each subject tone.

If a dark tone of a subject—perhaps a shadow area in which you wish to see the detail—is metered, you would stop down from the meter reading, let's say two stops, to get the proper dark tone in the print to represent that shadow area. In other words, you would place the shadow area at REV −2. You should not say that you "underexposed" that area two stops, since it was not really underexposed but instead was given the correct exposure for its dark tonal value.

## Exposure Index

For the placement method outlined in the preceding section to work, all equipment must be operating properly and all materials and procedures must be standardized. In chapter 5 (pages 104–06) the effects of exposure and development on the negative were discussed. It was shown that the densities in the low-exposure areas of the negative—those corresponding to the dark subject tones—depended primarily on exposure, but the densities in the areas corresponding to the lighter tones of the subject depended on both exposure and development. For that reason the subject tone chosen for placement is usually a dark tone—often called a "shadow" even though it may not be an actual shadow cast by a part of the subject.

Since the density of the dark tone areas changes very little with development, the only way to get correct density and detail in those areas is to use proper exposure placement. Midtone densities change more with development changes, and light tone densities change most.

It is easy to check your system and procedures to see if you are getting proper film exposure for the dark tone areas, but to understand what we are going to do, you need to know a little about the origin of the exposure index provided with the film. The exposure index is the scale on the meter that is usually labeled ISO or ASA or DIN. These are all standard systems for measuring the sensitivity of a film. The manufacturer tests the film and provides an exposure index that when set into the meter should provide the correct exposure. Since the low-exposure areas are least affected by development, the testing of film speeds looks for the proper amount of film exposure to yield correct dark tone density.

The density of unexposed processed film is not zero. The base of the film absorbs some light, and some silver—called chemical fog—is always produced by the action of the developer, even in unexposed areas. The density in an unexposed area of the film is therefore the density of the film base and emulsion plus the density due to fog, called **base plus fog density.**

If a strip of film is exposed to steps of exposure gradually increasing from zero, initially only base plus fog will result, but at a certain exposure additional density will begin to be produced because of the action of the light. In measuring the sensitivity of film, manufacturers are looking for the amount of exposure needed to produce the first printable density above base plus fog. When the printing time is adjusted so that base plus fog prints as maximum black, the first printable density will produce the first perceptible tone above maximum black. Through testing, it has been determined that for most printing papers a density of 0.10 above base plus fog is the printable density difference. Referring to the results of exercise 1, you see that the first tone above black occurs at REV −4.

If you had a densitometer—a machine for measuring densities—at your disposal, a simple test of your exposure would be to find the REV −4 frame in the second part of exercise 1, measure its density, find an unexposed area of the film and measure its base plus fog density, and then subtract. The difference should be 0.10. Custom photo labs usually have densitometers and may be able to supply readings. However, since densitometers are expensive and not available to most, exercise 2 (page 422) gives a method of testing to see whether your equipment, materials, and techniques are giving your proper dark tone density by use of a relatively inexpensive neutral density filter of density 0.10.

If these tests show that you are not getting a density of 0.10 above base plus fog, then several steps should be taken to find the reasons:

- Check the operation of your meter against that of other good meters.
- Have your shutter speeds and apertures tested by a well-equipped camera repair service. Appendix B gives some guidelines for evaluating such equipment tests.
- If your equipment is in good working order, review your metering and shooting techniques.
- Review your development procedures. Film development has little effect on the density of the REV −4, but if your development is more than 25 percent in error—because of any of the factors affecting development—the REV −4 density will show a noticeable change.

If all of these steps check out, you may still find that using the manufacturer's exposure index gives you the wrong density for REV −4. One reason is that the manufacturers' testing techniques used for determining exposure indexes are not the same as yours. ISO testing is not done with a camera and the development is not done in the same manner or with the same developer you use. If you consistently get something other than 0.10 above base plus fog for REV −4, a simple adjustment of the exposure index on your meter can insure correct exposure. Exercise 2 shows the amount of correction needed in each case.

Any number set into the meter exposure index scale to give you correct exposure is called a **system index,** or personal system index. Note that you have not changed the speed of the film by adjusting the exposure index but have simply changed the amount of film exposure your meter and camera supply to the film. Testing for numbers that you can set into your equipment to give you correct results is called **calibrating** your system.

## Fall

Only one subject tone can be controlled by placement. If a single area is metered and the camera settings are calculated to provide a specific REV for that area, all other luminances of the subject have been ignored and will "fall" at various film exposures—that is, REVs—depending on how they relate to the camera settings. Figuring out the REV for a specific area by comparing its luminance to the camera settings is called finding the **fall** for that area.

The actual method of getting the camera settings is of no concern in calculating fall, since the film exposure for an area depends only on the camera settings and the luminance. If the camera was set at C.S. f/5.6 at 1/60 second, an area metering M.R. f/5.6 at 1/60 second would provide the standard film exposure (REV M), since camera settings and meter reading match. Any luminances in the same subject that are *higher* than M.R. f/5.6 at 1/60 second will provide *positive* REVs, and any luminances that are *lower* will provide *negative* REVs. An area that meters M.R. f/8 at 1/60 second has a luminance one stop higher than the meter reading that matches the camera settings, so it will have a film exposure of REV +1. An area that meters M.R. f/2.8 at 1/60 second will have a film exposure of REV −2. Remember that these are not changes in the camera settings but are simply meter readings that correspond to the various subject luminances in the same photograph. Placement allows control of the film exposure for one area, and fall allows prediction of the film exposure for any area of the subject that you can meter.

In summary: To find the fall of an area, compare the meter reading from that area with the meter reading matching the camera setting. If the meter reading is higher—that is, the area is "brighter"—that area receives more than the standard exposure and has a positive REV. Lower meter readings indicate negative REVs.

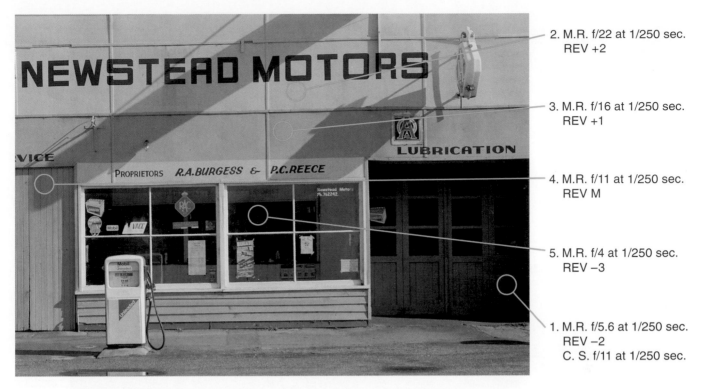

2. M.R. f/22 at 1/250 sec.
   REV +2

3. M.R. f/16 at 1/250 sec.
   REV +1

4. M.R. f/11 at 1/250 sec.
   REV M

5. M.R. f/4 at 1/250 sec.
   REV −3

1. M.R. f/5.6 at 1/250 sec.
   REV −2
   C. S. f/11 at 1/250 sec.

*Placement and Fall.* The circled area in the shadowed doorway at the right was chosen as the fully detailed dark tone. It metered M.R. f/5.6 at 1/250 second, and was used to determine the camera settings by placement.

1. Detailed Dark Tone:

M.R. f/5.6 at 1/250 second ▶ Place at REV −2 ▶ C.S. f/11 at 1/250 second

The REVs for the other areas were found by calculating their fall, comparing each meter reading with the camera settings found by placement.

2. Highlight:        M.R. f/22 at 1/250 second ▶ Falls at Rev +2
3. Light Midtone:   M.R. f/16 at 1/250 second ▶ Falls at REV +1
4. Midtone:         M.R. f/11 at 1/250 second ▶ Falls at REV M
5. Deep Shadow:    M.R. f/4 at 1/250 second ▶ Falls at REV −3

© Bognovitz.

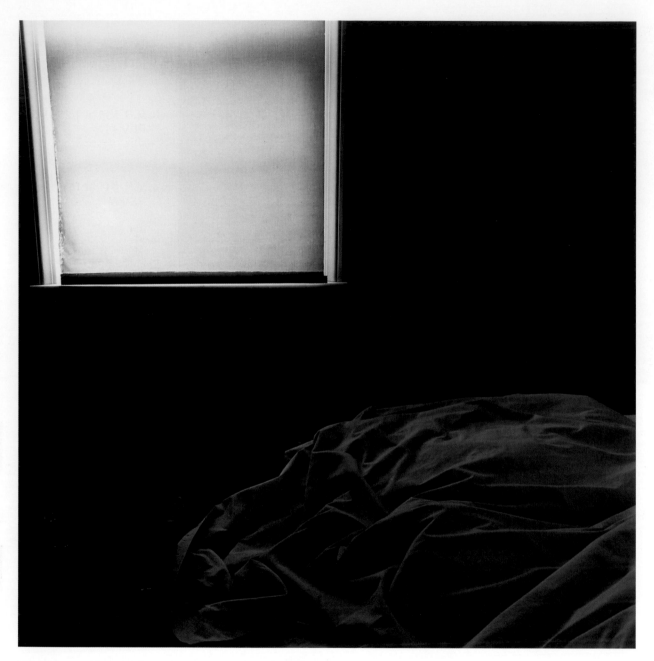

*Using Alternate Placement for Aesthetic Purposes.* The wall and floor below the window had detail in the original subject. For a representative print, a placement of REV −2 might have been used for that area to show the detail. In this case, however, the wall below the window was placed at REV −3 to suppress the detail, giving a more graphic design to the photograph and emphasizing the visual relationship between the window and the bedding. The lighter areas of the window shade fell at REV +3 and the slightly darker textured areas of the window shade fell at REV +2, indicating normal development (see the following section).

© Bruce Warren.

## ■ Film Development

If you have successfully calibrated your system index, you should be getting proper exposure on the film. The next step is to test your film development to see if your materials and techniques are yielding standard development. It is better to establish your own standards for development, geared to the materials and techniques you use. The film development that you establish as a standard for your system will be called your normal development.

## Normal Development

The amount of film development affects the negative contrast. This is true because the areas with more exposure on a film show greater density change with changes in development. As a result the difference between the low and high densities—that is, the negative contrast—changes with development. The negative contrast also depends on subject contrast, so to define your normal development you must first define the subject contrast and your standard system of materials, equipment, and techniques.

**Normal Subject Contrast**   Subject contrast is defined in terms of the difference between the dark tones and the light tones of a subject—in other words, the range of luminances. Since you are talking about tone control, you must be specific about which dark and light tones of the subject you are referring to. Subject contrast is defined as the difference between the darkest area of the subject showing full detail and texture in the print (**fully detailed dark tone**) and the lightest subject area showing full detail and texture in the print (**fully detailed light tone**). A normal-contrast subject is defined as one in which the difference between fully detailed dark tone and fully detailed light tone is four stops. Usually darker and lighter tones than these appear in many subjects.

   Testing will reveal that a good film exposure for a dark area showing full detail in the print is REV −2, so a better way of defining normal subject contrast is this: *A subject has normal contrast when the fully detailed dark tone is placed at REV −2 and the fully detailed light tone falls at REV +2.*

Some definitions measure subject contrast between the darkest tone above pure black and the lightest tone before pure white, which would produce a seven-stop difference for a normal-contrast subject.

**Normal-Contrast Printing Paper**   Since the negative is to be printed on a specific photographic printing paper, it is necessary to match the density range of the negative to the acceptable exposure range of the paper. The contrast of the printing paper is an indication of how much density range is acceptable in the negative. Low-contrast papers require higher negative contrast, and high-contrast papers require lower negative contrast for the same result. The standard chosen for paper contrast is usually grade 2, which you will use as the normal paper contrast for your system. Since different brands and types of paper may have slightly different contrast, and even the same paper may vary from package to package, a particular box of printing paper must be used as the standard for testing.

**Definition of Normal Development**   Standard processing techniques must be followed when testing, and some of these are outlined in the introduction to the exercises at the end of this chapter. It is best to keep all film developing variables—temperature, developer type and dilution, agitation, and so on—constant and to vary only the time to get the proper negative contrast for your standard paper.

You are now ready to define normal development. **Normal development** (N) is the amount of film development needed to produce a negative from film exposed to a normal subject that will print on normal-contrast paper with desired detail in dark tones and light tones; REV −2 should be the darkest fully detailed dark tone and REV +2 the lightest fully detailed light tone.

Exercise 3 (page 425) gives a detailed method for testing for correct normal development time. Any normal developing time determined through studio tests should be verified with the type of subjects usually photographed, called **field testing.** The last part of the exercise tells how to perform field tests.

## Print Values

Once exercise 3 has been performed successfully, you will have a set of prints that show a series of ten tones from maximum black to pure white. A tone ruler can be assembled as described in the exercise and will give an easy reference guide for the tones produced by the various REVs with normal development (page 428). Ten tones have been defined by this exercise, and it would be convenient to have names for them.

The tones in a print—which are actually print reflectances or luminances—are called print values and each is labeled with the number of the REV that produces it when normal development is used. For example, Print Value +1 (PV +1) results when the film is given an exposure of REV +1, developed at the normal time, and printed by standard printing techniques. Maximum black of the print is called Print Value Black (PV B) and would result from any REV of −5 or less. Maximum white of the print is called Print Value White (PV W) and results from REV +4 or higher film exposure.

Photography is a continuous-tone medium, and an infinite number of tones exist between one print value and the next. The print values should be thought of only as reference points on this continuous scale of tones from black to white. If the REV of an area can be determined by finding its fall, the tone in the print—in other words, the print value—can be accurately predicted for normal development by referring to the tone ruler.

## REVs and Print Values for Normal Development

| REV | PRINT VALUE | DESCRIPTION OF PRINT VALUE AND SUBJECT MATTER | |
|---|---|---|---|
| −5 or less | B | Maximum black of the photo paper. Openings into completely unlit spaces. | |
| −4 | −4 | First perceptible tone above maximum paper black, no visible texture or detail. Very deep shadows. | |
| −3 | −3 | First vestiges of dark tone detail and texture. Deep shadows. Dark materials with little detail or texture. | |
| −2 | −2 | Fully detailed dark tone. Shadow areas or dark subject matter showing a solid feeling of texture and detail. Surface irregularities, creases, etc. are easily visible in black or very dark materials or in lighter materials in shadow. | |
| −1 | −1 | Dark midtone. Dark foliage and dark materials not in shadow. Open shadows in landscape or cityscape. Shadows on Caucasian skin in specular light, such as sunlight or direct floodlights, with moderate fill light. | |
| M | M | Midtone. 18% gray (middle gray). Dark skin in sunlight, weathered wood, gray stone, open shadows on light toned subject matter. | |
| +1 | +1 | Light midtone. Sunlit Caucasian skin in areas of skin without glare. Snow in shadow when sunlit snow is in the same photograph. Poured concrete in diffuse light. | |
| +2 | +2 | Fully detailed light tone. Very light objects with definite feel of texture. Surface irregularities, creases, etc. in light materials easily visible. Light skin entirely in diffuse light. Average snow with strong side lighting. Light gray objects. Light colors. | |
| +3 | +3 | Lightest tone before maximum white of paper. Last vestiges of texture. Snow in flat light. Flat whites with no detail or texture. | |
| +4 or more | W | Pure white of paper. Specular reflections, for example off chrome or polished surfaces. Small intense highlights. Light sources appearing in photograph. | |

NOTE: The indicated subject matter corresponds closely to a representative rendering for most viewers. However, these are only suggestions, not rules. Feel free to experiment with alternative choices of tone. For photographic examples showing print values for various subject matter, see pages 38, 405, and 406.

## Contrast Control by Expansion and Compaction Development

With the placement and fall techniques you have a convenient way of measuring subject contrast. Once the camera settings have been determined by placement, the fall of an important light tone value can be determined to see if it will reproduce at the correct print value with normal development. If so, the subject is of normal contrast—that is, it is said to be a normal subject.

If the light tone falls too high, the print value will be too light, which means that the subject shows too much contrast to be handled by normal developing and printing. A subject with a light tone that falls too low shows lower-than-normal contrast.

The density of the light tone areas can be adjusted by changing the film development time. In the first case the film development time could be decreased so that the light tone area will print darker; in the second case the development time could be increased.

The process in which the film development time is increased to raise light tone densities is called plus development or **expansion development,** since fewer subject tones expand to fill the print tones. The process in which the film development time is decreased is called minus development or **compaction development,** or sometimes **compression development,** since more subject tones are compressed into the same range of print tones. Expansion (plus development) would be used for subjects of lower-than-normal contrast, and compaction (minus development) for subjects of higher-than-normal contrast.

Specific expansion and compaction times can be found by testing. If the fully detailed light tone falls at REV +1, a flat subject is indicated. The film development time must be increased enough to cause the REV +1 area to have a density that will print as PV +2, the proper print value for a fully detailed light tone. Because the light tone moves up one print value, the amount of development that has this effect is called **N + 1 development.**

A contrasty subject would be indicated by a fully detailed light tone that falls at REV +3. Less development, called **N − 1 development,** is needed to move this light tone down one tone in the print. Note that you are not changing the light tone's REV, which is indicative of the film exposure, but only its development, which gives a different density and a different print value. To summarize:

| FULLY DETAILED LIGHT TONE FALL | DEVELOPMENT | PRINT VALUE |
| :---: | :---: | :---: |
| REV +2 | Normal | PV +2 |
| REV +1 | N + 1 | PV +2 |
| REV +3 | N − 1 | PV +2 |

Subjects that demand N + 1 development are called N + 1 subjects, meaning lower than normal in contrast. N − 1 subjects are higher than normal in contrast and require N − 1 development. Exercise 4 (page 430) gives testing techniques for determining your own personal N + 1 and N − 1 development times and conducting field tests. Other expansions and compactions are possible, depending on the nature of the film and developer combination. An N + 2 development would raise the density of the REV M enough so that it would print as PV +2 and so on.

Subject tones other than the detailed dark tone and light tone can be predicted by finding their fall, but remember that the higher an area's film exposure is, the more its density changes with changes in development.

## Shifts of Tone Due to Changes in Development

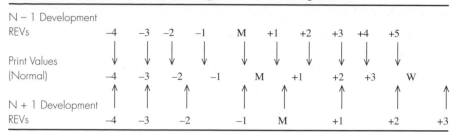

| N – 1 Development REVs | –4 | –3 | –2 | –1 | M | +1 | +2 | +3 | +4 | +5 |
|---|---|---|---|---|---|---|---|---|---|---|
| Print Values (Normal) | –4 | –3 | –2 | –1 | M | +1 | +2 | +3 | W | |
| N + 1 Development REVs | –4 | –3 | –2 | | –1 | M | | +1 | +2 | +3 |

NOTE: this is an approximate table. Actual tones will depend on the materials and techniques used.

*Tonal Shifts for N + 1 and N – 1 Developments. Follow the arrows to find the print value for each REV when N + 1 or N – 1 development is used.*

## Summary of Tone Control Techniques

Tone control is a flexible exposure and development system, and many refinements are made to the general approach outlined here:

**1.** Meter the fully detailed dark tone and place it at REV −2 by stopping down two stops from the camera settings suggested by the meter.
**2.** Find the fall of the fully detailed light tone—based on the camera setting calculated in step 1—to determine subject contrast and desired development.
**3.** Predict the print values of other tones in the subject by finding their fall. For normal development the print value number will match the REV number. For N + 1 and N − 1 developments shifts in print value will occur as shown in the above diagram.

*See the reading list at the end of this chapter for books offering a more detailed look at tone control.*

## Tone Control with Roll Film

Since application of tone control methods indicates specific development times for each negative, tone control is most easily used in its entirety with sheet film cameras. Nevertheless, with some compromises most of the system can also be used with roll film cameras. Even though each frame cannot be developed individually, the ability to change the print contrast by changing the paper contrast makes it possible to correct for negatives on the roll that should have had different development.

To use tone control with roll film you should complete a four-step procedure:

**1.** Place an important dark tone area on each frame to determine camera settings.
**2.** Find the fall of an important light tone area on each frame to determine subject contrast.
**3.** Record the contrast of each subject on the roll.
**4.** When you are ready to process the roll, look at the subject contrast throughout the roll. If you end up with subjects of different contrast on the same roll, choose a development time that gives you the best compromise.

For example, if half your roll is normal subjects and the other half is N + 1 subjects, you can develop for the subjects that are most important to you or develop for a time between normal and N + 1, bringing the contrast of the negatives well into the acceptable range for the contrast grades available with your paper.

## Tone Control with Color Materials

Much of the tone control system described previously can be applied to color. Contrast control in color is not easily achieved by development, so the use of the system is basically limited to placing an important tone and finding the fall of other tones to be sure they will fit the acceptable exposure range of the material being used. Color materials respond to changes of exposure differently than black-and-white materials, so tests must be run on each specific material to determine the number of tones possible and how the rendition of tone and texture—that is, detail—changes with exposure.

After testing, tone control can be applied to color negative materials much as to black-and-white materials, placing a detailed dark tone to determine camera settings, and finding the fall of the detailed light tone to determine subject contrast. Since little control over contrast is afforded by development, most photographers attempt to control the subject contrast by modifying the lighting.

Color positive, or transparency, films present different problems. In a positive image it is more important to hold detail and proper tone in the light tones than in the dark tones, so a fully detailed light tone would usually be placed to determine the camera settings. The fall of the dark tone would give an indication of the subject contrast, which could then be modified by lighting to give acceptable contrast for the film being used.

The REVs given for black-and-white materials in the first part of this chapter may not produce the same results in terms of tone and detail with color materials. Test before applying tone control techniques to a new set of materials.

John J. Dowdell III and Richard D. Zakia's *Zone Systemizer*, listed in the reading list at the end of this chapter, gives testing techniques for using tone control with color. Although this book is currently out of print, it is worth trying to locate a copy.

## ■ Sensitometry

Sensitometry is the science of how photosensitive materials respond to exposure and development. The tone control system is an example of practical sensitometry. If a densitometer is available more technical sensitometric methods can be applied for testing materials and techniques.

## Densitometer

The transmission densitometer is a tool for measuring actual densities in a negative. It consists of a standard light source and a metering device. The testing methods discussed so far have made use only of standard darkroom equipment plus the 0.1 neutral-density filter. Densitometers are expensive items but can save a great deal of time in testing. Two preliminary steps must be done before reading densities with a densitometer:

1. *Zero setting.* With no negative in the densitometer, take a reading. The reading should be zero. If it is not, look on the densitometer for a knob that controls the zero level and adjust it until the reading is exactly zero.

2. *Calibration.* A high density should be read to make sure the densitometer is calibrated. For this purpose a calibrated density step wedge is necessary. A density step wedge is a piece of film with a series of different densities on it. Calibrated step wedges have been read by the manufacturer on an accurate densitometer and come with the density values for each step. They are available from several manufacturers or may come with the densitometer. Choose a value of around 2.0–3.0 density and read it on the densitometer. Compare the

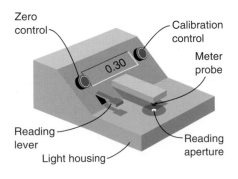

Zero control

Calibration control

Meter probe

0.30

Reading lever

Light housing

Reading aperture

Transmission Densitometer.

reading to the calibrated value. If the two do not match look for a knob labeled Calibration—or sometimes Slope—and adjust until the reading matches the calibrated value.

Once these steps have been performed, readings can be made by placing the desired area of the negative over the reading aperture of the densitometer and depressing the reading lever. The reading aperture is a circular opening lit from below. The diameter of the aperture is determined by the design of the densitometer. Some densitometers have interchangeable aperture plates. If readings are to be made on small-format negatives of images other than test target images, a 1mm aperture is desirable. The number read is the average density of the area included by the reading aperture.

## Plotting Density Curves

Line graphs put a great deal of data in a form that is compact and visual in the shape of a curve or curves. To make graphs, paper marked in a gridwork of vertical and horizontal lines is used.

One vertical line and one horizontal line are chosen as axes. Values for one data variable (e.g., density) can be measured along the vertical axis, and values for a second data variable (e.g., log exposure) can be measured along the horizontal axis. Any data that is in the form of pairs of numbers can then be plotted on the graph. If the data pairs are related in some fashion, they may be joined by a smooth line, called a curve. Characteristic curves (see appendix D) are examples of line curves that result when density is plotted versus log exposure for a particular film, developer, and amount of development.

Line Graph.

**Making Your Own Characteristic Curves**   If you have completed the testing procedures in the exercises, you already have the material for producing three partial characteristic curves for your film and developer combination, namely the normal, N + 1, and N − 1 target rolls. To make a graph, first read all the densities on the roll for the various REVs. In addition read the density of an

unexposed area of the film for a base plus fog density. Write the densities down in the form of a table:

| REV | DENSITY |
|---|---|
| (unexposed) | 0.29 (base plus fog) |
| −5 | 0.32 |
| −4 | 0.39 |
| −3 | 0.51 |
| −2 | 0.65 |
| −1 | 0.81 |
| M | 0.98 |
| +1 | 1.15 |
| +2 | 1.32 |
| +3 | 1.48 |
| +4 | 1.62 |
| +5 | 1.76 |

These are typical densities for 35mm Plus-X developed in D-76 1:1 at the normal development time for printing with a condenser enlarger with unfiltered tungsten light on Polymax paper developed in Dektol 1:2 for 2 minutes.

The easiest graph paper to use is 8½ × 11 inches, marked in centimeters, with five divisions to 1 cm. To plot a characteristic curve, you should have the log of the film exposure for each density. Sophisticated laboratory equipment is needed to measure actual film exposure, and then math tables or calculators must be used to find the log of each. Luckily you do not need to do all that to get acceptable characteristic curves. The REVs give a measure of the film exposure, in one-stop increments. You can simply plot these values along the horizontal axis in place of the log exposure values. Assign a value of 0.1 to every centimeter on the vertical axis for density. Assign a value of one-stop change in REV to every 2 cm on the horizontal axis for relative exposure. Now plot each REV and density pair from the table on the graph, one at a time. The base plus fog density is marked on the vertical axis.

Line Graph with the Densities for Normal Development Plotted.

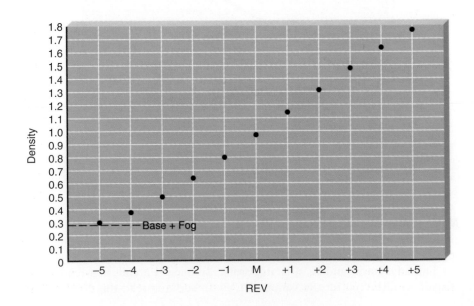

Once all the points have been plotted, connect them with a smooth curve. This is most easily done with a flexible plastic ruler and the help of a friend to hold the ruler on edge, bending it to follow the points. Drawing along the ruler edge will then produce a smooth curve. If an individual point does not seem to fit into the curve formed by the other points, that is an indication of a problem with that data point. Draw the curve without it, and check to see why that point does not fit in. The density could have been incorrectly read or plotted. A mistake could have been made in exposing that frame or the shutter speed or aperture could be inaccurate.

Note that the curve produced from this data is not a complete characteristic curve. The shoulder of the curve is not shown, as REV +5 does not produce enough film exposure. If a more complete characteristic curve is desired, test film must be shot of a target with REVs up to +10 or higher.

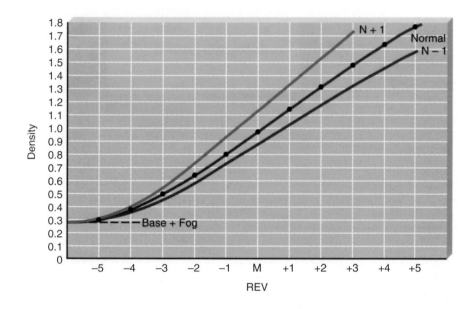

*Partial Characteristic Curves Plotted from Exercise Data for Normal, N + 1, and N − 1 Development Times.* The curves for the N + 1 and N − 1 test films are also shown on the graph and were plotted the same way as the normal development curve.

**Plotting Parametric Curves**   Characteristic curves give a great deal of useful information about a film and developer combination, but they are not as useful for testing purposes if a tone control system is being used. A different set of curves can be plotted if density is graphed against development time rather than exposure. When this is done, each REV will produce its own curve, giving a family of curves that are called **parametrics.**

To get the data for plotting parametrics, shoot four rolls of film just as in exercise 3, using a gray card target rather than a textured target. Develop the rolls at different times based on the manufacturer's recommended time or your normal time. For example, roll 1 could be developed at 50 percent of the normal time, roll 2 at the normal time, roll 3 at 150 percent of the normal time, and roll 4 at 200 percent of the normal time. Read all of the densities on each roll, making a data table for each. Plot all of the points on a graph with density on the vertical axis and development time on the horizontal axis. This will result in four "stacks" of points at each of the four development times. Now draw smooth curves through the four points representing each REV. Label each curve with its REV.

The advantage of the parametrics is to allow prediction of the actual density of any REV for any development time, simply by reading off the graph.

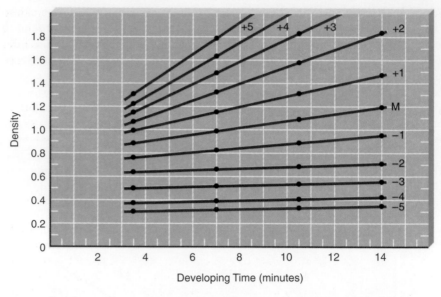

Parametric Curves.

This is useful in testing, since the purpose is to get proper density for specific REVs. Alternative testing techniques using parametrics are covered in the following section.

## Testing Techniques Using the Densitometer

**System Index**    The densitometer is excellent for evaluating the system index test as performed in exercise 2. Rather than using the 0.1 neutral-density filter, simply read the base plus fog and then read the density of the REV −4 frame. If the exposure is correct, that frame should show a density 0.10 higher than the base plus fog. For example, if base plus fog is 0.30, then the REV −4 frame should have a density 0.40.

If the REV −4 frame is incorrect, then a new system index must be estimated. Look for the frame that is closest to 0.1 above base plus fog. If REV −3 is 0.1 above base plus fog, the film is one stop underexposed and the system index must be halved. Fractional stops may be estimated by noting the density differences. For example, if base plus fog is 0.30 and REV −4 reads 0.37, the film is about ⅓ stop underexposed. If REV −4 reads 0.43 or 0.44, the film is about ⅓ stop overexposed and the system index is adjusted according to the procedures given in exercise 2.

**Normal Development**   The determination of the normal development time will always require printing, because the printing paper and print developer combination used determines the density difference needed in the negative. For that reason normal development times cannot be determined on the basis of densitometer readings of test films alone. However, if previous tests have been performed for a paper and developer combination, the densities of the test roll that gave the proper tones for normal development can be recorded. When future tests are made of films to be printed on that paper and developer combination, it is necessary only to run test rolls until the densities of the original normal test roll are matched.

**Expansions and Compactions**   Use of the densitometer will save printing the trial N+1 and N−1 test rolls. Since the purpose of N+1 development is to cause the REV +1 frame to print as a PV +2, it follows that the density of that frame must be the same as the density of the REV +2 frame from the normal test roll. Simply read both densities and compare them. If the REV +1 density on the trial N+1 roll is higher than the normal REV +2 density, reduce the development time. If it is lower, increase the development time. Likewise, REV +3 on the trial N−1 roll should have the same density as the normal REV +2.

If this comparison is to be valid, the exposure on all three rolls must be the same. To check the exposure, read the REV −4 frame on each and compare it to the base plus fog. Throughout the exercises it is assumed that the variations in the dark tone densities with development changes are negligible. With a sensitive densitometer, the changes in the REV −4 density with development can be measured. For example, with Plus-X developed in D-76 1:1, if the normal REV −4 is 0.10 above base plus fog, then the N +1 REV −4 will be about 0.12 above base plus fog and the N−1 REV −4 will be about 0.08 above base plus fog. This density shift is less than that which would result from a one-third-stop change in exposure. The light tone densities can easily be adjusted for minor exposure differences between rolls. For example, if the N+1 test roll is found to have one-third stop less exposure than the normal roll, find the density difference between the REV +1 and REV +2 frames on the N+1 roll, then add one-third of that difference to the REV +1 density to get a corrected density.

**Parametrics**   The parametric curves discussed earlier are an excellent tool for determining development times. Since the development time is measured along the horizontal axis and the density along the vertical axis, each curve gives the density of the REV represented by that curve for any development time within the limits tested. Conversely, if the desired density for an REV is known, the development time needed to produce that density can be read directly off the curve. This eliminates trial and error in finding expansions and compactions and normal times if the required density for REV +2 is already known.

Finding Expansion and Compaction
Development Times from Parametric Curves.

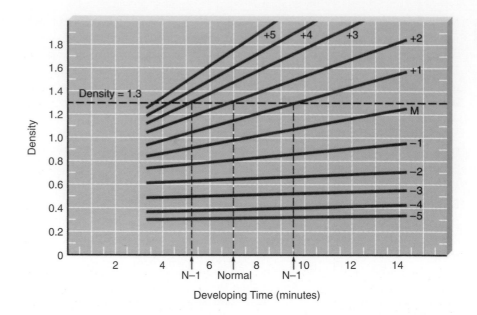

**EXAMPLE**    Refer to the parametric curves shown above to follow through this example: A normal development time of 7 minutes has been determined by a printing test. The REV +2 density for 7 minutes is read from the REV +2 curve and is 1.3. If we now wish to find the N + 1 development time, all that is needed is to find the place on the REV +1 curve where the density (D) is 1.3. This is most easily done by drawing a line across the graph for D = 1.3. Find the place this line intersects the REV +1 curve, and drop down to the horizontal axis to read the development time that will yield this density. This is the N + 1 development time, and in this case it is 9½ minutes. For N − 1 development find the place the D = 1.3 line crosses the REV +3 curve and read the N − 1 development time from the graph. Here it is 5¼ minutes.

Other expansions and compactions can easily be read. N − 2 is the time where the REV +4 curve crosses the D = 1.3 line, or 4½ minutes, and so on. For this graph the only expansion that can be read is N + 1, as the development time was not extended to the point where the REV M curve crosses the D = 1.3 line.

Each set of curves applies to a particular film and developer combination. If a different paper and print developer combination is used, it is necessary only to print tests to determine the new fully textured light tone density to use in place of the old one. In the preceding example the D = 1.3 line would be replaced if needed by a new line at the density that produced a fully textured light tone for that paper. Normal, expansion, and compaction development times can then be read directly from the graph with no need for further printing.

# ■ Exercises

These exercises are intended to give you a better idea of how exposure and development relate to tonal reproduction in a photograph and to calibrate your personal system for correct exposure and development. Exercises 2, 3, and 4 are calibration exercises, and you should use the same personal system throughout. Your personal system includes anything that will affect the final quality of the image: camera, lens, meter, film (same type and emulsion batch), developer, film development techniques, printing paper, printing developer, printing, and print processing techniques. Some general guidelines will help you perform the exercises:

■ *Understand.* Make sure you understand the purpose of an exercise and the reasons for the various steps and procedures *before* you start working.

■ *Follow directions.* Following directions is an important skill in photography. Read directions carefully and follow them to the letter.

■ *Be organized.* Careful organization can save many hours and reduce the number of errors and repeated exercises. Lay out your procedures, materials, and equipment in detail before starting. Get in the habit of writing down what you are going to do *before* you do it, what you are doing *as* you do it, and an evaluation of what you have done *after* you have completed the work. Do not trust your memory.

■ *Be consistent.* To get repeatable results in photography you must learn to be consistent in your working habits. Everything should be done exactly the same every time you do it. You must learn all the factors that affect the final result and carefully control them at all times. Sloppy or erratic working methods will always result in poor-quality work.

## ■ EXERCISE 1
# Effect of Subject Tonal Value on Exposure

This exercise is a demonstration of the operation of your light meter and its response to different subject tones. You will show the practical meaning of the statement *A light meter sees everything as if it were 18 percent gray.*

**EQUIPMENT AND MATERIALS**    Camera, meter, tripod, twenty-four-exposure roll of your usual film, 8 × 10 photographic paper, developing and printing equipment and materials.

**A. Part 1.** *Frames 1–12.* Find the following three types of subjects and expose as directed. Choose subjects that are fairly uniform in tone, neutral in color, and evenly lit and that have no specular reflections. Fill the frame completely with each object. You will learn more about finding test subjects if you look for these subjects on location, rather than setting them up in the studio. Try to work under various lighting conditions.

**1.** *Gray objects.*    Meter off each object only and use the meter reading as your camera setting. Find and photograph four gray objects.
**2.** *White objects.*    Meter off the object only and use the meter reading. Find and photograph four white objects.
**3.** *Black objects.*    Meter off the object only and use the meter reading. Find and photograph four black objects.

**Part 2.** *Frames 13–22.* Find a subject following the same general selection rules as those for the subjects in frames 1–12. The metered camera settings from the subject should be in the middle of your camera controls. With your camera on a tripod, make the following exposures of the subject by stopping down or opening up from the camera settings suggested by the meter. You may have to use both aperture and shutter speed to achieve the required exposure differences.

| FRAME | EXPOSURE | LABEL |
|---|---|---|
| 13 | 5 stops less than the metered exposure | −5 |
| 14 | 4 stops less than the metered exposure | −4 |
| 15 | 3 stops less than the metered exposure | −3 |
| 16 | 2 stops less than the metered exposure | −2 |
| 17 | 1 stop less than the metered exposure | −1 |
| 18 | Camera settings suggested by the meter | M |
| 19 | 1 stop more than the metered exposure | +1 |
| 20 | 2 stops more than the metered exposure | +2 |
| 21 | 3 stops more than the metered exposure | +3 |
| 22 | 4 stops more than the metered exposure | +4 |

**B.** Process the film at your normal time or the manufacturer's recommended time.

**C.** Print the film. Make a contact print of the entire roll, matching the print value of the gray objects to your memory of their original tone. Do the contact sheet in a printing frame under an enlarger to insure even printing exposure. When dry, label below frames 13–22 on the contact print as listed in part A of this exercise.

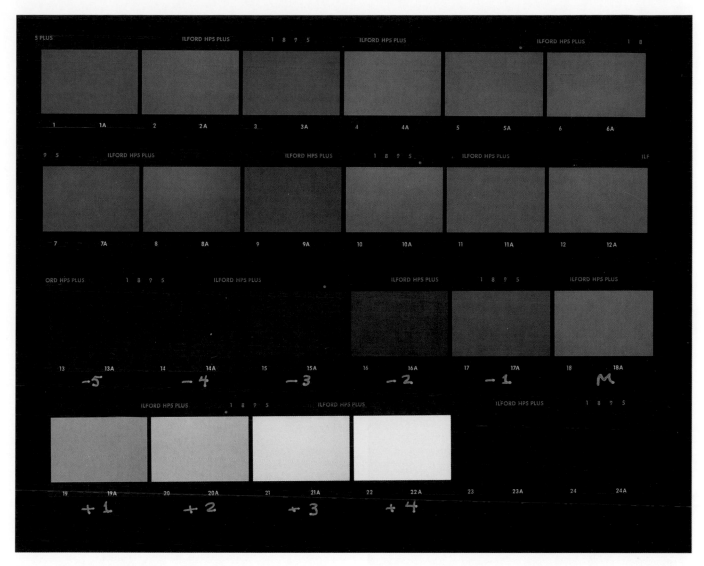

*Contact Sheet Results from Exercise 1.* In frames 1–12 the resulting print value should be the same, regardless of the original subject tone. Any variations are due to operator or equipment errors. Agreement is good in this example, with only frames 3 and 9 being a little darker because of about 1/2 stop underexposure, probably due to slight shutter speed variations. Frames 13–22 show the tones resulting from different REVs. As film exposure is increased, the print tones get lighter.

## ■ EXERCISE 2
# Determination of a Personal System Index

In this exercise you are going to calibrate your exposure system by determining a number, called a system index, that can be used in place of the manufacturer's ISO value on your meter. This is the first calibration exercise, so before beginning, your system must be in good operating condition and a choice of film batch must be made. If you wish to have enough film of one emulsion batch to do all of the calibration exercises, purchase a plastic-wrapped block of twenty rolls of twenty-four-exposure film. You should also have enough film developer in a single batch to perform all of the tests. Once calibration exercises are begun, do not change any part of your system: camera, meter, lens, film batch, paper batch, developer, and so on.

**EQUIPMENT AND MATERIALS**     Camera, meter, tripod, calibration film, gray mat board, two floodlights, 0.1 neutral density filter, film developing equipment and supplies.

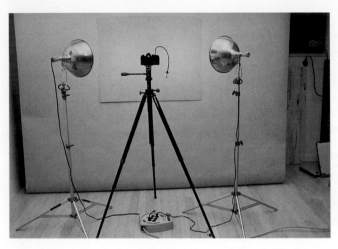

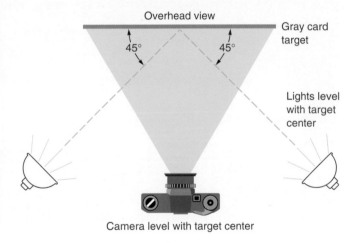

*Gray Card Target, Camera, and Lighting Setup for Exercise 2.* Lights and camera should be level with the center of the target.

Note: Do not use any f-stops that are not part of the standard scale, such as f/1.2, f/1.7, f/1.8, f/3.5 and so on. For zoom lenses with variable aperture, choose the focal length that gives correct readings on the f-stop scale.

**A.** Set up a large, neutral gray mat board as a target. Light the target evenly with two floodlights at 45°. Set the light meter on the recommended ISO for your film and adjust the lights until a meter reading of f/5.6 at 1/30 or f/8 at 1/30 is achieved. The reading must be *exactly* on an f-stop. The initial meter reading should be chosen so that all the placements in the following table can be produced with your camera controls. Avoid any settings that testing of your camera showed to be inaccurate (see chapter 7). Once a meter reading at an exact f-stop has been achieved, check the evenness of the lighting by metering the card close up from side to side and bottom to top. Adjust the lights if necessary to insure evenness. With the camera on a tripod, fill the frame with the target. Remember that most cameras do not show as much of the subject in the viewfinder as will appear on the negative. Focus on infinity. Record the meter reading from the target and the exposure index (ISO) set into the meter calculator.

**B.** Using your most reliable shutter speeds and apertures, make the following exposures on a roll of your calibration film:

| FRAME | REV | FRAME | REV |
|-------|-----|-------|-----|
| 1 | M | 11 | −2 |
| 2 | Blank (use lens cap) | 12 | Blank |
| 3 | −6 | 13 | −1 |
| 4 | Blank | 14 | Blank |
| 5 | −5 | 15–24 | M |
| 6 | Blank | | |
| 7 | −4 | | |
| 8 | Blank | | |
| 9 | −3 | | |
| 10 | Blank | | |

NOTE: The REV M exposures in frames 15–24 are to put density on the film so that a more normal load is placed on the developer.

**C.** Develop the film normally, being careful to use consistent, standard methods. *Do not cut the negatives*.

**D.** Determine the results: After the film is dry, put it on a light table and lay the 0.1 neutral-density filter on one of the blank frames next to the REV −4 frame. Visually compare the density of the REV −4 frame to the 0.1 plus base plus fog. If the match is good, then the manufacturer's ISO index is your system index.

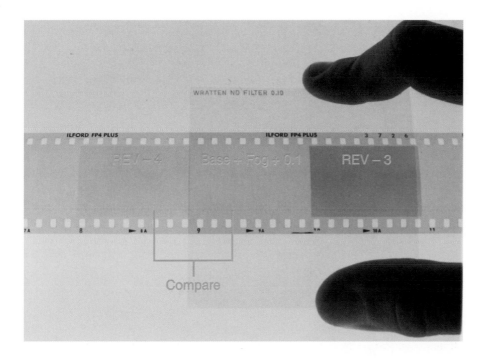

*Evaluating the System Index Test.* Lay the 0.1 neutral density filter on top of the blank frame—which has base plus fog density—adjacent to REV −4, carefully aligning the edge of the filter with the edge of the frame. Compare the density of the REV −4 frame with the combined base plus fog plus 0.1 density. In this example, the density of REV −4 is slightly less than the base plus fog plus 0.1 density, indicating about 1/3 stop underexposure. Correct exposure can be achieved by using the next lower exposure index than was used for this test. (See the list of ISO numbers on the next page.)

If the match is not good, compare the other frames to 0.1 plus base plus fog. If one of the other REVs gives a good match, then the index can be adjusted accordingly. For example, if the REV −3 frame is 0.1 above base plus fog, the film is showing one stop underexposure. To make sure that the REV −4 frame will be 0.1 above base plus fog next time you shoot, you must halve the index. If the film was shot with the ISO dial set on 125, you must use a system index of 64 to get correct exposure. Likewise, a match with REV −5 indicates overexposure, so a system index of 250 would be used.

With experience, fractional stops of exposure can be judged from the film. In our example, if the REV −4 frame is not dense enough but the REV −3 frame is too dense, determine which one the match with the filter is closer to. The ASA numbers between 125 and 64 are 100 and 80. If the match with the filter is closer to REV −3, use system index 80 (S.I. 80). If it is closer to REV −4, use S.I. 100.

The series of standard exposure index (ISO/ASA) numbers in one-third-stop intervals is

25, 32, 40, 50, 64, 80, 100, 125, 160, 200, 250, 320, 400, 500, 640, 800

Remember, the personal system index derived in this exercise is the result of only one trial. Any errors made in the metering or shooting of the film will give faulty results. The system index should be continually verified in future testing by checking the density of the REV −4, which should always be 0.1 above base plus fog for normal development. It requires only two frames of film to do a quick system index test on any roll of film. Find an evenly lit wall of a single neutral tone (gray or white). Meter the wall and stop down four stops to place the exposure of the wall at REV −4. Make one exposure of the wall. Put the lens cap on the lens and make an exposure to produce a blank frame. When the film is processed, compare the REV −4 density to 0.1 plus base plus fog as outlined above.

### ■ EXERCISE 3
# Determination of a Normal Development Time

This exercise provides a method for determining your personal normal development time.

**EQUIPMENT AND MATERIALS**    Camera, meter, tripod, calibration film, textured target, 18 percent gray card spot tester, calibration developer, calibration printing paper, processing and printing materials and equipment.

*Making an 18 Percent Gray Spot Tester.* A. Cut a 2-inch square from the corner of a cardboard 18 percent gray card and carefully lift up the top two or three layers of paper to give a gray patch on a relatively thin base.

B. Punch a clean ¼-inch hole in the center of the patch.

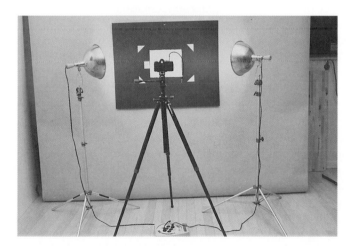

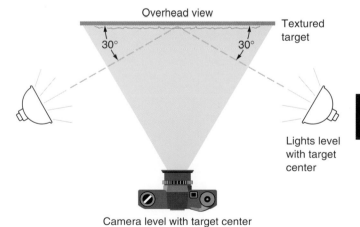

Overhead view — Textured target

30°    30°

Lights level with target center

Camera level with target center

*Textured Target, Lighting, and Camera Setup for Exercise 3.* The textured target was constructed by mounting a neutral-colored (white or gray) piece of terry-cloth on a black board. The triangles indicate the corners of the frame for a 35mm camera. Appropriate sizes are 8 × 10 inches for the terry-cloth and 12 × 18 inches for the outer rectangle defined by the corner triangles mounted on a 24 × 30-inch black matboard. Small cards labeled with the REV numbers can be pinned just to the left of the cloth. NOTE: To add texture, the lights are placed somewhat closer to the wall than they were in exercise 2.

Note: Do not use f-stops that are not part of the standard scale, such as f/1.2, f/1.7, f/1.8, f/3.5 and so on. For zoom lenses with variable aperture, choose the focal length that gives correct readings on the f-stop scale.

**A.** Set up the textured target and light it as evenly as possible with two lights at a 25°–30° angle to show some texture. With the light meter set on your personal system index, adjust the lights to get a meter reading in the middle of the camera controls: for example, M.R. f/5.6 at 1/60 second. Meter only the textured target, not the black background. The reading should be exactly on the f-stop, not in between. Once the desired meter reading is achieved, check the evenness of the lighting by metering the textured cloth from corner to corner, top to bottom. If necessary readjust for perfectly even lighting and the exact meter reading desired.

With the camera on a tripod, adjust so that the camera is level with the center of the target. The framing marks on the target should just be visible in the corners of the viewfinder. Focus carefully on the texture.

Expose five rolls of film identically in the following sequence. Some of these rolls will be saved for exercise 4. Include a label of the REV in each frame, as shown in the illustration.

| FRAME | REV | FRAME | REV |
|-------|-----|-------|-----|
| 1 | M | 8 | +1 |
| 2 | −5 | 9 | +2 |
| 3 | −4 | 10 | +3 |
| 4 | −3 | 11 | +4 |
| 5 | −2 | 12 | +5 |
| 6 | −1 | 13–24 | M |
| 7 | M | | |

NOTE: The REV M exposures in frames 13–24 are to put density on the film to approximate a normal developing load.

**B.** Develop one of the rolls at the manufacturer's time or your personal development time that seems to give you good results for normal contrast subjects. Use great care in proper processing—temperature, agitation, fresh developer, and so on. *Do not cut the negatives.*

Before printing, check exposure by comparing the density of the textured target in the REV −4 frame to a density of 0.1 above base plus fog, represented by the black background. This may be done with the 0.1 neutral density filter as discussed in exercise 2. Exposure should be within one-third of a stop for best results.

**C.** Print the negatives. Place frame 7 in the negative carrier. Using an easel for 4 × 5 enlargements, adjust the enlarger so that the textured target, the REV label, and about 1/2 inch of the black background are included in the picture. Cut several of the sheets from your normal-contrast calibration paper down to 4 × 5 inches. Find the printing exposure that will print frame 7 (REV M) as 18 percent gray. Do this by making a test strip and comparing it with the 18 percent gray card spot tester. Make sure no surface water is on the print when comparing it with the spot tester. With the spot tester in contact with the test strip, view from a distance and squint a little to make the tonal comparison between textured and untextured areas easier. Unless an electronic timer is being used, adjust the aperture so that the printing time is between 10 and 20 seconds. This will insure better accuracy of repeated printings.

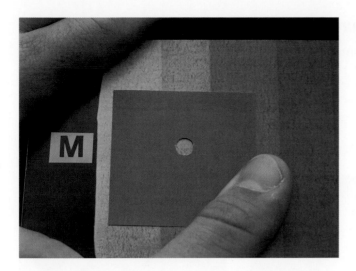

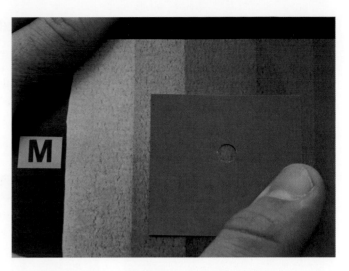

*Using the 18 Percent Gray Spot Tester.* A. Lay the spot checker on top of the test strip. Viewing it in good light, compare the spot of test strip visible with the surrounding 18 percent gray. Squinting your eyes slightly will help to blur the texture of the test strip. Here the test strip is too light.

B. Slide the spot tester until you find an exposure that matches the 18 percent gray. When the right tone is achieved, the spot of test strip seen will "blend in" with the surrounding 18 percent gray.

Making sure that all printing variables—enlarger, developer, paper, and so on—remain the same, produce a 4 × 5 print from frame 7. Compare with the gray card spot tester again to be sure you have the right value. If the print matches the gray card, then print all the frames from frame 2 (REV −5) through frame 12 (REV +5), giving each exactly the same exposure and development as the REV M print. Batch processing can be done with up to four patches, if care is taken to make sure the development time and agitation are exactly the same as for the initial tests. Label the back of each print as you are printing them.

**D.** Make a black patch and a white patch. To make the black patch on your paper, take a 4 × 5 sheet and expose it under the enlarger without a negative at f/8 for 15 seconds. Develop and process as usual. Trim off any white borders from the black patch. To make a white patch, simply fix, wash, and dry an unexposed 4 × 5 piece of paper.

**E.** Inspect the resulting series of prints using the descriptions and tones on page 409 as a guide. The REV −4 patch should show just perceptible separation from the surrounding black background, the REV −2 patch should be the darkest tone with full texture, and so on. If they are not correct, try a second roll. If the negatives are too low in contrast, the dark tones will be too light and the light tones too dark; increase your development time on the next roll. If the negatives are too high in contrast, the dark tones will be too dark and the light tones too light; decrease your development time on the next roll. Once the proper tones have been achieved, you have determined your normal development time.

## Making a Textured Gray Scale

If your series of normal patches looks as it should, you may use it to make your tone ruler—that is, your textured gray scale.

This gray scale can be used for visualizing shades of gray from a subject when metering and for analyzing your prints to see if your predictions were correct.

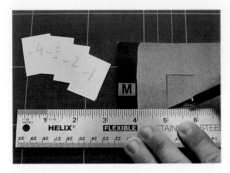

*Making a Tone Ruler.* A. Cut a 1 × 1½-inch piece from each patch. Carefully label the pieces so that you will not get them mixed up.

B. *Tacking Tissue to Card Stock.* For mounting use a lightweight card stock about 2 × 12 inches in size. Do not use regular mat board. Tack a strip of dry-mount tissue to the card stock, leaving a space for labeling.

C. *Tacking Patches to Ruler.* Tack the print patches to the card stock, starting with a maximum black piece on the left; continuing with −4, −3, and so forth, to +3; and ending with the white patch. Lay each piece on top of the tissue, and tack from the front, protecting the surface of the patch with a piece of paper.

D. *Mounting.* Place the assembled ruler in the dry-mount press for mounting.

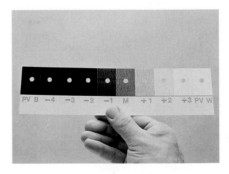

E. *Trimming and Labeling.* Trim the top and side edges of the ruler flush (no border), label each patch with its print value, and punch a clean quarter-inch hole in each. Your finished tone ruler should look like this.

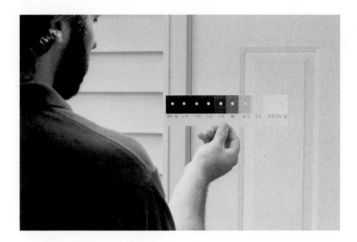

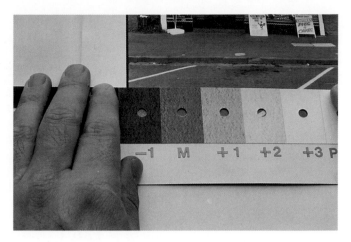

Left: *Previsualising with the Tone Ruler.* Viewing the subject over the flush edge of the ruler will help you to previsualize what that area will look like in the print.

Right: *Determining Print Values in a Print with the Tone Ruler.* The tone ruler may be placed directly on a print to determine the print value of any area. Place the ruler so that the tone you are interested in identifying appears in one of the punched holes, then slide the ruler until you see a match between it and the surrounding patch. Here the pavement matches PV M.

## Performing Normal Field Tests

Using a roll of calibration film, find a series of twenty normal subjects and expose as follows: On each exposure, determine camera settings by placing the detailed dark tone at REV −2. Read the detailed light tone to make sure it falls at REV +2. Make a sketch of the scene, meter all important subject luminances, and record the meter reading and the fall (REV) for each.

Develop the film at your normal time that you have just determined.

Make a contact print of the roll. Choose a representative frame from the roll and make an 8 × 10 print, matching the metered light tone to the PV +2 on your tone ruler. Use normal-grade test paper, no dodging or burning. After the 8 × 10 print has dried, use your tone ruler to see if the print values came out as expected. The detailed light tone should be PV +2, the detailed dark tone should be PV −2, and so on. Make prints from other negatives on the roll and examine them in the same way. If your tests have been successful, the print values should come out as predicted.

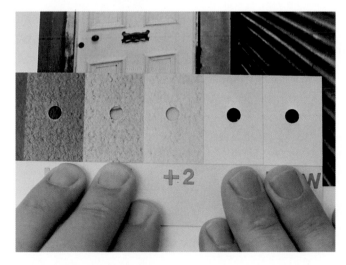

*Evaluating Field Tests.* A. Lay the tone ruler on the print so that the fully textured light tone area is seen through the hole punched in the PV +2 patch. The tone should match. If it does not, you had the wrong print exposure. Reprint until you get a good PV +2 match.

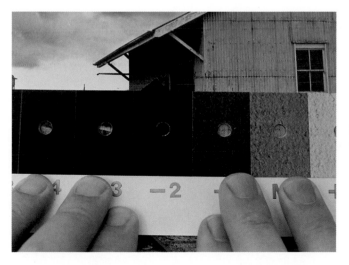

B. Next lay the Tone Ruler on the print so that the fully textured dark tone area is seen through the hole punched in the PV −2 patch. If they match, your field test is successful.

## ■ EXERCISE 4
# N + 1 and N − 1 Development and Field Tests

This exercise provides a method for determining the expansion development time N + 1 and the compaction development time N − 1. Do not attempt this exercise until satisfactory results have been achieved for exercise 3.

**EQUIPMENT AND MATERIALS**     Camera, meter, tripod, calibration film, extra rolls of textured target film shot in exercise 3, 18 percent gray card spot tester, calibration film developer, calibration printing paper, processing and printing materials and equipment.

## Part 1

Determination of N + 1 and N − 1 Development Times

**A.** Using two of the extra rolls shot for exercise 3, develop one for 35 percent more than your normal development time and the other for 25 percent less than your normal development time. Do not cut the film. **NOTE:** These times are appropriate for Plus-X in D-76 1:1. Other film and developer combinations may require more or less change. Try 25 percent more and 15 percent less if using T-Max 100 in T-Max developer.

**B.** Check the film exposure on both rolls by comparing REV −4 to 0.1 above base plus fog. The exposure must be the same as that on your normal test roll. For a check of your N + 1 and N − 1 development times, make a contact sheet of the mid tone and light tone frames (REV M through REV +4) of the normal, N + 1, and N − 1 rolls, as shown on the facing page. Choose a printing time for which the REV M frame on the normal roll matches the 18 percent gray spot tester.

**C.** Once you have the correct N + 1 and N − 1 development times, you may wish to make enlarged patches for more ease in seeing the effect on texture. Print 4 × 5-inch patches of both rolls, following the same cropping directions as for exercise 3. You must use the M frame from *your correct normal test roll* to determine the enlarging time to match the gray card. Using this time, print and develop all the frames from both your trial N + 1 and your trial N − 1 rolls. Mark each print so they do not get mixed up. As a reference you can cut and mount these two series in the form of tone rulers as you did your normal patches, but any comparisons with print tones should be done with the normal tone ruler for correct print value determination.

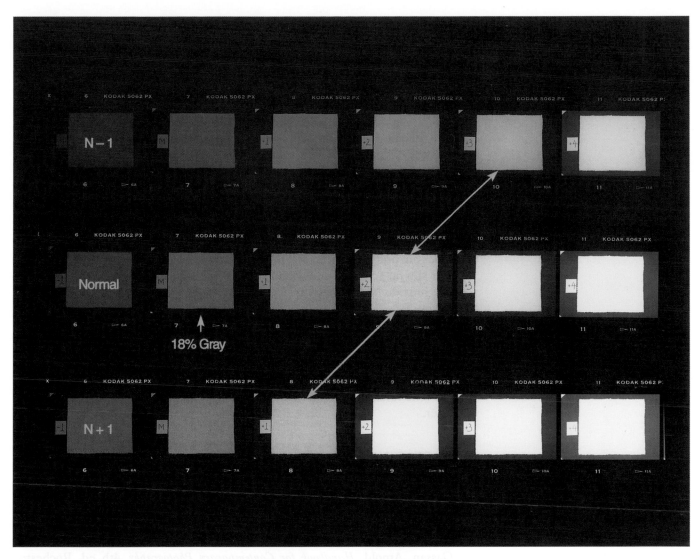

*Checking Your N + 1 and N − 1 Development Times.* A  Expose your contact sheet for 18 percent gray in the REV M on the normal development roll. Compare the REV +3 frame from the N − 1 roll, the REV +2 frame from the normal roll and the REV +1 frame from the N + 1 roll. They should all have the same tone if your development times are correct.

B. The comparison is easier if the contact sheet is cut up into the three development times and a hole is punched in the normal REV +2 frame to lay over the other strips. If either the N + 1 REV +1 frame or the N − 1 REV +3 frame is lighter than PV +2, reduce its trial development. If it is darker than PV +2, increase the trial development. Remember that this technique only works if the film exposure on all three rolls is the same.

# CHAPTER 15

# Lighting

Gerald Zanetti.

© Gerald Zanetti.

Because light is so important in photography, both technically and for visual communication, controlled lighting is a major tool used by photographers wishing to direct and mold the viewer's response to their photographs. The purpose of this chapter is to expand on the techniques for lighting control given in chapter 8. Although the information that follows may seem very technical in nature, it is based entirely on attempts to control the informational and emotive effect of the light. Keep in mind as you work through your early attempts to control light that it is not the technique that is important, it is the end effect. Technique is the stepping stone to control over the endless permutations of the qualities and characteristics of light and is useless without a sensitive understanding of the effect on the viewer of light as represented in a photograph.

The nature of light, its role in photography, and some techniques for controlling light have been discussed in several earlier sections of the book. The boxed section titled "Glossary of Lighting Terms" summarizes this information and adds a few new concepts.

---

# Glossary of Lighting Terms

**Ambience**   The light-reflecting nature of the subject environment. An environment with many light tone reflective surfaces has a high ambience. One with dark light-absorbing surfaces has a low ambience. The amount of environmental light is influenced by the ambience.

**Artificial Light**   Light from manufactured sources, including light bulbs, flash units, and other light sources powered by electricity. Fuel-powered lamps might also be included here.

**Available Light**   To most photographers, usually preexisting light of a low level of intensity.

**Continuous Light**   Light that does not vary greatly in intensity over time. Most normal lighting situations have continuous-light sources.

**Controlled Lighting**   The manipulation of preexisting light or the addition of supplementary light sources or both to achieve a desired result. Manipulation can consist of modifying the quality of the light sources by reflection or transmission of the light they emit, moving the subject for a more desirable relationship with preexisting light, or waiting for different conditions with natural preexisting light.

**Diffused Highlight**   The area of a subject receiving the full effect of the principal illumination and reflecting back diffused light. A diffused highlight shows the true tonality of the subject: gray appears gray, white appears white, and so on.

**Diffused-Shadow Contrast**   The difference in luminance between a diffused highlight and a shadow. When measured on the same tonal surface this is a direct measure of the lighting contrast.

**Diffused-Specular Contrast**   The difference in luminance between the diffused highlight and the specular highlight on a subject surface.

**Diffusion**   Scattering of the rays of light either by reflection from a slightly textured surface or by transmission through translucent materials. The diffusing surface then effectively becomes a new light source of larger area providing nonspecular light, usually called diffuse light. Diffuse light sources produce "soft-edged" shadows with a more gradual transition from lit areas to shadowed areas.

**Discontinuous Light**   Light of very short duration, also called momentary light. Since the only discontinuous light photographers normally use is artificial light supplied by electronic flash units, this type of light is almost always called "flash" lighting. Artificial discontinuous light can also be produced with some types of electrical arcing or discharge. Examples of momentary sources in nature are lightning and light-emitting explosions.

**Environmental Light**   Light that does not reach the subject directly from a light source but is scattered or reflected by the environment surrounding the subject or the subject itself. Environmental light may result from either preexisting or supplementary sources.

*continued on next page*

**Lighting Contrast** The difference between the illumination supplied to the fully lit parts of a subject (the diffused highlight) and the illumination supplied to (incident on) the parts of the subject shaded from the direct effect of the lighting (the shadow areas). This difference can be measured with an incident-light meter and expressed as a ratio. A lighting ratio of 2:1 means that twice as much illumination is being supplied to the fully lit areas as to the shadow areas; in other words, it indicates a one-stop difference in incident-light meter readings. Subject contrast depends partly on lighting contrast but will also depend on the tonal nature of the subject itself. High-contrast lighting is often called "harsh" and low-contrast lighting "flat."

**Natural Light** Light from sources occurring in nature. The sun is our principal natural-light source, though the moon—actually reflected sunlight—and stars are sources of light as well. Other natural-light sources include fires, fluorescent materials, and glowing hot objects. The only natural-light source commonly used for illuminating a subject for photographic purposes is the sun, though occasionally open flame or moonlight is used.

**Preexisting Light** Any light—natural, artificial, or a combination—that illuminates the subject and is not supplied by the photographer. *Existing, prevailing,* and *ambient* are all terms used by photographers to describe preexisting light, although *ambient* is also variously used to describe environmental light or continuous light.

**Specular Highlight** A visible reflection of the light source on the surface of a subject. Specular highlight is also called specular reflection.

**Specular Light** Light in which the rays are traveling as if they emanated from one point or are traveling parallel to each other. A specular light source produces shadows with sharp, distinct edges—"hard-edged" shadows. The apparent size of the light source affects specularity. The smaller a light source appears when viewed from the position of the subject, the more specular it will be. Specularity and intensity are often confused, since many intense sources, like the sun, are also specular. It is possible to have specular light with low intensity, as is the light supplied by small low-voltage bulbs.

**Soft Light** Light from a diffuse source producing "soft-edged" shadows. Although *soft* is also used by many photographers to indicate low lighting contrast, it is best to use *flat* to describe low contrast to avoid confusion.

**Supplementary Light** Artificial light supplied by a photographer in addition to the preexisting light. ■

## ■ Point Source

The quality of the light illuminating a subject is determined by the physical behavior of light. Light's straight-line travel and behavior when it strikes a surface—reflection, transmission, absorption, and scattering—are extremely important in controlled lighting. To understand the behavior of light, it is helpful to look at a hypothetical light source called a **point source**. A point source emits light in all directions from a single point. Since a point has no dimension it is impossible to manufacture a true point source. A tungsten filament has definite physical dimensions, but it is small enough that when viewed from some distance it behaves much as a point source.

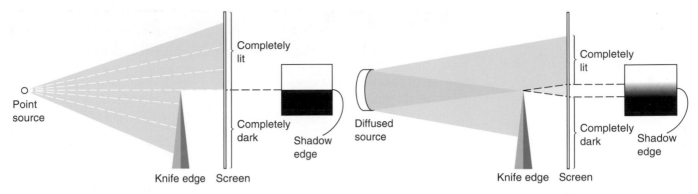

Knife edge   Screen                                              Knife edge   Screen

*Comparison of the Shadow Cast by a Knife-edge for a Point Source and a Diffuse Source.* Left: With the point source, below the dashed line the screen receives no light at all from the source. Above the dashed line the screen receives the full effect of the source, producing a knife-edged shadow. Right: With the diffuse source, below the lower dashed line the screen receives no light from the source. Above the upper dashed line the screen receives the full effect of the source. The amount of illumination gradually increases from the lower dashed line to the upper dashed line, producing the soft shadow edge shown.

A point source produces specular light. The illustrations demonstrate why the appearance of the shadow edge changes as the size of the light source increases. Notice that the lighting contrast in both cases would be the same if the intensity of the diffuse source could be adjusted so that the illumination on the fully lit area of the screen was equal to that from the point source.

Study of a point source also reveals the reason the amount of illumination decreases as the distance from the light increases. The **inverse square law** states that illumination from a light source varies inversely with the square of the distance:

$$\text{Illumination at distance 2} = \text{Illumination at distance 1} \times \left(\frac{\text{Distance 1}}{\text{Distance 2}}\right)^2$$

Doubling the distance from the light source will produce one-fourth the illumination. This reduction of illumination due to distance is commonly called **fall-off.** Remember that this law strictly applies only to a point source. Large-area diffuse lights usually show less fall-off than specular lights.

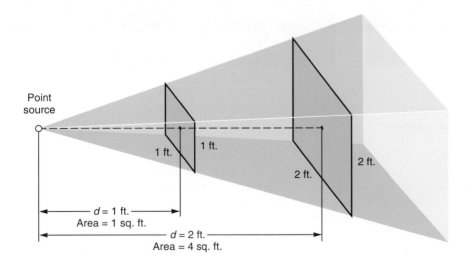

*Inverse Square Law (Point Source).* The same amount of light is spread over a greater area as the distance from the light source increases. Since the area covered by the same light quadruples when the distance is doubled, the light must cover four times as much area and provides one-fourth as much illumination.

## ■ Lighting Tools

The photographer's lighting tools are anything that provides light or a method of altering the light. Lighting tools range from simple to the complex. However, the quality of the result does not always depend on the cost or complexity of the tools but rather on the skill and taste employed in lighting the subject and whether the tools used are appropriate to the job at hand.

### The Studio

A photographic studio may be a large space with controllable lighting and expensive lighting equipment, but many studios are small rooms converted from other uses. Basically a studio is an enclosed space that offers the opportunity to block out or control any natural light and the ability to select artificial lights that will give the desired effects.

Studios depending entirely on natural light are rare today, but it is possible to build a studio with windows, skylights, and blinds for reasonable control over the light. Natural-light studios are at the mercy of the weather, so most photographers working on assignment keep a variety of artificial light sources for re-creating the feel of natural lighting or producing unusual lighting, giving them independence from natural conditions.

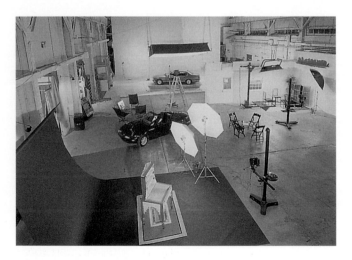

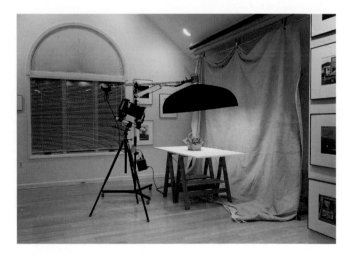

Left: *Large Commercial Studio.* Several large sets can be operating at once in this converted factory, which is now a studio for Photogroup, Inc. in Bethesda, Maryland.

© Photogroup, Inc.

Right: *Simple Studio in a Home.* Although space is limited, this studio has ample room to handle most still-life or portrait sessions for photographer Merle Tabor Stern.

© Merle Tabor Stern.

### Location

In location photography a controlled photograph is produced not in a studio but in a spot chosen either for its pictorial possibilities as an environment for the subject or because of its convenience. Although location work may offer less complete control over lighting, a surprising number of aids for controlling the lighting can often be found at the location. Light or dark tone surfaces can be used for control over environmental light. Preexisting light sources can be used as part of the lighting scheme, as either a main light or an effects light. An alternative is to completely eliminate or overpower the preexisting light to create what is essentially a studio with completely controlled lighting on location.

# Light Sources

The natural light sources most commonly used are the sun and occasionally an open flame. The two basic categories of artificial lights made for photography are incandescent—also called tungsten or hot—lights and electronic flash. Lights that are designed specifically for use in photographic studios or controlled location situations are called **studio lights.** However, the small flash units designed for on-camera use can also be adapted to studio use and are convenient for location work, since they are battery powered.

**Incandescent Photographic Lights**  **Incandescent lights** produce light when an electric current is passed through the filament of the bulb. Since the light produced is continuous, the effects of the lighting can be easily seen and metered, but incandescent lights of high wattage are required for reasonably short exposures. This produces a large amount of heat, which is not appropriate for all situations—photographing food that melts or wilts, for example.

Bulbs for photographic incandescent lights come in three general color temperatures: 3200°K, 3400°K, and blue-coated bulbs, which approximate daylight. **Photoflood bulbs** look much like household bulbs but are designed to provide more even light at a consistent color temperature. Although these are the cheapest of photographic incandescent bulbs, the burning life is typically short. The inside of the bulb is coated to provide some diffusion of the light.

**Quartz-halogen bulbs** produce a more intense light for their size and may have longer burning life than photofloods but are considerably more expensive. Quartz-halogen bulbs may be coated for some diffusion or may be clear, but in any case the direct light from a quartz-halogen bulb is quite specular because of its small size.

The extreme heat generated by incandescent lights—especially the quartz-halogens—creates some limitations on the methods for modifying light discussed later, since many of the techniques require enclosing the bulb in a housing or placing materials in the beam of the light, which could cause a fire hazard. Exercise extreme care when working with these high-wattage incandescent sources. Not only do the bulbs and lamp housings become very hot but also the beam of light itself is capable of setting flammable materials ablaze. To reiterate some of the safety rules from chapter 8:

- Keep the lights a safe distance from any flammable material, *especially* human hair.
- Do not touch the metal lamp housings or the bulbs. Incandescent bulbs are capable of exploding, so do not look into a lamp when turning it on or ever have it close to a person's face. Touching the glass of a quartz-halogen bulb leaves a deposit that will cause the bulb to blister, with resulting premature failure and increased possibility of explosion.
- Take care to arrange power cords so that they will not be tripped over, which could bring the hot housing down on a person or flammable object. Cords should drop straight to the floor and lie flat with plenty of slack.

**Electronic Flash**  Electronic flash units, in which a high voltage is discharged through a gas-filled glass tube, are the most common source of single short bursts of high-intensity light. The term *strobe* is often inaccurately used to refer to electronic flash. Although similar in construction, a true strobe light is designed to provide repeated flashes of light, often many in 1 second and usually low in intensity.

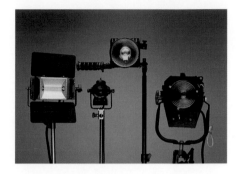

*Incandescent Studio Lights.* Left to right: quartz-halogen floodlight, minispot, variable-beam quartz-halogen light, spotlight.

*Incandescent Bulbs.* At top left is a mogul-base 1000 watt photoflood. At right center is a standard-base 500 watt photoflood. The remainder are variously styled quartz-halogen lamps, ranging in wattage from 600 to 1000.

See pages 206–11 for information on small on-camera flashes.

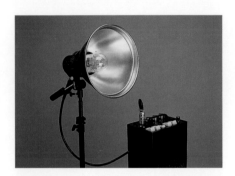

Studio Electronic Flash with Separate Power Pack.

Electronic flash units are available as small battery-operated flashes for on-camera use and as studio electronic flash units. The brief duration and high intensity of the electronic flash offer some real advantages where fast exposure times and small apertures are needed. However, if expense is a consideration, it is much cheaper to set up a basic studio with incandescent lights.

**Power Packs**    Studio flash units often consist of a power supply, called a power pack, which feeds the electrical current by means of cables to a separate flash head containing the flashtube. A power pack may be capable of powering several heads. Flash units of this type are typically heavy, but newer models employing advanced materials and electronics provide more power for less weight. The power pack contains large capacitors, which store electrical energy at high voltage. When the unit is triggered by means of a synch cord, this energy is dumped to the flashtubes that are plugged into it.

To make variable power available, the packs usually contain two or more sets of capacitors, called **banks,** which can be connected or disconnected by switches. The power of a bank is distributed equally to each of the flash heads plugged into it. Flash power supplies are rated in watt-seconds. Studio flash units vary from as small as 200 watt-seconds to as large as tens of thousands of watt-seconds. The actual illumination supplied to a subject depends on several variables other than the power—such as efficiency and head design—but watt-second rating is a convenient way to compare units or determine the balance of power being supplied to various heads in a lighting setup.

Packs having banks of unequal power, called **asymmetrical packs,** allow different power to be supplied to different heads. In the past it was impossible to continuously vary the power supplied by each bank—it was either all of the charge or nothing—but new electronic advances have made it possible to vary the power supplied to the heads in very small increments by way of dials or slide switches. This technology provides a great convenience in adjusting flash intensity.

■ **CAUTION**    The cables from the power pack to the flash heads carry large amounts of electrical current at high voltages. Take care in their handling and use. When the capacitors are charged, removing or inserting a cable on the pack may cause arcing between the power pack and the cable with the possibility of electric shock and the destruction of the power pack. Many newer units provide arc-free removal and replacement of cables, but it is best to make no assumptions regarding the presence of this safety feature.

To safely plug or unplug flash cables from a power pack, follow these steps:

1. Turn the unit off.
2. Discharge the capacitors by pressing the Test button.
3. Grasp the connector itself to remove a cable. Do not pull the cables out by pulling on the cord.

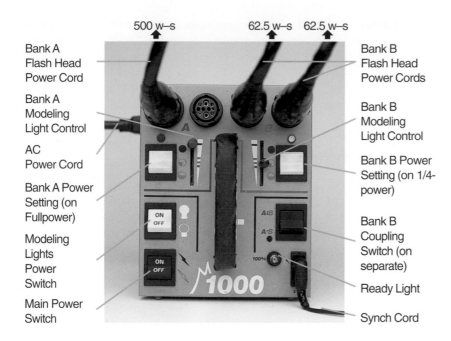

500 w–s    62.5 w–s  62.5 w–s

Bank A
Flash Head
Power Cord

Bank A
Modeling
Light Control

AC
Power Cord

Bank A Power
Setting (on
Fullpower)

Modeling
Lights
Power
Switch

Main Power
Switch

Bank B
Flash Head
Power Cords

Bank B
Modeling
Light Control

Bank B Power
Setting (on 1/4-
power)

Bank B
Coupling
Switch (on
separate)

Ready Light

Synch Cord

*Operation of Studio Flash Power Pack.* This 1000 watt-second power pack has two banks of 500 watt-seconds each, for powering up to four flash heads. It is of the symmetrical-asymmetrical type, with bank power switches that can be set so that the power from the two banks can be equal or unequal. The banks can also be linked to act as one bank with the bank coupling switch. When more than one head is plugged into a bank, the power of that bank is divided equally among the heads. The ready light glows to indicate a full charge on the banks.

The power pack pictured has three heads plugged into it. The bank coupling switch is set to separate the banks. Bank A, on the left, is set for full power, or 500 watt-seconds. It has one flash head plugged into it that receives the full 500 watt-seconds. Bank B is set for quarter power, or 125 watt-seconds. Since two flash heads are plugged into bank B, each head receives half of that bank's power, or 62.5 watt-seconds. Note that the modeling lights on this unit are not proportional (see the next section) and must be adjusted using the slide switches to match the power for each bank. This adjustment is for visual effect only and does not affect the flash power.

**Modeling Lights**   The effect of flash illumination cannot be seen. Studio flash units solve this problem by including in the flash head a **modeling light,** which is an incandescent bulb placed as close to the flashtube as possible. Although modeling lights give an approximate idea of the effect of lighting with flash, remember that they are not exactly the same as the flash and may give slightly different quality and evenness. Usually the modeling light can be switched independently of the power to the flashtube. This allows turning off the modeling light in situations where its intensity may affect the exposure. Most studio flash units also allow varying the intensity of the modeling light to match the visual effect of changing the flash power. Some may have a switch that will cause the modeling light intensity to vary automatically as flash power is changed; these are called **proportional modeling lights.**

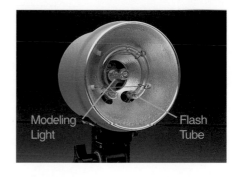

Modeling Light in Studio Electronic Flash Head.

**Monolights**   A second approach to studio flash construction is to include the power pack and flashtube in one unit, much like an overgrown on-camera flash. Although these units—called **monolights** or **monopacks**—have the convenience of no flash cables, they are considerably heavier than the flash heads powered by separate packs, putting more stress on light stands and accessories. Monolights offer many of the same features as power packs, with variable power to the flashtube—continuously variable on some—and modeling lights. Some monolights also offer battery power for use on location, but the modeling lights usually do not operate on battery because of their high power use.

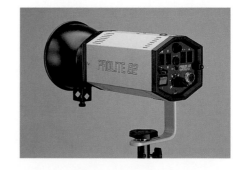

Monolight Electronic Flash.

**Continuous-Discharge Lights**   Light sources that make use of a continuous discharge of electricity through a gas-filled tube, such as neon and fluorescent lamps, are often found in preexisting light but are seldom used as supplementary light sources in controlled lighting. The color of light produced by gas discharge has sharp peaks of intensity at specific wavelengths. This property can create abnormal reproduction of colors with color materials.

## Tools for Modifying Light

The qualities of a light source can be modified by reflection, transmission, or absorption of the light coming from it, and all of these techniques are used to produce the quality of light that the photographer finds appropriate for the job at hand. Many of these techniques require enclosing the light source or placing materials in front of it and must be applied with caution to incandescent lights, since the heat generated by these lights can ignite many materials. Electronic studio flash is more easily modified, since the flash generates much less heat.

■ **CAUTION**   The modeling lights used in professional studio flashes are incandescent lights and do generate heat, so care must be taken not to place materials too close to them or enclose them too tightly. If the modeling light can be controlled separately from the flash, it can be either turned off or reduced in intensity to prevent overheating. Flash heads with built-in blowers can help in cooling.

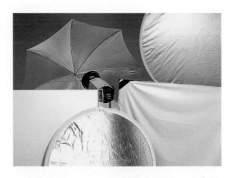

*Tools for Diffusion by Reflection.* At bottom center and top right are circular cloth reflectors supported by a flexible spring-steel band, which can be coiled for portability. In the middle are a white foamcore board and a white cloth stretched on a plastic pipe frame. At top left is a photographic umbrella.

**Diffusion**   Diffusion means scattering of the light, which can be done by either reflection from a slightly textured surface or transmission through a translucent material. Any light-toned surface can be used to reflect the light. Large white moveable surfaces, called **flats,** are used in the studio. These may be boards painted white, large sheets of foamcore, mat board, or cloth stretched over metal or plastic frames. When photographing with color film, remember that any color in the diffusing material will change the color of the diffused light that will show up in the photograph. This can be used intentionally. A reflector with a gold surface can create the warm-colored light associated with sunset hours. Photographic umbrellas diffuse the light by reflection off the white interior. Because of the shape of the umbrella, the light is more concentrated and slightly more specular than the light reflected from a flat.

Diffusion by transmission is achieved by placing translucent materials, called **scrims,** between the light source and the subject. The effect is to make the light less specular and also reduce the intensity. Materials used for this purpose include translucent Plexiglas, translucent cloth, spun fiberglass (good for hot lights), and translucent plastic sheet materials, such as those made by Roscoe. Many artificial light sources include a diffusing surface in the glass of the bulb itself. In a softbox the light source is in a black cloth enclosure with a translucent white front. The inside of the softbox is lined with reflective material to increase the intensity of the illumination. The effect is a diffuse source with a large area, with good control of the scattering of light into the environment. The lighting contrast is thus higher with a softbox than it would be with a diffusion screen illuminated with an open lamp from behind.

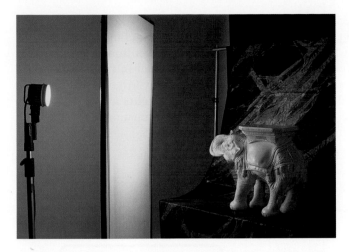

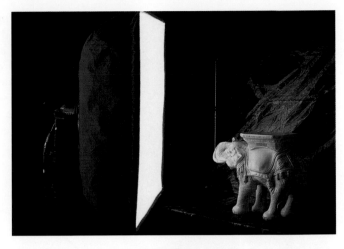

*Diffusion by Transmission through a Scrim.* An open scrim of translucent nylon cloth stretched on a plastic pipe frame is being used to diffuse the light, producing soft shadow edges. The lighting contrast is fairly low because of the environmental light scattered from the back of the scrim and the studio walls and ceiling.

*Diffusion by Transmission Using a Softbox.* A softbox has the same type of translucent cloth scrim in the front of it, but the lamp head is enclosed in an opaque housing so that the light reflected from the back of the scrim is not allowed to escape into the studio. The result is the same soft shadow edge as achieved with the open scrim, but much higher lighting contrast.

**Concentration**  Light from a source can be concentrated to increase the amount of illumination on the subject or to increase the specularity. Many artificial light sources include a reflective housing for concentration of the light. The reflector gathers the light from the back of the bulb and projects it toward the subject, increasing the effective intensity. If the reflector is polished, the specular nature of the bulb is preserved, but a large matte-surfaced reflector can be used for partial diffusion of the source.

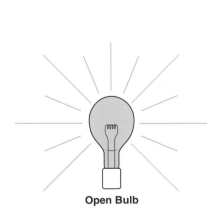

**Open Bulb**

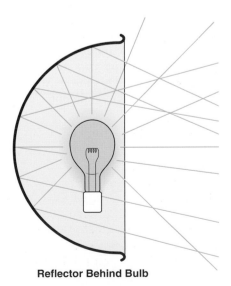

**Reflector Behind Bulb**

*Concentration of Light by a Reflector.* The first drawing shows the travel of light from an open bulb. The second shows the concentration in one direction resulting with a reflector housing. The photograph shows a quartz-halogen studio light that uses a reflector for concentration of the light.

**Collimation**　Proper shaping of a polished reflector can concentrate the light even further to the point where the rays of light are traveling in almost parallel paths. Light in which the rays are parallel is called **collimated light.** This is accomplished even more efficiently by a lens placed in front of the light. Since the light rays are nearly parallel they spread very little over distance, so the beam stays small and loses little intensity. **Spotlights** are of this design. Many spotlights are adjustable, so the amount of collimation and the size of the spot produced are variable.

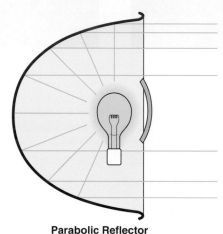

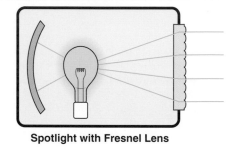

**Spotlight with Fresnel Lens**

**Parabolic Reflector**

*Collimation of Light.* The first drawing shows collimation of light by a parabolic reflector. The second drawing shows a spotlight that collimates the light with a **Fresnel lens.** The photograph shows a sophisticated studio spotlight that uses lenses and reflectors to collect and collimate the light and that features slide-in filters and apertures.

**Elimination of Unwanted Light**　Any opaque object can be used to block unwanted light from a subject, though it is best to use black materials to prevent scattering reflected light into the environment. A **gobo** is any opaque object used in this way. Snoots, cones, barn doors, and grids are accessories for lamp housings that restrict the size of the beam coming from an artificial light. Grids are even effective on diffused sources. Unwanted environmental light can be reduced by placing dark materials around the subject in place of existing lighter surfaces. This lowers the ambience and reduces the amount of light scattered by the environment.

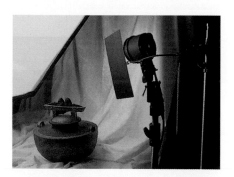

*Use of a Gobo to Keep Unwanted Light from a Subject.* The flash head on the right is illuminating the background. A small black gobo has been positioned beside it to prevent its light from falling on the subject.

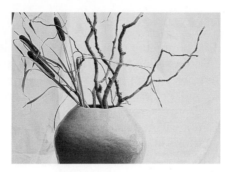

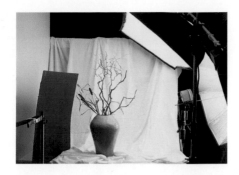

*Control of Environmental Light.* A. Unwanted fill light reflecting from a nearby studio wall is appearing on the left side of the vase.

B. A black card was placed between the studio wall and the subject to block the reflected environmental light from the subject.

C. The black card can be seen on the left. The main light is the softbox high on the right. The umbrella at the lower right is supplying fill light to the lower part of the vase and illuminating the background.

Another use for gobos is to prevent direct light from falling on the lens, thus reducing lens flare. To detect flare-producing light, look from the position of the subject for any light falling directly on the lens. A lens shade can also help to reduce flare. Flare can also be caused by brightly lit white areas just outside the view of the lens and can be reduced by covering these areas with black material.

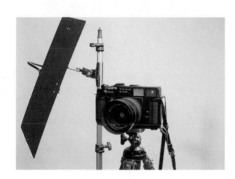

*Use of a Gobo to Prevent Lens Flare.* A. Without a gobo, light from a studio light falls directly on the lens, as evidenced by the shadow crossing the lens and the specular reflections of the light source seen in the lens surface. Even the use of a lens shade has not prevented flare-producing light from striking the lens.

B. Here, the camera and lights are in the same position, but a gobo has been placed to block the direct light from falling on the lens. When using this type of setup, check carefully through the camera viewfinder to make sure the gobo does not appear in the edge of the frame.

*Tools for Restricting Light.* All of these tools are designed to be attached to studio lamp housings. From left to right: cylindrical snoot, coarse honeycomb grid in holder, special truncated cone with white interior for lighting backgrounds, fine honeycomb grid, barndoors.

**Control of Light Color**  Colored acetate filters may be used between a light source and a subject to change the color of the light, but take care not to place them too close to hot lights. Colored reflectors will also alter the color of the reflected light. Also see pages 341–43 for methods of controlling the color of the image by filtering on the camera.

*Acetate Filters and Frames for Controlling the Color of Light.* Filters of this type are often called "gels."

445

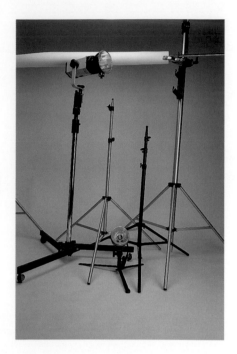

*Light Stands and Background System.* From left to right: rolling studio stand, folding portable studio stand, folding floor stand, folding portable studio stand in black, expandable pole system with heavy-duty folding legs used as a seamless background support.

*Electronic Flash Slaves.* At the top is a radio slave unit, with a receiver and a transmitter. The flash is fired remotely by a radio signal. Infrared slaves are similar, but the flash is fired by an infrared beam. At the bottom are dome-style slaves, which fire the flash they are plugged into when they sense the light from another flash. The one on the left plugs into the standard two-prong synch terminal found on many studio flash power packs. The other has a female PC terminal for use with a standard PC synch cord.

## Accessories

A large number of accessories are available for photographic lighting and studios, including background holders, seamless backdrops, and stands, clamps, and poles to support all of this equipment. Slave units are available to set off secondary flash sources when the primary flash connected to the camera is fired.

You will need a kit of tools and supplies for general studio usage, known as a **gaffer's kit** (*gaffer* is the movie industry's term for a person who rigs the lights on movie sets). Gaffer's tape is useful in a variety of situations, since it has great strength for temporarily mounting nearly anything but leaves no adhesive residue, as do duct tape and many other available tapes.

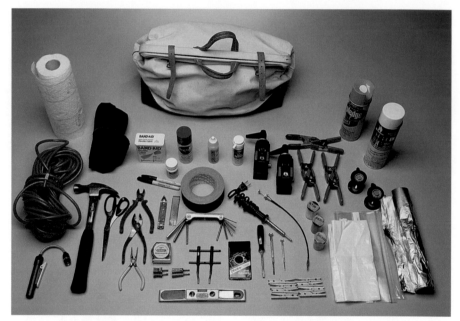

*Gaffer's Kit.* The gaffer's kit contains a number of standard tools, such as hammer, pliers, scissors, extension cord, and so forth, as well as some specialized items for working in a studio or on location, such as an assortment of A-clamps, specialized clamps for studio equipment, and a changing bag for handling film. This kit also includes cleaning and first aid items.

## Location Tools

The tools a photographer chooses for location work are basically similar to those already described, but an emphasis is placed on compactness, light weight, and flexibility in ways of supplying electrical power. The presence or absence of electrical power will influence the choice of lights, whether flash or continuous. A number of convenient battery-operated flash units are available. Another solution is to bring along gasoline-powered portable generators or converters that will provide line voltage from a car alternator.

Reflecting and diffusing flats are best for location work if they can be folded or rolled up. The PVC frames with cloth stretched on them are convenient, since they can be disassembled for carrying. Flexible circular steel hoops covered with stretched cloth can be coiled and placed in convenient zippered bags. The illustration shows a useful location lighting kit for applications requiring medium amounts of illumination in locations with line voltage available.

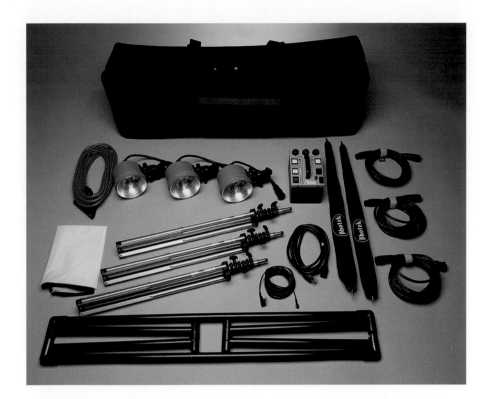

*Location Lighting Kit.* From front to back, left to right: folding plastic pipe frame for scrims and reflectors, white nylon scrim-reflector, folding light stands, synch cord, AC power cord for power pack, photographic umbrellas, flash head power cords, AC extension cord, flash heads with modeling lights, flash power pack, foam-cushioned case.

## ■ Metering and Exposure with Controlled Lighting

The photographic light meter is a useful tool not only for determining camera settings for correct film exposure but also for analyzing lighting.

See chapter 3 for basic information on meter types.

## Light Meters

Any type of photographic light meter is useful for analyzing lighting situations, but some specialized meters and meter accessories can make the job easier. An incident-light meter is convenient if you want to measure the illumination on different areas of a subject. If the desire is to control the tonal values of different areas of the subject through controlled lighting, the reflected-light meter is better, since the individual luminances of the subject can be measured for tone control. Both types are useful in controlled lighting situations.

Most light meters are designed for continuous light. If you intend to work with flash, a flash meter is a great convenience. Combining continuous light and flash provides special problems in determining balance of intensities, and a meter capable of incorporating both into one reading is helpful.

The current trend is toward meters that can perform any of these tasks by the use of attachments, accessories, or built-in modes. The more expensive of these convertible meters manage to do all of the jobs well. Typically a professional meter will have an incident dome about 1 inch in diameter. Smaller domes will still provide incident-light readings but may not as successfully integrate the light incident on the subject from different directions.

General techniques for using each of these metering methods follow. The lighting applications section at the end of the chapter shows how these techniques can be applied in real situations.

*Multi-mode Flash Meter.* The multi-mode flash meter has several modes, allowing incident-light, reflected-light, flash, and continuous-light readings. On the left, it is set up for continuous incident-light meter readings. On the right, it is set up for reflected-light flash meter readings, having a 5° reflected-light attachment with viewer in place of the incident dome. This meter can be used for either continuous or flash readings in both incident and reflected modes. In flash metering mode, it will even combine the effect of both flash and continuous light.

**Using Reflected-Light Meters for Controlled Lighting**   Tone control techniques apply quite naturally to controlled lighting. The camera settings can be determined by placement of one tonal area. The expected print values for other tones can then be found by fall. In addition to the controls offered by exposure and development, the lighting can be changed to alter tonal relationships in the subject.

Since the contrast of the lighting can be altered by increasing or decreasing the amount of illumination in the shadows, a common technique is to find the camera settings by placing a highlight area—often the diffused highlight. Once the camera settings are determined, the fall of the shadow is found. If the shadow falls too low, light is added to the shadows; if the shadow falls too high, illumination to the shadows must be reduced. Usually this can be done with little appreciable effect on the highlight readings, but always recheck the placement when lighting has been changed. In this way the subject contrast can be adjusted for normal development. This is especially valuable in color photography where little contrast control is available in processing.

Once the general lighting contrast has been determined, the fall of other areas may be calculated. For example, if the fall of the background is REV +1 a print value of +1 will result for normal development. If a white background is required, the illumination on the background must be increased until the desired white is achieved. For a pure white background, REV +4 or higher is needed; for the last tone before white, REV +3 is needed; and so on. If a modulated background—one that shows a variation of tone—is being achieved on a blank backdrop by use of lighting, the actual variation in tone can be predicted and then controlled by the use of fall. A spot meter or restricted-angle meter of 1°–10° acceptance is useful for this type of control, especially if the subject matter is small, as in many still life subjects.

If the meter is strictly a reflected-light meter, the functions of an incident-light meter may be approximated by use of an 18 percent gray card. Note that great care must be taken to insure that the reflected light measured from the gray card is diffuse light and does not include glare.

*Approximating an Incident-Light Meter Reading with a Reflected-Light Meter and an 18 Percent Gray Card.* To determine the illumination from a single light source with an incident-light meter, simply point the meter at the light from the subject position. To approximate this incident-light meter reading with a reflected-light meter, place a standard 18 percent gray card at the subject, oriented so that the light strikes it at 45°, then make a close-up reflected-light meter reading of the card with the meter at 90° to the card.

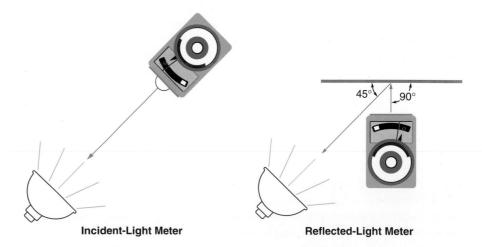

**Incident-Light Meter**          **Reflected-Light Meter**

**Using Incident-Light Meters for Controlled Lighting**  The dome of an incident-light meter integrates all of the light coming from the hemisphere in front of the meter. What is being measured is the illumination incident on the subject from that direction. To measure the illumination from a single source of light, the incident-light meter should be pointed from the part of the subject where the measurement is desired directly toward the light source. If you want to measure the average effect of the general illumination—including all sources and environmental light—on the side of the subject facing the camera, point the incident-light meter at the camera from the subject. An incident-light meter reading does not sense the effect of the subject on the light—due to reflection, absorption, or transmission—and gives no direct indication of the subject luminance, only the amount of light falling on the subject.

The calculator on an incident-light meter is designed to give camera settings for the correct exposure when a reading is taken at the diffused highlight. For normal reproduction of tones, the camera setting would be used as suggested by the meter. With normal processing, the diffused highlight area of each tone will show its true tonality in the photograph: gray will come out gray, black will be black, and white will be white. Any specular highlight on the surface, such as glare, will of course produce a lighter tone in the photograph than the true subject tonality. Any area of the tone shaded from the full effect of the light will be a darker tone than the true tonality.

Since the incident-light meter measures illumination, its strength is in comparing the illumination from different sources. Determination of lighting contrast is simple with an incident-light meter. Incident-light readings are made at the diffused highlight and in the shadow area and compared.

Strictly speaking, incident-light meters cannot be used for tone control, since they do not provide a measurement of the luminance, which is necessary for calculating film exposure for each area of the subject. However, with some knowledge of the reflectance of the area being metered, an incident-light meter reading can give a rough idea of fall and the expected print tone.

Since the camera settings suggested by an incident-light meter will provide the true tonality of a diffuse highlight for a tone, an 18 percent gray subject will be reproduced as 18 percent gray—for normal processing and printing. If the subject tone is white rather than gray, it reflects more of the incident light, producing more film exposure and a lighter tone in the photograph. If we know how much more of the light is reflected, we can predict the film exposure. A typical flat white wall or white paper backdrop will reflect back about two to two-and-one-half stops more light than 18 percent gray (an exact measurement of this difference could easily be made with a reflected-light meter). If the camera settings suggested by the meter for an incident-light reading at the wall or backdrop are used, the fall for that area will be approximately REV +2 to REV +2 1/2.

Remember that any glare from the surface under consideration will raise this film exposure value. Although this procedure provides only estimates of the REV and the resultant print value, for a studio where the photographer is familiar with the reflecting capability of the various materials used, it can be useful in control of background and other tones of the subject.

Controlling lighting ratio is discussed in more detail on pages 459–460

References to flash in this chapter deal only with electronic flash units. Flashbulbs are rarely used today, but if you find it necessary to do so, follow the instructions packed with the bulbs.

Note: Large studio flash units may have flash durations of 1/500 second or longer. When these are used with leaf shutters at high speeds, the exposure on the film due to flash may be affected.

Notice that the unit of measurement—feet in this case—must be specified. If the distance is measured in meters, a different guide number will result. If f/11 gives the best exposure at 3 meters for ISO 100 film, the guide number in meters is determined as follows: **G.N. (ISO 100) = 3 meters × f/11 = 33 meters.**

## Determination of Flash Exposure

The duration of electronic flash is typically much shorter than the shutter speed being used on the camera. Since the entire burst of light occurs during a small part of the time the shutter is open, leaving the shutter open for a longer or shorter time will not affect the exposure on the film due to the flash. Flash exposure is therefore controlled by changing the lens aperture, changing the power of the flash, or changing the subject-to-flash distance. Several methods exist for determining the exposure from flash illumination.

**Guide Number**    Usually the dimensions of a flashtube are fairly small, even for powerful electronic flash units. As a result direct light from the flashtube unmodified by diffusion is quite specular and will fairly closely obey the inverse square law. If the amount of illumination supplied by the flash unit at one distance is found by measurement or testing, the amount of illumination at other distances can easily be calculated. Sometimes these calculations are performed by the manufacturer and presented in the form of charts or calculators providing the aperture needed at each flash distance to provide proper exposure. The ISO of the film must be included in these calculations.

The **guide number** can also be used to calculate the correct f-stop for subject-to-flash distance. To determine the guide number for a flash, test for the f-stop that will give good exposure at a specific flash distance, then multiply that distance by the f-stop number.

**EXAMPLE**    A flash unit is tested at a distance of 10 feet. The best exposure on ISO 100 film is achieved with the aperture set at f/8. The guide number (G.N.) is calculated as follows:

$$\begin{aligned} \text{G.N. (ISO 100)} &= \text{Flash distance} \times \text{F-stop} \\ &= 10 \text{ feet} \times \text{f/8} \\ &= 80 \text{ feet.} \end{aligned}$$

To calculate aperture settings for other flash distances, simply divide the guide number by the flash-to-subject distance. In this example, if the new flash distance is 6 feet the correct f-stop is calculated as shown here:

$$\text{F-stop} = \text{G.N.} \div \text{Flash distance} = 80 \text{ feet} \div 6 \text{ feet} = \text{f/13.}$$

Note that f/13 is a fractional f-stop between f/11 and f/16. Set the aperture control halfway between the two stops. For exact fractional equivalents of f-stop numbers see appendix C. If you change to a film of different ISO, a new guide number must be calculated:

$$\text{New G.N.} = \text{Old G.N.} \times \sqrt{\text{New ISO} \div \text{Old ISO.}}$$

If the flash in the preceding example is now used with ISO 50 film rather than ISO 100, the new G.N. will be as follows:

$$\text{New G.N.} = 80 \text{ feet} \times \sqrt{50 \div 100} = 56 \text{ feet.}$$

**Flash Exposure Tables**    Guide numbers are based on the inverse square law, which means they strictly apply only to specular sources. If a diffuse light source is being used, it is best to do tests at several distances and construct a table of f-stop versus distance rather than using a guide number.

**Flash Meter**   Flash meters provide a much easier and more accurate method of determining flash exposure, since they can easily determine camera settings for complicated lighting situations. The operation of a flash meter is somewhat different from that of a continuous-light meter, but once the measurement is made, calculations of camera settings can be done in a similar way, with the exception that the shutter speed does not affect the flash exposure, but will affect any continuous light being mixed with flash. Flash meters may be either incident- or reflected-light meters and may be used with flash illumination in all the ways previously discussed for continuous-light meters.

Since the burst of light from a flash is brief, flash meters work by electronically capturing the burst and then measuring its effect. Many meters must be "preset" so that they are ready for the flash burst. After the flash meter has been preset—usually by pushing a specific button on the meter—the flash unit must be set off manually by means of the test button for a reading. For incident-light readings where the meter must be held at the position of the subject, this can require the services of an assistant, since one person must hold the meter and a second set off the flash. Some flash meters make this a more convenient procedure by providing a PC receptacle on the meter, into which the synch cord can be temporarily plugged while readings are being made. Alternatively a radio or infrared slave unit for firing flash units remotely can be employed.

*Cordless Flash Meter Operation.* Pressing and releasing the button on the right side of the meter presets the meter. The flash is then fired manually by depressing its test button or with a radio slave, and the reading is displayed.

*Radio Slave Operation.* The transmitter is plugged into the camera's synch terminal and can be mounted on the camera or clipped to the photographer's belt. The receiver is plugged into the flash's synch cord receptacle. When the shutter is depressed, the flash is fired remotely by radio signal. The transmitter also has a test button for firing the flash remotely without activating the camera shutter. Infrared slaves operate in a similar fashion.

*Corded Flash Meter Operation.* The synch cord is unplugged from the camera and plugged into the synch cord receptacle on the meter. When the metering button is pressed, the flash fires and the reading is displayed.

**Combined Flash and Continuous-Light Metering**   Some flash meters will include in the reading the illumination due to continuous sources. These meters will have a setting for the shutter speed, since the exposure due to the continuous light will depend on the shutter speed. The f-stop is calculated by the meter from the combined illumination due to both continuous-light and flash sources at the shutter speed set on the meter and camera. Often the number of shutter speeds that can be selected on the meter is limited, sometimes to only the common synch shutter speed of 1/60 second, but more sophisticated flash meters will give combined flash and continuous-light readings at any shutter speed.

Remember that the shutter speed is only important for the part of the exposure due to the continuous light, but the aperture used will affect both flash and continuous exposure. This fact allows balancing illumination from flash and continuous light by careful manipulation of camera settings and flash power or distance. Techniques for balancing flash and continuous light are covered on pages 466–467.

## ■ Lighting Judgment

Judgment of the lighting is the first step in the process of control. When viewing the subject itself, we can look for and usually identify the source or sources of illumination. If the light source is visible we can judge its nature and some of its qualities by experience. The appearance of shadows, diffused highlights, and specular highlights is affected by the lighting. Photographic light meters are a helpful tool in analyzing lighting.

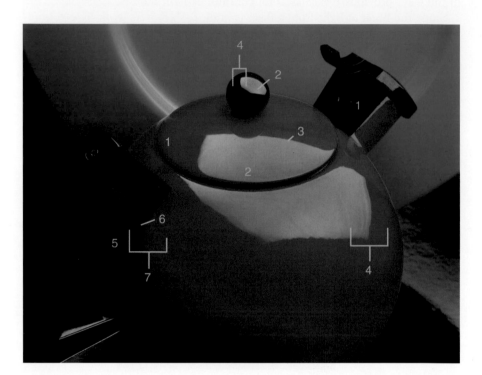

1. Diffused Highlight.
2. Specular Highlight.
3. Specular Highlight Edge.
4. Diffused-Specular Contrast.
5. Shadow.
6. Shadow Edge.
7. Diffused-Shadow Contrast.

*Effects of Lighting.* **Diffused highlights** show the true tonality of the subject: the medium red appears as medium red and the black appears as black. Diffused highlight luminances depend directly on the reflectance (tone) of the surface and the amount of illumination falling on the surface. **Specular highlights** are direct reflections of the light source, which in this case is a softbox. Note that the specular highlights on the red and the black are much closer in value than the diffused highlights on red and black. The luminance of a specular highlight is much more dependent on the specularity of the surface (its shininess) than on the tone of the surface. **Diffused-specular contrast** is the difference in luminance between the diffused highlight and the specular highlight on the same surface. The diffused-specular contrast is higher on glossy black than it is on glossy red because the diffused highlight on black is much darker. **Shadows** are areas blocked from the direct effect of the main light. Luminance in a shadow depends on the amount of fill light reaching that area and the tonal value of the surface at that point. The shadow edges in this case are soft, since the light source used provided diffused light. **Diffused-shadow contrast,** when measured on the same surface, is an indication of the lighting contrast, which in this case is relatively high, since the environmental light has been reduced to a minimum by use of a softbox and a low ambience.

© Bognovitz.

## Shadows

One primary way we sense the quality of light is by its absence—that is, the nature of the shadows formed by the light. A shadow is an area blocked from the direct action of the light by some opaque or partially opaque object—not to be confused with the use of the term *shadows* in printing where it simply means the dark areas of subject or print, whether an actual shadow or not.

Shadows are a primary indicator of the quality of light. Shape, position, deepness, and edge characteristics of shadows are all affected by the quality of the light and the lighting situation. A sense of the three-dimensionality—the volume or modeling—of a subject is largely provided by shadows. Texture of a surface is also shown by shadows.

## Diffused Highlight

Another indicator of the quality of the light source is the appearance of the fully lit areas of a subject. If no specular reflection is present, these areas are called **diffused highlights.** These areas show the true tonality of the subject matter. Gray will appear as gray, black as black, and white as white in a diffused highlight area—again not to be confused with a term used in printing, *highlights,* which refers to the lightest areas of a subject or print.

## Specular Highlight

Specular reflections—reflections of a light source, also called specular high-lights—may appear in fully lit areas of a subject. A specular reflection's edge characteristics, shape, size, and position and the difference in luminance be-tween it and the diffused highlight—called the **diffused-specular contrast**—are all affected by the specularity of the light, the surface nature of the subject (shiny, dull, etc.), the position of the light with respect to the subject, and the aperture and focus of the lens.

## Lighting Contrast

Lighting contrast was defined as the difference between the illumination sup-plied to the shadows and that supplied to the fully lit areas. **Diffused-shadow contrast** is the difference in luminance between a diffused highlight and a shadow and—when measured on the same surface—is an indication of the lighting contrast. The actual contrast seen in a print is the difference in tones between shadows and highlights, and that depends not only on the lighting but also on the tonal value of the subject. Dark-toned surfaces in the shadows or light-toned surfaces in the fully lit areas can increase subject contrast, and light-toned surfaces in the shadows or dark-toned surfaces in the fully lit areas may decrease subject contrast. If a subject has the same tonal value in shadows and fully lit areas, the subject contrast will be due solely to the lighting con-trast. Diffused-specular contrast can also contribute to the appearance of con-trast in a subject and photograph.

## Viewing Position

Viewing position can vastly affect the perception of light, shadows, and reflec-tions. Any visual analysis of lighting should be done from camera position, preferably through the viewing system of the camera itself. Even the effect of aperture and focus on specular highlights can be seen if viewing is done through the lens stopped down to taking aperture.

## Color of Light

If you are using color film you should think about the color temperature of the light sources illuminating the subject and any environmental conditions that might change the color of the illumination.

Choice of color balance for the film and filtering techniques for adjusting for the color temperature of the lights are discussed on pages 340–43.

## Judgment of Lighting in Photographs

It is a good learning experience to try to judge the lighting in published or ex-hibited photographs. In a photograph the light source may or may not be in-cluded. If it is included, it is easy to judge the nature of the light produced. If it is not, we must judge the quality of the light source or sources by the ap-pearance of shadows, highlights, and reflections.

## ■ Lighting Control Techniques

Lighting control techniques are summarized in the table "Altering Lighting Quality" on pages 469–70. Any physical change in the lighting usually affects more than one quality. The boxed section "Combined Effects of Physical Changes in Lighting" on page 471 will tell you what to expect for any changes in the lighting situation.

Once you have judged the qualities of the existing lighting situation, you can then make the decision whether to accept the lighting as is or make changes. The following sections will help you decide what physical changes you must make in the lighting situation to get the lighting quality you desire. The principles given here apply to any type of light source, whether natural or artificial. The methods of control and the extent to which the light can be modified will depend on each specific situation. Practical use of the lighting control techniques is demonstrated in the lighting applications beginning on page 471.

### Single Light Source

**Direction of Light**    The following photographs show the effects of changing the position of a single specular light for a full-face portrait, a profile portrait, and a still life. In each case the position and shape of the shadows differ and the position of the specular highlights is altered. Each example is labeled with a description of the position of the light, its position as keyed to the diagram below, and some commonly used names for a few of the lighting positions.

*Lighting Position Diagram.* Because the camera is located at position A, for level front lighting the light must be positioned just to one side or the other of the camera. For high front lighting, the light would be above the camera, and for low front lighting, it would be below the camera. Demonstrations are shown only for positions at camera right, A through E. Only the level positions were demonstrated for the profile. Depending on the circumstances, any of the remaining positions can be used, at any of the three heights. Because peoples' faces are seldom symmetrical, a lighting position may work better from one side than the other.

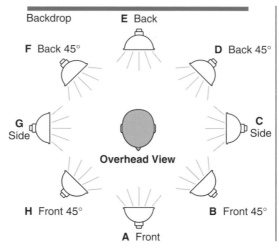

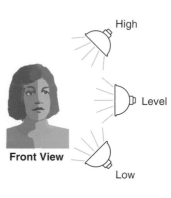

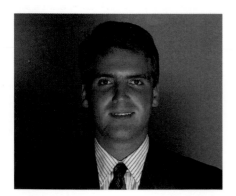

Low Front Lighting, Position A Low.

Level Front Lighting, Position A Level (Axis Lighting).

High Front Lighting, Position A High. (Butterfly or Paramount Lighting).

Low 45° Lighting, Position B Low.

Level 45° Lighting, Position B Level.

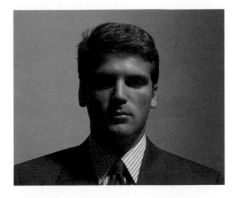

High 45° Lighting, Position B High (Rembrandt Lighting).

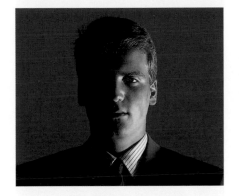

Low Side Lighting, Position C Low.

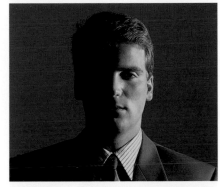

Level Side Lighting, Position C Level (Split or Hatchet Lighting).

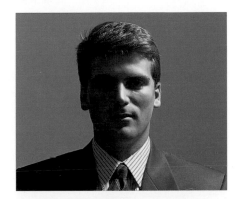

High Side Lighting, Position C High.

Low Back 45° Lighting, Position D Low (Kicker).

Level Back 45° Lighting, Position D Level.

High Back 45° Lighting, Position D High. This can be used as a hair light if the face is shielded from the light.

Low Backlighting, Position E Low.

Level Backlighting, Position E Level (Rim Lighting).

High Backlighting, Position E High (Hair Light).

*continued*

## Direction of Light—Continued

Profile, Level Front Lighting, Position A Level (Axis Lighting).

Profile, Level 45° Lighting, Position B Level.

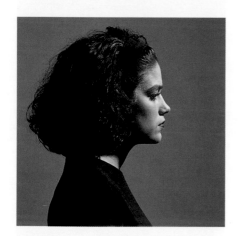

Profile, Level Side Lighting, Position C Level.

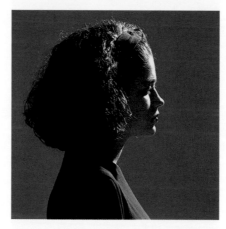

Profile, Level Back 45° Lighting, Position D Level.

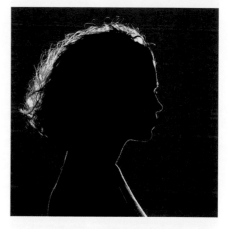

Profile, Level Backlighting, Position E Level (Rim Lighting).

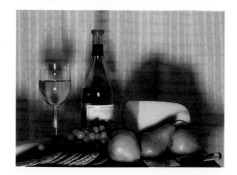

Low Front Lighting, Position A Low.

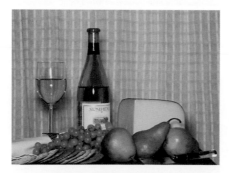

Level Front Lighting, Position A Level (Axis Lighting).

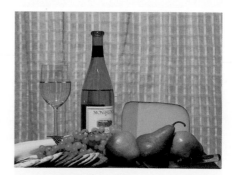

High Front Lighting, Position A High.

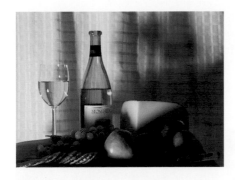

Low 45° Lighting, Position B Low.

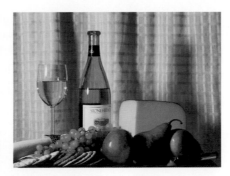

Level 45° Lighting, Position B Level.

High 45° Lighting, Position B High.

Low Side Lighting, Position C Low.

Level Side Lighting, Position C Level.

High Side Lighting, Position C High.

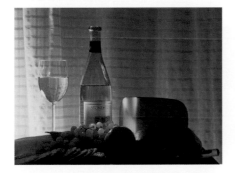

Low Back 45° Lighting, Position D Low.

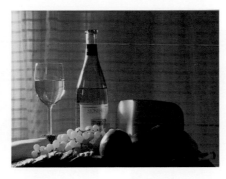

Level Back 45° Lighting, Position D Level.

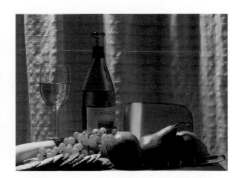

High Back 45° Lighting, Position D High.

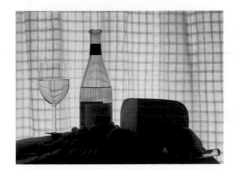

Low Backlighting, Position E Low.

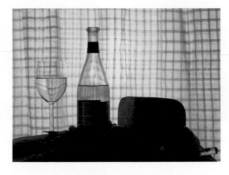

Level Backlighting, Position E Level.

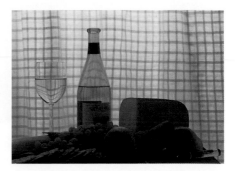

High Backlighting, Position E High.

**Specularity**   The following photographs demonstrate the effects of changing the specularity of the light. The tools outlined for diffusion and concentration of light can be used to alter the specularity of the light. Diffusion reduces specularity. Note especially the changes in the look of the specular highlights and the shadow edge.

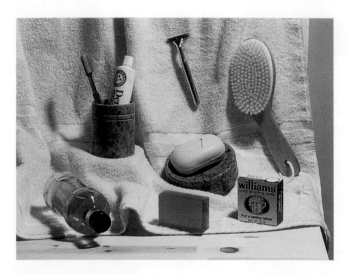

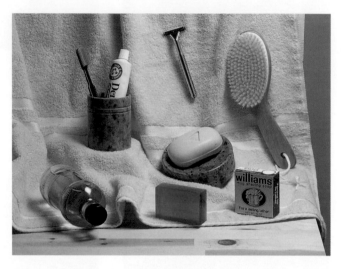

*Specular Light.* A single specular studio light is in the high 45° position.

*Diffused Light.* Again, the light is in the high 45° position, but a large scrim was placed in front of it to provide diffused light. Note the softened shadow edges. Because an open scrim was used, the lighting contrast has also been reduced.

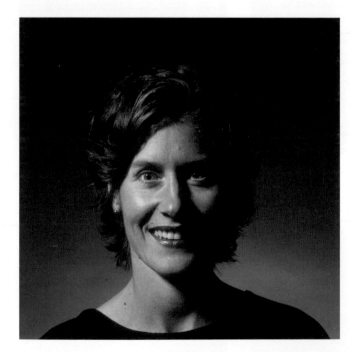

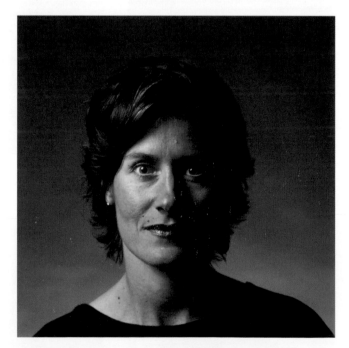

*Specular Light.* A single specular studio light is in the high 45° (Rembrandt) position.

*Diffused Light.* Again, the light is in the high 45° position, but a softbox was used in place of the specular light. The shadow edges have been softened, but the high lighting contrast has been retained because the softbox reduces scattered light.

**Lighting Contrast**   Lighting contrast is usually given as a ratio—called the lighting ratio—between the illumination at the diffused highlight and that in the shadows. With a single light source the only light reaching the shadows is environmental light, so the best way to measure lighting ratio is to make incident-light meter readings at the diffused highlight and the shadow.

See the boxed section "Lighting Ratio" on the next page for methods of determining lighting ratio.

If the ratio is too high—that is, too much contrast is present—either the highlight illumination can be decreased or the shadow illumination can be increased. Decrease highlight illumination by reducing the power to the light. Increasing subject-to-light distance or placing a scrim between the light and the subject will also decrease highlight illumination but will change specularity as well. Shadow illumination can be raised by increasing the environmental light by raising the ambience of the subject—placing light tone flats or reflectors near the subject.

Shadow illumination can also be raised by adding a supplementary fill light. See the section on multiple light sources beginning on page 461.

To increase lighting contrast, increase the illumination in the highlights or reduce the illumination in the shadows. Highlight illumination can be increased by increasing the power of the light source or decreasing the subject-to-light distance—which may also change specularity. Shadow illumination can be reduced by lowering the ambience by the use of light-absorbing surfaces around the subject and light source.

The choice of whether to alter the highlight or the shadows for lighting contrast control depends upon whether the specular nature of the light is important in the photograph. Any time the light source is manipulated by moving it or placing scrims in front of it, the specularity of the light changes. Altering the illumination in the shadows, on the other hand, leaves the specular nature of the main lighting unaffected.

Actual subject contrast also depends on the tonal values of the subject in shadow and highlight. When possible, tonal values of the subject as well as lighting contrast could be changed to control final subject contrast. For example, the white shirt of a portrait subject might be replaced by a shirt of lower reflectance to reduce subject contrast.

**Control Over Intensity of Light**   Often a specific shutter speed or aperture is needed for control over the appearance of motion or depth of field in a photograph. Changing the film speed may solve the problem, but if the lighting intensity is controllable, some choice of camera settings is possible. The intensity of a source can be changed by altering the power supplied to it. Changing the distance from the light source to the subject or scrimming the light will also change intensity but will affect specularity as well.

For an example of lighting control using a single light source, see lighting application 1 on page 472.

# Lighting Ratio

## Measuring Lighting Ratio

A comparison of incident-light meter readings at the diffused highlight and in the shadow is the best way to measure lighting ratio. Gray card readings at the same positions can also be used to determine lighting ratio.

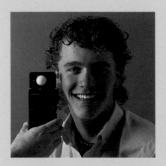 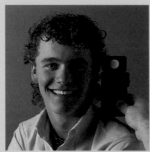

*Measuring Lighting Ratio with an Incident-Light Meter.* Above left: Take an incident-light meter reading at the diffused highlight, making sure the meter dome receives the full effect of the main light. Point the dome toward the camera to measure the general effect of any light striking the face from the camera direction. Above right: Next, take a meter reading in the shadow area, making sure the dome receives no direct light from the main light but receives the full effect of any environmental or supplementary fill light reaching the shadows. Find the difference in stops and refer to the first table on the facing page for the lighting ratio. Use the diffused-highlight reading for your camera settings. A reflected-light meter can also be used to determine the lighting ratio by finding the difference between reflected-light meter readings from an 18 percent gray card at diffused highlight and shadow.

*Calculating Lighting Ratio.* Right: If the illumination from the fill light is adjusted to be half that from the main light (one stop less illumination), the ratio is not 2:1, as might be expected, but 3:1, because the fill light is illuminating the highlight as well as the shadow. For low lighting ratios, the illumination added to the diffused highlight by the fill light will require a correction in camera settings. Refer to the second table on the facing page for lighting ratios and exposure corrections for calculated differences between main and fill lights.

## Calculating Lighting Ratio

If you do not have an incident-light meter but you know the relative power of the light sources being used for main and fill, you can calculate the lighting ratio. This applies when you are calculating flash exposure manually, either by guide numbers or exposure tables. Two things need to be remembered in calculating lighting ratios:

**1.** An assumption must be made that the environmental light reaching the shadows indirectly from the main light or any preexisting light is negligible compared with that from the supplementary fill light.
**2.** If the fill light is a front light, as most are, it is illuminating the diffused highlight as well as the shadows. This will affect the lighting ratio and the exposure for the diffused highlight. ■

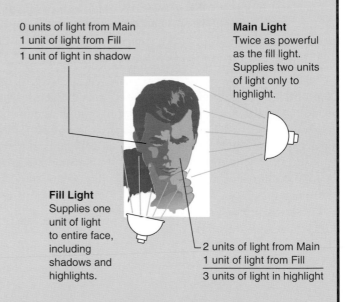

0 units of light from Main
1 unit of light from Fill
_____
1 unit of light in shadow

**Main Light**
Twice as powerful as the fill light. Supplies two units of light only to highlight.

**Fill Light**
Supplies one unit of light to entire face, including shadows and highlights.

2 units of light from Main
1 unit of light from Fill
_____
3 units of light in highlight

*continued*

| Lighting Ratio by Meter Readings | | Lighting Ratio by Calculation | | |
|---|---|---|---|---|
| Stops Difference Between Incident-Light Meter Readings at the Diffused Highlight and in the Shadow | Lighting Ratio | Stops Difference Between Calculated Illumination from Main Light and Fill Light | Lighting Ratio | Correction to Calculated Exposure for Main Light. Stop Down: |
| 1 | 2:1 | 0 | 2:1 | 1 stop |
| 2 | 4:1 | 1 | 3:1 | 1/2 stop |
| 3 | 8:1 | 2 | 5:1 | 1/3 stop |
| 4 | 16:1 | 3 | 9:1 | No correction |

## Multiple Light Sources

Since the standard of "normal" light is the sun, many feel that retaining the appearance of a single source of light is the most natural approach to photographic lighting. In fact people are exposed to subjects illuminated by multiple light sources nearly every day in artificially lit situations. Even in cases of a single light source, reflecting surfaces near the subject can create the impression of more than one light source. The following discussion is built around the attempt to capture the feel of natural lighting, but photographic lighting styles vary and many photographers intentionally light so that the presence of multiple sources is obvious.

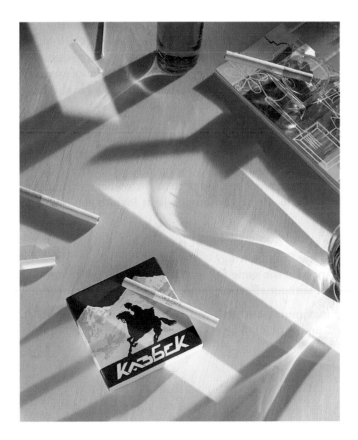

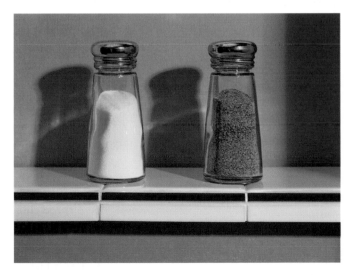

Above: Pete McArthur, Still Life. The lighting recreates a natural feel of late-afternoon direct sunlight, accentuated by the warm colors.

© Pete McArthur.

Left: Charles Purvis, Russian Cigarettes. The lighting is complex and stylized, with mirrors used to create a multidirectional feel for the light.

© Charles Purvis, Courtesy of Art and Commerce.

**Lighting Transparent Objects** Transparent materials offer a special challenge in lighting. In general, if you wish to show that a subject is transparent or translucent you must have some light coming through it, as in backlighting or top or bottom lighting. These positions are used alone or in combination with each other or with front lighting. With front lighting, the harshness of specular

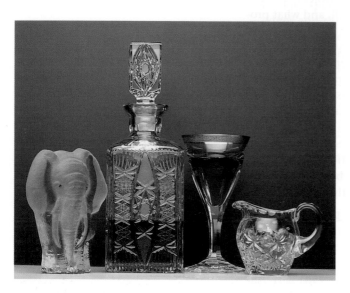

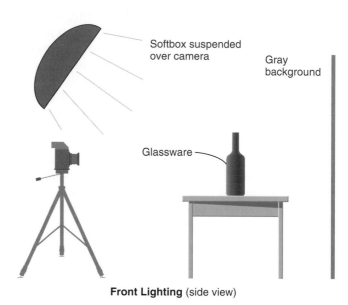

*High Front Diffused Lighting.* A softbox over the camera gives relatively large and gentle specular reflections, but the lack of light coming through the transparent and translucent objects makes them appear dark

and somewhat opaque. Cut glass responds well to this lighting because the facets pick up and refract the light.

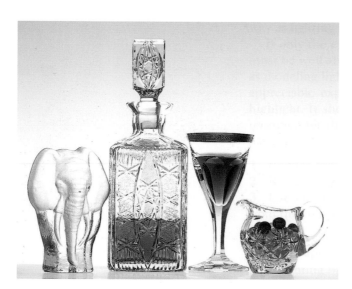

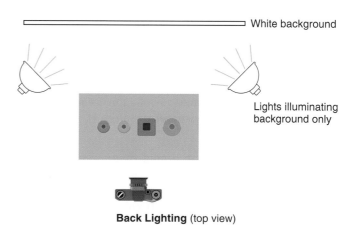

*Diffused Backlighting.* Backlighting is set up exactly like silhouette lighting, but the light is transmitted through transparent or translucent objects, giving a true sense of their transparency. Specular reflections are almost nonexistent. All of these objects respond well to backlighting,

especially the transparent liquids, but some of the sparkle is lost from the cut glass, since the facets tend to go black.

Photos © Bognovitz.

reflections from the shiny surfaces of many transparent objects can be softened by the use of diffused lighting. Additional specular reflections help to define the shape of the object and may be added by placing white cards near the object, just out of camera view.

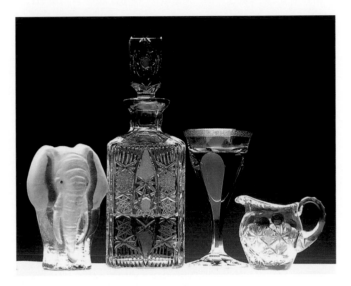

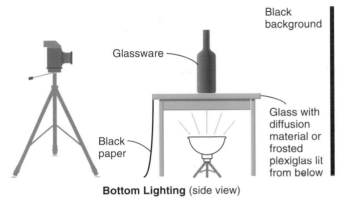

**Bottom Lighting** (side view)

*Diffused Bottom Lighting.* Bottom lighting gives a kind of inner glow to objects made of thick curved or faceted transparent materials. A few specular reflections appear, but objects that flare out, such as the wine glass, will reflect the lighted table surface. Cut glass responds well to

this lighting, but with tall objects such as the decanter, the effect may be lost at the top. Liquids tend to go dark. To avoid seeing the white tabletop, place a piece of black paper over the light table with holes cut the exact size of the bases of the objects.

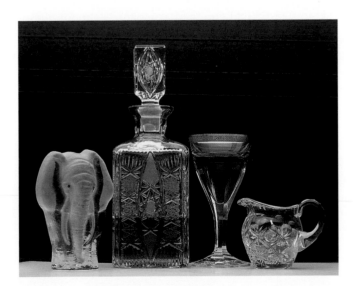

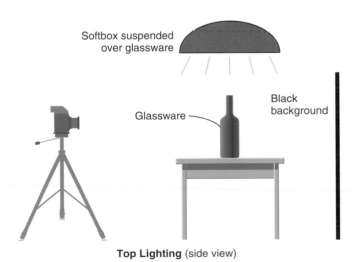

**Top Lighting** (side view)

*Diffused Top Lighting.* Top lighting gives less of an inner glow than bottom lighting but also gives specular reflections, which are very

effective at highlighting the tops of the objects—especially rounded tops—and at separating them from the background.

Photos © Bognovitz.

# Balancing Flash and Continuous Light

Exposure due to electronic flash is normally independent of the shutter speed set on the camera, being affected only by the aperture, subject to flash distance and the power of the flash. Exposure from continuous light, on the other hand, depends on both the aperture and the shutter speed. A careful choice of camera settings, flash distance, and flash power can therefore be used to balance the exposure due to flash and continuous sources in a mixed lighting situation.

## Using Camera Settings to Control Flash and Continuous-Light Balance

If you wish to change the exposure due to the continuous light without affecting the exposure from the flash, keep the aperture the same and change the shutter speed.

**EXAMPLE**    You are using the flash as a main light and preexisting continuous light as fill. Your maximum synch speed is 1/60 second. The continuous light meters M.R. f/4 at 1/60 second. The calculated f-stop for the flash—by its distance from the subject—is f/11. If you set your camera to C.S. f/11 at 1/60 second, the exposure due to flash is correct but the exposure due to continuous light is three stops less than the metered value—f/4 versus f/11. Three stops difference between main and fill results in a lighting ratio of 9:1 (see the table on page 461).

If you wish to have a lower lighting ratio, change your camera settings to C.S. f/11 at 1/15 second. The exposure due to the flash is unaffected, since the f-stop is the same, but the exposure due to the continuous light is now only two stops less than metered: metered M.R. f/4 at 1/60 second equals M.R. f/8 at 1/15 second compared with the camera setting of C.S. f/11 at 1/15 second. A one-stop difference between main and fill results in a lighting ratio of 3:1.

If you wish to change the exposure due to the flash without affecting the exposure from the continuous light, use a different equivalent exposure setting on the camera.

**EXAMPLE**    You are using daylight as a main light and electronic flash on the camera as fill. The daylight—continuous light—is giving an incident-light meter reading of I.M.R. f/11 at 1/60 second at the diffused highlight. For the distance the flash is from the subject, the f-stop from the flash calculator is f/8, giving a lighting ratio of 3:1—one stop difference in illumination supplied to shadows and the diffused highlight, with fill illuminating the highlight. You would like a higher lighting ratio, so you need to reduce the exposure due to the flash. Choose an equivalent camera setting with a higher f-stop: C.S. f/16 at 1/30 second. This will provide the same exposure due to the continuous light but reduce the exposure from the flash one stop, resulting in a 5:1 lighting ratio.

Shutter speed choices for balancing flash and continuous light are limited by the correct synch speed for the shutter. Leaf shutters, which synch with electronic flash at any speed, offer more control, especially when the continuous light is bright compared with the flash illumination. The newer focal-plane shutters with higher synch speeds also offer the convenience of reducing the effect of the continuous light by raising the shutter speed. Remember that some large studio strobes have shutter speeds of 1/500 second or longer and that exposure due to flash may be affected by the use of higher shutter speeds.

The process of balancing flash and continuous exposure is made easier by a flash meter that will combine continuous light and flash into one single reading. Determine the lighting ratio by making two incident-light readings, one in the shadows and one at the diffused highlight, and compare them for the lighting ratio (see the table on page 461). The diffused highlight reading includes both continuous-light and flash illumination, so the camera setting suggested by the meter can be used without correction.

## Using Flash Intensity to Control Flash and Continuous-Light Balance

Situations may arise where the camera controls cannot be used for control of flash and continuous-light balance. For example, if the maximum synch speed is 1/60 second, setting the camera controls for the continuous light may result in high f-stop numbers that give insufficient flash exposure. A reverse case is if the continuous light is low in intensity and the flash is powerful, resulting in undesirably high f-stop num-

bers and long shutter speeds to get the correct continuous exposure. In both cases the intensity of the flash can be changed to get the desired result. Flash intensity can be controlled in two ways:

**1.** Change the flash-to-subject distance. Moving the flash closer increases the flash exposure. Use the flash calculator or the inverse square law to figure out the exposure change.

**2.** Alter the power of the flash itself. Some flash units have power settings. Setting the flash on half power will provide one stop less flash exposure, setting it on one-quarter power gives two stops less exposure, and so on. If your flash does not have power settings, its intensity can be reduced by placing diffusing material in front of it. Translucent plastics or even a handkerchief can be used for this purpose. ■

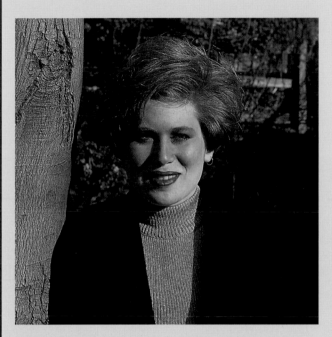 

*Combining Flash with Sunlight.* These photographs demonstrate the use of sunlight with a small electronic flash added as a supplementary light, known as **synchro-sun** or **sun-synch** photography. On the left, direct sunlight provided the illumination. The lighting contrast was high because little environmental light was reflected into the shadows. An incident-light meter reading at the diffused highlight was I. M. R. f/8 at 1/125 second for ISO 25, and camera settings of C.S. f/8 at 1/125 second were used. The camera was 5 feet from the subject.

For the photograph on the right, a lower lighting ratio was desired, so a small electronic flash was added, placed in a front lighting position to add fill light to the shadows. The lighting contrast has been reduced and catchlights added to the eyes by the flash. The maximum synch speed for the camera used was 1/60 second, so the camera settings were first adjusted to C.S. f/11 at 1/60 second, which is an equivalent exposure setting to C.S. f/8 at 1/125. A lighting ratio of about 3:1 was desired, so the exposure from the flash had to be adjusted to be one stop less than that from the sun. If the flash, which had a guide number of G.N. 56 at ISO 25, were placed on the camera at 5 feet, the recommended f-stop for the flash would be G.N. ÷ distance = 56 feet ÷ 5 feet, or about

f/11. This is the same as the sunlight illumination for C.S. f11 at 1/60 second and needs to be reduced one stop.

Any of the methods discussed in this section of the text for reducing the flash exposure without affecting the daylight exposure could have been used: (1) *Change the flash power to half-power.* This was not an option in this case, since the flash had only one manual setting. (2) *Change the camera settings to C.S. f/16 at 1/30 second.* The daylight would still get correct exposure, but the flash would be reduced one stop for the 3:1 ratio. The camera should then be set between f/16 and f/22 for the required half-stop exposure correction for a calculated 3:1 lighting ratio. However, with the camera used here, the minimum aperture was f/16, so the exposure correction could not be made. (3) *Increase the flash-to-subject distance.* This was the method chosen. Since the camera is set at f/11, we need a calculated f-stop of f/8 for the flash. To find the flash-to-subject distance, divide the guide number by the desired f-stop: G.N. ÷ f-stop = 56 feet ÷ f/8 = 7 feet. The flash was taken off the camera, attached by an extension synch cord, and held at 7 feet from the subject. The aperture on the camera was set between f/11 and f/16 to provide the half-stop exposure correction needed.

## Painting with Light

Trying to light large subject areas can present a problem if only a limited number of lights are available. One solution is painting with light, which is also useful for complex lighting on small subject matter. This technique requires that the subject be in almost total darkness so that the shutter can be locked open as for a time exposure. One light source is moved throughout the subject to selectively light different areas in sequence. This can be done with either flash or continuous-light sources.

With flash, the distance from the flash to the area of the subject being illuminated must be calculated from the f-stop being used on the camera. Repeated flashes are then performed to illuminate the parts of the subject that are to show in the photograph.

When a continuous-light source is used for painting with light, the distance from the light to the subject and the time the light is allowed to fall on the area can be altered to control exposure, taking into account the f-stop set on the lens.

*Painting with Light.* Aaron Jones. A number of devices for painting with light are available. They use fiber optics to provide a movable beam of light and feature controllable intensity and accessories to alter the pattern of light.

# ■ Summary of Lighting Control Techniques

Look for the change you wish to make in the quality of the lighting in the following table titled "Altering Lighting Quality." The table will tell you what physical change to make in the lighting to get the new quality. Note that the desired change in a particular quality of the light can usually be achieved in several ways. Each change in the lighting also usually affects qualities other than the one you are interested in changing. The boxed section "Combined Effects of Physical Changes in Lighting" on page 471 tells you all of the effects you get from making a physical change in the lighting. Refer to it to tell if the physical change in lighting you plan on making will have other possibly undesirable effects on the lighting quality.

## Altering Lighting Quality

| QUALITY CHANGE DESIRED | PHYSICAL CHANGE IN LIGHTING |
|---|---|
| *Shadow shape and position* | The shape and position of shadows depends on the relative positions of the light source and the subject and the three-dimensional form of the subject and the environment. The representation of the shadows in the photograph also depends on the point of view of the camera. See pages 454–57 for lighting positions. |
| *Shadow edge*<br>  A harder edge | Hard-edged shadows result from specular light. Increase specularity:<br>  a. Use a light source of smaller physical size.<br>  b. Increase the subject-to-light-source distance.<br>  c. Focus the light by reflectors or lenses so that its rays are parallel when they reach the subject. |
|   A softer edge | Soft-edged shadows result from diffuse light. Increase the apparent size of the light source to reduce specularity:<br>  a. Place translucent material between the light source and the subject.<br>  b. Diffuse the light by reflecting it off a matte surface (bounce the lighting).<br>  c. Reduce the subject-to-light-source distance (if the light source is nearly a point source this may not have much effect on specularity, but with large-area sources the difference will be marked). |
| *Lighting Contrast*<br>  Increased contrast | 1. Increase the illumination in the diffused highlight area:<br>  a. Increase the intensity of the light source.<br>  b. Decrease the subject-to-light-source distance.<br>  c. Add supplementary lights illuminating the diffused highlight.<br>2. Decrease the amount of illumination in the shadows to darken them:<br>  a. Reduce the amount of environmental light by lowering the ambience (use black flats, etc., around the subject).<br>  b. Reduce the amount of environmental light by controlling the amount of light scattered into the environment by the main light source (use barn doors or black flats or material around the light).<br>  c. Reduce the intensity of any supplementary lights illuminating the shadows. |
|   Decreased contrast | 1. Decrease the illumination of the diffused highlight<br>  a. Decrease the intensity of the light source.<br>  b. Increase the subject-to-light-source distance.<br>  c. Introduce translucent material between the light source and the subject.<br>2. Increase the illumination of the shadow:<br>  a. Raise the ambience (place white flats or materials near the subject).<br>  b. Allow more light to spill into the environment from the main light source.<br>  c. Add supplementary lights illuminating the shadows (fill light).<br>  d. Increase the intensity of any supplementary lights already illuminating the shadows.<br>  e. Decrease the distance of the supplementary fill light from the shadow area. |

*continued on next page*

## Altering Lighting Quality—Continued

| QUALITY CHANGE DESIRED | PHYSICAL CHANGE IN LIGHTING |
|---|---|
| *Specular highlight contrast and size* | |
| Increased diffused-specular contrast and reduced size of specular highlights | a. Reduce the physical size of the light source.<br>b. Increase the subject-to-light-source distance. |
| Reduced diffused-specular contrast and increased size of specular highlights | a. Increase the physical size of the light source.<br>b. Reduce the subject-to-light-source distance.<br>c. Place a translucent screen between the light and the subject.<br>NOTE: The tonal value of a subject also affects diffused-specular contrast. A shiny black object will show more diffused-specular contrast than a shiny white object, since the tone in the diffused highlight area of the black object is darker than that of the white object. |
| *Specular highlight position* | The position of the specular highlights on the surface of the subject depends upon the relative positions of subject, light sources, and camera. Refer to pages 454–57 for some of the effects of lighting positions on specular reflections. |
| *Specular highlight edge sharpness* | The sharpness of the edge of a specular highlight depends on the degree to which the specular reflection is in focus and does not depend directly on the nature of the light source. |
| A sharper edge | a. Stop down the lens aperture to bring the specular reflection into better focus.<br>b. Bring the light source closer to the plane of focus by moving it closer to the subject. |
| A softer edge | a. Open up the lens aperture to throw the specular reflection out of focus.<br>b. Move the light source farther from the subject to get it farther from the plane of focus. |
| *Surface specularity* | The appearance of the specular highlight depends greatly on the ability of the subject's surface to reflect an image; this is called the specular nature of the reflecting surface. Polished, shiny, or mirror surfaces reflect a sharper, brighter, more distinct image, resulting in higher diffused-specular contrast and a harder specular highlight edge. |
| Increased specularity | The specularity of a surface can be increased by polishing, spraying with a transparent glossy finish, or coating with oil or another reflective liquid. |
| Decreased specularity | The specularity of a surface can be reduced by roughening or spraying with a matte spray that produces a dull, less reflective surface, giving lower diffused-specular contrast and softer specular highlight edges. |

## Combined Effects of Physical Changes in Lighting

A physical change in the lighting can affect more than one of the visual evidences of lighting. Refer to this listing to find out all of the changes in quality to expect.

### Size of Light Source

The larger the area of the light source supplying light to the subject, the more diffuse and less specular the light. (Size here does not refer to the strength or power of the light source.)

**1.** *Increasing* the area of the light source gives these results:

    a. Softer shadow edges
    b. Lower diffused-specular contrast
    c. Larger specular reflections
    d. If the increased size of the light source is achieved by diffusing the light with a translucent screen or reflecting surface, a lowering of diffuse highlight illumination and a scattering of more light into the environment may result, both of which will reduce lighting contrast

**2.** *Decreasing* the area of the light source gives these results:

    a. Harder shadow edges
    b. Higher diffused-specular contrast
    c. Smaller specular reflections
    d. If the amount of environmental light is reduced by the change in light size, possibly increased lighting contrast

### Main Light Intensity

The main light is the principal illumination on the diffused highlight. If the intensity of the light source can be changed electrically—for example, by supplying less current to the light—without changing its position or physical nature, then the lighting contrast can be selectively controlled:

**1.** *Increasing* the intensity results in higher lighting contrast.

**2.** *Decreasing* the intensity results in lower lighting contrast.

**NOTE:** The amount the lighting contrast changes with intensity will depend on the ambience, since that will determine how much of the change in illumination reaches the shadows.

### Main-Light-to-Subject Distance

The main-light-to-subject distance directly affects the amount of diffused highlight illumination and the apparent size of the light source.

**1.** *Decreasing* the light-to-subject distance gives these results:

    a. Softer shadow edges
    b. Higher lighting contrast
    c. Harder specular highlight edges
    d. Lower diffused-specular contrast
    e. Larger specular highlights

**2.** *Increasing* the light-to-subject distance gives these results:

    a. Harder shadow edges
    b. Lower lighting contrast
    c. Softer specular highlight edges
    d. Higher diffused-specular contrast
    e. Smaller specular highlights

## ■ Lighting Applications

The lighting applications beginning on the next page outline four uses of controlled lighting: portrait photography, still life photography, illustration photography, and fashion photography. Each application gives some general information about the specialty, some information on lighting for that application, and a step-by-step account of an actual shoot by a working photographer. These are only a few of the areas of photography in which controlled lighting techniques are widely used, but the variety of subject matter, methods, and equipment covered gives information that should be useful in nearly any controlled lighting situation.

# Lighting Application 1: Portrait Photography

Portraits of people are probably the single largest application of controlled lighting. Successful portraits convey a sense of the person who is the subject, and the major tool for that is expression, which includes facial expression and body gesture (the position of the body, hands, and so on). Appropriate posing of the subject helps to achieve the desired body gesture. Posing can be accomplished by using specific directions on how to sit, position hands, turn the head, and the like but is often more successfully achieved by providing an appropriate choice of seating, placing a table or other object nearby on which to rest the arms or legs, and allowing the subject to settle into natural poses. Professional models or actors can assume poses and expressions at will with a natural effect, but most people must be helped along by unintrusive direction and a personal interaction that occurs between the photographer and the subject that will call up the desired expressions. Expressions are fleeting, and the photographer must be sensitive to the subject's mood and anticipate them.

Well-controlled portrait lighting is needed to support and enhance the impression given by expression. The character of the sitter may influence the quality of light used. A person of strong personality and features may look best with a specular light of high contrast, whereas the use of softer, less contrasty light can give an entirely different feel for the subject. Props, surroundings, and clothing also contribute to the impression given of the subject. ∎

Edward Steichen, *George Gershwin*, 1927. The high backlighting emphasizes the strong profile, the cigar and smoke, and the musical score. Front lighting gives detail in the face and jacket and highlights the hair. The specular light provides a theatrical feeling appropriate for Gershwin's personality and occupation.

© Edward Steichen, Courtesy of the International Museum of Photography at George Eastman House. Reprinted by permission of Joanna T. Steichen.

Paul Strand, *Young Boy, Gondeville, Charente, France, 1951*. The natural diffuse lighting provides a luminous open effect, which emphasizes the sculptural quality of the face and intensifies the direct, almost confrontational expression of the young man.

© 1971 Aperture Foundation, Inc., Paul Strand Archive.

**Portrait with One Light Source.** Left: The sitting began with a high 45° specular light, giving shadows that are dramatically dark with hard edges. Right: A different look was tried, with a diffuse light supplied by a softbox in a position slightly above level. This gave softer-edged shadows, but still with considerable lighting contrast. Bottom left: A flexible fill reflector was added to the right of the camera to bounce some of the main light into the shadows and reduce lighting contrast, giving a softer feel to the portrait.

© Jill Bochicchio

**Photographer:** Jill Bochicchio
**Studio:** Bochicchio Photography
**Camera:** Bronica ETRS 645
**Lens:** 150mm
**Lighting:** Venca flash, large softbox, reflector
**Film:** Kodak Portra VC
**Camera Settings:** f/8 at 1/125 second

# Lighting Application 2: Still Life Photography

The still life has been a popular subject since the beginnings of photography, both for art and for commerce. The challenge in lighting a still life is to show the form, volume, and surface nature of the objects in a convincing way, at the same time using the quality of light and the arrangement of the objects to convey the concept behind the photograph. Many still life subjects are a mixture of objects with greatly different surfaces and shapes. Trying to light these diverse objects in one photograph can present interesting problems.

The nature of the surface will affect the choice of quality of light. Mirror surfaces, such as polished silver, will show reflected images of any surrounding objects, requiring a totally controlled environment. A **light tent,** which surrounds the subject with translucent materials, is one solution to the problems of mirror reflections.

Shiny and glossy surfaces present some of the same problems, since they will reflect clear, distinct images of light sources and vague images of surrounding objects. If specular sources are used to illuminate a subject with this type of surface, the result is small, high-intensity specular reflections. Photographers often use diffused sources to produce larger, less intense specular highlights. The trend for many years has

been to light still life subjects with diffuse light, but styles change, and specular lighting is becoming more popular.

Matte surfaces are relatively easy to light, since they do not produce any extreme reflections or surface images. Nevertheless, they can reflect light in the form of glare, so care must be taken with the relative angles of lights, subject surface, and camera to avoid or make use of glare.

The texture in a surface can be emphasized by cross lighting or deemphasized by lighting directly into the surface. The impression of texture is increased with a more specular light source. Rough and broken surfaces respond in a similar way to crosslighting. ■

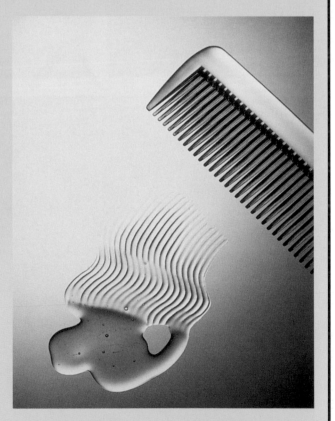

Roger Turqueti. Backlighting the transparent materials makes them glow, and the refractive quality of the viscous liquid adds sparkling highlights.

© Roger Turqueti.

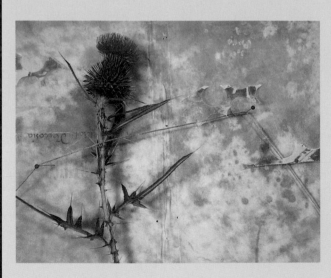

Olivia Parker, *Thistle.* The diffused lighting brings out the gentle colors and gives a subtle sense of depth to the subject.

© 1982 Olivia Parker.

**A.**

**B.**

**C.**

**D.**

**Still Life with Multiple Flash. A.** A medium softbox acts as main light (1 in the drawing). A blue-filtered spotlight (4) accents the foreground tablecloth. A small gobo (8) blocks the blue light from the orange on the left. **B.** Black strips over the softbox modulate the specular highlight in the bowl. A spotlight (5) accents the oranges and leaves and filters through the blue bowl onto the tablecloth behind. A gobo (7) blocks the main light from the background and the back of the table. **C.** Two blue-filtered lights (2 and 3) illuminate the background, and a third (6) accents the front of the tablecloth. The main light has been turned off here to show the effects of the accent and background lights. **D.** The final result. A lens shade on the camera (9) prevents flare. **Photographer:** John Burwell. **Stylist:** Claudia Burwell. **Camera:** Mamiya RZ67. **Lens:** 127mm. **Lights:** Speedotron. **Film:** Fujichrome. **Camera settings:** f/22 at 1/60 second.

Photos © John Burwell.

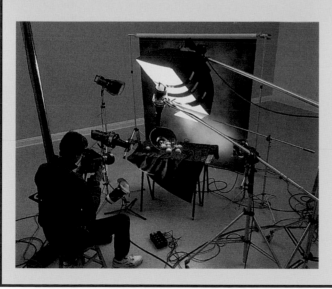

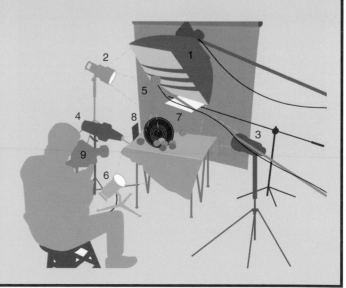

## Lighting Application 3: Illustration Photography

Illustration photographs are used to convey to a viewer a specific idea or concept. One frequent use of illustration photography is for advertising a product or service, or to win the public over to a way of thought. In all cases, the messages conveyed by the photograph must provoke the right response in the viewer, which usually means careful control over subject matter, sets, props, and lighting. As a result, illustration photography is a painstakingly planned process and may involve not only the photographer but the services of art directors, models, set and prop stylists, hair stylists, makeup artists, and assistants. The client is usually heavily involved in both planning and shooting the photograph.

When illustration photographs include people, the techniques are similar to those for portrait photography, with the difference that the models are acting out a scenario for the purposes of the illustration. Lighting can range from simple to complex. Natural light, natural light with supplementary artificial lights (most often electronic flash), and completely controlled studio situations with artificial light (again normally electronic flash) are all employed. Since some kind of story is usually being told, lighting is used to emphasize or suppress different parts of the subject to promote the visual narrative. Lighting also plays a major role in establishing the mood in the photograph. ∎

Jack Reznicki, *Mr. and Mrs. Claus.* Lighting control, set construction, propping, and the perfect models combine with Jack Reznicki's great sense of humor to produce a completely fabricated illustration of a sterling fantasy moment. Lighting for a slightly lower exposure on Mr. Claus and the background emphasizes Mrs. Claus and her gift.

© 1987 Jack Reznicki.

Stephen Wilkes, *Woman in a Yellow Taxi.* Part of a continuing ad campaign featuring a sophisticated woman-about-town, this photograph gives the feel of a spontaneous moment, glimpsed in passing. More careful inspection shows that everything is carefully controlled: the lighting, which highlights the important details, the styling of clothing and accessories, and the point of view.

© Stephen Wilkes.

**A.**

**B.**

**C.**

**D.**

Photos © 1992 Philips Electronics.

**Illustration with Multiple Flash.** From top left: **A.** A yellow-filtered light (1) through a simulated french door acts as the main light. It is supplemented by a yellow-filtered softbox (not shown). A Morris Mini-light slave strobe (10) lights the lamp. The TV cabinet (6) is gutted and equipped with an enlarged transparency backlit by a softbox. **B.** Three large softboxes (2, 3, and 4) and a light (5) bounced from a flat, all with yellow-orange filters, provide general fill light. The main light has been turned off to show the effect of the fill lights. **C.** Three lights accent the wall hangings. The main and fill lights have been turned off to show the accent lighting. **D.** The final result. This photograph was shot for a Magnavox brochure. The set was completely fabricated in the studio. Lighting included five softboxes, eleven flash heads, and nine power packs, totalling 21,600 watt seconds.

**Philips Consumer Electronics Company Staff:** Walter C. Kirk III (Senior Photographer), Scott Denison (Creative Director), Joey Heath (Art Director), Bill Collins (Assistant Photographer). **Modeling agency:** 18 Karat. **Make-up:** Charlene Saucier. **Camera:** 8 × 10 Horseman. **Lens:** 300mm Schneider. **Flash:** Pro Photo. **Camera settings:** f/32 at 1/60 second.

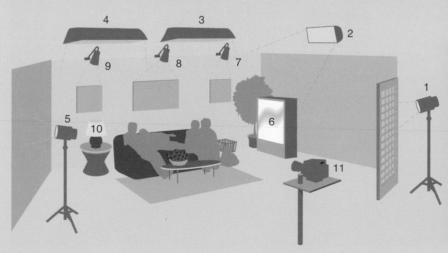

# Lighting Application 4: Fashion Photography

Fashion is a specialty in illustration photography. Since fashion is being sold, more attention is often paid to the clothing, showing the characteristics of the outfit clearly or alternatively providing a feeling of its style. Sometimes the clothing may not be clearly shown at all, since the emphasis is on the style or cachet the clothing is supposed to give the wearer.

As with other types of illustration photography, lighting in fashion involves a wide range of techniques. The specularity of the light, the lighting contrast, the direction—all the qualities defined earlier in this text—are used to convey the mood or style required. A complex set may call for complicated lighting setups, but some of the most effective fashion has been done with natural or relatively simple studio lighting.

Many other concerns also must be addressed in fashion photography. The clothing, models, sets or lo-cations, props, and accessories must all be carefully controlled for the desired effect. Good fashion models must not only have the required physical appearance but must be able to pose and act as well. A full-fledged fashion shoot can be a complicated affair, with many people on the set—models, stylists, art directors or other ad agency representatives, client representatives, assistants, and so on—and a fashion photographer must be capable of controlling this situation with all of these people involved.

When learning fashion photography, you will probably not have all of these resources, so you may be acting as your own art director and stylist. Models, makeup artists, and stylists who are at the same learning or career stage will often be willing to work with you for the experience and may provide valuable future contacts for your growing career. ■

Helmut Newton, "Heart Attack," Fashion Photograph. The feeling of institutional lighting has been retained in this startling depiction of high fashion in a crisis situation.

© Helmut Newton/Maconochie Photography.

**A.**

**B.**

**C.**

**D.**

**Photographer:** Murray Bognovitz
**Camera:** Hasselblad 500 C/M
**Lens:** Hasselblad Sonnar 150mm
**Film:** Fujichrome
**Flash:** Profoto
**Camera Settings:** C.S. f/16 at 1/125 second

© Murray Bognovitz.

**Fashion with Combined Daylight and Flash.** From top:
**A.** A test shot was made to see the effect of daylight alone. The sun was coming from behind the model resulting in high back lighting. A reflective meter reading was made of the background, which was M.R. f/16 at 1/125 second. The camera was set at C.S. f/16 at 1/125 second to produce correct exposure for the background.
**B.** A 30 × 40-inch softbox with electronic flash was set up to the model's left to add light to her face and clothing. In this photograph, the power of the flash was adjusted until an incident meter reading (combined flash and continuous light) at the model's face yielded I.M.R. f/11 at 1/125. The camera settings were left at C.S. f/16 at 1/125 second, giving one stop less than normal exposure on the model's face. Alternatively, the photographer could have used a camera setting of C.S. f/11 at 1/125 second, which would have given normal exposure on the face and a lighter background.
**C.** Here the power of the flash was adjusted to yield an incident meter reading at the face of I.M.R. f/22 at 1/125 second. The camera settings remained at C.S. f/16 at 1/125 second, giving one stop more than normal exposure on the model's face. A camera setting of C.S. f/22 at 1/125 would have given normal exposure for the model and a darker background. **D.** Polaroids were made to evaluate the effect of the lighting, and the decision was made to balance the lighting on the model with the background. In this final example, the power of the flash was adjusted to yield an incident meter reading at the face of I.M.R. f/16 at 1/125 second, and the camera setting was C.S. f/16 at 1/125 second.

# ■ READING LIST

Bidner, Jenni. *The Lighting Cookbook*. New York: Amphoto, 1997.

Freeman, Michael. *The Photographer's Studio Manual*, Rev. ed. New York: Amphoto, 1991.

Hunter, Fil, and Paul Fuqua. *Light Science & Magic*. Boston: Focal Press, 1997.

Krist, Bob. *Secrets of Lighting on Location*. New York: Amphoto, 1996.

Reznicki, Jack. *Illustration Photography*. New York: Amphoto, 1987.

———. *Studio & Commercial Photography*. Kodak Pro Working Series. Sterling Publications, 1999.

Schwarz, Ted, and Brian Stoppee. *The Photographer's Guide to Using Light*. New York: Watson-Guptil Publishers, 1986.

Zuckerman, Jim. *Techniques of Natural Light Photography*. Cincinnati: Writers Digest Books, 1996.

# Presentation of Photographs

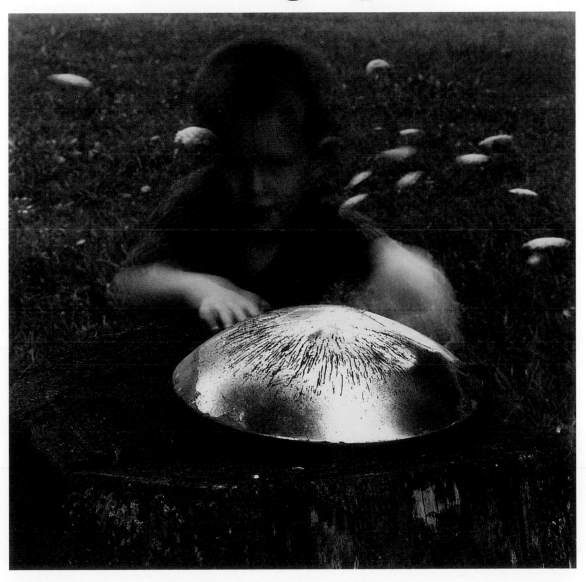

Ralph Eugene Meatyard, *Boy with Hubcap.*

© Ralph Eugene Meatyard, Courtesy of Christopher Meatyard.

Most photographers, having spent the effort and time needed to produce quality photographs, would like to show them to others. Many methods and styles of presenting photographs make them accessible to the viewer. Although some presentation techniques may be elaborate and become part of the experience of the image itself, the minimum requirement for presentation is that it be clean, neat, and free of distractions.

## ■ Print Finishing

## Toning for Intensification and Permanence

Toning black-and-white prints for changes in image color is discussed in chapter 11, page 330. For more on black-and-white print permanence see appendix F.

■ **HEALTH NOTE** Use gloves or tongs and adequate ventilation when working with toners.

*Selenium Toning Black-and-White Prints for Intensification and Permanence.* The list at right gives a trial method for selenium toning, starting with dry prints. The amount of toning depends on toner strength, time, temperature, type of printing paper, and type of print processing, so use this procedure only as a starting point. Print several identical prints, saving one as a comparison standard. Tone the remainder of the prints for various times, then compare under a good light once they are dry to choose the best toning time.

Prints can also be toned as part of the initial processing steps before they have been dried. Recommendations vary, but try toning in the washing aid-toning solution directly after the final fixer. After toning, complete your normal archival washing sequence (steps 3–5 in the table). Again, you will have to experiment to determine times.

Some print toners can be used for a slight intensifying, or darkening, of the blacks and longer print life. Selenium toner in a very dilute form works well for this purpose. Image color will change slightly with most print materials, usually toward a cooler color initially. Extended toning will begin to bring out the warm colors normally associated with selenium. Gold toner can also be used for print protection and longer print life, but it is expensive and the resulting bluish black image tones may not be to your taste.

### Dilute Selenium Toning Method for Dry Prints

1. **Water Soak.** Soak in room temperature water for 20–30 minutes.
2. **Toning Bath.** Mix 2 1/2 ounces of rapid selenium toner to one quart working solution of washing aid (Kodak Hypo-Clearing Agent, Perma Wash, Orbit bath, etc.). Try toning times of 1 to 10 minutes at 70°F with constant agitation. With dilute selenium toner, the working life of 1 quart of solution is about eight to ten 8 × 10 prints.
3. **Running Water Rinse.** If you are using an archival processing system, follow the manufacturer's directions or your own tested washing method. Otherwise follow procedures developed by the guidelines in appendix F for this and the remaining steps. In any case, this wash should be 5 minutes or more.
4. **Washing Aid.** Use a fresh bath of washing aid for the recommended time, with agitation.
5. **Final Wash.** Use a good flow of water in an efficient print washer. Use times based on manufacturer's directions or your own tests for archival results.

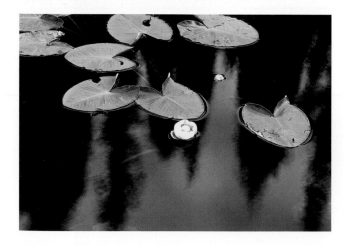

*Untoned Print.*

Photos © Bognovitz.

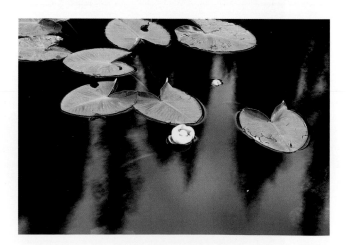

*Selenium Toned Print.* The differences in print quality are subtle, with a slight deepening of the blacks and a shift toward a cooler (bluer) image.

## Correcting Print Flaws

No matter how careful the darkroom technique, some flaws are usually found in prints. Dust, lint, and dirt on the film may leave white marks in a print from a negative and black marks in a print from a positive. Scratches on the film may show up as black or white in the print. These problems should be corrected before presentation, since their presence distracts the viewer into an awareness of the technical process and surface of the print, reducing the illusionistic possibilities of the photograph and indicating a lack of care on the part of the photographer. The correction of print flaws involves spotting, bleaching, and retouching. All are time-consuming hand-done processes, so it is best to avoid as many flaws as possible by careful handling in film processing and printing.

**Spotting**    Techniques for black-and-white spotting are covered in chapter 6 (pages 151–53). Spotting color prints requires a kit containing a range of colored dyes compatible with the print material. These can be mixed to match the area surrounding the spot. If you have a good eye for color and a steady hand, spotting of small areas in color prints is probably well within your capabilities.

**Bleaching**    Lightening undesirably dark areas in a print—such as black spots or scratches—is more difficult than spotting but can be done by bleaching. Spotoff is a commercially available bleach for black-and-white prints.

   Bleaching of color prints is somewhat trickier, because of the presence of three different layers of emulsion. Remember also that color prints contain dyes rather than silver, so appropriate bleaches must be used. Most photographers leave this technique to professional retouching artists.

**Retouching**    In some cases even more radical alterations may be desired, such as the removal of unwanted reflections, wrinkles, or other marks and blemishes or the addition of missing information to an image. Correcting flaws and altering a photograph for aesthetic reasons is called **retouching.** Since retouching is an expensive, time-consuming process, it is best to avoid it if at all possible by making sure that problems are taken care of through careful composing and lighting when shooting and controlled techniques during film processing and printing.

   Traditionally retouching has been done by hand using bleaches, dyes, etching tools, and special pencils. The techniques are difficult and take a great deal of training and practice to master. Digital retouching techniques open up new possibilities in the retouching of photographs. An image can be digitized and then manipulated. Colors can be easily changed, details removed or rearranged, and parts of different photographs combined into one. Digital film recorders can also produce a negative or positive containing the retouched image. Computer retouching reduces the painstaking handwork associated with traditional retouching techniques, but it still requires training, skill, and the use of computer hardware and software.

*Bleaching Black-and-White Prints.* Do not use the same brush for spotting and bleaching. Fix and wash the print after bleaching. It is difficult to control the bleaching action precisely, so it is usually necessary to spot the bleached area with a spotting dye once the print is dry. Larger areas of a print can be lightened by using the bleach in dilute form and applying it with a cotton swab or cotton ball. More detailed directions are given for bleaching black-and-white prints in chapter 11, page 331.

© Bognovitz.

See the next page and page 269 for examples of computer-retouched images.

*Professional Retouching.* At right top is an unretouched portrait. The original was a medium format 2 1/4 × 2 1/4 negative. A high-resolution scan was made from the negative and the resulting digital file was retouched in Photoshop. Prints incorporating the retouching were output on a digital enlarger on standard color negative print materials. As you can see by the retouched version at bottom right, wrinkles and shadows under the eyes were softened, skin texture was smoothed throughout the face, the lips were smoothed, and the teeth were whitened. This is considered moderate retouching, which is standard for personal portraiture work. The current price for the scan and retouching is about $50, which is comparable to the cost for hand-done retouching of a number of years ago, but with the advantage that once the retouched digital file is created, print output is inexpensive and all prints are exactly the same, unlike the traditional method of retouching prints directly by hand. In fashion photography and advertising, digital retouching can be far more extensive and, of course, the price increases. However, the cost of digital retouching is generally a fraction of the former cost of extensive traditional retouching in which dyes were applied by hand.

© Bognovitz.

## ■ Print Presentation

Presentation of a print usually involves mounting on a stiff material or insertion into a holder of some sort so that the print remains flat for easy viewing. Protection of the print is usually a concern as well, with some sort of barrier to prevent fingerprints, scratches, and other damage. Often the print is surrounded with high-quality cardboard—called mat board—or other materials to isolate it and set it off from the surroundings. Styles of presentation vary with culture, social taste, use, and the style of the photographer. New presentation materials—adhesives, laminates, print supports—are constantly being developed, and these technical advances also affect the possible styles of presentation.

## Mounting Methods

Mounting a print on a stiff support requires the use of some sort of adhesive. Several different types are available.

**Dry-Mounting**  Although dry-mounting strictly means any mounting technique that does not use a liquid adhesive, most often it refers to mounting techniques that use a press with a heated platen. Paper-based silver prints can be easily and permanently mounted this way, as can resin-coated papers in black and white and color. The original dry-mounting material—still in use and represented by Seal MT-5—is a resin-impregnated sheet that is placed between the print and the supporting surface. Upon heating, the resin melts, adhering to both the print and the support. The expense of the dry-mount press deters many from this method of mounting. A household iron can be used, but it is extremely difficult to get correct, even temperature and pressure over the whole surface of the print.

The method for dry-mounting fiber-base and resin-coated print materials is given on pages 154–156

A print mounted with MT-5 or similar resin-type materials is permanently attached to the support and can only be removed with great difficulty and at the danger of damaging the print. Plastic mounting materials that are available can also be used in a heated press and allow removal of the print from the board by reheating.

Because computer printer materials and techniques change so rapidly, it is best to contact the manufacturer for suggestions on how to mount digitally printed photographs.

**Cold-Mounting**  The development of adhesives that do not set and will adhere on contact makes it possible to mount prints without heat. Some print materials, such as glossy Ilfochromes, do not react well to standard dry-mounting techniques, so cold-mounting is a good alternative for them. Early cold-mounting adhesives were not always very long lasting and could cause damage to the print, but a number of newer mounting adhesives are said to be permanent and harmless to the print. Cold-mounting adhesives are available in three forms:

*Spray adhesives.*  Require some care to insure even application and complete adhesion.

*Transfer adhesives.*  Come on a carrier sheet to which the print is applied. When the print is lifted, the adhesive comes up with it and the print can be attached to the support.

*Two-sided adhesive sheets.*  Paper or plastic carrier sheets with adhesive on both sides.

■ **HEALTH NOTE**  Use a spraying booth and respirator mask when applying spray adhesives. Some of these adhesives contain substances that are health risks (see pages 92–93.

Some cold-mounting adhesives are positionable, which means that actual adhesion does not occur until pressure is applied by roller or squeegee. This allows easy positioning of the print on the support. Other adhesives adhere on contact, and these are a little more difficult to work with, since once you lay them on the support they are attached. Some professional cold-mount materials that are available require the application of high pressure with steel rollers. These materials provide an excellent long-lasting bond, but the equipment needed is expensive and the materials are typically available only in large quantities.

■ **CAUTION** Rubber cement has on occasion been used for mounting prints but is not recommended because of the temporary nature of the bond and possible chemical damage to the print.

*Cold-mounting with Two-sided Adhesive Sheets.* A. The adhesive sheet will have a protective paper on each side. Peel back about 2 inches of the cover paper on one side and crease.

B. Make sure the back of the print is free of dust and dirt. Carefully lay the print onto the exposed adhesive and press into place.

C. Reach under the print and grasp the cover paper, pulling it out from under the print. Smooth the print onto the adhesive as you pull the protective sheet to prevent air bubbles. After the print has been adhered to the sheet, it may be trimmed to size.

D. Peel back the remaining cover paper on the back of the print. Again peel back only 2 inches and crease as in step A.

E. Place the corners of the print with adhesive exposed on the mat board. Most two-sided adhesive sheets will adhere on contact, so make sure the print is in the proper position before letting the adhesive touch the mat board. Making two light dots with a pencil for the corner positions will help. Reach under the print and pull the cover sheet out as you did in step C, smoothing the print onto the mat board as you pull.

F. Once the print is entirely adhered to the board, place a protective piece of paper over the face of the print and apply pressure by rolling with a rubber roller—also called a brayer—available in art supply stores.

**Wet-Mounting** Adhesives in liquid form are sometimes used for mounting photographs, especially mural-sized prints. A number of different glues are used, among them mixtures of white glue and wallpaper paste. In general wet-mounting does not provide as much protection for the print as other methods, since the water-absorbing nature of the adhesive tends to attract damaging pollutants from the atmosphere.

**Hinge-Mounting** Many museums prefer to hinge-mount prints and photographs, since only a minute amount of adhesive needs to be placed on the print itself, with less possible damage to the print and the ability to change supports easily if necessary. One problem with hinge-mounting photographs is that silver-gelatin emulsions tend to buckle and curl with humidity changes, so the surface of a print will not remain flat when supported only by hinges. Traditionally hinge-mounting has been done with rice paper hinges and rice glue, but several modern alternatives are available, including self-adhesive hinges. Hinge-mounting may be the best alternative when you are unsure how the print material (for example, digitally produced photographs) will react to other mounting methods. Hinge-mounted prints are normally overmatted (see the next page).

*Hinge-mounted Print.* For each hinge, one piece of tape is adhered to the back of the print with a tab sticking up. A second piece of tape is adhered across the tab to the mat board.

## Presentation Styles

**Surface-Mounting** Surface-mounted prints have been mounted directly on the surface of a supporting material and then displayed. If the support is larger than the photograph, the result is a border of the support material around the print. This can provide extra protection for the print and visually separate the print from its environment. If the support is a mat board made of high-quality paper, the result of surface-mounting a print in this way can produce an attractive presentation.

An alternative to leaving a border is to trim the support to the same size as the image in the print, which is called **bleed-mounting** or **flush-mounting,** a presentation style that can be effective when the print is shown in a more controlled environment.

One problem with surface-mounting is that the print is slightly higher than its support and is subject to surface damage. Additionally the edges of flush-mounted prints are subject to fingerprints and chipping.

*Surface-mounted Prints.* On the left is a print that has been trimmed and dry-mounted on the surface of a mat board, with protective borders of mat board left around the edges. On the right is a flush- or bleed- mounted print. The print was dry-mounted to a mat board, and then mat board and print were trimmed right down to the image.

© Bognovitz.

**Overmatting** Extra protection can be given to a mounted print with an **overmat**—also known as a window mat—which is a second mat board, larger than the print, in which a window the size of the print or somewhat larger is cut. Often the blade of the cutter is tilted to produce a beveled cut for the window. The finished window mat can be attached to the support on which the print is mounted by hinging or attached permanently with adhesives.

The advantages of an overmat include the protection provided by the border plus the recessing of the print so that it is less exposed to surface scratches. Overmatting is an excellent technique for protecting prints that are to be stacked in boxes, as each print does not come in contact with the board above it, and should also be used whenever a photograph is to be placed under glass or acrylic plastics, to prevent surface damage to the photograph (see the next page).

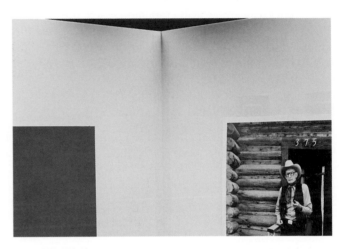

*Hinged Overmat.* On the left, the hinged overmat is shown closed over the print as it would be for display. On the right, the overmat has been opened to show its construction. The print in this case was hinge-mounted to the back mat board. Prints can also be dry-mounted or cold-mounted to the back board. A window of proper size was then cut in a second mat board, which was then attached to the back board with an archival tape hinge.

© Bognovitz.

**Counter-mounting** Dry-mounting a print back-to-back with an unexposed but processed sheet of the same type of photographic printing paper is called **counter-mounting.** Mounting the print in this way prevents curling with humidity changes and provides a lightweight, flat method of presentation. Printing the image with wide white borders will provide some protection of the image itself. Modern versions of the old photo corners formerly used in photo albums are now available, and with them a counter-mounted print can be conveniently attached to a supporting mat board.

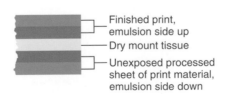

Finished print, emulsion side up
Dry mount tissue
Unexposed processed sheet of print material, emulsion side down

*Counter-mounted Print.*

Photo © Bognovitz.

**Lamination**  The development of crystal-clear adhesives and plastics has made it possible to laminate a print between layers of transparent materials. Laminating a print gives a stiff, flat sandwich that can easily be handled or even punched with holes to be placed in binders. It also provides a protective surface that is far less subject to damage than the delicate print itself, although the laminates can be scratched by careless handling. A layer of felt can be laminated to the back of the print to provide protection for prints stacked below it. High-quality lamination requires somewhat difficult techniques and costly materials but provides good protection for prints that must be handled a great deal.

**Framing**  A print that is mounted and matted can also be framed with a choice from a wide variety of wood or metal moldings. Modern metal frames are easy to assemble with simple tools and are reasonable in price. Wooden frames are more difficult to assemble and are most easily done with some specialized tools. Many cities have do-it-yourself frame shops, which will give you access to the necessary tools and materials.

For maximum protection a print should be framed under glass, but the glass does present reflection problems in viewing the print. Unfortunately the "nonglare" framing glass is not a good option, since it has a matte surface that kills the tonal range of a print, especially the blacks. Modern acrylic plastics, such as Plexiglas, offer the advantages of lighter weight and resistance to breaking—making them excellent for framed prints that are to be shipped but are more expensive and susceptible to scratching. Prints left in contact with glass or Plexiglas may adhere or develop shiny spots, but they may be overmatted to prevent contact. For easier viewing, prints can be framed without glass, recognizing that less protection is offered.

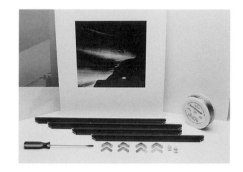

*Framing with a Metal Frame.* A. Assemble the matted print, frame standards, hardware, backing board, glass, and picture-hanging wire. The only tool needed is a straight-bladed screwdriver. Frames standards and hardware are available separately or as kits. The glass can be purchased at most hardware stores or in a glass shop. Single-strength window glass will work, or you can buy special framing glass or plastic at frame shops.

© Bognovitz.

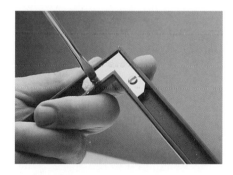

B. Assemble two corners of the frame, using three of the frame standards. The corner brackets have a backing plate. Slide the bracket and backing plate into the end of the standard and tighten the screw.

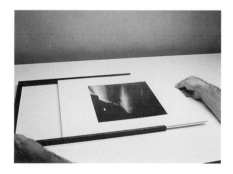

C. Clean the glass and the matted print, then make a stack of the backing board, matted print, and glass, and slide it into the open side of the frame. In this case the backing board is a piece of 1/8-inch foamcore board. Mat board can also be used as backing board, but then spring clips may be needed to hold the boards against the glass.

D. This close-up shows the assembly after it is in the frame. To complete the frame, slide the wire-mounting brackets into the open frame standards and tighten. Attach the final frame standard with its corner brackets and run wire between the wire-mounting brackets, twisting it securely in place.

## ■ Print Display

Your desire to display your print may extend no further than mounting, matting, and framing it for hanging on your living room wall. On the other hand, you may want more public exposure of your work and seek galleries or other display areas intended for showing art. Working photographers may wish to display their prints to promote their business. Although the style of presentation may vary to suit the purpose and the individual, the principles guiding a successful display of prints are much the same in all cases. Prints can also be displayed to individuals in the form of a portfolio or book, discussed in detail beginning on page 492.

### Display Area

The choices made in image selection, presentation style, size, and number of photographs are always limited by the physical space in which the prints are to be exhibited. The first step is to find the space for exhibiting your work. Display places can vary from a small showcase to large rooms with empty walls. The walls of your own home are a good place to start.

Public exhibition areas are more available than you might think. Many businesses and government organizations are willing and even eager to offer their blank walls to photographers for display of quality work that is nicely presented. Look for such spaces in libraries, banks, restaurants, churches, schools, and the lobbies of big businesses. Many art galleries are also interested in displaying photographs, but if a gallery is in the business of selling art your work must demonstrate some potential for selling to its clientele. Photographers often join together in cooperatives to rent or buy a gallery space, providing exhibition space for the members.

Arts-and-crafts fairs are another possible place to display. These are normally commercial ventures offering booths for rent to the artists. Photographic trade shows often offer exhibition space, usually for a price. Many museums show photographs. They usually have a particular agenda for selecting work based on the function of the particular museum, which often excludes artists who are new to the public. Some museums will show the work of new photographers, and if a museum is prestigious enough—as is the Museum of Modern Art—instant reputations can be made by exhibiting on their walls.

### Selection and Arrangement

Once an exhibition space has been found, measure it carefully and note the possible locations for hanging prints. The size of your finished photographs will limit the number of prints that can be displayed. If you are printing specifically for this space, the size of the prints can be tailored to the space. Some idea of arrangement of the photographs must be formed, since that will also affect the number and size of images to be shown. Styles of hanging a photographic show vary from a simple lining up of similar-sized photographs on a wall with sufficient space between them to prevent a crowded appearance—a typical modern museum and gallery approach—to a varied placement of prints of differing sizes in a highly designed arrangement.

Presentation style will depend on the purpose of the show as well. Professional photographers trying to promote their work will choose presentation styles consistent with current professional practices and ones that will be most likely to catch the eye of prospective clients. Once the overall design of the ex-

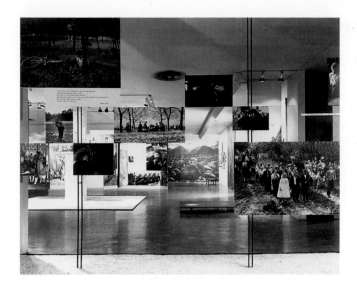

*Styles of Hanging Prints in a Gallery.* Left: Ezra Stoller's photograph shows the entrance to the style-setting exhibit, "The Family of Man," which was displayed at the Museum of Modern Art in 1955. Right: This is a clean, simple style of presenting framed prints.

Left: Ezra Stoller © ESTO. Right: Gallery photographs © Merle Tabor Stern.

hibition is roughed out, the number, size, and presentation style of the prints can be decided. The final decisions on placement of prints in the display space can only be made when the show is actually hung, but planning ahead will guarantee a more effective display.

The arrangement of the images depends on the nature of the exhibition. Some groups of photographs are sequential in nature and must be hung in order. If the show is simply a collection of individual images, more freedom can be exercised in the arrangement. An exhibition can be collectively thought of as an artwork, with the prints treated as individual design elements. Many of the principles of design can then be applied to the arrangement of the prints.

Standing back from the display will provide a view of the overall design of the show: Do the shapes and tones of the prints combine into an effective visual statement? Is some feeling of balance for the display as a whole achieved with the size and overall darkness or lightness of the prints? Does the content of the images show a comfortable progression when moving from print to print? Does the graphic design, tonality, or color of each print lead gracefully into the adjacent prints or complement them, or do uncomfortable visual clashes occur between the prints? Thinking of the show as an overall design can enhance the initial response to the exhibit and also show each individual image to its best advantage.

## Display Lighting

Display areas designed for exhibiting artwork may have special track lighting, which is easily adjustable and provides excellent lighting for each wall area. On the other hand, many of the display spaces mentioned earlier may have inadequate and uncontrollable lighting. If the lighting level varies throughout the display area (even well-lit spaces will show some variations) this may affect decisions on print placement. A print with dark tonalities may look wonderful in adequate light but lose its impact entirely in a dark corner. It is possible to print differently for various levels of viewing light, but if the prints are to be displayed in more than one space this is an inefficient way to solve the problem. An incident-light meter can be used to compare the level of viewing light in the display area to known levels of light.

## ■ Transparency Presentation

Transparency materials create special problems in presentation, since they must be viewed by transmitted light. One method is to backlight the transparency by placing a diffuse, even light source, such as a light table, behind it. This may be an adequate solution for fixed display places and is commonly used in businesses and trade shows, with images enlarged onto sheets of color material on a translucent backing. When lit from behind, these positives have a brilliance independent of the viewing light, although they will look relatively more brilliant in low light.

Small-format transparencies have the additional problem of their small size, which can be solved by making enlarged duplicates on color duplicating film. Large-format or enlarged duplicate transparencies can be placed in acetate sleeves for protection. The sleeves may in addition be attached to the back of window mats cut to fit the images. These window mats are usually black, since the saturated color and image brilliance of a transparency is accentuated when juxtaposed with black.

Transparencies can also be viewed by projection, a common method with 35mm slides. Although this is an effective presentation, it does require the use of a projector, a screen, and a darkened room. Use of multiple slide projectors and related control equipment, such as dissolve units, allows sophisticated sequencing of transparencies. Such multi-image shows, when combined with a sound track, are among the most effective high-quality presentations available today. These productions can be seen in many visitor centers and are often used at trade shows and business conferences.

## ■ Portfolios

A portfolio is a group of photographs, usually presented in a protective container suitable for carrying or easy storage. This form of presentation may be chosen because a photographer intends to carry the photographs to an inter-

*Black-matted Enlarged Color Transparency on a Light Table.*

© Bognovitz.

*Portfolio of Prints.* Steve Szabo's portfolio "The Eastern Shore" is a collection of his photographs of the Eastern Shore area of the Chesapeake Bay. The prints were individually matted, then placed in a luxurious slip-cover portfolio case. The portfolio was issued in a limited edition of 25 portfolios and 10 artist's proofs.

Portfolio © Steve Szabo.

view with a prospective client, art director, or gallery director. Portfolios are also assembled as a way of presenting a group of photographs with a common theme or unifying idea or for showing a particular selection of a given photographer's work. This type of portfolio serves some of the same functions as a book of photographs might, allowing a grouping of certain images, with the difference that the prints are usually original photographs and are individually mounted and unbound. Portfolios are often issued in a limited edition of copies.

The personal portfolio—often called the "book"—of a working photographer, whether in the fine art or applied area of photography, introduces the viewer to the work of the photographer, usually with the intent of promoting the photographer's sales or career. The working portfolio is often designed so that photographs may easily be added or deleted to tailor the presentation to the need at hand.

## Portfolio Cases

Spending the time and money to make sure that your portfolio case is of a quality and style to match the images you have to show will start the viewer out with a positive impression. The portfolio case should be designed so that the photographs are easy for the viewer to remove. Numerous styles of cases are available from retail sources, such as art supply stores.

A.

B.

*Portfolio Cases and Shipping Cases.* Some of these cases are luxurious, using expensive materials and construction. Others are intended as shipping cases rather than presentation containers and are built of sturdy, practical materials. If a portfolio must be shipped, this type of portfolio case might be appropriate, but the interior of the case can still be designed for the best presentation. A. Binders with Acetate Sleeves: Zippered Briefcase Style and Self-standing Presentation Style. B. Clamshell Boxes. C. Archival Museum Storage Boxes and Fiberboard Shipping Case. D. Luxury Nylon and Leather Case and Binder with Slipcover Case.

C.

D.

## Portfolio Selection and Arrangement

Once the use of the portfolio has been determined, the selection and arrangement of images can begin. The method of presenting the portfolio will influence the arrangement. Individual prints on mount boards stacked in a box are seen sequentially, one at a time from top to bottom. The viewer carries over impressions from the previous image, so some thought should be given to the relationship of succeeding images and whether the transition is smooth. As in a novel, where a writer tries to seize your attention from the first sentence, the portfolio should start off with a strong, accessible image geared to attract the type of viewer to whom you are showing your work.

The book-style portfolio, with prints in sleeves clipped into a binding, presents the possibility of facing images. A large portfolio case of this type will even allow grouping two or more images on a page or doing a two-page layout of smaller images, so more latitude for design decisions exists than in the simple one-print-to-a-board approach. If you wish to isolate an image in a book-style portfolio, the facing page can be left blank. Except for this purposeful use, empty sleeves should be removed from the portfolio. Leaving them shows a lack of attention to detail that is sure to be noticed by the viewer as he or she flips through empty pages looking for images.

The portfolio should show thought and control over detail from beginning to end. Many professionals, from gallery director to art director in an ad agency, notice details and are put off by lack of attention to a clean presentation. Do not leave unnecessary papers and miscellaneous objects in the pockets of the portfolio case. Display your name on the inside of the portfolio case, but in a neat and professional manner consistent with the style and purpose of the portfolio. Remove unsightly tags from the portfolio case. Make sure that acetate sleeves are free of scratches—in a well-used portfolio these will have to be replaced occasionally—and that mat and mount boards are clean and not dog-eared.

Think about the viewer's comfort and ease of looking at the book. If you mix horizontals and verticals, forcing the viewer to turn the portfolio many times, or if you mount facing images upside down from each other, it becomes awkward and time-consuming to look through the book. A busy professional will resent this, even if subconsciously. One solution is to choose a portfolio size large enough that both horizontals and verticals will fit in the pages. Another is to think about the grouping of horizontals and verticals so that turning of the book is minimized.

*Placement of Horizontals and Verticals in a Binder-style Portfolio.* In the arrangement on the left, the viewer must turn the portfolio 90° to view each photograph on the two-page spread. Arranging the book so that both photographs on the two-page spread are vertical makes for much more comfortable viewing. Alternatively, two horizontals could be displayed on one two-page spread, but make sure they are both oriented the same way.

Portfolio photos © Merle Tabor Stern.

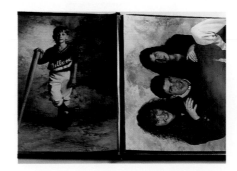 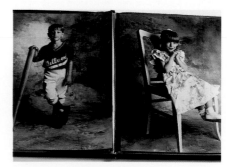

The portfolio is an important promotional tool in any working photographer's professional life, whether the intent is to show in a gallery or to obtain assignment work. With the large number of highly qualified photographers after the same things you are, every little edge helps. An overelaborate presentation of a portfolio may put off some viewers, but a clean, professional, thoughtfully designed and laid out portfolio can only leave a good impression.

*Art Photography Portfolio.* Murray Bognovitz, "Warrnambool—An Outsider's Inside Portrait." A selection of images from the portfolio is shown. As can be seen in the photograph of the museum curator looking at the portfolio, it is a series of matted prints presented in a clamshell-style case.

© Murray Bognovitz.

## Portfolio Selection and Arrangement—Continued

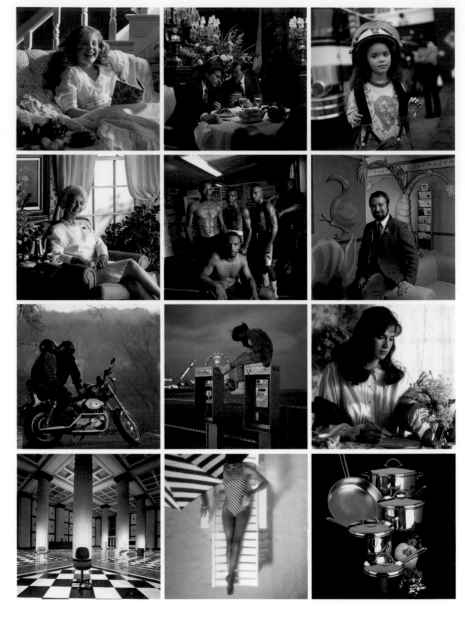

*Commercial Photography Portfolio.* A selection of photographs from the portfolio of Gary Landsman is shown. His portfolio is used as a marketing tool to procure photography assignments. An art director reviews the portfolio on a light table, since it is in the form of enlarged transparencies mounted in black mats.

Portfolio © Gary D. Landsman.

## ■ Making Transparencies from Prints

Portfolios that are shipped to be reviewed, especially by galleries and museums, often consist of 35mm slides, even when the originals are in print form. Transparencies can be made of original prints with either natural or studio lighting. If the original prints are black and white, using color transparency materials may produce a color cast in the finished slide. Corrective filtering on the camera can solve this problem, or use a black-and-white film with a direct-positive processing kit for a more neutral image color.

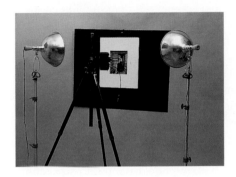

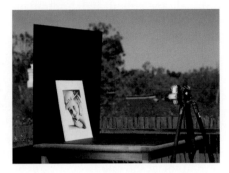

*Making Slides from Prints.* A. In a studio situation, attach the print to be copied to a black background and place two studio lights on each side, level with the print and 45° from the wall. Place the camera on a tripod, level with the center of the print.

B. When using natural light, orient the print so that the sun strikes it at a 45° angle, then adjust the camera so that its back is parallel to the print. Check through the viewfinder for reflections or glare on the surface of the print.

C. If you are making color slides, choose a film that matches the color balance of the light source. For daylight or electronic flash, use a daylight balance slide film. For tungsten studio lights, buy a tungsten balance film. For direct-positive black-and-white slides with any light source, use T-Max 100 and process with Kodak's direct-positive processing kit.

D. Meter with an incident-light meter placed at the surface of the print to be copied. Alternatively, place an 18 percent gray card at the surface of the print and meter with a reflected-light meter.

E. The finished slides can be viewed individually on a light table, or in groups placed in commercially available black mats or in transparent slide sheets. They can also be projected with a slide projector.

## ■ Photomechanical Presentation of Photographs

Photographers like to see their photographs in print. Even if the publication is a small one, knowing that the image is reaching a wider viewing audience than before is satisfying. Besides, publication lends an image an importance in most minds that it would otherwise not have had. This impression can serve you well in the promotion of your photography. If you have photographs published, be sure to get copies of the publications and neatly cut the reproduced image from them. Published examples of your work are called **tear sheets** and are excellent additions to your portfolio.

The downside of published photographs is that too often the quality of the reproduction is poor. Newspaper reproduction is a classic example. Your carefully photographed and printed image may come out looking like a flat, smudgy mess. If the reproduction is poor, it may not be advisable to include it in your book. If you do not have enough tear sheets of good reproduction quality and you think the poor-quality one is a good image, include it anyway, but match it with an original print so that the viewer can see that, yes, you were published and that the poor quality of the reproduction is not your fault.

Photographers often need to have their work photomechanically reproduced. Promotional flyers with high-quality printing can be produced in large quantities for far less money than actual photographs. Also, printing the work allows for the addition of type and other design elements as well as the possibility of including several images in one flyer or card. Some photographers have poster-size reproductions printed for promotional uses or for direct sales in poster shops.

Fine art photographers showing in galleries often send out show announcements with photomechanically reproduced images. An even larger project is the production of a book of photographs, which may be self-published or done through a contract with a publisher. The work of many professional photographers reaches the public eye only through printed reproductions. Photojournalists, magazine photographers, and advertising photographers all depend on the print media for the dissemination of their photographs.

In all of these cases the final quality of the work is subject to a whole chain of people, events, and processes. If your work is done for a client, this process may be entirely out of your hands. Some clients will include you in the process, giving you the opportunity to deal with quality control at some points of the preparation and printing. Any printing that you initiate yourself will of course give you complete input to each step of the printing process, so it is helpful to know something about modern photomechanical reproduction techniques.

## Layout and Design

If you have decided to have your own work printed, whether as a poster, a brochure, or a complete book, the first step is to figure out the design of the printed piece. Will it include type or other graphic elements? If more than one image is involved, how will they be arranged throughout the piece? What are the appropriate types of paper and printing techniques for the piece? Unless you have experience with this type of work, it is a good idea to consult a professional designer and layout artist to help you in this task. Nearly all page layout and design is now done on computers. Photographs are scanned and then sized, corrected, or manipulated using image-editing software. The resulting image files are imported into page layout or drawing programs to place them on the page and add any desired text or graphic design elements. The finished page design is saved as a digital file, which can be delivered directly to the printer.

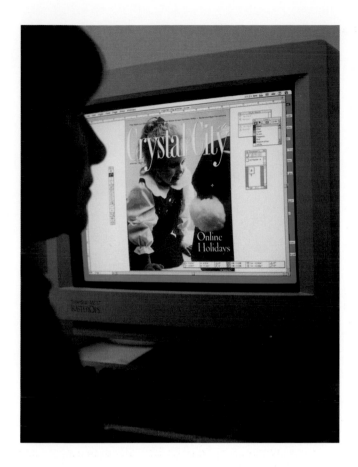

*Digital Page Layout and Finished Piece.* This magazine cover was prepared for printing digitally. The photograph was made on film, which was then scanned to produce a high-resolution digital image file. The digital image was corrected for color, contrast, and sharpness in Photoshop (see chapter 13 for digital imaging techniques). The corrected image file was imported into a page layout program (in this case Quark Xpress®), where the type was overlaid on the photograph. The resulting page layout file was sent in digital form to the printer, where the necessary separations and plates for off-set printing were made from the file.

Photograph © Murray Bognovitz.

Cover design by Tyler Whitmore.

Reproduction courtesy of Crystal City Magazine.

## Photomechanical Processes

Before a photograph can be printed in ink it must be reduced to a half-tone image. The files containing the digitized photographs and page layout information are input into an imagesetter, a device that superimposes the half-tone dot pattern into the images and outputs the pages as film. This film is used to expose the printing plate that is used in the printing press. Some modern presses bypass the film stage, producing the plates directly from the digital file.

The quality of the printed reproduction depends on several factors. The number of dots per inch in the half-tone screen affects the resolution possible in the image. The higher the number, the finer the detail. Newspaper half-tones are 60 to 80 dots per inch, and higher-quality reproductions are 133 to 300 dots per inch. The quality of paper used determines the ability to hold ink and show detail and rich tones. The best papers are heavy coated stock. Newsprint is a cheap, porous grade of paper, which produces poor blacks and loss of detail.

The level of craft on the part of the printer in each step heavily influences the final result. An improperly produced plate can create loss of detail in dark or light tones and inaccurate tonal rendition. Even with a high-quality plate the operation of the press is critical, with control over inking and other press operations affecting the result.

For all of these steps you are dependent upon other artisans. Paying attention to the quality of the printing in publications using photographs will give you standards of comparison for judging the quality of the work a printer is

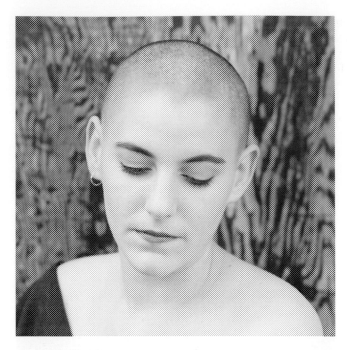

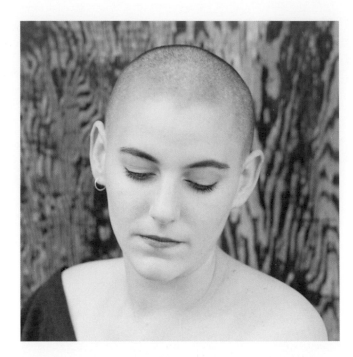

*Effect of Screen Line Number on Reproduction.*
Left: Reproduction Using 65 Dots Per Inch.
Right: Reproduction Using 150 Dots Per Inch.

© Bognovitz.

giving you. However, if you have opted for less expensive materials and techniques, you cannot expect the high quality associated with top-grade printing.

A higher-quality, and more expensive, printing process for reproduction of black-and-white images is duotone. Two half-tone negatives are prepared, one representing all the tones of the photograph, the second exposed to show only the shadow areas. Two printing plates are prepared from these negatives. When printed one on top of the other, the result is a strengthening of the blacks for a very rich reproduction. A slightly different color of ink can be used for the shadow impression, giving a subtle enhancement of the image.

*Duotone Printing.* Left: Reproduction Printed with a Single Half-tone Plate, Black Ink Only.
Right: Reproduction Printed in Duotone, with Two Plates.

© Bognovitz.

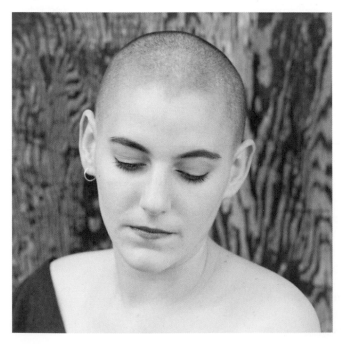

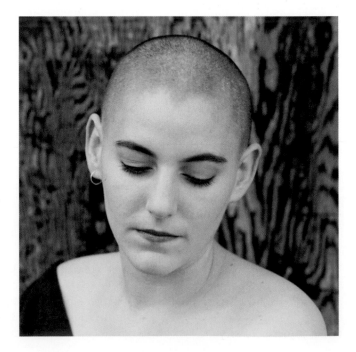

Reproducing color photographs is a much more complicated process. During the conversion to half-tone the color image must also be color separated, which produces three half-tone negatives representing the subtractive primaries. These negatives are used to prepare printing plates, which are inked with their respective color of ink and then printed one on top of the other to produce the correct color image. In four-color printing, a fourth plate is used for black ink, giving more solid blacks in the reproduction. The price of the process is high.

*Color Reproduction.* Left: Three-color Reproduction. Right: Four-color Reproduction. Above: Magnification of Four-color Half-tone Dot Pattern.

© Bognovitz.

You may have to deal with two businesses to have color printing done. Some printers are not set up to produce color separations, so these must be taken to places that specialize in digital prepress operations. Digital service bureaus can provide electronic retouching and image manipulation, and other quality control as well, supplying finished separations for delivery to the printer. They can also provide proofs made from the separations for checking color balance and reproduction quality before the negatives are sent to the printer. This is one of your opportunities to have input into the quality of the finished product, since changes are less expensive to make at this stage. Once the plates have been produced and the print run has started, changes in the separations are expensive and difficult. The printer can also supply proofs from an actual run of the press, but since the adjustments for controlling the quality of the finished result are only those that can be made in inking and other press controls, you must be on the spot when the run is being made, as the presses cannot sit idle while waiting for decisions from you.

## Selection of Printing Services

Quality printing is expensive, though the second thousand copies will cost you a fraction of what the first thousand cost. The reason is that most of the cost in the printing is in the initial setup. Once the presses are set and running, additional copies cost very little. Because of the expense, you should shop carefully

before choosing the printer and separator you use, not for the best price but for the artisans who will give you the best quality for the money. Look at samples of their work. Ask for references from customers. Ask other photographers or people in the business for recommendations of good printers. Be sure that the personnel in the shop seem interested in satisfying your needs and are easy to communicate with.

Printing services are available by mail. Some of these businesses will do the whole thing, including the separations, from your camera-ready copy. Proofs from the separations can be sent by mail for approval. Of course, the use of the mail creates some delay, and you lose some of the involvement in the process that is possible when you are on the spot with a local printer.

## ■ READING LIST

Keefe, Lawrence E., Jr., and Dennis Inch. *The Life of a Photograph: Archival Processing, Matting, Framing, and Storage.* Boston: Focal Press, 1984.

Oberrecht, Kenn. *Home Book of Picture Framing.* Mechanicsburg, Pa.: Stackpole Books, 1998.

Vestal, David. *The Craft of Photography.* New York: Harper & Row, 1975.

# CHAPTER 17

# Photography as a Business

Claude Mougin, Swissair Advertisement, Photographed in Nice, France.

© Claude Mougin, Courtesy of Graf Bertel Dominique Advertising.

Making all or part of your living from photography provides a high level of job satisfaction. Each time that someone puts cash on the line for photographs you have created positively affirms that your abilities are appreciated. Many people begin taking photographs for the dual pleasures of the process itself and showing their photographs to others, but reality begins to creep into the situation when you realize that your income depends on the exchange of money for the use of your images. Making a living at photography can be fun, but a few practical considerations outside of the photography itself can help keep the money coming in.

## ■ Jobs in Photography

### Salaried Positions

In many fields of employment the typical pattern is for a person to get a degree in the chosen field and then, after a job search, settle into a regular salaried position. Although some positions like this exist in photography, most job possibilities are very unlike this nine-to-five pattern. The salaried jobs in photography are usually those of staff photographer for a large business or government institution. The Civil Service register often lists photography jobs, though many may involve more lab work than shooting.

Working as a staff photographer usually requires a wide range of skills, since you may be called on to do anything from executive portraits to handshaking publicity shots—called "grip-and-grin" shots in the business—to product shots for advertising to industrial or scientific work. Staff photographers nearly always do a good bit of lab work as well and may be expected to have some knowledge of other graphic arts. Staff photographer positions exist with magazines, newspapers, and other publications, but these are few and far between. The trend in the publishing business today is to hire free-lance photographers for most assignments.

### Free-Lance Businesses

The counterpart to the staff photographer is the **free-lance photographer.** A free-lance photographer is self-employed and must generate business from a variety of clients. Depending on the type of photography, a free-lancer may or may not maintain a studio. Living as a free-lance photographer provides little security, since your income depends on your ability to keep the jobs coming in. A knowledge of business skills is extremely important. Far more photography businesses collapse from lack of business sense than collapse from lack of photographic talent and ability.

### Studio and Storefront Businesses

A variation on the free-lancer is a photographer who sets up a studio or storefront offering specific photographic services to the public, such as family and personal portraits. This type of photographer is more like any small business offering goods or services to the public and depends upon walk-in business and business procured through advertising and word of mouth.

## Auxiliary Businesses

Photography is a huge industry thanks to the billions of photographs taken by the public every year and offers a wide variety of jobs that do not involve taking photographs. Technical laboratory work, printing, management, retail, and manufacturing of materials and equipment all offer possibilities for employment in the photography industry.

## ■ Markets for Photography

One good thing about photography as a vocation is that its possible applications and markets are varied, covering a wide spectrum of working environments and techniques. If one field of photography does not fit your personality, another probably will. A short review of the possible markets for photography follows. For a more complete listing see a good reference like *Photographer's Market,* which is updated yearly with the latest information on selling photographs.

## Individual Print Sales

Many photographers make their first sale on an individual print basis. Someone sees their work, likes it, and asks to purchase it. It is possible to build a business on direct sales to individuals, but photography is so ubiquitous that the general public will usually not pay prices that will make a good living possible. High-volume sales can overcome the problem of low prices, but the

© Bognovitz.

*Art Photographer.* Chris Honeysett, "Laundry & Dry Cleaning, S.F.," 1989. Chris Honeysett is an award-winning art photographer, working exclusively with a 4 × 5 camera. Based in San Francisco, he participates in more than twenty juried art festivals annually. Along with the art festivals, his book, *Qualities of Light,* and web presence (*www.chrishoneysett.com*) are major venues Chris employs to generate successful print sales.

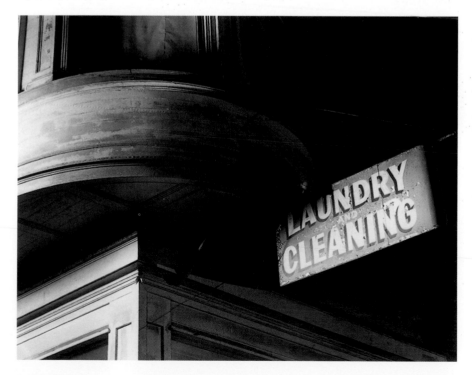

© Chris Honeysett.

markets for individual print sales are not large. This type of print sale is usually thought of as being the province of the fine art photographer, but the trend today is for less separation between art and commerce, and many well-known applied photographers command healthy prices for individual print sales.

Direct advertising out of your studio or home may bring print sales, if you can reach the right group of buyers. Increasing numbers of photographers are setting up Web sites to promote their work. Craft fairs are another possible contact point with buyers. Many of the private businesses mentioned in chapter 15 as possible exhibition spaces will let you place information regarding sales prices and phone numbers with the prints. Private galleries offer prints for sale, taking a commission of from 30 percent to 60 percent. Museums do not deal with direct sales, but a show in a museum is excellent exposure for your work and may lead to some private sales. Although it is difficult to make a living on individual print sales, they can provide an established photographer a nice supplement to other sources of income as well as offering a great deal of psychological satisfaction that her or his work is appreciated.

## Book and Portfolio Publication

Getting a publisher for a book of photographs is a difficult task. Although photography books seem to be everywhere, the market is not strong and the financial rewards to the photographer are far less than some of the prices might suggest. Production of books is an expensive proposition, and publishers look closely at the possible markets for a book before committing themselves. Original print portfolios are usually marketed through the same channels as individual prints, but a portfolio that has been reproduced by photomechanical means in a large production run may find a market in bookstores or by direct advertising.

If you have a book or portfolio you think is worthwhile, you may wish to publish it yourself. Be careful of the so-called vanity presses, which are companies offering to put your book in print. They offer little more service—sometimes actually less service—than you can get by approaching printers, separators, and designers yourself, and the cost of the vanity press will be much higher. If you are going to self-publish a high-quality book of photographs, be prepared for a sizable investment of money—possibly tens of thousands of dollars—and time. Even though many books languish on the shelves or never even reach distribution, careful choice of subject matter and marketing can make a book show a profit and return on your time. Although a publisher offers a ready-made distribution network, publishing yourself may pay more in the long run, since you receive all the profits on wholesale distribution rather than just a royalty. The advertising value of a quality book can be very high, providing future sales or jobs.

© Bognovitz.

*Photographers and Producers of Photographic Books.* Carl and Ann Purcell have produced and made the photographs for numerous popular books on photography and travel.

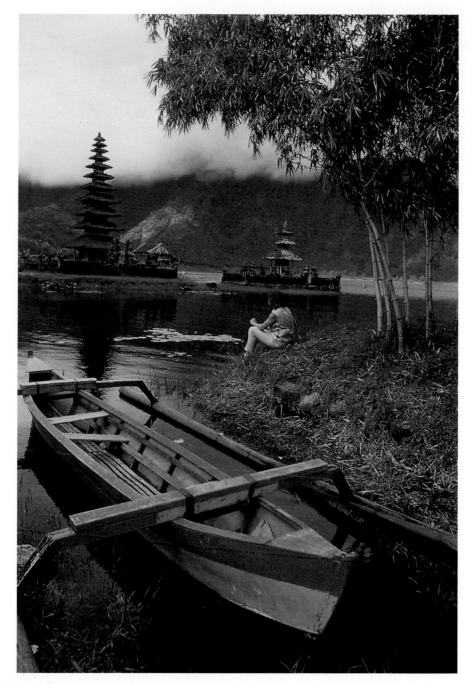

© Carl Purcell.

## Photojournalism

The days of huge permanent staffs of photographers at the big magazines are over, but the field of photojournalism—making photographs of newsworthy events—is alive and well. Newspapers and newsmagazines large and small have staff photographers and use free-lance photographs as well. Large news organizations such as the Associated Press also hire photographers and buy direct. Magazines like *National Geographic* and *Life* have permanent staff photographers but do a lot of contract work with free-lance photographers as well. Black Star and Magnum are two organizations that specialize in photojournalism and market photographs, much as a stock agency would (see page 510). One good way to break into photojournalism is to approach small-town newspapers. They cannot pay much, but they are nearly always looking for good photographs and they provide a wonderful training ground and a chance to get your photographs in print. Although the work can be exciting and rewarding, photojournalists are not generally the highest paid of photographers.

© Bognovitz.

*Photojournalist.* Nancy Andrews is a staff photographer for *The Washington Post* newspaper.

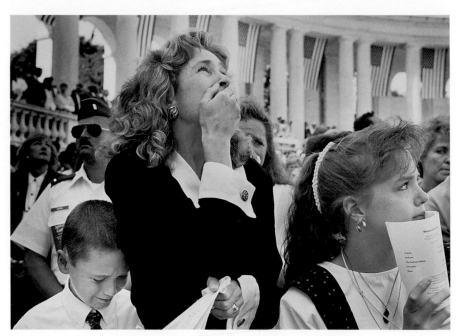

© Nancy Andrews, The Washington Post.

## Social Photography

Photographing weddings, bar mitzvahs and bat mitzvahs, parties, and other social events can provide a good living and is also an excellent way to pick up extra money on weekends. The equipment investment is smaller than in many fields of photography, and you can work out of your home. You must enjoy working with people for this kind of photography.

## Portrait Photography

Although the formal family portrait is not as much of a regular event as it used to be, family and personal portraiture is still a good business. Many people want professional portraits to mark stages in their own or their children's life. It is possible to do location portraiture only, going to your client's home with the necessary equipment, but most portrait photographers work out of a studio, sometimes one in their own home. Equipment investment is moderate, but if a storefront studio is maintained, the overhead can be considerable. Many photographers combine portrait and social photography into one business.

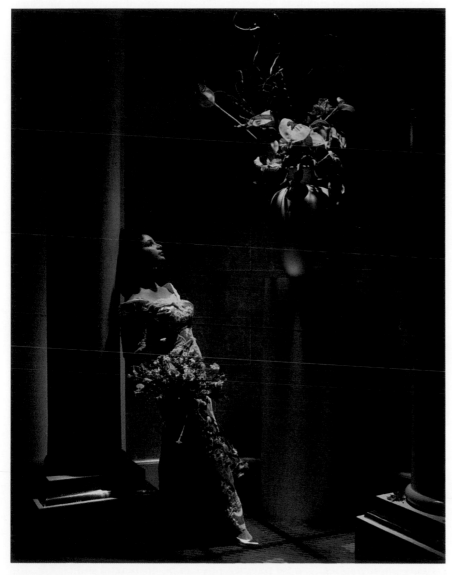

© Bognovitz.

*Wedding and Portrait Photographer.* Jim Johnson runs a successful studio that specializes in portraits and wedding photography.

© Jim Johnson.

## Assignment Photography

Assignment photography simply means performing a specific photographic job at the request of and under the direction of a client. It can cover the complete gamut of applications of photography: photographing an author for a book jacket; doing a product still life for an advertisement; running a glamorous fashion shoot with models, makeup artists, stylists, and numerous assistants; traveling to remote parts of the world to photograph a rare species of animal; shooting architecture; making industrial photographs—the list goes on and on. As long as you are under contract to photograph for a particular client for a particular job, you are on assignment. Although a staff photographer does assignments for his or her employer, usually assignment photography is thought of as the province of the free-lancer. Many free-lance assignment photographers specialize in particular fields or related fields of photography. The financial rewards for assignment shooting are as varied as the types of jobs available. Some jobs are extremely lucrative—usually the ones in advertising pay best—but others may barely pay expenses and a living wage. Assignment photography is a challenging and high-pressure job but seldom boring.

© Bognovitz.

*Assignment Photographer.* Mark Wieland is an assignment photographer specializing in large-format architectural photography for architects, interior designers, and construction companies.

© Mark Wieland.

## Stock Photography

Stock photographs are made by the photographer on speculation and then marketed to potential users, usually through an agency. A stock photography agency holds a large number—sometimes millions—of photographs belonging to many photographers. These photographs can be of specific subjects or situations but are usually generic in that they can be used by different clients in a variety of situations. The photographs belong to the photographer, and the stock agency normally sells only limited rights to use an image, taking a percentage of the sales—usually 50 percent—and passing the remainder to the

photographer. An individual image may sell many times for different purposes and can make thousands of dollars over its lifetime. Most stock collections are color transparencies, but a few agencies keep black and white as well.

Stock sales play an important role in photography today. In the past clients may have hired a photographer on assignment to make a specific photograph, but now they are likely to call an agency to send out a group of images with the general description of what they are looking for, from which they select the image or images they will use. The cost to the client is much lower for stock than for assignment work.

In past years most professionals thought of stock photography as a market for their outtakes (unaccepted images from assignments) or photographs made in their spare time and expected only a small supplement to their assignment income. Today many photographers make all or most of their living from stock sales, and they approach it as a full-time business, analyzing the markets and investing the capital needed to produce images that they hope will fit those markets. A high percentage of published photographs are stock images and include travel, nature, celebrity, and historical photos—to mention only a few—used in newspapers, magazines, advertisements, articles, and books.

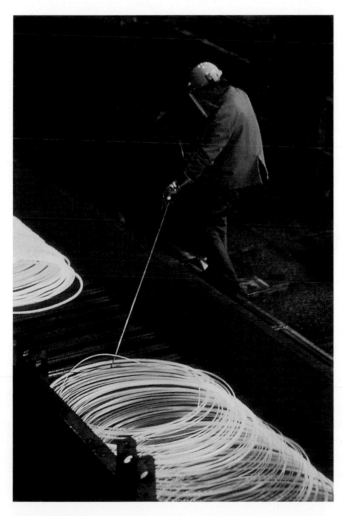

© 1992 Jim Pickerell.

© Bognovitz.

*Stock Photographer.* Jim Pickerell is a well-known stock photographer.

We have just scratched the surface of the great variety of job possibilities in photography, but as you have probably gathered, all of them are heavily competitive and you must like to work hard.

## ■ Planning Process for Making Salable Photographs

When photographs are being produced for profit, planning a photograph in advance can help to insure a more reliable output. Following a structured planning process is usually more productive.

## Defining the Function of the Photograph

Decide why the photograph is being taken. Functions can range from providing self-expression for the photographer's enjoyment to selling a specific product to a specific market. Defining the market can happen on two levels. The first is the sale of the particular photograph being produced. For portrait photographers and art photographers interested in print sales, the market is the purchaser of the photograph. Usually that market is refined even more. A portrait photographer, for example, may seek to attract customers in the higher economic and social classes or alternatively may wish to target the middle-class market. An art photographer may intend to show only in the "best" of uptown galleries or may have in mind promoting the photographs as wall decoration for businesses or individuals.

If the photograph is being produced at the direction of a client for functions that the client defines, then the market for whatever product or service is being promoted by the photograph must be considered. The ad agency or business hiring the photographer is a kind of market as far as the photographer is concerned, but the markets that these clients are trying to reach must also be considered in planning the photograph. Businesses spend considerable time and money in searching out and analyzing markets for their products or services, so they will normally provide specific information to the photographer about the intended market.

## Defining the Concept of the Photograph

*Concept* is a much-used word in all fields of photography. It is simply the central idea that guides technical and aesthetic choices when making a photograph. Concepts may be very simple or very complex. The concept behind a portrait may be simply to produce an attractive, casual rendering of the subject, but usually more is involved. An executive may need an entirely different concept, one involving formality, power, and position. Another executive may wish to show approachability, capability, and so on. All of these words are used to indicate concept.

In advertising, concept is extremely important, since products and services are usually coupled with other ideas to make them more desirable. The concept for an advertisement for toothpaste may be that using the product will make one more attractive to the other sex. An alternative concept might be that use of this toothpaste insures fewer cavities. Concept can involve mood, atmosphere, associations to be made, and style.

## Designing the Photograph

The function and concept for the photograph dictate the design, and this is where many of the control choices take place. Decisions must be made regarding type of film, type and quality of light, choice of subject matter, environment for the subject, models, props, and styling. Sometimes the function of the photograph is so specific that a sketch of the finished work is presented to the photographer in the form of a comprehensive or "comp sheet," often called a layout.

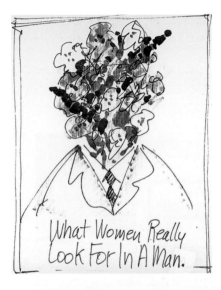

*Comp Sheet and Final Photograph.* This promotional poster started out with an idea or concept of the man as a source of flowers. The caption was written and the rough sketch of the visual seen at left was made. For presentation to the client and as a working tool for the art director and the photographer, the more elaborate and detailed drawing at lower left was made with colored pens. The photographer then worked with the ad agency to choose the props and design the final photograph. Every detail was considered carefully for its impact on the market, from the choice of clothing to the background color to the specific types and arrangement of the flowers.

**Art Director:** Chris Overholser. **Copywriter:** Jeff McElhaney, Liz Fitzgerald. **Photographer:** Michael Pohuski. **Agency:** Earle Palmer Brown, Bethesda, Maryland. **Client:** American Floral Marketing Council.

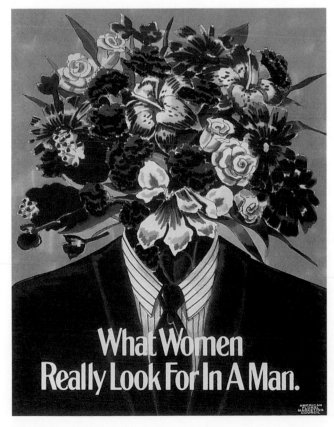

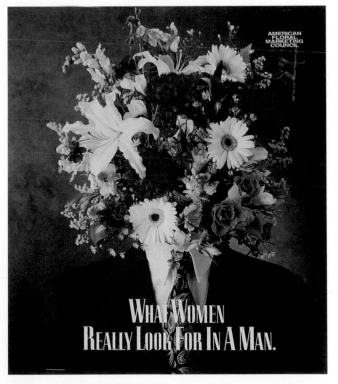

© American Floral Marketing Council.

For example, if the photograph is a product shot of perfume and the concept is one of high romance, a soft, glowing, diffused lighting might be called for. In a photograph of a high-tech piece of equipment where drama and intimations of the cutting edge of technology are to be conveyed, a more specular, hard-edged lighting of higher contrast might be desired.

The concept behind the photograph also affects the use of props and sets in the photograph. The photographic studio provides both a controlled lighting environment and a flexible space where props can be brought in and sets built—much as in the theater—to provide a controlled visual environment as well. The choice and arrangement of props and sets and materials used for their construction is called **styling.** Styling may be done by the photographer, but working photographers often call in free-lance professional stylists with an eye for design and a knowledge of the sources for the needed sets and props.

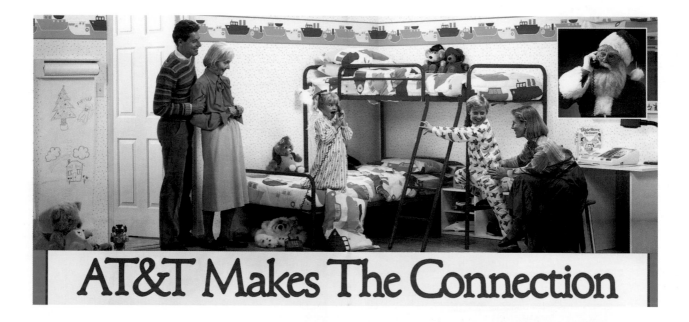

## AT&T Makes The Connection

*Use of Sets and Props in the Studio.* For this advertisement for AT&T, the complete set, down to the last detail, was constructed within a studio, as can be seen in the set shot. Every item in the photograph was carefully thought out and styled.

© Gary D. Landsman.

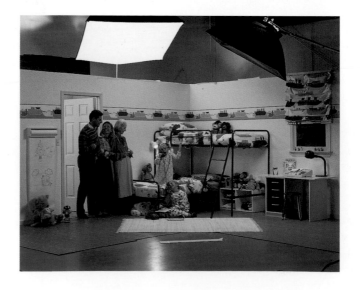

## Implementing the Plan

Naturally, any preplanning is subject to change, but the better the planning is, the more likely it is that the photographer will walk into the actual shooting session properly equipped to produce a usable result. Inspiration is a valuable part of the creative process, but it is useless without the proper tools and materials to realize it.

## ■ Business Aspects of Photography

Any free-lance or self-employed photographer is running a small business. If the business is to succeed, attention must be paid to good business practices. Many sources of information on running a business are available. College courses, information publications from the government, and books at your local library can all help you get started.

## Small-Business Management

**Funding**   The way you set up your business can make a great deal of difference in the chances for success. Failure of many small businesses is due to lack of initial capital, so your first task is to look for funding. The amount of money you need will vary widely depending on the type of photography you are intending to do. Setting up a commercial studio will require a considerably larger investment than setting up a weekend wedding photography business. It is possible to start out part-time while holding another job and build from there, but your business will grow at a much faster rate if you go at it full-time with enough capital to fund proper working space, equipment, and advertising. Remember that you have to eat during these initial months. Many experts say you need enough to keep you going for up to two years besides the money you are putting into the business.

**Incorporation**   If you are setting up a full-time business you will be smart to use the services of an accountant and a good business lawyer who knows incorporation statutes and the effect on taxes and legal liabilities. These will vary from state to state. One reason often given for incorporating is that it may help to isolate the business debts from your personal finances should the business have trouble. In fact, banks loaning to new businesses will require personal guarantees on the loans in any case, so incorporation probably will not be much help there. The amount of taxes may actually be higher for incorporated businesses. An incorporated business is also more difficult to dissolve. For these reasons, most photographers do not incorporate, but check with an expert before deciding.

**Licensing and Zoning**   Many states, counties, or cities require licenses for running a photography business, so be sure to contact each to ascertain any applicable laws. If you plan to run your business out of your home, look into the zoning laws in your area to be sure no legal problems will arise.

**Insurance**   Your personal homeowner's policy may not cover you for loss or liability if you are running a business. Check with your insurance agent to be sure. You should have some kind of business liability insurance and professional all-risk coverage on your equipment and property.

**Hired Help**   If you hire someone to assist you or do secretarial or other work, you may be responsible for withholding income and social security taxes or contributing to a workers' compensation fund. Check to see what your insurance situation is for coverage of damage or injury by an employee, or injuries an employee may sustain while in your employ. Some photographers try to circumvent many of these complications by hiring help as an independent, self-employed contractor for services, but check the laws in your locale.

**Taxes**   Taxes for a business can quickly become complicated, so unless you are running a fairly simple, straightforward business, it is a good idea to consult a tax accountant familiar with photography and the other creative arts. Record keeping is of paramount importance to keep you out of tax trouble and to give you the maximum benefits the law allows—and as a side benefit helps you to track the most profitable parts of your business.

Consulting a tax accountant when you set up your accounting system for your business can save you all kinds of headaches later on. You may be able to get by with as little as an IRS Schedule C, Profit or Loss from Business (Sole Proprietorship), attached to your personal return, but even if your business is a part-time home-based operation, the importance of running it like a business cannot be stressed enough. Have a separate business checking account. Retain receipts and canceled checks. Keep up the entries in your ledgers. The IRS pays especially close attention to part-time photography businesses, since so many hobbyists try to claim deductions as a business. In addition to federal income tax you may have state, county, and city taxes to pay. If you are selling photographs or other merchandise, you must collect sales tax and report it in some states and cities.

**Pricing and Negotiating**   One difficult thing for many photographers is pricing their services. If you are working in a field of photography where the services are reasonably standard, as they are in wedding or portrait photography, it is fairly easy to do a survey of area photographers to see what kind of packages are offered and prices charged. You can then price yourself accordingly, depending on where you think you fit into the market. Assignment photographers, on the other hand, are faced with a situation where nearly every job is unique and must be priced individually. It is difficult to find out how much another photographer would charge for a similar job, so you must figure out an appropriate amount yourself.

Many photographers starting out in business underprice their services. This can be for the purpose of underbidding the competition, but it often comes from a lack of understanding of what goes into making a photograph. Many think only of the film, the processing, and the time it actually takes to shoot the photographs, but what about the investment of time and money in equipment, training, testing, transportation, discussion of the job with the client, telephone service, arrangements with the labs, heat, insurance, maintenance, promotion of your business, bank accounts, services from accountants and lawyers—the actual making of the photograph is only the tip of the iceberg. Photographers who do not consider all the true costs of running a photography business in their pricing work at a loss and not only drive themselves out of business but also undercut more realistic professionals.

Sometimes a client will suggest a price for a job. Never accept without calculating what the job will truly cost you. Probably your figure will be higher than the client's, and that is where negotiation comes in. The public perception of photography as a quick, easy undertaking weighs against you, so ne-

gotiating takes a good deal of diplomacy, a certain amount of education of the client as to what goes into a shoot, and the willingness to compromise and come to a middle ground acceptable to both of you. Never go into a negotiation session without knowing the bottom line where you begin to lose money, and never start your negotiation at that figure. A curious psychology is involved in pricing. If you price your services too low, you may give the impression that you do not think they are worth much and the prospective client may begin to doubt your abilities as well. It is also difficult to raise prices once you have established a "low-price" working basis with a client. Sometimes a higher price carries its own cachet, lending your work a prestige in some eyes.

Setting prices for individual print sales is somewhat different, because this is usually done in advance. Some negotiating may take place at the time of a sale, but many galleries charge whatever price the photographer places on a print. The psychology of pricing applies here perhaps even more, since prestige is one of many reasons patrons buy art. The basic expenses listed earlier apply to art photographers just as much as to any other photographers and should be taken into consideration when pricing. In addition the low volume of most individual print sales must also be taken into account. The value of an artwork is often enhanced by its rarity, which is one of photography's problems in the art collection world, since unlimited prints can be made with most photographic processes. Limiting the number of prints of an image by destroying the negative can sometimes create higher value for art photographs.

## Legal Matters

Some legal matters are specific to photography and need to be considered by anyone selling photographs. The copyright law; releases for use of images of people, animals, and property; and other contracts are all important in the operation of a photographic business.

**Copyright**   The holder of the copyright on an original created work, be it in writing, painting, sculpture, or photography, has control over the reproduction and use of that work in all situations. No one may use or reproduce the work without the express written permission of the copyright holder, who may charge any fees deemed appropriate for that use. The copyright law of 1978 clarified some issues about ownership of copyright, and currently the creator of a work automatically owns the copyright from the moment of creation, whether or not the work is registered with the copyright office. For copyright protection, the work must be marked with a proper copyright notice.

Even if a work of art is sold, the artist still owns the copyright unless he or she specifically gives it up in writing. In photography the complete selling of a copyright, which transfers all rights of usage and reproduction of a particular image to the purchaser, is called a buyout. When you purchase a portrait of yourself from a portrait studio, you own only that specific print. The photographer owns the copyright. You cannot reproduce the photograph, and it must be used for personal applications only.

The owner of a copyright can sell limited rights to reproduction for specific uses or lengths of time. A photographer may, for example, sell one-time publishing rights to a photograph for use in an advertisement in a local paper. If the purchaser of the photograph wishes to later use the same photograph as a

Copyright Notices.

poster, a new negotiation for use must be initiated and further fees paid. This is true even if the photograph was shot on assignment for the client. The original assignment contract between client and photographer should clearly state the rights the client is purchasing. The copyright law is what makes the stock photography business work and is the reason that rights to the same photograph can be sold over and over.

Many businesses feel that they should own the copyright if they commission the photograph, and various means have been employed to acquire the copyright to the work. One ploy is to claim that the client or the client's representative holds the copyright, since she or he "created" the work when telling the photographer what was wanted in the photograph and giving suggestions during the making of the photograph. Also used is the "work-for-hire" section of the copyright law. If a photographer creates an image as an employee—for example, as a staff photographer—the employer owns the copyright. Many businesses try to apply this work-for-hire clause to free-lance work, even though it is clear that the photographer is independently employed.

Sometimes a minicontract is imprinted on the back of the check paying for services, stating that on signing the check the photographer agrees that it was work for hire. Remember that signing anything that uses the phrases *transfers all rights* or *work for hire* means that you are giving up the copyright to your work. Talk to a lawyer before signing any such forms.

It is actually to both client's and photographer's advantage to transfer only the rights that the client needs at the time. The cost of such usage can be less than that of all rights, since the photographer can continue to make money from the photograph in the future. If the client truly needs all rights, then the price should be high enough to cover the photographer's loss of future sales.

If you enter your photographs in contests or competitions, read the fine print in the rules. You may be surprised to find that you often give up your copyright upon entering. Contests of this nature are often only a way of getting cheap photographs for the sponsor.

**Releases**   When identifiable people or belongings—including animals—appear in photographs, the subjects or owners of the property have certain rights as to how the images can be used. The general rule is that if the use of a photograph is for advertising purposes, the subject or owner must sign a release

giving the photographer the right to use the image in that fashion. News photographs, art photographs, and photographs for editorial usage theoretically do not require releases. In fact, both photographers and publishers have been sued and in some cases have lost, even though the photographs fell into these categories. It is best to have a release for any identifiable person or property regardless of the use, just to be on the safe side.

Releases for persons photographed are called model releases, forms for which can be bought in many photography stores. Property releases are similar in wording but specify the property at issue and are signed by the owner. The American Society of Media Photographers (ASMP) also publishes sample model and property releases. Remember that a person under legal age—18 years in many states—must have his or her guardian sign. Refer to the contract laws of the state where the business is transacted. Sales of photographs are greatly enhanced if they are completely released, so it is a good habit to have models sign releases at the time of taking a photograph, even if they are family or best friend. The following model release is based on a release recommended by the American Society of Media Photographers.

## Adult Model Release

I, (model's name) _____ , for good and valuable consideration herein acknowledged as received, do hereby grant _____ , hereinafter called "the Photographer," his/her legal representatives and assigns, those for whom the Photographer is acting, and those acting with his/her authority and permission, the absolute right and permission to copyright and use, re-use and publish, and re-publish photographic portraits or pictures of me or in which I may be included, in whole or in part, or composite or distorted in character or form, without restriction as to changes or alterations, from time to time, in conjunction with my own or a fictitious name, or reproductions thereof in color or otherwise, made through any media at the Photographer's studios or elsewhere for art, advertising, trade, or any other purpose whatsoever, said photographs of me taken on the date(s) _____ . I also consent to the use of any printed matter in conjunction therewith.

I hereby waive any right that I may have to inspect or approve the finished product or products or the advertising copy or printed matter that may be used in connection therewith or the use to which it may be applied.

I hereby release, discharge and agree to save harmless the Photographer, his/her heirs, legal representatives, or assigns, and all persons acting under his/her permission or authority or those for whom he/she is acting, from any liability by virtue of any blurring, distortion, alteration, optical illusion, or use in composite form, whether intentional or otherwise, that may occur or be produced in the taking of said picture or in any subsequent processing thereof, as well as any publication thereof, including without limitation any claims for libel or invasion of privacy.

I hereby warrant that I am of full age and have every right to contract in my own name in the above regard. I state further that I have read the above authorization, release and agreement, prior to its execution, and that I am fully familiar with the contents thereof.

_____     Dated: _____

(Signature)

_____

_____     _____

(Address)     (Witness)

**Other Contracts**   Any time an agreement is made between a client and a photographer, it should be recorded in writing in the form of a contract. Written contracts are helpful in clearing up any questionable details about an agreement and provide a legal reference should something go wrong with a job. For examples of contracts, see the publications listed in the reading list at the end of this chapter.

## Marketing

Marketing covers all of the activities a photographer is involved with to sell photographs. If you expect to make any real money with photography, you must develop some marketing skills, whether you are selling individual art photographs or looking for high-dollar advertising accounts. Sales techniques are part of marketing and should be appropriate to the nature of the work being sold and the client being dealt with.

   The primary sales tool for a photographer is to show her or his photographs. If photographers sell their work or services directly, their personality, behavior, and appearance will also play a role in the client's decision to buy or to contract services. As much as photographers would like to hope that the work will sell itself, the harsh reality is that people buy by their impression of the artist as much as by the art. This is especially true in assignment photography, where the client may need to work closely with the photographer on a long and difficult project. If you come across as a person who will be a pleasure to work with and if your photographs show that you can handle the job, you are more likely to get the job than someone with the same, or perhaps even better, photographic skills with an apparently difficult personality.

**Knowledge of the Market**   It is important that you know the photographic markets—what sells where. With this knowledge you can then make some marketing decisions. You can choose to adapt your work to specific markets. You can choose markets that you think are appropriate for the work you like to do or have been doing on your own. If you cannot see a market for the photography you have been doing, you will either have to create a market for your work, adapt to current markets, or forget selling your work and photograph for your own enjoyment. To find markets look at publications where photographs are reproduced, check out the work of successful photographers in your area, and read professional photography magazines and journals (see the reading list at the end of this chapter). The lucky photographers are those who are doing the kind of work they enjoy and who have found good markets for that work.

Portfolios are discussed in chapter 16, pages 492–496.

**Advertising**   As with any business, advertisement is important. The portfolio interview is a principal way for photographers to get their work seen by prospective clients or others who can help sell the work. Remember that interviewing skills as well as the quality and presentation of the photographs are important here.

   Some interviews are to apply for specific jobs or assignments. Others may just be to introduce someone to you and your work or keep someone in touch with your latest work. In any case always call for an appointment first. When making the appointment, if possible speak to the person who will be doing the interview and ask some questions about what he or she is looking for. You may even ask how many images the interviewer would like to see and perhaps de-

scribe a little of what you are offering or looking for. A brief phone call such as this can save both of you time, since you may discover that you have nothing to offer the other person, or vice versa.

Other general forms of advertising can be used as well. Paid advertisements in publications reaching your markets, mail campaigns with promotional pieces, displays of photographs in places where prospective clients may see them are all tried and effective methods of promoting your work. If your interest is advertising photography, several national and regional trade publications, such as the *Black Book*, reach ad agencies, art directors, and others in the business. Ads in these publications are usually expensive but can pay off for some photographers.

The importance of making and keeping up contacts cannot be overstressed. The current term for this is *networking* and it means establishing a network of business acquaintances who know you and your capabilities and will hire or refer you if an appropriate job surfaces.

**Agents and Representatives**   Many photographers have the talent and photographic skills to make it but lack either the desire or the ability to market their work. Photographer's agents and representatives are professionals who market a photographer's work for a percentage of the sales. Usually in commercial photography the representative is an individual who sets up a business relationship with the photographer, carries the portfolio to possible clients, oversees the photographer's promotional campaigns, and generally attempts to increase the sales of the photographer. In art photography similar representatives exist, but often a gallery acts as an art photographer's agent, fulfilling much the same function, again for a percentage of sales.

A good representative will more than pay her or his own commission in increased sales and higher profits. Since representatives make their living doing this, they want to choose photographers whose work can be sold, so it is necessary to interview with them to see if you can work together. It is difficult for a photographer beginning in the business to find an agent, so most photographers do their own marketing initially, acquiring a representative after they are more established.

# ■ Getting Started

Do not let the preceding discussion discourage you from considering photography as a career. Although it is a competitive field requiring a lot of energy and motivation, the reward of working in a creative environment is compensation for the hard work and generally erratic hours. The nice thing about photography is that you can get into the professional end of it as much or as little as you wish. Some photographers are happy selling a few prints a year through gallery sales or at craft fairs or shooting the occasional wedding or portrait. If you are good at your job, part time may become full time with little promotional effort on your part, especially in a field of photography where personal referrals are important.

*Photography School.* Taking photography classes at a college or institute can be a good way to learn skills and gain experience. Many schools, like Montgomery College, also have excellent labs and equipment.

© Bognovitz.

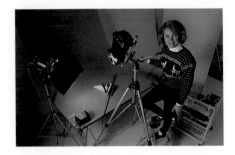

© Bognovitz.

*Graduate of a Photography School.* Rebecca Hammel attended a two-year photography program and now makes her living as an assignment photographer.

## Attending Schools and Workshops

As with many fields photography suffers a little from the syndrome known as "You can't get the job without the experience, but you can't get the experience without the job." A good photography school may offer some experience, provide access to equipment, and give you an opportunity to build a portfolio. Workshops and seminars are also widely available, offering a chance to learn from contact with established photographers.

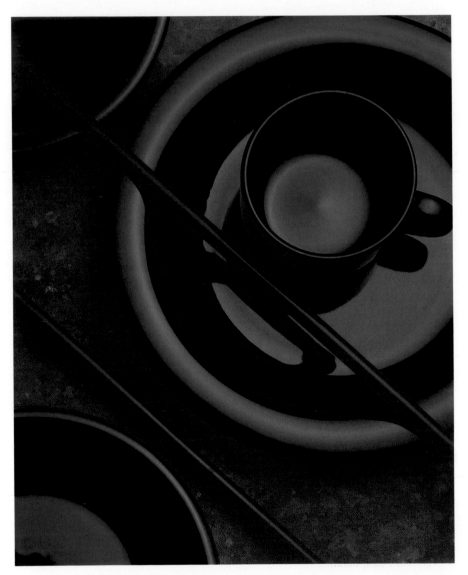

## Assisting Professionals

An excellent way to break the vicious "experience" circle is to work as an assistant for an established photographer. This usually pays little to begin with and can be a lot of rather menial work, but it gives a chance to see how things are done in a successful photography business and can help you build contacts in the business. Once you have improved your skills, in areas with a strong photography market it is possible to make a career of free-lance assisting.

## Joining Professional Associations

A number of professional organizations exist, such as the American Society of Media Photographers (ASMP), the Professional Photographers of America (PP of A), the Advertising Photographers of America (APA), and several others. Some of these require nomination and professional experience to join as a full member, but they usually have some type of student or nonparticipating membership, which will get you into their meetings and make you eligible for publications, newsletters, and other forms of support they provide the working photographer.

*Free-lance Photo Assistant at Work.* Free-lance assisting is hard work, but is an excellent way of learning the business and picking up new photography skills.

© Bognovitz.

## Handling Rejection

It is the nature of any creative field to have work rejected on a regular basis. Because art is subjective you will never be able to please all of the people all of the time. The important thing is to continually strive to improve your work. If your work is rejected, listen to any reasons given. If these are true deficiencies in your work, strive to correct them. If a rejection is on the basis of style, move on to the next contact in search of a market for your style. If no market seems forthcoming—if rejections are the rule rather than the exception—reevaluate your directions. But in any case do not take the rejections personally—unless it is made clear that a rejection is of you and not your work; if this is a recurring problem, some consideration might be given to behavior modification or a new wardrobe. What you are trying to do as a working photographer is to match your work to the market, or vice versa. Persistence in this process can pay off, especially if you remain objective about the setbacks to which every working artist is subjected.

## Deciding Whether or Not to Specialize

Since many possible directions exist in photography, you must make some decisions about which to pursue. Specializing has the advantage of reducing your equipment investment, since you need only the equipment to get your kind of photography done. Equipment is not always the issue. A number of different types of photography can be performed with the same basic camera gear, and the decision to specialize is made out of personal preference for a particular aspect of photography. Some photographers want to take photographs only of landscapes or do only studio product photography or specialize only in fashion. Other photographers enjoy the variety and challenge of attacking new subjects or new techniques.

The downside of specializing is that you are sure to have job possibilities in other specialties, which you will have to turn down. As an established photographer you may be comfortable with this, as the flow of business is enough to

provide full-time work, but new photographers with fewer jobs coming in may not have the luxury of turning down a job just because it is not what they prefer to do. The typical pattern is that early in their career, photographers take any job that pays and that they think they can handle. As their career progresses, they may begin to acquire a reputation in a particular specialty, either because they do a large amount of that type of work or because they are better at it.

## Building a Reputation

As you become better known in the community as a photographer, you establish a reputation, hopefully a good one. A good reputation is a powerful business asset. A number of elements go into building a good reputation, and these should be kept in mind in all of your business contacts at whatever level:

- Ability to get the job done on time and done right
- Ability to communicate well—in other words, knowing when to talk and when to listen
- Reliability
- Timeliness
- Professional behavior and appearance
- Good business ethics, including being honest and living up to your word

All of these are good basic skills or attributes, but you must add the ability to produce high-quality photographs. Exciting images and a distinctive style are the base for a solid photographic reputation.

## ■ READING LIST

Crawford, Tad. *Business and Legal Forms for Photographers*. New York: Amphoto, 1997.

———. *Legal Guide for the Visual Artist*, 4th ed. New York: Watson-Guptil Publications, 1999.

Heron, Michal, and David Mactavish. *Pricing Photography,* Rev. ed. New York: Amphoto, 1997.

Kopelman, Arie, and Tad Crawford. *Selling Your Photography*. New York: St. Martin's Press, 1980.

Willinas, Michael, ed. *Photographer's Market*. Cincinnati: Writer's Digest Books, updated regularly.

### Periodicals and Trade Publications

*American Showcase.*

*Corporate Showcase.*

*Creative Black Book.*

*Photo District News* (Photo District News, 49 E. Twenty-first St., New York, NY 10010). Monthly periodical.

# Appendices

# APPENDIX A

# Testing Your Safelight

Since photographic paper with small amounts of exposure is more sensitive to fogging than unexposed paper, a reliable test of your safelight requires preexposure of the paper. Set up the enlarger as if for printing but without a negative in place. By test strips, determine the printing time and aperture that give the first perceptible shade of gray darker than the pure white of the paper. Working in total darkness, expose a sheet of the paper about 5 × 8 inches to a series of exposures based on this time. For example, if the time needed for the first perceptible tone is 10 seconds, do a series of exposures at 4, 6, 8, 10, 12, 14, and 16 seconds. Increase the exposure along the long dimension of the test paper.

Lay the paper on a table where it will receive light from your safelight approximately as your paper does during normal handling. Cover one-fifth of the paper with a totally opaque black card and turn on the safelight. Expose the paper to the light from the safelight for a series of times based on the amount of time the paper is normally handled, from the time it is taken from the package until it is fixed. You might try exposures to the safelight of 0, 3, 5, 10, and 20 minutes. Progressively cover the paper with the opaque black card to achieve the different times, increasing the times across the short dimension of the paper. Process the paper with the safelight off.

Exposure Grid for Safelight Test.

Enlarger Exposure (seconds) →

| | 4 | 6 | 8 | 10 | 12 | 14 | 16 |
|---|---|---|---|---|---|---|---|
| **Safelight Exposure (minutes)** 0 | | | | | | | |
| 3 | | | | | | | |
| 5 | | | | | | | |
| 10 | | | | | | | |
| 20 | | | | | | | |

Inspect the resultant grid of printing and safelight exposure times to see if it shows a perceptible darkening of the tones with increasing exposure to the safelight. If so, the safelight is fogging the paper. Check for proper safelight bulb wattage and placement in the darkroom. Check to see that the type of safelight filter is correct for the type of paper used. If everything seems in order, check both the safelight and the darkroom for light leaks. If the fogging cannot be traced to any of these problems, try reducing the bulb wattage or moving the safelight farther from the working area.

# APPENDIX B

# Evaluation of Professional Equipment Tests

It is a good idea to have the camera exposure controls and the light meter periodically tested for accuracy by a qualified camera service center. Choose a service center with complete testing equipment. It should be able to determine the actual shutter speed in milliseconds for three points in the travel of a focal-plane shutter. That will not only provide the error in the shutter speed but also indicate any unevenness in shutter travel. The f-stops should also be tested, with results given in amount of error—or occasionally as actual f-stops, called T-stops. For example, if the error in an f-stop is given as −0.2, the f-stop is underexposing by two-tenths of a stop. Cameras with two metering modes, manual and automatic, should be tested in both.

The light meter should also be tested. The accuracy of the meter for at least three different levels of luminance should be determined. If the error at all levels is the same, the system index tests will compensate for that error. If the meter is nonlinear—that is, shows different errors at different levels—it should be repaired or replaced.

The following Camera and Light Meter Test Results form should be filled out by the technician. If you do not specifically ask for such data, the technician will make his or her own judgment of the performance of the equipment on the basis of the tolerance levels set by that shop. Many shops accept errors of as much as plus or minus one-half stop in a shutter speed or aperture. When exposure is critical this may be too much tolerance, especially if one of the shutter speeds is underexposing and another overexposing. In such a case the relative error between the two could be as much as a stop and the technician would still find it within the shop's tolerance levels.

With the data form completed, you can use appendix C to determine actual errors in your equipment and make your own judgments of equipment condition. If you find the level of error unacceptable, discuss with the technician the feasibility and expense of repair. If only one or two f-stops or shutter speeds are a problem, it is often a good idea to simply work around them, rather than attempting repair.

## Camera and Light Meter Test Results

| SHUTTER SPEEDS | ACTUAL VALUES (in Milliseconds) | | |
|---|---|---|---|
| | Opening | Center | Closing |
| 1 | _____ | _____ | _____ |
| 1/2 | _____ | _____ | _____ |
| 1/4 | _____ | _____ | _____ |
| 1/8 | _____ | _____ | _____ |
| 1/15 | _____ | _____ | _____ |
| 1/30 | _____ | _____ | _____ |
| 1/60 | _____ | _____ | _____ |
| 1/125 | _____ | _____ | _____ |
| 1/250 | _____ | _____ | _____ |
| 1/500 | _____ | _____ | _____ |
| 1/1000 | _____ | _____ | _____ |

### F-STOPS–T-STOPS

| Setting | 1.4 | 2 | 2.8 | 4 | 5.6 | 8 | 11 | 16 | 22 | 32 |
|---|---|---|---|---|---|---|---|---|---|---|
| T-stops or errors | ____ | ____ | ____ | ____ | ____ | ____ | ____ | ____ | ____ | ____ |

### METER (HAND-HELD OR MANUAL TTL)

| | | | | |
|---|---|---|---|---|
| EV (ISO 100) | 6 | 9 | 12 | 15 |
| F-stop at 1/125 | — | f/2 | f/5.6 | f/16 |
| Error | _____ | _____ | _____ | _____ |

### COMMENTS

# Fractional F-Stops and Shutter Speeds

**Decimal Equivalents for Shutter Speeds**

| SHUTTER SPEED | EXACT EQUIVALENT (in Seconds) | ERROR IN EXPOSURE (in Stops) FOR SHUTTER SPEED (in Milliseconds) | | | | | | |
|---|---|---|---|---|---|---|---|---|
| | | +2/3 | +1/2 | +1/3 | Exact | −1/3 | −1/2 | −2/3 |
| 1 | 1.000 | 1587 | 1414 | 1260 | 1000 | 794 | 707 | 630 |
| 1/2 | 0.500 | 794 | 707 | 630 | 500 | 397 | 354 | 315 |
| 1/4 | 0.250 | 397 | 354 | 315 | 250 | 198 | 177 | 157 |
| 1/8 | 0.125 | 198 | 177 | 157 | 125 | 99.2 | 88.4 | 78.7 |
| 1/15 | 0.0667 | 106 | 94.3 | 84.0 | 66.7 | 52.9 | 47.2 | 42.0 |
| 1/30 | 0.0333 | 52.9 | 47.2 | 42.0 | 33.3 | 26.5 | 23.5 | 21.0 |
| 1/60 | 0.0167 | 26.5 | 23.5 | 21.0 | 16.7 | 13.2 | 11.8 | 10.5 |
| 1/125 | 0.00800 | 12.7 | 11.3 | 10.1 | 8.00 | 6.35 | 5.66 | 5.04 |
| 1/250 | 0.00400 | 6.35 | 5.66 | 5.04 | 4.00 | 3.17 | 2.83 | 2.52 |
| 1/500 | 0.00200 | 3.17 | 2.83 | 2.52 | 2.00 | 1.59 | 1.41 | 1.26 |
| 1/1000 | 0.00100 | 1.59 | 1.41 | 1.26 | 1.00 | 0.794 | 0.707 | 0.630 |
| 1/2000 | 0.000500 | 0.794 | 0.707 | 0.630 | 0.500 | 0.397 | 0.354 | 0.315 |
| 1/4000 | 0.000250 | 0.397 | 0.354 | 0.315 | 0.250 | 0.198 | 0.177 | 0.157 |

**Error in F-stops for Actual T-stop Value**

| +2/3 | +1/2 | +1/3 | EXACT | −1/3 | −1/2 | −2/3 |
|---|---|---|---|---|---|---|
| 1.1 | 1.2 | 1.3 | 1.4 | 1.6 | 1.7 | 1.8 |
| 1.6 | 1.7 | 1.8 | 2 | 2.2 | 2.4 | 2.5 |
| 2.2 | 2.4 | 2.5 | 2.8 | 3.2 | 3.4 | 3.5 |
| 3.2 | 3.4 | 3.5 | 4 | 4.5 | 4.8 | 5 |
| 4.5 | 4.8 | 5 | 5.6 | 6.3 | 6.7 | 7.1 |
| 6.3 | 6.7 | 7.1 | 8 | 9.0 | 9.5 | 10 |
| 9.0 | 9.5 | 10 | 11 | 12.7 | 13.5 | 14.3 |
| 12.7 | 13.5 | 14.3 | 16 | 18 | 19 | 20 |
| 18 | 19 | 20 | 22 | 25 | 27 | 29 |
| 25 | 27 | 29 | 32 | 36 | 38 | 40 |
| 36 | 38 | 40 | 45 | 51 | 54 | 57 |
| 51 | 54 | 57 | 64 | 72 | 76 | 81 |

**Errors Given as a Multiplying Factor**

| ERROR IN STOPS | FACTOR IN SPEED | FACTOR IN F-STOP |
|---|---|---|
| +1/3 | 1.260 | 0.891 |
| −1/3 | 0.794 | 1.122 |
| +1/2 | 1.414 | 0.841 |
| −1/2 | 0.707 | 1.189 |
| +2/3 | 1.587 | 0.794 |
| −2/3 | 0.630 | 1.260 |

# A P P E N D I X   D

# Characteristic Curve

In about 1880 two amateur photographers, Ferdinand Hurter and Vero Driffield, began an investigation into the relationship of exposure and density for photosensitive materials. They published a paper in 1890 giving the results of their experimentation. One of their innovations was the presentation of exposure and density values in graphic form. The resulting graph or curve is known as the characteristic curve or sometimes the D log E curve or the Hurter-Driffield curve.

The method of plotting the curve is to subject a film to a series of different exposures. The densities resulting from these exposures, using a given development procedure, are then measured. The curve is achieved by plotting the log of the exposure values against their corresponding density values. This curve is unique for a given film, developer, and developing procedure—time, temperature, agitation, and so on. If any of these variables change, a new curve results.

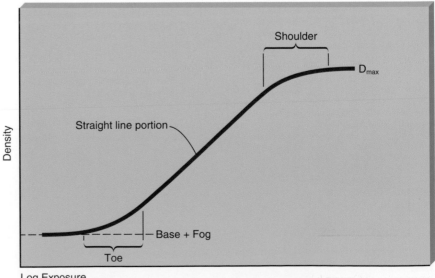

Characteristic Curve for Black-and-White Film.

A great deal of information about the behavior of a film can be gained from this curve. First note that the density never reaches zero, even for zero exposure. This is because of the density of the "transparent" base the emulsion is coated on plus residual fog due to chemical action or other reasons. This starting or minimum density is called base plus fog density and varies depending on film and development. Also, the density never goes above a maximum density value, called $D_{max}$, regardless of increasing exposure.

The curve between base plus fog and $D_{max}$ can be divided into three areas:

**1.** The curved part at the bottom, called the toe. This area usually corresponds to the lowest dark tone densities in a negative.
**2.** The straight part of the curve in the middle called the straight-line portion. Mid tone and light tone values normally fall on this part of the curve.
**3.** The curved part at the top of the curve, called the shoulder. Under normal conditions the shoulder is not used or at most the lower parts of the shoulder are used. Sometimes light tone values will fall in the shoulder because of high-contrast subjects or overexposure.

The characteristic curve also gives an indication of negative contrast, which can be thought of as the change of density for a given change in exposure. In other words, the slope of the curve is an indicator of the contrast. However, the slope of the characteristic curve changes with exposure, varying from zero in the base plus fog region—no change of density for changes in exposure—slowly increasing in the toe, reaching a maximum value in the straight-line portion, and then decreasing again in the shoulder, reaching zero again at $D_{max}$.

Early definitions of overall contrast were made in terms of the slope of the straight-line portion of the curve, called **gamma ($\gamma$).** Today, however, the toe region is commonly used for image information, and since the shape of the toe varies from film to film, $\gamma$ is not always a good indication of contrast. A more recent method of indicating contrast is to find the average slope between two defined points on the curve. This is called **contrast index (C.I.)** and is used by Kodak to give a measure of contrast.

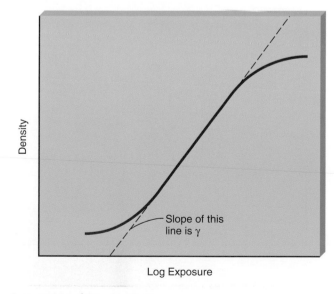

Determination of Gamma ($\gamma$).

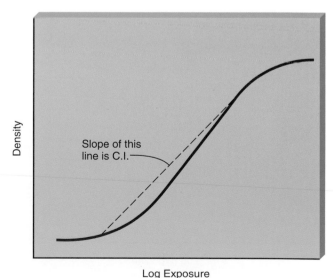

Determination of Contrast Index (C.I.).

Characteristic curves give a convenient picture of the effects of development and exposure. The following characteristic curves demonstrate the changes that take place as film development or overall exposure is changed.

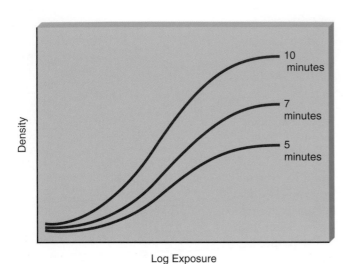

*Effect of Development Changes on Characteristic Curves.* If all variables—film, developer, temperature, and so on—are kept constant except for development time, a series of curves can be achieved, one for each development time. This set of curves shows the changes in contrast and film response for changing development. Contrast increases with increasing development.

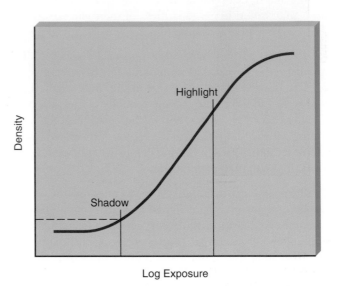

*Optimum Exposure for Small Format.* With optimum exposure, exposure values are placed low so that minimum density is achieved without losing printable dark tone detail.

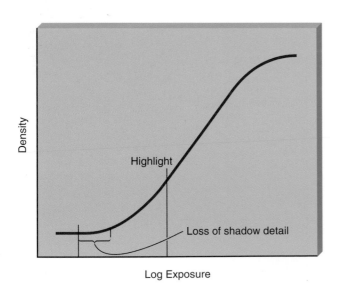

*Underexposure.* With underexposure, exposure values are placed too low to keep dark tone detail.

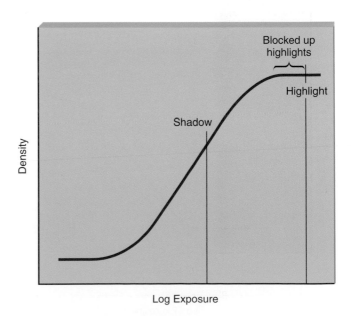

*Overexposure.* With overexposure, exposure values are placed too high, so some light tone values go past the shoulder of the curve, resulting in blocking up of those areas.

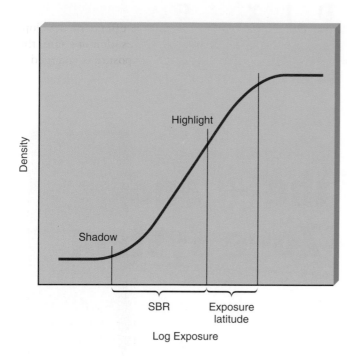

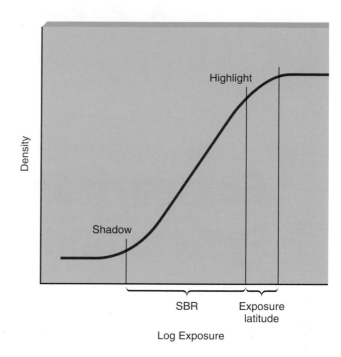

*Exposure Latitude.* Exposure latitude is the amount of exposure that can be given above the optimum exposure without blocking up light tones. The two graphs show that exposure latitude depends upon subject contrast. On the left, exposure latitude is shown for a subject of normal contrast. On the right, the subject contrast is high, resulting in less exposure latitude.

Characteristic curves can also be made for photographic papers. In this case reflective density is plotted against log exposure. Different paper grades will give curves of different slopes.

*Characteristic Curve for Black-and-White Paper.*

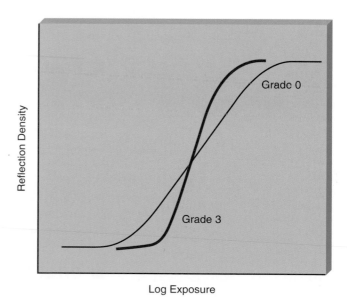

*Effect of Contrast Grade on Paper Characteristic Curves.* Note that even though the contrast has changed—as indicated by the slope of the curve—the maximum and minimum densities remain the same, so both papers have the same possible tonal range. (Graphs are for papers with the same emulsion and surface type.)

# Comparison of the + and − System and the Zone System

See the reading list on page 432.

The system presented in this text is based on the principles of the Zone System, originally devised by Ansel Adams. The differences are mostly in terminology and the symbols used for film exposure and print tones. For an excellent explanation of the Zone System, see Adams's book *The Negative* (1981). Following is a summary of the major differences.

| EXPOSURE ZONE | REV |
|---|---|
| 0 | −5 |
| I | −4 |
| II | −3 |
| III | −2 |
| IV | −1 |
| V | M |
| VI | +1 |
| VII | +2 |
| VIII | +3 |
| IX | +4 |
| X | +5 |

## ■ Film Exposure

Rather than give the film exposures as REVs, Adams used exposure zones. The exposure zones are labeled with Roman numerals. Zone V exposure is produced when the suggested camera settings indicated by the meter are used. This corresponds to REV M. A table of corresponding values can be constructed. This scale may be extended in either direction.

## ■ Print Values

To avoid confusion, the 1981 edition of Adams's book does not use the term *zone* for print tones. Instead it calls them print values. The print value that results from Zone V exposure and normal development is labeled Value V, corresponding to Print Value M (PV M), which is 18 percent gray.

Note that Adams lists Value IX as the last value before white and Value X as maximum white. He also states that small-format users may find that Exposure Zone IX (REV +4) with normal development prints as white. Since this text is designed primarily for small-format users, Value IX is listed as PV W (maximum white).

| ZONE SYSTEM PRINT VALUE | TEXT SYSTEM PRINT VALUE |
|---|---|
| 0 | B (maximum black) |
| I | −4 |
| II | −3 |
| III | −2 |
| IV | −1 |
| V | M |
| VI | +1 |
| VII | +2 |
| VIII | +3 |
| IX | W (maximum white) |

## ■ Other Terms

Most other terms are the same in both systems. The terms *placement* and *fall* are used in the same way. The descriptions for subject contrast and development are compatible: normal, N+1, N−1, and so on. Adams uses the term *contraction* instead of *compaction*. Some Zone System texts use normal plus (N+) for N+1, N− for N−1, and so on.

## ■ Testing Techniques

Over the years a number of testing techniques for calibrating the individual system for Zone System use have been devised. Many of them, especially *The New Zone System Manual*, by White, Zakia, and Lorenz, employ methods similar to those in this text. The major testing change in this text is in the method of determining a standard printing time for printing test patches. Most Zone System books use the minimum printing time needed to print a maximum black through the base plus fog of the film. This text uses the time necessary to match the tone of the REV M patch to 18 percent gray. Each approach has advantages. Distinguishing the subtle separations in black necessary to determine the shortest printing time to achieve a maximum black is difficult, especially for those new to such concepts. The 18 percent gray card provides an easily matched standard. The shortcoming of the 18 percent gray match is that it does not provide a fixed standard printing time. The reason is that the REV M negative density varies with both exposure and development. If the first trial development time is wrong and a new film development time is tried, then a different printing time will result.

See the reading list on page 432.

Some films with characteristic curves radically different from the "classic" curve may present problems with the 18 percent gray match method. The reason is that the testing attempts to achieve proper tone for three points on the curve: middle gray, a highlight, and a shadow. Not all curves can be made to fit this pattern. In such cases one of the tones must be sacrificed. For example, the choice may be to let the REV M exposure print darker or lighter than 18 percent gray to achieve the desired shadows and highlights. The maximum black method of determining print exposure does not solve this dilemma but can make it easier to deal with, as only one tone—for example, the highlight—is looked at to determine development and other tones fall wherever they may. With more experience at judging tones, the photographer may choose to use the maximum black method for some situations.

# APPENDIX F

# Archival Processing and Storage

The permanence of photographic print materials depends on a number of factors, including materials selection and processing techniques. The term used to describe print materials intended for maximum storage life is **archival.**

In the past only fiber-base black-and-white photographic papers have been recommended for archival purposes. However, recent research seems to indicate that the difference in longevity between fiber-base and resin-coated papers is not as great as previously thought. Pending more thorough research, fiber-base black-and-white papers are still the recommended choice. Printing with a wide white border, of at least 1 inch, around the image provides extra protection.

## ■ Processing

The fixing and washing steps affect print life the most, but care should be taken in all steps.

### Developing

Use any developer designed for use with fiber-base papers. Make sure the developer is fresh and used within the recommended development times.

### Stop Bath

Use an acid stop bath, according to directions. The use of a fresh stop bath extends fixer working life.

### Fixer

Fixing is necessary for print permanence, since it removes the unused, light-sensitive silver salts from a print. However, any residual fixer left in the print after washing will shorten the life of the print. The traditional method for archival fixing of prints is to use two separate fixing baths, with half the normal fixing time in each bath. The first bath does most of the fixing, and the

second bath stays relatively fresh, insuring complete fixing of the print. This method has been challenged in the past few years. The complaint is that although it produces well-fixed prints, the residual hypo is difficult to wash out because of the relatively long immersion in the fixer.

Ilford introduced a new concept of fixing, which considers both thorough fixing and ease of washing out residual fixer. The method uses a concentrated rapid fixer for a very short time: 30 seconds. The theory is that with the faster-working fixer complete fixing takes place, but the short time of immersion allows very little of the fixer to attach itself to the paper fibers, making it much easier to wash the print clean. Ilford sells the chemicals with complete instructions for archival processing. The drawback to this method is that the fixer must definitely be fresh. You can carefully observe the working life of the fixing bath to insure freshness or test with estimator papers to determine the silver content of the fixer—an indication of the amount of use. Estimator papers are available from Kodak as Silver Estimating Test Papers. After fixing, Ilford's archival processing recommends a 5-minute running water wash, followed by a 10-minute bath in Ilford Archival Wash Aid. A final wash of 5 minutes completes the process.

Photographer Ralph Steiner published an article suggesting a similar method using Kodak materials. He used film-strength Kodak Rapid Fixer for 30 seconds with constant agitation. Directly after the fixer the print was given a 3-minute bath in Kodak Hypo Clearing Solution. The print was then washed in a running water wash. Steiner tested the prints for residual hypo after various washing times and compared the results with those from prints fixed by the two-bath method. The Quickfixing method left far smaller amounts of residual hypo in the print. After 30 minutes of washing, the two-bath print had four times the residual hypo of a Quickfixed print with only 5 minutes of washing. In an attempt to compensate for the longer fixing by longer washing, Steiner washed a two-bath print for two days. The print still had the same residual hypo as a Quickfixed print with only 12 minutes of washing.

## Washing Aid

The purpose of the washing aid is to make the fixer easier to wash out, resulting in shorter wash times.

## Washing

The washing is a critical step in insuring archival results. A good flow of fresh water across both surfaces of each print is needed. The flow of water should be sufficient to completely change the water in the washer every 5 minutes. The small-volume, vertical print washers provide for thorough unattended washing of prints with minimum use of water.

## Toning

For maximum permanence prints should be toned in either selenium or gold toner. The attachment of the selenium or gold to the silver particles in the print helps to prevent the tarnishing of the silver. A method for selenium toning is given in chapter 16, on page 482.

### Testing for Residual Hypo

Since fixing and washing techniques vary widely from darkroom to darkroom, the only way to properly evaluate the process is to test the resultant prints for residual hypo (fixer). Kodak offers the HT-2 Residual Hypo Test Solution. (The formula for mixing HT-2 is also published by Kodak.) The solution is placed on a white area of a processed print, and the resulting stain is compared with sample stain patches also available from Kodak. A second, more sensitive method is discussed in the American National Standards Institute (ANSI) publication titled *Methylene Blue Method for Measuring Thiosulfate*, ANSI PH4.8-1971.

### Drying

To prevent contamination of prints by dryer belts or blotters, air dry them on regularly cleaned fiberglass window screening.

## ■ Storage

Even if a print has been archivally processed, it is still susceptible to damage. Proper storage will insure that the print lasts the maximum possible time. One thing that can be damaging to photographic prints is an acid environment. Any materials used in archival mounting, matting, or storage should be 100 percent acid free.

### Mounting

Museums and conservationists prefer that prints not be mounted permanently to a mount board. Instead a print can be attached to the board by the use of small rice paper hinges or held on the board by the use of archival paper photo corners. The print can be further protected by a window mat. The board used must be 100 percent acid free. Museum board is also 100 percent rag content. Newer techniques have made possible the manufacture of 100 percent acid-free boards from wood pulp, usually called conservation boards. Note that some archival boards use buffering agents to insure that they will not turn acidic. The buffering agents may be injurious to some types of photographic prints: albumen, dye transfer, and color prints.

For a more permanent bond between the print and the board, Seal makes a product called Archival Mount, which is said to be archival. It is used much like traditional dry-mounting tissues but at a lower temperature and can be heated and removed at a later date if desired.

### Storage Containers and Environment

Storage containers made of 100 percent acid-free materials are available from a few sources. Normal paper, wood, and cardboard containers can be harmful to a print. Some plastics and painted metals can also cause problems. Museums control the humidity and cleanliness of the air as well.

## Materials Sources

Check with your local framing and museum supply services for archival materials. Mail-order supplies are available from several sources:

Light Impressions
439 Monroe Ave.
P.O. Box 940
Rochester, NY 14603
800-828-6216

University Products
P.O. Box 101
S. Canal St.
Holyoke, MA 01041
800-628-1912

Maine Photographic Resource
2 Central St.
Rockport, ME 04856
800-227-1541

The catalogs for these companies have a complete selection of mounting and storage materials as well as tools and cabinets, plus a good deal of information on archival methods and materials.

# A P P E N D I X   G

# Partial List of Available Films

| NAME | ISO | SIZES | DESCRIPTION AND COMMENTS |
|------|-----|-------|--------------------------|
| Black-and-White Films | | | |
| **Agfa** | | | |
| Agfapan APX 25 Professional | 25 | 135, roll | Extremely fine-grained, extremely sharp panchromatic negative film |
| Agfapan APX 100 Professional | 100 | 135, roll, sheet | Especially fine-grained panchromatic negative film |
| Agfapan 400 Professional | 400 | 135, roll, sheet | High-speed panchromatic negative film; can be push-processed |
| **Fuji** | | | |
| Neopan 400 Professional | 400 | 135 | High-speed, fine-grained panchromatic negative film; can be pull- or push-processed |
| Neopan 1600 Professional | 1600 | 135 | Ultra-high-speed panchromatic negative film; can be pull- or push-processed |
| **Ilford** | | | |
| Pan F Plus | 50 | 135, roll | Ultra-fine-grained panchromatic negative film |
| FP4 Plus | 125 | 135, roll, sheet | Very fine-grained panchromatic negative film |
| HP5 Plus | 400 | 135, roll, sheet | High-speed panchromatic negative film; can be push-processed |
| Delta | 100, 400, 3200 | 135 | High-speed, fine-grained panchromatic negative film; requires somewhat longer fixing time |
| XP-2 Super | 400 | 135, roll | High-speed, very fine-grained panchromatic negative film; chromogenic film; process in C-41 color negative chemistry |
| **Kodak** | | | |
| Technical Pan | 25[1] | 135, roll, sheet | Micro-fine-grained panchromatic negative film; can be used as normal- or high-contrast film, depending on developer |

### Kodak *(continued)*

| | | | |
|---|---|---|---|
| T-Max 100 Professional | 100 | 135, roll, sheet | Extremely fine-grained, very high-resolving general-use panchromatic negative film; requires longer fixing times |
| Plus-X Pan, Plus-X Pan Professional | 125 | 135, roll, sheet | Extremely fine-grained general-use panchromatic negative film |
| Tri-Pan, Tri-X Pan Professional | 400 | 135, roll, sheet | High-speed, fine-grained panchromatic negative film |
| T-Max 400 Professional | 400 | 135, roll, sheet | High-speed, extremely fine-grained panchromatic negative film |
| Black and White +400 Film | 400 | 135 | High-speed, very fine-grained panchromatic film; chromogenic film; process in C-41 color negative chemistry |
| T-Max P3200 Professional | 1000 | 135 | Very high-speed, fine-grained panchromatic negative film; can be push- or pull-processed |
| High Speed Infrared | 80[2] | 135, sheet | Infrared-sensitive negative film |

### Polaroid

| | | | |
|---|---|---|---|
| PolaGraph HC | 400[3] | 135 | High-speed, high-contrast black-and-white instant positive transparency film; requires a special processing device |
| PolaPan CT | 125 | 135 | General-purpose, continuous-tone, medium-contrast black-and-white instant positive transparency film; requires a special processing device |

---

Color Negative Films[4]

### Agfa

| | | | |
|---|---|---|---|
| Agfacolor Optima II Prestige Professional | 100, 200, 400 | 135, roll, sheet[5] | Films with increased color saturation and sharpness |
| Agfacolor Ultra 50 Professional | 50 | 135, roll | Film with ultrahigh color saturation |
| Agfacolor Portrait 160 Professional | 160 | 135, roll | Film with soft color saturation |
| Agfacolor XRG | 100, 200, 400 | 135 | General-purpose films |

### Fuji

| | | | |
|---|---|---|---|
| Fujicolor Superia | 100, 200, 400, 800 | 135, roll | General-purpose films with vivid color and fine grain |
| Fujicolor Super HG | 1600 | 135 | General-purpose film with vivid color |
| Fujicolor Professional | 400, 800 | 135, roll | Film for general professional uses |
| Fujicolor NPS 160 Professional | 160 | 135, roll, sheet | Film for portrait and commercial photography; requires exposure times of 1/15 second or less |
| Fujicolor Reala | 100 | 135, roll | Film giving accurate color rendition |

### Kodak

| | | | |
|---|---|---|---|
| Portra NC Professional | 160, 400 | 135, roll, sheet | Film with moderate contrast and color saturation; excellent for portraits and weddings |
| Portra VC Professional | 160, 400 | 135, roll, sheet | Vivid color; general professional and commercial applications |
| Supra Professional | 100, 400, 800 | 135 | Extremely to very fine-grained films; may be stored at room temperature; bold color |
| Royal Gold | 100, 200, 400, 1000 | 135, roll[6] | General-purpose films with vivid color saturation; T-grain technology |

| NAME | ISO | SIZES | DESCRIPTION AND COMMENTS |
|---|---|---|---|
| **Konica** | | | |
| Centuria | 100, 200, 400, 800 | 135 | General-purpose films with improved grain structure offering fine grain |
| Impresa 50 | 50 | 135, roll | |
| Professional | 100, 160, 400 | 135, roll | |

Color Positive Films[7]

| NAME | ISO | SIZES | DESCRIPTION AND COMMENTS |
|---|---|---|---|
| **Agfa** | | | |
| Agfachrome RSX II Professional | 50, 100, 200 | 135, roll, sheet[8] | Films for professional applications |
| **Fuji** | | | |
| Fujichrome Velvia Professional | 50 | 135, roll, sheet | Film giving brilliant color rendition; can be push- or pull-processed; ultra-fine grain |
| Fujichrome Astia | 100 | 135, roll, sheet | Smooth, natural skin tones |
| Fujichrome Provia 100F | 100 | 135, roll, sheet | Film suitable for both general-purpose and professional uses; extremely fine grain |
| Fujichrome Provia | 400, 1600 | 135, roll[9] | High-speed films; can be push-processed |
| Fujichrome 64T Type II Professional | 64 | 135, roll, sheet | Tungsten-balance film; can be push- or pull-processed |
| Fujichrome Sensia II | 100, 200, 400 | 135 | General-purpose films |
| **Kodak** | | | |
| Kodachrome, Kodachrome Professional | 25, 64, 200 | 135 | Extremely to very fine-grained films; require K-14 processing |
| Elite Chrome | 100, 200, 400 | 135 | General-purpose color slide films |
| Ektachrome Professional | 64, 100, 200, 400, 1600 | 135, roll, sheet | Color slide films for professional purposes; some speeds available in saturated or warm color versions |
| Ektachrome Professional (Tungsten) | 64, 160, 320 | 135, roll | Tungsten 3200 K color-balance films |
| **Konica** | | | |
| Chrome R-100 | 100 | 135 | General-purpose film |
| **Polaroid** | | | |
| PolaChrome | 40 | 135 | General-purpose instant color slide film; requires a special processor |
| PolaChrome HC | 40 | 135 | High-contrast instant color slide film; requires a special processor |

NOTE: Descriptions and remarks are based on manufacturers' published data sheets and should be used only as a general guide. Films included were current as of publication. Check with the manufacturers for new or improved films. Not included in this list are films available only in roll- or sheet-film sizes and some special application films.

[1]Speed with Kodak Technidol Liquid Developer for continuous tone.
[2]ISO with 25A filter.
[3]Speed ratings on high-contrast films should be used only as a guide.
[4]C-41 process and daylight balance unless otherwise noted.
[5]Sheet sizes in ISO 100 only.
[6]Roll sizes in ISO 100 only.
[7]E-6 process and daylight balance unless otherwise noted.
[8]Sheet sizes in ISO 50 and 100 only.
[9]SO 1600 in 135 size only.

# Partial List of Available Black-and-White Printing Papers

| EMULSION NAME | CONTRAST[1] | BASE TYPE[2] | BASE WEIGHT[3] | SURFACE[4] | IMAGE COLOR[5] | BASE TINT[6] | PROCESS[7] | REMARKS |
|---|---|---|---|---|---|---|---|---|
| **Agfa** | | | | | | | | |
| Multicontrast Classic | VC | FB | S, D | G, SM | N | WH | T | All-purpose paper |
| Multicontrast Premium | VC | RC | MW | G, SM | N | WH | T, MP | All-purpose paper |
| **Ilford** | | | | | | | | |
| Multigrade IV FB Fiber | VC | FB | S, D | G, M, V | N | WH | T | Premium-quality paper; also available in Warmtone version |
| Multigrade IV RC Deluxe | VC | RC | MW | G, P | N | WH | T, MP | Premium-quality paper; also available in Warmtone and Cooltone versions |
| **Kodak** | | | | | | | | |
| Polymax Fine-Art | VC | FB | S, D | G, SM, LR | N | WH, CR | T | The cream base tint is available in luster surface only |
| Kodabrome II RC | GR 1-5 | RC | MW | G, SM, LR | N | WH | T, MP | Fast-speed paper; luster surface in grades 2 and 3 only |
| Polycontrast III RC | VC | RC | MW | G, SM, LR | N | WH | T, MP, AS | Developer incorporated |
| Polymax II RC | VC | RC | MW | G, SM, LR | N | WH | T, MP | Extended contrast range with new filters |

| EMULSION NAME | CONTRAST[1] | BASE TYPE[2] | BASE WEIGHT[3] | SURFACE[4] | IMAGE COLOR[5] | BASE TINT[6] | PROCESS[7] | REMARKS |
|---|---|---|---|---|---|---|---|---|
| P-Max Art RC | VC | RC | H | M | N | | T, MP, AS | Double-matte surface for handcoloring; no backprinting; developer incorporated |
| Azo | GR 1–4 | FB | S, D | G | N–W | WH | T | Contact printing paper |
| **Oriental** | | | | | | | | |
| New Seagull G | GR 2–4 | FB | D | G | C | WH | T | Exhibition-quality paper |
| New Seagull Select VC, FB | VC | FB | D | G | C | WH | T | Exhibition-quality paper |
| New Seagull RP | GR 2–4 | RC | MW | G, LR, SM | C | WH | T, MP | |
| New Seagull Select VC-RP | VC | RC | MW | SM | C | WH | T, MP | |

NOTE: All papers are enlarging papers unless otherwise noted. Descriptions and remarks are taken from manufacturers' published information and should be used only as a guide. This is a selection from the printing papers that were available at the time of publication from a few manufacturers. Other brands and types of papers are available. Refer to a photographic retail outlet or the manufacturers for more information.

[1]GR = graded, followed by available grades; VC = variable contrast.

[2]FB = fiber base; RC = resin-coated base.

[3]L = light; S = single; MW = medium; D = double; H = extraheavy.

[4]G = glossy; LR = luster; P = pearl; SM= semimatte; M = matte; V = velvet stipple.

[5]N = neutral black; W = warm black; BR = brown-black; BL = blue-black; C = cold black. If a range is given, it indicates that the developer choice affects the image color.

[6]WH = white; CR = cream.

[7]T = tray process; MP = machine process; AS = activation-stabilization process.

# Glossary

The study of photography can be confusing because quite often different terms are used to describe the same thing or, even worse, the same word is used to describe two or more different things. In an attempt to combat this problem, some of the terms used in this book were devised by the author; these are indicated in their definitions. Also, many terms common in the field of photography but not used in this book are included in this glossary as an aid to the reader who is studying other photographic texts or material. For a more comprehensive glossary of photographic terms, see the *Dictionary of Contemporary Photography*, by Leslie Stroebel and Hollis N. Todd (Dobbs Ferry, New York: Morgan & Morgan, 1974). Although by now somewhat dated, it still presents a standard for usage of most photographic terms. Terms that are printed in italics within a definition appear elsewhere in the glossary.

**aberrations**  Image flaws or imperfections due to lens design, causing image distortion or degradation of *image sharpness. See also astigmatism, barrel distortion, chromatic aberration, coma, compound lens, curvature of field, pincushion distortion, spherical aberration.*

**accelerator**  A developer component, usually an *alkali*, that increases the speed of development.

**acceptance angle**  *See angle of view.*

**acetic acid**  An acid used in diluted form as a stop bath. Also found in vinegar.

**achromat**  A lens system designed to correct the effects of chromatic aberration so that two different wavelengths of light have the same focal length.

**acid**  A compound that neutralizes *alkalis*. Acids have a pH of less than 7.0.

**acutance**  The ability of a film to produce a sharp edge between two tonal areas in the image, tested by placing a knife-edge on the film and exposing it to light. Acutance is an objective measure related to *image sharpness.*

**adapter rings**  Metal rings used to adapt smaller or larger threaded filters or accessories to the threaded fitting on a camera lens. *See also step-down ring, step-up ring.*

**additive color system**  A method of adding varying amounts of the additive primaries to achieve the desired color of light.

**additive primaries**  *See primary colors.*

**Advanced Photo System (APS)**  A subminiature film and camera system that uses film in a self-contained cartridge, and produces an image format size of $16 \times 24$ mm. The negatives are returned to the cartridge after printing, so the film is never directly handled.

**AE**  *Automatic exposure.*

**aerial image**  A real optical image formed in space. To be visible, it must be projected onto a ground glass or screen, or inspected through another lens.

**aerial perspective**  An indication of depth caused by the increasing effect of atmospheric disturbance or haze as distance increases.

**AF**  *Automatic focus.*

**agitation**  Movement—such as stirring or inverting a container—that causes a processing solution to circulate over the surface of a photosensitive material, providing fresh solution to all areas.

**air bells**  Bubbles of air that cling to a photographic material during processing. Also refers to the spots resulting from less complete development of the material where air bubbles clung to it during developing. Prewetting film and vigorous agitation prevent air bells.

**airbrush**  A spray device that uses compressed air. Used to apply dyes or paints for retouching and protective coatings.

**albumen**  The white of an egg. Used as a carrier for silver salts in 19th-century photographic prints and plates.

**alkali**  A compound that neutralizes acids and has a pH greater than 7.0. Also called a base.

**ambience**  The light-reflecting nature of the subject environment. An environment with many light-toned, reflective surfaces has a high ambience. One with dark, light-absorbing surfaces has a low ambience. The amount of *environmental light* is influenced by the ambience.

**ambient light**  *See available light, continuous light, environmental light, preexisting light.* This term is not used in this book because of inconsistent usage.

**ambient temperature**  The temperature of an environment. For photographic processes, this is usually room temperature.

**ambrotype**  A slightly underexposed collodion wet-plate glass negative displayed in a frame backed by black material. When viewed at the correct angle to a light source, it appears positive. Popular during the nineteenth century.

**American National Standards Institute (ANSI)**  An organization that develops and publishes standard methods for measurement and procedures in several fields, including photographic technology.

**American Standards Association (ASA)**  Former name of *American National Standards Institute.*

**amount of development**  The total amount of chemical reduction of silver salts to silver during development, which

is affected by the development time, development temperature, amount of agitation during development, type of developer, and condition of the developer.

**analogous colors**  Colors related to each other by their proximity in wavelength. For example, red, orange, and yellow are analogous colors, as are blue, green, and violet.

**analog image**  A photographic image in which the tones of the original subject are represented by a continuously variable substance. For example, in a black-and-white photographic print, the tones of the subject are represented by varying amounts of silver. In an analog video image, the subject tones are represented by voltage that produces varying magnetic patterns on video tape. As opposed to a *digital image*.

**analog readout**  A data display for a meter or other device that is in the form of a pointer, such as a needle, moving along a scale.

**anastigmat**  A lens system designed to correct the effects of *astigmatism*.

**angle of acceptance**  *See angle of view.*

**angle of coverage**  The angle between the lines from a lens to the ends of a diameter of the circle of usable image the lens can form on the film. The angle of coverage determines how large a format the lens can cover.

**angle of incidence**  The angle between a ray of light striking a surface and a line perpendicular to the surface at the point where the ray meets the surface.

**angle of reflection**  The angle between a reflected ray of light and a line perpendicular to the surface where the ray met the surface. *See also law of reflection.*

**angle of refraction**  The angle between a refracted ray of light and a line perpendicular to the surface where the ray passed through the surface.

**angle of view**  1) For a camera lens, the angle between the lines from the lens to the ends of the diagonal of a rectangle outlining the area of the subject included on the negative, determined by the focal length of the lens and the size of the film format. 2) For a reflected-light meter, the angle between the lines from the meter receptor to the ends of the diagonal of the rectangle or the diameter of the circle outlining the area of the subject included in the meter reading. Also called angle of acceptance or field coverage.

**ANSI**  *See American National Standards Institute.*

**anti-halation backing**  A film backing containing absorbing dyes, intended to reduce *halation*.

**antistatic**  A brush, cloth, or gun that is used to neutralize static charge on the surface of film or other material, making it easier to remove dust, lint, and other particles.

**aperture**  An opening, usually variable in size, located in or near a lens, that is used to control the amount of light that reaches the photosensitive material. *See also relative aperture.*

**aperture priority**  An automatic in-camera metering system in which the aperture is set manually and the meter sets the shutter speed automatically. *See also shutter priority.*

**apochromat**  A lens designed to correct for the effect of *chromatic aberration* so that three different wavelengths have the same focal length (compare with *achromat*). Often used to describe highly corrected lenses of excellent image quality.

**application**  *See program.*

**APS**  *See Advanced Photo System.*

**archival**  Photographic prints described as archival are produced using materials and processing techniques intended to provide maximum image permanence. Also describes storage and handling techniques intended to provide maximum image permanence.

**artifact**  A visible defect in a digital image, produced by the electronic imaging process.

**artificial light**  Illumination from manufactured sources, including light bulbs, electronic flash, flashbulbs, and other light sources powered by electricity.

**ASA**  *American Standards Association.* Also an *exposure index* system devised by that organization.

**aspect ratio**  The ratio of width to length of a negative or print. A square image has an aspect ratio of 1. An 8 × 10-inch print has an aspect ratio of 0.8.

**aspheric**  Describes a lens with one or more nonspherical surfaces.

**assignment photography**  Specific photographic jobs performed at the request of and under the direction of a client, usually on a freelance or contract basis.

**assistant**  A person in the photographic industry who assists a photographer in a studio or on location, working under the direction of the photographer, either on a freelance basis or as a permanent employee.

**association**  Connecting emotions or ideas with visual elements in a photographic image. Also refers to the connection of objects not represented in the photograph to shapes in the photograph by their similarity in appearance (as in seeing the shapes of animals in clouds).

**astigmatism**  A lens *aberration* that causes off-axis points to be imaged as two perpendicular lines in different planes. *See also anastigmat.*

**asymmetrical balance**  A visual *balance* in the design of a photograph that is achieved not by *symmetry* but by balancing the visual weights of the various design elements, taking into account all the factors that affect their visual importance.

**asymmetrical power pack**  A power pack for a studio *electronic flash* that has two or more banks of unequal power, allowing different amounts of power to be supplied to different heads.

**automatic diaphragm**  A *diaphragm aperture* that remains open to its maximum aperture, regardless of the f/stop setting, until the shutter is released. When the shutter is released, it stops down to the set aperture before the shutter opens and reopens to its widest aperture after the shutter closes. Used in single-lens reflex cameras to provide a bright viewing screen.

**automatic exposure (AE)** An in-camera metering system in which the shutter speed, aperture, or both are set automatically by the meter. *See also aperture priority, program operation, shutter priority.*

**automatic flash** An electronic flash containing a metering device that measures flash light reflected from the subject and cuts off the flash when sufficient exposure has been achieved.

**automatic focus (AF)** A camera system that automatically focuses the lens on the subject matter that appears within a specific area of the viewfinder. Also called autofocus.

**available light** Preexisting light. This term is used most often to refer to preexisting light at a low level of illumination.

**averaging meter** A reflected-light meter with an angle of view of 30–45°. When used from the camera position, it covers about the same subject area as a camera equipped with a normal lens.

**axial** In optics, describes image points on the axis or light rays that enter a lens along its axis.

**axis** In optics, a line drawn through the centers of curvature of the lens surfaces.

**axis lighting** Lighting a subject with a lamp or flash placed as close as possible to the camera lens. Also called level front lighting.

**B** *See bulb.*

**back** The part of a camera body that holds the film.

**back focal distance** The distance from the rear surface of the lens to the point of best focus for an infinitely distant subject. Important in camera design to allow room for shutters, mounts, mirrors, and so on.

**back lighting** Illumination of the subject from the side opposite the camera position.

**balance** In design, the feeling that the visual importance ("weight") of the various elements within the image is equally distributed throughout the frame. An image may be balanced left to right (horizontally), or top to bottom (vertically), or both. *See also color balance.*

**bank** In an electronic flash power pack, a set of capacitors that are electrically connected to deliver power to the flash heads as a single unit. Power packs usually contain two or more banks that can be connected or disconnected by switches. The power of a bank is divided equally among the flash heads plugged into it.

**bare-bulb lighting** The use of a photographic lamp or flash tube without a reflector. Produces a combination of direct light and environmental light reflected from nearby surfaces.

**barndoor** Adjustable metal flaps attached to a studio light to restrict the pattern of illumination.

**barrel distortion** A lens aberration that causes straight lines to curve outward toward the edges of the image.

**barrel mount** A metal or plastic tube in which lens elements are mounted. May also include an iris diaphragm, but does not include a shutter.

**baryta** A whitening agent of barium sulfate used as a coating under the emulsion on fiber-based photographic printing papers.

**base** 1) The support that carries a photosensitive emulsion. Photographic films use a transparent base; photographic prints use an opaque base, usually of paper. 2) An *alkali*.

**baseboard** On free-standing enlargers or copy stands, the flat board to which the vertical column is fastened, which provides a surface aligned with the lens for placement of photographic materials or material to be copied.

**base plus fog density** The transmission density of an unexposed area of a processed film, which consists of the density of the film base and emulsion plus the density caused by chemical fog. In processed photographic papers, it is the reflective density of an unexposed area of the paper.

**base weight** The thickness of the support for photographic papers. In order of increasing thickness, they are: light weight, single weight, medium weight, and double weight.

**bas-relief** An image produced by printing a sandwich of negative and positive film images, placed together slightly out of registration. It creates an outline effect of the subject, with a three-dimensional or raised appearance.

**batch** 1) A group of photographic materials manufactured at the same time, which provides consistency between packages of the material (as long as storage conditions are uniform). Each package from the batch is labeled with a number, called the batch number. 2) To process several sheets of photographic material at the same time.

**Bauhaus** A German school of architecture and design that, during the 1920s and 1930s, was a center for artists influenced by a number of radical trends in art, including Dadaism, Cubism, Constructivism, and Surrealism.

**bed** The frame or rails that support the front (lens) and back (film) standards of a view camera.

**bellows** A flexible, lighttight housing that connects the lens to the back or body of a camera, allowing for focusing and movements of the front or back of the camera. Usually accordion pleated, the bellows may also be in the form of a lighttight bag. Accessory bellows attachments for smaller format cameras are designed to be placed between the lens and the camera body for close-up photography.

**bellows extension** The distance from the rear *nodal point* of the lens to the film plane. Used in calculating the exposure corrections demanded by close-up photography. Equivalent to the image distance in optics. Bellows extension can be roughly measured from the center of the lens to the film plane, except for a *retrofocus lens* or a *telephoto lens*.

**bichromate** Chromium salt used in some photographic bleaching processes, and in the gum bichromate and other printing processes. Also called dichromate.

**bit** One binary digit. Only the numbers 0 and 1 can be represented by 1 bit.

**bit depth**   In a digital image, the number of binary digits (bits) that are dedicated to representing the luminosity and color information for each pixel. A 1-bit image can only represent two tones or colors. An 8-bit image can represent 256 shades or colors. A 24-bit image can represent millions of shades or colors. Larger bit depth gives better reproduction of a continuous tone image, but produces larger files.

**black-and-white image**   *See monochrome image.*

**black body**   A hypothetical body that absorbs all of the radiation falling on it and emits electromagnetic radiation with a wavelength spectrum dependent on its temperature.

**bleach**   A chemical solution used to remove silver or dyes from photographic images to reduce density. Bleaching can be done selectively to parts of a negative or positive, or as a treatment to the entire image. *See also Farmer's reducer, reducer.*

**bleed**   1) A mounting technique in which the support and the borders of the image are trimmed down to the image. Also called flush mounting. 2) In a picture layout, to butt images together with no space between them, or to run an image to the edge of the page.

**blocking up of highlights**   Loss of tonal separation in the subject light-tone areas of a negative because of overexposure, an extremely contrasty subject, or overdevelopment of the film. Can be explained in terms of the characteristic curve as the case in which the exposures from subject light-tone areas fall above the shoulder.

**blotters**   Absorbent sheets of paper assembled in rolls or books into which wet prints are interleaved for drying.

**blue-sensitive emulsion**   Sensitive only to blue light and therefore can be handled safely under yellow or amber light.

**book**   *See portfolio.*

**bounce flash**   *See bounce light.*

**bounce light**   Diffused illumination achieved by reflecting light from a flash or lamp off a white surface such as a wall or card.

**bracketing**   Making several exposures of the same subject, intentionally overexposing and underexposing from an initially determined or estimated exposure.

**brightener**   An agent added to photographic paper during manufacture or processing to make light areas appear whiter. Also called whitener. *See also baryta.*

**brightness**   A subjective interpretation of luminance or illuminance which is not measurable. Commonly, but inaccurately, used in place of luminance.

**broad lighting**   A lighting situation for a portrait of a person whose head is turned slightly away from the camera, in which the side of the face toward the camera is fully illuminated by the main light. Since a larger area of the face is illuminated, the face appears wider.

**bromide drag**   Streaks of uneven development resulting from bromide byproducts of the development process. These are heavier than the developer and drag downward across the surface of the film, inhibiting development in those areas. Agitation during development helps prevent bromide drag by bringing fresh developer to all areas of the film and flushing away the bromide products. Also called bromide streaks.

**bromide paper**   A photographic paper that has silver bromide as the principal light-sensitive compound.

**built-in meter**   *See in-camera light meter.*

**bulb (B)**   A shutter setting for which the shutter remains open as long as pressure is maintained on the shutter release.

**bulk film**   Film sold in long rolls that must be cut into strips and loaded into cassettes or magazines before use.

**burn**   Increasing the exposure in a particular area of a print by blocking everything else in the print from image light and giving additional printing time to that area. Burning will darken the area when printing from a negative. Also called burn in or print in. *See also dodge, flashing.*

**butterfly lighting**   A portrait lighting situation in which the main light is positioned directly in front of the model and higher than the model's head, producing a small shadow under the nose sometimes resembling a butterfly. Also called paramount lighting.

**byte**   Eight binary digits (bits). Numbers from 0 through 255 can be represented by a 1-byte binary number.

**C-41 process**   A Kodak process for developing color negative films for prints, widely established as the industry standard.

**cable release**   A flexible cable that allows tripping the shutter without touching the camera, reducing the possibility of camera movement during exposure.

**cadmium sulfide (CdS) cell**   A light-sensitive electronic component of the photoconductor type, in which the resistance changes with the amount of illuminance. Used in some photographic exposure meters.

**calibrate**   1) To compare the readings from a measuring device, such as a thermometer or light meter, against a known standard. 2) To determine numbers for the settings on photographic equipment, or times and temperatures of processes, that will give the desired technical results in terms of amount of exposure, development, or other physical result.

**calotype**   A photographic process in which paper sensitized with silver salts is used in a camera to produce paper negatives. Introduced to the public in 1840, it was William Henry Fox Talbot's improved version of his original photographic process. *See also talbotype.*

**camera**   A device for making photographs, consisting of a lighttight body with a lens or pinhole that forms an image on *photosensitive materials* held within the body.

**camera exposure settings**   *See camera settings.*

**camera obscura**   Latin for "darkened room." The forerunner of today's cameras, it was originally a dark room with a small hole in one side that formed images on the opposite wall. It was later developed into a portable lighttight box

with a lens that formed an image on tracing paper for hand copying.

**camera settings (C.S.)** The f-stop and shutter speed set into the camera for an exposure. Also called camera exposure settings.

**carbon process** A photographic printing process using paper coated with a mixture of gelatin, potassium dichromate, and carbon particles.

**carrier** *See negative carrier.*

**carte-de-visite** A small photographic portrait mounted on stiff cardboard that was used as a visiting card or a keepsake mounted in an album. Popular in the nineteenth century.

**cartridge** A lighttight container for strips of film, which are wound on a spool inside the cartridge. A cartridge contains a take-up reel and is inserted directly into the camera. It requires no rewinding or handling of the film itself.

**cassette** A lighttight container for strips of film, which are wound on a spool inside the cassette. Cassettes require a take-up spool in the camera. The film must be rewound into the cassette after use.

**catadioptric** An image-forming device that consists of both lens elements and curved mirrors.

**catchlights** Small specular reflections in the eyes of a portrait subject.

**cathode ray tube (CRT)** A vacuum tube used for viewing purposes in most computer monitors and televisions. In the tube, one or more streams of electrons are deflected across the back of the screen, which is coated with phosphors that release light when struck by the electrons.

**catoptric** An image-forming device that consists of curved mirrors.

**CC filters** *See color compensating filters.*

**CCD** *See charge-coupled device.*

**CdS** Cadmium sulfide.

**CdS meter** A photographic exposure meter using a cadmium sulfide cell as the light-sensing element.

**center of interest** A single object or event in a photograph that is of primary interest to the viewer.

**central processing unit (CPU)** In a computer, the main solid state chip that performs the calculations.

**changing bag** A lighttight bag into which the hands can be inserted that can be used on location for handling photographic films or papers.

**characteristic curve (Hurter/Driffield, H/D, or D-Log-E curve)** A graph of density plotted against log exposure for an exposed and processed photosensitive material. Each curve represents the response to exposure of a particular photosensitive material for a given set of developing conditions, including the developer type and developing time.

**charge-coupled device (CCD)** A light-sensitive, solid-state device that produces electrical voltage when struck by light. In a digital device, such as a scanner, the image is digitized by converting the voltage for each CCD to a number.

**chloride paper** A photographic printing paper that uses silver chloride as the principal light-sensitive compound.

**chromatic aberration** A lens defect in which light of different wavelengths (colors) is brought into focus at different distances from the lens. It is called axial when it occurs along the lens axis, and lateral when it occurs at the edge of the image. *See also color fringes.*

**chrome** Slang expression for a color transparency.

**chromogenic film** Monochromatic (black-and-white) film designed to be processed with standard color print film chemistry (the *C-41 process*).

**CI** *See contrast index.*

**circle of confusion** A disk of light that is the image of a point on the subject when the image is out of focus. The smaller the circle of confusion, the more the disk looks like a point and the sharper the image appears. Depth of field depends on the largest acceptable size of the circle of confusion.

**clearing time** The amount of time needed for fixer to remove the cloudy appearance in a negative that is due to the presence of silver-halide crystals. A common guide for finding the correct fixing time is to double the clearing time.

**click stop** A detention device at each step or half-step within aperture or shutter speed controls that indicates the exact position of the setting by feel and sometimes by an audible click.

**clip art** Drawings or photographs that are sold in groups as a collection, usually in digital form on a CD-ROM. The buyer can reproduce and publish the clip art images without further payment of fees or royalties.

**clip file** *See idea book.*

**clock speed** The speed at which the central processing unit of a computer can perform calculations, usually given in megahertz (million cycles per second). A major factor affecting the speed with which a computer can perform desired operations.

**close down** To reduce the exposure on a photosensitive material by changing the aperture to a smaller opening, for example from f/4 to f/5.6. This term is used loosely to mean reducing exposure by using a shorter exposure time, for example from 1/60 second to 1/125 second. Also called stop down.

**close-up** A photograph made at a closer subject distance than is usual for the camera equipment being used, normally requiring the use of accessory equipment and the correction of exposure.

**close-up lens** *See supplementary lens.*

**CMYK color** A color reproduction system in which the colors of the original are represented as percentages of the subtractive primaries (cyan, magenta, and yellow) plus black. Primarily used in printed processes using ink.

**coating** *See lens coating.*

**cocking the shutter** To make the shutter ready for release by putting tension on the springs, rewinding the curtains, or performing other mechanical operations.

Most in-camera shutters are cocked automatically when the film is advanced.

**cold light**  Illumination produced by gas-discharge lamps, such as fluorescent tubes. Sometimes used as a light source in enlargers.

**cold-mounting**  Mounting prints with adhesives that do not set and will adhere on contact or with pressure. Cold-mounting materials may come as two-sided adhesive sheets, sprays, or sheets of transfer adhesive.

**cold tone**  Describes black-and-white printing papers in which the image color tends toward blue or green.

**collimated**  Describes light in which the rays are parallel.

**collodion**  A transparent material with a syrupy consistency, made of guncotton (nitrocellulose) dissolved in ether and alcohol. Used as a carrier for light-sensitive silver salts in the *wet-plate process*.

**collotype**  A process of printing photographs in ink using a plate made with a sensitized gelatin film.

**color analyzer**  A device used as an aid for determining filtration in color printing that measures the component amounts of red, blue, and green light in the projected image.

**color balance**  1) The color temperature of illumination for which a color film will give correct color rendition. Two different color balance films are generally available: daylight balance (5500°K) and tungsten balance (3200°K). 2) Often used to refer to the color temperature of illumination, as in daylight balance illumination.

**color cast**  In a color photograph, the presence of a tinge of color throughout the image.

**color compensating (CC) filters**  Filters that are manufactured in varying densities of the additive and subtractive primary colors, red, blue, green, cyan, yellow, and magenta. Designed for use in the image path to produce specific changes in the color balance of the light reaching the film.

**color contamination**  A change in the color of light because of reflection from a colored surface or transmission through a colored translucent material. For example, light reflected off a green wall will take on a greenish color.

**color contrast**  1) The perceived brightness differences due to the relationship of adjacent colors rather than to their value. When yellow is adjacent to blue it usually appears brighter, even if the luminance of the two is the same. 2) In design, the use of color differences to add visual interest.

**color contrast filters**  The use of colored filters in black-and-white photography to change the tonal relationship of colored objects within the subject. A yellow filter used to darken the sky is an example of a color contrast filter.

**color conversion filter**  *See conversion filter.*

**color couplers**  Compounds incorporated into the emulsions of some color films that release dyes during the development process.

**color crossover**  The presence of a tinge of a color in specific tonal areas, such as light-tone or dark-tone areas, of a color transparency, negative, or print, caused by a lack of agreement between the characteristic curves of the three emulsion layers. Cannot be corrected by overall filtration.

**color fringes**  Outlines of rainbow colors around subject matter at the edges of an image from a lens, caused by lateral *chromatic aberration*.

**color head**  An enlarger head with a built-in filter system for color printing.

**color mode**  In electronic imaging, the method used to represent the tones and colors of the original. The most common color modes are *grayscale*, *RGB color*, and *CMYK color*.

**color negative film**  *See negative film.*

**color positive film**  *See positive film.*

**color printing (CP) filters**  Filters in varying densities of the additive or subtractive primary colors intended for use in the lamp housing of enlargers used for color printing. Not designed to be placed in the image path.

**color sensitivity**  An indication of the sensitivity of photosensitive materials to various colors of light. Several categories of emulsions with different color sensitivities are available. *See also blue-sensitive emulsion, infrared film, orthochromatic emulsion, panchromatic.*

**color temperature**  A measure of the color of the illumination from a light source, given in degrees Kelvin. Color temperatures are derived from comparison with the color of the illumination emitted from an ideal *black-body* radiator at different temperatures.

**coma**  A lens aberration in which subject points off the lens axis are imaged as comet-shaped patches of light.

**compaction development**  Less than normal film development, which lowers the density of subject light-tone areas in the negative, giving reduced negative contrast to compensate for high subject contrast or to produce a desired visual effect. Also called minus, compression, or contraction development. *See also expansion development, N-1 development.*

**comp book**  A notebook in which the ideas and procedures used in the creation of a photograph are recorded. A comp book can be used as a tool for planning and developing the concept of a photograph before shooting, as in a *comprehensive*, as well as a place to record technical data and lighting information for later reference.

**compensating developer**  A developer that continues vigorous development of subject dark-tone areas of a negative, while restraining development in the subject light-tone areas, producing less negative contrast without a loss of dark-tone detail or separation.

**complementary colors**  Two colors of light that, when combined in equal amounts, produce white light. Red and cyan are complementary colors, as are blue and yellow and green and magenta.

**completion**  A chemical process in which chemical activity is allowed to continue until no further chemical change takes place. Fixing is a completion process; development is not, because it is usually arrested before all of the silver salts are reduced.

**composition** The thoughtful arrangement of the visual elements within a work of art.

**compound lens** A lens combining two or more *elements* to reduce aberrations and improve the image quality.

**comprehensive** A document that outlines the planning of a photograph. A comprehensive may include written material that describes the purpose, content, concept, and other details of the proposed photograph, and may also include a rough sketch or detailed drawing of what the finished photograph is expected to look like. Often called comp sheet.

**compression** 1) The apparent reduction of distance between objects in photographs taken with long-focus lenses. Also called foreshortening or telephoto compression. 2) In film development, the same as *compaction*.

**comp sheet** *See comprehensive.*

**computer printer** A printer that accepts digital information directly from a computer and produces images or text on paper or other media. Common types are *inkjet, electrostatic,* and *dye sublimation printers.*

**concave** Describes a lens surface that curves inward.

**concentrate** A concentrated chemical solution that must be highly diluted before use. *See also stock solution, working solution.*

**conceptual art** Art in which the object created is of secondary importance to the idea or concept behind its creation. Conceptual artists may produce objects that are only temporary, or may not produce an object at all but simply orchestrate an event.

**condenser enlarger** An enlarger with condenser lenses between the light source and the negative carrier.

**condenser lens** A positive lens used in the lighting systems of enlargers and projectors to redirect and concentrate the light from the light source, increasing the illuminance and evenness of the light reaching the negative or transparency. Condenser lenses supply specular light for projection.

**contact paper** Photographic printing paper designed for contact printing with relatively high levels of illumination.

**contact printing** Exposing a print material to an image by placing the negative or positive transparency in direct contact with the emulsion of the printing paper and passing light through the negative or transparency. Produces a print image the same size as the film image.

**content** In design, refers to the apparent subject of a photograph, usually the objects that are pictured but sometimes an event or activity that is shown.

**continuous discharge lamp** *See discharge lamp.*

**continuous light** Light that does not vary greatly in intensity over time. Most normal lighting situations have continuous light sources.

**continuous spectrum** A display of the wavelengths of light from a source which emits all the possible wavelengths within the range of emission, but not necessarily in equal amounts. Tungsten lamps emit a continuous spectrum of light.

**continuous-tone** Describes a photographic image that can represent any increment of tone from the darkest possible tone to the lightest possible tone of the photographic material being used. Different from *high-contrast, posterized,* or *halftone images.*

**contraction development** *See compaction development.*

**contrast** In general, a difference between extremes. Used in many photographic contexts, including *lighting contrast, subject contrast, negative contrast, printing paper contrast,* and *print contrast,* among others. Contrast is also used in several contexts in design, such as contrasts in subject matter, mood, textures, and so on. *See* specific terms for definitions.

**contrast filters** *See color contrast filters.*

**contrast grade** *See paper contrast.*

**contrast index (CI)** A number derived from the characteristic curve of a film, which is an indication of the contrast of the film. The calculation of contrast index includes the parts of the characteristic curve normally used for tonal reproduction in photographs.

**contrasty** Describes a subject, lighting situation, negative, or photograph that exhibits more than normal or desired contrast.

**controlled lighting** The manipulation of preexisting light or the use of supplementary light sources to achieve a desired result. Manipulation can consist of modifying the quality of the light sources by reflection or transmission of the light they emit, moving the subject for a more desirable relationship with preexisting light, or waiting for different conditions in the natural preexisting light.

**controller** An electronic device in a computer that allows the computer to communicate directly with a peripheral device, such as a disk drive.

**convergence** The apparent reduction of the distance between parallel lines with distance. Convergence is one of the indicators of depth in a photograph.

**conversion filter** A color filter designed to adjust the color balance of a light source to the suggested color balance of the film. For example, an 80A blue conversion filter would convert the illumination from tungsten bulbs for use with daylight films.

**converter** A lens designed to be mounted between a camera lens and the camera body that has the effect of increasing the effective focal length of the lens. Also called extender or teleconverter.

**convex** Describes a lens surface that curves outward.

**cool** Colors that contain noticeable amounts of green or blue are described as cool.

**copy stand** A camera mount attached to a column so it can be adjusted in height, mounted on a baseboard. It is used for photographing flat materials. May also include arms for attaching lights for illumination of the materials.

**correction** 1) In color photography, the use of filters on a camera or enlarger to adjust the color of the photograph. 2) Moving the front or back of a camera by swinging, tilting, or sliding, to change the focus or subject shape in the photograph.

**counter-mounting** Dry-mounting a print back-to-back with an unexposed but processed sheet of the same type of photographic printing paper. Prevents curling due to humidity.

**coverage** The ability of a lens to produce an acceptably sharp and even image over a given format size. May also be given as an *angle of coverage*.

**CP filters** *See color printing filters.*

**CPU** *See central processing unit.*

**C-print** An outmoded but commonly used term for color negative print materials. Also called Type C print.

**crimp marks** Black marks on a negative, often of crescent shape, caused by bending the film before processing.

**crop** To show in a print only part of the entire image that appears in the negative or transparency. This can be done by increasing the enlargement of the image when printing or by physically cutting the print after processing.

**cross light** Light that crosses the surface of a subject at a low angle relative to the surface, used to accentuate the texture of the surface.

**CRT** *See cathode ray tube.*

**C.S.** An abbreviation for camera settings as used in this book.

**curtain shutter** A shutter in which the exposure is made by a slit, usually variable in size, in a metal or cloth curtain travelling in front of the film.

**curvature of field** A lens aberration in which the image of a flat subject comes to a focus on a curved surface.

**curvilinear distortion** A lens aberration in which straight lines in the subject bow in or out in the image. *See also barrel distortion, pincushion distortion.*

**custom lab** A photographic lab that provides a wide range of services catering to the professional photographer.

**cut film** *See sheet film.*

**cyanotype process** A photographic process using light-sensitive iron salts. The resulting images are monochromatic blue or cyan in color. Also known as the blueprint process. Sometimes used by photographers as a print material, the most widespread use of the cyanotype has been for reproduction of architectural and industrial drawings.

**D** *Density.*

**daguerreotype** A photographic process that uses silver-plated copper plates fumed with iodine. After exposure the plate is fumed with mercury as a kind of development. The result is a one-of-a-kind direct-positive photograph. The daguerreotype was invented by Louis Jacques Mandé Daguerre and was the first practical photographic process, announced to the public in 1839.

**darkroom** A room that can be sufficiently darkened and lit with a safelight for the safe handling and processing of light-sensitive materials.

**dark slide** An opaque metal or plastic sheet in a film holder that protects the film from light. Once the film holder has been inserted into the camera, the dark slide is pulled out of the way for the exposure.

**daylight** Natural illumination consisting of a combination of sunlight and skylight. The color and quality of natural daylight illumination vary widely with location, weather, and time of day. Standard photographic daylight is defined as illumination with a color temperature of 5500°K.

**daylight balance film** Film designed to give correct color rendition with daylight illumination (average direct sunlight in the middle of the day), usually defined as a standard color temperature of 5500°K. Also called daylight balance film.

**dedicated flash** An electronic flash that provides automatic flash exposure by coupling directly to the metering system of the camera. Since camera metering systems vary, each dedicated flash is designed for use with specific camera models.

**definition** The viewer's subjective perception of the amount of detail rendered in a photograph.

**dense** Describes an area of a negative or print that transmits or reflects little light. Also used to describe a negative or print that is darker than is desired. The opposite of *"thin."*

**densitometer** A device for measuring densities. A transmission densitometer measures the density of film. A reflective densitometer measures reflective densities of prints.

**density** A measure of the ability of a material to absorb light. The higher the density, the more light a material absorbs. In silver-based photosensitive materials, density is created by the presence of metallic silver in the processed image. Transmission density is defined as the log of one divided by the transmission $[D = \log(1/T)]$. Reflective density is defined as the log of one divided by the reflectance. In a print, the higher the reflective density, the darker the tone.

**density range** *See range.*

**density scale** *See scale.*

**depth of field** The nearest and farthest subject distances that are acceptably sharp in the finished photograph. Depth of field changes with focused distance, lens focal length, aperture, magnification of the printed image, and standards of acceptable sharpness. *See also circle of confusion.*

**depth-of-field scale** A scale, dial, or chart that gives an indication of the depth of field for different f-stops and distances for a specific focal length lens and format. Many lenses and cameras have depth of field scales on them.

**depth of focus** The distance the film can be moved forward or backward and still retain acceptable sharpness for a focused image.

**design elements** *See visual elements.*

**detail** 1) Visible texture or distinct separation of small tonal areas in a photographic negative or print. 2) A small part of a subject shown as a full-frame photograph.

**developer** A chemical solution that converts a latent image to a visible one. *See also amount of development.*

**developer-incorporated** Describes photographic papers that include some developing substances in the emulsion. They are designed for use with *stabilization processors.*

**developing-out paper**   A photographic paper that requires development after exposure to produce a visible image; as opposed to *printing-out paper.*

**development**   Used interchangeably to refer to the single chemical step that converts a latent image to a visible one, and to the entire process of chemical steps used, including stop, fixer, washes, and so on. *See also amount of development.*

**diaphragm**   An iris-type device made of overlapping metal blades that gives adjustable apertures for controlling the amount of light passing through a lens.

**dichroic filter**   A filter with a thin coating that allows only one color of light to pass through it. It is called dichroic because it transmits one color while reflecting its complement. Widely used in color-head enlargers.

**dichroic fog**   An iridescent coating on a print that appears when developer is carried into the fixer on the print surface. Use of an acid stop bath helps to prevent dichroic fog.

**dichroic head**   A color-head enlarger using dichroic filters to control the color of the light.

**diffraction**   The slight bending of light when it passes the edge of an object. Diffraction affects photographic image sharpness, becoming most noticeable when very small apertures are used.

**diffuse**   Describes illumination that has been scattered and reaches a surface from many directions. The opposite of specular. *See also diffusion.*

**diffused highlight**   An area of a subject that receives the full effect of the principal illumination, and reflects back only diffuse light. That area shows the true tonality of the subject (gray appears gray, white appears white, and so on).

**diffused-shadow contrast**   The difference in luminance between a diffused highlight and a shadow. When measured on the same tonal surface this is a direct measure of the lighting contrast.

**diffused-specular contrast**   The difference in luminance between the diffused highlight and the specular highlight on a subject's surface.

**diffusion**   Scattering of the rays of light either by reflection from a slightly textured surface or transmission through translucent materials. The diffusing surface effectively becomes a new light source of larger area providing non-specular light, usually called diffuse light. Diffuse light sources produce "soft-edged" shadows with a more gradual transition from lit areas to shadowed areas.

**diffusion enlarger**   An enlarger in which the illumination is diffused before it reaches the negative, as opposed to a *condenser enlarger.*

**digital camera**   A camera that produces digital photographic image files directly without the use of film.

**digital enlarger**   A device that produces images on traditional photographic papers directly from a digital image file. It may use laser beams or LCDs to expose the paper, which is then chemically processed by traditional means.

**digital image**   A photographic image that has been *digitized.*

**digital image-processing**   Altering the characteristics (e.g., color balance, contrast, luminosity, and sharpness) of a digital image using digital image-processing software, such as Photoshop.

**digital readout**   A data display for a meter or other device that gives readings in direct numerical form.

**digitize**   The procedure of breaking a photographic image into discrete areas, called pixels, and assigning numbers to the average color and luminosity of each area. The numbers can then be stored and manipulated by computer techniques. *See also pixel.*

**DIN**   Deutsches Industrie Norm. Also used to designate an exposure index system devised by that organization.

**diopter**   A measure of the power of a lens. A positive diopter describes a converging lens; a negative diopter describes a diverging lens. Most commonly used in photography to indicate the magnifying capability of the supplementary lenses used in close-up photography and sometimes used to refer to the lenses themselves. *See also supplementary lens.*

**direct-positive**   A photographic process in which the exposed photosensitive material produces a positive image without going through an intermediate negative stage.

**direct viewing system**   A viewing system in a camera that allows inspection of the image formed by the camera lens, as in a view camera. To be visible, this image must be formed on an actual surface, such as a *ground glass.*

**discharge lamp**   A source of illumination in which light is generated by an electrical discharge through a gas enclosed in a glass envelope. The illumination may be continuous, as in neon and fluorescent lamps, or discontinuous, as in electronic flash tubes.

**discontinuous light**   Light of extremely short duration. Since the only discontinuous light photographers normally use is artificial light supplied by flash units, this type of light is almost always called "flash" lighting. Artificial discontinuous light can also be produced with some types of electrical arcing or discharge. Examples of discontinuous sources in nature are lightning and light-emitting explosions. Also called momentary light.

**discontinuous spectrum**   Electromagnetic radiation from a source that does not contain all of the possible wavelengths within a range, but shows only specific wavelengths. Most discharge lamps produce discontinuous spectrums of radiant energy unless they are combined with a fluorescent coating on the tube, as with fluorescent lamps.

**dispersion**   Separation of light into its component colors, resulting from the differing amounts of refraction for different colors of light. A rainbow is a result of dispersion, as is the spectrum of visible light seen after passage of white light through a prism.

**distortion**   *See curvilinear distortion.*

**D-log-E curve**   *See characteristic curve.*

**Dmax**   The maximum density that can be produced by a photographic material.

**Dmin** The minimum density that can be produced by a photographic material. *See also base-plus-fog density.*

**dodge** To reduce the exposure in a particular area of a print by blocking image light from that area during part of the exposure. When printing from a negative, dodging will lighten the area. Also called hold back.

**dodging tool** Any opaque object used to block image light from an area of the photographic paper during printing.

**DOF** *Depth of field.*

**double exposure** Exposure of the same frame or sheet of film to two different images successively, either intentionally or accidentally.

**download** To transfer digital data from a Web site or other remote location to your computer, placing it into RAM or onto a storage medium, such as the hard disk.

**dropout** *See high-contrast image.*

**drum** 1) A cylindrical plastic or metal tube used for processing photographic materials. 2) A polished heated metal cylinder used in drying prints.

**drum dryer** A print dryer that uses a heated drum for drying prints.

**dry down** The tendency of some photographic print materials to appear darker after drying than they do when they are wet.

**dry-mounting** Strictly refers to any method for attaching a print to a support that does not use a liquid adhesive, but most often used to refer to mounting techniques that make use of a press with a heated platen and sheets of adhesive that adhere when heated.

**dry-mounting press** A press with a heated platen and clamping mechanism used to mount prints or other flat materials to supports, employing adhesives that require heating for adhesion.

**dry-mounting tissue** Sheets of adhesive for mounting prints that require heating for adhesion.

**dry plate** A glass photographic plate that is used dry. It is called dry plate to differentiate it from the wet-plate process, which it superseded.

**dye sublimation printer** A computer printer that produces photographic quality images consisting of dyes on special papers.

**dye transfer** A color separation process for making color prints, with images in each of the three subtractive colors combined in the printing. Both color negatives and color positives can be printed by the dye transfer process.

**DX coding** A pattern of electrically conductive patches indicating the ISO, printed on some film cassettes. Some cameras are capable of sensing this pattern and automatically setting the film speed into the in-camera meter.

**E-6 process** A Kodak process, widely accepted as an industry standard, for developing positive color transparency films.

**easel** A device for holding photographic print materials for exposure by an enlarger.

**EI** *See Exposure index.*

**18 percent gray card** A card with a matte surface of 18 percent reflectance used as a standard tone for metering and printing purposes.

**electromagnetic spectrum** All of the forms of electromagnetic energy arranged in order of increasing wavelength, from gamma rays to radio waves, including the visible light spectrum.

**electronic flash** A discontinuous light source in which illumination is generated by a brief high-voltage electric discharge through a gas-filled transparent or translucent tube. Commonly but inaccurately referred to as *strobe.*

**electronic shutter** A shutter that is electronically controlled and timed.

**electrostatic printer** A computer printer that produces type and images on paper by a process of charging the paper in a pattern corresponding to the image, which attracts toner to the paper. The toner is then heated to produce a reasonably permanent image. Similar to the process used in copy machines. Usually called a laserjet printer, even though no lasers are used in the image production.

**element** 1) An individual glass or plastic component of a compound lens. 2) *See visual elements.*

**emulsion** A mixture of gelatin and silver-halide salts that is coated onto a film or paper base to produce a photosensitive material. The emulsion side of the material is the side on which the emulsion is coated.

**emulsion batch** *See batch.*

**enlargement** A photograph that shows a magnified image of a negative or positive transparency.

**enlarger** A device used for projection printing. It consists of a column with a moveable head containing a light source, a negative carrier, and a lens for projecting an enlarged image of a negative or positive transparency onto a photosensitive material. The name is somewhat misleading, since images may sometimes be projected at smaller size than the original.

**enlarging paper** Photographic print materials with relatively high light-sensitivity designed for use in projection printing. Also called projection papers. *See also contact paper.*

**environmental light** Light that does not reach the subject directly from a light source, but is scattered or reflected by the environment surrounding the subject or the subject itself. Environmental light may result from either preexisting or supplementary sources. *See also ambience.*

**equivalent** The use of a photograph as a *metaphor.*

**equivalent exposure settings** Pairs of aperture and exposure time that yield the same exposure on a photosensitive material and, within the limits of the reciprocity law, the same density. For example, f/8 at 1/125 second and f/11 at 1/60 second are equivalent exposure settings.

**etch** 1) To remove silver from a photographic image by scraping the image. 2) To chemically remove unwanted material from an image, as in some photomechanical printing processes.

**EV** *Exposure value.*

**existing light**   *See preexisting light.*

**expansion development**   More than normal film development, which raises the density of subject light-tone areas in the negative, giving increased negative contrast to compensate for a lower contrast subject or to produce a desired visual effect. Also called plus development. *See also compaction development, N + 1 development.*

**expiration date**   A date printed on the packaging of some photosensitive materials, indicating that the material should be used before that date for optimum image quality. Storage at lower temperatures than recommended by the manufacturer can extend the useful life of the material well beyond the expiration date.

**exposure**   The total amount of light that a photosensitive material receives, equal to the product of the illuminance on the material and the amount of time the material is exposed to light.

**exposure factor**   A multiplication factor used to correct exposure in situations where accessories or procedures are used that alter the exposure on the photosensitive materials (as in close-up photography or use of filters). The indicated exposure time is multiplied by the exposure factor.

**exposure index**   A numerical measure of a photosensitive material's sensitivity to light. The standard system for measuring the exposure index is the ISO index, which is a combination of two older systems, the ASA index and the DIN index. In all systems, the higher the exposure index number, the more sensitive the film is to light. *See also system index.*

**exposure latitude**   The ability of a film to withstand overexposure or underexposure and still produce a usable image, with detail in both subject light-tone and subject dark-tone areas. The latitude for overexposure is usually greater than for underexposure. In general, slow speed films have less exposure latitude than fast films. In practice, exposure latitude also depends on the contrast of the subject being photographed—subjects with high contrast giving less exposure latitude—and the type and amount of development.

**exposure meter**   A device used for measuring light for photographic purposes, usually called a light meter. Most exposure meters have a calculator that provides suggested camera settings for the readings obtained. *See also incident-light meter, reflected-light meter.*

**exposure settings**   *See camera settings.*

**exposure value (EV)**   A number output by some light meters that gives an indication of the level of the luminance or illuminance, relative to the exposure index. Originally devised as a simplified method of setting aperture and shutter speed with one number, exposure values are most often used now for comparison of light meter readings or for giving the sensitivity range of a light meter. The EV number is meaningless without a specified ISO.

**extender**   *See converter.*

**extension tubes**   Metal tubes that are custom-designed to fit between a lens and the camera body, extending the distance between lens and film for close-up photography.

**eye relief**   The maximum distance between the eye and the eyepiece of a camera viewing system that still allows a view of the complete image.

**factor**   *See exposure factor.*

**fall**   Finding the film exposure as an REV (or as a zone in the Zone System) for a specific subject area by comparing its luminance to the camera settings. For example, if C.S. f/4 at 1/60 second is used, an area in the subject that has a reflected-light meter reading of M.R. f/2.8 at 1/60 second would produce a film exposure that falls at REV −1.

**fall-off**   1) The dimming of a lens image toward its edges as the distance from the image center increases. This effect can be reduced by careful lens design. 2) In lighting, the decrease in illumination as the distance from a light source increases.

**Farmer's reducer**   A bleaching agent that is a solution of potassium ferricyanide and sodium thiosulfate in water, used to reduce density in a processed silver image.

**fast**   Refers to: 1) Photographic materials with a high sensitivity to light. 2) Lenses with a large maximum aperture (small f-stop number). A lens with maximum aperture f/2 is faster than one of maximum aperture f/4. 3) Shutter speeds of shorter duration. 1/500 second is faster than 1/125 second.

**FB**   Fiber base. *See fiber-based paper.*

**feathering a light**   Using the edge of the beam of light from a light source to provide a transition from more to less illumination on an area of the subject. Can be used to even out the illumination on a subject with objects at different distances from the light source, or to provide less illumination on some part of the subject, such as when lighting a backdrop.

**ferrotype**   1) To dry a fiber-base glossary-surface print in contact with a polished plate or drum to achieve extremely high gloss. 2) *See tintype.*

**fiber-based paper**   A photographic print material in which the emulsion is coated on a paper base. *See also resin-coated paper.*

**field coverage**   *See angle of view.*

**field curvature**   *See curvature of field.*

**field test**   To photograph subjects usually photographed in order to confirm equipment and material tests or calibrations performed in a studio.

**figure-ground relationship**   A simple visual structure in which an object of interest or a strong visual shape (the figure) is seen against a relatively neutral surrounding (the ground). *See also negative space.*

**file**   A document or image stored in digital form. The method used for arranging the data in the file determines its file format. Many different file formats exist, depending on the use of the file and the program that produced it.

**fill light**   Light that illuminates the shadow areas of a subject.

**film**   Photosensitive material consisting of a light-sensitive emulsion coated on a flexible transparent support.

**film clip**   A spring-action clip used either to hang film or, attached to the bottom of a film, to weigh it down during drying.

**film crimp marks**   *See crimp marks.*

**film exposure**   The product of the illuminance of the image falling on the film and the length of time the film is exposed to the image. Depends on camera settings and subject luminance. Since a lens image consists of many different illuminances, one for each luminance in the subject, each frame actually receives a scale of different film exposures. *See also relative exposure value.*

**film hanger**   A metal frame designed to hold a piece of sheet film for processing in tanks.

**film holder**   A lighttight container for film, which is inserted into a camera for use.

**film pack**   A lighttight package of several sheets of film that is inserted into the camera and gives a provision for progressing from one sheet to the next. Seldom used for sheet film today, but still used for instant-print materials.

**film plane**   The plane at which the film is located.

**film recorder**   A device that produces images on photographic film directly from a digital image file. Older film recorders produce the image by photographing a cathode ray tube. Newer ones expose the film with laser beams. The film is then traditionally processed.

**film sensitivity**   *See sensitivity.*

**film speed**   *See sensitivity.*

**filter**   1) A sheet of glass, plastic, or gelatin placed over a lens or light source that selectively absorbs specific wavelengths (colors) of light. 2) A software routine that alters a digital image by changing its sharpness or producing special visual effects. May be part of the image-processing program, or may be purchased as a third-party *plug-in.*

**filter factor**   A multiplication factor used to correct the exposure when using a filter on a camera. The exposure indicated by the meter (without the filter) is multiplied by the filter factor to produce correct exposure with the filter. Filter factors should be used when it is impractical to meter through the filter.

**filter pack**   A stack of filters combined to absorb specific colors of light. Most commonly used in printing color photographs.

**first developer**   In the processing of reversal color photographs, the first developing solution, producing a negative silver image that is reversed to a positive dye image in subsequent processing steps.

**fisheye lens**   An extreme wide-angle lens, generally one that has an angle of view of about 180° and produces a round image with a considerable amount of barrel distortion on a rectangular format.

**fix**   To treat a photographic material in fixer.

**fixed focus camera**   A camera with a lens that cannot be focused, but is prefocused at its *hyperfocal distance.* Usually found on simple snapshot cameras. Also called prefocused camera.

**fixer**   A chemical solution that removes unexposed and undeveloped silver salts from a photographic emulsion.

**flag**   *See gobo.*

**flare**   Light reflected internally in passage through a lens from the surfaces of the elements or from parts of the lens or camera body. This reflected light can spread throughout the image, reducing contrast by adding undesirable light to the dark parts of the image, or appearing as unexpected streaks and shapes of bright light in the image.

**flash**   Illumination provided by *electronic flash* units or *flashbulbs.*

**flashbulb**   A glass enclosure filled with metallic fibers that are ignited by an electric current to produce an intense burst of illumination for photographic purposes.

**flash card**   A removable digital storage device in the form of electronic chips contained in a small card that can be plugged directly into digital cameras or readers attached to a computer.

**flashing**   The application of white light to an area of a print before processing by using an external light source such as a small flashlight. Used to selectively blacken areas of the print.

**flash meter**   A photographic exposure meter capable of sensing and measuring the illumination from an electronic flash.

**flash synchronization**   *See synchronization.*

**flat**   1) Lower than normal or desired contrast when used to describe a subject, lighting, a negative, or a photograph. *Gray* and *soft* are terms often used in place of flat, but are not preferred since they have other meanings in the description of photographic subjects, lighting, and images. 2) A large, flat, moveable surface that is used in a studio for controlling illumination. White flats are used to reflect light for redirection or diffusion, and black flats are used to absorb unwanted light. Flats can also be used as backdrops.

**floodlight**   A studio light that provides a broad beam of illumination.

**flop**   To place a negative or transparency with the emulsion side up in an enlarger when printing in order to reverse the image left-to-right.

**flush mount**   *See bleed.*

**f-number**   *See relative aperture.*

**focal length**   For a simple lens focused on an infinitely distant subject, the distance between the center of the lens and the point on the axis of sharpest focus. For a compound lens the focal length is measured from the rear nodal point of the lens to the point on the axis of sharpest focus. Increasing the focal length increases the image magnification for a given subject distance. *See also nodal point.*

**focal plane**   The plane of sharpest focus for a flat subject perpendicular to the lens axis.

**focal-plane shutter** A shutter that is located as close as possible to the film. Consists of a flexible curtain or a series of metal blades producing a rectangular slit that crosses the film for exposure.

**focal point** The point at which the image of an object point is at its sharpest focus.

**focus** The condition in which the film is located at the focal point for a particular subject distance.

**focusing** The act of adjusting the lens-to-film distance in order to bring the image of a particular subject to its sharpest focus on the film plane.

**focusing cloth** An opaque cloth draped over the ground glass of a view camera to block environmental light from the ground glass and make the image easier to see.

**focusing magnifier** A device that shows a magnified view of the projected image from an enlarger, providing for more accurate focusing. Also called grain focuser or focusing aid.

**focusing scale** A scale inscribed on a lens or camera bed that indicates the distance for which the lens is focused.

**fog** 1) An overall layer of silver (density) in a negative or print due to chemical action, age, exposure to heat, and so on. 2) Undesired density on film or paper due to accidental exposure of the photosensitive material to light before or during development.

**forced perspective** The apparent expansion of the distance between objects in a photograph taken with a short-focus lens at close distance. Also called wide-angle perspective or wide-angle distortion, although it is not distortion in the optical sense. *See also compression (1).*

**foreshortening** *See compression (1).*

**form** The three-dimensionality of an object. Must be implied in a photograph, since depth cannot be directly perceived in a two-dimensional photograph. The representation of shadows on the surface of an object (called shading or modeling) shows its form. Form can also be implied by the distortion of lines on the surface of an object. Also called volume.

**format size** The size of the image produced on a film. Format size is determined by camera design and film size.

**FP** Focal-plane flash synchronization, for use with focal-plane class flashbulbs, which have a long peak intensity for use with focal-plane shutters.

**frame** 1) The boundaries of a photographic image. 2) To adjust camera position or lens focal length to control which parts of a subject will be included in the image. 3) A single image on a roll of film.

**frame numbers** Numbers imprinted on the borders of strips of film to identify individual frames.

**free-lance** A photographer who is self-employed and must generate business from a variety of clients.

**fresnel lens** A positive, plano-convex (flat on one side, convex on the other) lens that is made lighter and thinner by collapsing the lens into a series of concentric sections, each retaining the curvature of a single convex surface. Used in spotlights to concentrate light and in camera viewing systems (in contact with the ground glass) to even the brightness of the viewing screen.

**frilling** The peeling away of small bits of emulsion along the edges of film or paper.

**frisket cement** A removable rubber-based cement used to protect specific areas of a print from being affected during toning.

**front lighting** Illumination that reaches the subject from the direction of the camera.

**f-stop number** *See relative aperture.*

**full-frame print** A print of the entire image that appears on the negative or transparency.

**full-range print** A print showing the maximum black and the maximum white of the printing paper, if demanded by the subject matter.

**full-scale print** A print that represents as faithfully as possible the total number of tones appearing in the subject.

**full-scale subject** A subject with a large number of luminances, from low to high.

**fully detailed dark tone** The darkest area of the subject that shows full detail and texture in the print.

**fully detailed light tone** The lightest subject area that shows full detail and texture in the print.

**gaffer** In the movie industry, a person who is responsible for arranging and operating lighting equipment.

**gaffer's kit** A collection of tools, supplies, and materials that are useful for working on lighting equipment or sets in a studio or on location.

**gaffer tape** A heavy-duty adhesive tape used for a variety of purposes in a studio. The adhesives used in gaffer tape leave no residue when the tape is removed.

**gallium photodiode (GPD)** A light-sensitive solid-state device used in photographic exposure meters that has a fast response time, no memory of high light levels, and low sensitivity to infrared radiation.

**gamma (γ)** The slope of the straight-line portion of a characteristic curve. Gives a rough indication of the contrast for that film-developer combination and amount of development, but is no longer widely used because it does not take into account the shape of the toe portion of the curve, which is currently used in photographic reproduction, and because some modern films have no true straight-line portion. *See also contrast index.*

**GAP** Gallium-arsenide phosphide, a compound used in the making of *gallium photodiodes.*

**gel** Slang term for *gelatin filters,* but also loosely used for any flexible plastic filter.

**gelatin** An organic protein substance manufactured from skins, bones, and other parts of animals. Serves as a carrier for silver salts in modern photosensitive emulsions.

**gelatin filters** Filters made of lacquered gelatin. Suitable for use in an image path. Useful when several filters must be combined because of their thinness.

**glacial acetic acid** The highly concentrated form of acetic acid, about 99 percent dilution. Capable of badly burning skin on contact. *See also acetic acid.*

**glare** Bright reflected light, from a surface. Usually specular but may also be partially diffused.

**glossy** 1) Describes fiber-based printing papers with a smooth surface suitable for ferrotyping, or resin-coated papers with a mirror-like surface. 2) Describes subject surfaces that are very smooth and capable of producing clear specular reflections but only indistinct reflected images of surrounding objects.

**G.N.** *Guide number.*

**gobo** Any opaque object used to block unwanted light from the subject or camera lens. Black materials are normally used to prevent scattering reflected light into the environment. Also called a flag or cutter.

**GPD** *See gallium photodiode.*

**gradation** *See local contrast.*

**grade** *See paper contrast.*

**graded-contrast paper** Black-and-white printing paper that has a fixed *paper contrast*, indicated by a number on the packaging. To change paper contrast, a new pack of paper with a different grade number must be used. *See also variable-contrast paper.*

**gradient** The rate of change of one variable compared to another. In a graphical presentation of the relationship between the two variables, this is the slope of the curve, which is the amount of vertical change divided by the amount of horizontal change (or the rise over the run). In photography, this refers most commonly to the slope of a characteristic curve, which is directly related to contrast. *See also gamma.*

**graduate** A container with an inscribed scale used for measuring liquids.

**grain** A granular texture visible under magnification in processed silver-halide emulsions, a result of clumping of the silver particles during processing.

**grain focuser** *See focusing magnifier.*

**gray** Describes a surface of neutral color, which reflects in equal proportions all colors of light incident on it. Although it is often thought of as a medium reflectance, the color gray can appear in any value from neutral black to neutral white. Also commonly but inaccurately used to describe a photographic print that is too low in contrast. *See also flat.*

**gray card** *See 18 percent gray card.*

**grayscale** A series of neutral tones. A step gray scale contains only a few of the infinite number of values of gray possible with continuous-tone photographic materials. A common choice of gray scale used in printing breaks the continuous gray scale into ten tones, ranging from the maximum black of the paper to the maximum white of the paper.

**grayscale image** A *monochrome image* in which the tones of the original are represented as shades of neutral gray. In digital imaging, grayscale images are usually 8-bit images, with 256 shades of gray.

**ground** *See figure-ground relationship.*

**ground glass** A sheet of glass with a uniformly roughened surface. It is used in some cameras to allow viewing of the aerial image formed by the camera lens.

**group** In lens design, one or more elements identified as a single component of a compound lens.

**guide number (G.N.)** In photography using flash illumination, a number given in feet or meters, used for calculating the f-stop required for a given flash-to-subject distance. To find the correct f-stop, the guide number for the flash is divided by the flash-to-subject distance.

**gum-bichromate process** A photographic printing process that is dependent upon the hardening effect of light on gum arabic mixed with potassium dichromate. Watercolor pigments can be added to the gum-dichromate mixture, producing prints of any desired color. Also called gum-dichromate process or gum process.

**hair light** A light used to illuminate the hair. Often placed above and slightly behind the model.

**halation** Unwanted exposure in the emulsion of a film that results from image light passing through the emulsion and reflecting off the backing to expose the emulsion a second time. It is called halation because of the halo effect it creates around the image of a bright light source. It can be reduced by *anti-halation backings* on films.

**halftone** A technique used for reproducing photographs in ink, in which the continuous-tone photographic image is broken down into small dots whose varying size and frequency simulate different tonal values.

**halides** Compounds that have iodine, chlorine, or bromine as a component. Silver halides are the most commonly used light-sensitive agent in photosensitive materials.

**hand-held meter** A light meter contained in its own integral housing, as opposed to an in-camera meter.

**handle** In digital imaging, a point on a selection marked by an icon that can be dragged to change the shape or position of the selection.

**hanger** *See film hanger.*

**hard** 1) In lighting, describes specular light. Also sometimes used to describe high lighting contrast, although the term *harsh* is preferable to avoid confusion. 2) Photographic printing paper of high contrast is also called hard.

**hardener** A chemical that limits the softening of gelatin emulsions when wet. Often included in fixer formulations.

**hardware** The physical electronic and mechanical parts of a computer system.

**harsh** A harsh lighting situation is one with high lighting contrast.

**haze filter** A filter of yellowish color that absorbs some of the blue and ultraviolet light present in atmospheric haze. The effect is to darken areas containing haze.

**H/D curve** *See characteristic curve.*

**heliograph** The first permanent photographic process, invented by Niépce. It made use of pewter plates coated with bitumen of Judea, an asphaltic varnish that hardens

with exposure to light. After exposure to an image, the plates were washed with a solvent to produce a one-of-a-kind direct-positive nonsilver image.

**high-contrast image**   A photographic image in which a subject with a full scale of luminances has been rendered as only two tones, black and white, with no intermediate tones shown. Sometimes called a dropout.

**high key subject**   A subject with predominantly light tones and only small areas of midtones or dark tones.

**highlight mask**   An underexposed black-and-white high-contrast negative of a color transparency showing density only in the subject light-tone areas. It is used in the preparation of a contrast reduction mask for printing the color transparency in order to retain local contrast and correct values in the highlights, at the same time reducing overall contrast in the print. *See also mask.*

**highlights**   The light tonal areas of a subject, represented by the high-density areas in the negative and the light print values in the print. *See also specular highlight.*

**hinge mounting**   Use of small hinges made of rice paper or archival tape to attach a print to a support board.

**histogram**   A graphical representation of the occurrence of tones or colors in a digital image.

**hold back**   *See dodge.*

**holder**   *See film holder.*

**home page**   The opening screen for a Web site that usually contains *links* to other pages within the Web site.

**horizontal framing**   Holding a camera with a rectangular format so that the long dimension of the image is horizontal. Called landscape orientation for computer printers.

**hot light**   *See incandescent lamp.*

**hot shoe**   A flash mounting shoe on a camera that contains the contacts needed to fire an electronic flash mounted in the shoe when the shutter is released.

**hue**   The specific color associated with a wavelength of light. *See also saturation, value.*

**Hurter/Driffield curve**   *See characteristic curve.*

**hydroquinone**   A developing agent that is slow acting but produces high contrast. Often used in combination with *metol*, another developing agent.

**hyperfocal distance**   The focused distance for a lens that provides the greatest possible depth of field for any given aperture, from half the hyperfocal distance to infinity. The hyperfocal distance is determined by formula from the focal length of the lens, the aperture at which it is set, and the standards of acceptable sharpness (the size of the circle of confusion). *See also circle of confusion, depth of field.*

**hyperfocal focusing**   Focusing a lens at the hyperfocal distance for the aperture set.

**hypo**   Fixer.

**hypo-clearing bath**   *See hypo eliminator.*

**hypo eliminator**   A chemical solution that is used after fixing a photosensitive material to convert residual fixer to a form that is more easily washed from the material. *See also washing aid.*

**hypo neutralizer**   *See hypo eliminator.*

**idea book**   A scrapbook or file in which examples of published photographs are kept as a source of ideas or inspiration. Also called clip file, source file, or swipe file.

**illuminance**   The amount of light falling on a surface. An incident-light meter measures illuminance.

**illuminance meter**   *See incident-light meter.*

**illumination**   Light falling on a surface. The measure of this light is called the illuminance.

**image**   1) The optical pattern of light formed by a lens that represents the subject matter in front of the lens. 2) Any photographic representation of subject matter in the form of a print, negative, or positive transparency.

**image distance**   In optics, the distance from the rear *nodal point* to the *focal plane.*

**image fall-off**   *See fall-off.*

**image magnification**   A measure of the size of the image on the film compared to the size of the original subject, or the size of the image on the baseboard of an enlarger compared to the size of the negative image. An image magnification of $2\times$ indicates that the image is twice the size of the original object. An image magnification of $2\times$ would be an image ratio of 2:1.

**image sharpness**   1) The amount of blurring in a photographic image due to movement or poor focus adjustment. The less blur that is present, the sharper the image is. 2) In design, the use of image blurring or lack of blurring as a visual element.

**implied lines**   A visualized line defined by the mental connection of two or more visual elements that are visually attractive, similar in shape, or in close proximity to each other. The attempt to follow the direction of a subject's gaze in the photograph also creates an implied line. A moving object implies a line of travel.

**implied shape**   A visualized shape created when implied lines enclose an area.

**I.M.R.**   *Incident-light meter reading* (as used in this book).

**in-camera light meter**   A light meter built into the body of a camera.

**incandescent lamp**   A light source containing a tungsten filament within a glass or quartz bulb. Produces continuous light when an electric current is passed through the filament. Also called tungsten lamp. Studio lights using incandescent lamps are often called hot lights. *See also quartz-halogen.*

**incident light**   Light falling on a surface; illumination. Measured as illuminance.

**incident-light meter**   A meter that measures the amount of light falling on the subject (illuminance). It is normally placed at the position of the subject and pointed back toward the camera. Also called illuminance meter.

**incident-light meter reading (I.M.R.)**   A measurement of illuminance made with an incident-light meter.

**index of refraction**   A measure of a transparent material's ability to bend light rays. The higher the refractive index, the more an oblique ray of light is bent when it passes into or out of the material.

**indexed color** A digital image in which specific colors are referenced by the number assigned to each pixel. In a 1-bit image a pixel can be one of only two colors. An 8-bit image has 256 color choices for each pixel. Used to reduce file size for images intended for use on the World Wide Web. *See also bit depth.*

**indicator stop bath** A stop bath that changes color when it is exhausted, usually from yellow when fresh to purple or blue when exhausted.

**indoor film** *Tungsten film.*

**infinity** In optics, a subject distance so great that the rays of light reaching a lens from the subject appear parallel, and come to a focus at the principal focal plane of the lens, which defines the *focal length* of the lens.

**infrared** Electromagnetic energy with wavelengths just longer than those of red light. Not visible.

**infrared film** Film that is sensitive to infrared radiation near the visible spectrum. Infrared film is also sensitive to some visible light and must be used with special filters if only the effect of infrared is desired. Since infrared films are not sensitive to the long wavelength infrared associated with heat, special imaging techniques must be used to record heat radiation.

**inkjet printer** A computer printer that produces images and text by spraying tiny drops of ink onto paper or other media.

**inspection** Determining the desired amount of development by periodically looking at a film under a very dim green safelight during development. As opposed to *time-and-temperature development.*

**instant film** Film with incorporated developers that produce a finished photograph within seconds or minutes of making the exposure. Instant-print films produce a print, while other instant films produce color or black-and-white transparencies. The original Polaroid process invented by Edwin Land was the first instant-print process.

**intensification** A chemical process that increases the density of a processed photographic image.

**intensifier** A chemical solution used in intensification.

**intensity** A measure of the rate at which light is emitted from a light source in a specific direction.

**interchangeable lens** A lens that can be removed from the camera body, allowing the attachment of different lenses or accessories.

**interference** The reduction or increase of energy caused by the superimposition of two waves of close wavelength. The reduction of reflected light by lens coatings depends on interference between transmitted and reflected waves.

**intermittency effect** The fact that lower density will result from several repeated exposures on a photosensitive material than from a single equivalent exposure. For example, four 5-second exposures would yield a lower density than one 20-second exposure would.

**internegative** A photographic negative made from a positive transparency as an intermediate stage to producing a print from the transparency.

**Internet** A world-wide system of linked computers allowing communication and data file transfer from user to user. Sometimes called the Net. *See also World Wide Web.*

**Internet service provider (ISP)** A business that allows an individual user to connect his or her own computer to the Internet. Connection to the ISP can be by modem, cable, satellite, or other data transfer method.

**interpolated resolution** A method of increasing the apparent resolution of a digital image by creating new pixels by *interpolation.*

**interpolation** In digital imaging, creating new pixels based on the color and luminosity of adjacent existing pixels.

**inverse square law** A law that states that the illumination from a *point source* varies inversely with the square of the distance. Doubling the distance from the point source will produce one-fourth the illumination. The inverse square law roughly applies to any source with a physical size that is small relative to the distance from light to subject.

**inversion** Agitating film during development by turning the tank completely upside-down and back about a horizontal axis through the center of the tank.

**iris diaphragm** *See diaphragm.*

**irradiation** Scattering of light within a photosensitive emulsion. Irradiation reduces resolution and apparent sharpness.

**ISO** *International Organization for Standardization.* Also designates an exposure index system devised by that organization. The ISO number is a combination of the ASA and DIN numbers.

**ISP** *See Internet service provider.*

**K** Kelvin temperature scale.

**Kelvin temperature scale** A temperature scale that begins at absolute zero and has the same size increments of temperature change as the Celsius scale. Used in the designation of *color temperature.*

**key light** *See main light.*

**kicker** A light used to separate subject matter from a background. Often placed low and slightly behind the subject.

**lamination** The adherence of a sheet of transparent plastic to the face of a photograph for protective purposes. A second sheet of plastic is sometimes adhered to the back of the photograph as well.

**landscape orientation** *See horizontal framing.*

**large-format camera** A camera that produces an image on the film equal to or larger than 4″ × 5″ and usually uses sheet film.

**laserjet printer** *See electrostatic printer.*

**latent image** An image on a photosensitive material that is invisible to the naked eye. It is composed of small specks of silver reduced from silver salts by the action of light in the optical image formed by a lens. Development reduces more silver in the area of the latent image, creating a visible photographic image.

**latitude** *See exposure latitude.*

**law of reflection**   A law that states that the *angle of reflection* is equal to the *angle of incidence.*

**layout**   An arrangement of photographs, type, and other graphic material for publication purposes.

**LCD**   *Liquid crystal display.*

**leader**   A piece of paper or film at the beginning of a roll of film that allows loading and handling the film without exposing the first frames.

**leaf shutter**   A shutter consisting of a series of overlapping metal leaves, which move radially to open for exposure.

**LED**   *Light-emitting diode.*

**lens**   One or more pieces of glass or transparent plastic with curved surfaces designed to produce an optical image of light. *See also compound lens, simple lens.*

**lens barrel**   *See barrel mount.*

**lensboard**   A wooden, metal, or plastic mounting device that allows lenses used in enlargers or view cameras to be easily attached and removed.

**lens coating**   A thin coating on a lens surface designed to reduce the amount of light reflected from the surface, thereby reducing lens flare and increasing image contrast and lens transmission.

**lens contrast**   The difference between light and dark that a lens can reproduce in its image in fine subject detail.

**lens element**   *See element.*

**lens extension**   Usually the same as *bellows extension* or *image distance.* This distance must be increased as subject distances are reduced. In some cases this term refers to the image distance minus the focal length.

**lens hood**   *See lens shade.*

**lens mount**   The mechanical coupling between camera body and lens that allows the lens to be removed from the body.

**lens resolution**   The ability of a lens to produce a distinct image of closely spaced lines.

**lens shade**   A black cylindrical or conical attachment placed on the front of a lens to prevent flare-producing light outside the picture area from striking the lens surface.

**lens tissue**   Tissue paper designed especially for cleaning coated lens surfaces.

**light balancing filter**   A colored filter designed to alter the color balance of light sources to match a specific film color balance. Similar to *conversion filters,* but designed for smaller changes in the color of the light.

**light-emitting diode (LED)**   Small solid-state device that produces light. Used as an indicator light in cameras, meters, and other photographic equipment.

**lighting contrast**   The difference between the illumination supplied to (incident on) the fully lit parts of the subject (the diffused highlight) and the illumination incident on the parts of the subject shaded from the direct effect of the lighting (the shadow areas). Sometimes given in stops, but often expressed as a *lighting ratio.* High lighting contrast is often called harsh or contrasty and low lighting contrast is called flat.

**lighting ratio**   The ratio between the illuminance at the diffused highlight and the illuminance in the shadow. A lighting ratio of 2:1 means that twice as much illumination is being supplied to the fully lit areas as to the shadow areas (in other words, one stop difference in incident-light meter readings).

**light meter**   *See exposure meter.*

**light table**   A table with a translucent surface illuminated from below, used to inspect negatives and transparencies.

**light tent**   Translucent materials arranged around a still-life subject to control surface reflections, especially in mirror-like surfaces such as polished metal. The subject is lit by lighting through the light tent.

**lighttight**   Describes any container or enclosure that is totally opaque and sealed so that light cannot enter.

**light trap**   A specially designed opening into a room or lighttight container that allows passage of objects, air, or people, but does not allow light to enter.

**line**   A visual element defined by the boundary between darker and lighter tones. Lines may be straight or curved.

**linear perspective**   The relative size in a photograph of objects at different distances from the camera. It is one of the principal indicators of depth in a photograph, the dwindling size of objects indicating greater distance from the camera. Perspective can be changed only by changing the distance from the camera to the subject.

**line copy**   A high-contrast photographic rendition with only two tones, black and white, usually of type or drawings containing only black and white tones.

**link**   A graphic icon or highlighted text in a Web page that when clicked takes you to a different place in the Web page or to another Web page or Web site.

**liquid crystal display (LCD)**   Electronic devices whose surfaces can be electrically induced to display patterns, including numbers, letters, and symbols. Used to display information in cameras, meters, and other photographic devices with digital readouts, as well as some computer monitors.

**lith film**   Slang for *lithographic film.*

**lithographic film**   High-contrast *orthochromatic* film designed for use in graphic arts and in photomechanical reproduction of photographs.

**local contrast**   Tonal or density separation within a particular area of a photographic image. Also called gradation.

**location photography**   Production of controlled photographs not in a studio, but in a spot chosen either for its pictorial possibilities as an environment for the subject or because of its convenience.

**long-focus lens**   A lens with a longer than normal focal length. Long-focus lenses for 35mm range from a moderate 70 mm to 500 mm (giving 10× the image magnification of the normal lens) and longer. Long-focus lenses for small formats are often of *telephoto* design, and the term telephoto is widely, if not always accurately, used to describe any long-focus lens.

**long lens**   *See long-focus lens.*

**low key subject**   A subject with predominantly dark tones and only small areas of midtones or light tones.

**luminance** The amount of light reflected from, emitted from, or transmitted through a surface. Luminance due to reflected light is determined by the illumination on the surface and the reflectance of the surface. A reflected-light meter measures luminance.

**luminance meter** *See reflected-light meter.*

**M** Medium flash *synchronization* for M-class flashbulbs.

**macro lens** A lens that has extra focusing extension in the lens barrel for close-up photography, with the ability to focus at distances from infinity to close enough for an image size equal to or half of the size of the original subject. The lens elements are designed for optimum image quality at close focusing distances.

**macrophotography** *See photomacrography.*

**macro-zoom** A zoom lens that includes extra focusing extension for moderate close-ups.

**magnification** *See image magnification.*

**main light** The light that principally determines the shape and position of shadows and highlights on the subject. Also called the key light.

**manual exposure** Transferring the readings from a meter reading manually to the shutter speed and aperture scales. As opposed to *automatic exposure.*

**manual flash** A flash unit that requires measuring or estimating the flash-to-subject distance and using a chart, table, or calculator to determine the correct f-stop for that distance. This f-stop is manually set on the aperture scale. As opposed to *automatic flash* or *dedicated flash.*

**manual mode** For cameras or meters with automatic features, the operational setting that allows manual operation of the controls.

**mask** 1) A same-size underexposed negative or positive of an original color negative or positive transparency, which is sandwiched with the original during printing to control print contrast. *See also highlight mask.* 2) A high-contrast image of the original, or an opaque material cut in the proper shape, used to block light from part of the image during printing.

**masking** Using a mask during printing.

**mat** 1) A piece of cardboard with an opening cut in it, which is placed over a photographic print to act as a border for the image. Also called overmat or window mat. 2) Any piece of cardboard used for mounting or overmatting a photographic print.

**match-needle system** An exposure meter readout in which two needles are superimposed to make a reading.

**mat knife** A device with a blade specially designed for cutting mats for mounting or overmatting prints. Some mat knives allow the blade to be angled for a bevel cut.

**matrix metering** An in-camera *metering pattern* in which the field of view is divided into zones. Each zone provides a meter reading to a built-in computer that analyzes the readings and provides a single meter reading.

**matte** Describes the surface of a print or other object that is smooth but dull in finish as opposed to glossy.

**medium-format cameras** Cameras that use 120 or 220 roll film and produce several different image sizes depending on the model but are limited by the width of the film, which is 60mm.

**memory** 1) In some meters and cameras, the ability to store meter readings or other data that can be recalled at a later time. 2) A characteristic of the cadmium sulfide metering cell, which will give inaccurately high readings for some time after being exposed to a very bright light source such as the sun.

**meniscus** A simple lens design that has one concave and one convex surface with the centers of curvature of the surfaces on the same side of the lens.

**metaphor** A photograph that implies ideas unrelated to the subject matter pictured. Also called equivalent.

**metering pattern** The shape of the area sensed by the meter, when pointed at a flat surface perpendicular to the direction of metering. Most meters have either a circular or rectangular metering pattern, but a few meters do have other patterns.

**meter reading (M.R.)** A reflected-light meter reading, as used in this book. A measure of the average subject luminance in that area and may be given in terms of a meter number, EVs, or a suggested f/stop and shutter speed, depending on the type of meter. *See also incident-light meter reading (I.M.R.).*

**metol** A developing agent used in the formulation of developers that is relatively fast acting, but produces low contrast. Often used in combination with *hydroquinone.*

**microphotography** The production of photographs at great reductions of size. The opposite of *photomicrography.*

**microprism** A multitude of small prisms embedded in a focusing screen as a focusing aid.

**middle gray** A neutral color of 18 percent reflectance. *See also 18 percent gray card.*

**midtone** Any subject tonal value close to the middle of the scale of possible subject tonal values. Also the corresponding density in the negative or the corresponding print value in the print.

**miniature-format cameras** Cameras that use *Advanced Photo System* film for a 16 × 24mm format. Specialized miniature cameras such as the Minox also fall in this category.

**mirror lens** A lens that uses curved mirror surfaces for image formation. *See also catadioptric, catoptric.*

**model** 1) A person (or in some cases a trained animal) who poses for a photograph and responds to the direction of the photographer with regards to position and expression. 2) A three-dimensional representation of an object constructed to be photographed in place of the real thing. For example, food models constructed of plastics or other materials are sometimes used in place of the food itself.

**modeling** 1) Posing for a photograph at the direction of the photographer. *See also pose.* 2) The representation of shadows on the surface of an object to show its form. Also called shading.

**modeling light** An incandescent bulb placed as close as possible to the flash tube of an electronic flash to give a visual indication of the direction and quality the flash illumination will have.

**model release** *See release.*

**modem** An electronic device attached to a telephone line that allows sending or receiving digital data.

**monobath** A chemical solution for processing films that includes developer and fixer in a single solution.

**monochrome image** A photographic image that reproduces the colors and tones of the subject as shades of a single color, usually a neutral gray. Also called black-and-white image.

**monolight** A studio electronic flash that includes the power pack, flashtube, and modeling light in one housing.

**monopack** *See monolight.*

**montage** *See photomontage.*

**motor drive** A device incorporated in or attached to a camera that automatically advances the film after each exposure. Slower or lighter-duty motor drives are often called winders.

**mottle** An uneven appearance, especially in the dark-tone areas of a print, resulting from too little development or no agitation during development.

**MQ** Describes a developer that uses a combination of *metol* and *hydroquinone* as a developing agent.

**multicoating** A lens coating technique that uses more than one layer on the lens surface. *See also lens coating.*

**multiple exposure** Exposing the same sheet or frame of film to two or more successive images, either accidentally or intentionally for aesthetic purposes.

**N + 1 development** An *expansion development* time that will cause an area of a negative with a film exposure of REV + 1 to print as PV + 2, a fully detailed light tone.

**N − 1 development** A *compaction development* time that will cause an area of a negative with a film exposure of REV +3 to print as PV +2, a fully detailed light tone.

**nanometer** A unit of measure equal to one-billionth ($10^{-9}$) of a meter.

**narrow lighting** *See short lighting.*

**natural light** Light from sources occurring in nature, including sunlight, moonlight, and firelight. The only natural light source commonly used for illuminating a subject for photographic purposes is the sun, though occasionally open flame or moonlight is used.

**ND** *Neutral density.*

**negative** A photographic image on film or paper that shows a reversed relationship of tones when compared with the original subject—light subject tones are represented as dark tones and dark subject tones are represented as light tones. A color negative image is also reversed in color, with subject areas represented as the complement of their original color. *See also negative lens, negative space.*

**negative carrier** A frame designed to hold a negative flat and aligned within an enlarger.

**negative contrast** The difference in density between the areas of the negative representing the dark subject tones and those representing the light subject tones. Can be measured using a densitometer. Depends on subject contrast, amount of development, type of film, and film freshness.

**negative film** A film that, when processed, produces a negative image of the subject.

**negative image** *See negative.*

**negative lens** A lens that causes parallel light rays to diverge.

**negative space** In a *figure-ground relationship*, a ground that is relatively featureless, with fairly uniform tonal values.

**neutral** 1) In reflection or transmission of light, describes a material that reflects or transmits all wavelengths of light in the same proportion, leaving the color of the light unchanged. The color of a neutral material is described as gray. 2) In chemistry, describes a solution with a pH of 7.0, neither basic nor acidic.

**neutral density (ND) filter** A filter that absorbs light without changing the color of the transmitted light. Neutral density filters are marked with their density; an ND 0.3 filter transmits 50 percent of the light incident on it, resulting in a one stop change in exposure.

**nicad battery** A rechargeable battery that uses a nickel-cadmium cell. Used as a power source in some portable photography equipment.

**nodal plane** In optics, the plane defined by the intersection of the extensions of incoming parallel rays of light and the exiting rays of light. In a simple lens, this coincides generally with the physical center of the lens, but with compound lenses it may fall within or outside the physical limits of the lens. A compound lens has two nodal planes, the second defined by parallel rays entering the back of the lens.

**nodal point** In optics, a point that is the intersection of the axis with the nodal plane. A compound lens has two nodal points, one on the object side—the front nodal point—and one on the image side—the rear nodal point. Focal lengths and other image measurements are normally made from the rear nodal point.

**nonsilver process** Any photographic process that uses a light-sensitive material other than silver salts for image formation.

**normal development** The amount of film development needed to produce a negative from film exposed to a subject of normal subject contrast that will print on normal contrast paper with desired detail in dark tones and light tones (REV −2 should be the darkest fully detailed dark tone and REV +2 the lightest fully detailed light tone in the print).

**normal lens** A lens that produces an image that most closely approximates the view and apparent perspective seen by the unaided human eye. The normal focal length changes with format size, being approximately the distance across the diagonal of the image formed on the film.

For the 35mm camera format the normal focal length is about 50mm.

**normal subject contrast** The contrast of a subject in which placing a fully detailed dark tone at REV −2 results in a fully detailed light tone falling at REV +2. It can also be defined as a subject in which the difference in luminance readings from a fully detailed dark tone and a fully detailed light tone is four stops.

**notching code** Notches of specific patterns and shapes cut in an edge of sheet film allowing identification of both the film type and the emulsion side in total darkness. When you hold the film with the notches at the upper right-hand edge, the emulsion side faces you.

**null system** An instrument readout system in which readings are made by adjusting the controls until a pointer (needle, LED, or LCD) is pointing to a zero or center position. Used in some photographic meters, both hand-held and in-camera, and color analyzers.

**number-transfer system** A light meter readout system in which a number is indicated by a pointer (needle, LED, or LCD). The number must then be manually transferred into the calculator to find suggested camera settings.

**object** In optics, the subject material from which light is reflected or emitted for image formation.

**object distance** In optics, the distance between the subject and the front nodal plane of a lens.

**objective** In optics, the lens element or elements that are closest to the subject matter.

**off-axis** In optics, a subject or image that appears away from the axis of the lens, as opposed to *axial*.

**off-the-film (OTF) metering** An in-camera metering system that meters light reflected off the film during the exposure. Off-the-film meters are useful when light may change during the exposure or when the camera meter is capable of metering and controlling flash exposure.

**one-shot developer** A film developer that is used once and then discarded.

**one-time use** To use a chemical solution once and then discard it.

**opacity** A measure of the ability of a material to absorb light, equal to the reciprocal of the transmission. If a material transmits 1/2 of the light incident on it, its opacity is 2. The higher the opacity, the less light the material transmits.

**opalescence** A milky, hazy appearance, sometimes with a tinge of color. Seen in some films at certain stages of their processing and in opal glass, which is a diffusing glass with a very fine texture.

**opaque** 1) Incapable of transmitting light. 2) In retouching, a paint applied to negatives or transparencies to prevent light from passing through. 3) In retouching, to apply an opaque paint.

**open flash** Describes the process of opening the shutter using a bulb (B) or time (T) setting, firing the flash manually, and then closing the shutter. *See also painting with light.*

**opening up** Increasing the exposure on a photosensitive material by changing the aperture to a larger opening, for example, changing from f/11 to f/8. This term is also loosely used to indicate increasing the exposure by using a longer shutter speed, for example, changing from 1/250 second to 1/125 second.

**operating system** Computer software that performs basic operations and allows the user to communicate with the computer. The two most popular operating systems currently are the Microsoft Windows operating system used on PC computers and the Macintosh operating system used on Apple computers.

**optical resolution** For digital imaging devices (scanners, cameras), the number of pixels per inch generated in the image directly by sensing cells (usually *CCDs*) in the device. *See also interpolated resolution.*

**optimum exposure** The exposure on a photosensitive material that yields the best quality results. In a negative, it is usually the least exposure that retains detail in the areas representing the dark tones of the subject. In a positive transparency or print, it is normally the exposure that gives desired tone and detail in the subject light-tone areas.

**ortho** Orthochromatic.

**orthochromatic emulsion** Emulsion that is sensitive to all colors except red and safe to handle under red safelights.

**OTF** *Off-the-film.*

**outdated** A photographic material labeled with an expiration date that has already passed.

**overdeveloped** Describes a photographic material that has received more than the necessary development. In a negative, overdevelopment results in excessive contrast.

**overexposed** Describes a photosensitive material that has received more than its optimum exposure. In a negative, overexposure results in excessive density, larger grain, and the possibility of blocked up highlights. In a positive transparency, overexposure results in loss of light-tone detail and overall tones that are too light. In a print from a negative, overexposure results in print tones that are too dark.

**overmat** *See mat.*

**override** To manually change a setting provided by an automatic operation. Many automatic metering systems, for example, offer a way to override the settings.

**oxidation** The chemical combination of a substance with oxygen, a major reason for deterioration of developers and other photographic chemicals.

**painting with light** The process of using repeated open flash or a moveable continuous light source to sequentially illuminate parts of a subject while the shutter is held open. This procedure is normally done in a darkened area, but can also be combined with preexisting light of low intensity.

**pan** 1) Panchromatic. 2) *See panning.*

**panchromatic emulsion** Emulsion that is sensitive to all the colors of the visible spectrum, although its degree of

sensitivity to individual colors may vary somewhat from that of the eye. Most general-purpose black-and-white films are panchromatic. Panchromatic materials must be handled and processed in total darkness.

**panchromatic paper** A special black-and-white printing paper sensitive to all visible colors. Used for making black-and-white prints from color negatives. Since it is sensitive to any color of light, panchromatic paper must be handled and processed in total darkness or under an extremely dim dark-green safelight.

**panning** Following the motion of a subject with the camera, usually with a slow shutter speed, giving a reasonably sharp subject image against a blurred or streaked background.

**paper** Commonly used to refer to photographic print materials, both fiber-based and resin-coated.

**paper contrast** The response of a photographic printing paper to changes in exposure. The higher the paper contrast, the greater the tonal difference for a given range of exposure. Print contrast is given as a number, the contrast grade, which may range from 0 to 5. Grade 0 produces the least contrast and grade 5 the most. The normal contrast grade is 2.

**paper negative** A negative image produced on a photographic print material. Can be made by using photosensitive paper in a camera or by exposing the paper to a positive image.

**parallax** A visual error that arises when the viewing system in a camera is in a different position than the lens that forms the image on the film, as in viewfinder or twin-lens reflex camera designs.

**parameter** Any physical variable that affects a result, such as time or temperature.

**parametrics** A graph of density versus developing time for a particular film and developer combination. The graph is in the form of a family of curves, one curve for each relative exposure value. Parametrics present much the same information that a group of several characteristic curves of different developing times would, with the difference being that developing times (normal, N + 1, N − 1, and so on) can be interpolated directly from the graph.

**pattern** Similar shapes, lines, or tonal areas repeated over an area of a photograph.

**PC card** A solid state device in the form of a card, which can be inserted directly into a computer or reading device. Primarily designed for digital data storage, but some cards may perform other functions such as modem operations. Formerly called PCMCIA card.

**PC connector** An electrical connector in which the male plug consists of a small pin surrounded by a concentric cylinder. Widely used for connecting flash synchronization cords to cameras.

**PC lens** *Perspective control lens.*

**PC terminal** The female half of the PC connector, a socket found on many camera bodies.

**pentaprism** A specially designed prism used in some camera designs to reorient a ground-glass image so that it appears upright and correct left-to-right to the eye.

**peripheral** Any electronic device connected to a computer to perform specific tasks; for example, printers, scanners, and external storage devices.

**perspective** *See linear perspective.*

**perspective control (PC) lens** A lens designed for small- or medium-format cameras that allows some vertical or horizontal shift for correcting the convergence of parallel lines in the subject.

**pH** A measure of the alkalinity or acidity of a solution. Acids have a pH of less than 7. Neutral solutions have a pH of 7. Bases (alkalis) have a pH of greater than 7.

**photodiode** A solid-state device that is sensitive to light. Used as a light-sensing cell in some photographic light meters.

**photoflood** Tungsten filament light bulbs similar in appearance to household bulbs but designed for photographic use. They provide more illumination and a color temperature compatible with tungsten balance color films.

**photogram** A photographic print produced by laying objects on a photosensitive material and exposing it to light.

**photogravure** A photomechanical process that uses etched metal plates to provide high quality reproductions of photographs in ink.

**photomacrography** Photography in which the image of the subject is life-size or larger on the film. Most photographers loosely include image magnifications as small as 1/5 life-size in this category. A less accurate but more commonly used term is macrophotography.

**photomechanical reproduction** The reproduction of photographs or other graphic material in ink by means of photosensitive plates used on mechanical printing presses.

**photomicrography** Highly magnified photographic images made using a microscope.

**photomontage** The combination of parts of images from two or more negatives into one print. The simplest method of making a photomontage is printing with a negative sandwich. Other methods include multiple images from different negatives printed sequentially on one sheet of printing paper, or an assembly of cut and pasted images. *See also sandwich.*

**Photo-Secession** A society formed in 1902 with the avowed intent to further the fight for the establishment of photography as art. Among its members were Alfred Stieglitz, Edward J. Steichen, Clarence H. White, Frank Eugene, and Gertrude Käsebier.

**photosensitive material** 1) A substance that shows a visible or measurable change when exposed to light. Photosensitive compounds that undergo a chemical change when exposed to light are used for films and printing papers. Light meters and electronic imaging use materials that exhibit a measurable electrical change when exposed

to light. 2) Often used as a general term to refer to photographic films and printing papers.

**Pictorialists** A loosely structured group of photographers who fought the battle for photography as an art from about 1890 through the first decade or two of the twentieth century. The term *Pictorialist* covered a wide range of styles, but the main principle that gave coherence to the movement was the idea that photography was a valid art form to be considered on an equal footing with painting, drawing, sculpture, and the other fine arts.

**picture element** *See pixel.*

**pincushion distortion** Curvilinear distortion in which the images of straight subject lines bow in at the edges of the photograph.

**pinhole** 1) Describes a camera that uses a tiny hole for image formation rather than a lens. 2) A tiny pit or hole in a photographic emulsion.

**pixel** Picture element. In digital imaging, refers to the small areas into which an image is divided for digitizing. The number of pixels determines the limits of *resolution* for a digital image, with a greater number of pixels providing higher resolution. *See also digital image processing.*

**place** To give an area of the film corresponding to a particular area in the subject a desired film exposure (REV) by choice of camera settings. For example, if an area of the subject has a reflected-light meter reading of M.R. f/8 at 1/60 second and the desired REV for this area is REV +2, a camera setting of C.S. f/4 at 1/60 second should be used. The area has been placed at REV +2. Only one area in a subject can be placed. The other areas fall at their own REV's. *See also fall.*

**placement** The procedure of metering the luminance of a particular subject area and manipulating the camera settings to produce a desired film exposure (REV) for that area. *See also place.*

**plane of focus** *See focal plane.*

**plate** 1) A photographic negative or positive on a sheet of glass. 2) In photomechanical printing, a sheet of paper, metal, or plastic that bears the image. 3) A flat surface that holds the film flat in a camera, usually called the pressure plate.

**platen** A flat surface used to flatten a material.

**platform** The physical computing system. The two most common platforms are the PC (meaning personal computer and referring to IBM-compatible systems), and the Macintosh system built by Apple. *See also operating system.*

**platinotype** *See platinum print process.*

**platinum print process** A photographic print process based on light-sensitive iron salts, which form an image of platinum metal in the finished print. Invented by William Willis in 1873, platinum papers were commercially available from 1880 until the early part of the twentieth century. Also called platinotype.

**plug-in** A software routine that is designed to perform specific tasks within a specific application. Plug-ins are not part of the application itself, but can be accessed from the application's menus. For example, scanner software may be supplied as a plug-in so the scanner operation can be accessed from within an application.

**point** In color printing, a change in filtration equivalent to a density change of 0.01.

**point of view** The direction and distance from which a subject is seen by the camera.

**point source** A hypothetical light source that emits light in all directions from a single point. Since a point has no dimension, it is impossible to manufacture a true point source. A tungsten filament has definite physical dimensions, but it is small enough that when viewed from some distance it behaves much as a point source. *See inverse square law.*

**polarized light** Light in which the electromagnetic waves are organized so that they all vibrate in the same direction. Appears naturally in reflections from nonmetallic surfaces at an angle of about 35° to the surface.

**polarizer** A filter that allows only light waves vibrating in a specific direction to pass. Can be used to produce polarized light from nonpolarized light, or to block polarized light from passing by orienting the filter against the orientation of the polarized light.

**polarizing angle** In reflection from nonmetallic surfaces, the angle at which the reflected light shows the largest amount of polarization. With many materials this angle is close to 35°, measured from the surface (55° measured from a perpendicular to the surface).

**polarizing filter** *See polarizer.*

**POP** *Printing-out paper.*

**portfolio** A group of photographs, usually presented in a protective container suitable for carrying or easy storage.

**portrait lens** A lens designed for taking portraits containing a provision for softening the image.

**portrait orientation** *See vertical framing.*

**pose** To assume positions and expressions for the purpose of being photographed. *See modeling.*

**positive** *See positive image.*

**positive film** Film that produces a positive image on a transparent base after processing. Positive films are available in both color and black-and-white. Also called reversal, slide, or transparency film.

**positive image** A photographic image on film or paper that shows the same relationship of tones or colors as the original subject. Dark subject tones are reproduced as dark tones in the image and light tones appear light.

**positive lens** A lens that converges, or brings to a focus, incoming parallel rays of light.

**posterization** The reproduction of a continuous-tone subject as an image containing only a few tones, accomplished with high-contrast materials or by digital image manipulation.

**postvisualization** Aesthetic decisions made about changing the appearance of a photograph after the exposure has been made on the film, usually in printing the image. *See also previsualize.*

**power pack**   The box or case that contains the electrical power source and control switches for operating one or more separately housed electronic flash tubes.

**preexisting light**   As used in this book, any illumination (natural, artificial, or a combination) on the subject that is coming from light sources other than those supplied by the photographer. Available, existing, prevailing, and ambient are all terms used by photographers to describe preexisting light, although ambient is also variously used to describe environmental light or continuous light.

**preservative**   In developers, a chemical substance that prolongs the life of the developer by retarding oxidation.

**previsualize**   To predict the final appearance of a photograph, both in composition and tonal values, while viewing the original subject.

**prewet**   To place film in a water bath prior to developing. Also called presoak.

**primary colors**   In additive color systems: red, blue, and green light, which combine in equal amounts to give white light. In subtractive color systems: cyan, yellow, and magenta dyes, which, when overlapped in equal amounts, produce neutral density.

**print**   1) A photographic image on an opaque base, usually paper. 2) To produce such an image from a photographic negative or positive transparency.

**print contrast**   1) The difference in reflective density (tonal value) between the areas representing the dark subject tones and those representing the light subject tones. 2) The degree to which a print shows a full range and scale of tones as demanded by the subject. Determined by how well the paper contrast matches the negative contrast. *See also contrasty, flat.* 3) An indication of the number of tones the print shows between maximum black and maximum white (the scale). A print with only two tones (black and white) from a subject with a full scale of tones is called a high-contrast print. *See also scale.*

**print finishing**   Any steps performed after the print is processed and dried to prepare it for presentation.

**print in**   *See burn.*

**printing filter**   A filter intended for use on an enlarger while printing, usually a color filter for printing color materials. Printing filters are generally not suitable for placing in the image path.

**printing frame**   A frame containing a sheet of glass, designed to hold photosensitive materials flat for exposure.

**printing-out paper (POP)**   A printing paper that does not require development, but produces a visible image directly from exposure.

**printing paper**   Photosensitive materials on an opaque base, usually paper.

**print quality**   A subjective term for describing the technical merits of a photographic print, including such things as image sharpness, contrast, lightness or darkness, and so on.

**print value (PV)**   1) Tone (reflectance) in a photographic print. 2) In this book, a numerical labeling system for print tones. The number attached to a print value is the same as the numerical value of the REV (film exposure) that produces that tone for normal developing and standard printing. For example, an area of the film receiving a film exposure of REV +1 will produce a print value of PV +1 if the film is developed normally and printed by standard methods.

**process**   1) To treat an exposed photosensitive material with a series of chemical solutions for the purpose of developing and preserving a visible photographic image from the latent image. 2) To correct or manipulate a digital image on a computer.

**process lens**   A lens of high optical quality used on copy cameras employed in photomechanical and other graphic arts applications.

**program**   Computer *software* designed to perform specific functions on the computer. Examples are word processing, database, spreadsheet, and image-processing programs. Larger programs are usually called applications; smaller programs may be called utilities or *plug-ins*.

**programmed mode**   On a camera that has several metering methods (modes), a control selection that changes the camera to program operation.

**program operation**   An automatic in-camera metering system that sets both the shutter speed and the aperture based on the amount of light and a built-in program of shutter speed-aperture pairs.

**projection print**   A photographic print made by projecting the image of a negative or transparency onto the paper in an enlarger.

**projection printing**   Using an enlarger to make a projection print.

**projector**   A device for projecting images of photographic transparencies in enlarged form onto a screen or other surface for viewing.

**proofing**   To make small photographic prints or contact prints of images for editing or selection purposes.

**prop**   Any object placed in a photograph to enhance the subject or contribute to the concept of the photograph. Shortened from property.

**property release**   *See release.*

**proportional modeling light**   A modeling light in an electronic flash head connected so that its intensity varies automatically as flash power is changed.

**protective toning**   The use of selenium or gold toner to protect a photographic silver image from deterioration with age.

**public domain**   Created material, such as photographs, on which the copyright has lapsed, making them available for anyone's use without compensation to the creator.

**pull**   To overexpose and decrease the amount of development of a film, for an apparent decrease in film speed.

**push**   To underexpose and increase the amount of development of a film, for an apparent increase in film speed.

**PV**   *Print value.*

**quality** 1) The desirable characteristics of a photographic image, as determined by objective measurements (resolution, acutance, and so on) or subjective judgments (sharpness, tonal reproduction, and so on). 2) The characteristics of illumination, including specularity, direction, color, and so on.

**quartz-halogen** A light source with a tungsten filament enclosed in a quartz bulb containing a halogen gas. Quartz-halogen lamps produce a more intense light for their size and have a longer burning life than photofloods.

**quartz lamp** *See quartz-halogen.*

**rack** To operate a focusing device, usually in a back and forth motion on each side of correct focus, gradually reducing the motion to accurately determine the point of best focus.

**random access memory (RAM)** Solid-state chips in a computer designed to store digital data. RAM is volatile, which means that if power to the chip is interrupted the data is lost. Access to data in RAM is very fast.

**range** The difference between the extremes of a physical characteristic. For example, the density range of a negative is the density difference from the lowest to the highest density. The term is also applied to contrast, print tones, luminance readings of a scene, and so on. Sometimes given as a ratio between the low and high values. Often used interchangeably with the term *scale*, which has a different meaning. *See also full-range print, full-scale print, scale.*

**rangefinder** An optical device for determining the distance from the camera to the subject in order to focus the lens.

**raster streaks** Streaks seen in photographs of television or other cathode ray tubes when a shutter speed fast enough to stop the scanning action of the tube is used.

**RC** *Resin-coated.*

**reading discrimination** The amount of exposure change a light meter is capable of distinguishing, given as a fraction of a stop.

**read-only memory (ROM)** Computer data stored on solid-state chips or other storage media that can be accessed but not changed. ROM chips do not lose data when power is interrupted and are used for storing the basic start-up instructions for the computer.

**readout** The mechanism or device used on a measuring instrument for providing numerical information to the operator.

**ready light** An indicator light on an electronic flash that lights when the capacitors are fully charged and ready to deliver power to the flash tube.

**real image** In optics, an image formed by a positive lens, which can be projected on a surface.

**realistic** *See representative photograph.*

**rear nodal point** *See nodal point.*

**reciprocity effect** *See reciprocity failure.*

**reciprocity failure** The failure of equivalent camera settings to produce equivalent density on the film, requiring increased exposure to produce the expected density, and changes in development to control contrast. Color films may also require color filtration corrections. Reciprocity failure occurs for long exposure times or very short exposure times. The exposure times requiring reciprocity failure corrections vary from film to film.

**reciprocity law** A law that states that the effect of exposure on the film, seen as density, is the same regardless of the rate at which the exposure is given. One demonstration of the reciprocity law is equivalent exposure settings, for which the same density can be achieved with many different combinations of aperture and shutter speed. *See reciprocity failure.*

**rectilinear** In optics, describes a lens that is free of *curvilinear distortion* and reproduces straight lines in the subject as straight lines in the image.

**reducer** A chemical solution used to lessen densities in photographic images. *See Farmer's reducer.*

**reducing agents** Chemical compounds that reduce silver-halide salts to metallic silver and the halide ion. Used in developers as developing agents.

**reduction** 1) The chemical process of breaking down light-sensitive silver salts to their component silver and halide during development. 2) The use of a reducer to lessen the amount of silver in an image. Note that this definition is the reverse of (1) in chemical activity. 3) A photographic image smaller than the original. The opposite of an enlargement.

**reel** A spiral-shaped wire or plastic spool onto which film is wound for processing.

**reflectance** The ability of a surface to reflect light. A surface with 18 percent reflectance reflects back 18 percent of the light falling on it.

**reflected-light meter** A meter that measures the amount of light transmitted, emitted, or reflected by the subject (the luminance). Normally pointed at the subject from the direction of the camera. Also known as luminance meter.

**reflection** Light that has been reflected from a surface. *See also diffusion, glare, specular highlight.*

**reflector** Any device used in photography to reflect light for the purpose of redirecting it or diffusing it.

**reflex camera** A camera that uses a mirror in its viewing system.

**refraction** The bending of light rays as they pass from one transparent medium to another.

**refractive index** *See index of refraction.*

**register** To superimpose two or more same-sized photographic images of the same subject on top of each other so that the images are perfectly aligned.

**relative aperture** A number, called the f-stop number, that is found by dividing the focal length of a lens by the effective diameter of its aperture. Also called the f-number.

**relative exposure value (REV)** As used in this book, a relative measure of film exposure, given as the difference in stops between the exposure an area of the film receives

and the standard film exposure produced by using the suggested camera setting resulting from a reflected-light meter reading. A Relative Exposure Value +1 (REV +1) means one stop more film exposure than the standard. REV −2 means two stops less film exposure than the standard. Relative exposure values are determined by using either placement or fall. A relative exposure value that is equal to the standard film exposure (that is, the camera settings used match those suggested by a reflected-light meter reading from an area) is labeled **REV M**. *See also fall, place.*

**relative film exposure**   *See relative exposure value.*

**release**   A contract between a photographer and a second person that gives the photographer the right to sell or otherwise make use of photographic images of that person (model release), or images of property belonging to that person (property release).

**repetition with variation**   A regularly repeated pattern in a photograph changed in one or more places to create a visual contrast.

**replenish**   The addition of chemical compounds to a used developing solution intended to replace depleted components of the developer for continued reuse.

**replenisher**   Chemical compounds or solutions used to replenish a developer.

**representative photograph**   A photograph that resembles the appearance of the original subject as much as possible within the limits of the medium.

**resin-coated paper**   A photographic print material with a paper base that is coated on both sides with a plastic material before the emulsion is applied.

**resolution**   1) A measure of the ability of a film to resolve fine detail, tested by exposing the film to a specially designed target with closely spaced parallel lines. A very high-resolution film can distinguish up to several hundred lines per millimeter, whereas a low-resolution film would distinguish fewer than fifty lines per millimeter. 2) In digital imaging, the number of *pixels* per inch or centimeter. *See also lens resolution.*

**restrainer**   A component in a developer that is intended to restrain the development process so that silver salts in unexposed areas of the film will not be reduced to silver.

**restricted-angle meter**   A light meter with a *viewing angle* of 15° or less.

**reticulation**   Wrinkling of the emulsion on a film due to sudden temperature changes during processing, resulting in a granular pattern in prints from the negative.

**retouching**   Correction of technical flaws or alteration of a photograph for aesthetic reasons, by hand techniques or computer.

**retrofocus lens**   A lens in which the rear nodal point is located some distance behind the physical body of the lens. This design is used for short-focal length lenses intended for single-lens reflex cameras, in order to leave room for the mirror between lens and film.

**REV**   *Relative exposure value.*

**reversal**   To change a photographic image from negative to positive during processing. Partial reversal of an image can also take place due to *solarization* or use of the *Sabattier effect.*

**reversal film**   *See positive film.*

**reverse adapter**   An adapter that allows an interchangeable lens to be mounted backwards on the camera for close-up photography.

**REV M**   A film exposure achieved by using the suggested camera settings from a reflected-light meter reading of a given area. For example, if an area is metered at M.R. f/8 at 1/60 second and the camera setting used is C.S. f/8 at 1/60 second, then that area on the film receives a film exposure of REV M. With normal development an area that received an exposure of REV M should print as 18 percent gray.

**RGB color**   A color system that uses the additive primaries (red, green, and blue) to reproduce colors. Computer monitors and televisions use RGB color.

**rim light**   A light source positioned behind the subject (on the side away from the camera) in such a way as to produce a rim of light outlining the subject.

**ring light**   A circular electronic flash tube designed to be mounted so that it encircles the lens. Produces a true front light used often in medical photomacrography.

**rising front**   A vertical movement of a view camera lens standard that is performed to keep vertical parallel lines, such as the corners of a building, parallel in the photograph.

**roll film**   A strip of film for several exposures rolled with protective opaque paper onto a spool. Roll films are threaded onto a removable take-up spool in the camera. Commonly available roll film sizes are 120 and 220.

**ROM**   *See read-only memory.*

**rotogravure**   An adaptation of the *photogravure process* to printing presses using rotating cylindrical plates.

**Sabattier effect**   A partial reversal of negative or print tones achieved by exposing the photosensitive material to light part way through the developing step, and then continuing the development and the remaining processing steps. A thin line, known as the Mackie line, is produced along boundaries between adjoining areas of dark and light subject tones.

**safelight**   A light providing illumination of the correct color for working with a specific photosensitive material. Blue-sensitive emulsions can be handled under a yellow or amber safelight. Orthochromatic emulsions can be handled under a red safelight.

**sandwich**   To stack two or more negatives or transparencies on top of each other in close contact in order to superimpose the images during printing or copying.

**saturation**   The brilliance or purity of a color, that is, the absence of other colors in that area. The colors of the rainbow show maximum saturation.

**save**   To write a digital data *file* to disk or other storage medium.

**SBC**  *Silicon blue cell.*

**SBR**  Subject brightness range. More accurately, the *subject luminance range.*

**scale**  1) The number of values between two extremes. For example, the number of luminances between darkest and lightest in a subject; the number of densities between maximum and minimum in a negative; or the number of tones in a photographic print between the maximum and the minimum tones. *See also full-scale print.* 2) A series of densities or tones as reproduced by a photographic material assembled into a strip, as in a *gray scale. See also tone ruler.* 3) The actual size of an object. Objects of known and obvious size may be included to demonstrate the actual size of another object in the photograph, that is, to show its scale. Choice of lens focal length and point of view may sometimes create a false sense of scale for objects in a photograph.

**scan**  To convert an *analog image* (such as a photographic print or film) to a *digital image.*

**scanner**  An electronic device that converts *analog images* to *digital images* by analyzing color and luminosity throughout the print or film and producing *pixels.*

**scattering**  The diffusion of light by reflection off a surface that is not perfectly smooth or by transmission through a translucent material. *See also diffusion.*

**screen**  A surface on which optical images are projected for viewing. A viewing screen in a camera may be a piece of ground glass; a screen for viewing projected transparencies is made of flat white material.

**scrim**  Translucent materials such as plastics or cloth placed between the light source and the subject to diffuse the light.

**seamless**  Wide rolls of paper without breaks designed for use as backdrops in studio photography.

**selenium cell**  A light-sensitive photovoltaic cell used in some photographic light meters.

**sensitivity**  1) The degree to which a photosensitive material responds to light, measured by the amount of exposure required to produce a given amount of density in the image. More sensitive (faster) materials require less exposure than less sensitive (slower) materials to produce the same amount of density. Also called the speed. 2) *See color sensitivity.*

**sensitivity dyes**  Dyes mixed with a photosensitive emulsion to improve its response to specific colors of light.

**sensitometry**  The science and study of photosensitive materials.

**separation**  1) Distinguishable tonal or density differences in an area of a photographic image that shows detail or texture. 2) A set of three monochromatic photographic images of a color original, representing the amounts of each of the three additive primaries (red, blue, and green) appearing in the original. Used in photomechanical printing of color images and some other color reproduction processes, such as pigment transfer.

**sepia**  A reddish-brown color, as produced by some print toners.

**series filters**  An older style of filters that were made in several series of different sizes. Adapters were used to fit larger series-size filters to lenses of smaller diameter. Largely replaced today by *step-down rings* and *step-up rings.*

**set**  Backdrops, flats, furniture, props, and so on constructed and assembled as a scene for making a photograph.

**shadow**  1) In lighting, an area of the subject shielded from the direct effect of the main illumination. 2) In metering and printing, any subject dark-tone area or corresponding areas in negative or positive photographic images.

**shape**  In design, a space enclosed by a line or lines, or defined by the outer boundaries of a tonal value.

**sharp**  A subjective description of a photographic image that appears to render small detail and texture clearly and precisely. The opposite of *soft* or blurred.

**sharpness**  *See image sharpness.*

**sheet film**  Photographic film manufactured as individual sheets, one for each exposure, packed in a lighttight box. Sheet film must be loaded into a lighttight film holder or magazine for use. Sometimes called cut film.

**sheet film holder**  *See film holder.*

**shelf life**  The maximum time a material that deteriorates with age can be stored and still retain optimum quality.

**shift**  Movement of the camera lens or camera back to one side or the other.

**short-focus lens**  A lens with a focal length less than that of a normal lens. Also called short lens or wide-angle lens.

**short lighting**  Lighting a portrait subject so that the main illumination falls on the side of the face turned away from the camera. Makes the face appear narrower. Also called narrow lighting.

**shoulder**  On a characteristic curve, the region above the straight line portion where the rate of change in density with exposure begins to decrease.

**shutter**  A device in a camera or lens consisting of curtains or overlapping blades designed to protect the film from exposure to the image until the shutter release is pressed.

**shutter priority**  An automatic in-camera metering system in which the shutter speed is set manually and the meter sets the aperture automatically. *See also aperture priority.*

**shutter release**  A button, lever, or plunger that is depressed to open the shutter.

**shutter speed**  A measure of the length of time a shutter remains open for an exposure, given in seconds or fractions of a second.

**silhouette**  An image showing the shape of the subject as solid black against a light background, achieved by lighting the background and allowing little light to reach the side of the subject nearest the camera.

**silicon blue cell (SBC)**  *See silicon photodiode.*

**silicon photodiode (SPD)**  A light-sensitive solid-state device with extremely fast response, good sensitivity to low light levels, and no memory of bright light sources. It is used in many photographic light meters.

**silver-halide crystals**  Light-sensitive crystals consisting of metallic silver in chemical compound with iodine, chlo-

rine, or bromine. Most modern photographic materials use silver-halide crystals as the light-sensitive component.

**simple lens** A lens consisting of a single piece of glass. When two or more simple lenses are combined to form a compound lens, the component simple lenses are called *lens elements.*

**single-lens reflex camera** A camera design in which the image from the lens is deflected to a ground glass by a mirror that swings out of the way when the shutter release is operated. Many single-lens reflex cameras use a specially designed prism (a pentaprism) above the ground glass that shows a correctly oriented image through an eyepiece.

**skin tone** An area of a subject's skin that is illuminated by the full effect of the main lighting, and reflects back diffused light. In other words, the diffused highlight for the skin.

**skylight filter** A pale pinkish-yellow filter that absorbs ultraviolet and some blue radiation, the skylight filter is designed to correct the color of the illumination in open shade or from skylight for use with daylight balance films.

**slave** An electronic device that is connected to an electronic flash and fires it when it senses the light from a second flash.

**slide** Color transparency.

**slope** *See gradient.*

**slow** A film or paper that is slow has a low sensitivity to light.

**SLR** *Single-lens reflex.*

**small-format camera** A camera that uses 135 (35mm) film and produces a 24 × 36mm image.

**snapshot** Casually composed, quickly executed photograph made for the purpose of documenting a personal event or subject in the photographer's life.

**snoot** An opaque cylinder or cone attached to a light source to limit the pattern of light.

**sodium thiosulfate** A chemical compound that was the first fixer, still used today in many fixing solutions.

**soft** 1) Describes a photographic image that is not sharp because of diffusion, lens defects, focus blur, or motion blur. 2) Illumination is soft when it has been diffused and produces shadows with graduated edges. 3) *Soft* is sometimes used to describe paper contrast, soft papers being of lower contrast than normal. 4) Variously used to indicate low lighting contrast or low print contrast, but these uses of *soft* are not recommended, in order to avoid confusion with definitions (1) and (2). The term *flat* is preferred to indicate low contrast.

**soft light** *See soft (2).*

**software** Any set of instructions (a *program*) that causes a computer to perform calculations for specific purposes. *Applications, operating systems, plug-ins,* and utilities are all software.

**solarization** A partial reversal of image densities resulting from gross overexposure.

**source book** A professionally produced periodical, usually an annual, displaying work by photographers or other artists and distributed to potential clients in the industry.

**space** 1) In design, an area with width and length. 2) *See negative space.*

**SPD** *Silicon photodiode.*

**spectrum** A display of radiation along a scale arranged according to wavelength, such as the electromagnetic spectrum or the visible spectrum.

**specular** 1) *See specular light.* 2) Describes a surface with a high reflective efficiency, such as glossy, shiny, or mirrored surfaces.

**specular highlight** Visible reflection of a light source on the surface of the subject. Also called specular reflection.

**specularity** 1) In reference to light, the quality relating to the amount of scattering in the light. Unscattered or collimated light is called specular. Scattered light is called diffuse. 2) In reference to reflection, the ability of a surface to reflect back a coherent image of a light source. Surfaces that are able to do so are called specular. Ones that cannot are called dull or matte.

**specular light** Illumination in which the light rays are traveling as if they emanated from one point or are traveling parallel. Unscattered light. A specular light source produces shadows with sharp distinct edges ("hard-edged" shadows). Specular light comes from sources that are small in size or appear small due to their distance from the subject, or from sources with lenses or reflectors that collimate or focus the light. Direct light from the sun is an example of specular light.

**specular reflection** *See specular highlight.*

**specular surface** *See specular (2).*

**speed** *See sensitivity.*

**spherical aberration** A lens defect in which axial and off-axis rays of light are brought to a different focus.

**split-image rangefinder** A rangefinder using two views of the subject juxtaposed next to each other. When the images are aligned the rangefinder is focused on that part of the subject.

**spotlight** A light source in a housing containing curved reflectors and lenses that collimate and focus the light, producing a small intense specular beam of light.

**spot meter** A reflected-light meter with an angle of view of one or two degrees, allowing very small areas of the subject to be read.

**Spotone** A proprietary spotting dye for retouching black-and-white prints or negatives.

**spot reading** A light-meter reading of a specific small area of the subject made with a spot meter.

**spotting** The application of dyes with a fine brush to light spots or marks in a print.

**spotting colors** Dyes used for spotting.

**stabilization processor** A machine used to develop prints. Printing papers for stabilization processing have some of the developer components incorporated into their emulsion. Prints processed in a stabilization processor are not

truly permanent, but may be fixed and washed for greater permanence.

**stain** Any undesirable discolored blotch or area in a photographic image, usually caused by chemical activity or deposit.

**star filter** A special-effects filter that creates a star shape around each point of bright light in the subject.

**step-down ring** An adapter ring designed to mount smaller filters or accessories on a camera lens of larger diameter.

**step tablet** A density scale for a photosensitive material, showing several steps of density from the minimum to the maximum.

**step-up ring** An adapter ring designed to mount larger filters or accessories on a camera lens of smaller diameter.

**stereograph** A matched pair of photographs made simultaneously with a camera with two lenses that, when viewed in special viewers, produces an apparently three-dimensional view of the subject. Stereographs were popular in the nineteenth and early twentieth centuries.

**stock photography** Generic photography that is performed on speculation at the expense of the photographer. Stock photographs are usually held by a second party (a stock agency), who sells rights to the photographs to a wide range of clients and retains a commission. Some photographers market their own stock images.

**stock solution** A solution of a photographic chemical that is at a dilution suitable for relatively long-term storage. Stock solutions may be used as is (straight) or diluted to a *working solution* for use.

**stop** 1) Originally, the plates with holes that were used as apertures in early optical experiments. 2) A measure of change in exposure. One stop is a change in exposure by a factor of two. Opening up one stop means doubling the exposure. Closing down one stop means halving the exposure.

**stop bath** A mildly acidic chemical solution, usually containing acetic acid, used after the developer to neutralize any developer still on the photosensitive material.

**stop down** *See close down.*

**straight-line portion** The central portion of a characteristic curve that approximates a straight line. Not all characteristic curves have a straight-line portion.

**straight photography** A style of photography in which manipulations of the photographic image are kept to a minimum for reasons of truthful documentation or as an aesthetic choice.

**straight print** A print made with a single exposure time, without dodging or burning.

**strobe** A stroboscope, which is an electronic device containing a flash tube that can be fired repeatedly in rapid succession at a rate of many flashes per second. Inaccurately but frequently used to refer to the electronic flash units used for photographic purposes, which must recharge capacitors between each flash.

**studio** An enclosed space that offers a photographer the opportunity to block out or control any natural light and the possibility of using artificial lights to achieve a desired lighting effect.

**studio lights** Lights that are designed specifically for use in photographic studios or controlled location situations.

**style** 1) In design, the distinctive way or manner in which a work of art is made. Style can be determined by choices in subject matter, materials, techniques, and visual design. 2) To make deliberate choices about the selection and arrangement of props, backdrops, furniture, and other materials used for the construction of photographic sets or as subjects for photographs, including the arrangement of hair or clothing for models appearing in photographs.

**subject** 1) An object that appears in a photographic image. Also called subject matter. 2) The most important object in a photograph. 3) An activity or idea that is conveyed by a photograph, and that is the dominant aspect of the photograph.

**subject brightness range (SBR)** *See subject luminance range.*

**subject contrast** The difference between luminance readings from the darkest fully detailed subject tone to the lightest fully detailed subject tone. Some systems of exposure measure from the dark subject tone that will be represented as the first tone above the black of the paper to the light subject tone that will appear as the last tone before white. *See also normal subject contrast.*

**subject luminance range** A measure of subject contrast. As it is used in this book, it refers to the difference in reflected-light meter readings between a fully detailed subject dark tone and a fully detailed subject light tone, given in stops.

**subtractive color system** 1) A color printing system that uses a single exposure on the enlarger, with the color of the enlarger illumination controlled by a combination of cyan, magenta, or yellow filters. 2) Any color reproduction method that uses the superimposition of three image layers containing cyan, magenta, and yellow dyes.

**subtractive primaries** *See primary colors.*

**sun-synch** *See synchro-sun.*

**supplementary lens** A glass disc that is attached to the camera lens like a filter, but has a curved surface to produce a magnification of the image, allowing the lens to be used for close-up photography. Also called close-up lens or sometimes diopter.

**supplementary light** Any artificial light supplied by the photographer in addition to preexisting light.

**surface** In photographic printing papers, a description of the surface nature of the paper, using terms such as glossy, matte, lustre, pearl, and so on.

**swing** The movement of the front or back standard of a view camera in a pivot about a vertical axis.

**swipe file** *See idea book.*

**symbol** An object, shape, or design that represents something else, often an abstract idea or concept.

**symmetry** The appearance of the same arrangement of visual elements in mirror image in both halves of a photo-

graph. Symmetry can be achieved horizontally, vertically, or diagonally.

**synch cord**   Synchronization cord. The electrical cord that connects a flash to the camera to synchronize flash and shutter.

**synchronization**   Timing the firing of a flash so that it reaches its maximum intensity while the shutter is open to its full extent, achieved by electrically connecting the flash to contacts in the camera. *See also X-synchronization.*

**synchronize**   To cause two activities to happen simultaneously, for example, making a flash fire while the shutter is fully open.

**synchro-sun**   Combining the illumination from the sun with the illumination from a flash unit to light a subject for photographic purposes.

**system index (S.I.)**   A personal exposure index that is set into the ISO scale of the meter to insure correct film exposure. This number is determined through personal testing using a given system (camera, lens, meter, film, developer, processing techniques, and so on), and is the exposure index that, when set into the meter, produces a density of 0.1 above base plus fog for a film exposure of REV −4. This number may differ from the ISO suggested by the film manufacturer, but it is not a new film speed because it includes variables in your system (for example equipment inaccuracies) different from the standard testing equipment and techniques used in determining ISO speeds. Sometimes called personal system index.

**T**   *Time* (shutter speed setting).

**tabular grain (T-grain)**   A specially evolved silver-halide crystal structure, tabular in form and presenting a greater surface area for exposure than normal silver-halide crystals of the same size. The result is finer grain for equivalent sensitivity. Invented by the Eastman Kodak Company, it is used in several of their color films and in the black-and-white films designated T-Max.

**tacking iron**   A heated, wedge-shaped tool of small size used to tack dry-mounting materials to boards or prints.

**taking lens**   In a twin-lens reflex camera, the lens that forms the image on the film.

**talbotype**   An improved version of the *calotype.*

**tank**   A container used for processing film, usually deep compared to its area, as opposed to a tray. Can be rectangular or cylindrical. *See also drum, tube.*

**tear sheet**   A photomechanically printed example of a photograph that has been used in an advertisement, article, or in some other published context.

**teleconverter**   *See converter.*

**telephoto lens**   A lens design in which the rear nodal point is located near the front of or out in front of the lens body. Used to make long-focus lenses of compact size. *See also long-focus lens.*

**tenting**   To enclose a subject in a *light tent.*

**tent lighting**   The use of a *light tent.*

**test strip**   A small piece of photosensitive material cut from a larger sheet, on which one or more trial exposures are made to determine the correct exposure for the full sheet of material.

**texture**   A pattern of small repeated areas of shape, line, or tone.

**T-grain**   *See tabular grain.*

**thin**   Describes negatives that have an overall density that is lower than normal. This usually results from underexposure, but can also be caused by underdevelopment.

**through-the-lens (TTL) metering**   An in-camera metering system that measures the light after it has passed through the camera lens. Through-the-lens meters will provide corrected camera settings as necessary to compensate for lens changes, filters, or close-up attachments.

**tilt**   A movement of the front or back standards of a view camera that is a rotation about a horizontal axis.

**time (T)**   A setting on some shutter-speed control dials that provides for long exposure times. When set on T, the shutter will open on the first depression of the shutter release and will remain open until the shutter release is depressed a second time.

**time-and-temperature development**   A method for developing film in which testing provides the proper time and temperature for the desired amount of development, as opposed to development by *inspection.*

**time exposure**   A longer than normal film exposure time, usually of one second or more.

**timer**   Any device used for measuring intervals of time.

**tintype**   A variation of the wet-plate process, in which the collodion emulsion is coated on a black-lacquered metal sheet and exposed directly in the camera. When viewed with the proper light, the resulting silver image appears as a positive. An inexpensive and popular type of photograph in the nineteenth century. Also called ferrotype.

**TLR**   *Twin-lens reflex.*

**T-number**   A number determined by testing and assigned to an f-stop setting on a lens as an indication of the lens's true ability to transmit light at that setting.

**toe**   The curved area at the base of the characteristic curve corresponding to low film exposure and low densities.

**tonal scale**   A series of tones in steps for a print material. A *gray scale. See also full-scale, scale.*

**tonal value**   Visual perception of the luminance of a specific area in a subject, or the reflectance of an area in a print (lightness and darkness).

**tone**   1) *See tonal value.* 2) To treat a processed print or film in a solution for the purpose of changing its color or protecting the image from degradation.

**tone control**   A system of exposure and development that depends on performing reflected-light meter readings from specific areas of the subject and then manipulating camera settings and film development to control the tonal appearance of these areas in the final photograph.

**tone-line process**   A procedure in which negative and positive high-contrast images of a photograph are sandwiched

together and then contact printed onto printing paper with oblique light, producing thin lines at the borders of dark and light tones.

**toner** Any chemical solution used for toning processed prints or films. *See also tone.*

**tone ruler** A print gray scale with ten steps of gray, from the maximum black of the paper to the maximum white of the paper. This ruler can be made from the patches produced for the normal developing time tests described in this book, each gray tone being the result of a different REV.

**trailer** A piece of paper or film at the end of a roll that protects the remainder of the roll from light, or allows for handling of the film without touching image areas.

**translucent** A material that transmits light, but in the process scatters the light and absorbs some of it.

**transmission** A measure of transparency defined as the fraction or percentage of light the material allows to pass. For example, if one-half of the light that strikes a given area of the film passes through it, the transmission for that area is 0.5 or 50 percent. Sometimes called transmittance.

**transmittance** *See transmission.*

**transparency** A photographic image, usually positive, on a transparent base.

**tray** A flat, shallow container used to hold solutions for processing films or prints.

**tripod** A collapsible three-legged stand on which a camera can be mounted to reduce movement.

**T-stop** *T-number.*

**TTL** *Through-the-lens.*

**tube** A cylindrical container, usually relatively long compared to its diameter, used for processing prints or films.

**tungsten balance film** A color film designed to be used with illumination from studio photofloods with a color temperature of 3200°K, formerly designated as Type B films.

**tungsten-halogen lamp** *See quartz-halogen.*

**tungsten lamp** *See incandescent lamp.*

**tungsten light** Illumination produced by studio incandescent lamps with a color temperature of 3200°K or 3400°K.

**twin-lens reflex camera** A camera with two identical lenses. One forms the image on the film. The image from the other is deflected by a mirror to a ground glass for viewing.

**Type A** An obsolete color film designed to be used with 3400°K tungsten illumination.

**Type B** A kind of color film designed to be used with 3200°K tungsten illumination.

**Type C** A commonly used but outdated designation for color negative printing papers. Also called C-print.

**Type L** A kind of color film designed for long exposures and 3200°K tungsten illumination.

**Type R** Used by some manufacturers to designate color reversal printing papers for printing directly from color transparencies.

**Type S** A kind of color film designed for short exposures and 5500°K daylight balance illumination.

**ultraviolet** Electromagnetic radiation with wavelengths just shorter than the blue-violet end of the visible spectrum. Not visible.

**umbrella** Special parasol used in photography to modify light. Light can be reflected from the inner surface of the umbrella or, if the material in the umbrella is translucent, transmitted through the umbrella for diffusion.

**underdeveloped** Describes a photographic material that has received less than the necessary development. In a negative, underdevelopment results in excessively low contrast.

**underexposed** Describes a photosensitive material that has received less than the optimum exposure. In a negative, underexposure results in loss of detail in the subject dark-tone areas and a loss of negative contrast. In a print from a negative, underexposure results in a print that is too light.

**unity** In design, a coherence of all of the visual elements in an image, promoting the impression that they belong together.

**UV** *Ultraviolet.*

**value** The lightness or darkness of a color; its *luminance. See also print value, tonal value.*

**variable-contrast paper** Black-and-white printing paper for which contrast can be altered by changing the color of the printing illumination with filters.

**vertical framing** Turning a camera with a rectangular format so that the long dimension of the image is vertical. Called portrait orientation for computer printers.

**view camera** A camera design allowing direct viewing of the image on a ground glass viewing screen. The lens and back of a view camera can be tilted or swung to alter the focus or shape of the image. View cameras are usually of large format size.

**viewfinder** An optical system on a camera separate from the taking lens, which gives a visual approximation of the subject matter that will appear in the photographic image.

**viewfinder camera** A camera with a *viewfinder.*

**viewfinder cutoff** A situation in which the *viewfinder* shows less of the subject than is recorded on the film.

**viewing lens** In a twin-lens reflex camera, the lens that forms the image on the ground glass, as opposed to the taking lens.

**viewing screen** A screen, usually of ground glass, onto which an aerial image is formed by the camera lens, making it visible to the eye.

**vignetting** The blocking of image-forming light around the edges of the image in a specific pattern. This can be done intentionally for aesthetic reasons, or may happen accidentally when the wrong lens shade or filters are attached to a lens.

**virtual image** An optical image that can be seen but cannot be projected on a surface for the purposes of viewing or making photographs. The image seen in a mirror or through a magnifying glass is a virtual image.

**visual elements** In design, distinguishable features in a work of art, such as tone, color, line, shape, form, and so on. Also called design elements.

**visual selection** Using camera position (point of view) and lens focal length to alter the arrangement of visual elements within the frame of the viewfinder.

**visual structure** A sense of organization in a work of art that results from mental analysis of the spatial relationship of visual elements, the recognition of identifiable shapes, and the path of eye travel when viewing the photograph.

**volume** *See form.*

**warm** Describes colors that contain red, yellow, or orange.

**washed out** A phrase often used to describe the appearance of underexposed highlights in a print, which are too light and lack detail.

**washing aid** An alkaline or salt solution in which film or print materials are treated to facilitate removal of residual fixer during washing. *See also hypo eliminator.*

**water jacket** A container of water into which a processing tray or tank can be set for purposes of stabilizing the temperature of the processing solutions. The temperature of the water in the water jacket is monitored and controlled at the desired processing temperature.

**watt-second** A unit used for measuring the power delivered by electronic flash power packs to the flash heads.

**wavelength** In a wave motion, the distance from peak to peak or from trough to trough. The wavelength of visible light determines its color.

**Web site** A digital document or set of documents residing on a computer that can be accessed through the *World Wide Web. See also home page.*

**weight** 1) *See base weight.* 2) In design, the relative visual importance of various design elements.

**wet-mounting** The use of liquid adhesives for attaching a photographic print to a support.

**wet-plate process** A photographic process in which glass or metal plates were coated with *collodion*, sensitized by being dipped in silver nitrate solution, exposed in a camera, and developed before the collodion could dry. Widely used from the 1850s into the 1880s.

**wetting agent** A pure and mild detergent solution in which film is treated after washing to prevent water marks during drying.

**white light** 1) In a darkroom, normal room illumination, as opposed to safelight illumination. 2) In color printing, the light from the enlarger when color printing filters are removed from the light path. 3) As a standard in the study of light, unaltered light as it comes from the sun.

**wide-angle lens** A lens with a shorter than normal focal length. On 35mm cameras, wide-angle lenses range from a moderate 35mm wide-angle to extreme-wide-angle lenses 14mm or less in focal length. Also called short lens or short-focus lens. *See also retrofocus lens.*

**winder** *See motor drive.*

**window mat** *See mat.*

**woodburytype** A photomechanical technique for high quality reproduction of photographs in ink that is dependent upon the hardening action of light on a gelatin layer. A relief pattern is produced that is then transferred to lead plates for inking and printing. Seldom used today because of its difficulty and expense.

**work for hire** Creative work (such as photography) that is done for an employer. The employer owns the copyright to any creative work done by the employee.

**working life** For reusable photographic chemical solutions, the amount of material that can be processed before the chemical solution is depleted. Also called working capacity.

**working solution** A photographic chemical solution that is at the proper dilution for use. *See also concentrate, stock solution.*

**World Wide Web** The global network of computers that are connected to the *Internet* and can be accessed using HyperText Markup Language (HTML), a programming language that allows interaction with a remote computer via a graphical interface with icons, highlighted text, and menus activating *links* to allow navigation through the accessible documents. Also called the Web and often used interchangeably with Internet, though not all computers on the Internet are accessible using HTML.

**X-synchronization** The correct *synchronization* for use of electronic flash units.

**zone** In the Zone System, the designation given increments of film exposure, labeled with roman numerals.

**zone focusing** Choosing an aperture and focal distance so that a specific range of subject distances is within the depth of field, and therefore acceptably sharp in the photograph.

**Zone System** A tone control system devised by Ansel Adams in which relative film exposure values, called zones, are labeled with roman numerals.

**zoom lens** A lens with a continuously variable focal length, usually controlled by sliding or turning a sleeve on the lens barrel.

# Bibliography

## Introductory and General Photography

Craven, George M. *Object and Image: An Introduction to Photography.* Englewood Cliffs, N.J.: Prentice-Hall, 1975.

Davis, Phil. *Photography,* 6th ed. Dubuque, Ia.: Brown & Benchmark, 1994.

Gassan, Arnold, and A. J. Meek. *Exploring Black and White Photography.* Dubuque, Ia.: WCB/McGraw-Hill, 1992.

Horenstein, Henry. *Black and White Photography: A Basic Manual,* 2d ed. Bulfinch Press, 1983.

London, Barbara, and Jim Stone. *A Short Course in Photography,* 4th ed. Prentice-Hall, 2000.

London, Barbara, and John Upton. *Photography,* 6th ed. Reading, Ma.: Addison-Wesley Publishing Co., 1997.

Swedlund, Charles. *Photography: A Handbook of History, Materials, and Processes,* 3rd ed. Fort Worth, Tx: Harcourt College Publishing, 2000.

## Darkroom Techniques

Coote, Jack H., and Keith Watson. *Ilford Monochrome Darkroom Practice: A Manual of Black-and-White Processing and Printing.* Boston: Focal Press, 1996.

Curtin, Dennis, Robin Worth, Roberta Worth, and Joe DeMaio. *The Darkroom Handbook,* 2d ed. Boston: Focal Press, 1997.

## Aesthestics and Design

Arnheim, Rudolf. *Art and Visual Perception: A Psychology of the Creative Eye.* 2d ed. University of California Press, 1983.

Barrett, Terry. *Criticizing Photographs: An Introduction to Understanding Images,* 2d ed. Mountain View, Calif.: Mayfield Publishing Co., 1996.

Bayer, Jonathan. *Reading Photographs: Understanding the Aesthetics of Photography.* New York: Photographers' Gallery, Pantheon Books, 1977.

Coleman, A. D. *Light Readings,* 2d ed. Albuquerque: University of New Mexico Press, 1998.

Hill, Paul, and Thomas Cooper. *Dialogue with Photography.* Stockport: Dewi Lewis Publishing, 1998.

Lyons, Nathan, ed. *Photographers on Photography: A Critical Anthology.* Englewood Cliffs, N.J.: Prentice-Hall, 1966.

Maier, Manfred. *Basic Principles of Design.* 4 vol. New York: Van Nostrand Reinhold Co., 1978.

Naef, Weston J. *The Art of Seeing: Photographs from the Alfred Stieglitz Collection.* New York: Metropolitan Museum of Art, 1978.

Newhall, Nancy, ed. *The Daybooks of Edward Weston.* 2 vol. Millerton, N.Y.: Aperture, 1996.

Ocvirk, Otto G., Robert O. Bone, Robert E. Stinson, and Philip R. Wigg. *Art Fundamentals: Theory and Practice,* 8th ed. New York: McGraw-Hill, 1997.

Scharf, Aaron. *Art and Photography.* Baltimore: Penguin Press, 1969, rep. 1995.

Sontag, Susan. *On Photography.* N.Y.: Anchor Press, 1990.

Szarkowski, John. *Looking at Photographs.* New York: Museum of Modern Art, 1973.

———. *The Photographer's Eye.* New York: Museum of Modern Art, 1966.

Ward, John L. *The Criticism of Photography as Art: The Photographs of Jerry Uelsmann.* Gainesville, Fla.: University of Florida Press, 1970.

Zakia, Richard D. *Perception and Photography.* New York: Light Impressions, 1979.

## History of Photography

Frizot, Michel. *New History of Photography.* Koneman, 1999.

Gassan, Arnold. *A Chronology of Photography.* Athens, Ohio: Handbook Co., 1972.

Gernsheim, Helmut, and Alison Gernsheim. *A Concise History of Photography.* 3rd rev. ed. New York: Dover Publications, 1986.

Newhall, Beaumont. *The History of Photography from 1839 to the Present Day,* rev. ed. New York: New York Graphic Society, 1978.

———. *The Latent Image: The Discovery of Photography.* Garden City, N.Y.: Doubleday, 1967.

Rosenblum, Naomi. *A World History of Photography,* 3rd ed. New York: Abbeville Press, 1997.

## Special Techniques

Adams, Ansel. "Ansel's Intensifier." *Popular Photography* (November 1980): 116ff.

Carr, Kathleen Thormod. *Polaroid Transfers.* N.Y.: Amphoto, 1997.

Crawford, William. *The Keepers of Light: A History and Working Guide to Early Photographic Processes.* Dobbs Ferry, N.Y.: Morgan & Morgan, 1980.

Gassan, Arnold. *Handbook for Contemporary Photography*, 4th ed. Rochester, N.Y.: Light Impressions, 1977.

Keefe, Lawrence E., Jr., and Dennis Inch. *The Life of a Photograph: Archival Processing, Matting, Framing, and Storage.* Boston: Focal Press, 1984.

McCann, Michael. *Health Hazards Manual for Artists.* New York: The Lyons Press, 1994.

"Myron: Santa Fe Transfer." *Test* (Polaroid) (Fall–Winter 1990): 2. Article on Polaroid transfer.

Oberrecht, Kenn. *Home Book of Picture Framing.* Mechanicsburg, Pa.: Stackpole Books, 1998.

Pittaro, Ernest M., ed. *Photo Lab Index.* Dobbs Ferry, N.Y.: Morgan & Morgan. Updated regularly.

Rempel, Siegfried, and Wolfgang Rempel. *Health Hazards for Photographers.* New York: The Lyons Press, 1993.

Shaw, Susan. *Overexposure: Health Hazards in Photography.* New York: Allworth Press, 1991.

Stone, Jim, ed. *Darkroom Dynamics: A Guide to Creative Darkroom Techniques.* Stoneham, Mass.: Focal Press, 1985.

Vestal, David. *The Craft of Photography.* New York: Harper & Row, 1975.

## Color Photography Techniques

Eastman Kodak Company. *Kodak Color Darkroom Dataguide.* Sterling Press, 1998.

Hirsch, Robert. *Exploring Color Photography*, 3rd ed. New York: WCB/McGraw-Hill, 1997.

Horenstein, Henry. *Color Photography: A Working Manual.* Bulfinch Press, 1995.

Krause, Peter, and Henry Shull. *Complete Guide to Cibachrome Printing.* Tucson, Ariz.: H. P. Books, 1982.

## Digital Photography

Adobe Creative Team. *Adobe Photoshop 5.5 Classroom in a Book.* San Jose, Calif.: Adobe Press, 1999.

Bouton, Gary David, Gary Kubicek, and Barbara Mancuso Bouton. *Inside Adobe Photoshop 5.5.* Indianapolis, Ind.: New Riders Publishing, 2000.

Dayton, Linnea, and Jack Davis. *The Photoshop 5.0/5.5 Wow! Book.* Berkeley, Calif.: Peachpit Press, 1999.

Dinucci, Darcy, Maria Giudice, and Lynne Stiles. *Elements of Web Design.* Berkeley, Calif.: Peachpit Press, 1998.

Haynes, Barry, and Wendy Crumpler. *Photoshop 5 & 5.5 Artistry.* Indianapolis, Ind.: New Riders Publishing, 2000.

McClelland, Deke, and Ted Padova. *Macworld® Photoshop® 5 Bible.* Foster City, Calif.: IDG Books Worldwide, 1998.

Pogue, David. *Macs for Dummies*, 6th ed. Foster City, Calif.: IDG Books Worldwide, 1998.

Rathbone, Andy. *Windows 98 for Dummies.* Foster City, Calif.: IDG Books Worldwide, 1998.

Stanley, Robert. *The Complete Idiot's Guide to Photoshop 5.* Que Education & Training, 1998.

Weinmann, Elaine, and Peter Lourekas. *Photoshop 5.5 for Windows and Macintosh (Visual Quickstart Guide Series).* Berkeley, Calif.: Peachpit Press, 1999.

## Tone Control and Sensitometry

Adams, Ansel, with Robert Baker. *The Camera.* The Ansel Adams Photography Series. Rep ed. Boston: Little, Brown & Co., 1995.

———. *The Negative.* The Ansel Adams Photography Series. Rep ed. Boston: Little, Brown & Co., 1995.

———. *The Print.* The Ansel Adams Photography Series. Rep ed. Boston: Little, Brown & Co., 1995.

Dowdell, John J., III, and Richard D. Zakia. *Zone Systemizer.* Dobbs Ferry, N.Y.: Morgan & Morgan, 1973.

Gassan, Arnold. *Handbook for Contemporary Photography*, 4th ed. Rochester, N.Y.: Light Impressions, 1977.

Horenstein, Henry. *Beyond Basic Photography: A Technical Manual.* Bulfinch Press, 1993.

Sanders, Norman. *Photographic Tone Control.* Dobbs Ferry, N.Y.: Morgan & Morgan, 1977.

Sturge, John M., ed. *Neblette's Handbook of Photography and Reprography.* New York: Van Nostrand Reinhold Co., 1977.

Todd, Hollis N. *Photographic Sensitometry.* Dobbs Ferry, N.Y.: Morgan & Morgan, 1981.

Todd, Hollis N., and Richard D. Zakia. *Photographic Sensitometry: The Study of Tone Reproduction*, 2d ed. Dobbs Ferry, N.Y.: Morgan & Morgan, 1974.

White, Minor, Richard Zakia, and Peter Lorenz. *The New Zone System Manual*, 4th rev. ed. Dobbs Ferry, N.Y.: Morgan & Morgan, 1990.

## Lighting Techniques

Bidner, Jenni. *The Lighting Cookbook.* New York: Amphoto, 1997.

Freeman, Michael. *The Photographer's Studio Manual.* New York: Amphoto, 1984.

Hunter, Fil, and Paul Fuqua. *Light Science & Magic.* Boston: Focal Press, 1997.

Krist, Bob. *Secrets of Lighting on Location.* New York: Amphoto, 1996.

Reznicki, Jack. *Illustration Photography.* New York: Amphoto, 1987.

———. *Studio & Commercial Photography.* Kodak Pro Working Series. Sterling Publications, 1999.

Schwarz, Ted, and Brian Stoppee. *The Photographer's Guide to Using Light.* New York: Watson-Guptil Publishers, 1986.

Zuckerman, Jim. *Techniques of Natural Light Photography.* Cincinnati, Oh.: Writers Digest Books, 1996.

University, Courtesy of The Minor White Archive. **317** (T) Courtesy of NASA. **317** (BL/BR) © Bognovitz. **318** Sheila Metzner, *Saxophone Vase*, 1985, © Sheila Metzner. **319** (L) Jerry Lake, Untitled. © 1985 Jerry Lake. **319** (R) Harold Edgerton, *Gussie Moran*, 1952, © Harold & Esther Edgerton Foundation, 1999, Courtesy of Palm Press, Inc. **321** Man Ray, *Male Torso*, © 2000 Man Ray Trust/Artists Rights Society, NY/ADGP, Paris. **322** (L) © Bognovitz. **323** Jerry Uelsmann, Untitled. © 1968 Jerry N. Uelsmann. **324** (ALL) © Bognovitz. **325** (T/B) © Bruce Warren. **326** (ALL) © Bognovitz. **327** (ALL) © Bognovitz. **328** Man Ray, *Rayograph*, 1927. © 2000 Man Ray Trust/Artists Rights Society, NY/ADAGP, Paris. **329** (L) Danny Conant Photography. **329** (R) Danny Conant Photography. **330** (ALL) © Bognovitz. **331** (TL/TR) © Bognovitz. **332** Allen Appel, *Kingbird with Flowers*, Courtesy Kathleen Ewing Gallery, Washington, D.C. **333** © Lila Arbona. **334** John Reuter, *Spirits of Pere La Chaise*. Photography by John Reuter. **335** Michael Going, *St. Maarten, 1985*. © Michael Going, All Rights Reserved.

## Chapter 12

**337** Ernst Haas. © Ernst Haas/Tony Stone Images. **351** © Murray Bognovitz. **362** Photo © 1990 by: Roy D. Query. **363** Pete Turner, "Road Song", Kansas City, 1967, Photograph © Pete Turner. **364** (TL) Fred McGann, *Yes I can and dog.* © 1992 Fred McGann. **364** (TR) © Ralph Pleasant/FPG International, LLC. **364** (BR) Paul Chauncey. www.chaunceyphoto.com. **365** (T) Stephen Shore, *Meeting Street, Charleston, South Carolina, August 3, 1975.* ©Stephen Shore, Courtesy of Pace/MacGill Gallery, New York. **365** (B) *Contrast by Differential Saturation.* Gary Perweiler. © Gary Perweiler, 1987. **366** Alex MacLean, *Chapel Hill, N.C.*, Alex S. MacLean/Landslides.

## Chapter 13

**367** Peter Garfield, *Siren.* © Peter Garfield. **368** Maria Eugenia Poggi, *Contemplation, Ceará, Brazil, 1994*, Courtesy of Maria Eugenia Poggi. **379** Howard W. Kreiner, *Busch Garden Fantasy*, © 1999 Howard W. Kreiner. **387** (B) © Bruce Warren. **388** © Bruce Warren. **389** © Bruce Warren. **392** © Kieffer Nature Stock. **393** © Chris Ward. **394** © Bruce Warren. **395** Zach Burris. © Lands' End, Inc.

## Chapter 14

**398** Ansel Adams, *Clearing Winter Storm, Yosemite National Park, Californani*, c. 1944. Copyright © 1992 by the Trustees of the Ansel Adams Publishing Rights Trust. All Rights Reserved. **405** © Bognovitz. **406** © Bruce Warren.

## Chapter 15

**434** © Gerald Zanetti/www.zanettifoto.com. **438** (CL) © Photogroup. **438** (CR) © Merle Tabor Stern. **461** (R) © Pete McArthur. **461** (L) Charles Purvis, *Russian Cigarettes*, © Charles Purvis **464** Photos © Bognovitz. **465** Photos © Bognovitz. **468** Aaron Jones. © Aaron Jones. **472** (L) Edward Steichen, *George Gershwin*, Reprinted with permission of Joanna T. Steichen. **472** (R) Paul Strand, *Young Boy, Gondeville, Charente, France*, 1951, © 1971 Aperture Foundation Inc., Paul Strand Archive. **473** © Jill Bochicchio. **474** (L) Olivia Parker, *Thistle*, © 1982 Olivia Parker. **474** (R) © Roger Turqueti. **474** Photos © John Burwell. **476** (L) Jack Reznicki, *Mr. and Mrs. Claus.* © 1987 Jack Reznicki. **476** (R) © Stephen Wilkes. **477** Photos Courtesy of Philips Electronics North America Corp. **478** Helmut Newton, "Heart Attack". © Helmut Newton/Maconochie Photography. **479** © Murray Bognovitz

## Chapter 16

**481** Ralph Eugene Meatyard, *Boy with Hubcap*, Courtesy of Christopher Meatyard. **482** Photos © Bognovitz. **483** © Bognovitz. **484** © Bognovitz. **487** (BR) © Bognovitz. **488** (L) © Bognovitz. **489** (T) © Bognovitz. **491** (L) Ezra Stoller, "The Family of Man," display at Museum of Modern Art, © Esto. **491** (R) © Merle Tabor Stern. **492** (T) © Bognovitz. **492** (R) Steve Szabo's portfolio, "The Eastern Shore", Courtesy Kathleen Ewing Gallery, Washington, D.C. **494** Portfolio photos © Merle Tabor Stern. **495** Photos © Murray Bognovitz. **496** Portfolio © Gary D. Landsman. **499** Photograph © Bognovitz. Cover design by Tyler Whitmore. Reproduction courtesy of Crystal City Magazine. **500** Photos © Bognovitz. **501** © Bognovitz.

## Chapter 17

**503** Claude Mougin, Swissair Advertisement. © Claude Mougin. Courtesy of Graf Bertel Dominique Advertising. **505** (L) © Chris Honeysett. **505** (R) © Bognovitz. **507** (L) © Carl Purcell/www. purcellteam.com. **507** (R) © Bognovitz. **508** (L) © Bognovitz. **508** (R) © Nancy Andrews. **509** (L) © Jim Johnson. **509** (R) © Bognovitz. **510** (L) © Bognovitz. **510** (R) © Mark Wieland. **511** (L) © Jim Pickerell. **511** (R) © Bognovitz. **513** Photos © American Floral Marketing Council. **514** © Gary Landsman. **522** (TL/BL) © Bognovitz. **522** (R) © Rebecca Hammel. All rights reserved. **523** © Bognovitz.

## Chapter 11

*Pregnant Woman*, 1959, photograph by Imogen Cunningham, © The Imogen Cunningham Trust. **223** Brian Brake, Untitled, © Brian Brake/Photo Researchers. **224** © Bruce Warren. **225** (T) W. Eugene Smith from the *Life* essay, "A Man of Mercy", (Albert Schweitzer) 11/15/54. Estate of WE Smith/Black Star. **225** (B) Alfred Stieglitz, *Equivalent*, 1930. Alfred Stieglitz Collection, © 2000 Board of Trustees, National Gallery of Art, Washington, 1930, silver gelatin developed-out print. **226** (L) Robert Imhoff, Mercedes Benz, © Robert Imhoff. **226** (R) Edward Steichen, *Iwo Jima*. © Edward Steichen, reprinted with permission of Joanna T. Steichen. **227** (T) Jim Brandenburg, *Arctic Wolf (Canis lupus) Leaping onto Ice Floe, Ellesmere*, © Jim Brandenburg/Minden Pictures. **227** (B) Danny Lyon, from *Danny Lyon Photo Film*, © Danny Lyon/Magnum Photos. **229** (TL) Arthur Fellig (Weegee), *The Critic*, 1943, Weegee/ICP/Liaison Agency. **229** (TR) Galen Rowell, *Last Light on Horsetail Falls, Yosemite's "Natural Firefall"*, © Galen Rowell/Mountain Light. **229** (BL) Margaret Bourke-White, *Generator Stator, AEG, 1930*, © Margaret Bourke-White Estate/Courtesy Life Magazine/ Contributors: Jonathon B. White & Roger B. White. **230** W. Eugene Smith from the *Life* essay, "Nurse Midwife", 12/3/51. Estate of WE Smith/Black Star. **231** Aaron Siskind, *Martha's Vineyard 111a, 1954*, © Aaron Siskind Foundation. **232** (T) Edward Weston, *Nude, 1927*. © Center for Creative Photography, Arizona Board of Regents. **232** (B) © Sebastio Salgado/Contact Press Images. **233** (L) Walter Chappel, Nancy Bathing, Wingdale, NY, 1962. © Walter Chappell. **233** (R) André Kertész, *Chez Mondrian*, 1926. © The Estate of André Kertész. **234** Neal Slavin, *Fencers*, © Neal Slavin/Superstock. **235** (TL/TR) © Bognovitz. **235** (B) Sylvia Plachy, *Sumo Wrestlers*, New York, 1985, © Sylvia Plachy. **236** (CL/CC/CR/BL) © Bognovitz. **237** (T) Garry Winogrand, *Untitled*, (Los Angeles, 1969). Courtesy Fraenkel Gallery, San Francisco; © 1984 The Estate of Garry Winogrand/ photo Courtesy of the Center for Creative Photography. **238** A. Aubrey Bodine, *Parking Meters Baltimore*, ca. 1960. Courtesy Kathleen Ewing Gallery, Washington, D.C. **239** Robert Mapplethorpe, *Calla Lily*, 1987, © The Estate of Robert Mapplethorpe. Used with permission. **240** Duane Michals, *Chance Meeting*, 1969, © Duane Michals. **241** W. Eugene Smith, "Spanish Village" Photo Essay from Life Magazine, W. Eugene Smith/Life Magazine, © Time Inc. **242** Ray K. Metzker, *Untitled* (Wanamaker's), 1966-67, © Ray K. Metzker, Collection, The Museum of Modern Art, New York. **243** (T) Walker Evans. Courtesy of the Library of Congress. **243** (B) Lewis Baltz, "West Wall, Unoccupied industrial structure, 20 Airway Drive, Costa Mesa", 1974, from *The New Industrial Parks Near Irvine, California*, Courtesy of Gallery Luisotti, Santa Monica, CA. **244** (T) © Ralph Gibson. **244** (B) Aaron Siskind, *Jerome, Arizona (21), 1949*, © Aaron Siskind Foundation. **245** (L) Peter Arnell, Donna Karan advertisement, Courtesy of Peter Arnell. **245** (R) Margaret Bourke-White, *Clinton, Louisiana*, Margaret Bourke-White/Life Magazine, © Time Inc. **246** Brett Weston, *Mono Lake, California, 1957*, © The Brett Weston Archive. **247** Elliot Erwitt, *Cannes, 1975*, © Elliot Erwitt/Magnum Photos. **248** Edward Weston, *Shell and Rock Arrangement, 1931*. © Center for Creative Photography, Arizona Board of Regents. **249** © Stuart Block/Sharpshooters. **250** (L) Joe Rosenthal, *Raising the Flag over Iwo Jima*. Courtesy of the Library of

Congress. **250** (R) Alicia Bailey, Imaginary Fragrance, 1984 © Alicia Bailey, 1984. **252** © Merle Tabor Stern.

## Chapter 10

**255** Edward Curtis, *Coastal Salish, Lummi Type*. **256** George Brander, *Table Camera Obsura, 1769*, Gernsheim Collection, Harry Ransom Humanities Research Center, The University of Texas at Austin. **257** (TR) C. Lauiche, Gouache Portrait of Joseph Nicéphore Niépce, Gernsheim Collection, Harry Ransom Humanities Research Center, The University of Texas at Austin. **257** (BR) Joseph Nicéphore Niépce, Photo engraving of Cardinal d'Amboise, 1827, Gernsheim Collection, Harry Ransom Humanities Research Center, The University of Texas at Austin. **257** (BL) Joseph Nicéphore Niépce, The World's First Photograph, 1826, Gernsheim Collection, Harry Ransom Humanities Research Center, The University of Texas at Austin. **258** (T) 10-5 Sabatier-Blot, *Portrait of L.J.M. Daguerre, 1844*. Courtesy George Eastman House. **258** (B) Louis Jacques Mandé Daguerre, *Still Life*, 1837. Daguerreotype. Courtesy of the Collection de la Société Francaise de Photographie. **259** (L) N.H. Shepherd, *Abraham Lincoln*, 1846. Courtesy of the Library of Congress. **259** (R) Southworth & Hawes, *Daniel Webster*, 1851, The Metropolitan Museum of Art, Gift of I.N. Phelphs Stokes, Edward S. Hawes, Alice Mary Hawes, and Marion Augusta Hawes, 1937. (37.14.2) **260** (TL) Courtesy of the Science Museum, London **260** (BR) William Henry Fox Talbot, *Lattice Window in Labcock Abbey* 1835. Courtesy of the Science Museum, London. **260** (BL) William Henry Fox Talbot, Photogenic Drawing with Feathers, Leaves and Lace, Gernsheim Collection, Harry Ransom Humanities Research Center, The University of Texas at Austin. **261** (T) William Henry Fox Talbot, *The Open Door*, April, 1844. Courtesy of the Science Museum, London. **261** (B) David Octavius Hill and Robert Adamson, *The McCandlish Children*, 1845. Collection, The Museum of Modern Art, New York. **262** (T) J.M. Cameron, *Sir John Herschel In a Cap*, Ashmolean Museum, Oxford. **262** (B) Hyppolyte Bayard, *Self Portrait as a Drowned Man*. Courtesy of the Collection de la Société Francaise de Photographic. **263** Gustave Le Gray, *The Imperial Yacht "La Reine Hortense"*, 1856, © The Board of Trustees of the Victoria and Albert Museum. **264** (TL) Timothy O'Sullivan, *Wagon and Mules in California Desert*. Courtesy George Eastman House. **264** (BL) Alexander Gardner, *Home of a Rebel Sharpshooter, Gettysburg*, July 1863, plate 41 from *Gardner's Photographic Sketchbook of the War*, 2 volumes, by Gardner, O'Sullivan, Wood and Gibson, others. 1865-66. Albumen print, 7 3/4 × 8 7/8" (19.7 × 22.5 cm). The Museum of Modern Art, New York. Given anonymously. Copy Print © 2000 The Museum of Modern Art, New York. **264** (R) Timothy O'Sullivan, *Canyon de Chelly*, 1873. Courtesy George Eastman House. **265** (TR) B. Disderi, Carte-de-Visite Portrait of Princess Gabrielle Bonaparte, ca, 1862, Gernsheim Collection, Harry Ransom Humanities Research Center, The University of Texas at Austin. **265** (TL) Studio of Matthew B. Brady, *Portrait of Unknown Man*. (c. 1860). Ambrotype, 7 1/4 × 6" (18.4 × 15.2 cm). The Museum of Modern Art, New York. Purchase. Copy Print © 2000 The Museum of Modern Art, New York. **265** (B) H.C. White Co., Telegraph Hill from Knob Hill, San Francisco Disaster, 1906. Collection of the author. **266** (L) Unidentified, *First Kodak Camera, 1888*.

# Photo Credits

Listed below are the complete credits for the exemplary photographs included within this text. A photograph's placement on a page is designated by the following code: T = Top, B = Bottom, L = Left, R = Right, C = Center.

**ii** Edward Weston, *Lily and Rubbish, 1939*, © 1981 Center for Creative Photography, Arizona Board of Regents

## Chapter 1

**2** Edward Steichen, *Lotus, Mount Kisco, New York, 1915*, Reprinted with permission of Joanna T. Steichen.

## Chapter 2

**13** William A. Garnett, *Four-Sided Dune, Death Valley, CA, #2*, ©1954 William A. Garnett. **18** (L) © Bognovitz. **18** (R) © Bognovitz. **22** William Wegman, *Sweatered Trio*, 1990, from "Kibbles n Knits," 20 × 24 Polaroid, © 1990 William Wegman, Courtesy of Pace/MacGill Gallery, New York.

## Chapter 3

**28** Dorothea Lange, *Migratory Cotton Picker, Eloy, Arizona*, 1940, © The Dorothea Lange Collection, The Oakland Museum of California, City of Oakland. Gift of Paul S. Taylor. **38** © Bognovitz. **40** (BL) © Bognovitz. **40** (BR) © Bognovitz. **42** (TL) © Bognovitz. **48** (BL) © Bruce Warren. **48** © (BC) © Bruce Warren. **49** (TLCR) © Bognovitz.

## Chapter 4

**51** Barbara Morgan, *Martha Graham in "Letter to the World"*, © Barbara Morgan/Willard & Barbara Morgan Archive/Time Inc. is the licensee. **58** (T) Craig Stevens, *Calla Lilies, Pacific Grove, California*, © 1981 Craig Stevens. **59** (T) © Bruce Warren. **62** (TL/TR/B) © Bognovitz. **67** (TL) © Bruce Warren. **67** (CR) © Bruce Warren. **71** Bill Brandt, *Nude East Sussex, 1957*, © Bill Brandt/Bill Brandt Archive Ltd.

## Chapter 5

**85** Yousuff Karsh, *Pablo Casals*, © Karsh/Ottawa. Courtesy of Woodfin Camp & Associates, Inc. **103** (CL/CC/CR) © Bognovitz. **107** (TL/TR) © Bognovitz.

## Chapter 6

**115** Brian Lanker, *Eva Jessye*, © Photograph by Brian Lanker. **117** (L/C/R) © Merle Tabor Stern. **119** © Bognovitz. **120** (L/R) © Bognovitz. **129** (T) Edward Weston, *Two Shells*, 1927,

© Center for Creative Photography, Arizona Board of Regents. **140** (TL/TR) © Bognovitz. **141** (CL/CR/BL/BR) © Bognovitz.

## Chapter 7

**157** Robert Gibson, *Astronaut in EVA*, © Courtesy of NASA. **180** © Bognovitz.

## Chapter 8

**181** Ralph Gibson, from *The Somnambulist*, 1970, © Ralph Gibson. **182** Frederick Evans, *Kelmscott Manor: Attics 1896*, courtesy of the Library of Congress. Used with permission. **189** (BL) Charles Sheeler, *Cactus and Photographer's Lamp, New York*, New York. (1931) Gelatin-silver print, 9 1/2 × 6 5/8" (23.5 × 16.6 cm), The Museum of Modern Art, New York. Gift of Samuel M. Kootz. Copy Print © 2000 The Museum of Modern Art, New York. **189** (BR) Robert Mapplethorpe, *Lydia Cheng*, *1985*, © The Estate of Robert Mapplethorpe. **190** Javier Vallhonrat, *Water Flowers*, © Javier Vallhonrat, Courtesy of the Michelle Filomeno Agency, Paris. **191** Galen Rowell, *Dawn over Eagle Falls, Lake Tahoe, California*, © Galen Rowell/Mountain Light. **192** Ansel Adams, *Mount Williamson, the Sierra Nevada, from Manzanar, California*, 1945. Photograph by Ansel Adams. Copyright © 1992 by the Trustees of the Ansel Adams Publishing Rights Trust. All Rights Reserved. **193** © Bruce Warren. **194** (CL/BR) © Bognovitz. **196** (TC/TR) © Bognovitz. **197** (T) Gilberte Brassaï, *Avenue de l'Observatoire*, 1934, © Gilberte Brassaï, courtesy of Mrs. Gilberte Brassaï.

## Chapter 9

**214** Dennis Stock, Liz Claiborne advertisement, © Dennis Stock/Magnum Photos. **215** © Bognovitz. **216** Ansel Adams, *Monolith, The Face of Half Dome, Yosemite National Park, California, 1927*. Photograph by Ansel Adams. Copyright © 1992 by the Trustees of the Ansel Adams Publishing Rights Trust. All Rights Reserved. **217** (L) © Henri Cartier-Bresson/Magnum Photos. **217** (R) A.J. Russell, *Meeting of the Central Pacific and the Union Pacific, May 10, 1869*. Courtesy Union Pacific Historical Collection. **219** (T) Eikoh Hosoe, *Embrace #46, 1970*, © Eikoh Hosoe. **219** (R) Werner Bischof, *Girls from a Village Near Patna, India, 1951*, © Werner Bischof/Magnum Photos, Inc. **220** (T) Emmit Gowin, *Hog Butchering, Near Danville, Virginia, 1975*, © Emmet Gowin, Courtesy Pace/MacGill Gallery, New York. **220** (B) Lee Friedlander, Buffalo, New York, 1968, © Lee Friedlander, courtesy Fraenkel Gallery, San Francisco. **222** (L) Bill Brandt, *Policeman in a Bermondsey Alley, 1951*, © Bill Brandt/Bill Brandt Archive Ltd. **222** (R) Imogen Cunningham,

# Index

A page number in *italics* indicates that a photograph or an illustration appears on that page.

## Business and Professional Photography

Crawford, Tad. *Business and Legal Forms for Photographers*. New York: Amphoto, 1997.

———. *Legal Guide for the Visual Artist*. New York: Watson-Guptil Publications, 1999.

Heron, Michal, and David Mactavish. *Pricing Photography*, rev. ed. New York: Amphoto, 1997.

Kopelman, Arie, and Tad Crawford. *Selling Your Photography*. New York: St. Martin's Press, 1980.

Willinas, Michael, ed. *Photographer's Market*. Cincinnati, Oh.: Writer's Digest Books. Updated regularly.